INTRODUCTION TO

Manuscript
Studies

Introduction to Manuscript Studies

RAYMOND CLEMENS *and* TIMOTHY GRAHAM

Cornell University Press

Ithaca & London

First published 2007 by Cornell University Press
First printing, Cornell Paperbacks, 2007

Printed in China
Design by Barbara E. Williams; composition by BW&A Books, Inc.

LIBRARY OF CONGRESS CATALOGING-IN-PUBLICATION DATA
Clemens, Raymond, 1966–
 Introduction to manuscript studies / Raymond Clemens and
 Timothy Graham.
 p. cm.
 Includes bibliographical references and index.
 ISBN 978-0-8014-3863-9 (cloth : alk. paper) —
 ISBN 978-0-8014-8708-8 (pbk. : alk. paper)
 1. Manuscripts, Medieval. 2. Manuscripts, Latin (Medieval
 and modern) 3. Paleography, Latin. 4. Codicology.
 I. Graham, Timothy. II. Title.
 Z105.C58 2007
 091—dc22
 2007010667

Cornell University Press strives to use environmentally responsible suppliers and
materials to the fullest extent possible in the publishing of its books. Such materials
include vegetable-based, low-VOC inks and acid-free papers that are recycled, totally
chlorine-free, or partly composed of nonwood fibers. For further information,
visit our website at www.cornellpress.cornell.edu.

Cloth printing 10 9 8 7 6 5 4 3 2 1
Paperback printing 10 9 8 7 6 5 4 3 2 1

Contents

Illustrations

Illustrations of manuscripts, printed books, and fragments at the Newberry Library are reproduced by permission of the Newberry Library, Chicago. Items from the Newberry's Wing collection are reproduced by courtesy of the John M. Wing Foundation, the Newberry Library. Illustrations of manuscripts at Corpus Christi College, Cambridge, are reproduced by permission of the Master and Fellows of Corpus Christi College. Illustrations of British Library manuscripts are reproduced by permission of the British Library. Illustrations from Bamberg, Staatsbibliothek, MS Patr. 5 are reproduced by permission of Staatsbibliothek, Bamberg. The illustration from Prague Cathedral, Chapter Library, MS A. XXI/I is reproduced by permission of Prague Castle Administration. The illustration from University of Chicago Library, MS Bacon 24 is reproduced by permission of the University of Chicago. The photographs of parchment making in chapter 1 were taken at William Cowley Parchment Works, Newport Pagnell, England (figures 1-10, 1-13, and 1-14), and at the workshop of Rick Cavasin, Kanata, Ontario (figures 1-9, 1-11, and 1-15). They are reproduced by permission of, respectively, Wim Visscher of Cowley's and Rick Cavasin. The photographs for figures 2-5, 7-6, 7-7, and 7-8 were taken by Susan Russick and appear here with her permission. Figures 14-1 and 14-2 are reproduced by kind permission of David and Sharon MacDonald. Figures 1-25, 1-26, and 4-11 were designed by Pamela S. Rups, and figure 1-28 was designed by Tommaso Lesnick; they hold the respective copyrights to these designs, and we are grateful for their permission to use them. The manuscript description from Paul Saenger's *A Catalogue of the Pre-1500 Western Manuscript Books at the Newberry Library* reproduced in chapter 9 appears by permission of the University of Chicago Press.

Preface

THIS BOOK aims to provide practical instruction and training in the paleography and codicology of medieval manuscripts, in particular manuscripts written in Latin. By drawing on materials in libraries and archives, the book addresses the needs of students beginning to work with manuscripts: understanding the various aspects of medieval book production; learning to read and transcribe a variety of scripts; becoming familiar with the processes of dating manuscripts and determining their provenance; and understanding the format of a variety of commonly occurring types of manuscripts. Wherever possible, we provide illustrations of features under discussion, for in manuscript studies it is especially true that a picture may make a point more succinctly and effectively than words; indeed, it is often only through a picture that the verbal description of a paleographical or codicological feature makes sense to those who have not yet encountered that feature in their own work. Rather than adopting an encyclopedic approach, we provide an overview of how books were made and select specific examples of one or two case studies to demonstrate how one might undertake more intensive study. This approach enables us to present the general rules of paleography and codicology and demonstrate their usefulness and, in some cases, their impracticality.

Part 1, "Making the Medieval Manuscript," offers an overview of the process by which manuscripts came into being. The first chapter surveys the various types of material used as writing supports in antiquity and the Middle Ages before focusing specifically on the production and preparation of parchment, the major writing support for most of the medieval period. The chapters that follow describe the stages through which manuscripts acquired their text, decoration, and illustration; consider the manufacture of medieval inks and pigments; discuss the correcting, glossing, and annotating of manuscripts by their original scribes or by later readers; and outline medieval practices for binding and storing manuscripts. In part 2, "Reading the Medieval Manuscript," the focus shifts to the modern student and how he or she may prepare for an encounter with manuscripts in situ and acquire the skills necessary to accurately read and interpret medieval books.

Specific guidance is given on such practical issues as how to set up an appointment to read manuscripts and what preparatory work students should aim to accomplish before making their visit, as well as how to interpret problematic aspects of manuscripts, what features to examine and record when preparing a description of a manuscript, and so on. Part 2 ends by presenting a selection of sixteen medieval scripts that both helps to tell the story of the evolution of handwriting in Western Europe from ca. 700 to the fifteenth century and offers students the opportunity to hone their transcription skills. Part 3, "Some Manuscript Genres," seeks to provide an illustrated introduction to certain types of manuscripts or texts that have their own characteristic features and layout; these include biblical commentaries, liturgical manuscripts and Books of Hours, calendars, charters and cartularies, maps, and rolls and scrolls. An appendix by Anders Winroth provides an annotated bibliography of Latin dictionaries that will aid the researcher in finding the appropriate dictionary for the time, region, and type of source under study. Finally, a glossary provides a key to technical language used in the book, and a bibliography, organized under subject headings keyed to the chapters of the book, offers suggestions for further reading.

Manuscript study has always been the holy grail of medieval studies. Advanced students were often barred from the archives until they had proven they had the necessary skills and familiarity with archival practices to understand the archived materials. Reading and interpreting manuscripts were skills passed on from one generation to the next, usually through apprenticeship rather than through formal class work. Even today, the practice in many archives is to interview the prospective researcher before allowing direct access to materials, questioning the scholar's training and reading, ascertaining whether the information sought could be acquired just as well through facsimile or microfilm, and requiring "blue seal" letters from the applicant's university certifying his or her affiliation and status. Even smaller repositories require readers to fill out a special application and provide sufficient references and identification. Such practices have ensured that only highly trained individuals have had access to manuscripts;

this limited access has made the materials, reserved for the initiated, seem special, even magical. Almost all senior researchers can remember and describe the first time they saw an actual manuscript, as opposed to a facsimile or microfilm or photocopy, and may fondly recall the difficulty they had in deciphering it, in understanding the precious object put before them. We hope that we do not in any way remove the special aura of archival work, but rather, whet the appetite for it so that when the treasure is placed before the reader, he or she will be a little less baffled but no less excited.

This book is based in part on courses taught at the Newberry Library, Chicago, between 1996 and 2001. It is largely for this reason that so many of the illustrations come from manuscripts and fragments held by the Newberry, which is second to no other North American collection in the materials that it offers for the study of the history of medieval Western script, manuscript production, and textual culture. The Newberry acquired its first manuscript in 1889, when London book dealer B. F. Stevens presented the library with a thirteenth-century missal from the Rhine region of Germany. It was subsequently enriched by the acquisition of two major collections, those of Cincinnati hardware merchant Henry Probasco (1890) and of Edward E. Ayer (1920), who had made his fortune manufacturing and selling railroad ties and then invested a considerable part of it in purchasing rare books, both printed and manuscript. The bulk of the manuscript materials in these two collections consisted of Bibles, Books of Hours, prayer books, and other richly decorated and illustrated service books of the types that may be found in other American libraries.

What gives the Newberry's manuscript collection its particular variety and character is the quality of the acquisitions made from the 1930s through the 1960s, when two highly distinguished scholars advised on what should be purchased. The first of these was B. L. Ullman, who served on the library's Committee on Collections. Ullman's book *The Origin and Development of Humanistic Script* remains the fundamental study of its topic. In his work on behalf of the Newberry, however, Ullman by no means confined his attention to the time period on which his own research focused but rather sought to ensure that the Newberry obtained materials that would facilitate the study of the progress of writing during a large part of the Middle Ages. From the late 1940s Ullman's mantle was taken over by Hans Baron in his capacity as the Newberry's Distinguished Research Bibliographer. A scholar with an international reputation for his outstanding contributions to the study of Italian civic humanism, Baron had a genius for seeking out manuscripts with textual content of special interest; volumes acquired under his tenure include a palimpsest containing letters of St. Jerome, among them many that had not been edited, and a variety of codices containing little-studied texts from time periods and regions ranging from twelfth-century France to fifteenth-century Burgundy and Italy. Although manuscripts no longer come on the market with the frequency they did some decades ago, the Newberry has not ceased to expand its holdings as opportunities have arisen, and the collection continues to develop and grow. Some of the materials featured in this book are recent acquisitions that are here illustrated for the first time.

Not every feature we discuss, however, could be described or illustrated from material in the Newberry. We have therefore drawn where necessary upon the riches of European libraries—in particular, the Parker Library of Corpus Christi College, Cambridge, and the British Library in London. The Parker Library holds special interest for the bibliographer and the student of manuscripts because its collection was the first of truly national scope to be assembled in the wake of the religious upheavals that beset England during the reign of Henry VIII. Its creator, Matthew Parker (1504–75), used his authority as archbishop of Canterbury under Queen Elizabeth I to rescue manuscripts throughout England from the uncertain fate they faced in the wake of the dissolution of the monasteries and the consequent dispersal of monastic libraries. His collection of some five hundred manuscripts passed upon his death to the college of which he had been master from 1544 to 1553. The quantity and quality of the British Library's manuscript holdings are of course unrivaled throughout the world. Originally housed within the British Museum but now a separate entity, the library is home to several different collections of manuscripts, of which the richest are the three acquired upon the foundation of the museum in 1753. These three "foundation collections"—the Royal, Cotton, and Harley manuscripts—all provide material used in this book and are the fruit of collecting activity spanning the sixteenth through the eighteenth centuries. During this period successive royal librarians enriched the library of the reigning English monarchs with their acquisitions. Sir Robert Cotton (1571–1631) built a collection that drew the leading scholars of his generation to Cotton House in Westminster—where they could peruse manuscripts housed in bookcases that were topped by the busts of Roman emperors—and Sir Robert Harley (1661–1724) and his son Sir Edward Harley (1689–1741), aided by their brilliant librarian, the paleographer Humfrey Wanley (1672–1726), amassed a library of several thousand manuscripts and charters. The activities of these and other early modern collectors and the impact that they had upon their manuscripts will come under the spotlight at several points in the pages that follow.

In writing this book we have received substantial help from many quarters, and it is a pleasurable duty to acknowledge our debts. The book began life as a manual designed to accompany the 1998 Summer Institute in the Archival Sciences held at the Newberry Library and funded by a generous grant from the Gladys Krieble Delmas Founda-

tion. Throughout its early gestation, Carolyn Lesnick, at the time Program Assistant at the Newberry's Center for Renaissance Studies, played a truly essential role in devising the original layout, coordinating sections of text as they issued from our computers, and organizing the photographing of images—work she frequently took home in order to consult her graphic designer husband, Tommaso Lesnick. In the intervening eight years, after Carolyn had left the Newberry to embark on doctoral study, both she and Tommaso have continued to support this book with tireless work, reformatting particular images to meet the specifications of the Press and troubleshooting at every crisis. Words cannot express our gratitude.

Students and faculty who attended the original paleography institute and the Renaissance Center's Consortium Seminars on paleography offered in 1996, 1997, and 2001 have contributed to the text in many important ways, and we are grateful to the consortium's executive committee for making the seminars possible. The many speakers and participants in the Newberry's ongoing History of the Book Seminar brought current and theoretical issues to the library, thereby greatly enriching the book. Many colleagues at the Newberry have generously allowed us to draw upon their expertise. We owe special thanks to the following: Susan Russick, Giselle Simone, and Elizabeth Zurawski of the Conservation Department; James Grossman, Vice President for Research and Education; retired Associate Librarian Mary Wyly; Hjordis Halvorson, Vice President for Library Services; Ayer Librarian John S. Aubrey; John Brady, Director of Reader Services; Bart Smith and Christine Colburn, former Senior Reference Assistants in the Department of Special Collections; JoEllen Dickey, Special Collections Public Services Librarian; Robert W. Karrow Jr., Curator of Special Collections and Maps; James Akerman, Director of the Herman Dunlap Smith Center for the History of Cartography; Carla Zecher, Director of the Center for Renaissance Studies; Paul F. Gehl, Custodian of the John M. Wing Foundation on the History of Printing; and Paul Saenger, George A. Poole III Curator of Rare Books. Drs. Gehl and Saenger, along with John B. Freed of Illinois State University, generously offered to read through our entire text before it went to press and it has benefited from their insights. Catherine Gass took all the photographs of Newberry material and also served as an invaluable scout for manuscripts containing a variety of anomalies; the plates illustrating this volume amply attest to her skills. John Powell of the Newberry's Photoduplication Service cheerfully and sensitively fulfilled our many photographic requests. Susan Russick, Giselle Simon, and Elizabeth Zurawski read drafts of several sections and provided the conservator's view on manuscript preservation. Most of the material on pigments was gleaned from a seminar led by Cheryl Porter and hosted by the Conservation Department.

Gill Cannell of Corpus Christi College, Cambridge, Martin Halata of Prague Castle Administration, Gerald Raab of the Staatsbiliothek Bamberg, Jay Satterfield of the University of Chicago, and Stephen Roper of the British Library were most helpful in assisting with our photographic orders from those institutions. Peter Barber and Michelle Brown offered invaluable insights on maps and manuscripts in the British Library's collections. David and Sharon MacDonald kindly allowed us to use materials from their collection. The inclusion of so many illustrations in the book would have been impossible without the generous award of a Newberry Library Weiss/Brown Publication Subvention and a grant from Illinois State University's History Foundation Fund.

Friends and colleagues who have helped us by offering advice on specific details or by their intellectual and personal support over many years include Ed Bailey, Charlotte Bauer, Lee Beier, Catherine Brown, Caroline Walker Bynum, Rick Cavasin, Neal and Patricia Clemens, Marcia Colish, John B. Freed, David M. P. Freund, David Ganz, Karen Green, Ruth and Leo Kadanoff, Richard Kieckhefer, Stuart E. Kirtman, Élisabeth Lalou, David and Sharon MacDonald, Bernard McGinn, Barbara Newman, William Paden, Richard Pfaff, Mary Beth Rose, Braxton Ross, Pamela Rups, Shuji Sato, Steve Severson, Robert Somerville, Peter Stallybrass, Paul E. Szarmach, Sidney Tibbetts, Teresa Webber, Gordon Whatley, Robert Williams, Grover A. Zinn Jr., and colleagues in the History Department of Illinois State University, at the Medieval Institute of Western Michigan University, and at the Institute for Medieval Studies and the History Department of the University of New Mexico. Jane Sayers, Robert Somerville, Anna Trumbore Jones, Anders Winroth, and Adam Kosto contributed in significant ways to the chapter on charters. We are grateful to Barbara Rosenwein for seeing the potential in the book and recommending it to Cornell University Press and to John Ackerman, director of Cornell University Press, for his enthusiasm and patient support throughout the long process of bringing it to completion. We received several important suggestions for improvement from the anonymous reader who reviewed an early version of our text. The final version was read by William Courtenay, Paul Szarmach, Anders Winroth, and another anonymous reader; we were greatly encouraged by their enthusiastic responses and appreciated their observations. During production, Lou Robinson, senior designer at Cornell, and Barbara Williams of BW&A Books have played a key role in devising layout and advising on the format for line art; Karen Hwa, Cornell's senior manuscript editor, has offered many insightful comments on the preparation of our text for print and we have greatly appreciated the work of Jamie Fuller, a copyeditor of exceptional ability. We thank Meghan Worth for proofreading the entire text with a dedicated and careful eye. We owe a very special debt of gratitude to our wives, Michal Ditzian and Marian Hessink, for tirelessly reading and rereading the manu-

script and bearing with this project from beginning to end; they have helped us in more ways than they know.

On 11 April 945, the scribe Florentius of Valeránica brought to a close the long labor of copying the *Moralia in Job* of Gregory the Great. It had taken him 501 leaves to complete his copy of this, the longest of the patristic texts. He ended his work with a colophon in which he ex-pressed a feeling familiar to many a writer of both former and subsequent eras: *Quam suavis est navigantibus portum extremum, ita et scriptori novissimus versus* (As sweet as the final port is to sailors, so too is the last line to the scribe). We echo those words. But let us leave our readers with the friendly injunction found in many a medieval manuscript: *Lege feliciter!*

Raymond Clemens
Timothy Graham

PART ONE

*Making the
Medieval Manuscript*

CHAPTER ONE

Writing Supports

IN THE history of writing, every conceivable surface has been used to record the written word, including clay, slate, pottery shards, linen cloth, bark, palm leaves, wood, metal, stone, animal skins, wax, and paper. Ancient Korean and Chinese calligraphers practiced writing characters in sand, on bark, and on polished slabs of jade. Jesus was said to have written in the sand with his finger. The predominant writing supports in medieval and early modern Europe were parchment made from animal skin and, increasingly from the fourteenth century, paper. This chapter presents the most common writing supports, including papyrus, wax, metal, wood, parchment, and paper and describes how these materials were produced. Because of its popularity in the period under study, greatest attention is given to the production of parchment, which was variously used in single sheets for charters, sewn into rolls, and bound into codices, but other media are described as well, as many were employed throughout the period.

PAPYRUS

Papyrus was the most widely used writing support in the ancient world (see fig. 1-1). Its use spread from Egypt to the Greek and Roman empires; through the Romans it was introduced to northern Europe. Although it continued to be used by the Merovingian court until 677 and the papal court until 1057, papyrus was replaced by locally produced parchment in most of Western Europe when the Roman Empire collapsed and papyrus became impossible to import. Papyrus was made from the pith of the papyrus plant grown almost exclusively in Lower Egypt. It was made by taking the triangular stalk of the plant, removing the outer bark, and cutting or peeling the underlying substrate or pith away from the

lower stem of the plant. The pith was then cut into manageable lengths and sliced into thin strips or fibers. The fibers were placed side by side until they formed a square; then a second layer of fibers was laid on top, at right angles to the first, and the two layers were pounded or pressed together to form a single square. The papyrus had to be wet during this stage so that its gummy sap would bond the sheet together. The sheet was then laid out to dry; once dry, it would be rubbed smooth, and several finished sheets would be pasted together to form a roll.

In a much debated section of Pliny's *Natural History*, the first-century Roman described the preparation of papyrus to receive writing. Not having actually made papyrus, Pliny was recording secondhand information. Still, his description provides a glimpse into the ancient world's understanding of papyrus production:

> Papyrus of all kinds is "woven" on a board moistened with water from the Nile, muddy liquid supplying the effect of glue. First an upright layer is smeared on to the board, using the full length of papyrus available after the trimmings have been cut off at both ends, and afterwards cross strips complete the lattice-work. The next step is to press it in presses, and the sheets are dried in the sun and then joined together, the next strip used always diminishing in quality down to the worst of all. There are never more than twenty sheets in a roll.[1]

The term *recto* is used to describe the writing on the inside of the papyrus roll (generally with the fibers running horizontally), and the term *verso* describes the outside of the roll, with the fibers running verti-

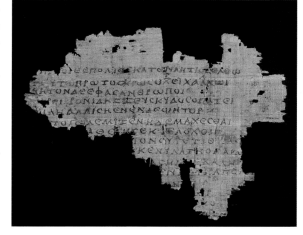

1-1 Papyrus fragment. Homer's *Iliad*, book 21, lines 567–81. Uncial hand, written across fibers. Newberry Library, Greek MS 1.

1. Pliny, *Natural History*, trans. H. Rackham, rev. ed., vol. 4 (Cambridge, MA, 1986), 145 (book XIII, xxiii.77).

cally. To protect the roll, the first sheet of papyrus either was left entirely blank or had only authentication markings. Rather than presenting a long continuous column of writing from the top of the roll to its end, the papyrus roll was opened from left to right, and each sheet would generally contain two columns of text.

With the decline of the Roman Empire, the means for obtaining papyrus was diminished, and Western Europeans turned to the more readily available and locally produced animal skins. Papyrus continued in use in the West for certain specialized purposes, particularly for documents such as charters, until the eleventh century; the last surviving papyrus papal bull is dated 1057.

WAX

Wax was one of the earliest writing materials in the West, employed widely in the ancient world, and its use continued to the nineteenth century. Wax tablets survive from the seventh century AD in Western Europe, while further east, a pair of tablets found in the 1980s in a ship wrecked off the coast of Turkey dates back to the fourteenth century BC.[2] Wax had several advantages as a writing surface: it was inexpensive, it could be easily corrected, and it was impervious to water. Wax tablets had three major functions. First, they were used by students to practice writing and to take notes. (Prudentius, writing in the early fifth century, tells a macabre tale of St. Cassian of Imola, a teacher whose students turned on him and attacked him with the styli they had been using to take notes on their tablets.) Second, wax tablets were used as an easily correctable surface for rough drafts of written and artistic works that would eventually be copied onto parchment (fig. 1–2). A well-known miniature from a now lost twelfth-century manuscript of the visions of Hildegard of Bingen shows the monk Volmar using a wax tablet for just such a purpose as he jots down the words Hildegard dictated while under divine inspiration. Finally, they were used by the French royal court when the king was traveling. The wax itself was poured into hollowed-out surfaces made from a variety of materials, most often wood, but also ivory and precious metals such as silver and gold; in the thirteenth century, the tablet maker was a documented *métier* in Paris, and the city's regulations allowed the use of wood, ivory, and horn for the purpose.[3] Wax tablets made from wood were called *tabulae* or *pugillares*. The wax itself was most often black in color (made by mixing pitch with the melted wax) but could also be green, red, or natural. Letter forms were made on the wax with a stylus made of wood, bone,

1-2 A monk writing on wax tablets with a stylus. Detail from Bamberg, Staatsbibliothek, MS Patr. 5, fol. 1v.

horn, iron, or silver. One end of the stylus had a point for writing, and the other broadened out to a wider edge that served as an eraser. Individual tablets could be grouped together as a set and kept in a leather case. One of the few surviving examples is a fourteenth-century set of seven ivory tablets and their case, which includes on its exterior a scabbard to hold the stylus. Five of the tablets have been hollowed out for writing on both sides; the outer surface of the first and last tablets in the set is carved with elegant scenes of courtly love.[4] A set of tablets could also be bound together in the fashion of a codex, with several leaves. For example, in the mid-thirteenth century, the accounts of Louis IX were recorded while traveling by his chamberlain Jean Sarrazin on fourteen rectangular tablets that were bound together. The tablets are preserved today in the Archives Nationales in Paris. These were clearly not drafts, given their almost perfect state of preservation and the fact that they were bound together. Wax was a perfect medium for the court as it traveled because it could not be damaged by water as could parchment or paper.

METAL

Like wax, metal was relatively impervious to the elements, although, with the exception of soft metals, it was difficult to inscribe. A common metal writing support was lead: it was soft and could be easily pounded into sheets, although any malleable metal could be used, including gold, silver, bronze, and copper. Metal sheets would be written on by striking the surface with a series of straight and curved punches. From the fifth century BC, *defixiones*, or "binding spells," used to effect a magic curse were often made of lead, both because it was an inexpensive writing support and because lead was associated with the Roman god of the forge, Vulcan. The lead would be pounded into extremely thin sheets that could be written on with a metal stylus; the sheet was then rolled up, often pierced with a nail, and thrown into a well or buried. The latest lead *defixiones* that survive date from sixth-century Gaul. Pilgrimage badges were also made of lead or silver, although the text would be stamped with a die much as coins were produced rather than incised with a punch or stylus.

A common use of metal in the Roman Empire was for

2. See George F. Bass, "Oldest Known Shipwreck Reveals Splendors of the Bronze Age," *National Geographic,* December 1987, 693–733, at 730–31.

3. See René de Lespinasse and François Bonnardot, eds., *Les métiers et corporations de la ville de Paris: Le livre des métiers d'Étienne Boileau* (Paris, 1879), 140.

4. See Peter Barnet, ed., *Images in Ivory: Precious Objects of the Gothic Age* (Detroit, 1997), 237–39 (with illustrations).

diplomas that granted citizenship and other rights to retiring soldiers. The diplomas were made of thin bronze plates. The text was incised on the inside (*intus*) and then repeated on the outside (*extrinsecus*) of the two plates, with the text on the back written at a right angle to that on the front. The plates were then folded together and sealed with wax. If there was a dispute about the external text of the diploma, a court could break the wax seal and read the inner text.

WOOD

Wood was a cheap writing support that could be prepared in various ways and easily erased for reuse by sanding. In the ancient world, wood was used in cases where long-term survival was not deemed necessary. Such uses included public notices, business transactions, accounts, drafts, practice exercises, informal letters, and invitations. According to Plato, in addition to being used as notebooks, wooden boards were used for ballots, legal records, and votive offerings (prayer requests to be hung in temples). Romans called such boards, whitened with gypsum, *alba*, from which we get the English word *album*. Whitened boards were still in use in the fifteenth century, when Cennino Cennini described how to make them in his artist's handbook, *Il libro dell'arte*. Cennini recommended that they be made from fig wood and treated with ground bone mixed with saliva; the surface could then be sketched upon by the novice artist using either a silver or brass stylus.[5]

The word *codex* originally meant a tree trunk and, before it was applied to a parchment book, it designated a set of wooden writing boards linked together into book format. Thanks to a 1986 archaeological find in the Dakhleh Oasis in Egypt, we know quite a lot about how these wooden codices were made.[6] The excavations brought to light two codices, a farm account book and a compilation of Isocrates' *Cyprian Orations*. Both date from around 360 AD and exhibit similar construction, each having originally contained eight boards, or "leaves," on which writing had been entered. In each case, the entire codex was cut from a single block of wood. The individual leaves are mostly about 2.5 mm thick, the outer leaves (which served as the covers) being a little thicker. When the artisan cut the leaves from the block, he made a mark on one side of the block (the side that would be the spine of the book) to ensure that when the book was finished, the leaves would maintain their original order. This was important, for it meant that, if there were any irregularities in the saw cuts

(as it was inevitable there would be), the finished book would still lie flat because adjacent leaves would share the same irregularities in mirror image. The artisan's mark for this purpose consisted of a V cut across the back of the block.

Each leaf therefore had two notches in it, with the notches set close together on the spine of one cover (at the apex of the V) and becoming progressively further apart on the succeeding leaves; when the leaves were set in their correct order, the V was reconstituted, but if a leaf was put in the wrong place, the design was disturbed. Once the leaves had been cut, they may have received some preparation such as gum arabic to facilitate the adhesion of the ink to the wood. There was writing on both sides of every leaf, except the first and last, which served as covers. The leaves were scored in drypoint, with vertical rulings defining the width of the columns and with just a few horizontal rulings to guide the entering of text (the Isocrates has one horizontal ruling for about every nine lines of text). Six small leather pads were glued to the verso of each leaf except the last (two at top left and right, two at middle left and right, and two at bottom left and right); these pads served to prevent the chafing of one board against another, which would have abraded the text. To hold the book together, a pair of holes was drilled in the upper inner and in the lower inner corners of each board, with one hole in each pair drilled about 25 mm above the other; a cord (a single piece of spun linen) was then loosely threaded through these holes to provide a rudimentary binding. At some point, a corner broke away from one of the leaves of the Isocrates codex, and it was evidently repaired by a method similar to that used in parchment books; although the corner has not survived, a series of tiny holes close to the broken edge of the leaf shows that the corner was once reattached by sewing. It is of the greatest interest that these wooden books, the best-preserved survivors of a genre that must once have been common, display numerous features that would be transferred to the parchment manuscript.

Wood could also be used in the form of bark shaved from trees. Portions of the Qu'ran are said to have been recorded on tree bark. From Roman Britain, several examples of ephemeral texts written on thin sheets of bark survive. Called the Vindolanda tablets after the Roman garrison town just south of Hadrian's Wall, these wooden supports were preserved from decay because they had been placed in a trough that was later sealed with clay to allow rebuilding. The clay and water created an anaerobic environment that prevented bacteria from destroying the tablets. The Vindolanda tablets are small (roughly 1 mm thick × 9 cm high × 20 cm wide). Many are folded down the middle to protect the text and maintain privacy. They were used for a variety of purposes: to keep accounts, for invitations, for letters, and for practice in writing Latin. They were for the most part written in Roman script.

5. Cennino d'Andrea Cennini, *The Craftsman's Handbook*, trans. Daniel V. Thompson Jr. (1933; repr., New York, 1960), 4–5.

6. See John L. Sharpe III, "The Dakhleh Tablets and Some Codicological Considerations," in *Les tablettes à écrire de l'Antiquité à l'époque moderne*, ed. Élisabeth Lalou (Turnhout, Belg., 1992), 127–48.

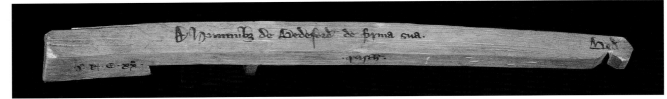

1-3 A tallystick from the fourteenth century. The writing on the top indicates the party; the abbreviation above the notch indicates the county (in this case "Bed." for Bedfordshire). The tallystick was dated on the side: here Easter during the twentieth year of the reign of King Edward. The notch, as wide as a man's little finger, indicates a sum of £20. There are no shilling or pence marks. Newberry Library, artifact 268.

A common use of wood as a writing surface in medieval England was the tallystick (fig. 1-3).[7] A tally or tallystick is an instrument designed to establish a financial contract; in this case it was a record of money paid into the English exchequer. The tallystick is a wooden chirograph: it was broken in half so that each party would have a record of the transaction (see chap. 14 for a discussion of chirographs). Once the writing and the notching were complete, the tallystick would be broken in half like a wishbone. The payee would receive the larger end, called the tally or stock (*stipes*); the exchequer kept the smaller half, called the countertally or foil (*folium*). When the account was made up, the stock was returned to the exchequer. Because the wood broke in a unique way each time, it was virtually impossible to forge a tallystick. Tallysticks were commonly made of hazelwood; the record of the transaction (the money paid or owed) was entered on the surface of the stick. Notches were made to indicate amounts: a notch the width of a man's palm signified £1,000, a notch the size of a man's thumb represented £100, and a notch the width of a man's little finger was £20. A small notch indicated one pound. Shillings and pence were indicated on the opposite side with cuts that did not remove the wood but were simply nicks on the wood. Tallysticks used to record transactions between private persons may differ in form from those produced by the exchequer. In 1783, George III ended the use of tallysticks, although their use continued until the death of the last chamberlain of the exchequer in 1826. William IV ordered the destruction of the remaining tallies, which set off a fire that destroyed the Houses of Parliament in 1834.

PAPER

Paper was in use in Europe well before the advent of printing. It was first made by the Chinese, and its discovery is usually attributed to Ts'ai Lun in 105 AD, although recent archaeological discoveries indicate its use up to two hundred years before that. The oldest surviving paper documents are Buddhist texts from the second and third centuries, currently in the British Library. Subsequently, the technology was exported east to Japan through Korea and west through the Arab world. It reached Moorish Spain in the eleventh century; by the middle of the twelfth century, an important mill was in operation at Játiva, near Valencia, where Jews participated in paper production. Arabic paper, as well as paper made in Spain in the Arabic fashion, was beaten with pestles and sized with starch. It generally lacked a watermark and had long fibers. Twelfth-century books on paper survive, but the origin of the paper is unknown. Prior to its production in Spain and then Italy, paper was imported from Arab countries, but this imported paper, although inexpensive, was of inferior quality compared with parchment and was thus not widely used. The 1231 constitutions of Melfi imposed by Frederick II on the kingdom of Sicily, which because of its location had easy access to Arab paper, forbade the use of paper for documents having legal authority ("Ex instrumentis in chartis papiri scriptis nulla omnino probatio assumatur"), and the 1265 Ordinance of Alfonso X of Castille made a distinction between "cartas las unas factas en pergamino de cuero e las otras en pergamino de paño" (charters made on leather parchment and cloth parchment, i.e., paper). Emperor Frederick II forbade the use of paper "quoniam incipiebat vetustate consumi" (because it was beginning to show signs of age).

Writing in the twelfth century, Peter the Venerable, abbot of Cluny, was even more scathing. Referring most likely to the Arabic paper produced in Spain and linking the paper with its Jewish producers, Peter commented:

> God, it says, reads the book of Talmud in Heaven. But what kind of a book? Is it the kind we have in daily use, made from the skins of rams, goats, or calves? Or, is it made from reeds and rushes out of Eastern swamps, or from old rags, or from some other more vile material, and written upon with birds' quills or reed pens from swamps, dipped in any kind of ink?[8]

7. M. T. Clanchy, *From Memory to Written Record: England 1066–1307*, 2nd ed. (Oxford, 1993), 123–24, plate VIII; H. Jenkinson, "Exchequer Tallies," *Archaeologia* 62 (1911): 367–80, and "Medieval Tallies, Public and Private," *Archaeologia* 74 (1925): 289–353.

8. Quoted in André Blum, *On the Origin of Paper*, trans. Harry Miller Lydenberg (New York, 1934), 57. The passage comes from Peter's *Tractatus adversus Judaeorum inveteratam duritiem*; see Migne, *Patrologia latina*, vol. 189, col. 606.

A lingering suspicion of paper can be seen in the decision of many wealthy collectors to have printed books copied onto parchment and in the words of Johannes Tritheim (1462–1516), who mourned the loss of manuscript culture caused by print: "If writing is put on parchment it may last for a thousand years, but how long is it going to last if it is printed on such a thing as paper?"[9] Parchment was also linked to prestige, while paper was seen as a cheap substitute and hence many high-status printed books were printed on parchment rather than paper.

In Italy, the first paper mill seems to have been established in Fabriano in the Apennine Marche region around 1268–76, although 1283 is the earliest date recorded of the use of the term "papermaker" in a legal document. Several improvements in paper production in Italy led to its being accepted as a suitable substitute for parchment: more finely ground pulp from metal beaters often powered by water, the use of gelatin as sizing material, short fibers, and watermarks. However, these refinements also made Italian-produced paper very expensive, inhibiting widespread adoption until prices dropped at the end of the fourteenth century. Figures quoted by Blum from an Italian account book of 1382 suggest that by then, the price of paper had dropped to about one-sixth the price of parchment.[10] From Italy papermaking seems to have spread to France in the mid to late fourteenth century and to Germany at the end of the fourteenth century. The first paper mill in England is purported to have been the John Tate mill (established in 1496), which produced paper used by early printer Wynkyn de Worde, among others.

Paper is made from cellulose (flax, hemp, linen), which in late medieval Europe was usually obtained from cloth rags or ship sails (as well as recycled scrap paper). The materials were moistened and pressed into great balls or placed en masse into a special vat, where they would ferment for a period of between six weeks and two months. This process, called *retting*, weakened the fiber and prepared it for maceration. The resultant digested material was then placed in a water-powered stamping mill, consisting of large stone or wood vats with wooden beaters, which would beat the material into a usable pulp. The slurry would then be cleaned and transferred to a vat or tub, usually by hand. The vatman would then dip a screen tray called a papermold into the vat, the contents of which would be agitated by another worker with a pole. The vatman would scoop up a thin layer of pulp, allowing the excess to return to the vat; he would then shake the mold in both directions (right and left, forward and backward) to evenly coat the bottom of the mold and to cause the fibers to cross and mat. The bottom of the mold was a wire sieve or screen that allowed the water to pass through while retaining the pulp. The wire sieve left marks that are apparent on all medieval paper: the long vertical sewing wires left marks called *chain-lines*, while the smaller, more numerous horizontal wires left marks called *laid-lines*. The mold had a removable rim called a deckle that contained the pulp and set the size of the sheet. After the pulp was spread on the mold, the deckle would be removed. The paper was allowed to dry and was taken off the mold by a second artisan, called the *coucher*, and placed by a third artisan, the *layman*, on a pile of sheets that would then be pressed to remove as much water as possible (fig. 1-4). There is at present a debate as to whether or not felt was used to separate the sheets of paper while they were being pressed. The sheets would be separated, restacked, and repressed several times, until the desired smoothness was achieved, and hung out to dry in stacks of four or five sheets (to prevent curling and wrinkling) on ropes coated with beeswax. Eventually drying houses were built to accommodate drying space for large production runs of paper. Finally, the paper would be dipped in size, usually gelatin made by boiling parchment and leather, and pressed to remove the excess. The sizing prevented the paper from absorbing water and ink, gave it more heft, and increased its durability. Gelatin sizing also made the paper more

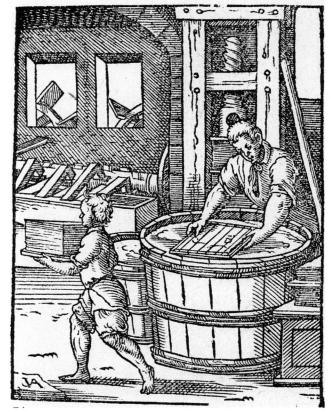

1-4 A late-sixteenth-century woodcut of a papermaker at work. In the background the water-powered macerators beat the rags into pulp while in the foreground, the vatman removes the frame from the vat. Behind the vatman is the press for removing water. Hartmann Schopper, *De omnibus illiberalibus sive mechanicis artibus* (Frankfurt, 1574); Newberry Library, Wing Collection, XP 547. F427, sig. C4r. Woodcut by Jost Amman.

9. Quoted in Blum, *On the Origin of Paper*, 63–64. The quotation comes from Tritheim, *De laude scriptorum* (Mainz, 1494).

10. *On the Origin of Paper*, 36.

suitable for writing with acidic ink (Asian papers were unsized because the lampblack ink used by calligraphers was thicker and not easily absorbed by the paper). The paper would be allowed to dry again and then burnished by hand. Paper made in this fashion was strong and long-lasting and of great value.

Knowledge about the manufacture of paper can provide information about the production and provenance of the books in which it is found (see further in chap. 8). Each papermold was unique. Rather than using one mold, most papermakers used two nearly identical molds to make paper, doubling the amount of paper that could be produced at a given time. The structure of the screens at the bottom of the molds (that is, the pattern of chain-lines and laid-lines) is readily apparent in most papers made by this method.

Watermarks were commonly used to identify paper. Watermarks survive on paper from as early as 1282, and they became increasingly common in later centuries. An emblem sewn with wire onto the mesh created the watermark (French *filigrane*, from the Latin *filum*, [thread or wire] and *granum* [grain]; German *Wasserzeichen*; Dutch *papiermerken*). The emblem was higher than the chains and lay wires, so the resulting paper was thinner over the emblem itself. Because they have a lower density than the surrounding paper, watermarks can be seen by applying a contrasting agent, usually by passing light through the paper. The emblems were made either by the mold maker or, for more complex images, by goldsmiths or other fine metalworkers. While emblems were sometimes placed in the middle of the sheet, most often there were two emblems, one placed in the middle of each half-sheet of paper (fig. 1-5).

Watermarks seem to have functioned first and foremost to identify the papermaker and to prevent one papermaker from passing off his work as another's. They may also have had a symbolic value, functioning as emblems that expressed some information about the values, beliefs, or self-perception of the papermaker or his membership in a guild or brotherhood. Especially popular as watermarks were images of bulls' heads, religious objects and symbols, and mythical creatures. Blum believed that the

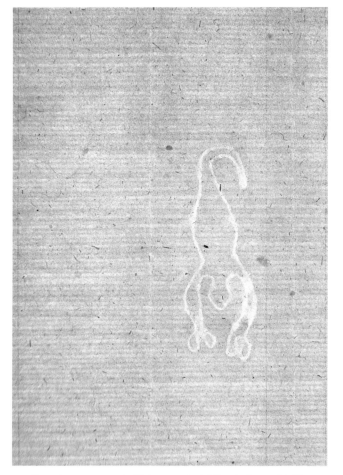

1-5 Scorpion watermark (Briquet 13610). The chain- and laid-lines are easily visible. The brighter areas on the emblem may indicate places where the device was affixed to the screen or where repairs were made to it. Newberry Library, MS 65.

1-6 A Florentine *ricordanza* belonging to Pepo degli Albizzi written between 1339 and 1360. Note the brightly colored leather binding that serves to enclose and protect the contents; a flap extends from the back cover and buckles to the front. Pepo added an *x* to his initials on the front cover to form the word *pax*. Newberry Library, MS 27.

emblems were intended to indicate the brands of paper, the location of the mill, the quality of the paper, and the physical size of the sheet.[11] These uses were legislated in the late fourteenth and, to a greater extent, during the fifteenth century, but knowledge of earlier practice remains vague. Hunter believed that watermarks must be viewed with suspicion as evidence of date or location of production, because a dated watermark could be used over a number of years, and papermolds were often transferred from one maker to another without the watermark's being changed.[12] Nevertheless, some significant discoveries have been made from the study of watermarks (see chap. 8).

In the late Middle Ages, paper was sometimes sold to the prospective user not in sets of sheets that would first be written on and then bound but as prebound books. Such books would then be used for practical purposes: as account books, inventories, journals, and the like. The colorful Florentine Registers are a case in point: they were sold prebound with ornate leather covers in various colors, and merchants would record their personal business affairs, often using a different colored register for each new year (fig. 1-6). Inventories were also composed in prebound booklets (i.e., books having only one gathering of sheets) and were clearly sold in various sizes and shapes, as notebooks are today. They might have a limp vellum cover (see chap. 4, fig. 4-7) or no cover at all. When paper books were bound, there seems to have been little concern about the direction in which the watermark was oriented, although it was customary to bind the pages so that the more distinct chain-lines had a vertical orientation and the more frequent laid-lines had a horizontal orientation and could be used almost as ruling.

PARCHMENT

Parchment is literally the substrate upon which virtually all knowledge of the Middle Ages has been transmitted to us. It is vital to know how it was prepared in order to understand how medieval people communicated with each other and with posterity. This section on parchment explains the general preparation of parchment; there were, of course, innumerable subtleties and differences in actual production, but the section should provide the basic information needed. Knowledge about parchment preparation can assist in establishing the date, provenance, and authenticity of the written record; its material history is as important as the text or image it transmits.

The great majority of medieval manuscripts were written on parchment, that is, on animal skins specially prepared to make them a surface suitable to serve as a writing support. Reputedly invented in Asia Minor by King Eumenes II of Pergamum (whence Latin *pergamenum*,

11. Ibid., 41.

12. Dard Hunter, *Papermaking: The History and Technique of an Ancient Craft*, 2nd ed. (1947; repr., New York, 1978), 264–65.

"parchment") in the second century BC, parchment had largely replaced papyrus, the favored writing support of the ancient world, by the fourth century AD, although, as noted above, papyrus was retained for certain special purposes as late as the eleventh century. Even with the expansion of paper production in Western Europe from the fourteenth century, parchment continued to be widely used, and it remained the writing support of choice for manuscripts of higher status. It was the most valued support for early printed books for those who could afford to have them printed on parchment; its use for such purposes continued into the twentieth century.

Types of Skin

The skins most commonly used for parchment were calf, sheep, and goat. Calf gave the best-quality parchment, although much depended on the nature of the preparation. Parchment made from calf and sheep was common in northern European manuscripts; goatskin was widely used in Italy. No doubt the skins of other animals were also used on occasion. Recognizing the species from which a sheet of parchment was made is difficult because a characteristic that may at first sight appear to be an indication of the type of skin used can in fact be the result of the method of preparation; this is especially true for the early medieval period, when the method of preparation used in the British Isles (and in certain continental centers founded by Irish and Anglo-Saxon missionaries) was significantly different from that of continental producers. A general guideline—to be observed with some caution—is that parchment made from calfskin tends to be whiter or creamier in color and may show a prominent pattern of veins; parchment prepared from sheepskin is often yellowish and may be somewhat greasy or shiny in some areas (see figs. 1-7 and 1-8).

Terminology

The terms most commonly used to refer to writing supports prepared from animal skins are *parchment* and *vellum*. Some scholars use the terms interchangeably, which can lead to confusion. The term *vellum* derives from Latin *vitulinum*, French *vélin*, meaning "of calf"/ "made from calf"; strictly speaking, therefore, this term should be used only for writing supports prepared from calfskin. In view of this, some scholars prefer to reserve the term *parchment* (which etymologically has no such specific connection) for supports prepared from sheep- or goatskins. Yet another system is observed by modern parchment makers and calligraphers, who use parchment and vellum to refer to writing supports of different thicknesses and degrees of preparation, without reference to the animals from which the skins come. To avoid the potential for confusion, some scholars prefer to use the neutral term *membrane* to refer to a writing support made from animal skin, particularly if they are unsure of the species of origin. In this book,

1-7 Sample of parchment prepared from calfskin. Note the prominent vein patterning. The dark color of these veins indicates that the animal was not properly bled at the time it was slaughtered.

1-8 Sample of parchment prepared from goatskin. This skin has been only roughly prepared, which explains why the grain pattern of the skin is so clearly visible.

parchment is used generically to refer to any writing support prepared from animal skin, while vellum refers specifically to parchment that has been prepared from calfskin.

Method of Preparation

Before a skin was turned into parchment, it had to be thoroughly cleaned and dehaired. First, the skin was washed in water and then soaked for several days in a bath of lime solution to loosen the hair (see fig. 1-9). Next, the parchment maker would remove the loosened hair. Modern parchment makers who follow traditional practices remove the hair by placing the skin over a beam of wood, first using their hands (gloved to protect them from the caustic action of any lime solution remaining on the skin) to pull out as much hair as they can (see fig. 1-10). Then,

to remove any remaining hair, they work the skin with a gently curved, two-handled blade, a process that is called *scudding* (see fig. 1-11).

Once the hair had been removed, the skin was washed again in water, after which came the critical stage in the process to turn the skin into a material suitable for writing upon: drying the skin under tension, while it was stretched on a frame. In contrast to the method used to turn a skin into leather—a chemical process involving the use of tanning or tawing agents—parchment making was a physical process that produced a change in the character of the skin. As the skin dried, it sought to shrink. Stretched tightly on the frame, however, it could not reduce its surface area. Instead, the structure of the skin began to change, the fiber network reorganizing itself into a thin, highly stressed

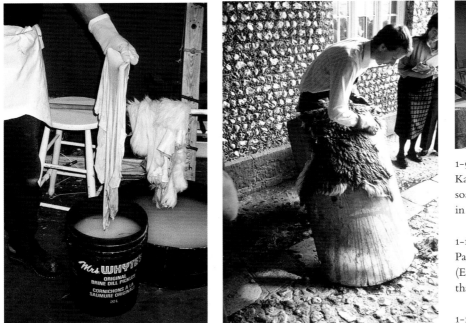

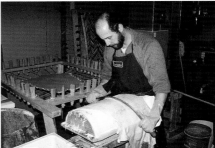

1-9 Rick Cavasin, parchment maker of Kanata, Ontario, with a skin that has been soaked in lime solution. Note also the skins in the background.

1-10 Wim Visscher of William Cowley Parchment Works, Newport Pagnell (England), removing the hair from a skin that has been soaked in lime.

1-11 Rick Cavasin scudding.

laminal structure that became permanently set as the skin dried.

The frame on which the parchment maker suspended the skin is called a *herse*; medieval evidence, both visual and written, indicates that the herse was sometimes square, sometimes round (see fig. 1-12 and compare the description quoted below). The parchment maker attached the skin to the frame by tying cord to the skin at several points around its circumference. To prevent the cord tearing the skin, modern practitioners—in all likelihood recreating medieval practice—first wrap the area of skin to which the cord is to be attached around a small, round pebble, called a *pippin*, then tie the cord around the knobbed area thus produced (see fig. 1-13). They then attach the other end of each length of cord to a peg with a rectangular head inserted into the frame. As the skin dries, the pegs are continually tightened up with a handle, much like a wrench, specially shaped to fit over the top of the pegs (see fig. 1-14).

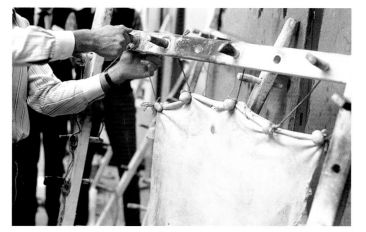

1-13 Attaching a skin to a herse. Note the pippins around which the cord is looped.

1-14 Parchment maker's handle ("wrist") for tightening the pegs on the herse.

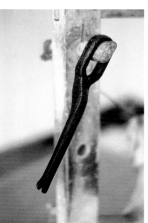

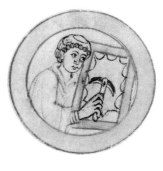

1-12 A monk working on a skin suspended on a parchment maker's frame. Bamberg, Staatsbibliothek, MS Patr. 5, fol. 1v.

While the skin was stretched upon the frame, the medieval parchment maker worked on it with a crescent-shaped blade called a *lunarium* or *lunellum* ("little moon"; see fig. 1-15). It was important to use a blade with a curving edge: as the skin "gave" somewhat under the pressure of the blade, the curve followed its contour where a straight blade might rip the skin. The parchment maker worked on both sides of the skin to remove any remaining hair from the outer surface (the *hair-side*) and any remaining fat and flesh from the inner surface (the *flesh-side*). Once the skin was completely clean and dry, it was removed from the frame and was ready to be cut into sheets of parchment. The number of sheets a single skin could provide depended, of course, on the size of the skin and the dimensions to which the sheets were cut. On average, a calf-skin might provide about three-and-a-half sheets of parchment of medium size. Each sheet was folded in two to form a *bifolium*, two conjoint leaves. The half-sheet that was left over would serve for a single leaf: not uncommonly a quire included two single leaves as well as several bifolia (see below, under "Forming the Sheets into Quires"). In a finished sheet of parchment, it is sometimes possible to see the line of the animal's backbone, which may appear darker where it is marked by a clustering of hair follicles (see fig. 1-16).

A thirteenth-century recipe for parchment making that includes all the steps outlined above occurs in a German manuscript now in the British Library, London (MS Harley 3915, fol. 148r):

To make parchment from goatskins in the Bolognese manner, take goatskins, and put them in water for a day and a night. Then take them out, and wash them until the water runs out clear. Then take a completely new container, and put in it lime that is not fresh, and water, and mix them well together, so that the water is good and thick. Then put the skins in, and fold them over on the flesh-side. Then stir them with a stick two or three times a day, and let them stand like this for eight days in summer, and for twice as long in winter. After this, take them out and dehair them. Then get rid of the entire mixture in the container, and replace it with another batch of the same quantity of the same mixture. Put the skins in again and stir them, and let them be turned each day just as previously, for another eight days. Then take them out and wash them very vigorously, so that the water runs out really clear. Then put them in fresh water in another container and let them stand for two days. Then take them out and

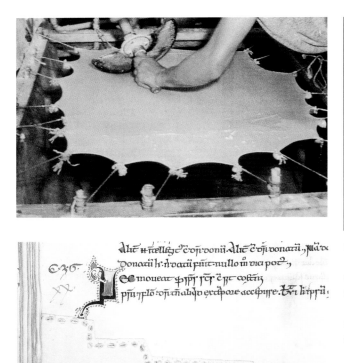

1-15 Working on a skin with a *lunellum*.

1-16 Sample of a finished sheet of parchment. Note the straight line of the animal's backbone on the left side of the membrane.

1-17 *(above, right)* A leaf with defective edge from an eleventh-century manuscript. Newberry Library, MS 2, fol. 45r.

1-18 *(left)* A parchment repair to the defective edge of a leaf. Cambridge, Corpus Christi College, MS 199, fol. 30v.

attach cords to them, and tie them in hoops, and prepare them with a sharp iron blade. Then let them stand for two days out of the sun. When all the water has been extracted, and the flesh has been removed with pumice, after two days dampen them again, sprinkling a smallish amount of water on them, and cleaning off with pumice all the flesh that has thus been dampened. Then suspend them with cord more exactly and evenly, according to the shape that they are to retain as parchment; and then there remains nothing more to do once they have dried.[13]

Defects in Skins

Quite commonly, especially in manuscripts of lesser quality, some leaves are not fully rectangular but have one curving, defective edge. Such defective edges resulted when the skin was being cut into sheets and it happened that there was not enough skin left to provide a full rectangular sheet; the defective edge marks a contour of the original skin—for example, the neck or shoulder line. When sheets with defective edges were used in a manuscript, the defective edge would generally be turned so that it occurred in the lower outer area of the leaf (see fig. 1-17). Usually, defective edges were left unrepaired. However, in the example pictured in figure 1-18, from a

13. The original Latin text is quoted in Daniel V. Thompson, "Medieval Parchment-Making," *The Library*, 4th ser., 16 (1935): 113–17, at 114.

manuscript produced at Llanbadarn Fawr, Wales, in the late eleventh century, a defective edge has been carefully cut into a stepped shape, then repaired with a parchment patch of the same shape. The patch, which just overlaps the edge of the original leaf, was laced to the leaf with a narrow strip of parchment that was partly colored with a red pigment that subsequently corroded and darkened. In this case, because the defective edge was shaped by hand, it is not possible to tell whether it was the result of an original defect in the skin or of subsequent damage to the leaf.

It is also common to find on some leaves of a manuscript holes that already existed in the skin at the time the animal was slaughtered. Such holes vary from the tiny, resulting from insect bites, to those that may span several lines of script, resulting from some injury to the animal. Sometimes, if the bite or injury was in the process of healing at the time of slaughter, it is possible to see an area of thinner scar tissue across part or all of the hole. Typically there are more leaves with holes toward the end of a manuscript than earlier on, an apparent sign that as the task of copying the manuscript approached its end, the scriptorium grew less selective in its choice of sheets and was prepared to use whatever came to hand.

Holes resulting from bites or injuries to the animal from which the parchment was prepared are easily distinguished from other types of damage, such as wormholes, that were acquired only after the manuscript had been completed. The scribe writing the text of the manuscript was of course obliged to enter the text around any holes that were already present at the time of writing, often having to di-

vide words in the process (see figs. 1-19 and 1-20). Holes produced by woodworm, on the other hand, are easily recognized when the holes have resulted in the loss of portions of letters through which the worm ate (see chap. 7, fig. 7-5). Also, since wormholes usually occur across a span of several consecutive leaves, if a hole or a pattern of holes in one leaf can be matched on the immediately preceding or succeeding leaf or leaves, that is a sure sign that the damage has been caused by woodworm.

Normally, holes that were already in leaves at the time of writing were left unrepaired (although sometimes scribes cut them into more regular or more decorative shapes). Occasionally, however, a large hole might be patched with parchment. Very unusually, in Cambridge, Corpus Christi College, MS 286 (the "Gospels of St. Augustine of Canterbury"), a manuscript written in Italy in the mid-sixth century, numerous small holes have been repaired with a fine, transparent adhesive membrane, per-

haps fish's bladder (see fig. 1-21). The repairs must have been made before the scribe wrote the text, for in some places the scribe's ink extends onto the tissue used for the repairs (see fig. 1-22).

Another form of damage commonly encountered in the leaves of manuscripts consists of gashes that may have been produced at the time the skin was flayed from the animal. Often such gashes were sewn together with thread; sometimes the thread still remains (fig. 1-23), but in many cases it was subsequently removed, with only the needle holes remaining to attest to the former repair (fig. 1-24). Such repairs were often made while the skin was stretched on the parchment maker's frame. If the needle holes around a gash are oval rather than fully round, that is an indication that the repair was made on the frame, the holes having been stretched into their oval shape while the skin dried under tension.

1-19 (far left) The holes in lines 7–8 and 12–13 are defects in the original skin, so the scribe had to enter the text around them, splitting the words *Anniuersarium* and *monachum*. There is scar tissue at the bottom of the upper hole. Newberry Library, MS 3, fol. 45r.

1-20 This hole was caused by an injury to the animal from which the skin was taken. Newberry Library, MS 8, fol. 38r.

1-21 Note the visible outline of the strip of transparent tissue that repairs the area in which the two holes occur. Cambridge, Corpus Christi College, MS 286, fol. 89r.

1-22 Detail of repair to folio 213v of Cambridge, Corpus Christi College, MS 286. The tops of the consecutive letters *ud* extend onto the repair tissue.

1-23 A gash in the skin has here been decoratively repaired with thread of several colors. Newberry Library, MS 7, fol. 49r.

1-24 The oval shape of the needle holes around this gash shows that the gash was repaired while the skin was on the parchment maker's frame. Newberry Library, MS 8, fol. 35v.

PREPARATIONS PRIOR TO WRITING

Forming the Sheets into Quires

Once the prepared skins had been cut into sheets of parchment, there were various operations to be performed before the scribe could begin to write. First, he or she would group several sheets together to form a *quire* (also called a *gathering*). The quire was the scribe's basic writing unit throughout the Middle Ages; it was generally true that only when all the quires of a manuscript had been written would the manuscript be bound (but see above and fig. 1-6 for cases of prebound paper "notebooks" in the late Middle Ages). Quires of various sizes were made throughout the Middle Ages. The most common sizes were quires of eight leaves (for which the Latin term was *quaternio*, plural *quaterniones*; see fig. 1-25) or ten leaves (*quinio*, plural *quiniones*). Quires of these sizes could be made by folding four or five sheets (*bifolia*) in two to produce eight or ten leaves, with each leaf in the first half of the quire being joined to its partner in the second half. Quite frequently, however, quires would not consist entirely of bifolia but would include two half-sheets (that is, single leaves) in place of a bifolium. In this way, a scriptorium could use those smaller pieces of parchment that might be left over when the full sheets were cut from the prepared skin. When a quire included two single leaves, those leaves were not placed at the beginning of the quire or at its midpoint, where they would be vulnerable and might more easily be lost or removed, but somewhere in between: in a quire of eight leaves, they would be placed in second and seventh or third and sixth positions, firmly anchored between the outer

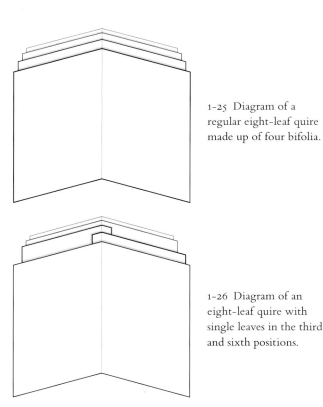

1-25 Diagram of a regular eight-leaf quire made up of four bifolia.

1-26 Diagram of an eight-leaf quire with single leaves in the third and sixth positions.

1-27 Hair follicles are visible in the margins of these two pages. Newberry Library, MS 79, fols. 55v–56r.

and inner leaves of the quire (see fig. 1-26). Each single leaf would include a stub that the scribe would fold around the spine of the next leaf so that the single leaf, like the bifolia, would have a gutter into which the binder could insert his needle when sewing the quires of the manuscript to its sewing supports at the time of binding. The projection of a stub between the immediately preceding and succeeding leaves is a sure sign of the presence of a single leaf in the quire.

In forming the quire, the scribe would decide how to arrange the hair- and flesh-sides of the sheets. It is normally simple enough to recognize the hair-side of a leaf: usually it is possible to see a clustering of hair follicles in one or another area of the leaf (see fig. 1-27). In continental European manuscripts of the Carolingian period, the hair-side frequently has an easily visible "peppering" of hair follicles all over its surface. The hair-side also tends to be darker in color than the flesh-side. The normal practice in Western Europe throughout the Middle Ages—but not in the early medieval British Isles or in certain continental centers founded by Irish and Anglo-Saxon missionaries (for which see below)—was to arrange the sheets so that, wherever the finished manuscript was opened, like sides would face one another across the opening: that is, hair-side would face hair-side or flesh-side would face flesh-side. This arrangement could be achieved by using either of two methods. One method was to take the precut bifolia, and for a quire of eight leaves, place the first sheet hair-side downward, the second sheet flesh-side downward, the third sheet hair-side downward, and the fourth sheet flesh-side downward (a quire of ten leaves would require a fifth sheet, placed hair-side downward). Then the sheets would be folded on the vertical axis to produce a quire in which like surfaces faced one another throughout. The alternative method to produce the same effect—a method certainly used on occasion and perhaps frequently—was more appropriate for manuscripts of smaller size. The scribe could take a large sheet of parchment, fold it in

two once, then fold it in two a second and third time, then make cuts along the appropriate edges: the result would be a quire of eight leaves in which like always faced like (fig. 1-28 illustrates this method for a quire of four leaves; one additional fold at stage three would produce a quire of eight leaves). For most of the Middle Ages, scribes who used either of these methods generally preferred to arrange the leaves so that the outside of the quire was a hair-side. This was not, however, the practice in late antiquity, when quires generally had a flesh-side on the outside; many humanist scribes of the fifteenth century reverted to the late antique practice by forming their quires so that the outermost sheet of the quire was a flesh-side.

The arrangement of hair- and flesh-sides was different in manuscripts produced in the British Isles up until the late tenth or early eleventh century. This variant practice may have been connected to the fact that the "Insular" method of preparing parchment gave a finished product in which the difference in appearance between hair- and flesh-sides was less pronounced than in continental parchment; to have unlike surfaces facing one another was, as a result, not aesthetically displeasing. When Insular scribes formed the sheets into quires, they oriented the sheets so that, except at the middle of the quire, a hair-side would face a flesh-side or a flesh-side would face a hair-side. To achieve this arrangement, the sheets of the quire were laid with the same side always placed downward as the pile was formed. Usually it was the hair-side that was laid downward, so that when the fold was made, a hair-side would be on the outside of the quire as its first and last page; there are, however, some quires in Insular manuscripts in which the flesh-side is on the outside. This method of forming the quires was also practiced for some time in continental centers founded by Irish and Anglo-Saxon missionaries (for example, Fulda in Germany and Bobbio in northern Italy). Beginning in the late tenth century, however, Insular scribes dropped their earlier practice and adopted the continental method by arranging the sheets so that like sides faced one another across openings.

Once the quire had been formed, the scribe might then lightly tie the leaves together with thread or a narrow strip of parchment in order to keep them united as a group during the writing process. This is called *tacketing*. Needle holes

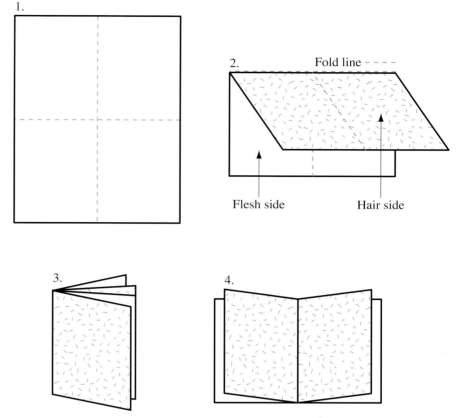

1-28 Diagram showing how a four-leaf quire could be produced by making two folds in a large sheet of parchment.

and lengths of thread or twists of parchment for tacketing have been discovered in numerous manuscripts, usually in the upper inner area of the leaves.

Pricking and Ruling the Leaves

Before beginning to write, the scribe would rule the leaves. Throughout the Middle Ages, scribes pricked small holes in the margins of the leaves to guide their horizontal and vertical rulings (see fig. 1-29). In many cases the prickings can still be seen on the leaves, but those in the outer margins were often lost when the edges of the leaves were trimmed at the time of binding. Scribes might make the pricks with a knife, an awl, or a compass: a knife would leave small slits in the parchment, while an awl or compass would leave rounded holes. To keep the line of pricks more or less straight, scribes would place a ruler on the margin to be pricked and use it as a guide, bringing the pricking instrument right up against, or close to, the ruler. Generally, scribes would prick a group of several leaves together, forcing the pricking implement through the upper leaf to the leaves below; the pricks would then be smaller and less visible on the leaves that were lower in the pile. There is evidence that some scribes pricked by using a small revolving, spiked wheel attached to a handle: in this case, the scribe would simply draw the wheel down the margin in

1-29 Note the prickings in the outer margin. Newberry Library, MS 3, fol. 90v.

order to leave a line of pricks. In some cases, scribes would press the parchment down onto a frame set with nails that would prick the parchment.[14]

The scribe could prick and rule the sheets of parchment either before or after folding them to form a pair of leaves. If pricking and ruling came first, then for the horizontal rulings the scribe only needed to make prickings at the far left and right of the sheet, that is, in what would be the outer margins of the individual leaves once the sheets had been folded. But if the scribe first folded the sheets and only then pricked and ruled them, it was necessary to make a line of prickings in both the inner and the outer margin of each individual leaf. In the early Middle Ages—just as had been the case with the arrangement of hair- and flesh-sides—there was a difference in practice between continental Europe and the British Isles (and continental centers under Insular influence). On the Continent, the sheets were ruled before folding, so for the horizontal rulings only the outer margins were pricked. Up until the late ninth century, however, the common Insular practice was to fold the sheets first and then rule; pricks were therefore made in both the inner and the outer margins of each leaf. After the late ninth century, Insular practice for pricking matched that on the continent, with pricks being made before folding, in the outer margins only. Then,

14. For a lucid description of different medieval practices for pricking manuscripts, see Leslie Webber Jones, "Pricking Manuscripts: The Instruments and Their Significance," *Speculum* 21 (1946): 389–403.

for a period of about one hundred years between the mid-twelfth and the mid-thirteenth century, both on the Continent and in the British Isles, it became normal practice to prick and rule only after folding, with pricks being made in inner and outer margins; thereafter scribes reverted to pricking in the outer margin only, before folding.

In addition to making vertical lines of pricks to guide the horizontal rulings, the scribe would also make pricks in the upper and lower margins to establish guides for the vertical rulings of the page. The number of vertical rulings made would depend on whether the text was to be laid out in a single column or in double or multiple columns. Normally, for a single-column manuscript, the scribe would rule a pair of vertical lines close together (about 5–7 mm apart) at both the left and the right edges of the page. These vertical rulings defined the width of the column. The scribe would begin each line of ordinary text immediately to the right of the inner of the two lines at the left side of the page. The space between the pair of lines at the left would be used for entering initials beginning sections of text. The pair of lines at the right of the column served to guide the entering of initials on the reverse side of the leaf. When making the horizontal rulings, the scribe would normally rule the top and bottom one, two, or three lines the full width of the leaf, extending these lines beyond the vertical rulings to the very edge of the leaf; a few manuscripts also have one or more lines in the middle of the page ruled the full width. The scribe would rule the other lines only between the innermost rulings of each of the pairs of vertical rulings at the left and right of the page (see fig. 1-30). More complicated patterns of pricking and ruling occur in manuscripts where the text was laid out in two or more columns to the page (see fig. 1-31) or in manuscripts containing tables.

Scribal practices for ruling varied from one period of the Middle Ages to another. In the early period, up until a time of transition beginning in the late eleventh century, ruling was in drypoint, that is, it was made by pressing into the page with a knife or stylus made of metal or bone. Occasionally an overenthusiastic scribe might even cut through the parchment when ruling in drypoint. For drypoint ruling, only one side of a leaf needed to be ruled; furrows were made on that side and ridges appeared on the other. It was also possible to rule more than one leaf at a time by assembling a batch of leaves in a pile and pressing hard so that the ruling on the top leaf would show through on the leaves below. The rulings would, however, become progressively fainter on the lower leaves, and sometimes it was necessary to rerule the leaves at the bottom of the pile to produce a ruling that the scribe could use.

From the late eleventh century, drypoint ruling began to be replaced by ruling in plummet (leadpoint). The

transition from drypoint to plummet, however, occurred over several decades, and manuscripts ruled in drypoint can be found as late as the third quarter of the twelfth century. Plummet ruling is either gray or reddish-brown in color; it leaves a thin, somewhat granular and sometimes barely visible line on the page (see fig. 1-31). A scribe who ruled in plummet (and indeed in any medium other than drypoint) was obliged to rule both sides of the leaf and could not rule more than one leaf at a time. In the fourteenth and fifteenth centuries, ruling in ink (usually of the same color as that used for the text but sometimes of other colors) became quite common. Humanist scribes of the fifteenth century frequently reverted to the practice of ruling in drypoint as part of their conscious revival of earlier scribal and codicological practices. With the sheets of parchment grouped into quires and each leaf pricked and ruled, the scribe could begin to enter text upon the leaves. The process by which the manuscript received its text and any accompanying decoration is described in the next chapter.

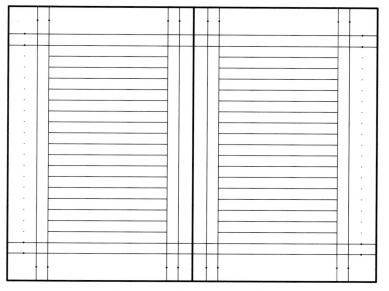

1-30 A typical pattern of pricking and ruling.

1-31 This page has been ruled in plummet to receive three columns of text. Newberry Library, MS 16, fol. 487r.

CHAPTER TWO

Text and Decoration

TOOLS OF THE SCRIBE

Once the parchment had been ruled, it was ready to receive text and/or images. Whereas the reed pen had been the writing implement of choice in the classical Mediterranean, the scribe's normal writing implement in Western Europe throughout the Middle Ages was the quill pen. Goose feathers produced the best quills, strong yet flexible. Best for the purpose were primary feathers (long feathers at the tip of the wing) plucked from live geese in springtime; most appreciated were feathers plucked from the left wing, which would curve away from the eyes of a right-handed scribe.[1] In medieval illustrations, scribes are almost never depicted writing with their left hand. Where a picture of a left-handed scribe does occur, as in fig. 13-1 (see chap. 13), it is likely to be the result of the accidental reversal of the image used as a model. In his *Il libro dell'arte*, written before 1437, the date of the earliest surviving copy, Cennino Cennini (ca. 1370–ca. 1440) describes how to prepare a goose quill that would be suitable for writing or drawing:

> If you need to learn how this goose quill should be cut, get a good, firm quill, and take it, upside down, straight across the two fingers of your left hand; and get a very nice sharp penknife, and make a horizontal cut one finger along the quill; and cut it by drawing the knife toward you, taking care that the cut runs even and through the middle of the quill. And then put the knife back on one of the edges of this quill, say on the left side, which

faces you, and pare it, and taper off toward the point. And cut the other side to the same curve, and bring it down to the same point. Then turn the pen around the other side up, and lay it over your left thumb nail; and carefully, bit by bit, pare and cut that little tip; and make the shape broad or fine, whichever you want, either for drawing or for writing.[2]

The penknife that Cennini mentions was another essential tool of the scribe. As well as serving for sharpening the quill whenever it became ragged (see fig. 2-1), the penknife was used to steady the page (parchment was naturally springy) and to erase mistakes made in copying. Numerous medieval illustrations show a scribe writing while holding down the parchment with a penknife held in the left hand (see fig. 2-2). If the scribe made an error, he could transfer the knife to his right hand, use it to scrape the ink from the surface of the parchment, and then enter the correct text in the erased area. Often it is possible to detect areas of roughened parchment in a manuscript where such corrections have been made; sometimes, sufficient traces of ink remain to read the original, erased text.

Scribes who traveled—and many did, particularly those who served in an official capacity at court—would require a means of storing and transporting the tools of their trade. Several late medieval illustrations show a type of portable pen case and inkpot that could be used by scribes on the move. This portable equipment is seen most frequently in images of St. John writing the Book of Revelation on the Isle of Patmos: either John's symbol, the eagle, proffers the

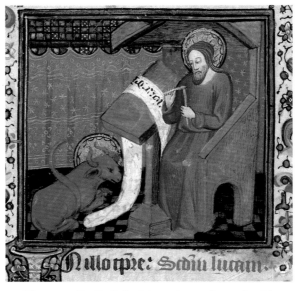

2-1 The evangelist St. Luke is here shown sharpening his quill. Newberry Library, MS 52, fol. 21v.

1. As noted by W. H. Riddell, "The Domestic Goose," *Antiquity* 17 (1943): 148–55, at 154. We thank Marian Hessink for providing this reference.

2. Cennino d'Andrea Cennini, *The Craftsman's Handbook*, trans. Daniel V. Thompson (1933; repr., New York, 1960), 8.

the devil. Inkwells or inkstands could have several compartments for inks of various colors to facilitate writing and rubricating (see fig. 2-4).

Ink was made by a variety of methods. One of the earliest black inks was lampblack, made from dense carbon (usually produced by scraping the carbon off a cold metal object placed in the flame of a candle), gum, and water. This ink was used extensively on papyrus but was less suitable for parchment because the ink sat on top of the parchment and, depending on the proportions of its ingredients, could eventually disintegrate. A better ink for parchment was iron-gall, or oak-gall, ink, which because of its acidic properties, worked its way into the parchment rather than simply sitting on top of it (the caustic property of such ink gave it its Latin name, *encaustum/incaustum*, from which comes the English *ink*). The principal medieval methods for making this acidic black ink involved the use of oak galls, the round excrescences produced on the twigs of an oak when the gall wasp lays its eggs in the buds of the tree (see fig. 2-5). The oak galls contain tannic and gallic acids, which are extracted by soaking the galls in liquid. The resulting solution is mixed with metallic salt (usually iron or copper) to make it black. Two recipes for making ink from oak galls occur in Newberry Library MS 25, an early fifteenth-century manuscript from the Veneto region of Italy, which contains a miscellaneous collection of recipes for ink (including invisible ink), various pigments, and glue (see fig. 2-6). In each recipe, oak galls were heated in acetic acid (vinegar or wine) and mixed with gum arabic (as a binding agent) and iron sulfate (*vitriol*). The mixture is allowed to stand for at least a day because the ink becomes blacker on exposure to air:

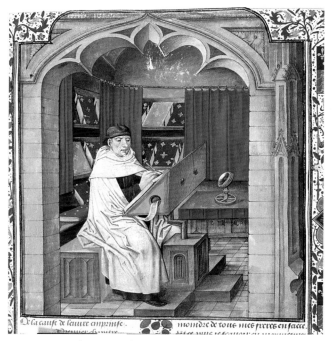

2-2 Vincent of Beauvais depicted writing in his study. London, British Library, MS Royal 14 E. i (pt. 1), fol. 3r.

equipment that it holds in its beak, or the devil attempts to steal it from John. Some images, like that in Newberry Library MS 43 (a fifteenth-century Book of Hours made in France), show both scenes (see fig. 2-3). The pen case and inkpot, probably both made of leather, are generally shown linked by a pair of cords. Even scribes who did not travel needed an inkpot in which to store ink between writing sessions; Luther is reputed to have thrown one at

2-3 St. John's symbol, the eagle, brings him a new pen case and ink pot to replace those the devil has just stolen. Newberry Library, MS 43, fol. 13r.

2-4 St. Matthew dips his quill into an inkstand that has three compartments. Newberry Library, MS 47, fol. 17r.

2-5 Oak galls.

2-6 A recipe for making ink. Newberry Library, MS 25, fol. 2r.

To make good ink. Take three ounces of oak galls. Grind them a little. Take two phials of wine. Put the galls in the wine and simmer until reduced by a third or a half. Then remove from the heat. Then take an ounce and a half of ground iron sulfate and sprinkle it on the simmered wine, mixing with a wooden spatula until cool. Also take an ounce and a half of gum arabic that has been ground a little, and put it in the same vessel, mixing with a wooden spatula, and leave to stand for a day.

Another method for making perfect ink of the best quality. Take little oak galls ground like broken chickpea, three pints of clean fresh water, and two ounces of gum arabic, and mix everything together. Then take an ounce and a half of the rind of pomegranates and wrap this in a cloth and put it in the aforesaid water and leave to stand for five days. Then simmer on a slow heat, and while it is slowly simmering, add a pint and a half of good vinegar, and simmer until reduced by a third. And when it has simmered sufficiently, strain it through a thick shirt while still simmering, and dissolve into it an ounce and a half of iron sulfate, stirring with a spatula, and then it is ready.

Another vital piece of scribal equipment was a surface on which to lean when writing. The scribe might rest the parchment on a lapboard supported on the knees, or else on a desk. Lapboards were common in the early medieval period. A notable example can be seen in the picture of the evangelist Matthew in the eighth-century Barberini Gospels (Vatican City, Biblioteca Apostolica Vaticana, MS Barb. lat. 570, fol. 11v), written probably in southern England. Here the lapboard is semicircular in shape; twelfth-century examples show a rectangular lapboard. Scribe's desks were normally tilted, but some illustrations show a flat desk. The desk might include slots into which the scribe could fit his pens and his inkhorn (which would be made from the horn of some animal). Some twelfth-century English illustrations show an ingenious hinged

desk attached to the chair: the desk portion could be swung upwards to allow the scribe to take his seat, then swung down into position as he began his work.[3] Late medieval scribes' desks often included an upper tier, at or somewhat above eye level, on which the scribe could set the exemplar being copied.[4] Figure 2-2, a thirteenth-century illumination of the Dominican Vincent of Beauvais, shows the author at work at his desk. He steadies the page with his knife and writes with the quill in his right hand. Two book weights hold the gathering open. He works from a draft, perhaps the scroll emanating from the hole in the side of his desk, behind which one catches a glimpse of additional tools. The curtains are parted, revealing his books bound in brilliant colors and stored so that they could be opened on the shelf.

STAGES OF COPYING: WRITING, RUBRICATION, DECORATION, ILLUSTRATION

The process by which text and decoration were entered into a manuscript broke down into a clearly defined series of stages. Normally (although exceptions occurred), the scribe would first write those portions of text that were in plain ink, leaving blank those areas that would later receive

3. See the illustration in Christopher de Hamel, *Scribes and Illuminators* (Toronto, 1992), 37 (fig. 29).

4. See the two illustrations of the desk of Jean Miélot (d. 1472), secretary to the Duke of Burgundy, ibid., front cover and 36 (fig. 28).

colored initials and titles. For initials, the scribe would carefully indent his text in order to leave a blank area of suitable size and shape for the planned initial. Up until the thirteenth century, scribes would invariably enter the first line of text on each page *above* the uppermost ruled horizontal line. During the thirteenth century a change took place, and by the end of the century the general practice was for scribes to enter the first line of text *below* the top ruled line, that is, on the second line. Paleographers refer to these practices as *above top line* and *below top line*.[5]

Clear evidence establishes that titles and initials were generally entered only after the ink text had been written. Sometimes the planned titles and initials were never entered, with the result that the areas intended to receive them have remained blank. When the scribe left an area blank to receive an initial, he or she would sometimes note down, within that area or in the margin, the letter that should be entered, as a cue to whoever would later enter it (see fig. 2-7). Similarly, the scribe might jot down

in the margin the wording of a title that was to be entered later (see figs. 2-8 and 2-9); often such cue titles would be written vertically, very close to the fore-edge of the leaf, perhaps with the intention that they should be trimmed away at the time of binding. In some cases, initials were sketched in the appropriate area in drypoint or leadpoint but never colored, as in figure 2-10. Sometimes portions of an initial or a title lie on top of one or more letters in the following line(s) of text, proving that the title or initial was entered only subsequently.

If a manuscript was to include a cycle of illustrations, the illustrations would normally be the last element entered, only after text, titles, initials, and glosses (if the glosses formed part of the original production) already stood upon the page. This sequence is demonstrated by examples in which all other elements have been completed except for the illustrations and by examples in which portions of the illustrations overlap parts of the text, titles, initials, and glosses (see, for example, fig. 2-21). A notable case of a manuscript in which the illustrations are incomplete is the illustrated copy of the Old English translation of the first six books of the Bible (the *Hexateuch*) made at St. Augustine's Abbey, Canterbury, in the second quarter of the eleventh century, now MS Cotton Claudius B. iv in the British Library (fig. 2-11).

5. See N. R. Ker, "From 'Above Top Line' to 'Below Top Line': A Change in Scribal Practice," *Celtica* 5 (1960): 13–16; reprinted in N. R. Ker, *Books, Collectors and Libraries: Studies in the Medieval Heritage*, ed. Andrew G. Watson (London, 1985), 71–74.

2-7 Cue initial next to the decorated letter. Newberry Library, MS 2, fol. 39v.

2-8 Here the scribe has written the cue title vertically along the outer edge of the page, presumably with the intention that it would be cut off at the binding stage (note the prick marks to the right of the cue title). Newberry Library, MS 11, fol. 96v.

2-9 Note the cue title entered in the margin: "De excellentia animi, ad imaginem creatoris sui conditi." Cambridge, Corpus Christi College, MS 199, fol. 62v.

2-10 The initial *D* has here been penciled in but not colored. Newberry Library, MS 82, fol. 191v.

2-11 A partially completed miniature of Moses and the Israelites from the Old English *Hexateuch*. London, British Library, MS Cotton Claudius B. iv, fol. 128r.

Of course, manuscripts including cycles of illustration required careful advance planning of their layout to ensure that the scribe would leave blank areas of the right size in the right places, where the illustrations would later be entered. In the later Middle Ages (roughly, from the thirteenth century onward), when book production had largely moved out of the monasteries and into the hands of secular professionals, the decoration and illustration of a manuscript would take place in a different workshop from that in which the manuscript was written: the patron would collect the completed text from the scribe and take it to the illuminator's workshop, where he would specify the amount and the quality of the decoration and illustration desired.

COPYING TEXT FROM AN EXEMPLAR

Writing the text of a manuscript of course required that the scribe have an exemplar from which to copy. The only time an exemplar was not necessary was in the case of an original composition, but even then, authors would generally not proceed immediately to a fair copy; they would first prepare a draft on wax tablets or scrap parchment. Evidence from the early medieval period, when large numbers of manuscripts were produced in monastic scriptoria, shows that if a monastic house did not possess its own exemplar from which to make a copy of a text, it might dispatch one of its scribes to another monastery that did own a copy; or else it might borrow the text from that monastery. Sometimes exemplars traveled quite long distances and even crossed national boundaries. For example, manuscripts produced in France and Flanders seem to have traversed the English Channel quite regularly in the Anglo-Saxon period, and the Norman Conquest of 1066 had the effect of accelerating this process. Thus the post-conquest English transmission of the *Confessions* of St. Augustine depends on two continental manuscripts—one apparently from St. Peter's in Ghent, the other from the abbey of Saint-Bertin in northern France—that entered England in the wake of the conquest and circulated rapidly, spawning copies at Canterbury, Exeter, Salisbury, and elsewhere.[6] No doubt borrowed exemplars were generally returned, but sometimes circumstances prevented this. A twelfth-century note in a Ghent manuscript records that it had been given to the abbey of Saint-Thierry at Reims as a replacement for a copy of a work by St. Bernard of Clairvaux that the monks of Ghent had borrowed and then lost![7]

The actual process of copying the text of a manuscript might be accomplished by a single scribe, but often it was the work of a team of two or more scribes. Scribes working as a team might simply alternate their stints; however, because the unit onto which they copied was the unbound quire, they could also work simultaneously, with each scribe laboring on his or her own set of quires that would be united with other sets when the finished manuscript was bound. Although manuscripts were sometimes produced at great speed—a note in a ninth-century manuscript of 109 leaves reveals that it was made in only a week—copying a text was generally lengthy, laborious work, often carried out in demanding conditions (insufficient light, cold that numbed the fingers, and so on).[8] The daily round of services and other duties meant that monastic scribes were probably able to devote no more

6. See Teresa Webber, "The Diffusion of Augustine's Confessions in England during the Eleventh and Twelfth Centuries," in *The Cloister and the World: Essays in Medieval History in Honour of Barbara Harvey*, ed. John Blair and Brian Golding (Oxford, 1996), 29–45, at 32–39.

7. Ibid., 35 n. 35.

8. The manuscript of 109 leaves is Munich, Bayerische Staatsbibliothek, Clm. 14437, a copy of homilies by St. Augustine on the gospel of St. John made at Regensburg in 823. It was written by a team of two scribes. See Michael Gullick, "How Fast Did Scribes Write? Evidence from Romanesque Manuscripts," in *Making the Medieval Book: Techniques of Production*, ed. Linda L. Brownrigg (Los Altos Hills, CA, 1995), 39–58, at 46.

than six hours a day to their scribal work; a good rate of production for such a scribe would probably have been between 150 and 200 lines of text a day.[9] Professional scribes could presumably devote longer hours to their work. A complex manuscript with rich decoration might well take more than a year to produce. Notes at the end of each of the two volumes of the Stavelot Bible (London, British Library, MSS Additional 28106–7) state that it took its scribe Goderannus and his assistant Ernesto four years to complete it, from 1093 to 1097, while a six-volume Bible, called the "Zwolle Bible," now in Utrecht (Universiteitsbibliotheek, MS 31), begun in 1462, was not completed until 1476.[10] Numerous manuscripts contain complaints by their scribes about the arduousness of their work. In a tenth-century Spanish copy of the *Moralia in Job* of Gregory the Great (Madrid, Biblioteca Nacional, MS 80), the comment that the scribe Florentius of Valeránica entered at the end is practically a literary composition in itself:

The labor of the scribe is the refreshment of the reader: the former weakens the body, the latter profits the mind. Whoever you may be, therefore, who profit by this work, do not forget the laboring one who made it, so that God, thus invoked, will overlook your sins. Amen. Because one who does not know how to write thinks it no labor, I will describe it for you, if you want to know how great is the burden of writing: it mists the eyes, it curves the back, it breaks the belly and the ribs, it fills the kidneys with pain, and the body with all kinds of suffering. Therefore, turn the pages slowly, reader, and keep your fingers well away from the pages, for just as a hailstorm ruins the fecundity of the soil, so the sloppy reader destroys both the book and the writing. For as the last port is sweet to the sailor, so the last line to the scribe. *Explicit*, thanks to God.[11]

With the rise of the universities in the later twelfth century, a special system of copying was devised to enable texts required by students to be produced rapidly and conveniently.[12] This system was known as the *pecia* system,

from the word *pecia*, meaning "part" or "piece." Under this system the university's authoritative copies of textbooks consisting of unbound quires or *peciae* could be hired out for the purpose of making copies for students. Apparently originating in Bologna ca. 1200, the *pecia* system spread to universities elsewhere in Italy and in France, Spain, and England. It continued in effect in northern Europe until about the middle of the fourteenth century and seems to have lasted rather longer in Italy. In most universities it operated only within the faculties of civil and canon law and theology, which alone required students to possess their own copies of the books studied; in Paris, however, the system spanned all faculties. Graham Pollard perceived five stages necessary for the operation of the *pecia* system.[13] First, a scholastic author such as Thomas Aquinas or Albert the Great would produce his own original copy of a work, the *autograph*. Next came the *apograph*, a copy of the autograph made under the supervision of the author but not necessarily by him. Then came the *stationer's exemplar*, that is, the copy of the work officially lodged with the university stationer, whose role was to oversee the provision of books to students. From the stationer's exemplar would be produced a set of unbound *peciae* that the stationer hired out to students so that they could either make copies themselves or pay a professional scribe to copy for them before returning the *peciae* to the stationer. The copies thus obtained by students for their own personal use are the fifth and final stage in the process, and are called *pecia copies*. The size of the individual *pecia* varied from one place to another and from one time period to another; a *pecia* might contain four, six, eight, ten, or twelve leaves. At Bologna, *peciae* of ten leaves were normal, and students were expected to return a *pecia* to the stationer within a week of borrowing it; late return would result in the imposition of a fine that was increased in the event that the *pecia* was lost. In addition to hiring *peciae* from the stationer to make their own copy of a text, students could also hire *peciae* for the purpose of checking and correcting their copies; the cost of hire was less for correcting than for copying.

We know about the *pecia* system because it was strictly regulated by university statutes and because there survive numerous examples both of the *peciae* hired out by the stationers and of the *pecia* copies owned by students. The original *peciae* are often numbered in the upper margin of their first page. *Pecia* copies typically have notes entered in their outer margins recording where the copying of a new *pecia* began; often it is possible to see a change in the script of the text at these points, signifying either that a different scribe has taken over or at least that the same scribe was beginning a new stint of work. Newberry Library MS 121 appears to be an example of a *pecia* copy (fig. 2-12). Now comprising just three quires, it is a fragment of Thomas Aquinas's commentary on the third book of Peter

9. Ibid., 52.

10. For the Stavelot Bible, see C. R. Dodwell, *The Pictorial Arts of the West 800–1200* (New Haven, 1993), 269; for the Utrecht Bible, see J. P. Gumbert, *The Dutch and Their Books in the Manuscript Age* (London, 1990), 61.

11. Our thanks to Professor Catherine Brown of the University of Michigan for providing the translation.

12. See Jean Destrez, *La pecia dans les manuscrits universitaires du XIIIe et du XIVe siècle* (Paris, 1935); Graham Pollard, "The *Pecia* System in the Medieval Universities," in *Medieval Scribes, Manuscripts and Libraries: Essays Presented to N. R. Ker*, ed. M. B. Parkes and Andrew G. Watson (London, 1978), 145–61; and Louis Bataillon, Bertrand Guyot, and Richard H. Rouse, eds., *La production du livre universitaire au Moyen Age: Exemplar et pecia* (Paris, 1988).

13. Pollard, "The *Pecia* System," 151–52.

2-12 Thomas Aquinas's *Commentary* on the third book of Peter Lombard's *Sentences*, with *pecia* markings. Given the quality of this manuscript, it was most likely copied by the student who used it rather than by a professional scribe. Newberry Library, MS 121, fol. 6v.

Lombard's *Sentences*, a text that at the University of Paris is known to have consisted of fifty *peciae*. As can be seen in figure 2-12, the abbreviation "p^a" for *pecia* has been entered in the right margin of folio 6v, and in the following line there is a change in the character of the script; the numeral "xlii" entered in the lower margin presumably records the number of the new *pecia* being copied.

Rubrication

Most manuscripts contain more than one text, and generally each text in a manuscript begins and ends with a title (respectively, the *opening title* and the *concluding title*). In Latin manuscripts, opening titles begin with the word *Incipit* (it begins/here begins). The first word of concluding titles, *Explicit*, literally means "it unfolds." The term originated at a time before the codex had replaced the *rotulus*, or roll: when the roll was fully unfolded, the text was at an end.

In some manuscripts—for example, the eleventh-century Newberry Library MS 2, made in southern France (figs. 1-17, 2-7), titles were written in ink that was then brushed over with color to make the title stand out from the text; this was a relatively cheap and easy method favored in some continental centers during the Merovingian and Carolingian periods. In such cases, the scribe would enter the title as part of the process of writing the text,

with the color being added later. Another simple, inexpensive method of highlighting a title was to write the title in ink and then strike through or underscore the desired text with a line of red pigment; this technique occurs in Domesday Book, the survey of English landholdings commissioned by William the Conqueror in 1085, and is also found, for example, in southern European manuscripts of the late Middle Ages. The most common practice, however, was to write titles in red pigment (or occasionally in some other color or mixture of colors). Because one of the Latin terms for red is *ruber*, the provision of a manuscript with titles is usually called *rubrication*: a rubric is, literally, a heading written in red. The rubricated title for a text or section of text would generally be written in one or more lines that the scribe of the text had left blank to receive the title. Short titles—some titles consisted of a single word— could simply be inserted in space available at the end of the last line of the preceding section of text (see chap. 10, fig. 10-7). On occasions when the scribe did not leave sufficient room for the title, the rubricator might write part or all of the title in the margin, perhaps entering it vertically, parallel to the fore-edge of the leaf (see fig. 2-13).

The red pigment most commonly used for titles (and for

2-13 Here the scribe has not left enough room for the full title, so the rubricator has continued the title along the edge of the text block. Newberry Library, MS 66.1, fol. 14r.

red initials also) was red lead, an oxide of lead for which the Latin term was *minium* (whence *miniature*, which in origin meant a drawing executed in minium). The twelfth-century German monk who wrote under the pseudonym Theophilus described in his artist's handbook, *De diversis artibus*, how red lead was made by firing white lead (*flake-white*), which itself was produced by submerging sheets of lead in vinegar or urine:

> To prepare flake-white, get some sheets of lead beaten out thin, place them, dry, in a hollow piece of wood . . . and pour in some warm vinegar or urine to cover them. Then, after a month, take off the cover and remove whatever white there is, and again replace it as at first. When you have sufficient and you wish to make red lead from it, grind this flake-white on a stone without water, then put it in two or three new pots and place it over a burning fire. You have a slender curved iron rod, fitted at one end in a wooden handle and broad at the top, and with this you can stir and mix this flake-white from time to time. You do this for a long time until the red lead becomes completely red.[14]

Red lead can corrode and darken over time, particularly under certain conditions of exposure, and frequently initials and titles that were originally bright red have blackened in part or even wholly (see fig. 2-14). Darkening is often more pronounced near the beginning and end of a manuscript, where the leaves were more exposed.

Types of Initials

The rubricator of a manuscript might be a different individual from the scribe who wrote the text. Rubricators were no doubt sometimes responsible also for entering colored initials in a manuscript, but more elaborate initials would require a skilled artist. Initials of greater and lesser degrees of elaboration, often termed by paleographers *litterae notabiliores* (more noticeable letters), provided an excellent means of highlighting the various divisions, sections, and subsections within a text. A very simple method whereby a scribe could emphasize initial letters that stood at sentence beginnings within a block of text entailed the scribe's using several strokes of the pen to thicken the individual parts of the letter: such ink letters are called *built-up initials* (see figs. 3-2, 6-2, and 10-5). Alternatively, the rubricator might put a blob or line of pigment within or beside an ink initial letter—for example, within the bow of a *P*, or to the right of an *I*; the pigment would help to isolate the letter from the surrounding text (see figs. 1-17, 1-18, 2-9, and 3-13). This habit of highlighting ink initials with touches of pigment (typically red or yellow) was frequent

in manuscripts produced in the British Isles between the eighth and the eleventh centuries (see figs. 6-1 and 6-4).

New sections of text (for example, new chapters) would normally begin on a new line with a colored initial standing more than one line high. The more important the division and the higher the status of the manuscript, the larger and more elaborate the initials would be. Sometimes colored initials might include no decoration at all, but normally they would have at least some minor form of decoration, such as round beads on their stems or bows or some type of foliate decoration, such as a leaflike finial (see fig. 2-15), or perhaps a beast head.

In English manuscripts of the tenth and eleventh centuries, the two colors most commonly used for initials—because they were among the simplest and cheapest colors to produce—were red and green. A common arrangement was that these red and green initials would alternate with one another so that one section of text would begin with a red initial, the next with a green one, and so on. The pigment used for red initials would normally be red lead, while a common form of green pigment was verdigris, which used the green deposit that forms on copper. The pigment was produced by mixing copper, perhaps in the form of filings, with vinegar and other ingredients.

2-14 The rubricated title *alia homelia* is in red lead pigment that has corroded and darkened. Newberry Library, MS 1, fol. 21v.

14. Theophilus, *The Various Arts*, ed. and trans. C. R. Dodwell (1961; repr., Oxford, 1986), 33.

2-15 The decoration of this initial from an English manuscript of the mid-twelfth century includes a foliate finial (with a rounded bead at its base) and a symmetrical foliate design within its bow. Newberry Library, MS 12.7, fol. 19v.

2-16 Remnants of green around the hole in this roll reveal that the circular illustration that originally occupied this area had a rim of verdigris pigment that ate through the parchment. Additional damage can be seen in the smaller circles just beneath the large hole. Newberry Library, MS 22.1.

2-17 This copy of the scientific works of Aristotle, made in Germany or Austria in the first half of the fourteenth century, includes alternating blue and red pen-flourished initials in the style typical of the period. Newberry Library, MS 23, fol. 42v.

The fifteenth-century Newberry Library MS 25 includes the following recipe for verdigris:

> To make verdigris green. Take one pound of copper filings or scraps and wash it a little through a linen bag. Take ground egg yolks, quicklime, tartar sediment, common salt, strong vinegar, and boys' urine, and mix everything in the vinegar and urine and put half of it in a copper vessel and stir four times a day, then put it over heat or in the sun to dry.

The resulting green pigment retained the acidity of the vinegar used in its production, and not infrequently portions of initials or even whole initials are now missing from manuscripts where the verdigris has eaten through the parchment, leaving behind a hole. A spectacular example of verdigris corrosion is provided by Newberry Library MS 22.1, an early thirteenth-century roll containing the *Compendium historiae in genealogia Christi* attributed to Peter of Poitiers (fig. 2-16). At the top of the roll, there was originally a large circular diagram with a green rim around its outside. The verdigris pigment in the rim ate through the membrane, causing the diagram to fall out with the result that only a large hole now remains.

In manuscripts of the Gothic period (thirteenth and fourteenth centuries), the two colors most commonly used for initials were red and blue. Many initials would include both colors and would extend into the margin with the pen-flourished decoration typical of the period. There would again be a pattern of alternation: a red initial with blue pen flourishes would follow a blue initial with red pen flourishes (see fig. 2-17). Humanist scribes of the fifteenth century favored initials with white vine-stem decoration that scrolled around the body of the letter (see fig. 2-18). The Florentine humanist Niccolò Niccoli (ca. 1365–1437) is believed to have been the originator of this type of decoration, though he based it on forms that he found in twelfth-century manuscripts (compare fig. 2-19). The taste for vine-stem initials spread rapidly from Florence to other parts of Italy and to humanist scribes active in other countries.

Initials that include human figures and scenes are called *historiated initials*, and often the scenes depicted relate directly to the text that the initial begins. For example, in Newberry Library MS 52, a Book of Hours made in France in the first half of the fifteenth century, the initial *D* that opens the Office of the Dead shows a group of figures holding vigil over a coffin in front of which three candles are burning (see fig. 2-20). Sometimes, the actual form of the initial itself might be incorporated into the composition. In missals and sacramentaries, this might happen with the initial *T* that begins the Canon of the Mass, that is, the consecratory prayer said over the eucharistic bread and wine: the *T* could serve as a cross bearing the figure of Christ (see fig. 2-21). Occasionally, a major initial might occupy the full height of the page, as in Newberry

2-18 This copy of Plato's *De republica*, made at Naples in the mid-fifteenth century, includes initials with the white vine-stem decoration popular in humanist manuscripts. Newberry Library, MS 97, fol. 1r.

2-19 It was the scrollwork decoration of initials such as this (from a twelfth-century missal) that inspired the forms adopted in fifteenth-century humanist manuscripts. Newberry Library, Medieval Manuscript Fragment 48, recto.

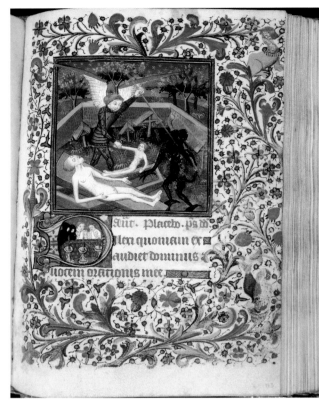

2-20 *(above, left)* The historiated initial *D* in this fifteenth-century Book of Hours opens the Office of the Dead. Newberry Library, MS 52, fol. 113r.

2-21 An initial *T* formed into a depiction of the Crucifixion, from a Cistercian missal, originally made in Germany in the late twelfth century; this leaf is a fourteenth-century addition. Newberry Library, MS 7, fol. 140v.

2-22 *(right)* Initial *I* of Genesis, from a Franciscan Bible made in France ca. 1250. Newberry Library, MS 19, fol. 4v.

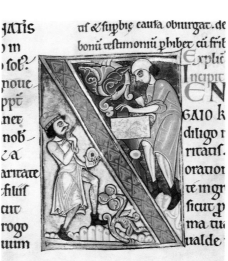

2-23 Detail of the sixth and seventh panels from figure 2-22, showing the creation of Eve and God resting on the seventh day. Newberry Library, MS 19, fol. 4v.

2-24 A whimsical self-portrait of the illustrator at work on the Dover Bible. Cambridge, Corpus Christi College, MS 4, fol. 241v.

Library MS 19, a thirteenth-century Franciscan Bible, in which the *I* that opens Genesis is divided into panels depicting the Seven Days of Creation, ending at the bottom with representations of the Crucifixion and of a Franciscan friar kneeling in supplication (see figs. 2-22 and 2-23). Many historiated initials bear no direct relationship to the accompanying text but rather afford the artist the opportunity to indulge a taste for the fantastic or to record interesting aspects of contemporary life, including details of scribal and artistic practice. The initial *S* that begins the third epistle of St. John in the twelfth-century Dover Bible whimsically shows the artist at work painting the initial itself, while his assistant grinds pigment for him (fig. 2-24).

Other Preparations and Techniques

The higher the status of a manuscript and the richer the patron for whom it was made, the more complex would be the process of its production and the larger the number of techniques and pigments involved. Some deluxe manuscripts of the late antique, Anglo-Saxon, Carolingian, Ottonian, and Renaissance periods were even written in gold and silver inks on parchment that had been colored purple. It has usually been assumed that the leaves of at least the best of these manuscripts were dyed with Tyrian purple, an extremely expensive dye whose use was restricted in antiquity to the imperial family and in the Middle Ages to kings and prelates. Tyrian purple was manufactured in the eastern Mediterranean by taking a specific gland from certain types of mollusk (*murex*, *purpura*, and *ianthina*): the gland had to be harvested while the mollusk was living, and it took a very large number of mollusks to produce a small amount of dye. Recent tests using x-ray fluorescence on certain medieval manuscripts, however, have shown that the pigment used to color the leaves of these manuscripts was not Tyrian purple but another pigment; the only case in which these tests revealed the presence of true purple was in the colored lettering of one eighth-century Insular manuscript, the Barberini Gospels (Vatican City, Biblioteca Apostolica Vaticana, MS Barb. lat. 570).[15] Further, it is now thought that the purple parchment of medieval manuscripts was produced not by dyeing but by brushing or rubbing the color onto the leaves. Cennini described techniques for painting parchment and paper a variety of colors, including green, purple (using the pigment known as folium, produced from the seeds of the herb turnsole), indigo, reddish or peach-colored, flesh-colored, and greenish gray; his method involved applying four or five coats of the tint to the surface of the parchment or paper.[16]

15. An article by Cheryl Porter on this topic, titled "The Identification of Purple in Manuscripts," is forthcoming in *Dyes in History and Archaeology* 23 (2007 for 2004).

16. Cennini, *The Craftsman's Handbook*, 9–12.

Illumination

Deluxe manuscripts often included illustrations, covering either all or part of a page. The number of illustrations might range from a single dedication miniature showing the manuscript being presented to its patron, to a cycle of several or even hundreds of pictures in a manuscript such as the Anglo-Saxon *Hexateuch* or a late medieval *Speculum humanae salvationis* or *Bible moralisée*. In most illustrated manuscripts, the pictures were copied from an exemplar, just as was the text. While a skilled artist would be able to work freehand to prepare a sketch and execute the composition in his or her own style, others, particularly artists in training, required additional help.

One method for copying, apparently used at least as early as the eleventh century, was a technique called *pouncing*.[17] The artist making the copy would first produce a template of the illustration to be copied by placing a sheet of parchment under the original picture and making prickings along the outline of the composition in such a way that the pricks penetrated through to the lower sheet of parchment, leaving a dotted outline. The template thus created would then be removed and placed over the parchment leaf on which the new illustration was to be made. Next, the artist would take a cloth bag filled with chalk or powdered pigment and would rub the bag over the template, forcing the powder through the pricks in the template so that it left a sketchy outline on the leaf below. The artist could then connect the dots to produce his copy.

Tracing paper was also known to and used by artists in the late Middle Ages. Cennini described how to make tracing paper from kid parchment that had been scraped as thin as possible, smeared with linseed oil, and then left to dry for several days.[18] Alternatively, a membrane made of glue could be used as tracing paper; the technique to produce this membrane is described in the compilation of artist's recipes made in 1431 by the Parisian notary Jean le Bègue:

> Grease thinly with mutton suet a smooth and polished stone of the breadth and length you wish your tracing paper to be. Then, with a broad brush, spread clear and transparent melted glue over the stone, and let it dry. Afterwards lift up from one of the corners of the stone a little of this skin of dried glue, which will be

as thin as paper, but transparent; and see whether it is thick enough, that is, whether it is not too thin; if so, do not pull it off, but leave it there and give it another coat of the same glue, and let it dry; and then again, as before, try whether it is thick enough. And repeat this until it is sufficiently thick. Afterwards take it quite off the stone, because the above-mentioned greasing with mutton fat will enable you to take off the said coat of glue easily, for it will not allow it to fasten or stick to the stone; and so you will have tracing paper.[19]

Cennini's treatise includes a description of how the artist would use tracing paper to make copies:

> To copy a head, or a figure, or a half figure, as you find it attractive, by the hand of the great masters, and to get the outlines right . . . put this tracing paper over the figure or drawing, fastening it nicely at the four corners with a little red or green wax. Because of the transparency of the tracing paper, the figure or drawing underneath immediately shows through, in such shape and manner that you see it clearly. Then take either a pen cut quite fine or a fine brush of fine minever; and you may proceed to pick out with ink the outlines and accents of the drawing underneath; and in general to touch in shadows as far as you can see to do it. And then, lifting off the paper, you may touch it up with any high lights and reliefs, as you please.[20]

PIGMENTS

Naturally, high-status manuscripts that incorporated a cycle of illustrations would include a broader range of colors than the simple reds, greens, and blues that were commonly used for the titles and initials in manuscripts of lower status. The initial *C* that begins the entry for *Color* in a fourteenth-century encyclopedia depicts an artist with a significantly broader range from which to choose: the colors before him include rose, pink, yellow, and orange in addition to red, green, and blue (fig. 2-25). In many manuscripts, the colors of the illustrations are as bright today as when they were first applied. In others, there has been considerable deterioration of certain of the colors, resulting from the effects of time, usage, and chemistry; and it requires an effort of the imagination to re-create mentally the initial appearance of the page. While it is impossible to determine exactly the ingredients that went into the pigments used by each medieval illuminator without (often destructive) chemical analysis, there are several surviving medieval and Renaissance treatises that contain recipes for pigments and that provide some insight into the materials commonly in use. The survival of such treatises is

17. The technique was discovered and described by Hellmut Lehmann-Haupt in Samuel A. Ives and Hellmut Lehmann-Haupt, *An English 13th Century Bestiary: A New Discovery in the Technique of Medieval Illumination* (New York, 1942), 35–41. Its use in the eleventh century was demonstrated by Dorothy Miner, "More about Medieval Pouncing," in *Homage to a Bookman: Essays on Manuscripts, Books and Printing Written for Hans P. Kraus on His 60th Birthday, Oct. 12, 1967*, ed. Hellmut Lehmann-Haupt (Berlin, 1967), 87–107, at 96–101.

18. Cennini, *The Craftsman's Handbook*, 13.

19. Mary P. Merrifield, ed., *Original Treatises on the Arts of Painting*, 2 vols. (1849; repr., New York, 1967), 1:292–94.

20. Cennini, *The Craftsman's Handbook*, 13.

both surprising and problematic, because painters tended to guard their recipes as trade secrets, handing them down orally through a process of apprenticeship. At best, the surviving treatises provide some of the possible ingredients and methods of manufacture, but they are by no means exclusive or exhaustive. The use of color was always meaningful, either to set off text, illustrate images, or represent symbolically an idea or concept. Thus gold, a precious metal in itself, also took on meaning through association with light and the sun; used in halos, it simultaneously distinguished the images in the eyes of the viewer and became itself sanctified

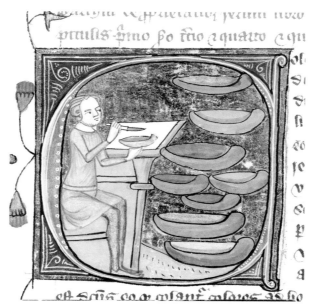

2-25 Various color pans are shown in this initial beginning the entry for *Color* in a fourteenth-century encyclopedia. London, British Library, MS Royal 6 E. vi, fol. 329r.

it in repeated cycles until the cloth was saturated. The clothlet was kept in a cool, dark, dry place and could be reconstituted with gum and hot water. Both organic and inorganic pigments needed to be mixed with a binding agent, both to allow them to flow onto the brush or quill and to help them to adhere to the support, whether parchment or paper. There were many suggested binding agents; the most popular were gum arabic (made from the secretions of the acacia tree), egg white (*glair*), and parchment sizing. Finally, pigments can be described as either transparent, in which case they would be mixed with other pigments or

through its association with the saints. Blue, generally used sparingly in antiquity and the early Middle Ages, grew in popularity from the eleventh century, when it began to be associated with the Virgin Mary, and it was eventually adopted as the color of the French royal family. Ingredients for certain colors such as ultramarine, gold, and Tyrian purple were so expensive that recipe books offer many substitutes. Some books also provide advice on distinguishing pure from adulterated ingredients, especially for the most costly ones.

There are several ways of differentiating among pigments based on composition. Such categories are fairly modern; medieval groupings of pigments were based on color rather than materials. Nevertheless, medieval artists, like their modern counterparts, were familiar with both organic pigments, those made from vegetable and animal products, and inorganic pigments, those made from minerals or through chemical reactions. In their natural state, organic pigments were difficult to use. They could not be easily stored as a liquid because they evaporated or became moldy; their color tended to darken quickly, and they could be used only during certain times of the year when the ingredients were available. To stem these problems, many organic pigments were made into *lakes* by precipitating them onto a colorless mineral base, usually aluminum hydroxide, which was achieved by mixing the pigment with alum salts (Al_2SO_4) and potash (an alkali make from ashes), also called quicklime or lye (KCO_3). The resultant color was much richer and more lightfast than the original organic pigment, and thus treated, the pigment could be dried and stored. Another method to preserve and store organic pigments was to make a *clothlet* by soaking cloth, usually wool, in the organic pigment and drying

used as a wash over other colors, or opaque, in which case they could stand alone.

Inorganic Pigments: Earth Pigments

Earth pigments were so called because they were mined from the earth and used with little processing. Earth pigments were the earliest pigments used by humans and are still in use today. They were extensively used in panel painting and to a lesser degree in manuscript illumination. There were several advantages to using earth pigments: they were cheap, readily available, chemically inert (so they would not react with other pigments), easily produced, and relatively lightfast. The process used to purify earth pigments was *levigation*. The mined material was mixed with water and allowed to settle. The sand would sink to the bottom and the grass and other impurities would float to the top. The impurities were skimmed off the top and the sand filtered out, leaving only the pigment. A richer and more opaque earth color could be obtained by roasting the pigment on iron plates, a process called *calcination*. Yellow ocher produced a dull yellow color; it was often used to modify green or red pigments. Red ocher varied enormously in color and was totally lightfast. It was commonly called *sinopia* and was one of the most frequently used reds. Green earth, or *terre-verte*, was not much used in manuscript painting because it was difficult to grind fine enough to use for illumination, but it was used on panel and wall paintings. It also varied in color; the best green was from Verona and was called Verona green. A yellow-brown green, called Bohemian green, was used by several early Renaissance artists as an underlayer to give flesh tones a greenish tint.

Inorganic Pigments: Other Natural Mineral Pigments

One of the most valuable and highly prized pigments in the Middle Ages was the blue made from lapis lazuli, which in the premodern era was obtained almost exclusively from a mine in northeastern Afghanistan; the pigment was called ultramarine (also known as blue azure) because the source of the mineral lay *ultra mare*, beyond the sea. Yielding a blue that was wonderfully deep and rich in hue, lapis lazuli seems first to have been used as a pigment in Western Europe around the year 1000. In the thirteenth century, a significant advance in the method of extraction led to increased usage. If lapis is simply ground, it turns a gray color. Prepared according to Cennini's recommendation, however, it produced many desirable shades of blue. First it was ground and combined with pine rosin, gum mastic, and wax, and the ingredients were melted together and strained through a white cloth. Next, the mixture was formed into a ball and kneaded for several days. Before use, it was mixed with lye, and the lapis-saturated lye was drawn off and allowed to dry. The first batch would be the richest in color; each subsequent addition of lye to the lapis mixture would become less saturated with blue.[21] To get the richest color the artist had to apply several layers, greatly increasing the cost.

One substitute for ultramarine was azurite (copper carbonate), which was mined in eastern France, Spain, and Italy. It was also expensive, although not as costly as lapis. Because it derives its color from copper, azurite was commonly called copper blue, but it was also known as blue verditer and German blue. It was a dark blue color that merely needed to be ground and mixed with a binding agent. The more coarse powder was dark blue; the finer the grind, the more gray the color. Artists ground azurite to varying levels of fineness to create various shades of blue from pale blue to light green. Malachite, azurite's close relative, is a sage-green color. It was mined along with copper in Germany and eastern Europe and was prepared as a pigment in the same way as azurite. Extremely poisonous orpiment, arsenic trisulfide (As_2S_3), was the most common yellow used in manuscript illumination until it was replaced by lead-tin yellow in the later Middle Ages. Brighter and lighter than yellow ocher, it can react with several pigments, particularly silver, to blacken them. Cinnabar was the naturally occurring form of mercuric sulfide (HgS) that produced a rich red color. It was primarily mined in Spain and was extremely expensive. Synthetic cinnabar (see the description of vermilion in the next section) was produced as an alternative in the twelfth century.

Synthetic Inorganic Pigments

Synthetic pigments are those produced by chemical reactions or processes from raw materials that are not in

themselves pigments. One of the most extensively used synthetic pigments, both on its own and mixed with other pigments, was lead white (lead carbonate, $2PbCO_3$. $Pb[OH]_2$), also called flake-white. Lead white was produced by hanging lead sheets above an acid vapor (usually wine) in a warm, moist environment in the presence of carbon dioxide. A white crust formed on the sheets that could be scraped off, ground, and mixed with a bonding agent. The resulting pigment was lightfast, had great covering power, and could be mixed with most other pigments, with the exception of orpiment and verdigris. There were several drawbacks to using lead white: it was poisonous, it could turn black over time, and it had a tendency to flake off, especially if mixed with too much gum. Lead white was, nevertheless, the only white available for artists until the seventeenth century. As noted above, the red lead pigment (minium) so commonly used for titles and initials in manuscripts was itself a derivative of lead white. Another lead-based pigment, lead-tin yellow ($PbSnO_4$), came into use around 1400 when it replaced orpiment. Although it also could blacken over time, lead-tin yellow was inexpensive and unaffected by light, and it could be mixed with many colors. Vermilion was a synthetic form of cinnabar formed by heating mercury and sulfur until they were vaporized and then scraping off the subsequently precipitated material, grinding it, and tempering it with egg (both albumen and yolk). Vermilion was completely opaque. It was often mixed with lead white to create flesh tones. Its defects were toxicity, high cost, and a tendency to powder and turn black.

Organic Pigments

Yellow pigment was popular in the early and high Middle Ages but was often replaced by gold leaf in the later medieval period. The most common organic yellow colors, all transparent, were made from weld, saffron, and unripe buckthorn berries, each of which had to be mixed with alum. Cultivated in southern Europe, weld was the most lightfast organic yellow. It could be mixed with indigo to create green, with woad (described below) to make black, or with lead white to make it opaque. Saffron, unlike weld, was very expensive. It was used for gold in manuscript illumination. It could also be used to enrich reds such as vermilion and to modify verdigris to make it less likely to burn through the membrane. Unripe buckthorn berries (ripe berries were used for the green pigment called sap green) also yielded a yellow dye and pigment.

Organic reds were made from madder, brazilwood, and kermes. Although D. V. Thompson, who pioneered the study of medieval pigments in the mid-twentieth century, speculated that madder was not used in medieval painting because there are no surviving recipes describing its preparation, modern chemical analysis suggests that it was used extensively in dyeing from the late antique period as well as in manuscript illumination. The madder root was dried and threshed and often gave a brick color, although

21. Ibid., 36–39.

its range of possible colors is quite large. Madder was usually incorporated into clothlets rather than lakes and was extremely lightfast.

Harvested in Asia in the Middle Ages, brazilwood was widely used to produce a purplish-pink pigment. The wood was chopped into small pieces and rasped to facilitate oxidation. It was almost always used as a lake. It was mixed with woad to produce purple and with lead white to produce a bright rose color. Because it was inexpensive and readily available, it was generally not used in luxury production. After the 1450s the disruption in trade caused by the fall of Constantinople to the Turks sharply curtailed the use of brazilwood.

The most sought-after organic red was kermes, made from the larvae of scale insects of the genus *Kermes* and often called St. John's Blood because it was harvested on St. John's Day (June 24). The larvae were taken from the roots of the kermes oak (*Quercus coccifera*), which was dug up and then replanted. The ground-up larvae produced a rich scarlet red that was extremely expensive. After the fall of Constantinople, Pope Paul II (1464–71) decreed that cardinals' robes had to be dyed in kermes when murex purple was no longer available. In the second half of the sixteenth century, kermes was largely replaced by cochineal, which was much cheaper and yielded a darker pigment. Cochineal was made from female insects harvested from cactus plants in the New World.

There were two organic blues, chemically identical but drawn from different species of plants. The first was made from the woad plant, grown in southern France, northern Italy, Spain, and Germany, which was turned into pigment through a complicated process of heating, fermentation, and drying. The second came from the indigo plant, imported from Asia during the Middle Ages and usually ground to produce pigment. Although the two pigments were chemically identical, indigo was much more concentrated than woad. Indigo could be mixed with orpiment or earth yellow to make greens that were less acidic than verdigris. It was mixed with lead white to make sky blue and with brazilwood for purple.

GOLD AND SILVER ILLUMINATION

The richest medieval manuscripts included illumination in gold and/or silver. These precious metals were used for initials, for the backgrounds to illustrations, and for details (such as halos) within illustrations. It has been well observed that, strictly speaking, only those manuscripts that include gold and silver decoration, which reflects the light, can properly be called illuminated manuscripts.[22] Silver, applied in the form of silver leaf, was much less common in manuscripts than gold, probably because the metal was subject to tarnishing that would cause those initials or portions of illustrations executed in silver to blacken over time. A common substitute for silver leaf was tin. Ironically, tin,

the less expensive alternative, tends not to oxidize and tarnish as quickly as silver. If a medieval manuscript includes silver-colored decoration that has not oxidized, it is likely that the decoration used tin rather than silver.

Gold decoration in manuscripts was much more common in the late than the early Middle Ages, when yellow was commonly used as an alternative to gold. Medieval artists used two quite different techniques for applying gold to manuscripts. One technique used powdered gold mixed with gum, applied with a pen or brush; because the artist often mixed this gold pigment in a shell, it is usually called shell gold (see the coat of arms in chap. 8, fig. 8-12 for an example). Gold of this type was applied to the page only after the other colors. It was often used for adding highlights, substituting for lead white in late medieval manuscripts. The second technique involved the application of gold leaf to the page and produced the most beautiful effect, especially when the gold stood out in relief as a result of being laid on a raised base. Gold leaf had to be applied first; otherwise it would stick to the other colors as it was being applied, and the vigorous burnishing that followed the application of the gold leaf would damage any colors already on the page (see fig. 2-26).

To use gold leaf, the artist had first to lay down on the page a base to which the gold would adhere, contoured very precisely so that it outlined exactly that portion of the illustration that the gold would occupy. The base could be egg white (as described by Theophilus in the example quoted below), but later medieval artists favored the use of gesso, a plaster of Paris mixture that included white lead and a little sugar and was colored pink or brown with bole armeniac, a type of red clay. The color both helped the artist to see where the gesso had been laid and imparted an undertone to the gold. Once the gesso was in place and allowed to dry, the artist would breathe gently on the gesso to make it tacky again so that the gold leaf would adhere to it. Multiple layers of gold leaf might be applied to give the illumination greater depth. Once in place, the gold was burnished with a stone (agate) or the tooth of a dog or some other animal. Burnishing polished the gold and rubbed away any excess extending over the edges of the gesso. The gold might also be tooled with a decorative pattern (for example, a repeating pattern of lozenges), as was frequently done with the gold backgrounds of the illustrations of deluxe manuscripts of the Gothic period (see fig. 2-26).

Theophilus described in instructive detail both how to make the gold leaf and how to apply it to the page (using glair as the base).[23] The artisan had first to beat out a quantity of pure gold with a hammer on an anvil, cut it into squares measuring two fingers long by two fingers wide, then place the pieces in a vellum pouch with strips of material ("Greek parchment," made from rags) placed between the sheets of gold, then hammer the pouch on

22. De Hamel, *Scribes and Illuminators*, 57.

23. Theophilus, *The Various Arts*, 20–22.

2-26 This incomplete illumination demonstrates that gold leaf was applied after ink but before any pigments. London, British Library, MS Add. 42555, fol. 41r.

a large, smooth stone until the gold reached the desired thinness. He continued:

> When you have thinned it out according to how you want it, cut off as many pieces as you wish with the scissors, and with them arrange the haloes round the heads of figures, stoles, the borders of draperies, and so on as you wish. To apply the gold, take the white of an egg beaten up without water, and with a paintbrush lightly coat the surface on which the gold is to be placed. Moisten the handle of this brush in your mouth, touch one corner of the leaf you have cut off, and, lifting it like this, apply it with the greatest speed and smooth it out with the brush. At this moment you should be careful of draughts and hold your breath because if you breathe out you will lose the leaf and only retrieve it with difficulty. When it has been applied and is dry, lay another over it in the same way if you so wish, and a third similarly, if required, so you can polish it more brightly with a tooth or with a stone.

Decorating with gold leaf was a costly process, not only because of the expense of the gold itself but also because the preparation of the leaf required the services of a skilled metalworker. Not surprisingly, there were cheaper substitutes for gold, of which one of the most common, called mosaic gold or musive gold, was tin disulfide (SnS_2), made by mixing tin, sulfur, ammonium, chloride, and mercury in an iron flask at an extremely high temperature. Once the mixture had cooled, it could be used like paint. The resulting pigment is gold in color with an especially grainy surface.

Medieval craftsmen, as will by now be clear, were familiar with a broad range of pigments and of techniques for making and applying them. Over the medieval period, there were significant developments in the use of pigments, as colors moved in and out of fashion, as materials were alternately readily available or unobtainable, and as new techniques emerged.

CHAPTER THREE

Correction, Glossing, and Annotation

CORRECTING: TYPES OF ERROR
AND METHODS OF CORRECTION

Once the text of a manuscript was complete, it had to be checked and corrected, and it might also be provided with glosses. While the scribe would no doubt make some corrections in the process of copying, upon completion a corrector subjected the entire text to comparison with the exemplar from which it had been copied so that mistakes could be spotted and rectified. In many cases corrections were made not by the original scribe but by more senior members of the scriptorium, who had a greater range of textual familiarity and insight.

Perhaps the most common scribal error was *eyeskip*, which could occur when the same word, phrase, or sequence of letters appeared twice in close succession in the text being copied (see figs. 3-1 and 3-8). As the scribe copied the first occurrence and then looked back to his exemplar, his eye might jump by mistake to the second occurrence so that he omitted to copy the intervening words/letters. If the error involved two words having the same letters at the beginning, it is called *homoeoarcton*; if two words having the same letters at the end, *homoeoteleuton*. A more extended omission in which the scribe failed to copy several words because of the recurrence of a particular word or phrase in the exemplar is often called by the French term *saut du même au même*. The opposite error, *dittography*, was

also common: having correctly copied in full a passage in which the same word or phrase occurred twice, the scribe's eye went back from the second to the first occurrence in his exemplar, causing him to copy the passage a second time (see fig. 3-2).

Two of the most common methods of correcting were erasure and subpunction (also called expunction). An incorrect letter or phrase could be scraped away with the penknife and the correct letter or phrase entered in its place (see figs. 3-1 and 3-3). Sometimes, when a phrase had been omitted through eyeskip, the corrector would erase several lines, then rewrite the text in smaller, more compacted script so that there would be room to include the omitted phrase (see fig. 3-4). An alternative method of correcting a wrong letter or group of letters was to place dots under the unwanted letters (subpunction/expunction), then write the correct letters above the original letters: the dots directed the reader to ignore the letters immediately above them (see fig. 3-5). This method is equivalent to the modern method of striking through an unwanted letter or group of letters, which is also found in some manuscripts; indeed, sometimes the same group of letters might be both under-dotted and struck through, the two corrections of the same error having perhaps been added at different times (see fig. 3-6).

Another type of error occasionally committed by me-

3-1 Here the scribe's original omission of a phrase because of eyeskip between two occurrences of the word *persecutionem* has been corrected by erasure and rewriting. Newberry Library, MS 12.3, fol. 4v.

3-2 The scribe here committed an error of dittography: his eye slipped from one occurrence of *mortem* back to a previous one, causing him to repeat the phrase "dauid, sed post mortem." Newberry Library, MS 12.2, fol. 64r.

3-5 The dots under the words "Spiritualem arbitror esse non corporalem" show that the phrase appears here in error: the reader should ignore it. Newberry Library, MS 12.4, fol. 118r.

3-6 Here correctors have marked the word *tuam* for deletion by entering dots under it and striking it through. Newberry Library, MS 104.5, fol. 32r.

3-3 The text that originally occupied lines 1–3 and 6–7 on this page has been erased by scraping: the parchment is roughened in these areas. Newberry Library, MS 20.1, fol. 29r.

3-4 A corrector has here erased several lines in order to create enough space to enter the required text. He then began to enter the new text in compressed script, trespassing into the outer margin and the intercolumn; as he reached the end of his correction, however, he had more space left than he needed. Newberry Library, MS 12.3, fol. 42v.

dieval scribes was inversion of word order, when two or more words were copied in the wrong order. The method devised to correct this form of error was to enter letters of the alphabet above the words in question; the reader should then take the words in the order indicated by the alphabetical sequence. That is to say, if the scribe had reversed the order of two words, the corrector would enter the letter *b* above the word written first and the letter

a above the word written second; the reader should take first the word marked *a*, then the word marked *b* (see fig. 3-7). A similar, but more extensive, method of entering letters of the alphabet over words in the main text was used by some early medieval readers, particularly Anglo-Saxon, Irish, and Welsh readers, to make it easier for them to understand Latin (usually Latin verse). Entire passages of Latin were sometimes marked in this way, to put the Latin words into an order that would be easier for an Insular reader to construe; modern scholars call such marks *construe marks* or *syntactical glosses*.[1]

1. For a fuller description of these marks, see, for example, Fred C. Robinson, "Syntactical Glosses in Latin Manuscripts of Anglo-Saxon Provenance," *Speculum* 48 (1973): 443–75.

3-7 A corrector (probably the original scribe himself) has here entered the letters *b* and *a* over the consecutive words *impleuit accepit* in the fifth line to correct the word order to *accepit impleuit*. Newberry Library, MS 12.1, fol. 18r.

Sometimes corrections would be entered in the margin rather than within the column of text. In such cases, paired letters or signs linked the relevant point in the text with the correction that related to it so that the reader's eye would be led easily from the one to the other. In early manuscripts, corrections made in the upper or lower margin would be linked with the text by entering *hd* or *hs* in the text, *hs* or *hd* next to the beginning or end of the correction in the margin. As the paleographer E. A. Lowe showed, the letters stand for *hic deorsum* (here downward, i.e., look downward) and *hic sursum* (here upward/look upward).[2] If the correction was entered in the upper margin,

hs would appear in the text to tell the reader to look to the upper margin; *hd* next to the correction told the reader to look downward to see the point to which the correction related. If the correction was in the lower margin, *hd* would appear in the text and *hs* next to the correction. Later scribes continued to use these letters but misunderstood their significance, entering *hd* in the text and *hs* in the margin, no matter whether the correction was in the upper or the lower margin; they apparently believed that *hd* stood for *hic deficit* (here there is an omission), *hs* for *hoc supple* (supply this).

From the tenth century onward, the most common method for linking text and marginal correction was to use a pair of matching signs (see figs. 3-8 and 3-9). Such signs, called *signes-de-renvoi*, or tie marks, took many different forms, from letters of the alphabet to geometrical shapes to more decorative forms. They were especially suitable when several corrections occurred on the same page because the reader could swiftly locate in the margin the match for the sign placed within the column of text.

Sometimes a longer correction would be written on a slip of parchment inserted into the manuscript. Newberry Library MS 6 presents an especially interesting case of how an original omission of a substantial portion of text was corrected in two stages. The manuscript, made in Austria or southern Germany in the first half of the twelfth century, contains a copy of Othlo of St. Emmeram's *Dialogus de tribus questionibus*. The original scribe omitted fifteen complete consecutive chapters. A corrector wrote the miss-

2. See "The Oldest Omission Signs in Latin Manuscripts: Their Origin and Significance," in E. A. Lowe, *Palaeographical Papers, 1907–1965*, ed. Ludwig Bieler, 2 vols. (Oxford, 1972), 2:349–80.

3-8 A marginal correction with matching *signes-de-renvoi* to indicate where the text should be inserted. The original omission was caused by eyeskip between two occurrences of the phrase *de ble*. Newberry Library, MS 20.1, fol. 84v.

3-9. Corrections in the margin linked to the appropriate points in the text with matching *signes-de-renvoi*. Newberry Library, MS 20.1, fol. 14r.

3-10 The rubricated instruction "Hic deficit uolue duo folia ibi inuenies. Demonstrauit" advises the reader to turn two leaves to correct an omission in the text. Note that the instruction has been crossed out in drypoint. Newberry Library, MS 6, fol. 72r.

3-11 Inserted slip on which have been entered the lines of text immediately preceding an omission that was corrected by the addition of six new leaves. Newberry Library, MS 6, fol. 65r.

3-12 The text written on the slip (see fig. 3-11) originally occupied the first seven and a quarter lines on this page. The lines were erased and the space was then reused for entering the last portion of the omitted text. Newberry Library, MS 6, fol. 72r.

ing text on six leaves (and presumably a portion of a seventh, no longer extant) that were inserted after the quire in which the omission occurred. To alert the reader to the omission, the corrector entered a rubricated instruction sideways in the outer margin of the leaf where the omission began (see fig. 3-10), two leaves before the end of the quire. The instruction states: "Hic defic(it) uolue duo folia ibi inuenies. Demonstrauit" (Here there is an omission. Turn two leaves; there you will find *Demonstrauit* [the first word of the omitted passage]). Soon afterward, however,

another corrector decided that the added leaves should be sewn into the quire in which the omission had originally occurred, close to the point at which the omission began. That was partway along the eighth line of the recto of a leaf. The six leaves bearing all but the last few lines of the correction were inserted immediately before that recto. The first seven-and-a-quarter lines on the recto, which contained text preceding the omission but which now of course followed the inserted leaves, were erased, but only after the lines had first been copied onto a slip that was inserted immediately before the added leaves (see fig. 3-11). The erased area was then used to enter the last portion of the omitted text, which it had not been possible to fit on the sixth of the added leaves (see fig. 3-12). No longer needed, the rubricated instruction telling the reader to turn two leaves was struck through in drypoint (see fig. 3-10): thanks to the second stage of correction, the text could now be read continuously, without the need to flip forward and backward through the leaves.

GLOSSING

Explanatory glosses of various kinds occur frequently in manuscripts. Rarely spontaneous reactions by a reader to the text (although examples of this do occur, particularly in the period before the twelfth century), glosses were more commonly copied from another manuscript along with the main text. Sometimes the same exemplar would provide both text and glosses; sometimes the text would be copied from one exemplar, the glosses from another. Often the provision of glosses formed part of the original process of production of a manuscript; sometimes glosses were added only later by someone who had come upon a relevant set of glosses.

Glossing became fuller and more complex in content and format as the Middle Ages advanced. Early glosses tend to offer simple explanations for words or phrases in the main text. Being brief, they could be entered in the interline directly above the textual element to which they related; the glossing scribe would typically use a script smaller than that of the main text (the result of using a more finely cut nib). Two common types of gloss were the *lexical* and the *suppletive*. Lexical glosses supplied one or more synonyms for difficult words or phrases in the main text (see fig. 3-13, ll. 1 and 10). Such glosses characteristically began with the abbreviation .*i.* for *id est* (that is), although *al.* for *aliter* (otherwise/alternatively) also occurs quite commonly; a succession of glosses on the same word or phrase would be linked by the abbreviation *t* or *ut* for *uel* (or). Suppletive glosses supplied a word or phrase omitted in the original text through ellipsis (see fig. 3-13, ll. 3 and 5). For example, the verb *to be* can often be omitted in Latin constructions. A suppletive gloss might add the verb in its appropriate tense and person. Again, a suppletive gloss might note the noun to which demonstrative or relative pronouns referred. Suppletive glosses commonly began with the abbreviation *s.* for *scilicet* (namely/understand).

When a term or phrase required a longer explanatory gloss to make its meaning clear, the gloss would be entered in the margin and would be linked to the relevant point in the text by a pair of matching *signes-de-renvoi* (see fig. 3-13) similar to those used for linking text and marginal corrections.

Occasionally, a scribe would misconstrue an interlinear or marginal gloss as a correction or addition to the text and would then erroneously copy the gloss into the main text of the manuscript he was writing. Once such an error had occurred, it could be transmitted from one manuscript to another over several generations, until someone realized that the phrase in question did not belong to the text proper.

In some manuscripts, glosses were entered neither in the interlines nor in the margin but in the main text area, gathered together at the end of the chapter or section to which they referred, immediately before the next chapter. In such cases, it was necessary to write down not only the glosses but also the word or phrase (the *lemma*) to which each gloss related. The *Rule of St. Benedict*, the most influential of all monastic rules, was sometimes glossed in this way; Newberry Library MS 79 offers an example of an Italian translation of the *Rule of St. Benedict* prepared for nuns, with the glosses gathered at the ends of chapters and with the keyword for each gloss written in red (see fig. 3-14). Sometimes sets of gathered glosses (known as *glossae collectae*) became separated from the text to which they related and circulated independently. Some medieval commentaries are little more than an assemblage of *glossae collectae*, without any accompanying discussion of the text.

Glossing grew in complexity, with a consequent call for advances in page layout, from the twelfth century onward, largely through the development of more sophisticated methods of biblical commentary and the wish to provide, as study tools, glossed copies of portions of the Bible—

3-13 This fragment of a tenth-century copy of St. Paul's first Epistle to Timothy includes interlinear lexical and suppletive glosses, as well as longer explanatory glosses entered in the margin and tied to the appropriate place in the text by matching *signes-de-renvoi*. Newberry Library, Medieval Manuscript Fragment 16, recto.

3-14 In this Italian *Rule of St. Benedict* prepared for nuns, the chapter "Che non presumi alcuna batere o excomunicare laltra. C. lxx" is followed by its glosses, which have their own rubricated heading, "Declaratio. Oue dice batere o excomunicare." Newberry Library, MS 79, fol. 56r.

script. However, as the amount of commentary varied from verse to verse, it could still be difficult to keep the commentary close to the verse to which it applied. Sometimes, therefore, scribes might write the main text only on every third or fourth line for certain portions of a page and might use the intervening lines to enter portions of the gloss within the central column, attempting thus to keep main text and commentary in step (see chap. 11, fig. 11-2). This meant that each page had to be carefully planned, and that, rather than writing all the main text first and entering the glosses later, as had been the earlier practice, the scribe would write both the main text and the gloss for each page before moving on to the next page. In some late medieval glossed biblical manuscripts (and also early printed books, which imitated manuscript formats), the density of the commentary so far outweighed the original text that on some pages a small island of one or two lines of text was surrounded by an ocean of commentary occupying the rest of the page. This is notably the case in early printed editions in which the biblical text is accompanied by the *Postillae*, or commentaries, of the Franciscan Nicholas of Lyra (ca. 1270–1349).

The habit of ruling pages to receive both main text and glosses spread from glossed biblical manuscripts to other types of text. Works typically attracting large amounts of glossing included legal texts (canon and civil; see fig. 3-15), the *Sentences* of Peter Lombard, and the works of Aristotle. Quite commonly, rather than having a narrow ruling for the whole page (with the main text entered only on every second line and the gloss on every line, as described above), the central column would instead be ruled more widely than the margins, with two marginal rulings for every central ruling. In some manuscripts, intentions exceeded execution and the glossing did not attain the anticipated density, with the result that large areas of the ruled margins remained devoid of gloss. In Newberry Library MS 20, a mid-thirteenth–century copy of the *Sentences* of Peter Lombard, the whole manuscript has been ruled to receive glosses, but the glossing varies greatly in density from page to page, with no glossing or very little glossing on some pages (see fig. 3-16 for an example of a densely glossed page). In this manuscript, red or

for example, the Pentateuch, the Minor Prophets, and the Epistles of St. Paul.[3] Scholars at the cathedral school of Laon and elsewhere gathered together comments made by various church fathers on individual verses of the biblical books, and scribes then produced manuscripts in which those comments were entered in the margins as closely as possible to the verses to which they related. Each page of such a manuscript would be ruled to receive both main text and gloss. Commonly, the lines would be ruled close together and would extend out into the left and right margins. Then the main text would be entered in a larger script in the central column, but only on every second line, while the gloss, entered in both the outer and the inner margins, would be written on every line, in a smaller

3. See the brilliant description of the impact of the evolution of biblical commentary on the design of glossed manuscripts in Christopher de Hamel, *Glossed Books of the Bible and the Origins of the Paris Booktrade* (Woodbridge, U.K., 1984).

3-15 In this glossed *Liber decretalium* of Gregory IX, the commentary is more extensive than the text itself. A complex system of lettered references leads the reader from text to commentary; dots link the portion of the commentary occupying the bottom of the left column with its conclusion at the bottom of the right column. Newberry Library, Medieval Manuscript Fragment 58, fol. 2v.

3-16 First page of a mid-thirteenth-century French copy of the *Sentences* of Peter Lombard in which each page has been ruled for both main text and gloss. The initial depicts Peter Lombard teaching. Newberry Library, MS 20, fol. 1r.

black underlining is used within the gloss to identify the *lemmata*, that is, the words or phrases of the main text to which the glosses relate.

SOME COMMON MARKS OF ANNOTATION

Roger Stoddard, with his 1985 exhibit and resulting catalogue, *Marks in Books*, has drawn attention to the various marks made in books after their initial creation and what those marks might indicate about the book's history.[4] Prior to the 1970s, many libraries and booksellers preferred books in their pristine state, and many books with marginalia (except those whose annotations were known to be of some importance) were less valued. It is safe to say that at present many historians (and libraries and booksellers) are more interested in what takes place in the margins of the books than in the text itself.[5] Some bibliophiles and booksellers, such as Bernard M. Rosenthal, began collecting annotated books in the 1960s and have amassed significant collections of printed books with manuscript marks.[6] While there were innumerable marks used by early readers, some of which are not at present decipherable, this section covers the ones the modern reader is most likely to encounter.

Finding Aids

Few books in the Middle Ages would have been read continuously from cover to cover. Most books were read discursively—that is, the reader would read some chapters or lines in one part of the book and then skip to another part, or even skip to another book. The reader would keep his or her place by inserting a hand or finger into the book while searching for the next section. The reader could also use bookmarks; almost anything might be pressed into use as a bookmark, a fact that may account for strange unidentifiable stains and any organic matter found in books (see chap. 7, figs. 7-3 and 7-4). Many finding aids were more permanent. Leather strings could be attached to the binding to easily mark one's place. There were also several methods of marking regularly used pages, including finger tabs cut from the page itself (see fig. 3-17) or objects attached to the page that could be seen while the book was

open to another page. Newberry Library MS 59.1, a missal of ca. 1470 from the Church of St. Michael in Ghent, has several finding aids. Liturgical books were particularly in need of markers that would enable the celebrant to find his place easily and quickly. While one part of a missal

3-17 Finger-tab produced by making a cut in the fore-edge of the leaf and passing the tab through the slit. Newberry Library, MS 45.5, fol. 6r.

3-18 Ghent missal with pippes and ball-tabs made of leather dyed in various colors. Newberry Library, MS 59.1, fol. 138r.

4. Roger Stoddard, *Marks in Books, Illustrated and Explained* (Cambridge, MA, 1985). See also Roger Stoddard, ed., *Marks in Books: Proceedings of the 1997 BSA Conference. The Papers of the Bibliographical Society of America* 91 (December 1997).

5. See, for example, Michael Camille's *Image on the Edge: The Margins of Medieval Art* (Cambridge, MA, 1992), which examines the interplay between the text and the images in the margin.

6. Bernard Rosenthal gave his collection to Yale University's Beinecke Library. It is catalogued in *The Rosenthal Collection of Printed Books with Manuscript Annotations: A Catalogue of 242 Editions Mostly before 1600 Annotated by Contemporary or Near Contemporary Readers* (New Haven, 1997).

3-19 *Nota* annotation in which the top of the *T* and the bottom of the *A* delimit the text to be heeded. Newberry Library, MS 8, fol. 11r.

3-20 *D(ignum) M(emoria)* annotation. Newberry Library, MS 8, fol. 59v.

contained the Canon of the Mass, which did not change from one mass to another, the prayers that had to be read out on particular feast days were scattered throughout the rest of the book. An examination of the binding of MS 59.1 shows several pippes—leather strips attached to the binding that could be used as page markers. The manuscript also has leather balls colored red and gold, attached by strips pasted to the outer margin of certain leaves so as to be visible on the fore-edge (see fig. 3-18).

One of the most common types of markings found in manuscripts is the *nota bene* marking, designed to draw the reader's attention to a significant passage. Among the many types of *nota bene* marks used during the Middle Ages, three occur with some frequency.

The first, used by twelfth- and thirteenth-century readers, consisted of a monogram formed by the four letters of the Latin imperative *Nota* (Take note; see fig. 3-19). The *O* would be written at the bottom of the left stem of the *N*, or perhaps (as in the example illustrated) on the right stem; the top of the right stem would be crossed to make a *T*; and the *A* would be written at the bottom of the right stem. One or other stem of the *N* might be extended to whatever height was desired, so that the top and bottom of the stem were next to the first and last lines of the passage to which attention was being drawn (see fig. 3-19). A second method of annotation favored in the twelfth century consisted in entering the letters *D.M.* alongside significant passages (see fig. 3-20). The letters stood for *Dignum memoria* (Worthy of memory/Worth remembering).

A second method favored in the late Middle Ages, from the later thirteenth century onward, was to enter in the margin a sketch of a hand with the index finger extended to point toward the beginning of the significant passage.

Paleographers term such a mark a *manicula* (little hand; see fig. 3-21). Some annotators might adjust the size of the hand or the length of the extended index finger so that it spanned a portion of the margin equivalent to the length of the significant passage. The appearance of the sketched hand varied considerably from one annotator to another, and sometimes one has only to see a particular shape of *manicula* to know that a manuscript has been read by a particular scholar. For example, the sixteenth-century English antiquarian John Leland used a crudely outlined, instantly recognizable *manicula*. He was no great draftsman; on occasion his *maniculae* would include six fingers.

Line Fillers

The aesthetics of medieval manuscript production dictated that the text within columns be arranged in block format with justified left and right margins. Often scribes would vary the size of their letter forms or the spaces between letters and words when approaching the end of a page or section to ensure that the margins remained straight. Other common techniques employed to achieve the same effect were word hyphenation or snaking the rubrics around the rightmost edge of several incomplete lines to even out the right-hand margin. In the event that there was leftover space at the end of a line that could not be filled with text, the scribe—or an artist working after the scribe had entered the text—would often use line fillers so that the page had the appearance of a justified right margin. These fillers can be simple vertical lines (minims) or more complex geometric designs. The more luxurious the manuscript, the more complex and decorative would be the line fillers. Notable examples of decorative line fillers occur in the Book of Kells of ca. 800 (Dublin, Trin-

ity College, MS 58) and in the fourteenth-century Queen Mary's Psalter (London, British Library, MS Royal 2 B. vii). Several of the Books of Hours illustrated in chapter 13 include colored, decorated blocks used as line fillers (see, for example, figs. 13-12, 13-13, 13-21, and 13-28). The fifteenth-century Carthusian lectionary pictured in chapter 10, figure 10-9, includes two modest forms of line fillers at the end of lines 10 and 11 of the left-hand column, consisting respectively of a minim and a letter *o*, each crossed by a slash.

Pen Trials

Typically, when a scribe cut his pen, his next step was to check that it was cut correctly by making a few common strokes, usually on a sheet of scrap parchment or paper. In some cases, however, a scribe used the recto or verso of the last folio in the gathering being worked on, or made the trial on available parchment in another book altogether (see fig. 3-22). Such *probationes pennae*, or pen trials, might consist of a sequence of letters of the alphabet, a well-known verse from the psalms or some other source, or a prayerful invocation of divine aid.

Sketches and Rough Drafts

Frequently, manuscript artists would make preliminary sketches of their more ornate initials before entering the final version of the initial in the space reserved

3-21 Example of a *manicula* from a Franciscan repertory of papal bulls, 1464–71. Newberry Library, MS 80, fol. 41r.

3-22 Pen trials on the flyleaf of a twelfth-century English manuscript of St. Augustine's *Enarrationes in Psalmos*. Newberry Library, MS 13, fol. 161r.

for it. In the early medieval period—up until the eleventh century—such sketches were often made in drypoint; thereafter, they more commonly occur in plummet or watered-down ink. Often the sketch would be entered in the area intended for the final version; in such cases, the sketch can be seen only when its lines deviate from those of the final version. Sometimes artists would make the sketch in the margin, either on the page on which the initial was to be entered or on another page. In the example illustrated here, a partially trimmed sketch of an initial (apparently a *B*) has been entered in drypoint at the bottom of what was originally a blank page at the end of a section (see fig. 3-23).

Doodles

There are some markings in books that have no practical function but may just represent the doodling of a bored or inattentive reader or scribe. Most commonly found are heads, often with exaggerated features, and animals. Such doodles were normally entered in the margins of manuscripts, on flyleaves, or on endpapers, but occasionally they are found in other available blank areas of the page, such as within the bows of initials. Newberry Library MS 12.1 has several border sketches in drypoint. Shown here are an owl, an unidentified object, a bird, and a head in profile; they bear no discernible relationship to the text (see fig. 3-24). Quite unusually, Newberry Library MS 8 has drypoint sketches of heads scratched into the turn-ins of the leather covers of its twelfth-century binding.

Pawn Markings

It was not uncommon for medieval books to be put up as collateral for loans. Numerous manuscripts survive that bear the name of the person pawning the book in their front or back inscriptions. Such pawn marks provide invaluable evidence for the history of the ownership of the book. In England, the universities of Oxford and Cambridge both had "chests" that were formed from endowments and from which loans were made to those affiliated

3-23 A detailed drypoint drawing of a capital *B*, from a twelfth-century Cistercian missal. Newberry Library, MS 7, fol. 95r.

3-24 Various sketches drawn in the bottom margin of a page of an Augustine collection belonging to St. Mary's Abbey, Reading. Newberry Library, MS 12.1, fol. 6r.

3-25 *Cautio* notices from the last leaf of the same Augustine manuscript. Newberry Library, MS 12.1, fol. 120v.

with the university. Each chest had its own scale limiting the amount of money an individual could borrow according to his academic rank, and guardians were appointed to ensure that the books left as collateral could cover the value of the loan. The books would remain in the chest until the debt was repaid or until the book was sent to the stationer for sale to cover the debt. The books themselves were marked with a *cautio* (note of security or pledge) that included the name and academic rank of the individual, the name of the chest from which he was borrowing, the date of the loan, and a reference to any supplemental books put up as collateral if the present book did not cover the full value of the loan.

Newberry Library MS 12.1, a twelfth-century copy of theological works by St. Augustine and others that originally belonged to the abbey of St. Mary at Reading, includes on its last leaf a set of three *cautiones* showing that in the early fourteenth century the book was in the hands of one William de Burghildbiri, who pawned it in three consecutive years, 1325–27 (fig. 3-25). The first two *cautiones* have been crossed through, showing that William redeemed the book on these two occasions. The third one notes that on the Saturday before the feast of St. Thomas the Apostle (21 December) in 1327, William pawned the book for two marks—the same amount as in the preceding years—that the loan was made to him from the Roubery Chest, and that the full value of the loan was secured with the supplementary pawning of another, unidentified book: "Cautio domini Willelmi de Burghhildbiri exposita in cista de Rouburi pro duabus marcis die sabati proxima ante festum sancti Thome apostoli anno domini m° ccc° [erasure] xxvii° et habet supplementum." As William is not identified in the *cautiones* as *magister* or *doctor*, he must have been a bachelor of arts. The Roubery Chest, from which he borrowed, had been established with a bequest of 250 marks made to Oxford University

by Gilbert de Roubery on his death some time after 29 November 1320. The limits on the amounts borrowable from the Roubery Chest were: for a master, forty shillings; for a bachelor, twenty-six shillings and eight pence; and for a scholar, thirteen shillings and four pence.[7] As the mark was valued at thirteen shillings and four pence, William's loan of two marks put him at the limit for his academic rank. If a book was not redeemed within a year and a month of the date recorded in the *cautio*, it would be sent to the stationer for sale to cover the cost of the loan. It is not clear if this is

7. For a list of the chests at Oxford and Cambridge and the amounts borrowable from them by each academic rank, see Graham Pollard, "Mediaeval Loan Chests at Cambridge," *Bulletin of the Institute of Historical Research* 17 (1940): 113–29.

what happened to William's book. Normally the stationer would remove the debtor's name from the book upon its resale. Perhaps, in the end, the cash-strapped William was indeed able to discharge his debt and recover his book.

Other Miscellaneous Marks and Notes

While it is impossible to categorize every sort of marking one might find in a manuscript, it is often important to note their presence because they may indicate an unexpected use for the manuscript. In particular, the endleaves that most manuscripts contain at their front and back and that were often originally left blank or largely blank typically collected a series of notes and jottings that can help to chart the history of the manuscript both during and beyond the Middle Ages. Such notes might be directly related to the texts within the manuscript—of this type are contents lists, index notes, or comments on particular passages of text. They might include library shelfmarks and other indications of medieval and later ownership (see chap. 8, "Assessing Manuscript Origin and Provenance"); and associated with these ownership inscriptions might be a curse against anyone who should steal or abuse the book. Or the added notes might be entirely miscellaneous, quite unrelated to the book itself but recording something of special interest to its owner or reader. Of this type are the record of a debt entered at the end of Newberry Library MS 13 and the note recording a perpetual grant of wine to the northern Italian abbey of Novalesa entered at the end of the first part of Newberry Library MS 3.[8]

One of the more interesting and enigmatic marks in the Newberry's collections is found in MS 20, a thirteenth-century French manuscript containing Peter Lombard's *Sententiae* (see fig. 3-26). On the last folio, a fifteenth-century annotator has drawn a straight line accompanied by this inscription: "Hęc linea bis sex ducta indicat mensuram domini nostri Iesu Christi. Sumpta est autem Constantinopoli ex aura [*sic*] cruce ad formam corporis Christi" (This line, extended twice six times, indicates the measurement of our lord Jesus Christ; it was taken at Constantinople from a golden cross in the form of the body of Christ). In other words, the length of the line, multiplied by twelve,

3-26 Added illustration showing a line purporting to be one-twelfth of the length of Jesus's body. Newberry Library, MS 20, verso of back endleaf.

corresponds to the length of Christ's body. Similar but more detailed inscriptions in other manuscripts (with variations in the number of times the length of the line must be multiplied) demystify this text and show that the line was viewed as a kind of wonder-working amulet that held special protective properties for the individual who bore it on his or her person: it guaranteed health, riches, invincibility against enemies, protection in childbirth, and so on. The properties are spelled out most clearly in a thirteenth-century English manuscript (London, British Library, Harley Roll 43.A.14):

This cros XV tymys metyn ys þe lenght of oure Lord Ihesu Criste. And þe day þat þou beryst it upon þe or lokist þer-vpon shalt haue þise gret giftis þat folowyth: The furst is þou schalt die no soden deth; The seconde is þou schalt not be hurte nor slayne with no maner of wepyn; The iij[d] is þou shalt haue resonabull godis & helth vn-to þy lyuys ende; The iiij[th] is þyne enmys shall neuer ouyr-com þe; The vth is no maner of preson nor fals wytnes shall neuyr greve þe; The vj[th] is þou shalt not die with-oute the Sacramenttes of the Chirche;

8. At the end of MS 13, folio 161r, there is a note written in the same fifteenth-century hand that has added marginal glosses throughout the manuscript. The note reads: "Edward Schepherde promysyd to pay xv[s] furtnyght after seynt James day nex ensuing. Item, a bargayn mayd for v pense a wek on Seynt Mary Maudelyns eve with Elizabeth Whawen. Of þis Sheper[de] is recuyed vi s. viii[d] parte of þis xv[s] above written. On sent Johanne a baptist day Rychard Gye have recuyd iii score of rede shevys." From Paul Saenger, *A Catalogue of the Pre-1500 Western Manuscript Books at the Newberry Library* (Chicago, 1989), 28. The note in MS 3 occurs on folio 107v; the first 107 leaves of this manuscript were once bound separately from the remainder of the book.

The vij[th] is þou schalt be defendid from all maner of wykkid spirites, tribulacions, & dissesis, & from all infirmitees & sekenes of þe pestilence; The viij[th] is yf a woman be in trauell of childe lay þis vpon her wombe & þe childe schall haue Cristendom & þe moder schall haue purificacion, ffor Seynt Cerice & Seynt Julitt, his moder, desirid þise graciouse gyftis of God, which He grauntid vn-to þem, and þis is regestird in Rome.[9]

The miscellaneous notes that most medieval manuscripts acquired over the centuries, both on their endleaves and in their margins, can present the scholar with a living record of use. In effect, every medieval manuscript presents its modern reader with a series of "strata," each of which was acquired by the writing support—whether parchment or paper—at a different stage. These strata include all those features listed in this and the previous chapters: the prickings and rulings, the original text, the rubrication, decorated initials, and illustrations, the glosses and corrections (both original and added), and the various annotations. To investigate the history of the production and use of a manuscript is in many ways akin to conducting an archaeological investigation, except that in the case of the manuscript, all the strata are usually visible at once. However, the book's outermost level, its binding, which can present the historian with a wealth of information if in its original state, was often the first thing to be discarded as the manuscript passed from owner to owner and from institution to institution. The next chapter will present the methods used to bind medieval books and describe in detail what the archaeology of the book can tell us about the book's history. Chapter 7 will assess what can be lost when a book is rebound.

9. Quoted in Curt F. Bühler, "Prayers and Charms in Certain Middle English Scrolls," *Speculum* 39 (1964): 270–78, at 274.

Assembling, Binding, and Storing
the Completed Manuscript

PREPARING THE MANUSCRIPT FOR BINDING: QUIRE NUMERALS AND CATCHWORDS

Once all textual and decorative elements of a manuscript were complete, the codex was ready to be bound. At this stage, the manuscript consisted of a collection of loose quires—the scribe's basic units during the process of copying—which had to be assembled in the correct order. As an aid to ordering, it was common to enter a number (or sometimes a letter of the alphabet) centered in the lower margin of the first or last page of each quire—more usually the last page (see fig. 4-1). Quire numerals, used at least as early as the sixth century, might be entered at the time that the scribe wrote the individual quires or might be added only once the whole text was complete and the manuscript was ready for binding. They consisted of a roman numeral, sometimes surrounded by some form of decoration, and sometimes preceded by the letter *Q*, abbreviating *Quaternio* or *Quinio* (the Latin terms for a quire of four and five bifolia, respectively). Because the numerals were often entered very low in the lower margins, in many manuscripts they have been lost as a result of the trimming of the edges of the leaves, either at the time of the original binding or at a subsequent rebinding.

An alternative method for ordering the quires was to use *catchwords* (sometimes called *stitchwords*), that is, to write in the lower margin of the last page of a quire the word or words with which the first page of the next quire began (see figs. 4-2 and 4-3). Then, at the time of binding,

the binder would check all the catchwords to make sure that they matched up with the words beginning the next quires. The earliest extant examples of catchwords date from the eighth century, but they only became common in the thirteenth century. Normally the catchword was written horizontally in the lower margin, but in humanist manuscripts of the fifteenth century, the catchwords were quite often written vertically. Sometimes the catchword would be provided with a decorative frame (see fig. 4-2). Because scribes sometimes copied their exemplars unthinkingly, binding aids such as quire numerals and sometimes even catchwords were occasionally copied from an exemplar even when they did not indicate the actual quire breaks in the new manuscript.

4-2 A catchword entered in the lower margin of the last page of a quire. Newberry Library, MS 75, fol. 79v.

4-3 The referent for the catchword at the top of the first page of the next quire. Newberry Library, MS 75, fol. 80r.

Another system, popular from the fourteenth century but also encountered earlier, ensured the correct ordering not only of the quires but also of the leaves within the quires. A number, preceded by a letter or some other symbol, would be entered on each leaf in the first half of the quire: for example, *a.i, a.ii, a.iii, a.iiii, a.v* in the first quire, *b.i* to *b.v* in the second quire, and so on. A cross might then be entered on the first leaf in the second half of the quire. Provided that the quire consisted only of bifolia and did not include any single leaves, if the leaves in the first half of the quire were in their correct numerical order, the leaves in the second half would fall into place automatically, so numbering them was unnecessary. The

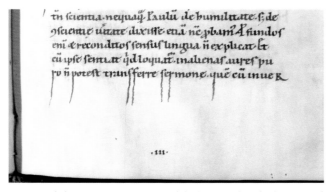

4-1 Detail showing a quire numeral (*III*) entered at the bottom of the first page of a quire. Newberry Library, MS 8, fol. 18r.

4-4 Leaf signature *M i* on the first leaf of a quire in a fifteenth-century copy of Ranulph Higden's *Polychronicon*. Newberry Library, MS 33.1, fol. 103r.

4-5 Leaf signature *M ii* on the second leaf of the same quire.

4-6 Leaf signature *M iii* on the third leaf of the same quire.

loose quires, without any form of binding: this may be the significance of the designation *in quaternis/in quaternionibus* (in quires) that occurs as a description of some books listed in medieval library catalogues. Other manuscripts were provided with no more than a limp parchment cover, to which the quires could be attached in a variety of different ways (see fig. 4-7). Ironically, this loose method of binding protected the book from some types of damage better than more substantial wood bindings. In the flood of the River Arno in Florence in 1966, those manuscripts with parchment covers survived in better condition than those with wooden covers because the parchment backing allowed the manuscript leaves to shrink and expand at the same rate as the cover.

If a manuscript was to receive a binding that included wooden boards, the normal procedure was that the quires would first be sewn, one by one, onto several cords or thongs (the sewing supports). Then the ends of these cords would be channeled into the wooden boards that were to serve as the front and back covers, and finally, the boards would be covered with skin, usually leather or alum-tawed animal hide.

To sew the quires onto the sewing supports, the binder would first suspend the supports vertically on a frame. An illustration of such a frame occurs in a mid-twelfth-century German manuscript that shows many of the different stages in the making of a book (see fig. 4-8). Commonly, the sewing supports were made of tawed leather (that is, leather produced by steeping animal skins in alum solution), and each support would have a central slit along most of its length (but not at the ends). Depending on the size of the book, the number of supports might vary from

alphabetical sequence of the letters that preceded the numbers would guide the correct ordering of the quires. The letters and numbers were commonly entered in pigment (often red or blue) in the lower right-hand corners of the rectos of the first leaves of the quires (see figs. 4-4, 4-5, and 4-6). Probably they were entered only after the full text had been copied, when the manuscript was receiving final attention prior to binding. This system of "leaf signatures" was adopted in early printed books but was eventually superseded by pagination. Leaf signatures might be used in conjunction with catchwords: examples occur in both manuscripts and early printed books.

BINDING THE MANUSCRIPT

By no means were all medieval manuscripts bound in hard covers. Some manuscripts may have remained in

two to five. Larger numbers of supports are characteristic of the late Middle Ages, when the distance between supports was reduced.

The binder would place the first quire of the manuscript on the frame and, using a needle and thread, sew it to the supports, inserting the needle through the parchment into the slit in the sewing support, looping the thread around the support, then pushing the needle back through the slit and into the parchment, then moving on to the next support. Having attached the first quire to all supports, the binder would lay the second quire on top of the first and continue until all quires had been sewn (see figs. 4-9 and 4-10). The loose ends of the supports would be detached from the frame. The manuscript was now ready to receive its front and back covers.

The wood used for the front and back boards would typically be oak in northern Europe, beech in southern Europe. Optimally, to avoid warping, the boards of the manuscript would be "quarter-sawn." That is, rather than taking a round length of tree trunk and sawing straight across it, a section shaped like a slice of pie would first be cut from the trunk, and then boards would be cut from this section (see fig. 4-11). The advantage of this method was that when the boards were cut from the section, the saw would cross the rings in the wood at almost a right angle. If the boards were produced by cutting straight across a round section of wood, the saw would cut through the rings at a more oblique angle, which would eventually produce warping in the board.

The binder would attach the free ends of the sewing supports to the boards by first channeling into the boards a passage for each support. He might start each channel by chiseling into the edge of the board (see fig. 4-10) or into its top or bottom surface; methods varied according to time and place. If he started the channel in the edge, he would then route it up to the top surface of the board and down to the bottom surface. When he had threaded the support through the channel (see fig. 4-12), he would hold it in place by hammering in a small wooden wedge or peg (see fig. 4-13).

The inner surface of both boards would normally be covered by a leaf of parchment called a pastedown. For this purpose, the binder would sometimes use a bifolium at each end of the manuscript, pasting one leaf of the pair to the board and leaving the other to stand free as a protective endleaf between the binding and the text proper of the manuscript. Sometimes binders used fresh parchment for their pastedowns and endleaves, but quite frequently they would employ used leaves—either leaves that had been discarded because the scribe had made an error on them or leaves that had been taken from outdated and unwanted manuscripts (see fig. 4-14). Such reused leaves are sometimes of great interest to scholars because they may provide significant evidence about otherwise lost manuscripts. In many cases, pastedowns consisting of re-

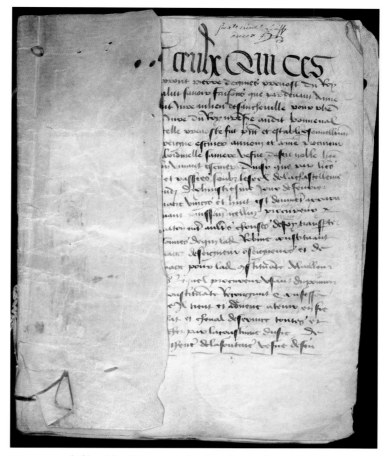

4-7 A rent fief booklet (France, 1490) with a limp vellum binding. Newberry Library, MS 123.

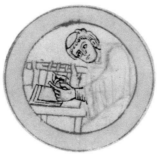

4-8 A monk at work on a binder's frame. Bamberg, Staatsbibliothek, MS Patr. 5, fol. 1v.

used leaves have now been lifted to allow scholars to read the text of that surface of the leaf that was pasted to the board. Newberry Library MS 158, a Latin biblical commentary dating from the fifteenth century, provides in its last leaf an example of a former pastedown—a fragment of a Hebrew manuscript—both sides of which are now available for study; cut down and turned sideways for its use as a pastedown, the leaf contains a portion of a text by the great eleventh-century commentator Rashi of Troyes (fig. 4-15). A further benefit of lifting a pastedown is that the inner surface of the board then becomes visible, allowing one to see the path by which the sewing supports were routed into the board (see figs. 4-12 and 4-13).

It is characteristic of medieval bindings that the edges of the boards lie flush with the edges of the leaves, rather than

4-9 Because the cover has been lost from this book, we can see how the quires were sewn to the supports. Note the split in each support, which allowed the binder's needle and thread to pass through the middle of the support, around its back, and again through the middle. Newberry Library, MS 37.4.

4-10 Another book that has lost the cover over its spine. Here it is possible to see both how the quires were sewn to the supports and how the supports were channeled into the edge of each board. Repeated opening has caused the supports to break. Newberry Library, MS 4.

4-11 Diagram showing how quarter-sawn wood was cut to produce the boards for a binding.

4-12 The manuscript leaf that served as the pastedown of this back cover has been removed, leaving traces of offset writing and making it possible to see how the ends of the sewing supports were routed through the board. Newberry Library, MS 6.

4-13 Note the wooden pegs that hold the ends of the sewing supports in place. Newberry Library, MS 8.

Quarter cut Wood for Book Board

projecting a little beyond as is normal for modern bindings. At the time of binding, the leaves would be trimmed both to even them up and to get them to the same size as the boards. If the manuscript was subsequently rebound (as often happened; few manuscripts retain their original bindings), the edges of the leaves might be trimmed again to even them up with the new binding. From the early modern period, when collectors such as Sir Robert Cotton (1571–1631) developed the habit of binding together medieval manuscripts of similar content and size, binders sometimes trimmed margins quite savagely, resulting in the loss of significant portions of text entered in the margins (see chap. 7).

Once provided with wooden boards, the manuscript could receive its tanned or alum-tawed cover. For this purpose, monastic libraries often favored the use of alum-tawed pigskin, which had remarkable properties of resilience and longevity. Bindings of alum-tawed pigskin are white or off-white in color with the characteristic pattern of groups of three follicles that is typical of pigskin. Leather made from calfskin and goatskin was also suitable for binding. Especially in the late Middle Ages, the skins were often brightly colored; while in most cases the coloring has faded from the outside of the codex, some traces often remain, especially on the turn-ins of the cover if the pastedown has been lifted from them. Sometimes the leather was decorated either by stamping a design onto it or by blind-tooling it, that is, by working a simple pattern into the leather with a hot metal tool (see fig. 4-17). Once covered, the manuscript might be given one or more clasps. An early form of clasp consisted of a strip of leather that was attached to the middle of the front or back cover. At the free end of the leather was a metal attachment with a hole in it. Mounted in the middle of the other cover was a pin over which the hole in the metal attachment could be passed to keep the manuscript closed. Later clasping mechanisms tended to be mounted closer to or indeed right at the edge of the boards; often there were two clasps, upper and lower (see fig. 4-16). In the later Middle Ages, L-shaped metal cornerpieces might be placed on the covers and round or square metal bosses might be mounted both at the corners and at the center of each cover (see figs. 4-16 and 4-18) to prevent chafing. In the Renaissance, bindings became ever more elaborate; the incunable shown in figure 4-19 has a portrait of Matteo Corti of Pavia on the front cover and his coat of arms on the back, covered with a thick coat of lacquer.

GIRDLE BOOKS AND OVERCOVERS

While most bindings enable the book to be stored on a shelf or in an armoire and read at a desk, there were several types of binding that enabled the user to wear the manuscript on his or her body and to read it in a standing or sitting position, without a desk or other support. Quite popular toward the end of the Middle Ages, the girdle

4-14 Inside front cover showing a manuscript leaf used as a pastedown. Newberry Library, MS 11.

4-15 A fragment of Rashi's Hebrew *Commentary* on the Talmud formerly used as a pastedown on the back cover of a fifteenth-century Latin biblical commentary. Newberry Library, MS 158.

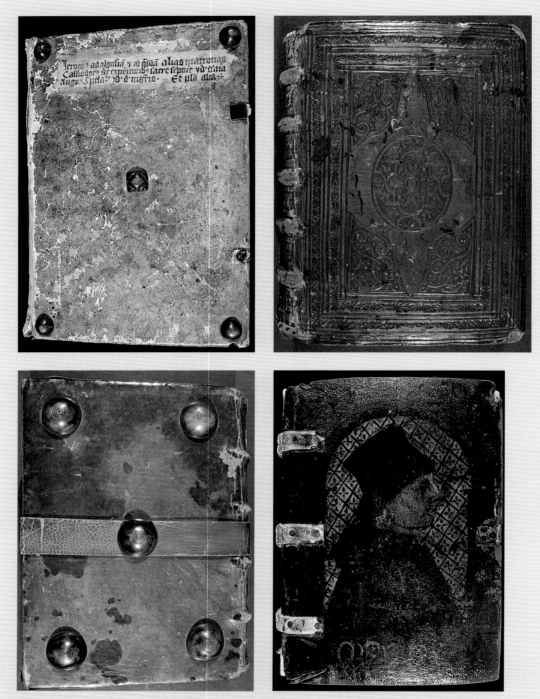

4-16 An example of a typical monastic plain leather binding (late twelfth century). The metal mounts and the label listing the contents are late medieval additions. Newberry Library, MS 8.

4-17 A stamped-leather binding of the late sixteenth century. Newberry Library, MS 56.

4-18 The central boss on this binding is mounted over the leather strap of the clasping mechanism. Newberry Library, MS 64.

4-19 *Discordantiae sanctorum doctorum Hieronymi et Augustini* (Rome, ca. 1482), by Filippo de Barbieri, with portrait of Matteo Corti of Pavia on the front cover, executed ca. 1500. Newberry Library, Inc. 3954.

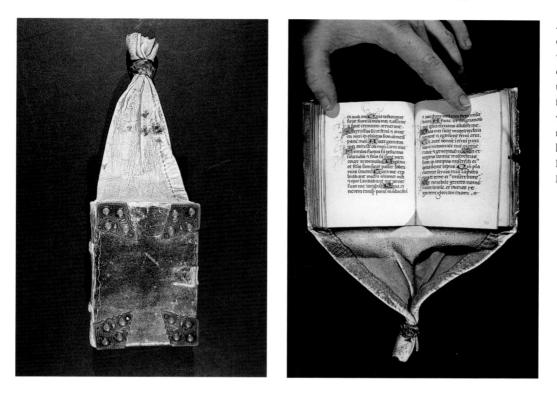

4-20 A mid-fifteenth-century Book of Hours with a girdle binding of deerskin. Designed to hang upside down from the belt, the book would have its text the right way up when held in the hands. Newberry Library, MS 38.

bookbinding enabled the manuscript to be carried at the belt. Relatively few girdle books have survived—no more than about two dozen.[1] In part this may be due to the fact that the texts themselves became outdated and in part because, exposed to the elements and the wear and tear of travel, the soft leather easily deteriorated and ripped. There is also evidence that in some cases, the excess material was later trimmed from girdle bindings to enable books to be stored on shelves.[2] In this form of binding, the leather cover, instead of being shaped to fit the boards exactly, extended downward below the boards as a flap or pouch often with a Turk's-head knot tied at the end. The knot could be slipped under the reader's belt so that the manuscript hung upside down at the waist, or else the flap could be grasped in the hand. Some girdle books had a metal hook that fastened to the belt; a hinge connected the hook to the flap of the binding, allowing maximal movement of the book while it was still attached. Girdle bindings were most commonly used on Books of Hours and other devotional texts, although an example in the Beinecke Library of Yale University (MS 84) occurs on a copy of Boethius's *Consolation of Philosophy*. Larger books may have been used by the friars in their travels; smaller books may

have been used by both religious and laity for their daily devotions. Newberry Library MS 38, a fifteenth-century Book of Hours made in the Netherlands, is a girdle book with a binding of green deer- or doeskin (see fig. 4-20). In this case, the girdle binding is the book's original binding; some girdle bindings were added at a later date and attached to books' original bindings. Not all girdle books were manuscripts; one surviving Nuremberg example is an incunable. That girdle books were more widespread than the number of surviving examples suggests is indicated by the frequency with which they are depicted in late medieval illustrations. In particular, the saints and apostles are often shown holding girdle books. The initial fragment in figure 4-21 depicts two women with girdle books.

4-21 An initial cut from its manuscript, depicting two women carrying girdle books. Newberry Library, Medieval Manuscript Fragment 65.

1 A recent inventory lists twenty-three. See Ursula Bruckner, "Beutelbuch-Originale," *Studien zum Buch- und Bibliothekswesen* 9 (1995): 5–23.

2 Szirmai, however, knew of only one clear example of this among surviving books. See J. A. Szirmai, *The Archaeology of Medieval Bookbinding* (Aldershot, U.K., 1999), 239.

4-22 A fifteenth-century *vade mecum* almanac of English provenance. Such books were attached to the belt and could be read without removing them; several folios were originally sewn together using the triangular tab, which would then be attached to the belt. Newberry Library, MS 127.

Another way to make a book portable was to attach rings to a standard binding, enabling the user to wear the book by inserting a cord through the rings and around the waist. A third type of book worn on the body also had rings, but the book itself was extremely small (no more than a few inches in height and width) so that it could be worn on a chain around the neck. A fourth was the *vade mecum* (go with me), usually a booklet or set of folded sheets that contained an almanac or medical information and could be suspended from a belt. Figure 4-22 shows one of six surviving parchment sheets from a fifteenth-century English almanac that originally included twelve sheets (one for each month). As can be seen, the sheet has been folded once horizontally and twice vertically. The writing was oriented so that when the sheet was attached by the triangular tab to the belt and unfolded for reading, the text would appear upright. Space has been left on the upper half for a figure that would illustrate the veins in the human body for bleeding. The text that surrounds the box describes which veins should be bled for different purposes; below are tables of solar and lunar eclipses for the years 1463 to 1478 and 1464 to 1479, respectively. The survival of such ephemeral objects is rare; this almanac was found in Chicago used as packing for a picture frame.[3]

From the twelfth century onward, some books were provided with an overcover, or chemise, in addition to the primary cover of the binding. These overcovers could be made of leather or fabric and could be either loosely slipped over the book or else attached to the primary cover by sewing or pasting.[4] Often the chemise would extend beyond, sometimes far beyond, the edges of the book; it could then be wrapped around the book to protect it or bunched under it to serve as a pil-

3. See also the example illustrated in Peter Murray Jones, *Medieval Medicine in Illuminated Manuscripts* (London, 1998), fig. 45. Here, the sheets of a similar almanac are shown folded and linked together.

4. Szirmai, *Archaeology of Medieval Bookbinding,* 164–66, 234–36.

lowlike support while it was being read. Late medieval inventories of books suggest that textile chemise bindings were especially prized by noblewomen. There are also several artistic representations of such bindings. In figure 4-23, from the mid-fifteenth-century Prayerbook of Marguerite de Croy, Marguerite is shown reading her book in a chemise binding as she contemplates the Virgin holding the crucified Christ in her arms.

STORAGE OF BOOKS

Textual references and manuscript illustrations show that for much of the Middle Ages, books were not stored upright on shelves in specially designed library rooms; it was only toward the end of the medieval period that the library as we now know it emerged. Before that, books were often kept in chests (*arcae*) or cupboards (*armaria*); when placed on the shelves of cupboards, they were more likely to have been stored flat rather than upright. An early indication of this practice occurs in the well-known illustration of the scribe Ezra in the Codex Amiatinus (Florence, Biblioteca Mediceo-Laurenziana, MS Amiatinus 1), a Bible made in the Venerable Bede's monastery of Wearmouth-Jarrow in the late seventh or early eighth century. The illustration, which is based on a lost sixth-century Italian prototype, shows books laid flat on the five shelves of a cupboard that stands against a wall.[5] (Similar arrangements may be seen in much later illustrations showing St. Jerome at work in his study; see fig. 4-24.) In

5. The image has been frequently reproduced. See, for example, Kurt Weitzmann, *Late Antique and Early Christian Book Illumination* (New York, 1977), pl. 48.

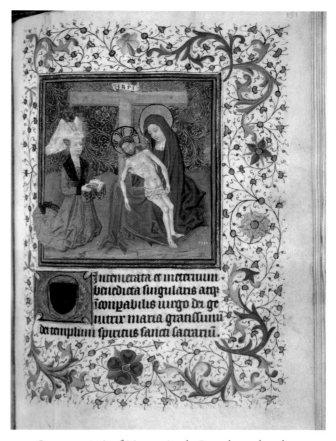

4-23 Owner portrait of Marguerite de Croy shown kneeling before the *Pietà* with her book in hand. Note the textile chemise extending from the binding. Newberry Library, MS 56, fol. 151r.

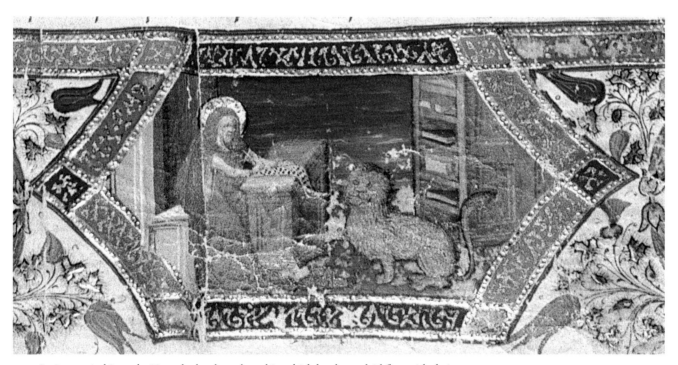

4-24 St. Jerome in his study. Note the book cupboard in which books are laid flat, with their fore-edges outward. Newberry Library, MS 102.2, fol. 3r.

4-25 Books with titles on their fore-edges. From top: *Vitae,*
Invective de Valle in Pogium, Ovid. Newberry Library, MSS 97.3,
97.7, and 57.

4-26 The titles of the works contained in this manuscript have
been written on a flap cut in the outer margin of one of its
leaves. Newberry Library, MS 12.1, fol. 63v.

many monasteries books were probably stored in chests
from which the monks took them to their cells for study.
Whether in chests or cupboards, the books would usually
be grouped by broad subject categories to aid finding. An-
ticipating the organization of the modern library as early
as the 1270s, Humbert of Romans, former master general
of the Dominican order, exhorted the Dominicans to or-
ganize their book cupboards by subject:

> Moreover, the cupboard in which the books are stored
> should be made of wood, so that they may be bet-
> ter preserved from decay or excessive dampness; and it
> should have many shelves and sections in which books
> and works are kept according to the branches of study;
> that is to say, different books and postils [i.e., com-
> mentaries] and treatises and the like which belong to
> the same subject should be kept separately and not in-
> termingled, by means of signs made in writing which
> ought to be affixed to each section, so that one will
> know where to find what one seeks.[6]

After the advent of the shelved library in which books
were stored upright, the books would often be turned
with their spines facing inward and the fore-edges out-
ward; this explains why frequently the titles of books were

6. The comment comes in Humbert's *Instructiones de offi-*
ciis ordinis, translated by Richard H. Rouse, "The Early Library
of the Sorbonne," in Mary A. Rouse and Richard H. Rouse,
Authentic Witnesses: Approaches to Medieval Texts and Manuscripts
(Notre Dame, IN, 1991), 341–408, at 357.

written across their fore-edges (see fig. 4-25). This practice
was prevalent in the sixteenth century and later, with oc-
casional interesting innovations of the type encountered
in Newberry Library MSS 12.1 and 12.5 (fig. 4-26). Here,
a seventeenth-century owner made cuts in the outer mar-
gin of one leaf of each manuscript in order to create a flap
on which he wrote the titles of the works contained in
the manuscripts. The dirt that has gathered on these flaps
shows that they were turned outward so that they pro-
jected beyond the fore-edge of the leaves, making it pos-
sible to read the titles when the books were stored fore-
edge outward.

Besides the fore-edge, other popular placements for ti-
tles included the front cover, a front or back endleaf, and
the upper or lower margin of the first page of text. Some-
times a metal frame would be mounted on the cover to
hold a title label that would be slipped into the frame; such
a frame, although the label itself has not survived, may be
seen on Newberry Library MS 65, a fifteenth-century Ger-
man copy of works by Thomas Aquinas and Heinrich von
Langenstein (see fig. 4-27). Title labels placed in frames
were sometimes protected by a cover of transparent horn.
For manuscripts that contained numerous texts, the title
would often cite only the first few or the most important
items. The title label on the front cover of Newberry Li-
brary MS 8 (fig. 4-16), a twelfth-century codex from the
Benedictine abbey of Admont that contains fifteen differ-
ent texts, lists only six works, summing up the remainder
of the contents as "et plurima alia" (and many other items).
The works that the label lists are by the major patristic

authors Jerome, Cassiodorus, and Augustine; it does not mention the works by the more recent authors Notker the Stammerer and Gerbert of Aurillac that conclude the volume. A surviving inventory of the Admont library drawn up in 1376 by the monastery's librarian, Peter of Arbon, provides an even less detailed account of the contents of this manuscript, listing only the first item and noting the full contents list at the front of the book.[7]

Many manuscripts include a library shelfmark usually entered on a front endleaf or one of the first pages of text and occasionally repeated at the back of the book (see fig. 8-13 for an example of this). Shelfmarks offer another form of evidence that can enable the modern scholar to reconstruct the ways in which books were grouped in medieval libraries. Consisting usually of a combination of letters and numbers, shelfmarks became common from the fourteenth century onward. Manuscripts known to have belonged to a particular medieval library often have their shelfmarks entered by the same hand, suggesting that it was common for a single individual to take on the responsibility for numbering the books. In the case of monastic libraries, this would normally have been the precentor, whose responsibilities included, in addition to direction of the choir and supervision of liturgical performance, the oversight of books.[8] The shelfmark commonly identified both the cupboard or bookcase and the actual shelf on which the book was stored. For example, the system of shelfmarks in use at St. Augustine's Abbey, Canterbury, took the form of the abbreviations *Di* and $\overset{a}{G}$, each followed by a roman numeral.[9] *Di* here stood for *Distinctio* and identified the bookcase; $\overset{a}{G}$ stood for *Gradus* and specified which shelf the book stood on. Thus *Di VII* $\overset{a}{G}$ *II* would mean that the book was kept on the second shelf of the seventh bookcase. Some St. Augustine's shelfmarks end with the word *retro* (behind), an apparent indication that the abbey possessed so many books that it was forced to double-stack them, with a second row of books behind those at the front of the shelf (an arrangement still used to this day in libraries with an overabundance of books).

The shelfmarks used at Dover Priory in the fourteenth century specify a book's location with an even greater degree of precision.[10] The marks include a capital letter of the alphabet followed by a roman numeral, with a small ara-

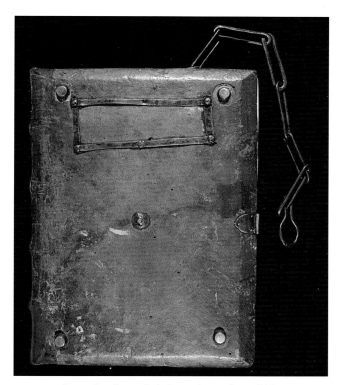

4-27 A volume that formerly belonged to a chained library. Newberry Library, MS 65.

bic numeral entered within the capital letter (for example, within its bow). The capital letter identified the bookcase, the roman numeral the shelf, and the arabic numeral the book's position on the shelf. Thus *D VII* with an arabic *4* entered within the bow of the *D* would indicate that the book was stored in fourth position on the seventh shelf of bookcase D. The Dover shelfmarks were all entered into the books by precentor John Whitefield, who in 1389 completed his catalogue of the priory's library. Whitefield's catalogue is remarkable among medieval library catalogues for its extraordinary precision and wealth of information.[11] Judging from the catalogue, the library at Dover had nine different bookcases, each with seven shelves that were numbered from the bottom upward; individual shelves contained between seven and ten books. Each bookcase was devoted to a different category of material, beginning with complete Bibles and individual books of the Bible in

7. See Gerlinde Möser-Mersky, *Mittelalterliche Bibliothekskatalogen Österreichs*, vol. 3, *Steiermark* (Vienna, 1961), 20, ll. 42–43.

8. See Margot E. Fassler, "The Office of the Cantor in Early Western Monastic Rules and Customaries: A Preliminary Investigation," *Early Music History* 5 (1985): 29–51, at 29.

9. For an example of a St. Augustine's Abbey shelfmark, see R. I. Page, *Matthew Parker and His Books* (Kalamazoo, MI, 1997), pl. 27a. The system of shelfmarks at Christ Church Cathedral Priory in Canterbury was similar; see ibid., pl. 26b.

10. For examples, see Mildred Budny and Timothy Graham, "Dunstan as Hagiographical Subject or Osbern as Au-

thor? The Scribal Portrait in an Early Copy of Osbern's *Vita Sancti Dunstani*," *Gesta* 32/2 (1993): 83–96, fig. 2, and William P. Stoneman, ed., *Dover Priory*, Corpus of British Medieval Library Catalogues 5 (London, 1999), pls. 4 and 5.

11. It is edited by Stoneman, *Dover Priory*. Whitefield's preface (pp. 15–16) describes his system of shelfmarks. See also Christopher de Hamel, "Medieval Library Catalogues," in *Pioneers in Bibliography*, ed. Robin Myers and Michael Harris (Winchester, U.K., 1988), 11–23, at 20.

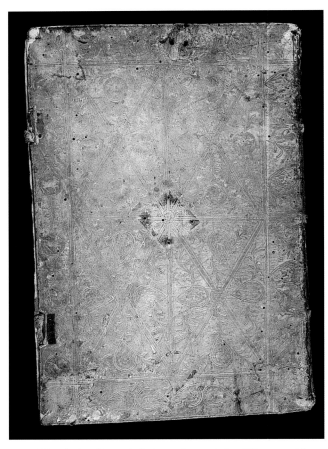

4-28 A book that formerly belonged to a chained library, with chain and bosses removed for upright storage. Newberry Library, MS 65.1.

bookcase A and ending with schoolbooks including grammars, dictionaries, and works by pagan classical authors in bookcase I. Whitefield's own catalogue occupied the first position on the first shelf of bookcase A.

Also by the late thirteenth century, as a means of preventing theft, some institutions started to chain the books in their collections. In the earliest chained libraries, books were laid side by side on a long, sloping lectern at which several readers could sit if there was a bench and stand if there was not. In some later chained libraries—of which Hereford Cathedral Library, dating from 1590, is a famous example surviving intact to this day—the books were stored vertically on the shelves of bookcases. Each bookcase had two or three shelves; in front of the lowest shelf there was a long desk at which readers could sit or stand. The length of the chain attached to each book depended on the shelf on which the particular book was stored; the chain had to be long enough to allow the book to be removed from its shelf and placed on the desk. To attach the chain to the book, a metal hasp was mounted on the front or back cover; one end of the chain was then fastened to the hasp, the other end to the lectern or bookcase. Newberry Library MS 65, the German manuscript mentioned above that contains works by Thomas Aquinas and Hein-

rich von Langenstein, still retains its original chain attached to the top of the back cover (fig. 4-27). Because the manuscript has round metal bosses at the four corners of each of its covers and a frame for a label on the front cover, it may have been laid flat on a lectern rather than stored on a shelf (where the bosses would have been an encumbrance to upright shelving). The chain is fairly short, measuring only 42 cm and ending in a ring that would have been attached to a metal fixture on the lectern. Many manuscripts that formerly belonged to chained libraries but have now migrated to other collections have had their chains and hasps removed. Evidence of their chaining may, however, survive in the form of rust stains left by the hasp on the first few leaves at the front or back of the book, and if the manuscript has not been subsequently rebound, the cover will bear a hole or groove where the hasp had been, as can be seen in Newberry Library MS 65.1, a German book of saints' lives completed in the year 1451 (see fig. 4-28); here, the groove from the former chaining mount is centered at the top of the back cover. Metalwork has also been removed from the covers of this manuscript to enable it to be stored upright on the shelf of a modern library. Formerly there was a diamond-shaped boss in the middle of both the front and the back covers, and there were leaf-shaped cornerpieces at the four outer corners of the covers; the impressions left by these metal mounts are still visible. The only remaining pieces of metalwork on this manuscript are three out of four attachments for two fore-edge clasps: one on the back cover and two on the front, all ornately decorated. A large red A entered on the front cover presumably identifies the desk to which the manuscript was once chained.

The chained library was the best means devised in the Middle Ages to guard against theft, which, judging by the curses against thieves entered in so many books (see chap. 8), was evidently a perennial problem. Even chaining, however, was hardly a guarantee against theft or mutilation if the testimony of the Franciscan friar William Woodford (ca. 1330–ca. 1397) is to be believed. Responding to charges that the Franciscans guarded their books overzealously, allowing no access to those who might profitably draw upon the books for material to be used when preaching, Woodford replied:

> To say that friars lock up books in order to prevent secular clerks from preaching the word of God is plainly false. The friars do not do so for that reason, any more than do the cathedrals, or the people in the colleges. Rather, the friars do so for two reasons. One is, that their books are held in safekeeping so that they are not exposed to theft. For in some places where books have lain about in the open, and secular clerks had free access to them, the books frequently have been stealthily removed, in spite of their being sturdily chained; and some of the quires were cut out of books,

leaving only the binding and the chains. So it behoved the friars to hold onto their books and to keep them more securely locked up. . . .[12]

FROM MONASTIC LIBRARY TO PRIVATE LIBRARY

Until the twelfth century, monasteries were the major repositories of learning in Western Europe, and it was in monastic collections that most books were to be found. Monasteries were crucial to keeping book culture alive and in preserving and transmitting not only patristic texts but also the works of classical authors, which were utilized for the purpose of teaching Latin. The Rule of St. Benedict, the most influential of all Western monastic codes, set a high value on *lectio divina* (the reading of sacred scripture); chapter 48 stipulated that time was to be set aside for reading every day and that Sunday was to be largely taken up with reading, except for those who had been assigned other specific duties. Lent was to be a time of especially concentrated study; at the beginning of Lent each monk was to be issued a book of the Bible that he was to read straight through.[13] Monks were not expected to read quickly. Rather, their reading was to be contemplative and ruminative. In line with the spiritual purpose of monastic reading, the book collections of the monasteries were dominated by scripture, biblical commentary, patristic writings, and devotional works such as saints' lives, all of which were suitable for meditation. Books would have been stored at different locations within the monastery, depending on their intended purpose. Books for contemplative reading and study would for much of the Middle Ages have been stored in chests kept in the cloister or some other suitable location; liturgical books that were required for the *opus divinum*, the daily round of divine services, would have been found within the monastic church and chapels; books that served for reading aloud at meal times were kept in the refectory. Surviving booklists and catalogues of the monastic libraries, coupled with the evidence of surviving manuscripts, offer a fascinating glimpse into the world of monastic learning. It would appear that in much of Western Europe there was a significant increase in the size of monastic libraries in the late eleventh and twelfth centuries and that by the twelfth century a well-established institution might expect to own several hun-

dred volumes. St. Mary's Abbey at Reading, for example, founded in 1121, owned nearly three hundred books some seventy years later.[14] By the close of the Middle Ages, the libraries of the largest and richest monasteries could often boast well over a thousand volumes. The fourteenth-century catalogue of the library of Christ Church Cathedral Priory in Canterbury, for example, lists more than eighteen hundred items, a number that is matched in the late fifteenth-century catalogue of nearby St. Augustine's Abbey.[15]

By the late Middle Ages, however, other types of libraries had emerged and had in many cases surpassed the monastic library in importance and in the range and usefulness of the materials they contained. Already in the eleventh and twelfth centuries, the cathedral schools, originally founded in Carolingian times, experienced a major growth that established them as the primary centers for educating clergy in the seven liberal arts. The most important of the cathedral schools were located in northern France, at Laon, Chartres, and Paris. The libraries of these schools were often built up through gifts or bequests by masters who had taught there. The library at Chartres, for example, grew significantly through its acquisition of the books of Bishop Fulbert (ca. 960–1028), the canonist Bishop Ivo (1040–1115), and the Englishman John of Salisbury (ca. 1115–80), a polymath associated with Thomas Becket and bishop of Chartres for the last four years of his life. John's bequest of books was deemed sufficiently important to be recorded, item by item, in the cathedral's cartulary. In addition to works of scripture, theology, canon law, and the classics, the library at Chartres possessed a significant number of Arabic and Greek books in translation. During the twelfth century, the school became renowned for the Platonism espoused by its teachers Bernard of Chartres (died ca. 1130), Thierry of Chartres (died 1151), William of Conches (ca. 1100–ca. 1154), and Bernard Silvester (ca. 1100–ca. 1169).[16] Their teaching was in large measure dependent upon the works available to them in their library.

The cathedral schools tended to be organized around a central figure rather than a common curriculum, and the books that were copied and preserved therein often made for a collection that was idiosyncratic rather than

12. Translated by Mary A. Rouse and Richard H. Rouse, "The Franciscans and Books: Lollard Accusations and the Franciscan Response," in Rouse and Rouse, *Authentic Witnesses*, 409–24, at 416–17.

13. On the interpretation of this passage of the Rule, see Anscari Mundó, "'Bibliotheca': Bible et lecture du carême d'après saint Benoît," *Revue Bénédictine* 60 (1950): 65–92. Mundó shows that Benedict's phrase *singulos codices de bibliotheca* here means "individual books of the Bible," not "individual books from the library."

14. See Christopher de Hamel, *A History of Illuminated Manuscripts* (Oxford, 1986), 84.

15. See M. R. James, *The Ancient Libraries of Canterbury and Dover* (Cambridge, 1903).

16. See M.-D. Chenu, *La théologie au douzième siècle*, 3rd ed. (Paris, 1976), partially translated as *Nature, Man, and Society in the Twelfth Century: Essays on New Theological Perspectives in the Latin West*, trans. Jerome Taylor and Lester K. Little (Chicago, 1968); and Winthrop Wetherbee, *Platonism and Poetry in the Twelfth Century: The Literary Influence of the School of Chartres* (Princeton, 1972).

programmatic. More systematic provision of books intended for study came with the rise of the universities from the late twelfth century onward in such cities as Bologna, Palermo, Paris, Oxford, and Cambridge. As curriculum became standardized, the *pecia* system developed to ensure that students had accurate and affordable copies of texts (see chap. 2). In addition to basic textbooks, the universities needed large libraries for the use of both students and masters. Despite this fundamental need for books, there is little evidence that college or university collections were acquired systematically. Rather, many of these libraries were built on the donations of benefactors, often alumni of the institution. The library of the Sorbonne in Paris, the growth of which is richly attested both by written documents and through the survival of many of its books, demonstrates the typical ways in which a university library could grow while also exemplifying important trends in the organization and regulation of institutional libraries that developed in the late thirteenth and fourteenth centuries.[17]

The College of the Sorbonne was founded in 1257 by Robert of Sorbon (1201–74) to provide instruction for students of theology at the University of Paris, then the leading university in Europe. The library grew first through quite modest donations but probably at least doubled in size on the death in 1272 of Robert's close associate, the master of theology Gerard of Abbeville. Gerard had already given some of his books to the Sorbonne in 1260. At his death he bequeathed about three hundred more manuscripts to the college, along with his *armarium* and three of his better chests, in which the books could be stored. A large number of Gerard's books came originally from the library of Richard of Fournival (ca. 1201–60), chancellor of the cathedral of Amiens and author of the popular *Bestiaire d'amour*, who in another work, the *Biblionomia*, provided a guide to his library presented in an allegorical stroll through a garden.[18] Gerard may have acquired Richard's books with the specific intention of presenting them to the Sorbonne. By 1290, thanks to a series of bequests following Gerard's, the college had 1,017 books, and fifty years later the total had risen to 1,722. This rapid growth, coupled with the needs of students and teachers, led to an important reorganization of the library during the years 1289 to 1292. It was then decided that the college should have both a circulating library from which masters and students could borrow and a reference library from which the books could not be removed. The circulating library, eventually known as the *parva libraria*, occupied the existing library room; its books continued to be kept in *armaria*. The reference library, known first as the *libraria communis* and later as the *magna libraria*, was established probably in a first-floor room with rows of windows on two sides, overlooking the street on one side and the interior court of the college on the other. All books in the reference library were to be chained. By the second quarter of the fourteenth century, this library contained about 340 volumes located at twenty-six desks. The books assigned to the chained library were those most in demand; the circulating library contained books not required for general study, as well as any additional copies of works that were in the chained library.

The notion that book collections should be divided so that commonly used works were retained in-house in a reference library while less essential works were allowed to circulate spread to other universities in the course of the fourteenth century. The Sorbonne offers the first clear example of the operation of such a two-tiered system. The Parisian college also set the trend in cataloguing. The earliest surviving fragment of a catalogue of the Sorbonne library dates from soon after 1274.[19] In addition to listing the author and title of every work contained in each codex in the library, the cataloguer made the identification of individual codices easier by quoting the opening words of the second or third leaf as well as those of the penultimate or last leaf of each book. This is the earliest known example of such a practice, which made it possible to distinguish between different copies of the same work and also meant that a book could be identified if it lost its first or last leaf, as sometimes happened. During the fourteenth and fifteenth centuries, quoting the opening words of the second leaf of each book in a collection became a regular feature of French and English catalogues and an occasional feature of catalogues drawn up in Germany (see further chap. 8).[20] Each entry in the Sorbonne fragment ends with a valuation of the book, a necessary piece of information given that whenever a book was borrowed from the library, the borrower had to leave in the pledge chest either a sum of money or a book greater in value than the item borrowed. A later Sorbonne catalogue, dating apparently from the 1320s, provides a full analytical description of the contents of the chained library and was evidently intended not as an inventory but as a comprehensive study guide that would assist readers in finding texts on particular topics. The catalogue provides a list of works arranged under subject headings, then cites the shelfmarks of the books in which these works may be found; it is the first known subject catalogue of any European library.[21] So keenly studious were the members of the Sorbonne that

17. See Rouse, "The Early Library of the Sorbonne."

18. On Richard of Fournival's books, see Palémon Glorieux, "Études sur la 'Biblionomia' de Richard de Fournival," *Recherches de théologie ancienne et médiévale* 30 (1963): 205–31, and Richard H. Rouse, "Manuscripts Belonging to Richard de Fournival," *Revue d'histoire des textes* 3 (1973): 256–69.

19. On the date, see Rouse, "The Early Library of the Sorbonne," 353–55.

20. See de Hamel, "Medieval Library Catalogues," 19–20.

21. See Rouse, "The Early Library of the Sorbonne," 381–93.

they even possessed their own composite catalogue listing the contents of other major libraries in Paris such as those of Notre-Dame, Saint-Victor, Saint-Germain-des-Prés, and Sainte-Geneviève.[22] By using this catalogue they would quickly be able to locate copies of texts not in their own library but in one of the city's other major libraries; perhaps they were even able to borrow such texts through a local "interlibrary loan" system.

The library of the Sorbonne grew largely through bequests, and it is clear that bequests were also the primary means by which monastic libraries continued to grow in the late Middle Ages: when additions were made to the catalogues of monastic libraries, the newly acquired books tended to be grouped together not by subject matter, as in the original portion of the catalogue, but under the name of the benefactor. The evidence of such bequests establishes that it was becoming increasingly common for individuals to build their own private collections of books, collections that at their deaths they frequently passed on to the institutions with which they were affiliated. The growth of lay literacy in the fourteenth and fifteenth centuries meant that it was not only clerics who compiled their own libraries. Naturally, the content of a layman's library would differ significantly from that of a cleric, with vernacular romances and popular devotional works commonly accounting for a significant portion of the library. In the case of rich laymen, books were kept as much for display as for study; not surprisingly, the most magnificent private libraries were those of royal and aristocratic patrons. Surviving inventories can tell us much about these libraries. Two of the most magnificent libraries were those assembled by King Charles V of France (1338–80) and his brother, Jean, Duc de Berry (1340–1416).[23] Charles's library included large numbers of romances, marvels, chronicles, and bestiaries, along with works on astronomy and medicine and many richly illuminated devotional books.[24] The library of his brother included the most famous of all medieval manuscripts, the *Très Riches Heures*, the illuminations of which the Duc de Berry commissioned from the brothers Limbourg. Royal and aristocratic owners would often have their coats of arms entered in the books in their collections; if the manuscript had been specially made for them, the emblem was often integrated into the border decoration of the first page. The coat of arms performed the same function as the *ex libris* inscriptions of monastic libraries; for the modern bibliographer, they are invaluable in helping to establish provenance (see chap. 8 and figs. 8-11, 8-12, 10-11, 10-13, and 10-15). Sumptuous, elaborately decorated bindings were a common feature of

royal and aristocratic libraries. Often the bindings served primarily for display, but they could also fulfill practical purposes. Piero de' Medici (1416–69), for example, color-coded his bindings according to the subject matter of the books they covered: blue for theology, yellow for grammar, purple for poetry, red for history, green for the arts, and white for philosophy.[25]

The private libraries of scholars contrasted with those of aristocrats in that they were consciously built up with the specific intention that they should serve as an instrument for concentrated study. This was notably true of the libraries of the Italian humanists, among whom Petrarch (Francesco Petrarca, 1304–74) stood out as a pioneer. Said to have been given his first manuscript—a twelfth-century copy of Isidore of Seville—by his father while still a boy, Petrarch was inspired by his love of the classics to become a tireless collector, seeking out texts wherever he could find them and adding them to his personal collection. He called upon his friends to help him in the task. On one occasion (perhaps in 1346) he wrote to the Dominican friar Giovanni dell'Incisa:

> I am still in the thrall of one insatiable desire, which hitherto I have been neither able nor willing to check. . . . I cannot get enough books. It may be that I have already more than I need, but it is with books as it is with other things: success in acquisition spurs the desire to get still more. . . . Books delight us through and through, they talk with us, they give us good counsel, they enter into a living and intimate companionship with us. . . . Now do you, as you hold me dear, commission trustworthy and competent men to go through Tuscany for me, examining the book-chests of the religious and of other studious men, searching for things that might serve to alleviate or to increase my thirst. And although you know in what streams I fish and in what woods I hunt, nevertheless, to avoid error I enclose a list of the things I chiefly desire; and that you may be the more eager, let me tell you that I am sending similar requests to friends in Britain, France, and Spain. So then, in order that none may surpass you in faithfulness and diligence, do your best—and farewell.[26]

Petrarch built up his library by searching far and wide for classical texts. While living in Avignon, he found copies of Seneca, Propertius, and a lesser-known work of Cicero; from Chartres Cathedral he obtained a codex of Livy, which had itself been copied from a fifth-century manuscript once in the possession of the Emperor Otto III; within Italy he acquired manuscripts from the abbeys

22. Ibid., 373–75.

23. The inventories of both libraries were published by Léopold Delisle, *Recherches sur la librairie de Charles V*, 2 vols. (Paris, 1907).

24. De Hamel, "Medieval Library Catalogues," 12.

25. See de Hamel, *History of Illuminated Manuscripts*, 241.

26. *Epistolae familiares*, bk. 3, no. 18, *Petrarch at Vaucluse: Letters in Verse and Prose*, trans. Ernest Hatch Wilkins (Chicago, 1958), 46–48.

of Pomposa and Monte Cassino, and in the ancient chapter library of Verona he rejoiced to find a copy of Cicero's *Letters to Atticus*. If he could not acquire the books he wanted by purchase or gift, he would arrange to have them copied by professional scribes. It has been estimated that by the end of his life he had accumulated a personal collection of some two hundred volumes.[27] His method of building his library by acquiring texts to be found in monastic and cathedral libraries was followed by other humanists, notably by Poggio Bracciolini (1380–1459). While serving as papal scribe at the Council of Constance in the years 1414–18, Poggio found time to travel to monasteries in Switzerland, Germany, and France, where he acquired many rare classical texts, among them works by Valerius Flaccus, Silius Italicus, Columella, Vitruvius, and Cicero. Like Petrarch, Poggio was sometimes able to obtain manuscripts by purchase, but when owners would not allow this, he himself would copy out the texts, using the new humanistic bookhand of which he is believed to have been the inventor (see chap. 10, fig. 10-15). Of all Poggio's many finds of classical texts, it was his discovery in the abbey of St. Gall of a complete copy of Quintilian's *Institutio oratoria* (otherwise known only from fragments) that meant the most to him. In a letter to Guarino of Verona of December 1416, Poggio describes that discovery and laments the conditions in which the monks of St. Gall had permitted this literary treasure to be stored:

> There amid a tremendous quantity of books which it would take too long to describe, we found Quintilian still safe and sound, though filthy with mold and dust. For these books were not in the Library, as befitted their worth, but in a sort of foul and gloomy dungeon at the bottom of one of the towers, where not even men convicted of a capital offense would have been stuck away. . . . Beside Quintilian we found the first three books and half of the fourth of C. Valerius Flaccus' *Argonauticon*, and commentaries or analyses on

eight of Cicero's orations by Q. Asconius Pedianus, a very clever man whom Quintilian himself mentions. These I copied with my own hand and very quickly. . . .[28]

Books that Poggio acquired by purchase or copying he frequently did not keep for himself; rather, he sent them back to Italy, to humanist friends like Leonardo Bruni (1369–1444) and Niccolò Niccoli (1364–1437), who were building up their own major private libraries. The activities of Petrarch and Poggio in hunting down and acquiring manuscripts herald an important trend that was to continue throughout the early modern period. Increasingly, books that had lain for centuries in the libraries of monastic and ecclesiastical institutions passed into private hands, from where they subsequently moved into the ownership of public institutions. Petrarch intended that his own collection would become the first public library that Europe had seen since ancient times; in 1362 he negotiated with the Venetian republic to establish an arrangement whereby he would donate his books to the republic in return for a place to live. (In the event, Petrarch's plan came to nothing, and his books are now to be found dispersed in several collections in different countries.) Niccolò Niccoli decreed that his magnificent library, a significant portion of which consisted of books obtained on his behalf by Poggio, was to pass on his death to the people of Florence. Niccoli's books formed the basis of Europe's first public library, established by the Medici in the Dominican convent of San Marco in 1444, and large numbers of his books are now to be found in Florence's Biblioteca Mediceo-Laurenziana and Biblioteca Nazionale. Because of the activities of these and many other collectors, coupled with major religious, social, and political changes, the vast majority of books produced during the Middle Ages are no longer to be found in the libraries that originally housed them. It is to the study of medieval manuscripts in their modern homes that we now turn.

27. See Pierre de Nolhac, *Pétrarque et l'humanisme*, 2 vols. (Paris, 1907), 1:115–16.

28. Phyllis Walter Goodhart Gordan, *Two Renaissance Book Hunters: The Letters of Poggius Bracciolini to Nicolaus de Niccolis* (New York, 1974), 195.

PART TWO

*Reading the
Medieval Manuscript*

Introduction to Part Two

AVING focused in part 1 on the methods of manuscript production, we turn now to look at what scholars do when they read and analyze these documents. We begin in this introduction by tracking manuscripts from the point of completion to the point where they may now be studied, exploring some of the factors that have had an impact on their survival and condition and affected their movement from their original homes into the collections where we find them now. Manuscripts produced during the Middle Ages have survived in astonishing numbers; they are our primary source for knowledge of medieval history and culture. Even so, what is preserved in archives today represents only a small fraction of what must have existed five hundred years ago. The reasons why particular types of documents tended to survive while others perished are complex and varied and not always well understood. In a recent book, Sandra Hindman, Michael Camille, Nina Rowe, and Rowan Watson explore changes in taste in manuscript collecting and illustrate some of the problems attendant on drawing conclusions about the survivability of any given text.[1] Nevertheless, it is possible to offer some observations regarding the types of books that tended to be destroyed outright, those that might be mutilated and dispersed, and those that had a strong chance of surviving intact.

Books have been systematically destroyed since the beginning of recorded history, whether by custom or as a result of changes in taste and ideology. Rough copies, documents containing errors, and writings such as business contracts that have expired or been rescinded have been routinely discarded from time immemorial. We can trace a similar pattern in our own age witnessed by the destruction of newspaper and journal archives and even hand-annotated cards in card catalogues based on the belief that once these items have been converted into digital form, the originals are no longer needed. Copies of works intended for greater permanence were themselves often subject to changes in fashion. Developments in handwriting, for example, could lead to the destruction of entire manuscripts: when a new script came into fashion, scribes would often update the libraries of their institutions by preparing fresh copies of important works, frequently jettisoning copies written in older scripts once they had served their purpose as exemplars. The invention and spread of printing brought a new twist, for once a printer had published an edition of a text, he might feel that the manuscript on which the edition was based served no further useful purpose; the printed text was deemed more authoritative, allowed uniformity of citation, and had the virtue of including finding aids such as indexes and tables of contents often lacking in manuscripts. There are numerous cases in which the manuscripts used for early printed editions can no longer be traced, presumably because they were discarded. Another cause of loss was that ecclesiastical service books often became outdated as a result of changes in the liturgy during the Middle Ages or because their decoration came to be deemed insufficiently rich or had fallen out of fashion. Occasionally, portions of manuscripts that have suffered for any of these reasons surface as a result of their reuse as binding material in other manuscripts or printed books (see chap. 4). When parchment was in short supply or too costly, discarded manuscripts were washed or scraped off and the parchment reused as a support for a new text. In such cases manuscripts could survive in their entirety as palimpsests (see chap. 7, figs. 7-27 and 7-28).

Religious zealotry and ideological and social change could lead to the selective destruction of certain types of books deemed offensive. In the New Testament, the newly converted Christians of Ephesus gathered together their old books on the magical arts and burned them (Acts 19:19), beginning a long history of Christian purification by fire of pagan or heretical works. Occasionally one of these proscribed works survives, allowing us a glimpse of what the Church wanted to destroy. In the sixteenth century, the passions unleashed by the Reformation prompted a new wave of book burning by both Catholics and Protestants. Not all books, however, were equally targeted. The Index of Prohibited Books, compiled by the Sacred Congregation of the Roman Inquisition to stop the spread of

1. See Sandra Hindman, Michael Camille, Nina Rowe, and Rowan Watson, *Manuscript Illumination in the Modern Age: Recovery and Reconstruction* (Evanston, IL, 2001).

heresy, first published in 1559, demonstrates that Catholics did not always condemn all works by an author who was suspect; they might proscribe certain works only, or excise particular chapters or lines out of books that were otherwise acceptable. Reformers had little taste for late medieval liturgical or scholastic manuscripts and might treat them with contempt, yet they often spared the works of Catholic humanists. In England, many books were selectively censored in response to Henry VIII's dispute with the pope and his injunction that all references to St. Thomas Becket (who had defied the will of a king) should be deleted. Subsequent zeal even resulted in the censorship of manuscripts produced many centuries earlier (see chap. 7 and fig. 7-29). Conversely, intense religious feeling might stimulate special efforts to secure manuscripts from danger. Those English men and women who remained Catholic after the Reformation and who came to be known as Recusants often hid suspect books in their homes or sent them overseas where they would be safe. Protestants, for their part, went to special lengths to secure and preserve copies of medieval texts that, in their view, attested to the corruption of the Church and the unwarranted growth in power of the papacy. The group of historians active in sixteenth-century Germany and known as the Magdeburg Centuriators initiated an international effort to seek out such texts, which they incorporated into their multivolume *Ecclesiastica historia*, published between 1559 and 1574. In England, Matthew Parker, archbishop of Canterbury (1559–75), set special store by manuscripts of the Anglo-Saxon period that in his view attested to an early form of English Christianity that had much in common with the reformed Anglican Church. During the sixteenth century, given the nature of the issues that threw medieval materials into the spotlight, manuscripts tended to be sought out more for their textual content than for their illumination.

In more recent centuries, the fate of manuscripts has been affected less by religious fervor than by other types of ideological, social, and commercial pressure. Documents relating to the possession of land have been targeted in times of uprising and revolution; the French Revolution, for example, was accompanied by the destruction of large numbers of records of this type. In the nineteenth and twentieth centuries, the rise of connoisseurship, the cult of "medievalism," and the growth of a commercial art market have represented both a blessing and a curse for the well-being of manuscripts. Intensified interest has undoubtedly encouraged efforts to rescue many manuscripts from obscurity and provide them with a secure home, especially by directing attention toward those books containing rich illumination. Often, however, the interest has had deleterious side effects. In the Victorian era, even so sensitive an art critic as John Ruskin felt justified in cutting up manuscripts for the sake of their illuminations, which he then pasted into his own scrapbooks. Since they have been divorced from their proper context, we may never

know the original provenance of such rich but now isolated fragments. More recently, unscrupulous dealers, realizing that more can be made by marketing leaves singly than by selling them in the form of a complete manuscript, have not hesitated to break manuscripts up, with the result that the different parts of what was originally a single volume may now be dispersed in the hands of tens or even hundreds of owners.

Sadly, even books supposedly safe within library walls have occasionally been mutilated by scholars who are in a unique position to know their value and who, because of their expertise, are often most trusted by librarians and conservators. Such unethical individuals, acting either for private financial gain or simply to prevent other scholars' access to certain materials, have removed portions of leaves and entire leaves—the notorious theft from the Vatican Library of two illustrated leaves of a codex commissioned and annotated by Petrarch is one recent case. Needless to say, such behavior on the part of scholars who have been entrusted with the care of these precious and unique objects is utterly reprehensible. Dealers have also occasionally perpetrated crimes of this kind, as the case of E. Forbes Smiley III, convicted during 2006, graphically demonstrates. Smiley was a rare map dealer who was caught at the Beinecke Library of Yale University with an X-Acto knife that he used to remove maps from early printed books. Yale was not the only victim; among the ninety-seven maps Smiley admitted to stealing in his guilty plea, two were from the Newberry and numerous other libraries have found missing materials.

Not only have manuscripts been subjected to a broad range of pressures that have affected their chances of survival; many have also wandered far from their original homes. Only a few manuscripts still belong to the institutions that owned them in the Middle Ages; those that do are in the libraries of certain cathedrals and of monasteries that have avoided suppression and succeeded in retaining greater or lesser portions of their medieval collections. Even within the Middle Ages, manuscripts might move from one center to another, for reasons touched on below (see chap. 8). Since the close of the medieval period, religious, social, and political changes have had a major impact on the movement of manuscripts. In England, the dissolution of the monasteries under Henry VIII and the consequent threat posed to the abandoned monastic libraries initiated a long process wherein manuscripts typically first passed into the hands of small-scale local collectors, then made their way into the libraries of major national figures such as Matthew Parker and Sir Robert Cotton (1571–1631), and finally came to rest in the institutions to which they still belong today. Parker entrusted his manuscripts to Corpus Christi College in Cambridge upon his death, while Cotton's collection passed through the hands of his son and grandson before being donated to the English nation and, in the middle of the eighteenth century, becom-

ing one of the foundation collections of the newly created British Museum. On the Continent, manuscripts tended to rest in their medieval homes longer than in England, but during the seventeenth and eighteenth centuries several countries established centralized and nationalized collections, and with the suppression of many religious houses in the era of the Enlightenment, officials often selectively plundered their libraries, taking the most desirable books for state or royal collections while selling others in large lots to book dealers.[2]

War has also played an important part in the movement of books across national boundaries: many manuscripts came into national archives through the conquest of territory in much the same way that the antiquities of Greece and Egypt came to rest in European museums. Napoleon famously raided the libraries of conquered territories with the rationale that "all men of genius, all those who have attained distinction in the republic of letters, are French, no matter in what country they may have been born."[3] During the Bourbon Restoration, the allies took back as many of their artistic works as possible, although many had been shipped from Paris to more rural areas and some had been damaged in transit; they also took works that had not previously been in their possession as a form of reparations. The Hague Conventions on the Laws and Customs of War of 1899 and 1907 forbade the wholesale destruction and looting of artworks (including books), but although this was largely respected in World War I, both unintentional destruction and theft occur during any period of chaos.[4] The Nazis treated different areas differently. The Third Reich acted as an occupying army in France and in general did not ship materials from French institutions to German ones. They did, however, confiscate private works from many people, particularly Jews and other collectors, and attempted to completely obliterate Polish culture when they occupied Poland. Much of the damage inflicted on cultural institutions was done by retreating armies (the retreating German army blew up several of Florence's historic bridges, and heavy fighting did extensive damage to Monte Cassino) and by the actual bombing of cities (London, Rouen, Dresden, and Hamburg).[5] There have been several tales (some certainly genuine) of Ameri-

can GIs bringing manuscripts home from the European theater of World War II. A celebrated case is the theft of the ninth-century Samuhel Gospels (often referred to as the Quedlinburg Gospels) from the church of St. Servatius in Quedlinburg, Saxony, along with other books and numerous richly decorated liturgical objects that had been hidden in a mine near the church during the war. The theft was discovered when the heirs to Joe T. Meador's estate sold the manuscript. Meador was stationed in Germany at the end of the war and apparently shipped the items to his home in Texas through the military mail. The materials were eventually recovered and returned to the church. One notable casualty of the war was a manuscript of Hildegard of Bingen's visions, made during her lifetime and probably under her direction and later studied by Goethe. In 1945, this unique manuscript disappeared from the Hessische Landesbibliothek in Wiesbaden; it is by no means impossible that it may surface again one day.

These various factors affecting the movement of manuscripts have meant that, while some codices are still in their medieval homes and others (along with numerous fragments) have come via the market into private hands, the great majority are now to be found in national, regional, municipal, and university or college libraries. These are the institutions with which the researcher typically has to become familiar when pursuing a project that requires firsthand work with manuscripts.

The chapters that follow offer advice on how to plan and carry out such work and how to develop the skills that will foster the accurate reading and analysis of manuscripts. Chapter 5 provides some tips to the researcher who will venture into an archive to consult manuscripts firsthand by offering suggestions about how to prepare for the visit, what materials to take, whom to contact, and how to proceed on arrival. The chapter discusses the fundamental difference between transcribing and editing, presents guidelines for making transcriptions, briefly covers the competing philosophies of textual editing, and concludes with a guide to the most commonly used abbreviations and signs found in modern editions of Latin texts. Chapter 6 addresses two topics generally found problematic by novice researchers: the systems of punctuation and abbreviation employed in medieval manuscripts. The chapter discusses the varieties of punctuation marks most commonly encountered in manuscripts and provides a guide to frequently occurring abbreviations. Chapter 7 outlines the types of damage the researcher may come upon when examining manuscripts and offers some guidance on the various technologies that may be brought to bear on damaged passages to render them legible. In chapter 8 we describe the types of evidence a researcher can look for when seeking to establish the history, origin, and provenance of a manuscript. Chapter 9 focuses on the conventions of manuscript description, detailing the types of information most important to record when preparing one's

2. For France, Léopold Delisle's *Le cabinet des manuscrits de la Bibliothèque impériale*, 3 vols. (Paris, 1868–81), provides an invaluable account of the routes by which manuscripts made their way into France's national library.

3. Albert Sorel, *L'Europe et la Révolution française*, vol. 4 (Paris, 1892), 154, quoted in Dorothy Mackay Quynn, "The Art Confiscations of the Napoleonic Wars," *American Historical Review* 50 (1944–45): 437–60, at 439.

4. Ernst Posner, "Public Records under Military Occupation," *American Historical Review* 49 (1943–44) : 213–27.

5. Francis Henry Taylor, "The Rape of Europa," *Atlantic Monthly*, January 1945, 52–58.

own description and offering guidance on how to read and interpret modern catalogue descriptions of manuscripts. Chapter 10, which completes part 2, seeks to acquaint the reader as closely as possible within the confines of this volume with what a researcher actually encounters. The chapter includes a selection of some of the most important medieval scripts, illustrated by examples from the Newberry Library. Each plate of a script is accompanied by a partial transcription of the page, an account of the evolution and main characteristics of the particular script, and a brief orientation to the manuscript from which the plate has been chosen; readers are encouraged to complete the transcriptions for themselves.

Working with Medieval Manuscripts

HOME AND AWAY

"Distance Reading"

Not everyone has the opportunity to travel to see a manuscript in situ, particularly if it is housed in a location that is off the beaten track. Even when a researcher is able to consult a manuscript firsthand, it is vital to prepare for the experience by becoming as familiar as possible with the manuscript beforehand, so that the actual examination will be highly focused and the investigator will approach the manuscript with the right questions in mind. The commonest way to get to know a manuscript at a distance is to order a microfilm copy from the archive that houses the manuscript. Most manuscript libraries either have their own photographer or have access to the services of a photographic studio for the purposes of making microfilms. Allow several weeks for delivery from the date of order, as some libraries have to let orders build up before sending a batch of manuscripts to the studio to be filmed. On the other hand, if the film to be ordered is of a well-known manuscript from a major library, it is likely that a master film already exists, and thus it will only be necessary to have a copy made from the master. Some libraries and archives now offer color and digital microfilming, making examination more rewarding.

Reading a microfilm can be a challenging experience, especially for anyone doing it for the first time. Rather than view the film on the screen of a microfilm reader, many prefer to make a paper printout of the film and work with that. Most universities have microfilm reader-printers on which it is possible to make such paper copies; they can also be made commercially by taking the film to a business that deals in microfilms. For a scholar who is interested only in a small portion of a manuscript, it is worthwhile to ask the archive housing the manuscript whether it can supply paper copies of the desired pages rather than a film of the complete codex.

When working from a microfilm, it is important to bear the following points in mind:

1. Most microfilms are black-and-white. Rubricated titles and other portions of colored text may there-fore appear to be almost the same color as the main text, making them difficult to distinguish. Changes in the color of the ink within the main text area—for example, where a later scribe has corrected a letter or word or made adjustments to the punctuation—will simply not be visible on the film. One must be wary of making any but the most straightforward paleographical judgments based on examination of a film alone.

2. Many manuscripts include at least a few leaves on which there are holes in the text area, these holes being the result of damage sustained by the skin of the animal from which the parchment was made (see chap. 1). Such holes can be difficult to see on a microfilm; this can be particularly confusing when text from the next or previous leaf shows through the hole. If, when you are reading a film, a passage of text appears to be impossibly corrupt, check the next recto or the previous verso to determine whether the problem letters or words in fact belong to the text of those pages and are simply showing through a hole in the leaf under examination (see figs. 5-1 and 5-2).

3. Watch out for missing or duplicated pages on the film. When a long manuscript is being microfilmed, it is not uncommon for the photographer to turn two leaves at once, omitting an opening, or to film an opening twice; sometimes, indeed, an opening will be deliberately filmed twice if the photographer feels the first exposure was too light or too dark. If the leaves of the manuscript are numbered, keep careful track of the foliation, watching for omitted or duplicated leaves. Bear in mind also that often a microfilm will not include all the endleaves of a manuscript, particularly if the endleaves are postmedieval. This can be frustrating, as sometimes such endleaves include important notes attesting to the ownership and transmission of a manuscript.

Nowadays, thanks to the advent of new and inexpensive digitizing technologies and the growth in the use of

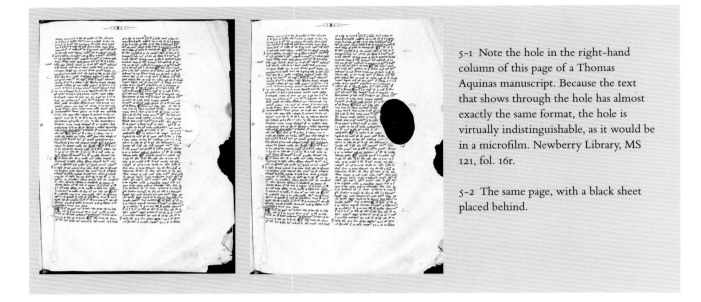

5-1 Note the hole in the right-hand column of this page of a Thomas Aquinas manuscript. Because the text that shows through the hole has almost exactly the same format, the hole is virtually indistinguishable, as it would be in a microfilm. Newberry Library, MS 121, fol. 16r.

5-2 The same page, with a black sheet placed behind.

the Internet, many medieval manuscripts are available for viewing online, either in their entirety or in the form of selected pages. Because most of these electronic reproductions are in color, they can provide more information than microfilm or photocopies from microfilm, although on physical matters of codicology it is still necessary to examine the manuscript itself before making judgments. Some websites for viewing manuscripts attempt to replicate the process of reading by presenting facing pages and even using graphics to simulate the turning of pages. While such sites can be useful for teaching, they may also provide the impression that distance reading is an appropriate surrogate for examining the actual codex; ultimately, however, there can be no substitute for examining the manuscript itself. What digital facsimiles can do rather well is to allow the reader to conduct a preliminary examination of a number of manuscripts in order to decide which ones will be most important for a particular study. They are also useful (as are microfilms) in allowing the reader to determine the actual contents of a manuscript rather than having to rely on often outdated, incomplete, or erroneous catalogue descriptions. Many of these sites have search engines that enable a variety of useful types of search. Digitized manuscripts also offer a wonderful opportunity for practice in transcribing a wide variety of scripts and allow a casual observation of very rare and costly manuscripts that might otherwise be off limits to the novice researcher.

Reading in Situ

Anyone intending to examine a manuscript firsthand must plan the visit well in advance: in all but the most exceptional circumstances, it simply is not possible to arrive at a library out of the blue and be given immediate access to materials. Most libraries now have websites that list their opening hours and outline their conditions of access.

For national libraries such as the British Library in London and for major university libraries, the researcher may be required to obtain a reader's ticket on arrival, a process that normally entails an interview in the admissions office. At the interview, it will be necessary to show some form of identification such as a passport or driver's license and to offer proof of academic status and of the need to consult materials; this normally means that the researcher must produce a letter on institutional letterhead from the dissertation director (in the case of a graduate student) or from a colleague, preferably a senior colleague. The letter should address the researcher's need to consult specific manuscript materials; it may be necessary to back this up at the interview by providing a more detailed verbal description of one's project. Even after you have been given a reader's ticket, be sure to bring photocopies of your letters with you each day as they may be needed if you apply to consult particularly rare or fragile materials. Smaller libraries such as the Oxford and Cambridge college libraries normally do not issue reader's tickets, but for such libraries it is usually necessary to contact the library staff many weeks in advance of the planned visit to request permission to view materials and to set up an appointment: these smaller libraries often have no more than a handful of seats available and can therefore admit only a limited number of readers on any given day. An additional reason for making arrangements well in advance is that during the summer, which often offers the best opportunity for researchers to conduct their work, many smaller libraries close their doors for a week or two. Mailing addresses, telephone numbers, and URLs for most North American and European libraries and archives can be found in *The World of Learning*, published annually by Europa Publications and available in the reference section of most university libraries.

It is important to be aware that library staff have the authority to deny access to materials if they feel the prospective researcher is insufficiently prepared or if the materials in question are especially old, fragile, or precious and fall into the category of "select manuscripts," that is, those manuscripts that librarians allow to be consulted only for the most persuasive of reasons. For such manuscripts, library staff may permit the researcher to examine only a microfilm copy or photographs, or they may insist that the researcher should begin by examining such reproductions and then be allowed a brief consultation of the manuscript itself to address issues that cannot be resolved without actual contact. Researchers should at all times respect any constraints imposed by librarians who, as custodians of materials that have survived for hundreds of years, have a heavy responsibility to ensure the continued preservation of those materials for the future. When planning and conducting their project, researchers should also remember that librarians and curators can be a significant source of information. They may well be able to recommend additional materials that would repay consultation, and, through their detailed knowledge of the collections they oversee, they may be in a position to explain aspects of a manuscript that are puzzling to someone visiting the collection for the first time.

Tools of the Paleographer

Not only must a researcher be prepared to set up a library visit far in advance; it is also important to carry to the library those items of equipment that will best facilitate the effective examination of manuscripts. It is now standard practice in manuscript libraries to ban pens and allow readers to use only pencil to take notes. Pencils are, in any event, the best writing instrument for making transcriptions, as pencil can be erased with ease, and mistakes in transcription are inevitable, even for advanced paleographers. In addition to carrying a stock of ordinary pencils (using several pencils averts the need to waste time on continually sharpening a single pencil), some paleographers find it worthwhile to have at hand a set of colored pencils for transcribing rubricated titles and initials; the colors that most commonly occur in manuscripts are red, blue, and green. Magnifying glasses will prove helpful for reading damaged passages of text and small or difficult script, and for examining physical features such as the hair follicles in the parchment, the shape of prickings, and the medium of ruling. It can be worthwhile to carry two magnifying glasses, one with a large lens for reading text, the other with a smaller, more powerful lens for close study of physical features and for the examination of erasures, pigment deterioration, and the like. A pocket microscope may be useful on occasions when yet higher magnification is required but is a poor substitute for a binocular microscope, an item of equipment available in some libraries upon request. A microscope can be used for detailed visual analysis of pigments, for detecting preliminary drypoint sketches underlying initials and illustrations, and for distinguishing between the hair- and flesh-sides of leaves when the two surfaces barely differ in appearance (as is often the case in Insular manuscripts of the early Middle Ages).

For taking measurements of leaves and their written areas, a ruler or tape measure calibrated in millimeters is essential. An eighteen-inch ruler will be serviceable, as many manuscripts exceed twelve inches in height, but few exceed eighteen inches; a tape measure may, however, prove more useful than a ruler because it is flexible and its calibration begins at the very end of the measure, an asset when measuring the width of a leaf from gutter to fore-edge. A bone folder, an item available from a good artist's supplier, can be helpful for gently probing in the gutters of leaves (for example, when looking for the sewing in the middle of a quire) or for holding back a stub or flap of parchment; a small flashlight is good for examining shadowy areas in the gutters and can be of assistance when reading erased passages where traces of ink remain or looking for watermarks on paper. Permission should, however, be sought from library staff before using either of these items. For reference purposes, it can be useful to have at hand photocopies of catalogue descriptions of those manuscripts one plans to examine; carrying a copy of Cappelli's eminently portable *Dizionario di abbreviature latine ed italiane* may save much time that would otherwise be spent on puzzling over the meaning of particular abbreviations.

Certain important items of equipment that cannot easily be carried may be available at the library upon request. Especially useful for examining drypoint glosses and sketches is a cold fiber-optic light source. The flexible tubes may be bent to the desired angle so that the light rakes across the page to throw the drypoint into relief; because there is no heat at the end of the tube from which the light emerges, the tube can be brought very close to the surface of the page without risk of damage to ink or pigment. Watermarks can best be viewed by backlighting, that is, by shining a fiber-optic light source from behind the leaf. For attempting to read areas of erased text, an ultraviolet lamp will be necessary. Library staff may provide a lamp at the reader's table or may ask the researcher to use the lamp in a special room or cubicle reserved for the purpose. The lamp must be used with caution, as too long an exposure to ultraviolet light can cause the deterioration of inks and pigments on a page; and to avoid harmful effects on the eyes, the user must beware of looking directly at the bulb of the lamp. Libraries often impose strict limits on the amount of time for which an ultraviolet lamp may be used. That said, viewing a page under ultraviolet light may produce astonishing results, rendering legible certain areas of text that may at first sight have seemed irretrievably lost (see further chap. 7).

Practices and Procedures

Most manuscript libraries have their own house rules and require researchers to read those rules before beginning to examine a manuscript. Such rules must of course be strictly adhered to. Here are some general guidelines applicable to all collections:

1. When reading a manuscript, always rest the book on an adequate support; do not pick it up and read it in your hands. Almost all libraries now provide supports: either an angled book-rest or a roll of fabric (futon) on which to set the book. Use the supports provided.

2. If you leave your desk, never leave the manuscript open; close it and, if you wish to mark your place, use a strip of acid-free paper to do so (library staff can normally provide such strips). Be careful not to place a marker directly on an illumination. Some libraries insist that, if you are leaving your desk for more than a brief interlude, you must not leave the manuscript out but must return it to the issue desk.

3. If you wish to keep a manuscript open at a particular pair of pages—for example, while making a transcription—do not hold it open with your hands or by placing another book on it. Rather, use the equipment provided for the purpose. This may be a specially designed clip or a weight of some sort; nowadays, the weight is often a lead-filled string (sometimes known as a "bookworm" or "snake"). Be sure to place weights in the margins of pages, where they cannot abrade ink or pigments. In general, avoid overhandling the manuscript, and never point at a page with the sharp end of your pencil.

4. Be sure always to wash and thoroughly dry your hands before handling manuscripts. Some libraries require readers to wear white cotton gloves to protect manuscripts from dirt and oils on the fingers. The gloves supplied do not always fit well; if you know you will be visiting a library that requires the use of gloves, you might consider purchasing a pair beforehand in your own size.

5. If you bring a laptop computer to the library, be aware that you may not be allowed to bring the case into the reading room. Many libraries now have power outlets at the reading desks into which it is possible to plug a computer; some libraries, however, insist that a member of staff must first test your computer before you use it at your desk. If traveling to a library outside your home country, bear in mind that to plug your computer in you will need to obtain an appropriate adapter.

6. Notify a member of staff if, when examining a manuscript, you notice any missing or damaged folios or any materials in need of conservation.

7. When examining manuscripts, avoid sudden and impetuous movements (even if you think you have made a major discovery!). Think carefully about what you are doing, bearing in mind at all times that you are handling an artifact of great value and that you have a responsibility to help ensure its continued transmission to future generations.

RECORDING TEXTUAL DATA: TRANSCRIBING AND EDITING

The purpose of examining a manuscript is often to record data about the manuscript with a view to eventually communicating the data to others. Perhaps the most challenging task in archival research is reducing the manuscript page with all its complexity and peculiarities to a standardized format that preserves as much as possible of the information on the original page. How, for example, can one convey the richness and complexity of a page such as that illustrated in fig. 5-3, from an eleventh-century German copy of Boethius's *De consolatione philosophiae*? While a careful transcription will be faithful to the text, it cannot capture the process by which the page was constructed, the layering of glossing and correction, the underlining that signals Greek words in the text, the large space originally left between the lines of text in anticipation of the interlinear translations and glosses, the gaping hole in the parchment that neatly bifurcates the text, the varying colors of the inks, the idiosyncratic hyphens that appear at the beginning of the second half of the divided word rather than at the end of its first half, the abbreviation markers, the use of the lower margin for transliterating the Greek on the page, or the overall quality of the text and parchment. A detailed description of the manuscript could summon up a picture of these aspects in a reader's mind, yet probably such a description can really come alive only for those who have themselves had an encounter with the manuscript in situ. Rendering the particularities of a manuscript intelligible to others is a formidable task.

Often, however, the primary concern of the researcher is more limited, being restricted to recording and passing on the specifically textual data of a manuscript. The first step in this process is to prepare a transcription of the text. Ultimately a transcription may feed into a critical edition that is based on the examination of multiple manuscripts of a particular text. It is important to realize that a transcription differs from an edition in significant ways, and the two require quite different approaches. We here offer some practical guidelines on making transcriptions and on interpreting editions and their critical apparatus. Because the focus of this book is on primary manuscript study,

5-3 A page from an eleventh-century manuscript of Boethius's *De consolatione philosophiae* with interlinear glosses. Newberry Library, MS 10, fol. 16/23v.

ern readers. A transcription therefore uses modern letter forms rather than seeking to imitate the letters of the original script. If words are run together without separation in the manuscript, or if, in contrast, the manuscript introduces a gap within a word, the transcription should override these features and present the text with normalized word separation. Abbreviations should be expanded, but the transcriber must make it clear which letters have been supplied to complete an abbreviated word.

The general principles of transcription can be expressed in the following guidelines:

1. Start a new line in the transcription for every new line in the manuscript; or, alternatively, signal the manuscript line divisions by placing a slash (/) at the appropriate points in the transcription. Starting a new line is preferable, particularly for short transcriptions; a slash used to signal line endings can be confused with the *virgula suspensiva*, a mark of punctuation commonly used in late medieval manuscripts (see chap. 6).

2. Use capitals where the manuscript uses capitals; use lowercase letters where the manuscript does so. Remember that principles of capitalization were different in the Middle Ages. Personal names commonly do not begin with capital letters (unless they are written entirely in capitals, as is the case in some manuscripts); the transcription should follow the manuscript in this regard. Do not, however, attempt to imitate the letter forms of the manuscript. Where the letter forms in the manuscript differ from modern letter forms, use the modern equivalents: for example, when transcribing tall Caroline minuscule *s*, use the accepted modern form of the letter.

3. Use the forms of punctuation that occur in the manuscript. Do not attempt to "translate" them into modern punctuation marks. For example, when transcribing a *punctus elevatus* (roughly equivalent in value to a modern semicolon; see chap. 6), transcribe it as a *punctus elevatus*, not as a semicolon.

4. Do not normalize spelling. Transcribe the text just as it occurs in the manuscript, even when you can

these guidelines are not designed to cover in detail the topic of how to prepare a critical edition; several works listed in the bibliography are better suited for that.

Preparing a Transcription

The purpose of a transcription is to provide an accurate record of the text, or a portion of the text, in a particular manuscript. This means that, in general, the transcriber should resist the temptation to normalize. If the manuscript includes peculiarities of spelling and even outright errors, the transcription should preserve these features (it is the task of an edition to normalize such features where appropriate). Thus, if where classical Latin would use *ae*, the manuscript uses a spelling with *e* or *e*-caudata (that is, *e* with hook: *ę*), the transcription should record the manuscript spelling. Similarly, a transcription should reproduce the original punctuation rather than use modern marks of punctuation. (Some guides to transcription suggest modernizing punctuation, but this practice is to be discouraged; medieval marks can express nuances of meaning that cannot always be captured by modern marks.) On the other hand, a transcription is not a facsimile, and in certain respects it must cater to the needs and expectations of mod-

SYMBOL	DESCRIPTION	USE		EXAMPLE
()	Parentheses	Expanded abbreviation		d(omi)ni
† †	Obeli or Daggers	Problematic readings: text is corrupt, or transcriber is uncertain of the text		†dominit†
/ \	Slashes	Scribal insertion on the line		do/mi\ni
\ /	Slashes	Scribal insertion in the interline		do\mi/ni
\\ //	Double slashes	Scribal insertion in the margin		\\domini//
[]	Square brackets	Letters canceled by scraping or washing; legible erased letters are placed within the brackets		do[mi]ni
[..]	Square brackets and subscript dots	Letters canceled by subpunction		do[ṃị]ni
[/]	Square brackets and slash	Substitution of a new letter or word over an erasure; if original reading is legible, it is placed to left of slash		[/d]omini (original reading not legible) [h/d]omini (original reading legible)
[[]]	Double square brackets	Portion of text lost through damage (trimming of the margin, rodent activity, etc.)		domin[[*]] (asterisks indicate the estimated number of letters lost; if no estimation is possible, nothing is entered within the double brackets)

see that it includes errors. Transcribe the letters *u* and *v* as they appear in the manuscript; if a word includes *u* where a modern edition might show *v* (for example, *uideo/video*), the transcription should show a *u*.

5. Normalize word separation. If two words are run together in the manuscript, with no space between them, the transcription should show two separate words.

6. Expand abbreviations. When doing so, identify the letters supplied to complete the word by placing them within parentheses: for example, *d(omi)ni, int(er)pretat(ur)*. If you do not know how to expand a particular abbreviation, use an abbreviation symbol similar to the one in the manuscript. On further reading, reflection, or with the aid of another scholar, you may be able to expand the abbreviation at a later time.

7. Transcribe as normal letters any letters that are written in superscript in the manuscript; do not enclose these letters within parentheses. For example, if *qui*

is abbreviated as *q* with *i* standing in superscript above the *q*, the word should be expanded as *q(u)i*, with just the omitted *u* within parentheses. An exception to this rule is presented by numbers, which are sometimes left with their superscript ending: for example, *iiii^{or}* rather than *(quattu)or* or *iiiior*, or *lx^a* rather than *(sexagint)a* or *lxa*.

8. Record the beginning of a new page in the manuscript by entering the folio number within brackets at the appropriate point in the transcription. Similarly, if the manuscript is in two-column format, record the beginning of a new column with a column letter within brackets.

These guidelines cover the basics of transcription. The information that a transcription should record becomes more complex, however, when the manuscript includes erasures, corrections, interlinear insertions, and the like. Various systems of marks have been evolved to enable a transcription to indicate such features. The two best known are the "Leiden" system, originally devised for the fields of papyrology and epigraphy and described by

E. G. Turner, *Greek Papyri: An Introduction* (Oxford, 1968); and the "Scriptorium" system, devised for use in *Scriptorium*, the journal of manuscript studies. The paleographer T. J. Brown produced his own system drawing upon the strengths of these two, and his pupil Michelle Brown published a modified version of this.[1] The table opposite illustrates and explains the most important marks used in the Brown system; these marks are used within the present book, where appropriate.

Producing an accurate transcription is much harder work than may at first appear; even experienced paleographers find it challenging to produce a flawless transcription. Repeated practice, however, while it may not make perfect, will certainly prove hugely beneficial. Transcription is, indeed, one of the best possible means by which to learn how to read medieval scripts accurately, for it encourages close observation and obliges the transcriber to puzzle over difficult words and to tease out the meaning of abbreviations in a manner that mere reading does not. To increase their own familiarity with a broad range of medieval scripts, readers of this book are strongly encouraged to study and make their own transcriptions of the sample scripts illustrated in chapter 10.

Editions and Editorial Conventions

The process by which texts were transmitted through the Middle Ages—passed from one generation to another and from one region to another by being copied from one manuscript to another—was usually marked by decay and corruption; every time a new copy of a particular text was made, there was an attendant likelihood that new errors would be introduced as the result of scribal inattention or misunderstanding. Even medieval commentators were sharply aware of this danger. The early fourteenth-century bibliophile Richard de Bury puts this complaint against sloppy copyists in the mouth of the books themselves: "Alas! How you deliver us to blundering scribes to be copied! How corruptly you read us, and how often by your remedies you slay us, all the while believing you are amending us with pious zeal!"[2]

Whereas the purpose of a transcription is to record accurately the textual content of an individual manuscript, including its errors, it is the business of an edition to try to undo the process of corruption, to present the text of a particular work in as correct a form as possible. This fundamental difference between a transcription and an edition is worth emphasizing once again. The process of creating an edition involves the comparison of numerous different manuscripts of a text and, on occasions when variations occur among the manuscripts, the exercise of judg-

ment as to what the correct reading should be. Presented with a choice between two possible readings of a given passage, editors have various ways to determine which is more likely to represent the author's original intent. One method often employed (although it is to be used with caution) is to give the benefit of the doubt to the *lectio difficilior*, the "more difficult" reading, on the assumption that scribes were more likely to mistranscribe an unfamiliar word as a more familiar one than vice versa. For example, faced with the variant readings *socrus* (mother-in-law) and *socius* (companion), an editor might select *socrus* on the grounds that it is the less familiar word and in scripts in which the arm of the *r* was short and attached to the following *u*, could easily have been misread as *socius*.[3]

It is helpful for the student of manuscripts to have some idea about how editions are produced, the nature of their relationship to their underlying manuscripts, and the conventions typically used by editors. The first printed editions of classical and medieval works were undertaken during the Renaissance by humanist scholars who sought to preserve these works by putting them into wider circulation through the medium of print. Often, however, these early editions were not editions in the modern sense. In many cases, they were based on no more than a single manuscript, not because of the textual excellence of that manuscript but merely because it happened to be the one that had come into the hands of the editor. There were exceptions; the French scholar Jacques Lefèvre d'Étaples (ca. 1455–1536), for example, consulted many copies of Aristotle's works, both manuscript and printed, before issuing his own editions. Another unfortunate characteristic of early editors is that, once they had published their editions, they sometimes discarded the manuscripts on which they were based, believing them to be of no further use. While early editions can have distinct value as evidence for the evolution of the science of textual criticism, they are of limited use as witnesses to the text of a work and should be consulted with due caution. Some of these early editions, however, have continued to wield influence through later reissues. It is important to be aware that many of the editions published by J.-P. Migne in his massive *Patrologia Latina* are verbatim reprints of Renaissance editions based on few manuscripts and often "corrected" for sense or style to conform to humanist models of Latin composition.

In the modern period, it is generally agreed that the production of an edition requires the editor to become familiar with any and all available manuscripts of a work. Nevertheless, there are significant variations in method that reveal deep differences in the conceptions of manuscript transmission. One fundamental division is between the "optimist" method (often called the Bédier approach)

1. See Michelle P. Brown, *A Guide to Western Historical Scripts from Antiquity to 1600* (London, 1990), 5–7.

2. Translation adapted from Richard de Bury, *Philobiblon*, trans. E. C. Thomas (Oxford, 1960), 48–49.

3. On the principle of *lectio difficilior*, see L. G. Reynolds and N. G. Wilson, *Scribes and Scholars: A Guide to the Transmission of Greek and Latin Literature*, 3rd ed. (Oxford, 1991), 221–22.

and the "recensionist" (or Lachmannian) method.[4] These two schools are diametrically opposed to each other and often quite hostile. On the one hand, the optimist chooses a single "best" manuscript after reviewing all available manuscripts and bases the edition on it, calling upon the remaining manuscripts only when they provide better readings of problematic passages. The recensionist, on the other hand, seeks to reconstruct the earliest recoverable form of a text through painstaking examination of the surviving manuscript witnesses. To do this, the recensionist must discover the relationships among the surviving manuscripts: which belong to the same textual family, which can be shown to be direct copies of other survivors (and therefore of no independent value), which belong to divergent textual traditions, etc. The relationships are established on the basis of shared errors or variants. The result of the recensionist's investigations is normally expressed in the form of a *stemma codicum*, a family tree, or genealogy, of the manuscripts that has at its point of origin the hypothetical archetype, the form of whose text it is the recensionist's aim to recover. In addition to this archetype and the surviving manuscripts, the *stemma* normally incorporates other lost manuscripts whose former existence can be posited by the nature of the interrelationships between the surviving manuscripts.[5]

In drawing up the *stemma* and in compiling the critical apparatus to an edition, it is normal for an editor to use a shorthand form of reference for the various manuscripts, assigning each manuscript a *siglum*, or special mark; this saves always having to cite the full shelfmark of the manuscript. For actual surviving manuscripts, these *sigla* normally consist of letters of the Roman alphabet—usually uppercase letters, though sometimes lowercase letters will be used to denote less important or less ancient manuscripts. Sometimes a set of *sigla* will begin with *A* and continue through as many letters of the alphabet as are necessary to cover all the manuscripts. Often, however, the *siglum* reflects the place of origin or present location of the manuscript. Thus, a manuscript in the Vatican Library

might be identified as *V*, a manuscript in a Paris library as *P*, and so on. An editor who has to deal with two manuscripts from the same location may distinguish between them by adding a superscript number to the *siglum* (thus *P¹* and *P²* could be used to identify two different manuscripts from Paris libraries); but it is important to be aware that many editors use such superscript numbers to indicate the work of different scribes within a single manuscript (in which case *P¹* would refer to the work of the original scribe, *P²* to a correction or some other intervention by a second scribe). Sometimes an editor drawing up *sigla* will use abbreviations for the adjectives derived from the Latin forms of the appropriate place names: thus *Rot.* would indicate a manuscript now in or originally from Rouen (*Rotomagensis*), *Gem.* a manuscript in or from Jumièges (*Gemmeticensis*). Lost manuscripts whose former existence can be demonstrated by the nature of the relationships among the surviving manuscripts are normally referred to by lowercase Greek letters (α, β, etc.). Editors will normally include a full list of *sigla* either in the introduction to their edition or in a table directly preceding the opening page of text.

The critical apparatus at the foot of each page of an edition is where an editor can record the detailed information revealed by the painstaking comparison of the various manuscripts of a text. The apparatus can show where one or more manuscripts depart from the reading that the editor believes to be correct and can note the presence of corrections, additions, textual lacunae, glosses, and the like in individual manuscripts. The apparatus will repay close study, particularly if it has been compiled by a good editor who is judicious in the selection of the information there presented (by no means all variants are worth recording; simple spelling variations, for example, should find no place in the apparatus, though some overassiduous editors have zealously noted them). Less experienced scholars, however, can find the critical apparatus dense and forbidding, mainly because it includes a large amount of information in a relatively small space and, as a result, makes heavy use of abbreviations. Those abbreviations include not only the various manuscript *sigla* but also a large range of abbreviated Latin terms used to signal what is happening in the text of individual manuscripts. To some degree, individual disciplines and subdisciplines have their own terminology and related abbreviations: thus, the abbreviations used in the apparatus of an edition of a legal text may differ somewhat from those used in an edition of a historical chronicle or a literary or medical text.[6] Sometimes an editor will include in his or her introduction a list of the abbreviations used in the apparatus; sometimes a major series has its own set of abbreviations, which are

4. Joseph Bédier presented an important justification of the optimist method in his article on "La tradition manuscrite du *Lai de l'ombre*: Réflexions sur l'art d'éditer les anciens textes," *Romania* 54 (1928): 161–96, 321–56. The Lachmannian method, formulated in the first half of the nineteenth century, derives its name from the classical and biblical scholar Karl Lachmann (1793–1851), though in reality his contribution to the method was smaller than was at one time supposed. Leonard E. Boyle sought to reconcile the two methods in his "Optimist and Recensionist: 'Common Errors' or 'Common Variations'?" in *Latin Script and Letters A.D. 400–900: Festschrift Presented to Ludwig Bieler on the Occasion of His 70th Birthday*, ed. John J. O'Meara and Bernd Naumann (Leiden, Neth., 1976), 264–74.

5. For a fuller account of the recensionist approach, see Reynolds and Wilson, *Scribes and Scholars*, 207–16.

6. A useful list of guides to editorial techniques and marks is given in Leonard E. Boyle, *Medieval Latin Palaeography: A Bibliographical Introduction* (Toronto, 1984), nos. 2079–91.

to be followed by the editors of individual volumes within the series. There have also been important efforts to standardize the abbreviations used by editors. The following table, which concludes this chapter, is based on that originally published by the Société Internationale pour l'Étude de la Philosophie Médiévale as part of such an effort and will serve as an introduction to the majority of the most commonly used abbreviations and editorial marks.[7] Note that in some cases there is more than one possible way to expand an abbreviation, depending on the context and the editor's preference (for example, *add.* could be expanded into various tenses of the verb *addo*, or could signify the noun *additio*), but the basic purpose and meaning of the abbreviation remain unchanged.

7. See Antoine Dondaine, "Abréviations latines et signes recommandés pour l'apparat critique des éditions de textes médiévaux," *Bulletin de la Société internationale pour l'étude de la philosophie médiévale* 2 (1960): 142–49.

ABBREVIATION	EXPANSION	MEANING
add.	addidit (addit, addiderat, additio, etc.)	Signals an addition
adscrips.	adscripsit	Signals an addition
al. man.	alia manus	Signals that something has been written by a hand other than that of the original scribe
al.	aliter (alias)	Signals an alternative reading
alt.	alterum (altera, etc.)	Means "the other"
c.	caput (capitulum)	Means "chapter"; will be followed by the number of the chapter referred to
cap.	caput (capitulum)	An alternative to *c.* (see above)
cancell.	cancellavit (cancellatum, etc.)	Signals that a word or phrase has been canceled
cet.	ceteri	Means "the rest"; is used to indicate that a reading is shared by all manuscripts except those specifically identified as having a different reading
cf.	confer (conferas, conferatur, etc.)	Means "compare"

ABBREVIATION	EXPANSION	MEANING
cod.	codex	Means "manuscript"
codd.	codices	Plural of the above
col.	columna	Identifies a column within a manuscript
comm.	commentum (*or* commentarius)	Signals commentary within a manuscript
comp.	compendium	Means "abbreviation"
conf.	confusum	Signals that the state of the text is confused
coni.	conicimus (conicio, etc.)	Introduces an editorial conjecture
corr.	correxit (correctio, etc.)	Signals a correction in a manuscript
damn.	damnavit	Signals that someone has condemned a particular reading
def.	deficit	Signals that a word or portion of text is missing
del.	delevit (deletum, etc.)	Signals a deletion
des.	desinit	Signals that the text ends; used when the text is truncated in a particular manuscript
det.	deterior (deteriores)	Means "worse"; signals that an editor rates one (or more) of a set of readings as inferior to the other(s)
dub.	dubitanter (dubium, etc.)	Signals a dubious or uncertain reading
ed.	edidit (editio)	Means "edited" or "edition"
edd.	editiones	Means "editions"
e.g.	exempli gratia	Means "for example"
em.	emendavit (emendat, emendatio, etc.)	Signals a textual emendation
eras.	erasit	Signals an erasure
excerpt.	excerptum (excerptiones, etc.)	Signals that text has been excerpted from another source
exp.	expunxit (expunctum, etc.)	Signals the deletion of letters by expunction, i.e., by entering dots under the letters to be deleted
expl.	explicit	Signals the end of a text

ABBREVIATION	EXPANSION	MEANING
f.	folium	Means "leaf"; is normally followed by the number of the leaf referred to
ff.	folia	Plural of the above
fort.	fortasse	Means "perhaps"; often used when an editor proposes a solution to a problematic or barely legible reading
gl.	glossa	Signals a gloss
hab.	habet	Means "has"
h.l.	hoc loco	Means "in this place"
hom.	homoeoteleuton	Signals a scribal error of eyeskip or dittography caused by two words or phrases having identical endings
i.e.	id est	Means "that is"
imp.	imperfectum	Signals that a text is imperfect, i.e., incomplete
inc.	incipit (incipiendo, etc.)	Signals the beginning of a text
ind.	indicavit	Means "indicated"
induc.	inducente	Means "leading on"/ "inducing"; can be used to suggest the source of an error
inf.	inferior (inferius, etc.)	Means "lower"/"inferior"
inser.	inseruit	Signals an insertion within a text
inv.	invertit	Signals an inversion of word order
iter.	iteravit (iteratum, etc.)	Signals a repetition
l.c.	in loco citato	Means "in the cited place"
lac.	lacuna	Signals that there is a gap in the text of a manuscript
lect.	lectio	Means "reading"
leg.	legit	Means "reads" (pres. tense) or "read" (past tense)
legend.	legendum	Signals a preferable reading
lib.	liber	Means "book"; followed by a number, refers to a specific book within a work

ABBREVIATION	EXPANSION	MEANING
lin.	linea	Means "line"; followed by a number, identifies a particular line on a page of a manuscript
lit.	litura	Means "blot"; signals where a word or phrase is unreadable because of an ink blot
litt.	littera	Means "letter"
man.	manus	Means "hand"; is used when identifying the contributions of different hands within a manuscript
marg.	margo	Means "margin"; signals a marginal entry in a manuscript
ms.	codex manu scriptus	Means "manuscript"; an alternative abbreviation to *cod.*
mss.	codices manu scripti	Plural of the above
mut.	mutavit	Signals that a word or phrase has been altered
n.	numerus	Means "number"; may be used when citing the number of a line, page, etc.
obsc.	obscurum	Signals that the text is obscure
om.	omisit (omittitur, omissio, etc.)	Signals a textual omission
omn.	omnes	Signals the agreement of all manuscripts on a reading
op. cit.	in opere citato	Means "in the cited work"
p.	pagina *(when preceding a number)*	Means "page," when followed by a page number
p	forma pristina textus (e.g., pA, pG, pV)	When placed before a manuscript *siglum*, signifies the original reading of that manuscript (i.e., before a correction was made)
post.	posterior (etc.)	Means "later"
pr.	prius (primum, etc.)	Means "previous(ly)" (or "first")

ABBREVIATION	EXPANSION	MEANING
praef.	praefatio	Means "preface"
praem.	praemisit	Means "placed before"
pr. man.	prima manus	Means "first hand"; used to signal the work of the original scribe of a manuscript
ras.	rasura	Signals an erasure
rec.	recentior (recentiores)	Means "more recent"; is used to refer to a more recent manuscript or manuscripts
rel.	reliqui	Means "the rest"; used as *cet.* above
rep.	repetivit (repetitio, repetit, etc.)	Signals the repetition of a word or phrase
rest.	restituit (restitutum est, etc.)	Signals the restoration of the original text
rub.	rubrica (rubricator, etc.)	Signals rubricated text
s	secundus status textus (e.g., sA, sG, sV)	Signals the second state of the text of a manuscript (i.e., after a correction has been made)
saep.	saepius	Means "more frequently" or "rather frequently"
scil.	scilicet	Means "namely"
scrips.	scripsimus (scripsi, etc.)	Means "we wrote," "I wrote," etc.
sec.	secundum	Means "according to"
sq.	sequens	Means "following" (singular)
sqq.	sequentes	Means "following" (plural)
subscr.	subscripsit (subscriptus, subscriptio, etc.)	Signals that something is "written underneath" (so can indicate a signature, etc.)
sup.	supra (super, superior, etc.)	Means "above," etc.
suppl.	supplevit	Signals that a word or phrase has been supplied
susp.	suspicatur	Signals an editorial surmise

ABBREVIATION	EXPANSION	MEANING
t.	tomus	Means "volume"; is normally followed by a number to indicate which volume is referred to
tert.	tertium	Means "third"
transp.	transposuit (transpositio, etc.)	Signals a transposition of letters or words
v.	versus	Means "verse" (of a poetic work or of the scriptures)
v.g.	verbi gratia	Means "for example"
vid.	videtur (videas, vide, etc.)	Means "seems"/"is seen" (or "you may see," "see," etc.)
vol.	volumen	Means "volume"; is normally followed by a number to indicate which volume is referred to
Vulg.	Vulgata Sacrae Scripturae interpretatio	Identifies a reference to the text of the Vulgate version of the Bible

MARK	MEANING
[text]	Signals that text within brackets is an interpolation
<text>	Signals that text within angle brackets has been supplied by the editor
⌉ or]	Placed after a lemma (i.e., after the word or phrase of the text that is the subject of the note in the critical apparatus), indicates the agreement of all manuscripts save those specifically listed
. . .	Used to save printing a lemma in full when it consists of several words; for example, if the lemma is *ego in hac lectione devotionem colligo*, it can be indicated in the critical apparatus as *ego . . . colligo*
-	Used to save repeating that part of a lemma that remains the same in the variants; for example, *tempta-vit*⌉ *-verit A, -verint G*

CHAPTER SIX

Punctuation and Abbreviation

PUNCTUATION IN MANUSCRIPTS

The punctuation found in medieval manuscripts differs considerably from modern punctuation. Some medieval punctuation marks resemble modern marks in their appearance but have different values, while other marks have forms unlike those of any modern punctuation. Moreover, methods of punctuation evolved as the Middle Ages progressed, with the result that different marks were used at different times, while the same mark might acquire different values over time. As Malcolm Parkes has stated: "The fundamental principle for interpreting punctuation is that the value and function of each symbol must be assessed in relation to the other symbols in the same immediate context, rather than in relation to a supposed absolute value and function for that symbol when considered in isolation."[1] Thus, the general rules outlined below are merely meant to provide basic guidance to the meaning and value of punctuation marks; scribes were capable of adapting symbols and systems to their own particular usage, and the range of meanings of a set of marks must be established in each context. In addition, in many cases, punctuation may have been added or supplemented after the composition of the original manuscript, sometimes subtly altering the meaning of the text. In such cases, one has to establish the sense both of the original text and of the text as re-punctuated, and to decide whether the additional marks were intended to entirely replace or merely augment any original marks.

It has been well observed that punctuation may serve either as an aid to oral delivery of a text (indicating where the reader should pause) or to help clarify the grammatical structure of sentences (in which case it is of most use to the silent reader) and that in the Middle Ages—unlike the present—punctuation generally served the first of these purposes.[2] The layout of a text could also assist oral de-livery, and one method of "virtual" punctuation used in late antiquity and the early Middle Ages was the system of layout applied by St. Jerome to the text of the Bible and based, as Jerome himself noted, on established practices for copying the speeches of Demosthenes and Cicero. The method, which used no punctuation marks as such, consisted in entering the text on the page *per cola et commata*, that is, laid out sense-unit by sense-unit. In classical usage, the terms *colon* and *comma* originally referred not to marks of punctuation but to rhetorical divisions of a sentence: a *colon* was a major division, a unit in which "the sense was complete but the meaning was not";[3] a *comma* was a lesser division, a portion of the sentence that was followed by a minor disjunction of the sense, where the reader might need to pause for breath. Effectively, layout *per cola et commata* meant that each new clause, or sense-unit, was begun on a new line; if a sense-unit required more than one line, subsequent lines would be indented so that it was always clear where a new sense-unit began. This form of layout was used for numerous biblical manuscripts in the early Middle Ages and can be seen in the specimen of Luxeuil script in chapter 10 (fig. 10-1); the layout is preserved in the standard modern scholarly edition of the Vulgate.[4] Layout *per cola et commata* was not, however, used for other texts in the Middle Ages, and it was eventually abandoned in biblical manuscripts in favor of punctuation marks.

Two different systems of medieval punctuation marks are described below, respectively known to paleographers as punctuation by *distinctiones* and punctuation by *positurae*. (Note that paleographers use these terms with a somewhat different meaning than they had for late antique and early medieval authors, who, as will be seen from the texts by Donatus and Isidore quoted below, could refer to *distinctiones* as *positurae*; for paleographers, the terms refer to two different sets of marks.) The former system developed early and can still be found as late as the twelfth century; the latter first emerged in the late eighth century and con-

1. M. B. Parkes, *Pause and Effect: An Introduction to the History of Punctuation in the West* (Aldershot, U.K., 1992), 2.

2. See the comments by T. J. Brown, "Aspects of Palaeography," in *A Palaeographer's View: The Selected Writings of Julian Brown*, ed. Janet Bately, Michelle P. Brown, and Jane Roberts (London, 1993), 47–91, at 79.

3. Cf. Parkes, *Pause and Effect*, 302, s.v. "colon."

4. Robert Weber, ed., *Biblia sacra iuxta Vulgatam versionem* (Stuttgart, 1969).

tinued in use for much of the Middle Ages, with some later developments that brought adjustments to it.

Punctuation by Distinctiones

In late antiquity, scribes wrote literary texts in *scriptura continua* (also sometimes called *scriptio continua*), that is, without any separation between the words. Moreover, often they did not enter any marks of punctuation on the page. In many cases, punctuation was added by the reader, in particular by the reader who had to recite the text aloud. Such punctuation was often only sporadic, inserted at those points where it was necessary to counteract possible ambiguity (for example, when it was not immediately clear where one word ended and another began). One system of punctuation known in antiquity used a single point (the *punctus*, plural *punctūs*) placed at different heights to indicate pauses of different values. This is the system of *distinctiones*. The system, described by the fourth-century grammarian Donatus, was taken over by early medieval scribes. According to this system, a *punctus* placed low (at the level of the ruled line) signified a pause of lowest value; this was called a *subdistinctio*. A *punctus* placed at midheight, i.e., at the level of the middle of the immediately preceding letter, indicated a pause of medium value; this was called a *media distinctio*. A *punctus* placed high, at the level of the top of the letter, had the strongest value, marking the end of a sentence; this was called a *distinctio*. Donatus described this system in his *Ars grammatica*, book I.6, as follows:

> On marks of punctuation. In all, there are three marks of punctuation or *distinctiones*, which the Greeks call θέσεις. They are the *distinctio*, the *subdistinctio*, and the *media distinctio*. It is a *distinctio* when the whole sentence is completed; for this, we place the *punctus* at the height of the top of the letter. It is a *subdistinctio* when not much of the sentence is left, which remaining portion, while necessarily separate, is to be introduced right away; we place the *punctus* for this at the level of the bottom of the letter. It is a *media distinctio* when almost as much remains of the sentence as we have already spoken, but when it is necessary to pause to take breath; we place the *punctus* for this at the level of the middle of the letter. In reading, the whole sentence is called the *periodus*, of which the parts are *cola* and *commata*.[5]

The *cola* and *commata* to which Donatus here refers are the rhetorical divisions of the sentence described above. The system of punctuation by *distinctiones* was also described in the seventh century by Isidore of Seville in his *Etymologiae* (I.xx.2–5), an encyclopedic text that was widely read in the early Middle Ages and beyond. Although Isidore describes

the marks in a different order than Donatus, he gives them the same names and assigns them the same values:

> On marks of punctuation. A mark of punctuation is a sign for dividing the sense into *cola*, *commata*, and *periodi*; when it is put in its proper place, it shows us the sense of the reading. Such marks are called *positurae* either because they are indicated by points that are placed in position [*positis*], or because the voice is there silent [*deponitur*] for the duration of the *distinctio*. The Greeks call these marks θέσεις, the Latins *positurae*. The first mark is called a *subdistinctio*, and signifies a *comma*. Next comes the *media distinctio*, which signifies a *colon*. The final *distinctio*, which closes the whole sentence, signifies the *periodus*, whose parts, as we have said, are the *colon* and the *comma*. The difference between these is shown by points placed in differing positions. For when, at the beginning of delivery, a sense-unit has not yet been completed, yet it is necessary to draw breath, that makes a *comma*, that is, a minor portion of the sense, and a point is placed at the level of the bottom of the letter; and it is called a *subdistinctio* from the fact that the point is low down, that is, at the base of the letter. But when, as it proceeds, the sentence offers a sense-unit, yet there still remains something to complete the sentence, that is a *colon*, and we mark the midheight of the letter with a point; and we call it a *media distinctio*, because we place the point at the level of the middle of the letter. But when in the course of our delivery we bring the sentence to a full close, that makes a *periodus*, and we place a point at the level of the head of the letter; and it is called a *distinctio*, that is, a division, because it marks off the entire sentence.[6]

Use and Adaptation of the Distinctiones System

Irish and Anglo-Saxon scribes made notable contributions to the use and development of the *distinctiones* system. Following their conversion to Christianity in the fifth and sixth through seventh centuries, respectively, the Irish and the Anglo-Saxons copied Latin texts avidly. Because their native languages were not directly related to Latin, these scribes required more visual cues to understand Latin than did Italian, Spanish, or French scribes. It was Irish scribes who were primarily responsible for the introduction of the practice of word separation, a major contribution to what has been called the "grammar of legibility."[7] Once

5. Latin text in Heinrich Keil, ed., *Probi Donati Servii qui feruntur de arte grammatica libri* (1864; repr., Hildesheim, Ger., 1961), 372.

6. Latin text in W. M. Lindsay, ed., *Isidori Hispalensis episcopi etymologiarum siue originum libri XX*, 2 vols. (Oxford, 1911), 1:xx.

7. See M. B. Parkes, "The Contribution of Insular Scribes of the Seventh and Eighth Centuries to the 'Grammar of Legibility,'" in *Grafia e interpunzione del latino nel medioevo*, ed. A. Maierù (Rome, 1987), 15–29, reprinted in M. B. Parkes, *Scribes, Scripts and Readers: Studies in the Communication, Presentation and Dissemination of Medieval Texts* (London, 1991), 1–18.

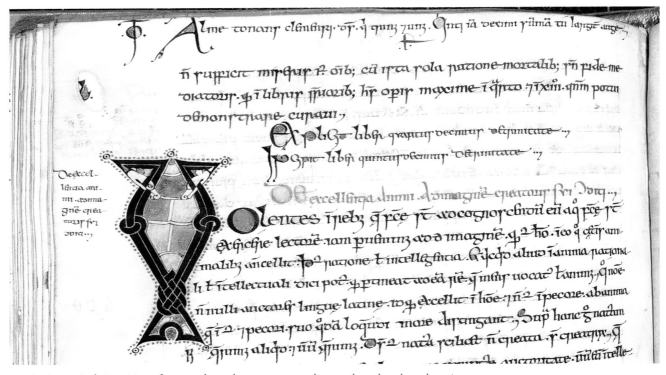

6-1 St. Augustine's *De trinitate*, from an eleventh-century copy that employs the adapted version of *distinctiones*. Cambridge, Corpus Christi College, MS 199, fol. 62v.

word separation became common, later scribes sometimes "updated" earlier manuscripts by placing a *punctus* between words in texts originally written in *scriptura continua*. To further clarify meaning, both Irish and Anglo-Saxons punctuated assiduously, using the *distinctiones* system. A notable (and quite late) use of the system in its basic form, with a single *punctus* placed at differing heights, occurs in the well-known Bury Psalter (Vatican City, Biblioteca Apostolica Vaticana, MS Reg. lat. 12), written in the early eleventh century, probably at Canterbury. There the high point is used at the end of each verse of the Psalms, the midpoint is used to mark the break at the middle of each verse, and the low point is used to mark off minor sense-units within each half of the verse.[8]

Insular scribes also adapted the *distinctiones* system, giving it new forms. The system in its basic form was better suited to a majuscule script such as rustic capitals and uncials in which all or nearly all the letters were of the same height; it was not so suitable for a minuscule script in which several letters had ascenders or descenders, for then the height of the midpoint or top of the letter would vary from one letter to another. To take account of this, some Irish scribes, and following them some Anglo-Saxon and Welsh scribes, chose not to place a single point at different

heights but instead used a differing number of punctuation marks to signify the value of the pause: one mark for a minor pause, two for a medium pause, three for the strongest pause. Normally, when two or three marks were used, they would be aligned horizontally, but sometimes a group of three marks was arranged in triangular formation. The marks most commonly used were the *punctus*, a comma-shaped mark, and a 7-shaped mark. The *punctus* was often used in combination with one of the other marks, as follows: . for the minor pause, ., or ., for the medium pause, and .., or ..., for the major pause. Other favored sequences were: (1) , ,, and ,,, and (2) , ,, and ,,,. This adapted version of the *distinctiones* system was used less by Anglo-Saxon than by Irish and Welsh scribes. A notable, fairly late example of its use occurs in Cambridge, Corpus Christi College, MS 199, a copy of St. Augustine's *De trinitate* made by the Welsh scribe Ieuan ap Sulien at Llanbadarn Fawr in west Wales between 1085 and 1091 (see fig. 6-1).[9]

Punctuation by Positurae

A different system, in which the value of the pause was indicated not by the height of the mark or by the number of marks used but by the form of the mark, first emerged in the Carolingian world in the late eighth century, in a

8. See the reproductions of numerous pages of text from the Bury Psalter in Thomas H. Ohlgren, *Anglo-Saxon Textual Illustration: Photographs of Sixteen Manuscripts with Descriptions and Index* (Kalamazoo, MI, 1992), plates 3.2–3.49.

9. Several other pages of MS 199 are reproduced in Mildred Budny, *Insular, Anglo-Saxon, and Early Anglo-Norman Manuscript Art at Corpus Christi College, Cambridge: An Illustrated Catalogue*, 2 vols. (Kalamazoo, MI, 1997), vol. 2, plates 723–45.

liturgical context. The original function of the new marks was to indicate how the voice should be modulated—whether it should rise or fall when chanting the liturgy in church. Gradually the marks migrated into other contexts: into manuscripts containing texts to be read aloud in the refectory or the monastic chapter-house and then into all types of manuscripts. Paleographers call these marks *positurae*. The four basic marks in this system are as follows:

MARK	NAME	VALUE
.	*punctus*	Indicates a minor pause
∴	*punctus elevatus*	Indicates a major medial pause
⸗	*punctus versus*	Indicates the strongest pause (sentence end)
⸮	*punctus interrogativus*	Indicates a question

The *punctus* used in this system was normally (but not always) placed low, on the baseline. These *positurae*, originating on the Continent and spreading from there, first reached England in the late tenth century, probably under the influence of continental manuscripts imported into England during the Benedictine reform movement initiated by Saints Dunstan, Æthelwold, and Oswald. Figure 6-2 shows an example from an English collection of saints' lives dating from the third quarter of the eleventh century. Once the system had been adopted, it was not uncommon for readers to repunctuate earlier manuscripts by adding strokes to convert the *punctūs* of the *distinctiones* system into *punctūs elevati* and *punctūs versi*. Often such adjustments to the punctuation can be detected by a difference in the color of the ink used for the added strokes. The difference will be clear if one has the opportunity to consult the manuscript itself, or a color photograph, but will not show up in black-and-white reproductions.

A fifth mark was to join the system of *positurae*:

MARK	NAME	VALUE
⸎	*punctus flexus*	Indicates a minor medial pause

The *punctus flexus* (sometimes called *punctus circumflexus*) first occurs in manuscripts of the tenth century, but it enjoyed its period of greatest use in the late eleventh and twelfth centuries (although it was never as widespread as the other marks); it occurs frequently in Cistercian manuscripts of the twelfth century, which tended to be punctuated with great care. It marked a pause of lesser value than that signaled by the *punctus elevatus*, but more important than the minor pause indicated by the simple *punctus*.

The *punctus versus* (⸗) largely disappeared from use in the late eleventh/early twelfth century, when its function was taken over by the simple *punctus*, which from that time forward had two different values, representing both the most minor and the most major pause; its two different values would not have been confused, for when it came at sentence endings, it was followed by a capital letter (see fig. 6-3, where, somewhat unusually, several of the *punctūs* are extended with an upward tick). One reason that the *punctus versus* fell into disfavor could have been that the same symbol was also used as a mark of abbreviation to indicate the suspension of *us* in dative and ablative plural -*bus* endings, of *ue* in enclitic –*que*, and of *ed* in *sed* (see fig. 6-3).

6-2 Punctuation by *positurae*. The marks used include the *punctus elevatus*, the *punctus versus*, and the *punctus interrogativus*. Cambridge, Corpus Christi College, MS 9, fol. 10r.

6-3 Punctuation by *positurae*. This passage includes several examples of the *punctus elevatus* as well as the *punctus interrogativus*. This manuscript does not use the *punctus versus*; the simple *punctus* indicates both the minor pause and the end of a sentence. Newberry Library, MS 12.5, fol. 52r.

Later Medieval Developments

Punctuation by *positurae* continued in use, especially in liturgical manuscripts, until the end of the Middle Ages, although the shapes of the marks underwent some changes. Nonliturgical manuscripts, including vernacular manuscripts, tended to be punctuated less sedulously; indeed, some manuscripts were punctuated by the *punctus* alone, which represented pauses of all values. The most important mark to join the repertory of punctuation in the late Middle Ages was the slash (/), called the *virgula suspensiva*. Quite often scribes used this in conjunction with the *punctus*, with the two marks being used to indicate pauses of different values, and perhaps being used in combination (./) to indicate the pause of strongest value. In late medieval manuscripts it is often advisable to ascertain the value of the punctuation marks by reading the text rather than to approach the text with a preconceived idea of the value of the marks.

Quotation Marks

Medieval scribes evolved a variety of conventions to indicate when a text included a direct quotation from another author.[10] The earliest forms of quotation marks, used already in late antiquity, were entered in the margin rather than within the column of text. The mark most commonly used in early manuscripts was some form of the diple, which originated as a wedge-shaped mark (>) but often degenerated into other forms, of which one of the most common was a comma-shaped mark (,). In most cases, a diple would be entered in the margin alongside each line over which a quotation extended, so the reader could tell from a glance at the margin how long the quotation was; sometimes, the diple entered beside the line

10. On early forms of quotation marks, see Patrick McGurk, "Citation Marks in Early Latin Manuscripts," *Scriptorium* 15 (1961): 3–13.

6-4 Marginal marks are entered alongside the second line of text on this page to indicate the two biblical quotations that occur within the line. Cambridge, Corpus Christi College, MS 199, fol. 18v.

in which the quotation began might be larger than those marking the subsequent lines of the quotation. Insular scribes often used not a single diple next to each line but a combination of one or two dots and a comma-shaped mark (., or ..,), similar to the marks they used for punctuation in their adaptation of the *distinctiones* system. These marginal quotation marks were sometimes written in ink, sometimes in red or some other color. Figure 6-4 shows a late example from the copy of Augustine's *De trinitate* made by the scribe Ieuan ap Sulien toward the end of the eleventh century. Ieuan has here entered two quotation marks (each consisting of two dots and a comma) alongside the second line of the page because the line includes two different scriptural quotations.

Early in the eighth century, the Venerable Bede devised his own method to indicate when, in his theological commentaries, he was quoting from one of the four great Doctors of the Church: identifying each doctor by two letters of the Latin form of his name—*AM* for Ambrose, *AV* for Augustine, *GR* for Gregory, and *HR* for Jerome (Latin *Hieronymus*)—he would place the first of these letters in the margin alongside the beginning of the quotation and the second letter alongside its end. If not during Bede's lifetime, then shortly after his death, scribes at his monastery of Wearmouth-Jarrow used an elegant method to indicate quotations from the scriptures within Bede's commentaries. In addition to entering diples in the margin, they identified the quotation, and demonstrated their reverence for its holy text, by employing a higher grade of script for it: using minuscule for Bede's commentary, they switched to uncial for the scriptural quotations.

From at least the twelfth century,

scribes also developed methods to identify quotations by entering some form of mark *within* the column of text. A notable example of this is provided by the twelfth-century missal that is now Newberry Library MS 7. On many pages of the manuscript, the rubricator has entered pairs of diples above words of direct speech that occur within readings from the Bible. In the example shown (see fig. 6-5), where the reading narrates the raising of Lazarus (John 11:31–39), words spoken by Jesus and by a group of the Jews have been marked in this way.

The Layout and Punctuation of Verse

Scribal conventions for the layout and punctuation of verse were somewhat different from, if influenced by, those for prose. It was already standard practice in antiquity when copying Latin verse to give each poetic line its own line on the page. This practice continued throughout the Middle Ages. From the ninth century, it became common to begin each line of poetry with a capital letter. Often these capitals were placed within the pair of bounding lines marking the left edge of the column of text; as a result, there was usually a small gap between the initial and the other letters of the first word of each line. If the verse text was divided into stanzas, the scribe sometimes left a

6-5 In this twelfth-century missal, the pairs of red diples entered above words indicate passages of direct speech. Newberry Library, MS 7, fol. 42v.

6-6 A typical form of layout for Latin verse. Each line begins with a capital; the punctuation marks ending the individual lines form a column at the right. Newberry Library, MS 21.1, fol. 19v.

line endings, entering the marks on the ruled vertical line that delimits the right edge of the writing area.

In the early medieval period, poetry written in the vernacular languages was usually not laid out in verse lines but had the same layout as prose. In England, for example, where a considerable corpus of poetry has survived from the Anglo-Saxon period, not one Old English poem is copied in verse lines. (As a result, it took antiquarian scholars of the early modern period some time to recognize Old English verse for what it was.) Early vernacular poetry was structured by meter and alliteration rather than by rhyme, and by the early eleventh century, the scribes who copied Old English poems were using punctuation as a way of marking the meter, placing a *punctus* at the end of each poetic half-line; the most noteworthy example of this occurs in Oxford, Bodleian Library, MS Junius 11, which contains vernacular poetic renditions of several biblical texts.[11] Eventually, however, it became standard to copy vernacular poetry in the same way as Latin poetry, with each verse occupying its own line. As rhyme emerged as a major structural element in both Latin and vernacular verse, scribes evolved a variety of conventions to make the rhyming scheme of a poem more apparent to readers. For poems in which the rhyming scheme was AABBCC—that is, in which each pair of lines rhymed—a scribe, instead of writing the rhyming letters at the end of each individual line, might write these letters just once, between and to the right of the two lines, using braces to link the letters to the lines, like this:

$$\left.\begin{array}{l}\text{Ars urbem tr}\\[1ex]\text{Ignis edax r}\end{array}\right\}\text{adit}$$

When the rhyming scheme was more complex, the scribe would often use braces to link the ends of those lines that

line blank between stanzas; and it was normal to begin the new stanza with a larger initial, or else place a paraph mark (¶) to the left of its first line. Figure 6-6 is taken from a thirteenth-century English copy of the *Anticlaudianus*, a lengthy didactic poem by Alain of Lille. Each line begins with an initial letter entered between the ruled bounding lines, and in this manuscript, larger initials with pen-flourished decoration begin sections of Alain's poem; new sections may also be marked by paraphs entered in the left margin. The punctuation marks used in Latin verse were the same as for prose. Often, however, a punctuation mark was placed at the end of every line of verse even when the syntax did not require it; and many scribes preferred to place these punctuation marks at the far right, separated from the end of the last word of the line so that the punctuation formed a column that paralleled the column of initials on the left side of the page. In figure 6-6, the scribe of the *Anticlaudianus* has used *punctūs* and *punctūs elevati* at

11. On the development of pointing in Old English verse, see Katherine O'Brien O'Keeffe, *Visible Song: Transitional Literacy in Old English Verse*, Cambridge Studies in Anglo-Saxon England 4 (Cambridge, 1990). For reproductions of pages from MS Junius 11, see Ohlgren, *Anglo-Saxon Textual Illustration*, plates 16.1–16.51.

rhymed. Figure 10-12 in chapter 10 shows an example of this practice from a fifteenth-century copy of John Lydgate's *The Fall of Princes* in which the rhyming scheme is ABABBCC. Within each stanza, the scribe has used three sets of braces, entered in red pigment, to link together the two A lines, the three B lines, and the two C lines.

ABBREVIATIONS

A basic knowledge of abbreviations is vital to sound paleography. Very common in Latin manuscripts of the Middle Ages, abbreviations occur most densely in late medieval manuscripts intended for study and are most scarce in texts intended to be recited aloud, such as liturgical texts. The forms of abbreviations varied according to place and time. Especially in manuscripts of the early Middle Ages, from the seventh to the tenth century, the forms of the abbreviations employed can provide vital clues to the date and place of origin of a manuscript. Thus it was that the great paleographer Ludwig Traube could write: "Ego cum aetatem codicis sciscitor, statim me ad compendia verto" (When I am inquiring into the date of a manuscript, I immediately turn to the abbreviations).[12]

Abbreviations may be divided into three broad classes: suspensions, contractions, and symbols. In suspensions, one or more letters are omitted at the end of the word. Some suspensions, notably for personal names, consist of one letter only, for example *M.* for *Marcus* or *f.* for *filius*. A subcategory of suspensions is syllabic suspension, in which one or more letters are dropped from the end of each syllable of a word, as in *tm̄* for *tamen*.

In contractions, the abbreviation includes the first and the last letter(s) of the word, and perhaps one or more letters from within the word, while the other letters are omitted; for example, *dr̄* for *dicitur* or *noīe* for *nomine*. A special class of contractions is formed by the *nomina sacra*, that is, names of the Deity and related biblical and religious names and terms. As Ludwig Traube showed, these "holy names" were abbreviated not out of scribal convenience but out of reverence, from the belief that the name of God was ultimately inexpressible;[13] thus it is that in certain manuscripts, the *nomina sacra* may be the only, or almost the only, words to be abbreviated. The habit of contracting the *nomina sacra* first developed in Latin manuscripts under the influence of Greek practice, which itself was influenced by the wish of Greek scribes to reproduce the Jewish reverence for the name of the Deity. Thus Greek $\theta\epsilon\acute{o}\varsigma$ was abbreviated $\overline{\Theta C}$, and similarly in Latin, *deus* became *ds̄*. Some of the Latin *nomina sacra* included Greek characters—for example, *xp̄s*

for *christus*, where the first two characters were the Greek letters *chi* and *rho*. The abbreviation for *iesus* was *iħs*. Here, the *h* represented not the eighth letter of the Roman alphabet but the Greek letter *eta*, for which the capital form was *H*. When Latin scribes abbreviated the name of Jesus in minuscule script, they used the minuscule form of the Roman *H* rather than the minuscule *eta*, but the letter was still supposed to represent the *e* in Jesus's name. The correct expansion of *iħs* is therefore *iesus*; however, by the late Middle Ages, the origin of the abbreviation had been forgotten, with the result that when scribes wrote the name in full, they often erroneously wrote *ihesus*. Some of the *nomina sacra* of Latin manuscripts use the Greek *sigma*, for which one of the capital forms was *C*; again, when the abbreviated word was written in minuscule, scribes used *c*, even though this was not a genuine Greek form. Using *c* to represent *sigma* was an alternative to using the Roman *s*; thus, *iesus christus* might be written as either *iħs xp̄s* or *iħc xp̄c*. Similarly, *spiritus* could be abbreviated as either *sp̄s* or *sp̄c*; and, while the standard abbreviation for *episcopus* was *ep̄s*, *ep̄c* is also found. Other important, frequently occurring contractions of religious and ecclesiastical terms include *dn̄s* for *dominus* and *sc̄s* for *sanctus*. Of course, when any of these words occurred in one of the oblique cases, the last letter of the abbreviation would change accordingly: thus *dm̄* represented accusative *deum*, *dn̄i* represented genitive *domini*, *ep̄o* represented dative or ablative *episcopo*, *sc̄os* represented accusative plural *sanctos*, and so on.

A third class of abbreviations consists of symbols, among which the most frequent include ⁊ for *et*, and a backwards *c* (ɔ) or a symbol resembling an arabic number nine (9) for the prefix *con-*. Some of these abbreviation symbols (such as ⁊) were derived from the shorthand system known as Tironian notes, believed to have been developed by Cicero's secretary, Tiro, to record his master's speeches; others originated in the Roman system of legal shorthand known as *notae iuris*. Some medieval scribes knew a large repertory of Tironian notes and used them for writing instructions or making annotations in the margins of manuscripts; there even survives a handful of psalter manuscripts in which the entire text of the Psalms is written in Tironian notes (the psalter was probably chosen for this purpose because its text was so familiar to Benedictine monks, the entire cycle of the Psalms being recited in the monastic divine office on a weekly basis). Certain abbreviation symbols were especially popular among Insular scribes; these included *h* with a tick attached to the top of the arm of the letter for *autem*; .*H*. for *enim*; ÷ for *est*; and ɘ for *eius*. The ampersand (&) representing *et* actually originated not as a symbol but as a ligature of the letters *e* and *t*; over time it became stylized into the form still used today. An additional type of mark that is occasionally encountered in manuscripts, entered above vowels to show whether or not they should be aspirated, is the equivalent of a Greek rough or smooth breathing. The two marks, called by Latin grammarians

12. Ludwig Traube, *Hieronymi chronicorum codicis Floriacensis fragmenta Leidensia, Parisina, Vaticana phototypice edita* (Leiden, Neth., 1902), vii.

13. See Ludwig Traube, *Nomina sacra: Versuch einer Geschichte der christlichen Kürzung* (Munich, 1907). While Traube's views have been subsequently refined, his study remains a classic.

dasia and *psile*, respectively consist of the left and right halves of a capital *H*, with the left half (*dasia*) indicating that the vowel should be aspirated; for example, if a scribe wrote *ibernia* with this symbol entered above the first *i*, it would indicate that the word should be pronounced *hibernia*.

In both suspensions and contractions, the scribe entered some sign to indicate that letters had been omitted. The most commonly used sign was a horizontal line (which paleographers often call a *macron*) entered above a letter; this line was usually more or less straight, but in some manuscripts (notably English manuscripts of the twelfth century) it developed a curved, "cupped" form, while in Gothic manuscripts it often has a tick at either end. A basic use of this mark was above a vowel at the end of a word to indicate the omission of a final *m* (or, more rarely, an *n*)—for example, *tū* for *tum*. The line could also indicate the suspension of a full syllable at the end of a word, as in *tām* for *tamen*. It was frequently used in this way for suspended verb endings—as in *dic̄* for present tense *dicit* or *dix̄* for perfect tense *dixit*—and also for the suspension of the endings of adjectives formed from place names, such as *londineñ* for *londinensis* (and the various inflections thereof). In these cases where the macron replaces a syllable, the reader must be able to work out the word intended if the abbreviation is to be expanded correctly. The macron was also used within words, where it might again indicate the omission of an *m* or *n* (or both), as in *nāque* for *namque*, *oīa* for *omnia*, or *noīe* for *nomine* (note that in this latter case, the omitted letters are not consecutive); or it might indicate the suspension of an internal syllable, as in *ūba* for *uerba*. If the letters omitted came before or after (or before and after) a letter with an ascender, the macron would be entered on the page so that it either extended to the right of the ascender or cut through the ascender horizontally or on the diagonal, as in *ecc̄ia* for *ecclesia* or *euḡlm* for *euangelium*.

Two of the most commonly occurring suspensions, known in antiquity and persisting throughout the Middle Ages, involved the omission of the letters *us* in dative and ablative plural *–bus* endings and of *ue* in the enclitic *-que*. In both cases, the letters were replaced by a mark resembling a modern semicolon or colon (see *quisque* and *motibus* in the table at the end of this chapter) or by one resembling an arabic numeral 3 (see *hominibus* in the table). The latter mark was also used in certain commonly occurring words to replace an entire sequence of letters of which the last two were *et*, as in *l3* for *licet* and *o3* for *oportet*. The modern *viz.* for *videlicet* preserves such an abbreviation, which in its original form used, not a *z*, but the 3-shaped mark. A mark resembling a number 9, entered above the line at the end of a word, signified the suspension of *us* in verb endings and second or fourth declension nominative noun endings, for example *dicim⁹* for *dicimus* and *man⁹* for *manus*. The passive verbal ending *–ur* was regularly suspended, being replaced by a looped mark entered above the last letter written; the loop at first resembled an arabic number 2 but

later developed into a tilde-like mark with a closed loop at its left end (see the abbreviation for *impeditur* in the table). For much of the Middle Ages, the genitive plural ending *–orum* was abbreviated with a suspension in which the *o* was followed by a special form of the letter *r* resembling a 2, with a diagonal slash through the foot of the *r* (see *signorum* in the table). This special form of *r* came to be used for unabbreviated forms also, whenever *r* followed *o*, and even, in many Gothic manuscripts, whenever *r* followed the bowed letters *b* and *p*.

Other common abbreviations incorporated a vowel written in superscript above a consonant. This method served for certain frequently occurring adverbs, such as *g̊* for *ergo*, *ǵ* for *igitur*, *m̊* for *modo*, and *ů* for *uero*. It also indicated the omission of *u* after *q* and of *r* following a *t* or *p*: thus *q̊ndo* for *quando*, *q̊* for *quo*, *q̊sq̊s* for *quisquis*, *por* for *prior*, *insire* for *transire*, *ibuendo* for *tribuendo*, and so on (see also *detrimentum* in the table). Note that when *a* was written in superscript, the bow of the *a* was normally left open (so that it resembles, and can be mistaken for, a *u*; see, for example, *quam*, *quando*, and *transire* in the table).

Of course, a single word, particularly a long one, could include more than one abbreviation: see, for example, the abbreviations for *animalis* and *hominibus* in the table. Abbreviations are especially dense and complex in scholastic and legal manuscripts of the thirteenth to fifteenth centuries, making these manuscripts extremely difficult to read, even for practiced manuscript scholars. Anyone attempting to read a heavily abbreviated manuscript will be well advised to have on hand a copy of Cappelli's *Dizionario di abbreviature*, which contains the most comprehensive compilation of abbreviations obtainable in print; an English translation of Cappelli's introduction is available.[14] Also now available is the important computer program, *Abbreviationes*, designed by Olaf Pluta of Ruhr-Universität Bochum.[15] The table provided here offers no more than a guide to some of the most frequently occurring abbreviations in Latin manuscripts. The examples are largely taken from Newberry Library MSS 12.1–12.7, a set of seven manuscripts containing works by Augustine and others made by scribes working at St. Mary's Abbey, Reading, in the second and third quarters of the twelfth century. The table opens with abbreviations that consist of or open with symbols. Thereafter, for ease of reference, the listing is alphabetical according to the order in which letters (not including any superscript letters) occur in the abbreviated, as opposed to the expanded, form of the words; thus *aīa* for *anima* is listed before *atta* for *alleluia*, even though the expanded words would be listed the other way around. Some

14. Adriano Cappelli, *The Elements of Abbreviation in Medieval Latin Paleography*, trans. David Heimann and Richard Kay (Lawrence, KS, 1982).

15. Information about *Abbreviationes* is available at http://www.ruhr-uni-bochum.de/philosophy/projects/abbrev.htm.

words are shown in more than one inflection, and readers should remember that the last letter(s) of an abbreviated noun or adjective will of course depend upon the case in which the word appears in any given context. A dash (-) preceding or following an expansion in the table indicates that the letters shown occur as part of a word rather than standing alone. As described in the previous chapter, when abbreviations are expanded in a transcription, parentheses should be placed around all letters supplied to complete the word; note, though, that an alternative practice often used in print is to print any supplied letters in italic font, without parentheses.

Appended to the table of abbreviations is a table showing the forms that arabic numerals typically have in medieval manuscripts. Arabic numerals first became known in Spain in the tenth century, began to spread in Western Europe in the twelfth century, and became common from the fourteenth century.[16] Special attention should be paid to the numerals 4, 5, and 7; only from the late fifteenth century did those three numerals assume forms more similar to those they have today. Roman numerals, both cardinal and ordinal, were of course represented by letters: *i* for *unus/primus* (one/first); *u* or *v* for *quinque/quintus* (five/fifth); *x* for *decem/decimus* (ten/tenth); *l* for *quinquaginta/quinquagesimus* (fifty/fiftieth); *c* for *centum/centesimus* (one hundred/hundredth); *d* for *quingenti/quingentesimus* (five hundred/five hundredth); and *m* for *mille/millesimus* (one thousand/thousandth). Note that *u* rather than *v* was used for the number 5 for much of the Middle Ages, and that when a number includes more than one *i*, the last *i* may be written as a *j*; thus *uiij* for eight and so on. Four was often rendered as *iiii* rather than *iv* and nine as *viiii* or *uiiii* rather than *ix*. To mark off roman numerals from surrounding text, scribes commonly placed a point to either side of the numeral (for example, *post .xxxii. dies*). Points might also be used to separate decimal groupings (thousands from hundreds, hundreds from tens; for example, *m.ccc.xxii*). The ordinal number often has its inflected ending written in superscript: *m°* for *millesimo*, *c°* for *centesimo*, and so on. Dates are commonly given in the form *anno m° cccc° xxx° vi°*, that is, *anno millesimo quadringentesimo trigesimo sexto* (in the one thousandth four hundredth and thirty-sixth year, i.e., in 1436).

ꝯ	(con)-
ꝯtra	(con)tra
∻	(est)
⁊	(et)
⁊	(et)

16. See G. F. Hill, *The Development of Arabic Numerals in Europe Exhibited in Sixty-Four Tables* (Oxford, 1915).

ꝯ	-(us)
aĩa	a(n)i(m)a
aĩaɫ	a(n)i(m)al(is)
alƚa	all(elui)a
apd̄	ap(u)d
apl̃o	ap(osto)lo
apl̃s	ap(osto)l(u)s
aū	au(tem)
autͤ	aut(em)
b;	–b(us)
bn̄ facis	b(e)n(e)facis
c̄	c(on)-/c(om)-
corꝑa	corp(or)a
creatͣ	creat(ur)a
cū	cu(m)
dd̃	d(aui)d
det̃m̃tu	det(r)im(en)tu(m)
d̃i	d(e)i
dic̄	dic(it)
dm̃	d(eu)m
dnm̃	d(omi)n(u)m
dn̄s	d(omi)n(u)s
d̃o	d(e)o
documͭs	docum(en)tis
dr̃	d(icitu)r
d̃s	d(eu)s
ē	e(st)
ęcclͣs	ęccl(esi)as
ęcclͣsticū	ęccl(esi)asticu(m)
ēe	e(ss)e
ẽet	e(ss)e(n)t
ei⁹	ei(us)
enī	eni(m)

coʒ	eor(um)
epc̄	ep(iscopus)
eptā	ep(isto)la
ętr̄io	ęt(er)no
euǵlm̄	eu(an)g(e)l(iu)m
frēm	fr(atr)em
frs̄	fr(atre)s
g̊	ig(itur)
g̊	(er)go
gg̊	g(re)g(orius)
glā	gl(ori)a
grā	gr(ati)a
ħo	h(om)o
ħōibʒ	ho(min)ib(us)
ħōif	ho(min)is
idŏ	id(e)o
iertm̄	ier(usa)l(e)m
iħc	i(esus)
iħs	i(esu)s
iħf	i(esu)s
iħu	i(es)u
impeda̋	impedit(ur)
int̄	int(er)
ioħēm	ioh(ann)em
ioħf	Ioh(anne)s
ipi	ip(s)i
ifr̄l	isr(ae)l
ŧ	(ue)l
m̄	-m(en)
m̊	m(ih)i
m̊	m(od)o
motibʒ	motib(us)
mś	m(eu)s
N	N(omen)
ñ	n(on)
ṅ	n(is)i
ñc̄	n(un)c
nóia	no(m)i(n)a
nõie	no(m)i(n)e
nr̊	n(oste)r
nr̃a	n(ost)ra
nr̃am	n(ost)ram
nr̄if	n(ost)ris
nr̊o	n(ost)ro
oĩa	o(mn)ia
om̃s	om(ni)s / om(ne)s
oʒ	-or(um)
ꝑ	p(er), *but within a word can also* *represent –p(ar)– and –p(or)–*
ꝑ̊	p(ost)
p̌	p(rae)
ꝑ	p(ro)
ṗ	p(r)i-
ꝑ̄	p(os)t
ṗmū	p(r)imu(m)
popti	pop(u)li
pꝑħ̄a	p(ro)ph(et)a
ꝑpħaf	p(ro)ph(et)as
cꝑp̄	p(ro)pt(er)
ꝑpu̇	p(ro)p(r)iu(m)
ṗr	p(ate)r
prħŧ	pr(es)b(y)t(er)
prīf	p(at)ris

q́	q(uae)	t̆	t(er)-/-t(er)
q;	-q(ue)	t̆	-t(ur)
ꝗ	q(uia)	t̆	t(r)a-
q̈	q(u)a	ṫ	t(ib)i
q̈	q(u)a(m)	tã	tam(en)
q̈	q(u)ę	t̃uxim	t(r)aduxim(us)
q̇	q(u)i	t̃n	t(ame)n
q̊	q(u)o	t̃nſire	t(r)ansire
qẟ	q(uo)d	tꝑ̃	t(em)p(o)r(e)
q́ẟ	q(u)id	tꝑ̃ale	t(em)p(o)rale(m)
qm̃	q(uonia)m		
q̊m̃	q(u)am	ů	u(er)o
q̊m̃	q(u)om(od)o	ůba	u(er)ba
q̃nꝺo	q(u)ando	ur̃	u(este)r
q̃ntu	q(u)antu(m)	ur̃a	u(est)ra
q̊q;	q(u)oq(ue)	uſq;	usq(ue)
q̃ſı	q(u)asi	utꝛ	utr(um)
q́ſq;	q(u)isq(ue)		
quoꝛ	quor(um)	x̃	(christ)i
		xꝑ́c	(christus)
ſ;	s(ed)	xꝑ́ıanı	(christ)iani
ſacrãta	sacram(en)ta		
ſcdm̃	s(e)c(un)d(u)m		
ſã	s(an)c(t)i	J	1
ſclã	s(ae)c(u)la	2	2
ſclı	s(ae)c(u)li	ʒ	3
ſclo	s(ae)c(u)lo	ꝛ	4
ſcptã	sc(r)ipt(ur)a	ꝗ	5
ſcĩ	s(an)c(tu)s	Ꝿ	6
ſẽꝑ	se(m)p(er)	Λ	7
Sic	Sic(ut)	8	8
ſignoꝛ	signor(um)	ꝯ	9
ſꝑ́c	sp(iritus)	Jo	10
ſp̄u	sp(irit)u		
ſt̆	s(un)t		
ſup	sup(er)		

CHAPTER SEVEN

Encounters with Damaged Manuscripts

THE RESEARCHER who works on medieval manuscripts quite frequently comes upon codices that have experienced damage of one kind or another. There are many ways in which manuscripts can become damaged, and it often requires a certain amount of ingenuity for a scholar to overcome the effects of the damage and obtain an accurate reading of a text. Ironically, however, a damaged manuscript may contain more useful information than a well-preserved one. Damage can provide important evidence about the history of a book, including its provenance and the type of use to which it was put. Fire damage, for example, may help to tie the ownership of a manuscript to an institution known to have suffered a library fire, and, as Nicholas Pickwood has pointed out, may be crucial in helping to determine if and when additions were made to the volume, in cases where some leaves are damaged and others are not.[1] This chapter will provide a preliminary exploration of the types of damage manuscripts may suffer, consider the evidence such damage may reveal about the history of a codex, and suggest some techniques for reading damaged manuscripts where visual examination is possible. Preservation of the manuscript from further deterioration is, of course, paramount, even over the need to read the text.

Medieval manuscripts that are well constructed and have been properly cared for are often in better condition than many nineteenth-century printed books. Parchment and early paper are durable and stable media, and medieval binding materials have generally done a very good job in protecting the internal pages of the books they once covered (and in some cases continue to cover, where there has been no subsequent rebinding). Nevertheless, most manuscripts exhibit some wear and tear, along with the gradual changes resulting from the aging of the materials used to construct them. Where damage is severe because of faulty construction, defective materials, or some catastrophe in the history of the book, especially gentle handling may be required, and the manuscript may present grave challenges

to the reader. For the purposes of this chapter, we divide manuscript damage into two categories: unintentional (where the damage is the result of defects in construction or accident) and intentional (where the damage has been inflicted for specific purposes). On the one hand, unintentional damage can be the result variously of environmental or human factors. In some cases, "acts of God" such as fire or flood have disfigured manuscripts, but more commonly, environmental damage has arisen from storage in damp or otherwise unsuitable conditions or from exposure to attack by insects or rodents: woodworm, mice, or mold may touch even the most prized and well-cared-for of books. Human factors include the well-meaning work of book owners and conservators whose efforts to preserve or read a manuscript have caused lasting damage. The most common types of damage in this category have been caused by rebinding, which has frequently resulted in the removal of important historical evidence from a book. Other types of unintentional damage include that caused by the effects of the use of chemical reagents to bring out faded texts and the employment of irreversible methods of conservation to preserve failing materials. Sometimes the book's manufacture itself led to decay; for example, inks that were too acidic could eat through the parchment, and improperly mixed pigments could result in poor membrane adhesion and lead to flaking or peeling and the friability of the medium (that is, its tendency to crumble into powder). In addition, the normal usage of books (particularly heavily used liturgical books) could lead to their acquisition of disfiguring marks such as dirty fingerprints, liquid and food stains, or blobs of candle wax.

Examples of intentional damage, on the other hand, include the erasure of text either so that the parchment might be reused for another text, as in a palimpsest, or to render the text ideologically "correct," as when a manuscript was censored, or to alter the appearance of a manuscript for sale. Sometimes manuscripts were intentionally dismembered by medieval or later binders who used the parchment as binding material in other books. In both medieval and modern times, precious illuminations and historiated initials might be cut out by unscrupulous users or by thieves. Sadly, some of the most destructive and

1. Nicholas Pickwood, "Determining How Best to Conserve Books in Special Collections," *The Book and Paper Group Annual* 13 (1994): 35–41, at 37.

permanent types of damage have resulted from attempts in modern times to increase the market value of a book, leaf, or fragment (often appropriately called a "cutting"); unprincipled book dealers have frequently opted to dismember manuscripts in order to sell the individual leaves separately. Dismembering manuscripts and reassembling the parts in personal scrapbooks or collages were common practices in the nineteenth century. A contrasting practice that also adversely affected manuscripts involved not the removal but the addition of material: owners might add their own decoration where it was lacking in the original, as has happened in Newberry Library MS 98.5, a fifteenth-century Italian copy of Lucan's *Pharsalia* to which late-nineteenth-century pseudo-Gothic decorative elements have been added throughout (fig. 7-1). In such "hybrid" manuscripts, the color and style of the additions clash noticeably with the original decoration, making the additions easy to spot.

UNINTENTIONAL DAMAGE

Use, Misuse, and Abuse

The most obvious unintentional damage comes from the common use and misuse of manuscripts. As early as the fourteenth century, the bibliophile Richard de Bury lamented the many malpractices of his contemporaries in their treatment of books:

7-1 A fifteenth-century Italian manuscript of Lucan's *Pharsalia* with added nineteenth-century ornamentation in a pseudo-Gothic style. Newberry Library, MS 98.5, fol. 1r.

You may happen to see some headstrong youth lazily lounging over his studies, and when the winter's frost is sharp, his nose running from the nipping cold drips down, nor does he think of wiping it with his pocket-handkerchief until he has bedewed the book before him with the ugly moisture. Would that he had before him no book, but a cobbler's apron! His nails are stuffed with fetid filth as black as jet, with which he marks any passage that pleases him. He distributes a multitude of straws, which he inserts to stick out in different places, so that the mark may remind him of what his memory cannot retain. These straws, because the book has no stomach to digest them, and no one takes them out, first distend the book from its wonted closing, and at length, being carelessly abandoned to oblivion, go to decay. He does not fear to eat fruit or cheese over an open book, or carelessly to carry a cup to and from his mouth; and because he has no bag at hand he drops into books the fragments that are left. Continually chattering, he is never weary of disputing with his companions, and while he alleges a crowd of senseless arguments, he wets the book lying half open in his lap with sputter-

ing showers. Aye, and then hastily folding his arms he leans forward on the book, and by a brief spell of study invites a prolonged nap; and then, by way of mending the wrinkles, he folds back the margin of the leaves, to the no small injury of the book.[2]

While certainly hyperbolic, Richard's complaint points out many of the abuses books have suffered at the hands of their users, both medieval and modern. Although modern users should do everything possible to avoid damaging a manuscript (washing hands before handling the manuscript, using only acid-free archival bookmarks, never eating or drinking near a manuscript, and certainly never sleeping on one), historical damage can be helpful in documenting the use a manuscript may have seen. For example, if a book of miracles kept at a shrine shows fingerprints, wax drippings, and water damage, one might assume that this was

2. Richard de Bury, *Philobiblon*, trans. E. C. Thomas (Oxford, 1960), 157.

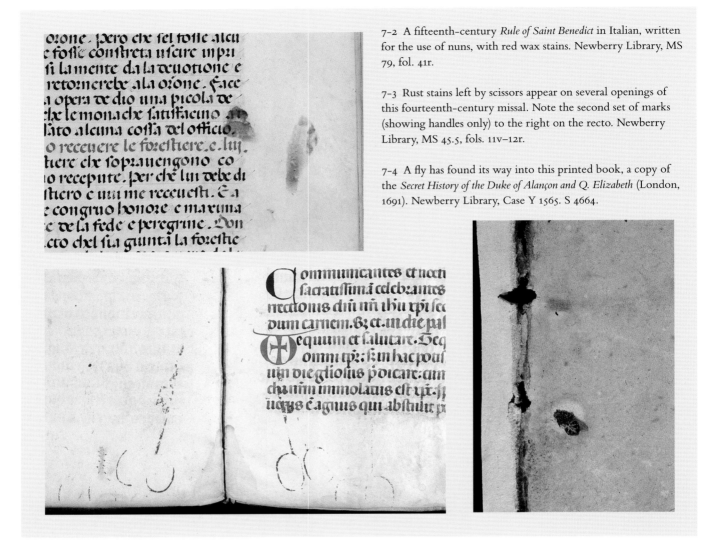

7-2 A fifteenth-century *Rule of Saint Benedict* in Italian, written for the use of nuns, with red wax stains. Newberry Library, MS 79, fol. 41r.

7-3 Rust stains left by scissors appear on several openings of this fourteenth-century missal. Note the second set of marks (showing handles only) to the right on the recto. Newberry Library, MS 45.5, fols. 11v–12r.

7-4 A fly has found its way into this printed book, a copy of the *Secret History of the Duke of Alançon and Q. Elizabeth* (London, 1691). Newberry Library, Case Y 1565. S 4664.

a copy that was frequently consulted and may have been kept in a location easily accessible to the shrine. A pristine copy of the same book might indicate an archival copy kept from the hands of daily users. Drops of candle wax may quite frequently be found in manuscripts. Newberry Library MS 79, a fifteenth-century vernacular Italian copy of the *Rule of St. Benedict* written for a community of nuns, has numerous uncolored and red wax stains on its pages, attesting to the reading of the manuscript by candlelight, either by individual nuns or in a group setting (fig. 7-2). All manner of materials has been found in manuscripts, including organic matter (flowers, leaves, insects) and stains left by food or drink. One Newberry manuscript has several openings where the rust stains from a pair of scissors can clearly be seen (fig. 7-3). Why someone would have kept scissors in a book is an open question; the fact that the

same stains appear on at least three openings indicates that it was not a chance occurrence. Another Newberry book has an insect that has been squashed between the pages (see fig. 7-4).[3] The famous *Exeter Book of Old English Poetry* (Exeter Cathedral Library, MS 3501) has round liquid stains on one of its leaves, perhaps the result of someone having set down a beer mug on the manuscript; a series of scores on the same leaf suggests that the codex may also have seen use as a cutting board.[4]

Damage by Insects and Rodents

Damage inflicted by insects is especially common in both manuscripts and early printed books. In the case of parchment manuscripts, some of this damage even preceded the production of the manuscript, the result of wounds inflicted by insects on the skin of the live ani-

3. *Secret History of the Duke of Alançon and Q. Elizabeth* (London, 1691), Newberry Case Y 1565. S 4664.

4. See Kevin Crossley-Holland, trans., *The Exeter Book Riddles*, rev. ed. (London, 1993), xii. Cambridge, Corpus Christi College, MS 173, pt. II, an eighth-century English copy of

Sedulius's *Paschale carmen*, presents another case of a manuscript apparently marked by a beer mug; see R. I. Page, "The Conservator and the Scholar," in *Conservation and Preservation in Small Libraries*, ed. Nicholas Hadgraft and Katherine Swift (Cambridge, 1994), 15–19, at 15.

7-5 Pages from Martinus Polonus, *Sermones de tempore et de sanctis* (Germany, 1433), illustrating the damage woodworms have visited on this manuscript, as seen (a) within the manuscript and (b) from the fore-edge. Newberry Library, MS 141.

mal (see above, figs. 1-19 through 1-22). Once books were complete, they could become subject to the depredations of woodworms—actually larvae, usually of moths or beetles—which commonly eat through covers, binding materials, and the parchment itself (see fig. 7-5). Books have always been affected by this type of damage: in classical times, Horace referred to it in his poetry, and in eleventh-century Wales, the scholar Rhigyfarch, author of a *Life of St. David*, lamented how many of his source materials had been exposed to the "incessant voracity" of woodworms.[5] Except in extreme cases, this type of damage does not interfere significantly with the book's legibility. Woodworm holes can be helpful in identifying materials that have been added to manuscripts, particularly endleaves. For example, if the first and last leaves of text in a manuscript display woodworm holes, but the same patterns of holes do not occur on the endleaves placed between the text and the binding, then the endleaves must be a later addition. Wormholes can also help establish that what is now a single manuscript originally consisted of separate parts, as where the first or last leaves of those parts have their own patterns of wormholes not shared by adjacent leaves belonging to the other parts.

Another type of insect attracted to paper is the silverfish species. Rather than bore through the manuscript, silverfish "graze" along the page, often obscuring text before eating through the paper entirely (see fig. 7-6). Cockroaches may also nest in books, attracted by paste and glue. Former cockroach infestation is readily identified by their dark liquid excrement, which leaves a stain upon the page (see fig. 7-7). Sometimes a book provides a convenient place to spin a cocoon; in the case of the two books shown in figure 7-8, the cocoons have inflicted no discernible damage.

5. Horace, *Epistulae*, 1.20.12, in H. Rushton Fairclough, trans., *Horace: Satires, Epistles and Ars Poetica* (London, 1926), 388; J. W. James, ed., *Rhigyfarch's Life of St David* (Cardiff, 1967), 27.

Because most insect damage was sustained before books came into modern repositories, what the researcher normally encounters are the effects of past infestation. For manuscripts displaying signs of present infestation, two methods of extermination are currently practiced: fumigation of books with a substance toxic to insects (although such fumigation can lead to further damage) and deep freezing at −20°F for seventy-two hours. Deep freezing has been practiced since 1977 at the Beinecke Rare Book and Manuscript Library of Yale University (and occasionally at the Newberry Library), both to combat present infestation and as a prophylactic measure. This method leaves no toxic residue that might harm library staff or readers and appears to have no negative impact upon the book.

A perennial problem in the medieval and early modern periods, when conditions of storage often left much to be desired, was the exposure of books to attacks by rodents. Rats and mice find books quite tasty and will nibble at any part of the parchment or paper that is exposed. Typically, this means the edges of leaves, but sometimes the damage can reach spectacular proportions, as in an eleventh-century copy of Boethius's *De consolatione philosophiae* at Corpus Christi College, Cambridge (MS 214), where rodents have devoured entire margins and have eaten into parts of the text. Rodent damage is detected by the teeth marks left behind, usually in a group of consecutive leaves (see fig. 7-9). Sometimes the damage can be approximately dated, as in Corpus Christi College MS 94, an early-twelfth-century copy of the *Panormia* of Ivo of Chartres, where rodents have nibbled through a marginal annotation by Archbishop Matthew Parker; the damage must therefore postdate Parker's acquisition of the manuscript in the 1560s or early 1570s, and probably occurred after Corpus Christi College obtained the manuscript following Parker's death in 1575, for similar damage occurs in other manuscripts known to have been stored close to this one in the college library. Little can be done to counteract rodent damage, but where the effects are severe, as in

7-6 *(top)* In this modern printed book, silverfish have eaten their way through the paper page.

7-7 *(top, right)* Cockroach feces have discolored sections of this book.

7-8 The bottom edges of these books have provided an ideal location for larvae to form cocoons. While the cocoons themselves do not present much danger to the books, there is concern about further infestation.

7-9 *(below)* Rodents have eaten through the paper pages of this book, leaving teeth and claw marks that make such damage easily recognizable. Newberry Library, Case +K 335.068 v.1.

7-10 *(right)* The scribe Hildebert cursing the mouse that is stealing his cheese. Prague Cathedral, Chapter Library, MS A.XXI/I, fol. 153r.

the copy of Boethius mentioned above, the leaves may be protected from further deterioration around the edges by mounting them in paper or parchment frames.

Mice or rats could also intervene in unwanted ways in the process of manuscript production, as is graphically illustrated in a mid-twelfth-century copy of St. Augustine's *De civitate Dei* now in Prague (fig. 7-10). Here the scribe Hildebert attempts to stone a mouse that is disturbing his labors by devoting its attention to his lunch: the mouse nibbles at a piece of cheese and has knocked a cooked chicken from Hildebert's dining table. Inscribed on the book on Hildebert's lectern is the curse that he directs at the unwanted intruder: "Pessime mus, sepius me prouocas ad iram; ut te deus perdat" (You worst of mice, too often do you rouse me to anger; may God destroy you).

Fire and Water Damage

Medieval towns and their churches were notoriously subject to damage and destruction by fire. Historical chronicles abound in references to conflagrations that varied greatly in the degree of devastation they inflicted. There can be no doubt that fire produced the wholesale destruction of large numbers of medieval manuscripts of which not a trace now survives. Fires that impacted upon library holdings were, however, by no means restricted to the medieval period. Probably the best known of all library fires is the one that broke out on the night of 23 October 1731 at Ashburnham House in London, which at the time was the repository of Sir Robert Cotton's great collection. While large numbers of the Cotton manuscripts were fortunate enough to escape damage of any kind, thirteen were destroyed outright and many others suffered in ways ranging from the mere singeing of the outer edges of leaves to the reduction of leaves to scraps of burned parchment (see fig. 7-11 for an example of a badly burned leaf). Several manuscripts emerged from the fire with their leaves shrunken and stuck together at the edges as a result of the heat's having drawn out the gluten in the parchment; such manuscripts were referred to as "crusts" by those who saw them before their eventual restoration, and one manuscript in this condi-

tion has been deliberately left unrestored as a testimony to the effects of the fire.[6] Among the manuscripts most severely damaged was the magnificent fifth-century Cotton Genesis, an illustrated copy of the Greek text of the first book of the Bible, which was reduced to a pile of fragments; fellow sufferers included the unique surviving copy of *Beowulf* and the bull by which Pope Leo X had granted Henry VIII the title "Defender of the Faith." The fire had a severe impact on the legibility of the text of many manuscripts, as can be seen from figure 7-11. One interesting aspect of the damage is that the fire seems in general to have attacked the outer leaves of quires more heavily than leaves within quires; this suggests that as the books tumbled from the burning shelves, the quires fanned apart from one another, exposing the outer leaves to the flames.

Following the Ashburnham House fire, the damaged manuscripts were put into storage for decades until curators at the British Museum (which had acquired the Cotton collection in the 1750s) at last took measures to restore them as best they could. The story of the restoration—a process that itself extended over several decades and in some cases still continues today—is one of the most remarkable episodes in the history of bibliography.[7] Beginning in the 1820s, badly damaged manuscripts were treated by being immersed in a solution of spirits of zinc and water, a process that enabled the leaves to be separated from one another and then flattened out. In the early years of this treatment, the restorers found it necessary to make incisions at the edges of the leaves to help flatten them; such incisions may be seen in figure 7-11. The leaves so treated were then stored loose in boxes and made available to readers.

7-11 A leaf from a Cotton manuscript badly damaged in the Ashburnham House fire in 1731. London, British Library, Cotton MS Otho A. vi, fol. 75r.

6. This manuscript is in fact not from the Cottonian collection but is MS Royal 9 C. x in the British Library. At the time of the Ashburnham House fire, the Royal and Cottonian manuscripts were stored together in the same building; some of the Royal manuscripts also suffered in the fire.

7. See the brilliant account of the restoration by Andrew Prescott, "'Their Present Miserable State of Cremation': The Restoration of the Cotton Library," in *Sir Robert Cotton as Collector: Essays on an Early Stuart Courtier and His Legacy*, ed. C. J. Wright (London, 1997), 391–454.

This, however, left them liable to further damage around the edges when handled; several manuscripts have as a result lost letters or complete words from the ends of lines. In the 1840s a method was devised that would stabilize the condition of the fragments and make it possible for scholars to be given access to them without the risk of further damage: each fragmentary leaf of a damaged manuscript was inlaid in a frame of heavy paper, and then the frames were bound up as a book. The frame was made by laying the parchment fragment on a paper leaf and tracing the contour of the fragment onto the paper in pencil. Then a cut was made just inside the pencil outline, following its contour and leaving in the middle of the paper a hole in the shape of the fragment but very slightly smaller than it. Paste was applied to the very edge of the frame thus created, and the fragment was then pressed into place; additionally, strips of a transparent adhesive membrane resembling Scotch tape were laid over the edge of the fragment to assist in holding it in place.[8] This method protected the edges of the fragment from damage and left the text of one side of the fragment entirely visible, with just the very edge of the other side covered by the edge of the paper frame. Revolutionary and remarkably successful in its time, this method of inlaying has, however, produced its own problems, for the paper frames and the parchment fragments have responded to ambient environmental conditions in differing ways. Because in many cases the frames have severely cockled and begun to pull away from the parchment inserts, further conservation must now be contemplated.

Manuscripts gravely damaged by fire can present major challenges to the scholar seeking to recover their text. Examination under ultraviolet light can help in some but not all cases, as can shining fiber-optic light from behind the page (in the case of restored Cotton manuscripts, this will render legible letters covered by the paper frames just described). Especially exciting are possibilities that have emerged as a result of recent technological advances. These include the use of digital photography to produce images of damaged pages that may then be electronically manipulated in ways that enhance the legibility of the text while suppressing background interference. Researchers should also inquire from library staff whether there might be any transcripts made before a manuscript suffered damage from fire. A full transcript exists of the damaged copy of the Old English translation of Boethius's *Consolation of Philosophy* shown in figure 7-11; this transcript was made in the mid-seventeenth century by the great Dutch philologist Franciscus Junius. Similarly, about twenty years be-

fore the Cotton fire, David Casley, the librarian then in charge of the Cotton collection, made a transcript of the Anglo-Saxon heroic poem *The Battle of Maldon*, the original version of which was in MS Cotton Otho A. xii and has been entirely destroyed by fire. Early modern scholars often made transcripts of texts of interest to them; in an age before photography, this was the only way in which they could have their own copies of such texts. These transcripts can be of crucial importance in enabling present-day scholars to reconstruct the original state of a damaged manuscript.

Water damage often goes hand in hand with fire damage, for manuscripts have frequently been exposed to the water used to extinguish fires. In the case of the Ashburnham House disaster, the antiquarian Thomas Hearne commented, "[W]hat the fire did not entirely destroy suffer'd very much by water."[9] More typically, however, manuscripts have suffered water damage as a result of defective conditions of storage: leaking ceilings, flooded floors, broken windows, and the like. Occasionally, manuscripts have been accidentally submerged in water. A poem entered in the eleventh-century Gospels of St. Margaret of

7-12 A severely liquid-damaged manuscript of John Lydgate's *The Fall of Princes*, written in England around 1470. Newberry Library, MS 33.3, fol. 23v.

8. See the description of the use of this method on the *Beowulf* manuscript in 1845 in Kevin S. Kiernan, *"Beowulf" and the "Beowulf" Manuscript*, rev. ed. (Ann Arbor, 1996), 68–69.

9. Quoted by Prescott, "'Their Present Miserable State of Cremation,'" 441n29.

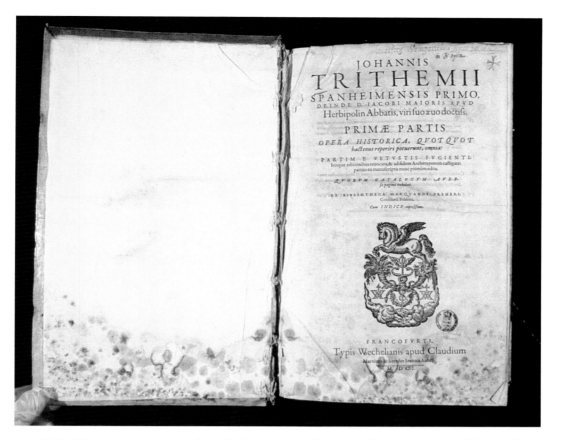

7-13 Mold, following water, has risen from the bottom edge of this copy of Johannes Tritheim's historical works, presumably stored upright at the time of its damage. Newberry Library, folio F. 447.887.

Scotland (Oxford, Bodleian Library, MS lat. lit. F. 5) narrates how the book was dropped into a river (and miraculously preserved from damage) while being carried to an oath-taking ceremony.

Water damage may leave the parchment discolored, often creating dark, wavy patterns (see fig. 7-12); the ink may run and form dark brown "ink lakes" that stain large areas of the page. Usually the original letters remain easily legible, but in cases of heavy damage, reading under ultraviolet light may prove helpful. Contact with water can also cause the parchment to become transparent. Moisture also creates the ideal environment for the growth of mold spores, readily identifiable by the purple and black discoloration they produce. To judge by the mark left on the fore-edge tail, the book shown in figure 7-13 was stored upright at the time it suffered damage; on the inside, mold has grown up to the level of the water, particularly on the outermost pages. Because some molds are noxious and some are irritating to those who are sensitive to them, care should be exercised when handling books with active mold damage. An analogous form of damage found in many paper books is known as "foxing," which leaves a pattern of brown spots on the page. While the causes of foxing are debated, two theories predominate: either it is caused by a fungus or it results from too great a concentration of iron deposits in the paper during manufacture.

In the nineteenth century, it was a common practice to clean the pages of early printed books by washing them with water. The book was first unbound and its leaves then washed with damp rags. In addition to dirt, the washing might remove handwritten annotations (often an intended effect): the ink of these annotations was water-soluble whereas the printer's ink was not. Figure 7-14 shows the final page of an incunable that has been cleaned in this way; the written comments that once surrounded the colophon are now barely visible.

Deterioration of Inks and Pigments

Because most medieval inks included a major acidic constituent (often tannic acid), it has sometimes happened that the ink has burned its way through the parchment or paper, leaving behind holes in the shape of the original letters. In some cases the process of corrosion still continues, and little can be done to arrest it. Placing a sheet of acid-free paper behind an affected leaf can, however, make the damaged text more legible (see figs. 7-15 and 7-16). As noted in chapter 2 (see fig. 2-16), verdigris pigment is also highly acidic and may eat its way through the membrane. A different kind of problem is presented by Newberry Library MS 13, a mid-twelfth-century copy of St. Augustine's *Enarrationes in Psalmos* in which the ink has literally peeled off the page, leaving blank spaces where formerly

7-14 Traces of ink remain visible on this page that has been washed of its water-soluble ink. Newberry Library, Case W. 1025.01694.

7-17 Improper preparation of the membrane or the ink and pigments has led to significant damage in this twelfth-century Augustine manuscript: ink letters have peeled off the page while the red pigment has bled and the blue pigment has faded. Newberry Library, MS 13, fol. 2r.

7-15 The acidic component of the ink has eaten through the parchment on this leaf with the concluding title ("ffinis libri Bochasii") of John Lydgate's *The Fall of Princes*. Newberry Library, MS 33.3, fol. 200v.

7-16 Placing a black sheet of acid-free paper behind the damaged folio allows one to read the text more easily.

there were words and obscuring words not yet affected by peeling (see fig. 7-17). This same manuscript exhibits major pigment deterioration: initials originally colored blue have almost completely faded, and red titles have bled into the parchment, making them appear fuzzy. While some of the various problems in this manuscript appear to be the result of water damage, others may indicate the use of defective mixtures for the ink and pigments, or perhaps something unusual in the preparation of the parchment, resulting in imperfect adhesion.

As manuscripts age, small problems with pigments can be exacerbated, particularly through the effects of humidity and temperature change. A common variety of damage is the result of pigments and parchment responding at different rates to changes in atmospheric conditions that cause expansion or contraction. Occasionally pigment will become detached from its original place on a membrane and adhere elsewhere, making it difficult or impossible to read the areas where it has affixed itself. In cases where pigment responds to the environment by contracting, it will bulge off the page, a phenomenon known as cleavage. The reverse effect, where the sides of the pigment have

curled but the center adheres to the surface, is called cupping. A range of causes may produce cracks in pigments; the use of too much binder or too much pigment, for example, can lead to "alligatoring," which takes the form of random cracks in the pigment. When the glaze expands or contracts at a different rate than the pigment itself, the result is a finely graded cracking of the surface known as *craquelure*.

If the binding medium fails, pigments may return to their original powdered form, a process known as chalking. Some colors are particularly friable and will deteriorate into a fine powder; ultramarine blue, malachite green, and some red pigments are especially prone to this. At present there is no conservation practice that can inhibit flaking and powdering if it is the result of improper mixing of the original ingredients. The three miniatures in a copy of the prose *Lancelot* made in France ca. 1300, now Newberry Library MS 21, have suffered damage of this kind. The miniature shown here (fig. 7-18), a depiction of the two kings and their sisters mentioned in the opening lines of the text, is on the first page of the manuscript; the damage is probably the combined result of friable pigments

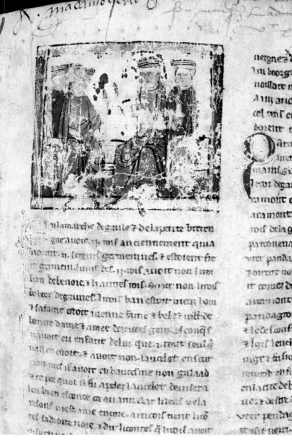

7-18 The damage to this miniature has been exacerbated by its position on the outermost leaf in the book. Two additional images show signs of wear but not as severe as on this one. Newberry Library, MS 21, fol. 1r.

7-19 The coat of arms of the Bothe family. The background is argent (silver) that has tarnished to black. Newberry Library, MS 33.1, fol. 15r (detail).

7-20 In this fifteenth-century copy of Gregorio Dati's *La Sfera*, the binding medium used to attach gold leaf has begun to break down, causing the gold to flake off in large chips. Newberry Library, Ayer MS Map 1, fol. 13r.

and wear caused by friction against either the binding or an endleaf.

As noted in part 1, many metallic pigments tarnish and corrode over time, changing their original color. Silver often tarnishes to black (see fig. 7-19), while copper impurities in gold or silver can produce a greenish coloration or create halos around the illumination. Lead white and red lead, two commonly used pigments, often turn black over time as a result of oxidation (see chap. 2, fig. 2-14). The materials used to bind gold leaf to the page are liable to break down, causing the leaf to flake from the page (see fig. 7-20).

Faded and Erased Text and the Use of Chemical Reagents

Occasionally the researcher will encounter a manuscript with pages on which the ink has badly faded, perhaps as a result of heavy use or overexposure to sunlight. In other cases, the red lead pigment employed for rubricated titles may have bleached into near invisibility, leaving on the page just the pinkish-white ghosts of the original letters.[10] Again, many manuscripts include passages of text that have been erased with greater or lesser efficiency (possible causes of such erasure are considered in the section on intentional damage). In all these cases, provided sufficient traces of the original text remain on the page, it may be possible to recover the complete text by examining the manuscript under an ultraviolet lamp (see chap. 5 for cautions regarding the use of ultraviolet light on manuscripts). In Newberry Library MS 33.1, part of the original inscription identifying the donation of the manuscript to King's College, Cambridge, has been scraped away. The original inscrip-

tion read: "Orate pro anima Magistri Roberti Bothe quondam decani ecclesie cathedralis eboracensis qui dedit hunc librum cathenandum in aula regia uniuersitatis Cantabrigie anno domini m° cccc^mo lxxxix cuius anime propicietur deus. Amen" (Pray for the soul of master Robert Bothe, late dean of the cathedral church of York, who gave this book to be chained in King's Hall of the University of Cambridge in the year of the Lord 1489. May God have mercy on his soul. Amen). The entire phrase *qui dedit hunc librum cathenandum in aula regia* (who gave this book to be chained in King's Hall) has been erased, presumably when the book passed into the hands of a later owner, probably the Edward Ayscough who has signed his name lower down on fol. 14v. The erased text is nearly invisible under normal light, but is quite clear under ultraviolet light (see figs. 7-21 and 7-22).

Before the invention of ultraviolet technology, however, scholars devised another method to render such texts legible. This method consisted in brushing a chemical reagent onto the affected areas of a manuscript; the reagent rendered the traces of ink more legible, at least in the short term. The first scholar to make use of reagents in a major way was Angelo Mai (1782–1854), who during terms of office as curator first at the Ambrosian Library in Milan and then at the Vatican recovered many previously lost works by applying reagents to palimpsests. The earliest reagent used was gallic acid; others have included potassium bisulfate or alternating applications of hydrochloric acid and potassium cyanide. In the late nineteenth century in England, the liturgical specialist F. E. Warren employed hydrophosphate of ammonia to decipher certain passages in an eleventh-century sacramentary (Cambridge, Corpus Christi College, MS 270) that had been erased during the twelfth century as a result of changes in the liturgy at St. Augustine's Abbey, Canterbury.[11]

10. On the tendency of red lead to turn white under certain conditions, see Elisabeth West Fitzhugh, "Red Lead and Minium," in *Artists' Pigments: A Handbook of Their History and Characteristics*, ed. Robert L. Feller, vol. 1 (Cambridge, 1986), 109–39, at 118.

11. See F. E. Warren, *The Leofric Missal* (Oxford, 1883), 294n1.

7-21 Partially erased donorship inscription in a fifteenth-century copy of Ranulph Higden's *Polychronicon*. Newberry Library, MS 33.1, fol. 14v.

7-22 The same page photographed under ultraviolet light.

7-23 *(below)* A reagent applied in the nineteenth or early twentieth century has stained this copy of the Anglo-Saxon *Dialogues of Solomon and Saturn*. Cambridge, Corpus Christi College, MS 422, p. 16.

The great problem with all these reagents is that their long-term impact upon the manuscript is catastrophic; as a result, scholars have now entirely abandoned their use. As the reagents dried, they darkened and stained the page, in many cases rendering completely illegible the very text they were intended to enhance and sometimes even destroying the membrane. The type of staining produced by reagents may be seen in figure 7-23, which shows a page of the fullest surviving copy of the Anglo-Saxon text known as the *Dialogues of Solomon and Saturn*; the reagent was probably applied in the second half of the nineteenth century or the first years of the twentieth, when two scholars were preparing editions of the text. Technological advances may eventually make it possible to manipulate digital images of affected pages in such a way that passages now obscured by reagent may become legible once again. At this point, however, it is often the case that the editions that resulted from scholars' use of reagents are now the only full witnesses to the texts.

Conservation and Its Effects

Although librarians, archivists, and bibliophiles have for centuries worked assiduously to preserve their collections, the birth of modern manuscript conservation can be traced to the flood of the River Arno in Florence in 1966, a catastrophe that ravaged the collections in the city's Biblioteca Nazionale Centrale. Faced with the destruction of one of the richest manuscript collections in the world, librarians sought expert help from both book conservators and scientists. Much of what was learned as a result of this disaster has subsequently been utilized to preserve books in less precarious circumstances, but perhaps more important has been the ongoing interaction between librarians, conservators, scientists, and historians, which continues to bring new advances in book preservation. In manuscript libraries throughout the world it is now standard practice

for conservation to be very carefully planned before it is undertaken, to ensure that the work carried out will indeed be in the best long-term interests of the book being treated.

A primary aim of modern conservation is to preserve the book with as little intervention as possible in order to avoid destroying evidence that may later prove to be crucial for the history of the use of the book. Further, insofar as is feasible, modern conservation aims to be reversible; that is, the work performed is done in such a way that it may later be undone should that be found to be desirable (for example, if a superior method of conservation comes to light). Most present-day conservators treat only those manuscripts that would deteriorate significantly if not treated, for any conservation will alter the object in some way and potentially remove information that might be useful for later generations. To avoid such an outcome, conservators often now make a complete record of the manuscript before conservation begins; this record should preferably be photographic as well as written. Further, any materials removed from the manuscript in the course of conservation should be preserved, catalogued, and made accessible. Scholars working with manuscripts that show obvious signs of conservation (or who are concerned with the history of a given manuscript) can and should make use of such records. It is also important for scholars to alert library staff to materials that are in need of conservation; it quite frequently happens that the researcher is the first person to examine a particular manuscript for several years and may therefore come upon problems of which library staff is unaware.

Conservation practice has not always been as careful as it now is, and in the past there has often been miscommunication or insufficient communication between conservators and curators; conservators were not given sufficiently specific guidelines for the work to be accomplished and were not made aware of the potential bibliographic importance of material they believed to be expendable. As a result, well-meaning individuals have often damaged books through misguided conservation efforts. The most common conservation disasters have occurred during rebinding. In the early modern and well into the modern period, it was normal for libraries or collectors to rebind books when they were purchased. The rebinding was often necessitated by the poor state of the existing binding, but in many cases the primary purpose of rebinding was to mark the book as the property of a particular individual or institution and to provide an expression of the new owner's taste. Many of the books in royal collections, for example, were rebound to reflect the new status of the book. In the eighteenth and nineteenth centuries, manuscripts were rebound in accordance with contemporary notions of the status of medieval books, often using intricately tooled leather or red velvet. In modern times, many libraries have conducted rebinding campaigns to replace aging and damaged bindings. Any time a book is rebound, essential information about its construction, provenance, and history may be lost. Until relatively recently, former covers, pastedowns, and endleaves were routinely discarded during rebinding, and leaves were often trimmed, with the resultant loss of marginalia. Seventy-five years ago, E. P. Goldschmidt uttered a heartfelt plea against discarding any element of an old binding and recommended that conservators should not interfere with books that still retain their medieval or Renaissance bindings, for fear of destroying vital information whose significance might not yet be apparent but might be better understood in the future as the result of advances in bibliographical research:

DO NOT REMOVE THE LINING OF OLD BINDINGS! I cannot earnestly enough pray all collectors, librarians, or any owners and custodians of old books, not to interfere with any scraps of paper or vellum found in their covers, and not to remove anything either written or printed from their bindings, whether on the ground that it is interesting or on the ground that it appears uninteresting! Our knowledge of old owners' marks and old library press-marks, and our experience in working out the clues afforded by casual-looking scribblings, is far too limited to permit us to judge what essential data we may be destroying when we allow an old book to be handed over to a binder "to be restored." There is no such thing as restoring an old binding without obliterating its entire history. Even if the restorer promises to leave "everything as it was," he cannot preserve such characteristic details as the attachment of the original bands to the boards, details that further research may well prove to be of decisive significance for determining the provenance of a book. If an old binding is nearly or completely falling to pieces, it should be preserved such as it is in a flannel-lined case, but it should never be patched, relined, rebacked or otherwise barbarously treated. The books contained in the extant fifteenth or sixteenth-century bindings are rarely required for the perusal of their contents, which are usually available either in later editions or in other copies rebound in modern times. But every book that has through the kindness of fate come down to us in its original binding through the centuries is a precious relic, bearing in a hundred hidden ways the whole tale of its history, and the hand that dares to "renew it" destroys all that is significant, leaving nothing but an empty mask. As for the well-meaning people who deliberately remove the written or printed linings from old book covers "because they are interesting," the curse of Ernulphus on their vandalism![12]

12. E. P. Goldschmidt, *Gothic and Renaissance Bookbindings,* 2 vols. (London, 1928), 1:123, quoted from David McKitterick, "Evidence in the Printed Book and the Avoidance of Damage;

A common practice when a book was rebound was to trim the margins so that the book would conform to a somewhat smaller binding or merely so that the leaves would all be the same size and would present an even profile. Trimming the leaves to even them up was indeed normal at the first binding of a manuscript and often produced the loss of elements not intended to be preserved, such as instructions to the rubricator or artist written vertically in the margins (see chap. 2 and fig. 2-8). Trimmings associated with subsequent rebindings have frequently resulted in the removal of important marginal accretions to the book, such as readers' annotations and glosses. At times the loss has been catastrophic, as in Newberry Library MS 97.7, a fifteenth-century copy of works by the humanist Lorenzo Valla: on most pages, only the first few letters of the marginal annotations can be read (fig. 7-24). Disastrous trimming of this kind was practiced even as late as the mid-twentieth century, before conservation practices were tightened up and conservators became more alert to the historical importance of every aspect of the materials entrusted to their care. The oldest surviving quatrain of Old Welsh poetry was formerly to be found in an upper margin of an eleventh-century copy of St. Augustine's *De trinitate* (Cambridge, Corpus Christi College, MS 199, fol. 11r); as a result of a 1953 rebinding, nothing more than the illegible bottom portions of the letters now survives, the rest having been trimmed away.[13] In early modern times, extensive loss of marginal material quite often resulted when collectors bound together manuscripts of different dates and provenance that happened to be of approximately the same size. In such cases, the margins of the larger component manuscript were routinely trimmed to bring the leaves into conformity with those of the smaller one. Many of the manuscripts in the British Library's Cotton collection have suffered loss of this kind, as a result of the rebinding activities of Sir Robert Cotton in the early seventeenth century.

The quality of rebindings has varied greatly over the centuries but has often not been adequate to the needs of the book and has resulted in some form of damage. Typi-

cally, books have been rebound too tightly, which causes the pages to cockle or ripple and the manuscript to strain when opened; the problem is exacerbated if glue has been used in the rebinding process. A tightly bound book will not lie flat, and attempts to coax it open to make the text more easily legible may cause further damage. In most cases, books in such bindings are left alone unless so much harm is being done that it would be less destructive to bind the book again than allow it to continue in its present state. A unique manuscript in the Newberry's collections, the richly illuminated *Speculum humanae salvationis* (Newberry Library MS 40), commissioned by Philip the Good, Duke of Burgundy, presents such a case. A nineteenth-century rebinding (by Niédrée) was so tight that the pages began to cockle, causing the miniatures to rub against each other, which promoted the flaking of pigments (see fig. 7-25). A few years ago, in a carefully planned and

7-24 Only the first few letters of the marginal annotations survive as a result of the brutal cropping of this fifteenth-century manuscript. Newberry Library, MS 97.7, fol. 6r.

A Bibliographer's Viewpoint," in Hadgraft and Swift, *Conservation and Preservation*, 23–28, at 27. The "curse of Ernulphus" mentioned by Goldschmidt at the end of this passage refers to the extraordinarily long and detailed curse entered in the Textus Roffensis (a manuscript belonging to Rochester Cathedral and ostensibly presented by Bishop Ernulphus); the curse is best known to modern readers because of its appearance in Laurence Sterne's *The Life and Opinions of Tristram Shandy, Gentleman* (vol. 3, chap. 11).

13. See Timothy Graham, "The Poetic, Scribal and Artistic Work of Ieuan ap Sulien in Corpus Christi College, Cambridge, MS 199: Addenda and Assessment," *National Library of Wales Journal* 29 (1995–96): 241–53, at 243.

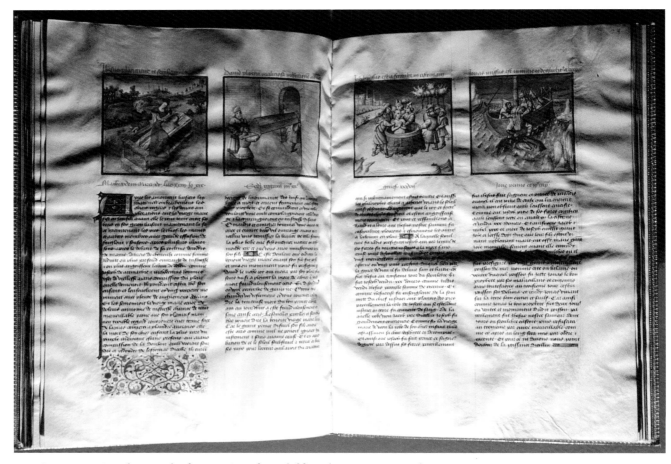

7-25 Preconservation photograph of an opening of a mid-fifteenth-century Burgundian copy of the *Speculum humanae salvationis*. The photograph was taken under raking light to highlight the cockling of the parchment caused by the tight nineteenth-century binding. Newberry Library, MS 40, fols. 27v–28r.

conducted campaign of conservation, the codex was completely unbound and the leaves were placed in a humidification chamber until they lay flat, the vellum being gently stretched to remove the wrinkles. Finally, the manuscript was rebound using natural materials. Special "concertinas" were inserted in each gathering to lift each folio and provide room for glassine inserts to protect the miniatures. In its present state, the manuscript lies flat when opened, greatly reducing damage to the miniatures through friction (see fig. 7-26).

Attempts to arrest continuing damage to manuscripts caused by such factors as mold, flaking pigments, and acidic inks eating through leaves have over the years led to a variety of conservation practices that were well intended at the time but may now be seen to have been in some respects misguided. In the 1960s, for example, several major institutions used soluble nylon to stabilize and preserve damaged leaves within manuscripts. Over time, however, the nylon became pitted and attracted dirt, eventually turning some pages almost black. Another technique used was lamination, for which manuscripts were disbound and their leaves placed between two sheets of plastic and rolled

through a laminating machine that affixed the plastic to the leaves with heat and pressure. In certain cases, the heat and pressure may have caused more damage to the manuscripts than if they had remained untreated. Neither of these treatments is at present reversible. They demonstrate that conservation is a continually evolving science that is intimately linked with contemporary technological advances. The best-intended efforts of one generation may prove to have unexpected and undesirable consequences in the next, but as knowledge has accumulated, techniques have steadily become more refined, more appropriate, and more attuned to the best interests of the book, the curators who look after it, and the scholars who study it.

INTENTIONAL DAMAGE

Palimpsests

A palimpsest is created when an unwanted manuscript is "recycled" by washing or scraping the original text from the parchment and entering a new text in its place. The term *palimpsest* derives from Greek *palinpsêstos* (πάλιν ψηστος), "scraped again." Any book no longer needed was poten-

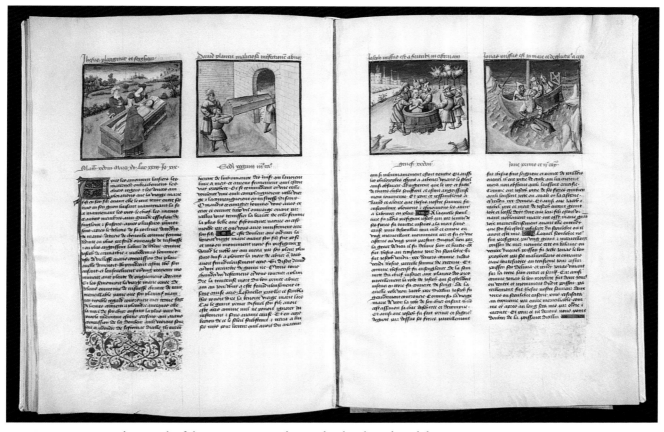

7-26 Postconservation photograph of the same opening. The new binding has relieved the pressure and allows the leaves to lie flat.

tially subject to this type of recycling, which eliminated the expense of preparing fresh parchment. In practice, the texts most frequently erased to give way to new ones were classical texts deemed pagan (they would be replaced by Christian texts), outdated liturgical texts, and legal texts that had been rendered void. Greek or Hebrew texts might be erased in areas of the Latin West where those languages were not understood. Palimpsests survive from all periods of the Middle Ages, but the era of greatest palimpsest activity was the seventh and eighth centuries, when many manuscripts dating from the fourth to seventh centuries were erased in order to receive new texts at such monastic centers as Bobbio in Italy, Luxeuil, Corbie, and Fleury in France, and St. Gallen in Switzerland.

There are two notable examples of palimpsests at the Newberry Library. The eleventh-century German copy of Boethius's *De consolatione philosophiae* (Newberry Library MS 10) discussed in chapter 5 (see fig. 5-3) was produced only after a still-unidentified text had been erased from the leaves; insofar as it is still visible, the script of the original text appears to date from the tenth century (see fig. 7-27). Newberry Library MS 102.2 is a large-format copy of the letters of St. Jerome that, according to its colophon, was completed in 1459; the following year it was presented to the Franciscan community at Ancona, Italy. The original fourteenth-century text that was erased to give way to

the Jerome is visible on every page. The parchment is now thin and furry, and the leaves tend to curl when the book lies open, perhaps as a result of the scraping process. On many leaves it is possible to see the horizontal and vertical scrape marks (see fig. 7-28). In these two palimpsests, both the original text and the new text run horizontally across the leaves, although in some cases the leaves were rotated 180 degrees before the new text was entered, and thus the original text is now upside down (see fig. 7-27); in some palimpsests, where the leaves were rotated ninety degrees, the lines of the original text now run vertically up or down the pages.

In the early nineteenth century Angelo Mai pioneered a method of deciphering the original text in a palimpsest, first at the Ambrosian Library in Milan (the repository for many manuscripts from Bobbio), then at the Vatican. Important works that were recovered in this way included Cicero's *De republica*, plays of Plautus, and Ulfilas's Gothic translation of the Bible. As noted above, Mai's technique involved treating the texts with chemical reagent, a method that has resulted in their permanent disfiguration and in some cases the destruction of treated leaves. Sometimes, however, mere painstaking examination under a magnifying glass suffices for reading a palimpsest: this was the method used by the Danish philologist Johan Ludvig Heiberg when in 1906 he deciphered a palimpsest

at Constantinople containing the earliest surviving copy of works by Archimedes, including a work on the mathematics of mechanics that survives in no other manuscript. Examination under ultraviolet light may also be helpful. Advances in digital photography, coupled with multispectral imaging whereby the upper text can be filtered out and the lower text enhanced, present exciting possibilities. The Archimedes palimpsest, which is currently undergoing major conservation at the Walters Art Museum in Baltimore, has been photographed in this way, and a facsimile is planned that will once again show the manuscript in something like its original condition.

Censorship

Censorship is the correcting of a text to bring it into ideological, rather than literal or factual, correctness. The most drastic method of censorship, the burning of books,

leaves little room for survival. In some cases, however, censorship involved lesser forms of intervention such as the erasure of offending passages in a book. One of the most remarkable episodes in the history of censorship occurred in England in the wake of Henry VIII's break with the Church of Rome and the formation of an independent Church of England. Because the universal authority of the pope was no longer recognized in England, some owners of medieval manuscripts obliterated the word *papa* (pope) when they came upon it; if the word appeared in the genitive case, *pape*, they sometimes erased just the first letter, leaving *ape*! (This has happened in Yale University, Beinecke Rare Book and Manuscript Library, MS 310.) Even greater care was taken to expunge references to Thomas Becket, the pro-papal archbishop of Canterbury who defied King Henry II and in 1170 was murdered in his cathedral by Henry's liegemen. In 1538, at the height of his

7-27 In this Boethius palimpsest, some leaves were rotated so that the erased original text—which has not yet been identified—was upside down in relation to the new text. Here the book has been turned so that the original text appears the right way up. Newberry Library, MS 10, fol. 132r.

7-28 The parchment of this fifteenth-century palimpsest copy of St. Jerome's *Letters* is rough and scored from the scraping necessary to remove the original fourteenth-century text. Such recycling speaks to the relatively high cost of new parchment and the desire to turn unneeded manuscripts to new use. Newberry Library, MS 102.2, fol. 206v.

dispute with Rome, Henry VIII destroyed Becket's shrine at Canterbury and issued a proclamation condemning his memory, eliminating his feast day from the calendar, and ordering all images of him to be removed from churches and all references to him in service books to be erased:

Item, forasmuch as it appeareth now clearly that Thomas Becket, sometime Archbishop of Canterbury, stubbornly to withstand the wholesome laws established against the enormities of the clergy by the King's highness' most noble progenitor, King Henry II, for the commonwealth, rest, and tranquillity of this realm, of his froward mind fled the realm into France and to the Bishop of Rome, maintainer of those enormities, to procure the abrogation of the said laws, whereby arose much trouble in this said realm. . . . Therefore his grace straightly chargeth and commandeth that from henceforth the said Thomas Becket shall not be esteemed, named, reputed, nor called a saint, but Bishop Becket, and that his images and pictures through the whole realm shall be put down and avoided out of all churches, chapels, and other places, and that from henceforth the days used to be festival in his name shall not be observed, nor the service, office, antiphons, collects, and prayers in his name read, but erased and put out of all the books.[14]

Newberry Library MS 35, a fifteenth-century Book of Hours made in Bruges for use in England, offers dramatic proof of the effectiveness of this proclamation. On the front endleaves have been added the names of children born to members of the Gonstone (or Gonson) and Mildmay families in the sixteenth century, and the book seems to have belonged successively to these two families, which were united in the 1530s when Thomas Mildmay married Avis Gonson. Thomas served Henry VIII as auditor, while his father, also called Thomas, was commissioner for receiving the surrender of the monasteries dissolved by the king; Avis's father, William, was Henry's treasurer for the navy. Both families were thus closely linked to the crown, and it is not difficult to imagine members of either family zealously seeking to comply with the injunctions of the 1538 proclamation. The effects are to be seen at several points in the manuscript. Within the calendar, Becket's name has been scraped out both for his feast day (29 December) and for the commemoration of the translation of his relics (7 July). A further erasure of his name occurs within the litany, and the memorial to him within the suffrages of the saints has been vigorously crossed out—although the facing-page illustration of his martyrdom has not been tampered with (fig. 7-29). Nor is this the full extent of the book's censorship. Within the text

known as the Seven Joys of the Virgin, a reference to an indulgence of one hundred days granted by Pope Clement to anyone who should recite the text aloud has been expunged—papal indulgences were seen as a major abuse by the reformed English Church—and at other points in the manuscript, objectionable passages of text have been masked from view with sheets of paper pasted over them.

Alteration and Mutilation

Numerous medieval manuscripts have been subjected to some degree of alteration at some point in their history. Alteration here refers not to the routine correction of the text or its annotation, nor to censorship for ideological reasons, but to some form of intervention (other than rebinding) that affected the physical state and appearance of the book. In early modern times, such alteration was often the work of owners acting, at least in their own eyes, to improve the state of the book; more recently, alterations have sometimes been effected by forgers or dealers seeking to increase the market value of a book. The alterations were often aimed at countering damage the book had already suffered.

For example, some of the manuscripts that came into the hands of great early modern collectors such as Matthew Parker and Sir Robert Cotton reached them in a damaged state. Typically, such manuscripts might have lost leaves at the beginning or end, with the result that the first text in the surviving manuscript lacked its beginning or the last one lacked its end. Matthew Parker, in particular, disliked incomplete texts, and in several cases he erased the portions of such texts that remained, in order to "neaten" the appearance of the book; sometimes, he would use the blank parchment created by his erasure to enter a table of contents.[15] Others adopted similar practices. Figure 7-30 shows the current first page of Newberry Library MS 92.5, a collection of miscellaneous texts in Latin and Italian made in the second half of the fifteenth century. The upper part of the page has been bleached or scraped to hide the fact that the manuscript has lost leaves at the beginning and that the text originally occupying this area was acephalous. The presence of such a blank area at the beginning or end of a manuscript should itself alert readers to the possibility that leaves have been lost. The quire structure should also be examined to see if any leaves have been cut out before the leaf with the blank area (if it is at the beginning of the book) or following it (if it is at the end). In many cases, the book may have lost one or more complete quires at its beginning or end. The item of text left incomplete by this loss might itself have occupied several leaves within the first or last surviving quire.

14. Paul L. Hughes and James F. Larkin, eds., *Tudor Royal Proclamations*, vol. 1 (New Haven, 1964), 275–76.

15. See the account of Parker's interventions in his manuscripts in R. I. Page, *Matthew Parker and His Books* (Kalamazoo, MI, 1993), esp. chap. 2, "The Conservation of Ancient Records and Monuments."

An owner or dealer who objected to this incompleteness might then have cut out and discarded any leaves that contained only the incomplete item, and might have erased that portion of the item that remained on the first or last retained leaf. In the case of Newberry Library MS 92.5, as in some other manuscripts that have suffered similar loss, there happens to be an old table of contents at the end of the book, compiled before the loss; such tables should be examined carefully, for they will identify exactly what has been lost. Newberry Library MS 102.1, a fifteenth-century copy of saints' lives by the Paduan writer Sicco Polenton, is another manuscript in which an erasure on the current first page attempts to mask the loss of preceding leaves (see fig. 7-31). In this case, the addition of decorative flourishes in the erased area compounds the attempt to neaten up the beginning of the book.

Occasionally the loss of text from a manuscript was counteracted by more than mere erasure. If an owner happened to possess or could succeed in borrowing another, complete copy of the affected text, he might use it as an exemplar from which to make a transcript of the lost portion of text that could then be added to the damaged manuscript. Matthew Parker was a pioneer in this method of repair, retaining in his household professional scribes who, when making such transcripts, attempted—although often somewhat crudely—to imitate the character of the original script; several of Parker's manuscripts include at the beginning or end one or more added leaves that make good a loss to the original manuscript. Normally such additions are easy to identify. Attempts by early modern scribes to imitate medieval scripts were never entirely successful (the work of modern forgers, however, can be much more difficult to detect). Again, the ink might be quite different in appearance; sixteenth-century ink, for example, often has a greenish tinge not found in medieval inks. If both the original and the added leaves are of parchment, the preparation might be very different for the added leaves, giving the membrane a quite distinct appearance. If all the leaves

7-29 Memorial for St. Thomas Becket, from a fifteenth-century Book of Hours made for English use. The text has been crossed out to comply with Henry VIII's 1538 injunction against commemorating Becket. Newberry Library, MS 35, fols. 23v–24r.

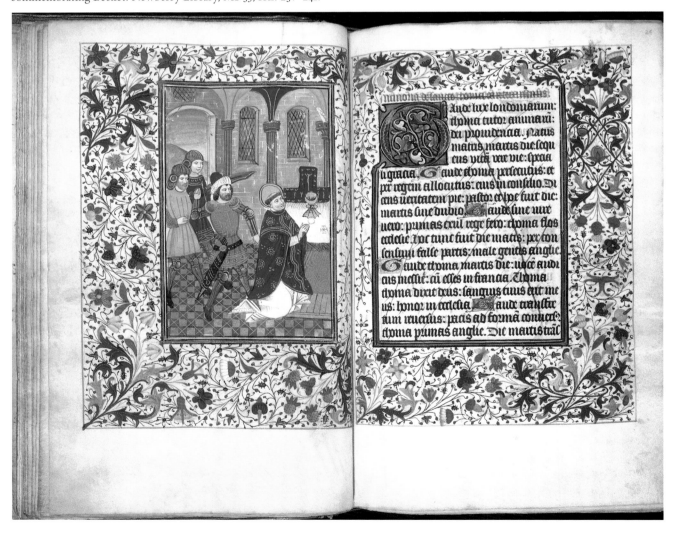

7-30 The loss of leaves from the beginning of this fifteenth-century manuscript has prompted an owner to erase the fragment of text in the upper part of the first page. Newberry Library, MS 92.5, fol. 1r.

7-31 This fifteenth-century Italian manuscript has had a decorative border applied to the top and left side of its first page to disguise the loss of text from the beginning of the manuscript. Newberry Library, MS 102.1, fol. 1r.

are of paper, watermarks can be checked. Sometimes paper leaves were used to make good a loss in a parchment manuscript, and this is easily spotted.

Efforts to rectify damage sometimes affected only portions of pages. In medieval times, manuscripts with generous margins often invited despoliation: the margins might be cut away to serve as binding materials (for example, to reinforce the spine of a binding) or as document slips. Sometimes small portions of script were trimmed away along with the margins. A later owner might make good this loss by pasting new strips of parchment or paper to the edges of the despoiled leaves and then having any lost portions of script entered onto the restored margins; Parker did this in several of his manuscripts. Such refurbished margins are easy to detect, for they will overlap the original leaves at the point where they have been pasted on. A somewhat different type of restoration is presented by Newberry Library MS 97.2, which contains a fifteenth-century Florentine copy of Leonardo Bruni's *De primo bello Punico*. Here a leaf in the middle of the book had suffered a diagonal rip. The rip has been repaired with a piece of fresh paper pasted to the original leaf; on this, a seventeenth-century hand has entered the portion of Bruni's text covered by the repair (fig. 7-32).

It is a remarkable irony that the preservation of some manuscripts may be intimately linked with the mutilation, dismemberment, or outright destruction of others. As mentioned above, once a medieval scriptorium had produced a new copy of a text in up-to-date script, the older manuscript that had served as the textual exemplar might be discarded: the production of the new thus led to the destruction of the old. Again, several of those who did most to collect and preserve manuscripts in the early modern period are now known to have perpetrated varying degrees of mutilation on codices that had little value or interest for them. For Protestant collectors, the books esteemed least were often those that transmitted late medieval Catholic practices they deemed to be superstitious or superfluous. When Matthew Parker repaired the despoiled margins of two Anglo-Saxon manuscripts that he valued highly, he did so not by using strips of freshly prepared parchment but by cutting up a fourteenth-century breviary that evidently meant little to him.[16]

16. See Timothy Graham, "Changing the Context of Medieval Manuscript Art: The Case of Matthew Parker," in *Medieval Art: Recent Perspectives*, ed. Gale R. Owen-Crocker and Timothy Graham (Manchester, U.K., 1998), 183–205, at 196–200.

7-32 Here a ripped page has been repaired and the text restored without any attempt to simulate the original script; completeness of text, not deception, seems to have been the restorer's aim. Newberry Library, MS 97.2, fol. 81v.

ments were handed down from one generation of binders to another.[17] Several of the leaves used to illustrate medieval scripts in chapter 10 are fragments rescued from bindings (see figs. 10-1 through 10-4).

One of the most surprising characteristics of early modern collectors was the freedom with which they allowed themselves to cut richly colored illuminations out of some manuscripts in order to embellish others that had special value and meaning for them. Parker plundered a thirteenth-century psalter for six of its prefatory illustrations depicting incidents from Christ's life, then pasted the illustrations into three manuscripts of earlier date.[18] Sir Robert Cotton was even prepared to compile composite images by cutting materials out of two different manuscripts and recombining them in a third. Cotton owned two ninth-century continental manuscripts that according to tradition had been given to King Athelstan of England in the tenth century; these are now MSS Cotton Galba A. xviii and Cotton Tiberius A. ii in the British Library. He valued both manuscripts highly for their antiquity and their royal association, and at the front of each of them he added a decorative frontispiece consisting of a picture cut from one late medieval manuscript surrounded by an arch-shaped border cut from another. He also overpainted some areas of the decoration and entered his own inscription at the bottom of the image.

More commonly, illustrations, initials, or portions of script were cut from manuscripts so that they could be reassembled in an album, often for educational purposes, or sold for profit.[19] This type of mutilation has a long history, perhaps going back to the medieval period itself

Rejected materials often ended up in the hands of binders, both during the Middle Ages and afterward. Binders could reuse complete leaves as pastedowns or endleaves at the front or back of a book they were binding, or they might turn the leaves sideways, fold them, and put them into service as limp covers. Alternatively they could cut leaves up into suitable sizes and shapes to serve as spine liners or other varieties of binding reinforcement. Fragments of manuscripts have frequently turned up in the bindings of printed books; binders of the late fifteenth, sixteenth, and seventeenth centuries seem often to have kept at hand a store of manuscript fragments that they could use for such purposes, and in modern times some exciting discoveries have been made when scholars have happened to notice small pieces of manuscripts protruding from some part of the binding of a printed book. Sometimes fragments of a single manuscript have been found in printed books bound decades apart, which suggests that the frag-

17. See R. I. Page, Mildred Budny, and Nicholas Hadgraft, "Two Fragments of an Old English Manuscript in the Library of Corpus Christi College, Cambridge," *Speculum* 70 (1993), 502–29, at 504.

18. See Graham, "Changing the Context," 189–95.

19 On this topic, see also Christopher de Hamel, *Cutting Up Manuscripts for Pleasure and Profit: The 1995 Sol M. Malkin Lecture on Bibliography* (Charlottesville, VA, 1996).

(there is evidence, for example, that at least one precious manuscript at Canterbury may have had decorated pages removed from it well before the Reformation). In recent times, the motivation has usually been financial or the result of a desire for selfish personal gratification. Dealers have made cuttings from manuscripts that came into their hands so that they could increase their profit margin by selling off the more precious parts of a manuscript as individual collectible items. Newberry Library Medieval Manuscript Fragment 65 (above, fig. 4-21) provides an example of such a cutting, although it is not known who made it. A fifteenth-century copy of Ranulph Higden's *Polychronicon* at the Newberry (MS 33.1) demonstrates what a researcher may find when a manuscript has been subjected to this

kind of mutilation; here the largest and presumably most elaborately decorated initial in the manuscript has been removed, and the cut has badly damaged the margin of the preceding leaf (fig. 7-33). Most regrettably, such mutilation has sometimes taken place within the supposedly safe walls of libraries, when unscrupulous individuals have registered as readers and then desecrated the materials to which they have been granted access. Sometimes—particularly in cases where complete leaves were removed—the damage and theft have gone unnoticed for years, making difficult if not impossible the identification and prosecution of the individual responsible. One Newberry manuscript has had a full-page illumination of John the Evangelist cut out; the excision would have gone unnoticed but for the instructions to the illuminator at the bottom of the previous folio, and a mere stub remains from which the page has been cut (see fig. 7-34).

In the premodern era, cuttings were often made from manuscripts for more benign, if still questionable, reasons. For example, miniatures might be cut out so that they could be pasted into religious primers and catechisms, where they would have some instructional value. From at least the seventeenth century, scholars started to compile their own scrapbooks of cuttings that illustrated the history of script. Among these scholars was the diarist Samuel Pepys (1633–1703), whose calligraphical collection is now in the Pepys Library at Magdalene College, Cambridge. Often we do not know exactly how such scrapbooks were compiled—whether the scholars cut out the fragments themselves or whether they received them from a third party. In Pepys's case, we do at least know that two fragments of Insular script in the first volume of his calligraphical collection (Magdalene College MS 2981, nos. 18 and 19) came from eighth-century Gospel books belonging to Durham Cathedral Library (MSS A.II.16 and A.II.17) and that the dean and chapter of the cathedral presented the cuttings to him, sanctioning their removal from the manuscripts presumably because they felt the educational value of the collection Pepys was forming outweighed the importance of preserving the manuscripts intact. A hundred years or so later, Thomas Astle (1735–1803), Keeper of the

7-33 A large initial has been cut from this copy of Ranulph Higden's *Polychronicon* (the black background makes the outline of the initial more visible). Newberry Library, MS 33.1, fol. 16v.

7-34 In this fifteenth-century Book of Hours, the guide words to the artist, *Ioh(ann)e Avangeliste* [*sic*], signal the loss of the illumination on the facing page. Note also the stub of the leaf that has been removed. Newberry Library, MS 35, fols. 18v–19r.

Records in the Tower of London, was assembling material for his *The Origin and Progress of Writing*, a major contribution to paleography that was published in 1784. For the most part, Astle was able to obtain handwritten facsimiles of medieval manuscript pages prepared by skilled draftsmen; these he compiled in a personal collection that is now MS Stowe 1061 in the British Library. A dozen leaves at the end of the volume, however, have manuscript cuttings pasted onto them. It is a challenging paradox that the early evolution of the science of paleography rested in part on the mutilation of the very objects whose study it promotes. Nowadays, of course, photography has made possible a nondestructive form of "fragmentation," allowing students and scholars to study within the covers of a single book images culled from large numbers of manuscripts, with no attendant damage to the manuscripts themselves.

Assessing Manuscript Origin and Provenance

I T I S I M P O R T A N T for students of manuscripts to learn to distinguish between *origin* and *provenance*. The provenance of a manuscript means its history of ownership beginning with the first owner for whom evidence of ownership survives. Many manuscripts had only one institutional owner during the medieval period, but some manuscripts passed from one institution to another. Some manuscripts were specifically made by one institution with the intention that they would be given to and owned by another; for example, when one monastic house was founded by another, it was not unusual for the mother house to give the daughter house volumes from its own library and to have its scribes copy manuscripts for the new foundation, at least until the latter established its own scriptorium. Manuscripts were therefore not necessarily made at the institution that the evidence suggests was their first known owner. To establish the place of origin of a manuscript requires some form of evidence beyond that of early ownership (although the evidence of ownership can help support other kinds of evidence). Listed below are some of the most important features that can provide information about the origin of a manuscript, while the following section considers evidence attesting to manuscript provenance.

EVIDENCE FOR ESTABLISHING
MANUSCRIPT ORIGIN

Colophons

The best form of evidence for manuscript origin is a scribal colophon, that is, an inscription that a scribe enters at the end of a manuscript, or sometimes at the end of a particular text within a manuscript, in which he or she provides information about the production of the manuscript. However, only a relatively small proportion of medieval manuscripts include such colophons.[1] Although colophons survive from most periods and regions,

they were more popular at certain times and places: for example, among early medieval Irish and Spanish scribes and among Italian humanist scribes of the fifteenth century. The amount of detail included in colophons also varied greatly. Generally they include the name of the scribe (often accompanied by a request to the reader to offer a prayer on the scribe's behalf); in many cases they also provide information detailing where and for whom the manuscript was written and when it was finished. The colophon in Newberry Library MS 58.1, a fifteenth-century Bible, is quite typical in the kind of information it provides. Stating first that the manuscript was copied by Gerard de Scurhoven, a priest of the diocese of Liège who was chaplain to the Beguines of Saint-Trond, it then notes that Gerard finished his work on 2 March 1433 and ends by requesting prayers on his behalf: "Scriptus est hic liber per manus Gerardi de Scurhoven presbiteri leodiensis diocesis pro tunc capellani cure beghinarum opidi Sancti Trudonis et finitus anno domini millesimo quadringentesimo tricesimo tercio mensis marcii die secunda. Orate pro eo." An informative addition in another hand, entered at least twenty-three years later, requests prayers for Gerard's soul, noting that he died in July of 1456 and bequeathing the book to the brothers of the third order of St. Francis in the village of Zepperen (near Saint-Trond). Colophons may even be sufficiently precise as to mention the actual time at which the scribe completed the book; thus the colophon at the end of Newberry Library MS 70.5, a copy of a commentary on Petrarch by the early Florentine humanist Poggio Bracciolini, tells the reader that the book was transcribed by Bassianus de Villanis, who finished his work at the fifth hour of the night on 24 October 1480: "Transcriptus per me Bassianum de Villanis et finitus die xxiiij° octobris 1480 hora noctis quinta." Sometimes, however, rather than give a specific date, the scribe would date his work by reference to an important contemporary event, as in the late-eleventh-century Stavelot Bible (London, British Library, MSS Additional 28106–7), in which the scribe Goderannus noted that it took him four years to copy the Bible and that he completed it in the year in which certain leaders departed for the First Crusade: that is, 1097. Newberry Library MS 97, an Italian humanist copy of the Latin

1. For a survey of medieval manuscripts that have colophons, see *Colophons de manuscrits occidentaux des origines au XVIe siècle*, 6 vols. (Fribourg, Switz., 1965–82), compiled by the Benedictine monks of Le Bouveret, Switzerland.

8-1 Colophon by the scribe Masullus of Naples. Newberry
Library, MS 97, fol. 229r.

8-2 Colophon by an anonymous female scribe. Newberry
Library, MS 64, fol. 155v.

translation of Plato's *Republic*, ends with a verse colophon
in which the Neapolitan scribe Masullus records that he
wrote the manuscript in the year in which the royal Nea-
politan fleet was devastated by a storm at sea (fig. 8-1). As
yet it has not been possible to date the naval disaster to
which he refers.

When using colophon evidence to establish the origin
of a manuscript, it is important to bear in mind that occa-
sionally scribes unthinkingly copied a colophon from the
exemplar from which they were working; in such cases
the colophon says nothing about the origin of the copy
beyond indicating where the scribe was able to obtain his
exemplar. A famous case of a transcribed colophon occurs

in a late-twelfth-century copy of the *De virginitate* of St.
Ildefonsus (Parma, Biblioteca Capitolare, MS 1650), which
repeats the colophon of a copy made by the scribe Gómez
for Gotiscalc of Le Puy in 951. Paleographical assessment of
the date of the script of a manuscript will help to indicate
whether or not a colophon is genuine. A more problematic
case is presented by Newberry Library MS 64, a fifteenth-
century collect book from Austria. A colophon at the end
notes that the manuscript was completed on the feast day
of St. Florian (4 May) in an unspecified year, invokes the
Virgin as "most beloved lady," and identifies the scribe as
a female by requesting readers not to forget the *scriptrix* in
their prayers: "Finitum est in die sancti Florini. O dilec-
tissima dompna. Nolite obliuisci scriptricis in oracionibus
vestris deuotis" (fig. 8-2). The colophon is entered in red
and blue letters, so in theory it could refer to the rubrica-
tor rather than the scribe of the manuscript; but the script
of the rubrication appears to match that of the text, sug-
gesting that the entire manuscript was the work of a sin-
gle hand. It is therefore puzzling that an ownership note
entered on the first leaf of the book offers information
contradicting the colophon, for it states that the book was
commissioned in 1427 by Poppo de Wildek, who caused it
to be written by a Carmelite friar, Paul, and later presented
it as a New Year's gift to one Henry, the author of the note.
On the verso of that first leaf is a picture showing Poppo
de Wildek wearing knight's armor and praying before his
coat of arms; above him, the Virgin and child appear on
a crescent moon (fig. 8-3). This first leaf is a loose sheet
tipped into the manuscript and does not belong to the first
quire, but it was not unusual for illustrated pages to be in-
serted as frontispieces in this manner. The contradictory
evidence found at the beginning and end of the manu-
script is somewhat bewildering and raises the possibility
that the colophon referring to the female scribe could have
been copied from an exemplar; without further evidence,
however, that remains unproven.

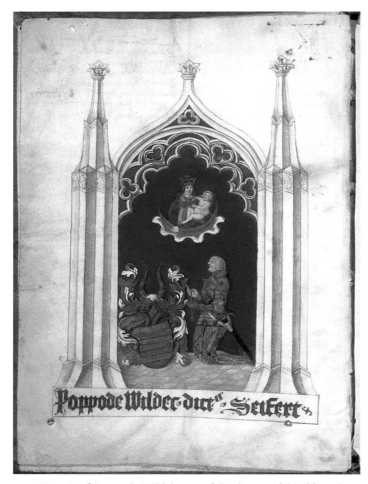

8-3 Portrait of Poppo de Wildek, one of the donors of this fifteenth-
century collect book, on a tipped-in leaf. Newberry Library, MS 64,
fol. 1v.

Also difficult to interpret is a whimsical sketch of a
male bust entered toward the end of Newberry Library
MS 91, a late-fifteenth-century Italian copy of the letters

of St. Jerome and other works (see fig. 8-4). The accompanying inscription notes "Ego sum qui hunc librum scripsit" (It is I who wrote this book), so the sketch proclaims itself to be a self-portrait of the scribe. The manuscript is, however, the work of a group of four scribes, none of whose hands matches that of the inscription. In all likelihood the sketch offers no information about the origin of the manuscript but is simply a piece of wishful thinking on the part of an early reader. It alerts scholars to treat all forms of manuscript evidence with due caution.

Evidence within the Contents

Even if a manuscript has no colophon, there may be evidence within the text that will help to establish its place of origin. Students of manuscripts have long recognized that "all scribes were editors"—that is, scribes had an innate tendency to alter the texts they copied; and certain types of alteration may be indicative of where the scribe wrote. For example, if a scribe was copying a historical chronicle, he might add to the text information about his own region and about the specific institution to which he belonged, say, by adding the dates of succession and death of local abbots or recording the translations of saints' relics possessed by the institution. This was a common way to make the text of greater local relevance and interest. Thus a late-twelfth-century copy of the *Chronicon ex chronicis* of John of Worcester (London, Lambeth Palace Library, MS 42) weaves into John's text many additional passages about the abbots of Abingdon, a sure sign that the manuscript was copied at Abingdon. Again, the seven surviving copies of the *Anglo-Saxon Chronicle* differ among themselves in important ways that help to establish their place of origin, although in some instances the evidence is difficult to interpret.

Many liturgical manuscripts begin with a calendar, which can provide excellent indications of the place of origin (see also chap. 12). The purpose of the calendar was to record which saints' feast days were celebrated at the institution that used the manuscript: the names of the saints celebrated would be entered alongside the appropriate dates in the calendar. While major saints such as the apostles and evangelists were celebrated at all institutions, lesser saints were venerated only locally. The minor

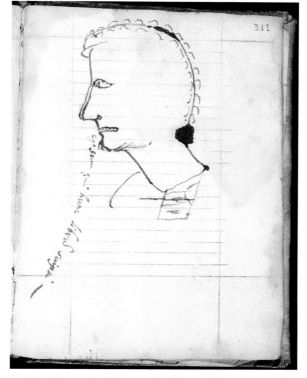

8-4 A self-portrait of a man who claims to have written this fifteenth-century copy of works of St. Jerome. The portrait is most likely a later addition. Newberry Library, MS 91, fol. 311r.

saints listed in a calendar can therefore furnish an important clue to the place of origin. For example, the page for July in the eleventh-century calendar of Cambridge, Trinity College, MS R.15.32, lists Sts. Grimbald, Hædde, and Swithun, all closely associated with Winchester, as well as St. Sexburga of Ely, whose cult was promoted at Winchester by Bishop Æthelwold (963–84); the manuscript can be attributed to Winchester on the strength of the Winchester connections in its calendar.[2] Often it is possible to determine from a calendar the religious order for which a book was made, as the saints most revered by the order (St. Dominic and St. Catherine of Siena for the Dominicans, St. Bernard for the Cistercians, etc.) would be accorded special prominence in the calendar. In late medieval calendars, the relative status of saints is typically indicated by the color in which their names are entered.

Appropriate caution must, however, be exercised in using calendars as evidence for manuscript origin, given that a manuscript might be produced in one center for use in another. In such cases, the producing center would specifically "customize" the manuscript to the requirements of the receiving center. The calendar then provides evidence not of the place of origin but of the institution for which the manuscript was intended. In the late Middle Ages, ecclesiastical institutions often obtained their manuscripts from nearby professional secular workshops rather than making them themselves. Newberry Library MS 75, an early-fifteenth-century lectionary made for the Carthusian monastery of San Lorenzo at Galluzzo, near Florence, offers a good example of this. The manuscript's Carthusian connection is established, among other things, by the high status that the calendar accords the feast days of St. Bruno, the founder of the Carthusian Order, and St. Hugh, bishop of Grenoble, who supported Bruno financially (see fig. 8-5). However, the character of the decora-

2. For a reproduction of the page for July from this calendar, see Simon Keynes, *Anglo-Saxon Manuscripts and Other Items of Related Interest in the Library of Trinity College, Cambridge*, Old English Newsletter, Subsidia 18 (Binghamton, NY, 1992), pl. 19.

8-5 Page for October, from the calendar of a lectionary made for the monastery of San Lorenzo at Galluzzo. The high status accorded to St. Bruno in the calendar (*Brunonis confessoris*, entered in red under October 6) indicates that the manuscript was made for a Carthusian community. Newberry Library, MS 75, fol. 5v.

tion of the manuscript indicates that it was made by professionals based in Florence, not by the monks of San Lorenzo.

For liturgical manuscripts that lack calendars, the presence within the body of the manuscript of texts for services in honor of lesser saints can offer valuable evidence for the place of origin. Thus Newberry Library MS 7, a twelfth-century missal, includes on folio 176r a set of texts for a mass in honor of St. Kilian, the first bishop of Würzburg, and his companions, a compelling indication that the manuscript originated within the diocese of Würzburg (see fig. 8-6). More specifically, there is evidence to indicate that the missal was made at or for the Cistercian abbey of Erbach, situated within the diocese. On folios 182v–183r, the text of the service commemorating the dedication of a church is placed within the manuscript's Sanctorale cycle between the texts for the feast of Sts. Marcellus, Apuleius, Sergius, and Bacchus (7 October) and those for the feast of St. Denis and his companions (9 October); it therefore commemorates a dedication that took place on 7, 8, or 9 October. This offers a powerful indication that the missal was made for the abbey of Ebrach, which was founded on 7 October 1134.[3] At some later point, however, the manuscript was transferred to the Cistercian abbey of Hohenfurt in Bohemia, where Kilian was not venerated, and the title heading the texts for St. Kilian's Day was then crossed out (see fig. 8-6), while masses were added in honor of saints venerated in Bohemia, including St. Wenceslas. Both the original and the added texts in the manuscript thus offer important evidence enabling the scholar to chart its history.

Presence of a Known Scribe

If the contents of a manuscript include no information that helps to establish its place

8-6 Page of a missal on which the rubricated title for the prayers for the feast of St. Kilian was crossed out after the manuscript had been transferred out of the diocese of Würzburg. Newberry Library, MS 7, fol. 176r.

3. See *Dictionnaire d'histoire et géographie ecclésiastiques* (Paris, 1912), 1:462.

of origin, it is still possible that its scribe—or one of its scribes if it was the work of a team—may have written another manuscript whose origin can be firmly attributed. In such circumstances, it is reasonable to suggest that the unattributed manuscript had the same place of origin, always bearing in mind, however, that some scribes worked for more than one institution in the course of their careers. A notable case of attribution on the evidence of scribal identity is offered by the manuscripts copied by the eleventh-century Anglo-Saxon scribe Eadwi Basan ("Eadwi the Fat"). Eadwi's hand has been recognized in a total of eleven manuscripts. In one of these, a Gospel book now in Hanover, he provides his name in a colophon and identifies himself as a monk but does not record where he worked. Another of his manuscripts is a psalter that includes a calendar with Canterbury associations. Eadwi was also the scribe of a charter recording a grant of land by King Cnut to Christ Church Cathedral Priory, Canterbury. Evidently Eadwi was a monk at Christ Church, and, barring contrary evidence, it is reasonable to assume that the other manuscripts in which his hand occurs originated in Canterbury.

"Dated" and "Datable"

Some manuscripts contain clear evidence of their date of origin. In considering such manuscripts, paleographers distinguish between those that are "dated" and those that are "datable." A dated manuscript is one that includes some clear statement of the date at which it was written. Such a statement may come in a colophon, which, as noted above, may record not only the year, month, and day but even the precise time at which the scribe finished copying. Sometimes a dating statement may occur within the body of the text: for example, in a historical text, a scribe will sometimes refer to an event and then comment that he or she is working in the same year that the event occurred. Datable manuscripts contain no such explicit statement about their date, but their contents include some form of evidence that points toward their date with greater or lesser precision. For example, the calendar in the psalter written by Eadwi Basan includes a reference to the feast of St. Alphege, archbishop of Canterbury, who died on 19 April 1012, but not to the feast of the translation of his relics from London to Canterbury, which occurred on 8 June 1023; given that the manuscript was made at Christ Church, Canterbury, where scribes would have immediately started to record the feast of Alphege's translation in any calendars they produced, the psalter is datable between 1012 and 1023. Sometimes it is not possible to say more than that a manuscript is datable before or after a certain year, leaving open how long before or after. In Newberry Library MS 7, a set of texts has been added for the feast day of Thomas Becket, who died in 1170 and was canonized in 1173 (see fig. 8-7). His cult spread quite rapidly throughout Western Europe. As the manuscript in its original form

8-7 The addition in the margin of this page of texts for the feast of St. Thomas Becket would have been made soon after 1173, the date of Becket's canonization. Newberry Library, MS 7, fol. 170r.

lacked texts for Becket's feast, it is datable before ca. 1173; the addition is datable soon after 1173.

Of course, many manuscripts are neither dated nor datable but can be dated only approximately through paleographical assessment of their script or art-historical assessment of the style of their decoration. The cautious scholar will naturally be wary of assigning anything more than an approximate date on such grounds. Scribes could have careers lasting several decades, and once a scribe's hand had become set, it would probably not change much over the course of his or her career; further, manuscripts produced in minor centers were more likely to be conservative in terms of their script than those produced in the major scriptoria. Neil Ker, one of the twentieth century's finest paleographers, emphasized that all assessments of the date of a script are no more than approximations and that when dating a manuscript on paleographical grounds, one should factor in a possible margin of error of a quarter century or so.[4]

4. See his comments in N. R. Ker, *Catalogue of Manuscripts Containing Anglo-Saxon* (Oxford, 1957), xx.

8-8 Radiographs of the "wheel of Tate"—the distinctive watermark (Briquet 6608) used by the first English papermaker, John Tate—demonstrating that two similar but not identical screens were used to make the paper. Newberry Library, Inc. 9708.

Watermarks

Watermarks are the emblems seen in relief when passing light through paper, the emblem itself being constructed of brass wire and then attached with finer wire to the papermaker's mold (see chap. 1). In the late Middle Ages, large numbers of manuscripts were written on paper; used with due caution, watermark evidence can assist in establishing the date and place of origin of paper manuscripts.[5] For example, in a region where paper mills were plentiful, such as Italy or France, a manuscript whose leaves bear the watermark of a known mill may reasonably be assumed to have originated in a center located not far from that mill, provided other evidence does not contradict this. Some regions, however, had no or few mills of their own and had to import their paper from far afield; the paper of English manuscripts, for example, tended to come from France or the Low Countries, so the watermarks in English manuscripts can assist little in establishing their place of origin. Watermarks can play a role in dating manuscripts because papermakers frequently changed their watermarks, with the result that a particular mark had a limited life. The French scholar C. M. Briquet, who did so much to establish the scientific study of watermarks, suggested that if a manuscript contained paper with a watermark known from other evidence (for example, a dated letter) to have been in use in a particular year, it was reasonable to assume that the manuscript was written no more than fif-

teen years before or after that year. Briquet's monumental four-volume survey of watermarks in use between ca. 1282 and 1600 includes reproductions of literally tens of thousands of different marks, with Briquet's notes on dated documents exhibiting each mark.[6]

Allan Stevenson, in a now famous essay, demonstrated that papermakers habitually used two papermolds at a time in order to increase their rate of production and that paper made from these two molds could, in almost every case, be distinguished by careful observation of the watermarks.[7] Thus, two apparently identical watermarks in a manuscript or printed book may in fact be merely similar, designed to look alike but made from two different molds. There were several circumstances that might account for differences between these twin watermarks: subtle differences in manufacture, repairs made to one or both emblems, differences in placement of the emblem on the mold (centered on chain-lines or not, for example), and so on. Stevenson presented a sophisticated system of measurements to identify and isolate these twin watermarks that took into account the size of the emblem, the spacing of chain- and laid-lines, and the relationship of chain- and laid-lines to the emblem itself. When studying and recording watermarks, it is important to note such details, as

5. For a fuller discussion and important caveats to dating by watermark, see David Landau and Peter Parshall, *The Renaissance Print: 1470–1550* (New Haven, 1994), 17–19.

6. C. M. Briquet, *Les filigranes: Dictionnaire historique des marques du papier dès leur apparition vers 1282 jusqu'en 1600*, 4 vols. (Paris, 1907).

7. Allan H. Stevenson, "Watermarks Are Twins," *Studies in Bibliography* 4 (1951–52): 57–91. See also Stevenson's "Paper as Bibliographical Evidence," *The Library*, 5th ser., 17 (1962): 197–212.

well as visual features such as deformities in the emblem, its reversal or signs of repair, points of light that indicate where the emblem was sewn onto the mold, etc. The watermarks reproduced here (fig. 8-8) are from a fragment of Jacobus de Voragine's *Legenda aurea* printed at Westminster by Wynkyn de Worde, dated 8 January 1497, on paper made by John Tate. While at first sight these marks may look identical, they are in fact different: if one counts the chain-lines, it emerges that these sheets were made from two different molds.

Perhaps the most famous use of watermarks to date production was Allan Stevenson's own contribution to the controversy over the first printed book. Several nineteenth-century German scholars had argued that Gutenberg's *Missale speciale* (also known as the *Constance Missale*) predated his Bible and should therefore be known as the first printed book. Using watermarks that he found in a Strasbourg printed book that could be dated from the 1470s, Stevenson was able to argue that the *Missale speciale* could not have been printed long before 1470.[8]

Accurately capturing and reproducing watermarks for the benefit of scholars has been a problem from Briquet's time onward. Initial reproductions were simply sketches or tracings of the marks. Sketches often did not exactly match the scale of the original marks, and neither technique reproduced the chain- and laid-lines, knowledge of the exact positioning of which is necessary for detailed analysis. More accurate images can be produced by radiographs that use beta radiation to take a picture of the structure of the paper. This technique gives a very clear image of the emblem and chain-lines and hides the text on the page, which often distracts from the clarity of the marks. However, the technique is expensive and potentially dangerous because radioactive materials are involved. A less costly and safer method is the use of Dylux, a photosensitive paper manufactured by DuPont. When exposed to ultraviolet light, it changes from yellow to blue; when exposed to visible light the coating turns white, and the medium no longer reacts to the ultraviolet light. One is left with an image of the watermark, but it may be obscured by the print on the page. Using digital filtering (such as those filters in Adobe Photoshop), one can manipulate the image to reduce the background "noise" and produce a clearer impression of the watermark, and no doubt emerging technologies will be able to isolate the watermarks and chain-lines without danger to the operator or interference from text on the page. There are at present several projects devoted to digitally reproducing and cataloguing medieval and early modern watermarks.

Fakes and Forgeries, Medieval and Modern

From medieval times onward, individuals and institutions have sometimes sought to make manuscripts appear to be older than they really are. Paleographers draw a distinction between "fakes," created with no dishonest intention, and "forgeries," where there is a clear intention to deceive. Fakes occurred when, for example, a part of a manuscript became damaged and a scribe replaced it by rewriting the damaged text not in his own script but in one imitating that used in the original manuscript. Such fakes are easily detected, for medieval scribes who attempted to imitate earlier forms of script almost always gave themselves away by reverting to habits that came all too naturally to them but were out of place in the scripts they were imitating. For example, in MS 57, from Cambridge, Corpus Christi College, an eleventh-century scribe attempted to replace three leaves (fols. 8, 19, and 22) in a late-tenth-century copy of the *Rule of St. Benedict*; although he made a valiant attempt to imitate the Square Minuscule script of the original, his own letter forms are significantly more rounded than those of the original scribe, and on several occasions he forgot himself and employed the Caroline minuscule forms of *a*, *g*, and *r*, whereas the original scribe had used the traditional Insular forms of these letters.[9] Similarly, when, in the late fifteenth century, the professional scribe Jacques Neell was asked to replace a damaged quire at the beginning of an Anglo-Saxon Bible owned by Christ Church, Canterbury (London, British Library, MS Royal 1 E. vii), he gave himself away by consistently using rounded *s* rather than tall Caroline *s* at word endings and by the forward ductus of his *f* and *s*: both features offer proof of a fifteenth-century date. Neell also ruled his leaves in ink, omitting to imitate the drypoint ruling of the original leaves.[10]

The type of document most subject to forgery in the Middle Ages was the charter. Some forged charters no doubt represented an attempt to replace genuine documents that had been lost or destroyed, but in many cases they were the result of efforts by institutions (commonly, ecclesiastical or monastic institutions) to establish a bogus claim to land or to demonstrate that a piece of land had been given to them much earlier than was truly the case. Although such forgeries may have deceived medieval audiences, they reveal themselves for what they are both on paleographical grounds—with the forging scribe

8. Allan H. Stevenson, *The Problem of the Missale Speciale* (London, 1967). For an excellent summary of Stevenson's publications and the debate over the *Missale speciale*, see Paul Needham, "Allan H. Stevenson and the Bibliographical Uses of Paper," *Studies in Bibliography* 47 (1994): 23–64.

9. See Timothy Graham, "Cambridge, Corpus Christi College 57 and Its Anglo-Saxon Users," in *Anglo-Saxon Manuscripts and Their Heritage*, ed. Phillip Pulsiano and Elaine M. Treharne (Aldershot, U.K., 1998), 21–69, at 29–30 and pl. 4.

10. See M. B. Parkes, "Archaizing Hands in English Manuscripts," in *Books and Collectors 1200–1700: Essays Presented to Andrew G. Watson*, ed. James P. Carley and Colin G. C. Tite (London, 1997), 101–41, at 111 and pl. 10.

falling into the kinds of errors described above—and, often, through aspects of their content. The charter might, for example, include legal terminology that did not come into use until well after the date to which the charter purports to belong (see also the section "Medieval Forgery" in chap. 14). The part of a charter that frequently proved the most difficult to forge successfully was the witness list, the roll call of names at the end of the document listing those individuals present at the original grant and noting their status or office. Because forgers generally did not have access to records attesting to the exact dates at which bishops, abbots, and others held office, many forged witness lists include the names of individuals whose tenures of office did not overlap and who therefore could not have simultaneously witnessed the purported grant.

In modern times, given the high price that medieval manuscripts have long commanded on the market, it is perhaps not surprising that unethical individuals have attempted to create forgeries and pass them off as genuine or to doctor the appearance of genuine manuscripts to make them appear more complete and thus fetch a higher price. Some notorious forgers were, for a time, spectacularly successful, none more so than the "Spanish Forger," active in Paris ca. 1900 and responsible for some two hundred forged manuscript illuminations and panel paintings. The same methods used for dating and localizing a manuscript can assist in determining whether or not a manuscript is a modern forgery, but if the forger was careful, it can be extremely difficult to determine whether or not certain documents are in fact authentic (that is, that they are what they purport to be). Some have suggested carbon-dating the parchment or using chemical spectroscopy to determine if the inks of suspected forgeries contained compounds not available before the nineteenth or twentieth centuries. While this would certainly work to establish a document's lack of authenticity (if the parchment or inks postdated the supposed creation of the document), it cannot prove its authenticity if the forger was careful to use parchment from medieval books or inks prepared in the medieval manner. At present, most techniques for dating parchment and chemically analyzing inks are in some measure destructive to the materials or require equipment that is extremely expensive; and even the most sophisticated forms of analysis may prove inadequate to convince in especially problematic cases. Among these, none is better known than that of the Vinland map, MS 350A in the Beinecke Rare Book and Manuscript Library of Yale University. Purporting to be the first map to show part of the northeastern coastline of the New World and to date from ca. 1440—some fifty years before Columbus's voyage—the Vinland map has not ceased to stir the strongest of passions since it came to public attention in the 1950s. While carbon-14 dating has indicated that the parchment on which the map is drawn dates to the fifteenth century, chemical analysis of the ink has revealed the presence of titanium dioxide, the synthetic form of which was not developed until the 1920s; this has persuaded some that the document has to be a twentieth-century forgery, while others have pointed to the presence of naturally occurring titanium traces in late medieval maps whose authenticity is not in doubt. Ultimately, the furor over the Vinland map may be resolved not by advanced technological analysis but through more rigorous examination of some problematic paleographical and linguistic inconsistencies in its inscriptions.[11]

EVIDENCE FOR ESTABLISHING MANUSCRIPT PROVENANCE

Ownership Inscriptions

Ownership inscriptions that institutions entered in their books are among the best forms of evidence for establishing manuscript provenance. Although such inscriptions can be found from as early as the ninth century, they did not become common until the twelfth century. They frequently begin with the words "Liber de" (The book of), followed by the name of the institution to which the book belonged; for example, "Liber de claustro Roffense" (The book of the monastery of Rochester). Often, the institution was identified by naming the saint to whom it was dedicated, as in the inscription at the front of Newberry Library MS 12.1: "Liber sancte Marie Radyng'. . . " (The book of [the abbey of] St. Mary, Reading . . . ; see fig. 8-9). The ownership inscription was normally entered at the beginning of the manuscript, on a front endleaf or in the upper or lower margin of the first page of text. It might also be written on the binding of the book, as has happened in Newberry Library MS 8, a twelfth-century copy of patristic texts from the Benedictine abbey of Admont in Austria (fig. 8-10). In this case, the inscription appears inside the back cover, written on the leather turn-in of the cover: "Iste liber pertinet ad sanctum Blasium in Admund" (This book belongs to [the monastery of] St. Blasius in Admont).

The inscriptions in both MS 12.1 and MS 8 have a second clause, respectively "quem qui alienauerit anathema sit" and "si quis abstulerit anathema sit," cursing anyone who should steal the book. Many medieval ownership inscriptions end with such a curse, and in almost all cases the curse includes the formula "anathema sit" (cursed be). These curses occasionally reached high points of vindictiveness, as in the one entered by Jean de Flixécourt in a thirteenth-century liturgical collection from the abbey of Corbie (Paris, Bibliothèque nationale de France, MS lat. 13222): "Quem qui furatus fuerit seu maliciose abstulerit,

11. See especially R. A. Skelton et al., *The Vinland Map and the Tartar Relation* (New Haven, 1965) (the second edition, 1995, incorporates some new material), and Paul Saenger, "Vinland Re-Read," *Imago Mundi* 50 (1998): 199–202.

anathema sit, et cum Iuda traditore Domini et cum Iuliano apostata, cum his etiam qui dixerunt Domino Deo; Recede a nobis, scientiam viarum tuarum nolumus, in districti iudicii die recipiat porcionem. Fiat, fiat. Amen" (Cursed be he who steals this book or maliciously removes it, and on the Day of Judgment may he receive what is due to him along with Judas the Lord's betrayer, and Julian the Apostate, and with those who said to the Lord, "Depart from us, we desire not the knowledge of thy ways" [Job 21:14]. May it be so, may it be so. Amen).[12]

Many manuscripts that formerly had ownership inscriptions have now lost them, either because they were entered on an endleaf that was subsequently cut out or discarded at a rebinding or because they were erased by a subsequent owner who wished to efface the record of the previous owner. If sufficient traces of ink remain in such erased inscriptions, they can often be read when viewed under ultraviolet light.

Coats of Arms

Most surviving medieval ownership inscriptions name an institution rather than an individual, both because (at least in the early Middle Ages) many more books were owned by institutions than by individuals and because books owned by institutions had a better chance of being preserved than books owned by individuals. In the late Middle Ages, however, laypeople in ever greater numbers started to compile their own libraries. Especially in the fifteenth and sixteenth centuries, lay patrons (and some prominent churchmen) who commissioned manuscripts would often have their coats of arms entered in the manuscripts as marks of their ownership (see fig. 8-11). Provided that the coat of arms is identifiable, the name of the owner, or at least of the family to which he or she belonged, can be established. Coats of arms normally occur on a page at the front of the manuscript, either in the lower margin or incorporated into the lower border of the decoration. If a manuscript changed hands, the new owner might erase the coat of arms of the former owner and replace it with his or her own, as has happened in Newberry Library MS 90, a mid-fifteenth-century copy of Aulus Gellius's *Noctes Atticae* in which the silhouette of an earlier, now largely erased coat of arms is clearly visible beneath the arms of a member of the Finardi family of Bergamo (fig. 8-12).

Library Shelfmarks

If a manuscript lacks an ownership inscription, it may nonetheless have a library shelfmark that will help to identify its medieval owner. Shelfmarks were normally entered at the top or bottom of a leaf at the front of the manuscript; sometimes they also appear at the end. Institutions

8-9 Ownership inscription of St. Mary's Abbey, Reading, added in the upper margin of the first leaf of this twelfth-century manuscript. Newberry Library, MS 12.1, fol. 1r.

8-10 Ownership inscription of St. Blaise, Admont, entered on the turn-in of the back cover of a collection of patristic texts. Newberry Library, MS 8.

differed from one another in the forms that they gave their shelfmarks (those for St. Augustine's Abbey, Canterbury, and for Dover Priory are described in chapter 4). Further, it was often a single individual—no doubt the librarian—who took it upon himself to enter shelfmarks in large numbers of the books belonging to a particular institution, and these individuals often had quite distinctive, easily recognizable hands. If the shelfmark in a manuscript whose provenance is otherwise unknown corresponds in form and in the character of its script to the shelfmarks of a known institution, ownership of the manuscript may be attributed to that institution. Some manuscripts may have two different library marks in them that may chart their movement from one institution to another. Such is the case with a late-eleventh-century copy of the *Life of St. Dunstan* by Osbern, precentor of Christ Church Cathedral Priory, Canterbury (London, British Library, MS Arundel 16): two library marks, respectively entered at the top of

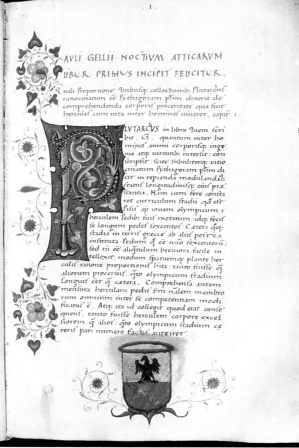

8-11 Three unidentified coats of arms on the first page of a fifteenth-century Italian collection of religious texts. Newberry Library, MS 105, fol. 1r.

8-12 Aulus Gellius, *Noctes Atticae*, with the arms of a member of the Finardi family entered over the erased arms of an earlier owner. Newberry Library, MS 90, fol. 18r.

the first leaf and the bottom of the second leaf, reveal that it first belonged to Christ Church and was then transferred to Dover Priory, a daughter house of Christ Church.[13]

Entries in Medieval Library Catalogues

Many medieval institutions drew up catalogues of their library's holdings, and many of these catalogues have survived to the present day.[14] They differ greatly in their degree of detail, with those from the later Middle Ages tending to include more information. Thus whereas a twelfth-century catalogue may list only the author and title of the main item in a manuscript, a fourteenth-century catalogue may provide a detailed listing of all the items, citing the opening words of each or at least of the first item and noting the shelfmark of the manuscript. Late medieval catalogues also frequently noted the word(s) with which the second leaf of a manuscript began, this being a helpful means of distinguishing between two copies of the same text (it was unlikely that exactly the same amount of text would be entered on the leaf of two different manuscripts of the same work, so their second leaves would begin with different words). Sometimes an otherwise unprovenanced manuscript will correspond with an item listed in a catalogue because, for example, its miscellaneous textual contents agree with those in the catalogue listing, its shelfmark agrees with that noted in the catalogue for a manuscript listed as having the same contents, or the words with which its second leaf begins correspond with those cited in the catalogue. Catalogue entries may be numbered, and sometimes the catalogue number for a manuscript has been entered in the manuscript itself, as has happened in Newberry Library MS 102.5, a mid-fifteenth-century copy of the letters of St. Jerome (fig. 8-13). Above the ownership inscription of the abbey of Santa Giustina, Padua, on the last page of the manuscript is (on the right) the shelfmark "B 15" and (on the left) the number "325,"

13. See Mildred Budny and Timothy Graham, "Dunstan as Hagiographical Subject or Osbern as Author? The Scribal Portrait in an Early Copy of Osbern's *Vita Sancti Dunstani*," *Gesta* 32/2 (1993): 83–96, at 85–86 and figs. 1, 2.

14. The Corpus of British Medieval Library Catalogues project is in the process of publishing all surviving medieval library catalogues from the British Isles. The volumes are published by the British Library in association with the British Academy.

> teſ in remiſſionem peccatorum baptizandoſ in ſimilitudinē pre
> uaricationiſ adam. Ǫ ſi iniuſta uobiſ uidetur alienorum remiſ
> ſio peccatorum qua non indiget qui peccare non potuit. tranſi
> te ad amaſium ueſtrum qui preterita in celiſ et antiqua delic
> ta ſolui dicit in baptiſmo. ut cuiuſ in ceteriſ auctoritate duci
> mini: etiam in hac parte errorem ſequamini :—

<div align="center">

÷ EXPLICIT ÷

</div>

> iſte liber ē monachorum congregacioniſ ſcē Iuſtine ipſi moaſterio ſcē Iuſtine
> deputatuſ

8-13 This ownership inscription of the abbey of Santa Giustina, Padua, includes the shelfmark *B 15* (to the upper right of the inscription) as well as a reference (upper left) to the listing of the manuscript in the abbey's library catalogue, in which it is no. 325. Newberry Library, MS 102.5, fol. 284v.

which corresponds to the numbering for this manuscript in Santa Giustina's fifteenth-century library catalogue (Padua, Museo Civico, MS B.P. 229). Catalogue entries may also allow the modern scholar to detect textual loss in a manuscript when other evidence for such loss is lacking. For example, the fourteenth-century catalogue of Dover Priory—in many respects a model catalogue—provides a detailed description of the *Life of St. Dunstan* manuscript mentioned above and establishes that originally the manuscript contained three additional hagiographic texts that have now disappeared from it and whose former presence might otherwise not have been suspected.[15]

Evidence of Added Texts, Glosses, and Notes

Most manuscripts acquired various forms of additions after they had been completed. Such additions might include entire texts, pen trials, or doodles added in originally blank areas such as margins and endleaves; added glosses to the original text; and annotations drawing attention to or commenting on particular passages of text. Such additions can sometimes help to establish the whereabouts of the manuscript at the time they were made.

For example, in the early medieval period, scribes in many monastic institutions would enter on available blank leaves in their Gospel books, or in other manuscripts kept within the church, copies of important documents such as charters granting land to the institution. This was a means of enshrining the grant. As the institution would be named in such documents, they provide evidence for the owner-

ship of the manuscript at the time they were entered into it. It is because of just such a document that the Gospels of St. Augustine of Canterbury (Cambridge, Corpus Christi College, MS 286), a manuscript that may well have been brought to England at the time of St. Augustine's mission in 597, is known to have been owned by St. Augustine's Abbey at least as early as the tenth century, when a copy of a will granting land to the abbey was added to a leaf originally left blank between the gospels of Matthew and Mark. Liturgical manuscripts quite often received other types of additions that can attest to their provenance. Thus if a liturgical manuscript moved from one institution to another, new texts (hymns, prayers, masses, etc.) might be added in honor of those saints venerated by the new owner, as happened in the case of Newberry Library MS 7 after it moved to the abbey of Hohenfurt in Bohemia (see above, "Evidence within the Contents"). Sometimes an apparently insignificant doodle can be an indicator of the provenance of a manuscript. A copy of the *Hexameron* of St. Ambrose made in northern France ca. 800 (Cambridge, Corpus Christi College, MS 193) includes in the outer margin of its last page the added note, "Sanctus sebas" (a truncated reference to the Roman martyr, St. Sebastian), written in a ninth-century hand (fig. 8-14). This note has no connection with the text on the page and there is at first sight no obvious reason why anyone should have written it. The paleographer T. A. M. Bishop believed there must be a connection with the fact that relics of St. Sebastian were translated to the city of Soissons in northern France ca. 825; he suggested that at the time the note was entered, the manuscript must have belonged to a monastery in Soissons and that the note was prompted by heightened interest in the saint following upon the translation. Bishop's suggestion was subsequently vindicated when examination of the manuscript under ultraviolet light revealed an erased ownership inscription of

15. See Budny and Graham, "Dunstan as Hagiographical Subject?" 86–87. The Dover catalogue of 1389 (Oxford, Bodleian Library, MS Bodley 920) has been edited by William P. Stoneman, *Dover Priory*, Corpus of British Medieval Library Catalogues 5 (London, 1999). See also the discussion of this catalogue in chapter 4.

8-14 The added note *Sanctus sebas* in the left margin helps to establish the ninth-century provenance of this manuscript. Cambridge, Corpus Christi College, MS 193, fol. 170v.

8-15 This tenth-century copy of King Alfred's translation of Gregory the Great's *Regula pastoralis*, which otherwise has no established provenance, has numerous glosses by the "Tremulous Hand" of Worcester. Cambridge, Corpus Christi College, MS 12, fol. 3r.

the abbey of Saint-Médard, Soissons, the very abbey to which the saint's relics were transferred.[16]

Even if the content of the additions to a manuscript provides no indication of provenance, sometimes the hand in which additions are entered is recognizable as that of a scribe known to have been active at a particular institution. For example, some twenty manuscripts of the Anglo-Saxon period have glosses or notes that were added in the thirteenth century by a reader known to scholars as the "Tremulous Hand" because of the unusual quivery character of his script, the result probably of some disease of his nervous system (see fig. 8-15). Evidence in several of these manuscripts demonstrates that they originated at or at least belonged to Worcester Cathedral Priory. It is therefore reasonable to assume that those otherwise unprovenanced manuscripts in which the Tremulous Hand's glosses occur belonged to Worcester Cathedral in the thirteenth century, when he was at work. Other additions that may be recognizable and help to establish provenance include particular forms of *nota* marks or *maniculae*, that is, the sketches of pointing hands that late medieval readers often entered in the margins of manuscripts to draw attention to passages of particular interest (see chap. 3). For example, a late medieval annotator at Christ Church, Canterbury, used a form of *nota* mark that modern scholars have likened to an ice-cream cone lying on its side; manuscripts in which this mark occurs can be presumed to have belonged to Christ Church.[17] Thus, even when a manuscript bears no obvious indicator of its provenance, careful examination of a variety of features may reveal compelling evidence for its history of ownership.

16. See Mildred Budny, *Insular, Anglo-Saxon, and Early Anglo-Norman Manuscript Art at Corpus Christi College, Cambridge*, 2 vols. (Kalamazoo, MI, 1997), 1:125.

17. On this mark, see Neil R. Ker, "Membra Disiecta, Second Series," *British Museum Quarterly* 14 (1939–40): 79–86, at 85n1. The mark is reproduced in Ker's *English Manuscripts in the Century after the Norman Conquest* (Oxford, 1960), pl. 7.

CHAPTER NINE

Manuscript Description

VERY MANUSCRIPT is unique. It is therefore vital, when examining a manuscript, to record accurate information about it, both to preserve the information for oneself and so that it can be transmitted to others who may wish to know about the manuscript. This chapter briefly outlines which textual and physical features of a manuscript should be recorded and describes the conventions that have evolved for succinctly noting these characteristics. A knowledge of the conventions not only is helpful for preparing one's own descriptions but will also facilitate the reading of the information presented in modern catalogues of manuscripts. Although the science of manuscript description made great strides during the twentieth century, this has not been without its complications. Whereas the typical problem with many nineteenth-century catalogues—such as the early volumes in the long series *Catalogue général des manuscrits des bibliothèques publiques de France*—is that they present much less information than the modern scholar requires, the modern catalogue often presents a wealth of information that the inexperienced reader may not know how to interpret.

A good description of a manuscript must necessarily meet the needs of several different types of scholars. Textual scholars, for example, will want precise information about the various texts that a manuscript contains. A description of the contents of a manuscript should therefore list every separate text within the manuscript and should provide not just a citation of the title of each item but also a record of the item's opening words and, ideally, its closing words also. The scholar will then be able to check and confirm the identity of the text by reference to a printed edition and, if the description has included the closing words, will know whether the manuscript has a truncated or a complete copy of the text. It is important to transcribe the title and the opening and concluding words exactly as they are in the manuscript and not to emend silently any apparent errors, orthographical or other: features of the wording and spelling may provide vital clues to the origin of the manuscript or to the textual family to which it belongs. Art historians consulting a manuscript description will be interested in the extent and the nature of a manuscript's decoration and illustration; a good descrip-

tion must therefore note the presence and character of any decorated initials and illustrations. Scholars whose concerns are primarily paleographical and codicological will require precise information about physical characteristics of the manuscript such as the dimensions of the pages, the dimensions of the written area, the number of lines to the page, the structure of the quires (known as the *collation*), the character of the script, the nature of the binding, and so on.

To meet these various scholarly needs, a good description typically includes an itemized list of the contents followed by one or more paragraphs covering the physical characteristics and what is known of the history of the manuscript. The guidelines below cover the conventions by which these aspects of the manuscript are normally described.

LISTING THE CONTENTS

The texts in a manuscript should be numbered and listed one by one, in the order in which they occur in the manuscript. In each case, the listing should begin by noting the page span of the item. This is normally done by simply citing the pages on which it begins and ends, for example, "fols. 1r–12v." A more detailed listing, however, will also include the line numbers for the beginning and ending of the item, adding those numbers directly after the folio numbers: for example, "fols. 1r1–12v22" means that the item begins in the first line of folio 1r and ends in line 22 of folio 12v. If the pages of the manuscript are divided into more than one column, it is normal to refer to columns by lowercase letters of the alphabet; thus, in a two-column manuscript, *a* refers to the left column on each page, *b* to the right column. When noting the span, the scholar should cite the column between the folio number and the line number, for example, "fols. 1ra1–12vb22."

Next, if the item has a title in the manuscript, the title should be quoted exactly as the scribe wrote it, for the reasons noted above. If there are obvious grammatical or orthographical errors and one feels the need to note the fact, *sic* may be added in parentheses or brackets after the offending word or phrase: for example, "Homilia de ascesione [*sic*] domini." This will inform the reader

that the error is indeed a feature of the manuscript, not a typographical error in the description. Abbreviated words in the manuscript may be expanded silently, or the missing letters may be supplied in italic font or within parentheses (many modern catalogues expand silently). It is likely that the title will be rubricated in the manuscript. This is often shown in catalogues by printing the title in bold font or by adding "(in red)" at the end of the quoted title.

The listing should continue by quoting the opening words of the item, again preserving any errors there may be. Sufficient words should be quoted to enable accurate identification of the text; it is generally worthwhile to quote a complete clause. As noted above, it can also be most helpful to quote the closing words of the item, placing an ellipsis between the opening and closing words, thus: "Dicebat uero sanctus Fulgentius iuxta regulam patrum uiuere stude . . . sectatores suos perducunt ad celi palatia. Amen." Next, the listing should be completed in a new line that includes the name of the author of the text (if known), the accepted modern title for the work, and a reference to the best available modern edition. In order to provide this information, the cataloguer must verify the identity of the text. In cases where it is adequately identified by the manuscript title, this will be straightforward. It can be more problematic when the manuscript title is inadequate or inaccurate, or when dealing with a fragmentary text that has no title in the manuscript. In such cases it is necessary to conduct a search to establish the identity. This used to be a difficult and challenging task: it was necessary to rely on memory, experience, intuition, and, if one was lucky, on a word concordance of the kinds that have been produced for the Bible and for certain major authors such as Thomas Aquinas. Today, electronic databases such as the CETEDOC Library of Christian-Latin Texts or Chadwyck-Healey's Patrologia Latina Database make it possible to type in a string of three or four words and find the text in a matter of seconds. Of course, experience still helps: even the newest databases cover only a portion of all the texts found in manuscripts. Having identified the text, the cataloguer needs to locate the best modern edition. Often, for Latin texts, this will mean referring to the appropriate volume of one of the major series of editions, such as Migne's Patrologia Latina (Pat. Lat./PL) or the two series currently in course of publication by Brepols, Corpus Christianorum Series Latina (CCSL) and Corpus Christianorum Continuatio Mediaevalis (CCCM). Then, with the listing for the item complete, one can move on to the next item, treating it in exactly the same way.

The following example demonstrates how, following these guidelines, the first three items of a hypothetical homiletic manuscript would be listed.

1. fols. 1r1–4r12. Homilia de resurrectione domini nostri Iesu Christi (in red). Passionem uel resurrectio-

nem domini et saluatoris nostri Iesu Christi . . . et hominem quem fecerat liberauit. Amen.
Pseudo-Augustine, *Sermo 160*. Pat. Lat. 39:2059–61.

2. fols. 4r13–6v8. Alia homilia de eodem (in red). Gaudete, fratres karissimi, quia redentionis [*sic*] nostre precium persolutum est . . . ut ad eterni sponsi thalamum peruenire mereamur prestante domino nostro.
Caesarius of Arles, *Sermo 203*. Ed. G. Morin, CCSL 104:817–19.

3. fols. 6v9–10v14. Incipit homilia sancti Gregorii in festiuitate sancti angeli Michaelis (in red). Angelorum quippe et hominum . . . quia per charitatem spiritus ab alio in aliis habentur.
Gregory the Great, *Homiliae in evangelia*, 34. Pat. Lat. 76:1249–55.

RECORDING THE PHYSICAL CHARACTERISTICS

The physical characteristics of a manuscript that a good description should aim to record include the following: material of the writing supports (parchment or paper), number of leaves, collation, size of leaves, size of the written area on an average page, number of lines per page, type of script used for the main text (with a note of the number of scribes involved in the copying of the text), character and location of the decoration, binding. In published catalogues, the order in which these features are noted varies from one catalogue to another, although the order given above is fairly typical. Occasionally a description may also note how the hair- and flesh-sides are disposed within the quires (it is more important to include this information for early manuscripts); this information is often given after the collation. Some descriptions identify the medium of the ruling (drypoint, plummet, or ink) and comment on the character of the rubrication, noting its color (red, orange-red, or some other color or combination of colors) and the type of script used, if different from the main text script.

When noting the number of leaves, it is important to distinguish between medieval leaves and added modern leaves that the manuscript will have at the beginning and end if it has been rebound in modern times (as most manuscripts have). Arabic numerals should be used to indicate the number of medieval leaves, lowercase roman numerals for any modern leaves. Thus, if the number of leaves is cited as "ii + 162 + ii," that means that the manuscript has a pair of modern endleaves at each end, with 162 medieval leaves between them. If the manuscript includes at one or both ends one or more added medieval endleaves that do not form part of the first or last quire of the original manuscript, they are noted in the appropriate place in arabic numerals. For example, "ii + 1 + 162 + 1 + ii" would

mean that at either end of the manuscript there is an added medieval endleaf between the main part of the manuscript and the pairs of modern endleaves.

The description of the collation of the manuscript should inform the reader how many leaves there are in each quire and what the structure of each quire is. Many manuscripts consist entirely, or almost entirely, of regular quires of eight or ten leaves (four or five bifolia). If a manuscript included fifteen quires, each of which contained four bifolia folded to make eight leaves, this would be expressed in the collation as "I–XV8." If the first six quires contained four bifolia and the remaining nine quires five bifolia each, this would be expressed as "I–VI8, VII–XV10." As noted in chapter 4, it is not uncommon for a quire to include two single leaves in place of a bifolium; in an eight-leaf quire, the two single leaves would normally be placed as the second and seventh or third and sixth leaves in the quire. A good collation will take note of such quires and will record the position of the single leaves. If, for example, a manuscript has fifteen quires of eight leaves each, with fourteen of the quires comprising four bifolia but with the ninth quire including two single leaves placed in third and sixth positions, this would be expressed as "I–VIII8, IX8 (3 and 6 are half-sheets), X–XV8." Occasionally a quire will include one or more extra leaves added by the scribe; typically this might occur at the end of a manuscript, when a scribe found that a quire of regular size was insufficient to complete the copying of the text and deemed it preferable to increase the size of the last quire rather than to begin a new quire. Normally, such extra leaves would be added not at the very end of the quire, where they might easily become detached, but somewhere within the quire. The collation should note the presence of such extra leaves by recording where in the quire they are placed. For example, if the fifteenth quire in a manuscript consists of four bifolia with an additional leaf inserted after leaf 6, this would be expressed as "XV8 + 1 after 6." It also happens not infrequently that one or more leaves that originally belonged to a quire were subsequently removed from it. This might happen at the end of the manuscript if the scribe began with a quire of, say, eight leaves, found that only six were necessary to complete the text, and left the last two leaves blank; later, someone requiring the parchment might cut out those two leaves. When a quire is missing leaves that originally belonged to it, the collation should note the fact and record the position within the quire that the leaves originally occupied; thus "XV8 (wants 7, 8)" would mean that the fifteenth quire originally contained eight leaves of which the seventh and eighth were subsequently removed.[1]

Because the way in which the hair- and flesh-sides of parchment leaves were arranged varied in the early medieval period, with Insular scribes favoring one arrangement and continental scribes another (see the section "Preparations Prior to Writing" in chap. 1), descriptions of early manuscripts often follow the collation with a reference to the disposition of the hair- and flesh-sides. Such a note may be in the form "hair outside all sheets" (the typical Insular arrangement); or "like surfaces facing, with hair outside the first sheet" (the typical continental arrangement). Alternatively, a shorthand method of reference may be used. A popular method uses the formula "HF'HF" to denote the typical Insular arrangement, "HF'FH" to indicate the normal continental arrangement. The formulas give the disposition of the first two leaves of the quire and imply that the rest of the quire follows suit. Thus, "HF'HF" means that the first leaf has hair-side on the recto and flesh-side on the verso and that the second leaf is similarly disposed; "HF'FH" means that the first leaf has hair-side on the recto and flesh-side on the verso, while the second leaf has flesh-side on the recto and hair-side on the verso. It is worth noting here that some Insular manuscripts, or some quires within Insular manuscripts, do exhibit the arrangement "FH'FH"; that Insular scribes switched to the typical continental arrangement in the late tenth/early eleventh century; and that late antique and humanist manuscripts frequently exhibit the arrangement "FH'HF." It is rare for the method of arranging hair- and flesh-sides to vary within a single manuscript, but this does occur on occasion; when it does, the fact should be duly recorded with a note stating which quires follow which arrangement.

Dimensions of leaves and of written area should be given in millimeters and should cite height before width. Thus, if the size of the leaves is given as "278 × 173 mm," that means that the leaves are 278 mm high by 173 mm wide. Because the leaves of almost all manuscripts have experienced a certain amount of trimming around the edges at rebindings, it is important to remember that the dimensions given in a description record only the present extent of the leaves, not their original size. Many paleographers find it more useful to know the size of the area of the page on which text was entered, and a good description will record this information following the note about leaf size. Almost certainly, the size of the written area will exhibit slight variations in the course of a manuscript; an "average" page should therefore be selected for measurement (and if different parts of the manuscript have significantly different written areas, the dimensions of each different area should be recorded, with a note of the folio spans on which they occur). Some cataloguers record the height of the written area by measuring from the top ruled horizontal line to the bottom ruled horizontal line and the width

1. This paragraph has covered the most commonly occurring characteristics of quires but not every possible configuration. For a discussion of further aspects of quire structure and the ways to note them, see N. R. Ker, *Catalogue of Manuscripts Containing Anglo-Saxon* (Oxford, 1957), xxii.

by measuring from the left ruled margin to the right ruled margin. Others view the height as being the measurement from the top of the minims in the first line of text to the bottom horizontal line, and the width as the measurement from the left to the right edge of the text (the right edge will often extend somewhat beyond the ruled margin). Still others may measure the height as the distance between the tops of the ascenders in the first line and the bottoms of the descenders in the last line. Because the method by which the measurements are made will affect the recording of the dimensions by a matter of several millimeters, it would be helpful if cataloguers would describe their method in the introduction to their catalogues, but for the most part they do not.

Further details about the entering of the text should follow the record of the dimensions of the written area. First should come a note about the number of lines per page. "27 long lines" would mean that the manuscript is in single-column format and that each page has twenty-seven lines. (Sometimes the number of lines will vary from one part of a manuscript to another; in such cases, the number of lines per page should be noted for each part, along with the folio spans of the parts.) "Double columns of 31 lines" or "31 lines in two columns" would mean that the manuscript has two columns to the page, with thirty-one lines in each column. If the copying of the text was the work of more than one scribe, the description should state how many scribes were involved and note the span of each scribe's work. The type of script used should be identified (Caroline minuscule, English Protogothic minuscule, Gothic *quadrata*, humanistic bookhand, etc.); if the script has any peculiarities, such as unusual letter forms or ligatures, these can be briefly described. The description should also note the character of any decoration the manuscript includes. If the decoration consists merely of colored initials with minor decoration of a standard type, this can be expressed quite summarily; for example, "pen-flourished initials in alternating red and blue," "initials with white vine-stem decoration," etc. If certain initials include more major decoration or are historiated (i.e., contain scenes with human figures), or if some pages include decorative borders and/or miniatures, the page numbers on which such decoration occurs should be listed and the decoration of those pages briefly described. Finally, the enumeration of the physical characteristics usually includes a brief reference to the current binding of the manuscript, noting its material and its date.

Descriptions commonly follow the account of the physical characteristics by succinctly detailing what is known of the history of the manuscript, citing any evidence from within it or from external sources (such as catalogues) that allows its history to be charted. For example, if the manuscript includes a medieval ownership inscription or library mark, this should be quoted, as should any owner's signatures, stamps, or library marks of the postmedi-

eval period that help demonstrate the route by which the manuscript traveled from its medieval home to its current repository.

THE HEADNOTE

It is customary to begin a description with a short headnote preceding the itemized list of contents. The headnote should briefly identify or summarize the contents of the volume (for example, "Augustine, *De trinitate* and other works," "Collection of homiletic texts," "Chartulary of St. Mary's, Abingdon," etc.) and should note the place and date of origin. If the place of origin has to be assessed on paleographical grounds alone, it may not be possible to do more than name the region or country to which the manuscript may be attributed ("duchy of Benevento," "northern France," "southern England," etc.). If the manuscript contains no evidence allowing it to be precisely dated, the approximate date should be indicated in a shorthand form. The dating formulas most commonly encountered use the abbreviation *s.* (*saeculo*) followed by a roman numeral to indicate the century of origin, associated with a number or abbreviated word (often rendered in superscript) to indicate the appropriate part of the century. Thus:

$$s.\ xii^{in} = \text{beginning of the twelfth century}$$
$$s.\ xii^{1} = \text{first half of the twelfth century}$$
$$s.\ xii^{med} = \text{middle of the twelfth century}$$
$$s.\ xii^{2} = \text{second half of the twelfth century}$$
$$s.\ xii^{ex} = \text{late twelfth century}$$
$$s.\ xii/xiii = \text{late twelfth or early thirteenth century}$$

In these formulas, *in* stands for *ineunte* (coming in, i.e., the beginning of the century), *ex* for *exeunte* (going out, i.e., the end of the century), and *med* for *medio* (middle). Some paleographers prefer a slightly different set of formulas that divide the century into quarters, as follows:

$$s.\ xii^{1/4} = \text{first quarter of the twelfth century}$$
$$s.\ xii^{2/4} = \text{second quarter of the twelfth century}$$
$$s.\ xii^{3/4} = \text{third quarter of the twelfth century}$$
$$s.\ xii^{4/4} = \text{fourth quarter of the twelfth century}$$

CATALOGUING IN PRACTICE

The guidelines provided above cover the basics of manuscript description. Further helpful information will be found in sections of catalogue introductions that describe the methods followed by individual cataloguers; see, for example, N. R. Ker's *Catalogue of Manuscripts Containing Anglo-Saxon*, xx–xxiii, or Paul Saenger's *A Catalogue of the Pre-1500 Western Manuscripts at the Newberry Library*, xv–xvi.

This chapter ends with a sample description of a manuscript that will repay study of its structure and method. The description is of Newberry Library MS 12.3, a twelfth-century English manuscript, and is taken from Saenger's *Catalogue*. The clear structure of the description is readily apparent. It comprises (1) a headnote summarizing the

contents and stating the place and date of origin; (2) an itemized listing of the contents, with references to modern editions; (3) a paragraph describing the physical characteristics of the manuscript; (4) a brief note about the current binding; and (5) a paragraph describing the provenance of the manuscript. Catalogues that cover specific collections of manuscripts often include particular details pertinent to the collection, and Saenger's is no exception. Thus, at the beginning of the description, "Ry 24" is the Newberry's own acquisition number for the manuscript and indicates that it was purchased through the Edward L. Ryerson Book Fund. Note that for his itemized list of contents, Saenger customarily refers to the recto of a leaf by the bare number of the leaf, unaccompanied by *r* (but a verso is always identified by the addition of *v* after the leaf number). When citing editions, Saenger uses the abbreviations *PL* for Patrologia Latina and *CC* for Corpus Christianorum Series Latina; *CPL* refers to Eligius Dekkers, *Clavis Patrum Latinorum*, 2nd ed. (Steenbrugge, 1961), a reference work that provides a conveniently numbered list of all Latin patristic writings. When in his description of the physical characteristics of the manuscript Saenger

notes that the ruling of parts of the manuscript is in pencil, he is referring to the medium that in this book is called plummet (that is, medieval lead point, the precursor of the modern pencil). In tracing the provenance of the manuscript, Saenger refers both to medieval listings in which it is mentioned—the Franciscan *Registrum* and the late-twelfth-century catalogue of books owned by St. Mary's, Reading, that is found in the document known as "Lord Fingall's Cartulary"—and to N. R. Ker's *Medieval Libraries of Great Britain*, the most authoritative modern reference work listing the known medieval owners of British manuscripts. Saenger's citation, near the end of the entry, of the first words of the manuscript's second folio follows a practice used in medieval catalogues as a means to distinguish between different copies of the same text (see the section "Entries in Medieval Library Catalogues" in chap. 8). His closing reference to "Faye-Bond" alludes to C. U. Faye and W. H. Bond, *Supplement to the Census of Medieval and Renaissance Manuscripts in the United States and Canada* (New York, 1952), a basic reference work for manuscripts in North American libraries that includes a mention of MS 12.3.

12.3
(Ry 24)
Augustine, *De Sermone Domini in Monte*,
In Iohannis Epistulam ad Parthos Tractatus X;
Ambrose, *De Officiis Ministrorum*
England s. XII med.

1. ff. 1–44v Aurelii Augustini doctoris de sermone domini in monte liber [I] incipit (in red). Sermonem quem locutus est dominus noster Ihesus Christus in monte . . . si uolumus edificari super petram.

Headings rewritten and divisions marked for use as a book of homilies.

Augustine, *De sermone domini in monte*, ed. A. Mutzenbecher, *CC* 35 (1967). *PL* 34:1229–1308; cf. *PL* 47:1199–1200. *CPL* 274.

2. ff. 45–84v Incipit tractatus primus sancti Augustini in epistolam sancti Iohannis apostoli ab eo, Quod erat ab inicio, usque ad id quod ait, Quam (*sic*) tenebrę, excecauerunt oculos eius (Io 2:11; in red). Meminit sanctitas uestra euuangelium secundum Iohannem . . . quam tu credas Christo prędicanti. Explicit expositio sancti Augustini super epistolam sancti Iohannis (in red).

Augustine, *In Iohannis epistulam ad Parthos tractatus x*. *PL* 35:1977–2062. *CPL* 279.

3. ff. 85–146 Incipit liber I[us] sancti Ambrosii episcopi de officiis ministrorum (in red). Non arrogans uideri arbitror . . . series tamen uestustatis (*sic*) quodam conpendio expressa plurimum instructionis conferat. Explicit liber tercius beati Ambrosii de officiis ministrorum.

f. 146v blank.

Ambrose, *De officiis ministrorum*, ed. J. G. Krabinger (Tübingen, 1857). *PL* 16:25–184. *CPL* 144.

Parchment with paper flyleaves of s. xviii. ff. iii + 146 + i. Rear flyleaf has pasted on it original table of contents cut out and removed from original position in rebinding in s. xviii. Trimmed to 258 × 190 mm (213 × 140 mm). f. 48, portion of outer margin removed to form a tab, now wanting. 1–13[8], 14[6], 15–17[8], 18[12]. Quires 7–18, first and third and penultimate and last lines extending into margin. Ruled in pencil and hard point with single boundary lines. Written in protogothic textualis and caroline textualis by several hands. On change to two-column format and pencil ruling, see Ker, *English Manuscripts*, p. 41. Incipits and explicits in mixed rustic capitals and uncials. Headings in script of text in orange-red ink. f. 31, correction by rubricator. Ink varies from brown to very black. Written in 35 lines in two columns. Quire 17 written in 34 lines; quire 18 written in 31 lines. Red and green patterned initials 7–10 lines high.

Bound in modern boards by the Newberry identical to MS 12.1.

Written in England in the middle of the twelfth century, at Saint Mary's Reading; see MS 12.1. The first item appears in the Franciscan *Registrum* 1:19 as being at St. Mary's Reading. Listed in the late twelfth-century inventory, Barfield, "Lord Fingall's Cartulary," p. 119. Ker, *Medieval Libraries*, p. 155. Flyleaf iii, copy of ownership inscription of Reading Abbey. f. 1, signature of J. Reynoldes, followed by a roman numeral. Flyleaf iii, "James Bowen Salop anno 1748." Twelfth-century Saint Mary's Reading ex libris "copied from the old cover" and table of contents all in a pseudo-gothic script by the same hand. Flyleaf iv bears signature T. Fownes and Phillipps stamp, no. 241. See provenance of MS 12.1. Acquired by the Newberry in 1937 from William H. Robinson.

Second folio: -bantur amittunt.

Faye-Bond, p. 149.

Selected Scripts

THIS CHAPTER presents selected examples of manuscript pages that demonstrate the major developments in the evolution of handwriting during the Western Middle Ages. The period covered spans the eighth century to the fifteenth. Roman scripts are not included, although of course the principal scripts of the ancient world—capitals, uncials, half-uncials, and cursive—were foundational for the Middle Ages; these scripts can be studied in other handbooks—for example, Michelle P. Brown's *A Guide to Western Historical Scripts from Antiquity to 1600*. The story outlined here begins with one of the most important and well-attested scripts of the Merovingian era, then continues with examples that bear witness to the strongly independent script tradition of the British Isles and areas under Insular influence; the emergence and "canonization" of Caroline minuscule; the adjustments to Caroline minuscule that were made in so-called Protogothic script; the long survival in southern Italy of a script of pre-Caroline origin and character; the elaboration of a range of formal bookhands in the Gothic period; the reemergence of a variety of cursive scripts in that same period; and, finally, the reforms introduced by Italian humanist scribes in the fifteenth century.

The pages illustrated all come from manuscripts or fragments in the Newberry Library. In each case, a photographic reproduction of the page is accompanied by a partial transcription (which it is hoped readers will be prompted to complete for themselves) and a description. The description offers an orientation to the particular script and some guidance on its most characteristic or problematic features, an assessment of other significant aspects of the page, and some information about the manuscript to which the page belongs. Above all, each description aims to draw the reader's attention to the salient features of the page as they relate to its history and interpretation and thereby to demonstrate how every aspect, from layout and decoration to correction and glossing, reveals important clues about the manuscript's production, use, and provenance. The bibliography for this chapter—to be found at the end of the book—is subdivided into sections that correspond to each script and is designed to assist readers in locating further information about the manuscript, its script, and its genre.

The arrangement is basically chronological, except where it seemed more sensible to cut across chronology in the interests of grouping related scripts together. Thus the two examples of more formal Gothic hands precede the four examples of Gothic cursive or cursive-derived scripts, and humanistic hands come at the end, although the manuscript selected to illustrate humanistic bookhand happens to be a little earlier in date than some of those chosen to represent the varieties of Gothic cursive. While this method of presentation helps in telling the story of how Western European script developed over the medieval period, a potential drawback is that the scripts do not proceed from easier to more difficult; indeed, the first script illustrated, Luxeuil minuscule, is also one of the most idiosyncratic of the entire Middle Ages. Bearing in mind that the script reforms that produced Caroline minuscule in the late eighth century and the humanistic hands of the fifteenth century were consciously aimed at correcting earlier scribal excesses, making script more legible by clarifying letter forms and reducing the number of ligatures and abbreviations, those who are new to the study of paleography may prefer to begin with the Caroline and humanistic hands and then work their way back from those two reference points to the pre-Caroline and the Gothic scripts.

Luxeuil Minuscule

10-1 Newberry Library, Medieval Manuscript Fragment 1, recto (156 × 221 mm).

𝔲	= *a* [glorific*a*bor, line a7]	𝔷	= *g* [li*g*num, line a5]
ᵭ	= *d* [*d*omum, line a6]	𝔯	= *r* [zo*r*obabel, line b2]
𝔞𝔩	= *ed* [a*ed*ificate, line a6]	𝔯	= *ri* [glo*ri*ficabor, line a7]
&̄	= *er* [ex*er*cituum, line a1]	𝔯	= *s* [d(omi)n(u)*s*, line a1]
&	= *et* [*et*, line a6]	𝔱	= *t* [dici*t*, line a1]
ſ	= *fi* [aedi*fi*cate, line a6]	𝔮𝔢	= *te* [aedifica*te*, line a6]
		𝔷	= *z* [*z*orobabel, line b2]

Luxeuil Minuscule

Haec dicit d(omi)n(u)s exercituum
Ponite corda uestra superbias (*recte* super uias)
 uestras
Ascendite in monte portate
 lignum
Et aedificate domum et accepta(-)
 bilis mihi erit et glorificabor
 dicit d(omi)n(u)s
Respexistis adamplius et ecce
 factum est minus
Et intulistis in domum et exu(-)
 flabi (*recte* exsuflaui) illud
Quam ob causam dicit d(omi)n(u)s exer(-)
 cituum

Luxeuil minuscule derives its name from the abbey of Luxeuil in eastern France, founded by the Irish missionary St. Columbanus ca. 590. The abbey grew in importance during the seventh century, attracting royal interest and spawning up to fifty daughter houses in different parts of Gaul, but it was devastated by the Saracens in 732, when the community was forced to disperse. That the form of script exemplified on this fragment was practiced at Luxeuil was established conclusively, against earlier, more skeptical views, by E. A. Lowe in 1953. As Lowe acknowledged, the script may also have been used in some of the houses affiliated with Luxeuil; it is also clear that Luxeuil minuscule significantly influenced other forms of Merovingian minuscule, for example, those practiced at Corbie (founded ca. 660 with monks drawn from Luxeuil). Examples of Luxeuil script survive in twenty-two manuscripts or fragments dating from the seventh and the first half of the eighth century; the Newberry fragment comes from a manuscript copied ca. 700.

Despite the abbey's Irish foundation, Luxeuil minuscule displays few Insular features (although such a feature is the *diminuendo* at the beginning of this fragment, where the text begins with a large colored initial followed by several progressively smaller colored letters before reaching the standard text script with the second word, *dicit*). Rather, the script is strongly Merovingian in character, with several features apparently derived from Merovingian chancery script. The more distinctive letter forms include the open-topped *a* resembling two *c*s written side by side (this letter must be carefully distinguished from *u*); *d* in which the shaft descends below the baseline; tall *e*; *g* with a sharply angular approach stroke to the lower bowl; *r* with a sharply bent "shoulder" (not to be confused with the *s*, in which the upper right portion curves

more gently); and *t*, which, when not in ligature, has at the left a loop that curves down toward the stem of the letter. As is characteristic of Merovingian scripts as a whole, ligatures are plentiful. They include an *ed* ligature in which the bow of the *d* remains open (line a6); an *et* ligature, which approaches an ampersand in its shape (lines a6 and a7); *ri*, in which the *i* descends below the baseline (line a7); and *te*, in which the *t*, rather than forming a downward loop at the left, loops high up above the baseline (lines a2 and a4). A further characteristic of the script is the use of tall ascenders with "clubbed" serifs at the top. Although the script is at first challenging to read, it is pleasing in appearance, and Lowe justifiably called it "the first calligraphic minuscule of France."

The fragment, which comes from a copy of the Old Testament Books of the Prophets, carries text from Haggai 1:7–1:9 (left column) and 1:11–1:14 (right column). As is frequently the case in early medieval biblical manuscripts, the text is laid out *per cola et commata*, that is, sense unit by sense unit (see chap. 6). In accordance with this system, each new sense unit begins at the left edge of the column, and if a sense unit requires more than one line, any subsequent lines are indented. Special features of this fragment are that the beginning of a sense unit is additionally emphasized by the presence of a colored initial, and that if a sense unit requires a third line, that line is indented yet further than the second line. The intercolumnar inscription *In dedicatione*, entered by the same scribe as wrote the main text, is a liturgical note and shows that the passage that begins at the top of the left column would have been used as a reading in the service for the dedication of a church. The passage is eminently suitable for that purpose, for it describes how the Lord, through the prophet Haggai, commanded Zerubbabel, the governor of Judah, and Joshua, the high priest, to rebuild the temple in Jerusalem.

The horizontal fold-line at the bottom of this fragment and the cuts (made to accommodate stitching holes) spaced at intervals along the fold-line show that after it was removed from its original manuscript, the fragment was turned sideways and sewn into another book. The plentiful woodworm holes scattered across the fragment indicate that in its new position, it would have been close to the wooden board of a binding; in other words, it was used as a protective endleaf. The date by which this must have happened is shown by the pen trials in Caroline minuscule, perhaps of the tenth century, toward the bottom of the left column: the orientation of the pen trials shows that the leaf would already have been turned sideways at the time they were entered. Fragments of ten other leaves of the same original manuscript survive in collections in Austria, Germany, and the United States; the lower portion of the leaf from which the Newberry fragment comes is now Admont, Stiftsbibliothek, MS Fragm. 12, no. XI.

Insular Minuscule

10-2 Newberry Library, MS 1.5, no. viiii, verso (151 × 200 mm).

DISTINCTIVE LETTER FORMS, LIGATURES, AND ABBREVIATIONS

℀	= æ [cælorum, line 1]		℥	= g [gratiam, line 8]
ð	= d [dubitatione, line 3]		ᵯ	= ma [humane, line 6]
℮	= e [uenire, line 1]		ᵯ	= mo [Quomodo, line 12]
℮	= eg [regnum, line 1]		ᵯ	= nisi [nisi, line 5]
ſ	= es [necessarium, line 9]		ſ	= r [regnum, line 1]
ſ	= es [fides, line 16]		ſ	= s [nobis, line 1]
℮	= et [docet, line 12]		ß	= si [possidebit, line 9]
f	= f [fidem, line 2]		⁊	= (et) [(et), line 2]

Insular Minuscule

TRANSCRIPTION OF LINES 1–9:

ad regnu(m) cælorum p(er)uenire, q(uo)d nobis a d(e)o
 omnipotenti

p(ro)missum (est) (et) p(rae)paratu(m)꞉ fidem recta(m) (et)
 catholicam sine

dubitatione firmiter tenere., qui\a/ ad æterna(m)
 beatudi(-)

ne(m) (*recte* beatitudinem) nemo p(er)uenire pot(est) nisi
 d(e)o placeat., (et) nullus d(e)o placere

potest nisi p(er) fide(m) recta(m)., fides namq(ue)
 omniu(m) bonor(um) fundam(en-)

tu(m) (est)., fides humane salutis initium (est)., sine hac
 nemo ad nobili(-)

tate(m) filiorum d(e)i p(er)uenire poterit., Q(uia) sine ipsa
 nec in hoc

s(ae)c(u)lo quisqua(m) iustifitionis (*recte* iustificationis)
 consequit(ur) gratia(m) nec in futu(-)

ro. uitam possidebit æternam.,

This fragment, written in Insular minuscule and dating prob- ably from the early ninth century, is likely to be the product of one of the Anglo-Saxon foundations on the European con- tinent. The early development of script among the Anglo- Saxons reflected strong influences from Italy and Ireland, absorbed during and in the wake of the conversion of Anglo- Saxon England to Christianity, beginning with the mission of the Roman monk St. Augustine in 597. From the seventh to the ninth century, Insular scribes practiced a hierarchy of dif- ferent scripts in which the higher grades (uncials, rustic capi- tals, and half-uncials) served for high-status texts such as the scriptures, while lower grades (various forms of minuscule) served for copying nonreligious texts or texts by more re- cent authors; two different text scripts might be used within a single manuscript and even on a single page—for example, when passages of scripture were quoted within another text. When, during the late seventh and eighth centuries, Anglo- Saxon missionaries became active on the Continent, in par- ticular within the German territories—founding monasteries at Echternach, Fulda, Würzburg, and elsewhere—they took with them their system of scripts, along with Insular codico- logical practices.

Distinctive letter forms of Insular minuscule, all of which are to be seen on this fragment, include rounded *d*, low-set *f*, flat-topped *g*, *p* with a bow not fully closed, *r* with a descender at the left, and low-set *s*. Within England, with the excep- tion of the open-bowed *p*, these letter forms continued to be characteristic of Anglo-Saxon script until the late eleventh/ early twelfth century; however, following the introduction of Caroline minuscule into England from the mid-tenth century, the use of these non-Caroline forms eventually became con- fined to vernacular texts only. The fragment also includes cer- tain ligatures typical of Insular minuscule, ligatures in which

vowels linking with a preceding consonant are written be- low the baseline (see lines 5, 6, 12, and 13, and the examples within the table of distinctive forms). The letter *e* rises high above the headline in the *æ* digraph and when *e* enters into ligature with the following letter (see lines 1, 9, 12, and 16); *i* is often tall when it is in initial position (see, for example, lines 6 and 7). The script favors the use of the Tironian abbreviation for *et* (see lines 2 and 4). It is in accord with Insular codicologi- cal practice that the fragment has been pricked for ruling in both the outer and inner margins.

Among the paleographical features that suggest that the fragment is of continental origin are the form of the abbrevia- tion used for the passive *-tur* ending (see line 8)—a form that by the ninth century was more common in the Anglo-Saxons' German foundations than in England itself—and the upright form of the Tironian *et*, standing on the baseline rather than dropping below it. The punctuation basically follows an Insu- lar version of the *distinctiones* system, with a single point mark- ing minor pauses and a point followed by a comma-shaped stroke marking major pauses (see chap. 6). However, one ma- jor pause (line 11, after *apos/tolicam*) is marked by a *punctus ver- sus* (꞉), a type of mark that apparently originated in Char- lemagne's Palace School in the late eighth century and soon spread on the Continent but that seems not to have reached England until significantly later. On the fragment, the *punctus versus* is the work of the original scribe, not a later adjustment to the punctuation.

Perhaps the most persuasive evidence that the fragment is of continental rather than English origin comes from the text. The reverse side of the fragment (the original recto) carries a portion of a work known as *De gradus Romanorum* that de- tails the duties of local officials within the Frankish territo- ries. The text on the verso, shown here, comes from the first of a collection of sermons formerly attributed to St. Boniface (ca. 675–754), the Anglo-Saxon missionary who evangelized parts of Germany and was martyred in 754 while on a mission to convert the Frisians. Recent scholarship suggests that the sermons more likely originated within the Frankish region some time after Boniface's death. They address basic points of Christian doctrine; the content of the first sermon, which emphasizes the necessity of faith for attaining salvation, ap- pears to reflect guidelines for preachers laid down by Char- lemagne in his *Admonitio generalis* of 789. There is no surviving Anglo-Saxon copy of these sermons; all known manuscripts are continental.

The provenance of the fragment also supports its continen- tal origin, for in the early nineteenth century it was to be found in the library of the German scholar Ernst Spangen- berg. At that time, the fragment had already been removed from its original manuscript and reused as a front endleaf in an early printed book. Physical evidence on the fragment corrob- orates its reuse: the horizontal fold-line that runs the length of line 16 and the stitching holes that occur at intervals along the fold-line show that when the fragment was cut down, it was turned sideways and sewn into another book.

German
Minuscule

DISTINCTIVE LETTER FORMS
AND LIGATURES

a = *a* [*a*nni, line 3]

cc = *a* [iud*a*eis, line 5]

e = *e* [*e*nim, line 1]

et = *et* [*et*, line 9]

ŋ = *ri* [mo*ri*, line 7]

ro = *ro* [int*ro*-, line 11]

s = *s* [discipulu*s*, line 9]

10-3 Newberry Library, Medieval Manuscript Fragment 4,
verso (250 × 87 mm).

German Minuscule

TRANSCRIPTION OF LINES 1–11:

Erat enim socer caiphe
qui erat pontifex
anni illi(us) ; Erat au(tem)
caiphas qui con(-)
silium dedit iudaeis.
qui expedit unu(m) homine(m)
mori pro populo ; Seque(-)
batur au(tem) i(esu)m simon pe(-)
trus et alius discipulus ;
Discipulus au(tem) ille erat
not(us) pontifici ;

During the second half of the eighth century, scriptoria in different parts of Western Europe worked to develop minuscules that were easier to write and to read than the pre-Caroline scripts with their wealth of unusual letter forms and ligatures. The final fruits of these developments were the emergence of Caroline minuscule in the late eighth century and its rapid spread in the ninth. Centers in which early approximations to Caroline minuscule emerged included Corbie in northeastern France, St. Gall in Switzerland, and some of the German scriptoria.

This fragment comes from a manuscript written in southeastern Germany in the early ninth century. While the script resembles Caroline minuscule in many of its letter forms, it also betrays its pre-Caroline roots. Two letters occur in variant forms: in addition to the small uncial *a* typical of Caroline script, the scribe used the *cc* form of *a* (for example, in *iudaeis*, line 5) and frequently wrote *e* in a tall form in which the closed upper portion rises above the headline (see *enim* and *socer* in line 1). These are both reminiscent of Merovingian forms, as are the use of tall, clubbed ascenders, in which the tops are thicker than the bottoms; the *ri* ligature, in which the *i* descends diagonally below the baseline (lines 7, 12, and 17); and the *ro* ligature with "horned" *o* (line 11), a form that also occurs in Luxeuil minuscule and in the script known as *ab*-minuscule that was practiced in northeastern France (apparently at Corbie and Soissons) in the late eighth and early ninth centuries. The *et* ligature, which approaches an ampersand in its shape, is used both as a complete word and for the letter sequence within words, as in *Petrus* (line 13). To abbreviate suspended final *m*, the scribe used both an upright, curving abbreviation stroke (line 6) and a horizontal macron (line 18). Late-eighth-century reforms in punctuation are reflected in his use of the *punctus versus* (;) at verse endings; minor pauses are indicated by the low *punctus*.

The text on the fragment is from the Gospel of St. John,

18:13–17, narrating Christ's appearance before Annas following his arrest in the Garden of Gethsemane and Peter's denial of Christ. The portions of letters visible at the right-hand side of the fragment, toward the bottom, show that the original manuscript was in two columns; the right-hand column of this page survives at Brno in the Czech Republic, and a further fragment of the manuscript is at Děčín, also in the Czech Republic. From the evidence of all three fragments it is possible to glean that the original manuscript was a lectionary containing the Old and New Testament lessons to be recited at Mass throughout the church year. The four Gospel accounts of Christ's Passion were traditionally read during Holy Week: Matthew's on Palm Sunday, Mark's on Tuesday, Luke's on Wednesday, and John's on Good Friday. A special reciting tone was used for these Passion readings, and often three individuals would participate, each taking a different part. Evidence on this fragment, in the form of the letters that have been entered in the interlines above the beginning of each verse, indicates that this method of recital was used in the monastery that owned the lectionary from which this fragment comes. The letter *c* (probably abbreviating *cantor*) is entered above all those verses in which the evangelist relates his narrative (see the verses that begin in lines 3, 7, 10, 11, 13, and 15); *sac* (presumably standing for *sacerdos*) occurs over verses in which a character other than Christ speaks (in the example in line 20, at the bottom of the page, it is the maidservant who challenges Peter); and on the reverse side of the fragment, *l* (probably standing for *lector*) is entered over verses in which Christ himself speaks. In this dramatic method of reciting the Passion narratives lay the germ of the medieval Passion play.

The two holes in the upper part of the fragment are original defects in the skin, resulting from an injury received by the animal (a goat, judging by the grain pattern visible on the reverse side) from which the skin came; there is an area of fragile scar tissue to the upper right of the holes, where the wound had started to heal before the animal was slaughtered. In lines 2–4, the scribe was obliged to deploy his text around the damaged area. At the bottom, a horizontal cut and its repair with thread have distorted and almost completely obscured the last line of text, now illegible and all but invisible. A clue as to the manner in which the fragment was used after it had been cut from its original manuscript is provided by the vertical fold-line visible toward the right, extending the whole length of the fragment, from above the *i* of *caiphe* in line 1 to below the second *i* of *disci(-)* in line 20. Spaced along this fold-line are four stitching holes; diagonal cuts extend from the right edge of the fragment to these holes. Although this evidence is difficult to interpret precisely, it seems likely that the fragment was sewn in at the front or back of another book as some kind of binding reinforcement.

suis cum lampadibus.
Moram autem faciente
sponso dormitauerunt
omnes et dormierunt.
Media autem nocte
clamor factus e. ecce
sponsus uenit. exite
obuiamei. Tunc surre
xerunt omnes uirgines
ille. et ornauer lampa
des suas. Fatuae autem
sapientib; dixerunt.
Date nobis deoleo uro.
quia lampades nostre
extanguntur. Respon
derunt prudentes di
centes. Neforte non suf
ficiat nobis et uobis ite
potius ad uendentes. et
emite uobis. Dum autem
irent emere. uenit
sponsus. et quae parate
erant. intrauer cum eo

10-4 Newberry Library, Medieval Manuscript Fragment 3, verso (254 × 155 mm).

DISTINCTIVE LETTER FORMS

a = *a* [Medi*a*, line 5]

g = *g* [*g* uirgines, line 9]

ſ = *s* [*s*ponso, line 3]

Caroline Minuscule

TRANSCRIPTION OF LINES 2–13:

Moram aute(m) faciente
sponso. dormitauerunt
omnes et dormierunt.
Media autem nocte.
clamor factus e(st)ꞏ Ecce
sponsus uenit. Exite
obuiam ei. Tunc surre(-)
xerunt omnes uirgines
ille. et ornauer(unt) lampa(-)
des suas. Fatuae aute(m)
sapientib(us) dixerunt.
Date nobis de oleo u(est)ro.

The creation of Caroline minuscule was the most important development in the evolution of script in the entire Middle Ages; its repercussions remain with us today, for, with one exception (tall *s*), all its letter forms are still in use. The script first emerged in the last third of the eighth century. In its early phases, however, certain letters (principally *a, d, e, n, r,* and *t*) could be written in variant forms. It was during the first half of the ninth century that the script took on its canonical form. The monastery of Saint-Martin at Tours in western France played a major part in this process. In 796 Charlemagne appointed his adviser, the Anglo-Saxon scholar Alcuin, as abbot of Saint-Martin. While at Tours, Alcuin labored on the correction of the text of the Bible, and during his abbacy and those of his successors, the Tours scriptorium produced large numbers of manuscripts, many of which were exported to other centers within the Carolingian empire and thereby served to diffuse the newly perfected script.

This fragment comes from a Gospel book written at Tours in the second quarter of the ninth century; the script has the characteristic lean toward the right that developed in the ninth century. Among the distinguishing features of Caroline minuscule—apart from the clarity of its letter forms—were the drastic reduction in the number of ligatures (as compared with Merovingian scripts) and the restricted use of abbreviations. This page includes not a single ligature; abbreviations occur sparingly. It is characteristic of the concern at Tours for correct orthography that the full *ae* ending is used for *Fatuae* (line 11) and *quae* (line 22). However, *e*-caudata is also used (lines 14 and 22). The occurrence of *ille* in line 10, where the sense clearly requires *illae*, may have resulted from the scribe's inattentive copying from an exemplar in which the *ae* ending had been reduced to *e*.

The text on the fragment comes from the parable of the wise and foolish virgins in Matthew's Gospel (25:4–10). The text is laid out not *per cola et commata*, as in the example of Luxeuil minuscule above, but in a block; each new sentence begins with an initial in uncial script. The fragment carries just the left column of a page that originally had two col-umns. The two pieces of textual apparatus that are entered in smaller script at the right of the fragment relate to the now missing right column of the page and exemplify an important system of referencing the Gospels that was used in the early Middle Ages. In each case, the apparatus begins by providing the section number of the portion of Matthew's Gospel that began in the adjacent line of the right column: the numbers are, respectively, *MT CCLXVIIII* and *MT CCLXX*, where *MT* abbreviates *Mattheus*. These numbers derive from a system whereby each Gospel was divided into a continuous sequence of numbered sections (the chapter numbers that we use today did not come into use until the thirteenth century, while modern verse numbers originated only in the sixteenth century). This system was invented by Ammonius of Alexandria (ca. 175–242) but was apparently applied by him only to part of Matthew's Gospel; it was Eusebius, bishop of Caesarea (ca. 315–ca. 340), who expanded the system by dividing up the full text of all four Gospels into numbered sections. Eusebius also compiled a set of ten tables (canon tables) in which he listed, in parallel columns, the section numbers of the passages for which equivalent versions existed in the different Gospels: canon 1 tabulated those passages of which equivalent versions occur in all four Gospels; canon 2 those passages of which equivalent versions occur in Matthew, Mark, and Luke; and so on, down to canon 10, which was divided into four parts and listed those passages in each Gospel that have no equivalent in any of the others. Sets of canon tables, often highly decorative, are to be found at the beginning of numerous early medieval Gospel books. On the Newberry fragment, the numbers in red that are entered below the Matthew section numbers supply the numbers of the two canon tables (*II* and *V,* respectively) in which these two sections are listed. Immediately below the red canon table numbers, the apparatus provides references to the section numbers of the equivalent passages in the other Gospels: *MR CLIIII* and *LC CCXXVIII* for the first passage, *LC CCXXVIII[[I]]* for the second (the last *I* has been lost through trimming). *MR* and *LC,* respectively, abbreviate *Marcus* and *Lucas; Iohannes,* not referred to on this page, was abbreviated as *IO.* That the section numbers are entered in ink and the canon table numbers in red follows a practice established by St. Jerome in the original copy of his Vulgate translation of the Gospels, made for Pope Damasus in the 380s. Note that there is no textual apparatus in the left margin of the fragment for the reason that all the text in the left column belongs to a long section of Matthew's Gospel that begins on the other side of the fragment.

After it had been cut from its original manuscript, this fragment was used as a cover for another book, as is clear from the fold-lines and cuts on its surface. For its new use, the fragment was turned sideways, and to envisage the reuse it helps to mentally rotate the fragment (or even physically rotate this book) through ninety degrees. The two fold-lines running horizontally across the middle of the fragment show the dimensions of the spine of the book that it covered. Along each of these fold-lines are three pairs of slits (the pairs at the left

are the most easily visible; the others fall within the column of text, where the writing partly obscures them). These slits were made to enable the sewing supports of the book to be laced through them, to hold the cover in place. Further evidence about the reuse is provided by the faint lines of writing to be seen running vertically down the fragment. This writing is in reverse (parts of it can be read with a mirror); it has therefore offset from another leaf. Traces of paste on the fragment show that this other leaf must have been stuck to the fragment—no doubt to make the cover stiffer than it would have been had it consisted of just a single piece of parchment. The offset writ-

ing appears to be seventeenth-century; it provides an approximate date before which the fragment could not have been reused as a cover. The parchment leaf was placed outermost, for on its reverse side, at the bottom of the spine area, it is possible to see that a label (presumably containing a shelfmark or a title) was formerly pasted to the parchment. The top of the parchment was tapered to serve as a turn-in for the cover; the narrow horizontal band visible just below the tapering indicates that this portion of the parchment, which would have projected beyond the fore-edge of the leaves of the book, was bent forward as a "Yapp edge."[1]

1. On Yapp edges, see Matt T. Roberts and Don Etherington, *Bookbinding and the Conservation of Books: A Dictionary of Descriptive Terminology* (Washington, DC, 1982), 286. See also the definition in the glossary at the end of this book.

English Protogothic Bookhand

sed tantu(m) dolebam (et) flebam. Miser
 eni(m) eram. (et) amisera(m) gaudiu(m)
meu(m). An (et) fletus res amara est. (et)
 p(rae) fastidio reru(m) quib(us) prius
fruebamur. (et) du(m) ab eis abhorrem(us)
 delectatͻ Quid autem ista
loquorͻ Non enim temp(us) quẹrendi nunc
 estͻ sed confitendi t(ib)i.
Miser eram. (et) miser e(st) omnis anim(us)
 uinctus amicitia reru(m)
mortaliu(m). (et) dilaniat(ur) cu(m) eas
 amittit. Et nunc sentit miseriam
qua miser e(st)ͻ (et) antequa(m) amittat eas.
 Sic eni(m) ego eram illo t(em)p(o)r(e).
(et) flebam amarissime (et) requiescebam in
 amaritudine. Ita
miser eram. (et) habebam cariore(m) illo
 amico meo uita(m) ipsam
miseram. Nam quanuis eam mutare uellem.
 nollem tamen
amittere magis qua(m) illum. Et nescio an
 uellem u(e)l p(ro) illo sicut
de ORESTE (et) PILADE traditur si non fin-
 gitur. qui uellent p(ro) inui(-)
ce(m) u(e)l simul mori. quia morte peius
 erat n(on) simul uiuere.

10-5 Newberry Library, MS 12.7, fol. 22r (258 × 190 mm).

DISTINCTIVE LETTER FORMS AND LIGATURES		
𝖆	= *a*	[*a*nim(us), line 5]
𝖈𝖙	= *ct*	[dele*ct*at, line 3]
ẹ	= *ẹ*	[quẹrendi, line 4]
&	= (*et*)	[(*et*), line 3]
ꝛ	= *r*	[loquo*r*, line 4]
ſt	= *st*	[e*st*, line 2]

English Protogothic Bookhand

Caroline minuscule reached England in the second half of the tenth century, its adoption there being stimulated by the importation of continental manuscripts during the period of monastic reform initiated by Sts. Dunstan, Æthelwold, and Oswald. The script spread quite rapidly, being employed in many English centers for the copying of Latin (but not vernacular) texts; during the first half of the eleventh century, English scribes developed a rounded, beautifully proportioned version of Caroline minuscule justly valued for its easy legibility. English Caroline minuscule was one of the major formative influences on Protogothic script, in reality a late form of Caroline minuscule that first emerged in the late eleventh and early twelfth centuries in post-Conquest England and in parts of France, especially Normandy, and was practiced until the early thirteenth century.

The alphabet of Protogothic script is entirely Caroline, but the letter forms have undergone certain minor modifications. These include the regular application of "feet" to the bottoms of minims, a feature clearly evident on the illustrated page, which comes from a copy of St. Augustine's *Confessions* made in southern England in the third quarter of the twelfth century. The scribe made these feet by drawing the pen to the right when completing the minim (see, for example, the six consecutive minims of *enim* in line 4). Characteristic also was the application of wedge-shaped serifs to the tops of minims and ascenders; these were formed by the scribe's making a short diagonal stroke descending from left to right before writing the main vertical stroke. In some English centers, scribes would also regularly apply a short hairline stroke, rising diagonally to the right, to the top of the vertical, to give the serif a horned appearance. Certain serifs on the present page exhibit this feature—see, for example, the *d* of *immunditia* in line 21. Another typical feature of Protogothic is that the letter *o* is less rounded, more oval than in Caroline minuscule, as are the bows of other letters. A common characteristic of English twelfth-century manuscripts is that initial *a* is often written somewhat taller than *a* in other positions. It rises above the minim line and is of the "trailing-headed" variety; that is, the top stroke of the letter ends to the left of the bow: see, for example, the initial *a* of *autem* (line 3), *amittit* (line 6), and *amico* (line 9). The 2-shaped form of *r*, typically used for the abbreviation of the genitive plural *–orum* ending, had in Anglo-Saxon times already begun to be used in other places where *r* followed *o* and was a regular feature of English Protogothic. On this page, it is used for every occurrence of *r* following *o*: see, for example, *abhorrem(us)* (line 3), *loquor* (line 4), and *mori* (line 13). The ligatures for *ct* and *st* that were permitted in Caroline minuscule occur also in Protogothic and may be seen here. For the *st* ligature, the scribe simply extends the top of the *t* so that the two letters run into each other (see *ista*, line 3); for the *ct* ligature, a curved linking stroke joins the midpoint of the top of the *c* to the top of the extended ascender of the *t* (see *delectat*, line 3, and *uinctus*, line 5). An elegant, upright ampersand is used in place of *et*. The hook of *e-caudata* is somewhat elaborate, including an additional curving stroke attached to the loop below the *e*: see *querendi*, line 4, and *cet(er)os*, line 22. The macron that replaces final *m* and signifies certain other abbreviations has become curved, or "cupped," as was normal in English manuscripts for much of the twelfth century.

A notable feature of the page is the scribe's use of thickened ink initials, built up by several strokes of the pen, at the beginning of sentences (see the section "Types of Initials" in chap. 2). Such initials make it possible to see at a glance where each sentence begins, and it was largely because of these more easily identifiable sentence beginnings that scribes who used the *positurae* system of punctuation abandoned the *punctus versus* at sentence endings, preferring the simple *punctus*, which also (as on this page) served to indicate minor pauses within a sentence; the presence or absence of an initial made it quite clear which of its two functions the *punctus* was performing (see chap. 6). The punctuation of this page includes the use of the *punctus elevatus* to signify a pause of medium value within a sentence (lines 4, 7, 22, 29, 34) and the *punctus interrogativus* to indicate questions (lines 3 and 4). Legibility is enhanced by careful word separation, although, as was normal until the thirteenth century, there is frequently no space between monosyllabic prepositions and the following word: note the lack of a space in *p(ro) illo* (line 11) and *ad te* (line 22), for example. Adopting a practice found in many other twelfth-century manuscripts, the scribe has made it easy for the reader to pick out personal names by writing them entirely in capitals (line 12).

Not the least interesting aspect of this page is its set of marginal entries. In the center of the upper margin the roman numeral "iiii" has been added in plummet to serve as a running head, indicating that the text on the page falls within book IV of the *Confessions*. The page includes Augustine's description of the depths of grief into which he sank when, as a young teacher of rhetoric in his home town of Thagaste, he experienced the death of a dear childhood friend; in retrospect, Augustine condemns the selfishness and self-indulgence of his grief, noting that he would not have been willing to give up his life for that of his friend, as the Greek friends Orestes and Pylades had reportedly sworn to do. The interest that this passage held for twelfth-century readers is shown by the notes in the right margin, written in a more informal version of English Protogothic that includes the use of uncial rather than Caroline *d*. The first note, entered alongside Augustine's mention of the two Greeks, comments that "Hic tangit fabula(m) quanda(m) de ORESTE et Pilade in amicitia copulatis" (here he alludes to a certain tale of Orestes and Pylades, joined in friendship). It is interesting that the annotator follows, at least in part, the text scribe's practice of capitalizing personal names. Further down comes a typical twelfth-century form of *nota bene* mark, consisting of the four letters of the word *nota* formed into a monogram (see also chap. 3, fig. 3-19); in the text alongside, Augustine describes how his friend was his "other self," the half of his soul. The last note on the page sum-

marizes the content of the lines of text next to which it stands as "Gemit(us) seu q(ue)rimonia s(an)c(t)i AUGUSTINI de obitu amici sui" (St. Augustine's groan or complaint over the death of his friend). This note originally included a further line with the name "NEBRIDII" written in capitals. The annotator thus erroneously identified Augustine's dead friend as Nebridius, another friend who was associated with Augustine throughout much of his life; the name was no doubt subsequently erased by a reader who realized that the identification was wrong. Augustine never does name the dead friend of his youth, just as he never names the woman with whom he lived for many years and by whom he fathered his son, Adeodatus.

This manuscript of Augustine's *Confessions* was made for, and probably at, the abbey of St. Mary's, Reading (for the abbey's ownership inscription, see chap. 8, fig. 8-9). Together with its companion manuscripts at the Newberry, MSS 12.1–12.6, as well as other twelfth-century Reading manuscripts surviving elsewhere, it provides eloquent testimony to the abbey's early efforts to build up its library holdings. The abbey had been founded by King Henry I in 1121 as an affiliate of the great French house of Cluny, which since the tenth century had been the focal point of a major movement of reform among Benedictine monasteries. The importance that the king attached to his new foundation is shown by his choice of it as his own place of burial, and Reading quickly established it-self as one of the leading monasteries in England. The earliest surviving manuscripts from Reading date from about the late 1130s to the 1170s, during which time the abbey made a serious effort to acquire appropriate reading material for its brethren; thereafter, the rate of the library's growth slowed. Similarities in the script and decoration of many of the early manuscripts, including MSS 12.1–12.7, suggest that they were made at a single center, in all likelihood Reading itself. The abbey probably followed the common pattern of starting a scriptorium some years after other, more pressing tasks necessary for the establishment of a new monastery had been accomplished. The majority of the first manuscripts in the Reading library consisted of patristic texts and glossed copies of books of the Bible, exactly the type of material that would provide edifying reading for the brethren. The emphasis on building up a significant collection of patristic works linked Reading with an important trend that had been emerging since the late eleventh century, when monasteries all over Western Europe embarked on a major effort to enhance their patristic holdings. The dissemination of copies of Augustine's *Confessions*, a work esteemed especially for its devotional content, was very much part of this process. There is no evidence that the *Confessions* was known in England during the two hundred years before the Norman Conquest, but thereafter, copies quickly began to proliferate.

10-6 Newberry Library, MS 7, fol. 146v (316 × 218 mm).

German Protogothic Bookhand

TRANSCRIPTION OF LINES 2–13:

DEVS q(u)i nos rede(m)ptionis n(ost)rẹ In vig(i)lia
 nat(a)l(is) d(omi)ni.

annua expectatione letificasꞇ pr(aest)a ut unige(-)

nitu(m) tuum que(m) rede(m)ptore(m) leti suscipim(us)ꞇ
 uenien(-)

tem quoq(ue) iudicem securi uideamus. P(er) eunde(m
 dominum nostrum iesum christum).

Da nobis q(uaesumu)s om(ni)p(otens) d(eu)s. ut sic(ut)
 adoranda filii tui S(E)CR(ETA)

natalicia p(rae)uenim(us). sic ei(us) munera capiam(us)
 sempit(er)na

Da nobis d(omi)ne q(uaesumu)s unigeniti filii
 P(OST)C(OMMUNI)O /gaudentes. Q(u)i t(ecum
 uiuit . . .).

tui recensita natiuitate respirareꞇ cuius cęlesti

mysterio pascimur et potam(ur). P(er) eunde(m dominum
 nostrum . . .). Missa de

nocte ad s(an)c(t)am MARIA(M) maiore(m). Ad ha(n)c
missam n(on) d(icitu)r n(is)i una coll(ect)a. Gl(ori)a in ex(-)
celsis d(e)o. et Credo in unum. dicit(ur).

This page of a missal made in southern Germany in the second half of the twelfth century (probably before 1173—see chap. 8, fig. 8-7) is written in the late form of Caroline minuscule characteristic of the region. The individual letter forms are all Caroline but have undergone some evolution: notable features are the oval shape of the *o* and the application of feet (consisting of short upward pen strokes) to the bottoms of minims. The arm of the *h* tapers to a hairline that curves toward the left, extending under the baseline and sometimes ending to the left of the stem of the letter (see *hęc* in line 21); when the tip of the arm comes close to the bottom of the ascender, one must be careful not to misread the letter as *b*. The lower bow of *g* extends to the right so that it often appears below the following letter or the first element thereof (see, for example, *unigeniti* and *gaudentes* in line 8). There is one occurrence of uncial *d*, in the last line on the page (*Sed*). When two *is* occur in succession (see *mysterii* in line 1, *filii* in lines 6 and 8), the scribe places a diagonal slash above each, to avoid possible confusion with *u*; such dashes later came to be used more frequently and are the precursors of the dot over *i*.

The page includes plentiful abbreviations. Most of these are standard, although it is worthwhile to call attention to the way the scribe attaches the macron to the preceding letter when that letter has an ascender: see *rede(m)ptionis* in line 2 and *ha(n)c* in line 11, for example. The use of *c* at the end of the abbreviation for *omnipotens* in line 6 reflects the combination of Latin and Greek letter forms that characterized abbreviations for the Deity: the *c* represents the Greek letter *sigma* (see the discussion of *nomina sacra* in the section on abbreviations in chap. 6). Certain abbreviations on this page are to be found frequently in liturgical manuscripts but are less common in other contexts. These include the abbreviations *pr(aest)a* (grant; line 3) and *q(uaesumu)s* (we beseech; lines 6, 8, 17, and 20). The large, decorated *UD* monogram in lines 23–25 is a specifically liturgical form: it abbreviates *Uere dignum*, the opening words of that portion of the Preface of the Mass that varies depending on the feast day being celebrated. Each text on the page ends with an abbreviated closing formula that would have been sufficient to indicate the needed wording to the celebrant. In lines 1, 5, and 10, *P(er)* and the fuller *P(er) eunde(m)* abbreviate *Per eundem dominum nostrum Iesum Christum* (Through our same Lord Jesus Christ). (For other abbreviated endings beginning with *Per*, see the example of Beneventan minuscule in the next section of this chapter.) At the end of line 8, *Q(u)i t(ecum)* stands for *Qui tecum uiuit et regnat per saecula saeculorum* (Who lives and reigns with thee for ever and ever); fuller abbreviations for this formula occur in lines 19 and 23. Within the preface, following the *Uere dignum* monogram, the scribe skips to the words *aeterne d(eu)s* (omitting the intervening words that did not vary from one mass to another), then provides just the first words of the variable portion; these words, ending with the single-letter abbreviation *n* for *noua*, would have sufficed to identify the appropriate text to the celebrant: *Quia per incarnati uerbi mysterium noua mentis nostrae oculis lux tuae claritatis infulsit, ut dum uisibiliter deum cognoscimus, per hunc inuisibilium amore rapiamur* (Because through the mystery of the incarnated Word the new light of your splendor illumined the eyes of our mind, so that, by perceiving God visibly, we might thereby be seized by the love of things invisible).

The function of a missal was to provide the texts, both spoken and sung, for all masses throughout the church year. The year began with Advent Sunday, some four weeks before Christmas, and had its high points in the feasts of Christmas, Easter, Ascension, and Pentecost, which commemorated the major events in Christ's earthly life and the descent of the Holy Spirit upon the Apostles. The section of the manuscript from which this page comes has, in fact, more the character of a sacramentary than a missal in that it provides not the full set of texts for each mass but just the "proper prayers," that is, the prayers or portions of prayers whose text varied according to the day being celebrated. There were four such prayers at each mass: the introductory *collecta*; the *secreta*, which took its name from the fact that the celebrant recited it silently after offering the bread and wine to God; the *prae-*

DISTINCTIVE LETTER FORMS AND LIGATURES			
ƀ	= *b* [no*b*is, line 6]	**ſ**	= *s* [*s*alutis, line 1]
ȣ	= *g* [*g*audentes, line 8]	**ſt**	= *st* [my*st*erii, line 1]
ƅ	= *h* [*h*ęc, line 21]	**ẏ**	= *y* [m*y*sterii, line 1]
ο	= *o* [n*o*s, line 2]		

fatio, which formed the first part of the eucharistic prayer; and the *postcommunio*, recited at the end of the mass, following the communion. The rubricated titles for these prayers punctuate this page. Toward the bottom of the page, the rubric *Infra act(ionem)* in line 25 heads a portion of the consecratory prayer for which a variable form was used only on the most important feast days.

The first line on the page completes the *postcommunio* for the fourth Sunday in Advent, begun on the preceding page of the manuscript. Lines 2–10 contain the texts for Mass on Christmas Eve (for this Mass, the scribe has not provided a *praefatio*). The rest of the page contains prayers for the midnight Mass that was the first of three masses traditionally celebrated on Christmas Day. At Rome, the pope celebrated midnight Mass at the church of Santa Maria Maggiore (which claimed to have the remains of the manger in which Christ was born); it is for this reason that Santa Maria Maggiore is mentioned in the rubric in lines 10–13, a rubric that, like many others in liturgical manuscripts, combines a title with instructions to the priest on how the service is to be celebrated. Each prayer on the page begins with a colored initial; following the initial, the other letters of the first word(s) of the prayer have an infilling of red pigment to highlight them (Mary's name, written in capitals, is similarly highlighted by the use of red in lines 27 and 29). The initial of the collect for midnight Mass, which is much larger than any other initial on the page, has also been accorded special decoration to single it out as commencing the texts for Christmas Day; the initial combines geometric and foliate decoration, with the white tendril that fills the bow of the letter ending in a human hand that holds a flaming taper. The opening of the collect is further emphasized through the first two lines being written in capitals of alternating colors.

One notable feature of the layout of the page is that several of the rubricated titles are placed at the end of the first line of the prayer to which they relate, following the opening words of the prayer (lines 2, 6, 14). In this way, the scribe, who was also the rubricator of the manuscript, was able to save space and also have each new prayer open at the beginning of a new line. His method was that when the end of the preceding text filled a line (as it did in lines 1, 5, and 13), instead of entering the rubric of the next prayer at the left of a new line, leaving the rest of the line blank, and beginning the prayer in the next line, he combined the opening words of the prayer and its rubric in a single line, with the opening words at the left and the rubric at the right. In line 8, the rubric *P(ost)c(ommuni)o* relates to the prayer that begins in that line. However, the words *gaudentes. Q(u)i t(ecum)* to the right of the rubric are the last words of the preceding *secreta*, following on from *capiam(us) sempit(er)na* at the end of line 7; the scribe has signaled them as a runover from line 7 by placing a red runover mark before *gaudentes*.

A further feature is the plentiful use of the *punctus flexus* among the marks of punctuation (lines 3, 4, 9, 18). Serving to indicate a pause of lesser value than that signaled by the *punctus elevatus*, the *punctus flexus* never obtained widespread usage. It was, however, favored in Cistercian manuscripts of the twelfth century, which tended to be sedulously punctuated. Newberry Library MS 7 was made for the Cistercian abbey of Ebrach within the diocese of Würzburg. By the late thirteenth century, it had been transferred to another Cistercian abbey, that of Hohenfurt in Bohemia (now Vyšší Brod, Czech Republic), a daughter foundation of Ebrach (see the section "Evidence within the Contents" in chap. 8, with fig. 8-6).

Beneventan Minuscule

TRANSCRIPTION OF LINES 1–12:

es⸴ tribue q(uaesumu)s⸴ ex eorum imita-
tione p(ro) amore tuo pro(-)
spera mundi despicere⸴ et nulla ei(us)
aduersa formi(-)
Hostia d(omi)ne q(uaesumu)s quam
s(an)c(t)orum tuorum Sec(reta) dare.
p(er christum dominum nostrum).
dionisii/ rustici/ et euletherii (*recte* eleu-
therii)/ natalicia recensen(-)
tes offerimus⸴ et uincula n(ost)rę praui-
tatis absol(-)
uat⸴ et tuę nob(is) m(isericord)ię dona
conciliet. p(er omnia saecula saeculo-
rum). Com(munio)
Q(uaesumu)s om(n)ip(oten)s d(eu)s⸴ ut
qui cęlestia alimenta p(er)cepimus⸴
intercedentibus s(an)c(t)is martyrib(us)
tuis/ dyonisio
rustico et eleutherio⸴ p(er) hęc contra
om(n)ia aduersa
muniam(ur). p(er christum dominum
nostrum) S(an)c(t)i calixti cant(us)
p(er) ordine(m).
Statuit ei d(omi)n(u)s testam(en)tu(m)
pacis et principem fecit eu(m) ut sit
illi sacer(-)
dotii dignitas in eternum. p(salmus)
M(isericord)ias tuas d(omi)ne. or(atio)

10-7 Newberry Library, MS 163 (olim 36a),
verso (232 × 179 mm).

DISTINCTIVE LETTER FORMS, LIGATURES, AND ABBREVIATIONS

⍺ = *a* [*a*more, line 1]	= *ei(us)* [*ei(us)*, line 2]	= *ri* [offe*ri*mus, line 5]
= *ci* [rusti*ci*, line 4]	= *et* [*et*, line 2]	= *s* [-*s*pera, line 2]
= *d* [*d*ionisii, line 4]	= *ex* [*ex*, line 1]	= *t* [-ua*t*, line 6]
= *e* [alim*e*nta, line 7]	= *fi* [de*fi*cere, line 13]	= *te* [-*te*s, line 5]
= *ę* [m(isericord)i*ę*, line 6]	= *r* [s(an)c(t)o*r*um, line 3]	= *ti* [imita*ti*one, line 1]

Beneventan Minuscule

While Caroline minuscule spread to most parts of Western Europe during the ninth and tenth centuries, southern Italy long continued to practice its own form of script, which was of pre-Carolingian origin. This script is known as Beneventan minuscule because its major centers of production fell within the duchy of Benevento. Those major centers were the scriptoria at Monte Cassino, Benevento itself, and Bari. Because of the strong influence of Monte Cassino—founded by St. Benedict, the "father of Western monasticism"—the script spread to Benedictine houses throughout southern Italy; through Bari it made its way to cities on the eastern edge of the Adriatic and from there to monastic houses in Dalmatia (within present-day Croatia). Originating in the mid-eighth century, the script was used regularly until the thirteenth century and even persisted into the fifteenth century in certain provincial areas. Many of the surviving manuscripts and fragments in Beneventan script contain liturgical material. They include an unusual genre of liturgical roll, the Exultet roll, which carried the text for blessing the Paschal Candle on Easter Saturday and included illustrations that were upside down in relation to the text so that they would become visible to the congregation as the roll was unfurled (see chap. 16, fig. 16-3). The example of Beneventan minuscule illustrated here is a fragmentary leaf of a missal made in the late eleventh or early twelfth century.

The script is easily recognizable because of several distinctive letter forms, particularly *a*, *t*, *e*, and *r* (see the table of distinctive forms). When reading the script, one must take special care to distinguish between the *a*, which is of the *oc* variety (that is, it resembles the letters *o* and *c* written side by side), and the *t*, which includes a loop extending from the left end of the headstroke down to the baseline; at first glance, the two letters look quite similar. The letter *e* has an upper bow that rises above the headline; the *r*, which both rises above the headline and descends below the baseline, must not be mistaken for *s*, which has a more rounded top. The *d* has the rounded uncial form; the letter *i*, when beginning a word, has a tall form that rises above the headline. Beneventan scribes often joined the horizontals of the letters *e*, *f*, *g*, *r*, and *t* to form a continuous line. This "binding line" style (see, for example, *intercedentibus* in line 8) is prominent in manuscripts from Monte Cassino; manuscripts from Bari do not usually display this feature.

Beneventan minuscule uses several ligatures. The ligatured *et* (see the examples in lines 2, 4, 5, and 6) closely resembles an ampersand and makes it possible to see how the ampersand originally evolved from a ligature; it must be distinguished from the *ex* ligature, which includes a stroke descending below the line as the lower left limb of the *x* (see lines 1 and 13, *ex*, and line 17, *expediat*). For the *fi* ligature, the *f* loses its tongue and the *i* becomes an angular form that descends from the tip of the headstroke of the *f* (see line 13, *infirmitate* and *deficere*). In the *ri* ligature (line 1, *tribue*, and line 4, *euletherii*),

the *i* is a thin diagonal stroke that slants down to the left underneath the *r*. The script renders the sequence *ti* in two different ways, depending on whether the sound was to be unassibilated (as in *tibi*, where the *t* was pronounced hard) or assibilated (as in third-declension nouns ending in –*tio*, such as *discretio*, where the *t* was given a sibilant, or hissing sound). For the unassibilated version, the *t* is written in the normal way, and the *i* descends vertically from the right end of its headstroke, ending just below the baseline (see line 5, *prauitatis*, and line 8, *intercedentibus*); for the assibilated form, the loop at the left of the *t* reverses its normal direction, ascending above the headline to link with the top of the *i* (see line 1, *imitatione*, and line 16, *oblatio*). Abbreviations that are characteristic of the script include that for *eius*, consisting of the letters *ei* with the *i* descending below the baseline, where it is crossed by a horizontal stroke (see the example in line 2); and the angled, wavy mark that replaces final *m* (see line 11, *testamentum* and *eum*, and lines 14–15, *exem/pla*).

The page contains material for masses on three different feast days, as follows: (1) the conclusion of the texts for Mass on the feast of the martyrs Sts. Dionysius, Rusticus, and Eleutherius (9 October; lines 1–10); (2) the texts for the feast of St. Calixtus (14 October; lines 10–20); (3) the opening of the texts for St. Luke's Day (18 October; lines 20–29). For each of these feast days, the missal provides three proper prayers: the collect, labeled *Or(atio)*; the secret, labeled *Sec(reta)*; and the postcommunion prayer, labeled *Com(munio)* (compare the Cistercian missal and note that unlike that manuscript, this one does not include the *praefatio*). In addition, this missal provides the opening words of the Epistle for each feast day, labeled *L(ectio)*, and likewise of the Gospel, labeled *Eu(an)g(elium)*. Further, the texts for the feast of St. Calixtus begin in lines 11–12 with a musical chant and the opening words of a psalm, both written in smaller script to allow room for musical notation to be entered above, although in this case the music was not added. As in the Cistercian missal, formulaic prayer endings are highly abbreviated, being reduced on this page to the single word *p(er)*, which should here be expanded to *per omnia saecula saeculorum* (for ever and ever) or *per Christum dominum nostrum* (through Christ our Lord). Another point of comparison with the Cistercian missal is the way the scribe has sought to save parchment by not leaving portions of lines blank in the transition from one text to the next. The method employed here is that the scribe may enter the last words of a text at the right-hand end of a line, reserving the left-hand end for the opening of the next text and placing the rubricated title for this text to the right of its opening words so that it separates them from the concluding words of the previous text. This form of layout occurs in lines 3 and 18. Thus in line 3, the words –*dare per* at the end of the line conclude the collect for the feast of Sts. Dionysius, Rusticus, and Eleutherius, while the words to the left of the rubric, *Hostia d(omi)ne q(uaesumu)s quam s(an)c(t)orum tuorum*, are the opening of the secret, which then continues in line 4.

Gothic Quadrata *Bookhand*

TRANSCRIPTION OF LINES 1–11:

In aduentu d(omi)ni d(omi)nica
p(r)ima ad p(r)imas v(esper)as
 Ca(pitulu)m.
Deus pa-
cis sancti-
ficet vos
per om(n)ia⸗
vt integer
sp(irit)us v(este)r (et)
anima (et) corpus sine que-
rela i(n) aduentu d(omi)ni
 n(ost)ri i(es)u
(christ)i seruet(ur)

10-8 Newberry Library, MS 64, fol. 9r (225 × 160 mm).

During the high Gothic period (thirteenth to fifteenth centuries), professional scribes practiced a range of different scripts, both formal and cursive, varying their hands in accordance with the nature and status of the book or document being written and the wishes of their patrons. Among the formal scripts, four principal types of bookhand emerged, distinguished from one another especially by the manner of treating the tops and bottoms of minims. These four varieties of bookhand were known as *quadrata* or *fracta*, *semi-quadrata* or *semi-fracta*, *praescissa* or *sine pedibus*, and *rotunda*. The page illustrated here, from a collect book made in Austria in 1427 (according to a contemporary note on its first leaf), provides an example of *quadrata*, in which the scribe begins and ends each minim with a diamond-shaped serif; these serifs can be seen, for example, at the top and bottom of each of the three minims of the letters *ni* of *d(omi)ni* in line 1. *Quadrata* script was the model for the earliest German printers (it lies behind the font of the Gutenberg Bible) and even survived into the twentieth century as *Fraktur*, the font used in Germany for printing vernacular texts. In *semi-quadrata*, only the tops of minims are consistently given diamond-shaped serifs, while the bottoms are treated more loosely; in *praescissa*, the bottoms of minims have no feet but end flat on the line (or are even concave); in *rotunda*, the least formal of the Gothic bookhands, the minims

begin with a simple approach stroke and are rounded off at the bottom. (Italy had its own distinctive form of *rotunda*, described in the next section.)

Among the most characteristic features of *quadrata* and the other formal Gothic bookhands are uprightness and angularity. The angularity was achieved by using, instead of curves, a series of straight strokes for bows and for the letter *o*. As can be seen on this page, the *o* consists of six separate strokes and resembles a hexagon. Great care was taken to give the formal scripts regularity of appearance, with all minims being the same height, but ironically, this very regularity can make Gothic script difficult to read, especially when a word includes a string of consecutive minims: it is not easy to identify the letters to which the various minims belong, an example here being the six consecutive minims of *anima* in line 9. The scribe of this manuscript has, however, offered some help by placing a slash over *i* every time it occurs next to another letter made up of minims. Often scribes would seek to distinguish *n* from *u* by joining the two minims of *n* at the top while leaving a space between them at the bottom, doing the opposite for *u*; but as can be seen from this page, they were not always consistent in this. Another very common feature of Gothic bookhands is the "biting of bows" whereby, when two consecutive letters have bows facing one another, the bows overlap and share a stroke. Just two examples occur on this page:

DISTINCTIVE LETTER FORMS,
LIGATURES, AND ABBREVIATIONS

𝕬 = *a* [p*a*-, line 3]

𝕭 = *b* [e*b*do(mad)am, line 12]

𝕮𝕚 = *ci* [-*ci*s, line 4]

𝕮𝕥𝕚 = *cti* [san*cti*-, line 4]

𝕯 = *d* [*d*(omi)ni, line 10]

𝕯𝕺 = *do* [eb*do*(mad)am, line 12]

𝕬 = *(et)* [*(et)*, line 9]

𝕲 = *g* [inte*g*er, line 7]

𝕳 = *h* [i*h*u, *pro* i(es)u, line 10]

𝕺 = *o* [v*o*s, line 5]

𝕻 = *p* [*p*a-, line 3]

𝕻𝕰 = *pe* [*pe*r, line 6]

𝖅 = *r* [co*r*pus, line 9]

𝕾 = *s* [vo*s*, line 5]

𝖃 = *x* [*x*pi, *pro* (christ)i, line 11]

the *pe* of *per* in line 6 and the *do* of *ebdo(mad)am* in line 12.

The basic letter forms of the Gothic bookhands are those of Caroline minuscule, with a few modifications. Uncial *d* is usually preferred to the straight-backed Caroline *d* (there is no example of Caroline *d* on this page); round *s* rather than tall Caroline *s* is used at the end of words (see, for example, *vos* in line 5, *sp(irit)us* in line 8). The 2-shaped form of *r*, which had long been used in the abbreviation for the genitive plural ending –*orum*, was employed by Gothic scribes whenever *r* followed *o* (see *corpus*, line 9; *horas*, lines 11 and 12; *oracio*, line 13); indeed, many Gothic scribes—but not the scribe of this manuscript—adopted this form whenever *r* followed a letter with a bow. The Tironian abbreviation for *et* was favored over the ampersand and was often given a horizontal cross-stroke; here the additional stroke extends only to the left side of the stem (see the examples in lines 8, 9, 12, and 15). A further feature well exemplified by this page is the tendency to use *v* in preference to *u* in initial position: see *vos*, line 5, and *vt*, line 7, for example. As these two examples show, the issue is not one of pronunciation but simply of position; except at the beginning of words, *u* is preferred to *v*. Two other features of the letter forms on this page are the extension below the baseline of the right limb of *h* (see *horas*, lines 11 and 12) and the use of a cross-stroke on *x* (see the first letter of the *nomen sacrum* for Christ in line 11). The page also includes a special form of *m*, resembling an arabic numeral 3, that was quite commonly used at word endings in the late medieval period and was taken over into print culture. The example here occurs at the end of *ebdo(mad)am* in line 12. The same word, along with *v(esper)as* in line 2, demonstrates how the open-topped form long used for superscript *a* has now come to resemble *u* more than *a*. An additional paleographical feature worth drawing attention to on this page is the use of doubled hyphens, angled at a diagonal, where words are split between two lines.

The undated colophon at the end of this manuscript appears to indicate, by using the female form *scriptrix*, that the scribe was a woman; but it is contradicted by a contemporary note at the front of the book, which claims that in 1427 one Poppo de Wildek commissioned the book to be written by a Carmelite friar named Michael (see the discussion in chap. 8 and figs. 8-2, 8-3). The manuscript is a collect book, or *collectar*, that is, it contains the collects, and also the short scriptural readings known as *capitula*, that were recited at the various services of the Divine Office throughout the church year. The page illustrated comes at the beginning of the manuscript, immediately following the calendar, and opens the year by providing in lines 1–11 the *capitulum* (I Thessalonians 5:23) for "first vespers" of Advent Sunday, that is, vespers at sundown on the previous day, which was when major feast days officially began. The *capitulum* begins with a decorated initial *D* on gold background that spans six lines and is larger than any other initial in the manuscript; the status of this page as the opening page of the main text of the manuscript is also highlighted by the elaborate scrollwork border with floral sprays that fills the upper,

right, and lower margins. Trimming of the upper margin for binding has removed some small portions of the decoration; the outer margin, by contrast, may not have been trimmed, for the original prickings for the ruling can still be seen. The smaller colored initials *I* and *E* at the top and bottom of the page, respectively, begin the rubric of the *capitulum* and open the second text on the page, the collect for the first week of Advent. By combining a blue letter with red paneling, these initials use the two colors most common for minor initials in Gothic manuscripts; it is also typical that throughout the rest of MS 64, blue and red initials alternate with one another.

Italian Gothic *Rotunda*

> Scimus
> q(uonia)m dilige(n)-
> tib(us) deum
> omnia co-
> operantur in bonum:
> his qui secu(n)dum p(ro)-
> positum uocati sunt
> s(an)cti. ad sextam cap(itulum).
> Non uos me ele-
> gistis: s(ed) ego
> elegi uos: et posui
> uos ut eatis: et fruc-
> tum afferatis: (et) fruc-
> tus u(este)r maneat.

A particular form of *rotunda*, different from the *rotunda* of northern Europe, was the preferred bookhand of Italy in the Gothic period (and can also be found in manuscripts from southern France, Spain, and Portugal). The script was long-lived, being retained for use in liturgical manuscripts as late as the seventeenth century. The features of the Italian *rotunda* are to be seen on the page illustrated here, which comes from a lectionary and capitulary made ca. 1408 for the Carthusian monastery of San Lorenzo in Galluzzo, near Florence. The script has a broader, more rounded appearance than those in use in northern Europe; this tendency toward roundness had first emerged in Tuscany and central Italy in the twelfth century and can be seen in the giant Bibles produced in the region at that time. It is characteristic of Italian *rotunda* that, in general, only the last minims of *m* and *n* end at the bottom with a short upward stroke; the other minims end flat on the baseline, as do the shafts of *f*, *h*, *r*, and tall *s*, while the bottoms of the descenders of *p* and *q* are also flat (for these features see, for example, the sequence of words *sine macula: et qui post* in lines b19–20).

As in the Gothic bookhands of northern Europe, round *s* is consistently preferred to tall Caroline *s* at word endings (see *Scimus*, *uos*, and *elegistis* in lines a1 and a9–10); and uncial *d* is generally preferred to the straight-backed Caroline *d*, although the latter does occur twice on this page, in *sup(er)hedificati* (line a19) and *meditabit(ur)* (line b14). The arm of *h* is notably rounded, curving so that it almost meets the bottom of the shaft; care must be taken to distinguish the letter from *b*. The 2-shaped form of *r* is used whenever *r* follows *o* (*coronam*, line b8; *morabitur*, line b13). The form of *m* that resembles the arabic numeral 3 is used at some word endings (for example, *bonum*, line a5; *fundame(n)tum*, line a20; *p(ro)ph(et)arum*, line a21); the same form also serves as an abbreviation symbol, replacing the last two letters of *sed* (lines a10 and a17). The preferred abbreviation in the Italian *rotunda* for the suspended dative and ablative plural –*us* ending is a

simple curved stroke resembling a backwards *c* that attaches to the shoulder of the preceding *b*: see *dilige(n)tib(us)*, lines a2–3. As is normal in the northern Gothic bookhands, the Tironian abbreviation for *et* is preferred to the ampersand; the Italian version has a curved shaft (lines a13, a21, b13). The punctuation of this page includes both the *punctus flexus* and the *punctus elevatus*; the latter, as is common in late medieval liturgical manuscripts, takes a form in which the tick at the end of the upper stroke is reduced to a barely visible hairline, causing the mark to resemble a modern colon.

This page includes numerous examples of the biting of bows so characteristic of Gothic bookhands (as noted in the preceding section): see the *de* of *deum* in line a3, the *pe* of *co/operantur* in lines a4–5, the *bo* of *bonum* in line a5, and so on. A feature common in deluxe manuscripts of the Gothic period is the use of line fillers to take up the remaining space when a word ended short of the end of a line and the scribe did not wish to begin another word on that line (see the section on line fillers in chap. 3). Sometimes highly decorative, in this manuscript the line fillers are simple and must not be mistaken for letters. They occur in two forms, one narrow, resembling a letter *i* with two hairline diagonals through it (line a10), the other broader, consisting of an *o* with a single diagonal through it (line a11). At one point on this page (line a17),

	DISTINCTIVE LETTER FORMS, LIGATURES, AND ABBREVIATIONS
𝖆	= *a* [omni*a*, line a4]
𝖇	= *b* [-ti*b*(us), line a3]
𝖇𝖔	= *bo* [*bo*num, line a5]
𝖉	= *d* [*d*ilige(n)-, line a2]
𝖉𝖊	= *de* [*de*um, line a3]
𝗓	= (*et*) [(*et*), line a13]
𝖌	= *g* [dili*g*e(n)-, line a2]
𝖍𝖊	= *he* [sup(er)*he*dificati, line a19]
𝖍𝖔	= *ho* [*ho*spites, line a16]
𝖔𝖈	= *oc* [u*oc*ati, line a7]
𝖕𝖊	= *pe* [o*pe*rantur, line a5]
𝖕	= *p(ro)p* [*p(ro)p*h(et)arum, line a21]
𝗋	= *r* [s(an)c(t)o*r*um, line a18]
𝖘	= *s* [Scimu*s*, line a1]
𝖘𝖙	= *st* [-gi*st*is, line a10]
𝗑	= *x* [*x*po, *pro* (christ)o, line b2]

the scribe encountered the problem of having not too much but too little space at the end of the line; his solution was to complete the word *ciues* by writing the final *s* in superscript, above the line.

The lectionary and capitulary to which this page belongs contains both the scriptural passages read out at Mass throughout the ecclesiastical year and the short scriptural readings (*capitula*) for the various hours of the Divine Office. The section of the manuscript within which this page falls contains the *capitula* to be read out at the "little hours" of terce, sext, and none and covers the Common of Saints; that is, it includes texts for the feast days of those saints who did not have a complete individual Office of their own. The left column and the first two lines of the right column have the readings for the feast day of an apostle (the rubricated title indicating this, *In natale apostolorum*, is entered at the foot of the pervious page); the rest of the right column relates to the feast day of a martyr, as is indicated by the title in lines b2–3 (*In natiuitate unius martyris*). The three hours of terce, sext, and none were all structured in the same way, with the reading coming toward the end of the service, before the concluding responsory, prayer, and versicles. Often the reading was very brief, consisting of a single verse of scripture. Here the readings for the Common of Apostles are from Romans 8:28, John 15:16, and Ephesians 2:19–20; those for the Common of Martyrs, focusing on the qualities of the blessed man and mentioning the crown of eternal life that he will obtain, come from James 1:12, Ecclesiasticus 14:22, and Ecclesiasticus 31:8. A notable characteristic of the page is the way the scribe has laid out the rubrics for the readings. If any space was available at the end of the last line of a reading, he used that space for the rubric of the next reading; if the rubric had to extend into a second line, he used the right portion of that line, entering the opening words of the reading itself at the left end of the line and separating these words from the rubric with a pair of parallel red verticals. (Compare the methods used for the layout of rubrics in the examples of German Protogothic bookhand and Beneventan minuscule discussed above.)

The first reading for the Common of Apostles begins with a historiated initial *S* on a gold background, embellished with an elaborately decorative floral border that brackets the left column. Within the initial are three nimbed apostles, two of whom lack attributes and are therefore unidentifiable. The apostle in the foreground holds a closed book in his left hand. The depiction of a scroll-like object in his right hand is perhaps the result of a misunderstanding by the artist. The top right portion of the object resembles the end of a key, and it seems likely that a key was what was represented in the model from which the artist worked. This apostle would then be St. Peter, the keeper of the keys of the kingdom of heaven; his short hair and trimmed beard would fit with the traditional iconography for St. Peter. The other readings on the page each begin with a colored initial on a decorated paneled background: either red on blue or blue on red. A three-line initial begins the first text for the Common of Martyrs, while two-line initials serve for the other readings. The left sides of the panels of the initials in the right column extend upward and downward to join in a border that echoes, in a minor key, the floral border of the left column. Following the colored initial, the second letter of each reading is rendered as a decorative capital form with background penwork in which the principal motifs are sets of parallel lines and roundels that contain a central dot; such decoration of secondary letters is quite common in Italian manuscripts of this period.

10-10 Newberry Library, MS 147 (108 × 194 mm).

TRANSCRIPTION OF LINES 1–8:

Sciant p(rae)sentes (et) fut(ur)i q(uod) ego Ioh(ann)es
le sleye. dedi (con)cessi (et) hac p(rae)senti carta mea
(con)firmaui Ioh(ann)i de la com(-)
be de Cotintone. vna(m) ac(r)am t(er)re mee. que iacet
in campo q(uod) voca(tur) le ruding. int(er) t(er)ram
Henr(ici) Wic ex vna p(ar)te
(et) t(er)ram d(i)c(t)i Ioh(ann)is ex alia p(ar)te. videl(icet) in
exchambio. p(ro) vna alia ac(r)a que iacet iux(t)a Alepinis
medue. (et) eciam
vendidi eid(em) Ioh(ann)i vnu(m) puteu(m) q(u)i restat infra
d(i)c(t)am ac(r)am q(u)a(m) eid(em) Ioh(ann)i alt(er)naui.
silic(et) p(ro) q(u)atuordecim den(ariis). (et) illa

ac(r)a se extendit in vno capite vsq(ue) ad via(m) que ducit
vers(us) molendinu(m) de Colewalle. (et) in alio capite
vsq(ue) ad t(er)ram d(i)c(t)i Ioh(ann)is. Hab(e)nd(um)
(et) Tenend(um) d(i)c(t)am ac(r)am t(er)re (et)
puteu(m) p(rae)d(i)c(tu)m cu(m) om(n)ib(us) eor(um)
p(er)tine(n)ciis
de me (et) h(er)ed(ibus) meis. d(i)c(t)o Ioh(ann)i (et)
h(er)edib(us) suis u(e)l suis assignatis imp(er)petuu(m).
lib(er)e. q(u)iete. bene (et) in pace
sine om(n)i (contr)ad(i)c(ti)o(n)e u(e)l vexac(i)o(n)e mei.
u(e)l h(er)edu(m) meor(um) imp(er)petuu(m).

DISTINCTIVE LETTER FORMS, LIGATURES, AND ABBREVIATIONS			
𝒜	= a [alia, line 3]	𝔭	= i [iacet, line 3]
𝔮	= a [mea, line 1]	𝓋	= l [alia, line 3]
𝔟	= b [exchambio, line 3]	ſ	= s [p(rae)senti, line 1]
𝔈	= C [Cotintone, line 2]	ꝯ	= s [Ioh(ann)is, line 3]
ꝯ	= (con) [(con)firmaui, line 1]	𝔖	= S [Sciant, line 1]
𝔇	= d [dedi, line 1]	𝔈	= T [Tenend(um), line 6]
ſ	= f [(con)firmaui, line 1]	𝔙	= v [vna(m), line 2]
𝔥	= h [exchambio, line 3]	𝔵	= x [iuxta, line 3]
𝔥	= H [Hab(e)nd(um), line 6]		

English Cursive Documentary Script (ca. 1300)

One consequence of the rapid diffusion of Caroline minuscule from the ninth century onward was the virtual elimination of cursive scripts, that is, scripts designed for rapidity of execution and typically used for documentary purposes such as recording grants of land. In those territories where scribes adopted Caroline minuscule for copying books, they also tended to employ it for recording transactions. During the twelfth century, notably at the English royal court, scribes drafting documents developed a version of Protogothic bookhand that incorporated some quasi-cursive features—linked minims and occasional loops—intended to increase the speed of writing. Only during the thirteenth century, however, did true cursive script reemerge in Western Europe. This was a consequence both of the great increase in royal and other business transactions and of the explosion in the demand for and production of books, which prompted scribes to develop methods to copy books more rapidly. In England, the type of script that emerged and was widely used for both documents and books from the thirteenth to the fifteenth century is highly distinctive and is known as Anglicana. This script is here illustrated by a charter dating from around the turn of the fourteenth century.

The main features that distinguish a cursive script from a formal bookhand are a reduction in the number of pen lifts necessary for the execution of individual letters and the introduction of loops both to facilitate this reduction and to link one letter to another. The resulting script often presents a severe challenge to novice paleographers but will repay careful examination. A proliferation of loops is one of the most characteristic features of cursive Anglicana, as can be seen here. For example, the scribe turns the slanted ascender of uncial *d* into a loop that descends to touch, or almost touch, the base of the letter (see *dedi*, line 1, and *molendinu(m)*, line 5). The tops of the ascenders of *b*, *h*, *k*, and *l* are all looped, and these ascenders also have a stroke applied at the left, giving the ascender a "horned" aspect: see, in line 3, the *l* of *alia* and the *h* and *b* of *exchambio*. Note that when *i* is in initial position, it often has a lengthened form rising above the headline and descending below the baseline, and its ascender then shares the characteristics of other ascenders: see *iacet* and *int(er)* in line 2. Tall *s* and *ʃ* have a loop at the top but not the additional stroke at the left, and both letters descend below the baseline: see *(con)cessi*, *p(rae)senti*, and *(con)firmaui*, all in line 1. Final *s* is written in a cursive version of the round form, with the bottom part of the letter forming a closed loop, as in *Ioh(ann)is* and *Alepinis* (line 3); this form is sometimes used within words, as in *vsq(ue)* at the beginning of line 6. In initial position, *v* is preferred to *u*, and the left limb of the letter rises and loops above the headline: see again *vsq(ue)* in line 6. The letter *a* typically has a two-compartment form, with the upper part of the letter rising well above the headline, as in the three *as* of *carta mea* in line 1; but sometimes it is written in single-compartment form, as

in the two occurrences of *alia* in line 3. The superscript *a* used in abbreviations has a horizontal headstroke. While a straight macron is used for some abbreviations, in other places the macron has been transformed into a cursive loop, as in *vnu(m) puteu(m)* (line 4). Among the most difficult features of Anglicana script are the forms of the capital letters, which are often elaborated with additional strokes: see especially the *S* of *Sciant* at the very beginning of this charter, but also the *C* of *Cotintone* (line 2) and *Colewalle* (line 5); the *H* of *Henr(ici)* (line 2) and *Hab(e)nd(um)* (line 6); the *T* of *Tenend(um)* (line 6); the *R* of *Reddendo* (line 8); and the *E* of *Et* (line 11).

A primary purpose of charters was to provide an authentic record of a transfer of land from one individual or institution to another. In this charter, John le Sleye grants one acre of land to John de la Combe in exchange for an acre belonging to de la Combe; le Sleye also sells to de la Combe, for fourteen pence, a well located on his acre. The charter goes on to stipulate the rent that de la Combe and his heirs must pay to the lord of the fief: two pence annually, divided into two installments of one penny each, to be paid at Michaelmas (29 September) and on the feast of the Annunciation (25 March). The structure and language of charters are usually highly formulaic, beginning with an address to all those who may read the document, continuing with the description of what is granted and a precise account of its extent and boundaries, and ending with an injunction against any who would presume to violate the charter and a list of those who witnessed the grant. Because the language was formulaic and repetitive and because the documents were produced at speed, charters may include many abbreviations. Charters were generally not written on the highest grade of parchment; a middling grade was normally deemed sufficient and has been used for the present charter, on which hair follicles are clearly visible.

It was most important that a charter should be properly authenticated. One method of authentication devised in the British Isles in the early Middle Ages was to produce a chirograph, that is, to make two or three identical copies of the charter on a single sheet of parchment, with the word CHI-ROGRAPHUM written between the copies. The document would then be divided by cutting through this word with a straight or indented line, and the copies would be given to the different parties; the authenticity of any of the copies could be proven by seeing if it matched up when reunited with the other(s) (see chap. 14, fig. 14-1). Later, a more common method of authentication was to append a seal to the charter, as has been done in this case. To apply the seal, the scribe folded over the bottom of the charter and made a slit through both parts. A strip of parchment was then passed through the slits, twisted together at the end, and sealed with wax. If the strip was cut from the same parchment as the charter itself, it is called a tongue. Often, as with John le Sleye's charter, the parchment strip has survived into modern times but the seal itself has not.

The fold-lines clearly visible on this charter indicate that it has been folded up for storage. Because single-sheet charters

could not easily be bound up into codices, in several regions it was common to fold them and store them in a burlap sack or similar receptacle that would then be labeled and hung from a hook in an armoire; or they might be put in a muniments chest, a long narrow box with several compartments for storing charters with the contents of each compartment indicated by a label, as in the surviving chest from Ely. This method of storage kept the parchment off the floor and behind closed doors, making it more difficult for rodents to attack and consume the documents. The charter would be folded with the text inward, and for this reason it was common for a brief summary of the content of the document to be entered on its reverse side (the dorse), which would be visible after folding. The dorse of this charter carries a note with the names of the two parties to the grant. The dorse may also contain notarial information, such as a reference to taxes paid to register the charter.

Bastard Anglicana Script

Bastard Anglicana Script

TRANSCRIPTION OF LINES A1–16:

P(ro)logus. Cap(itulum) p(r)imu(m).

Post p(rae)claros arciu(m) scriptor[i/e]s
quib(us) circa rer(um) noticia(m) aut
mor(um) modestia(m) dulce fuit
quo aduiu(er)ent insudare il-
li m(er)ito velut vtile dulce
co(m)miscentes g(r)andiosius su(n)t p(rae)coniis attollendi
qui magnifica p(r)iscor(um) gesta b(e)n(e)ficiis sc(r)ipture
 poste-
ris deriuaru(n)t. In historico na(m)q(ue) contextu crono-
g(r)aphor(um) diligencia nobis delegato relucet clarius
norma mor(um) forma viuendi p(ro)bitat(is) incentiuu(m)
t(r)inu(m) quoq(ue) theologicar(um) vi(r)tutu(m) (et)
 q(u)adriuiu(m) cardi(n)ali-
u(m) teabear(um) (*recte* trabearum) quoq(ue) noticia(m)
 app(re)hendere seu vestigiu(m)
imitari n(ost)ra modicitas no(n) suffic(er)et n(is)i
 sollicitudo
n(ost)re sc(r)iptor(um) t(r)ansfu(n)deret imp(er)icie
 memoria(m) t(r)ansactor(um)
sc(r)ibere bonu(m) e(st) ad me(m)o(ria)m futuror(um).

DISTINCTIVE LETTER FORMS, LIGATURES, AND ABBREVIATIONS

a	= a [*a*ut, line a3]	**l**	= l [ve*l*ut, line a6]
b	= b [*n*obis, line a10]	**o**	= o [n*o*bis, line a10]
be	= be [la*be*(n)s, line a17]	**pp**	= p(ro)p [*p(ro)p*on(er)e, line b18]
c	= c [relu*c*et, line a10]	**q**	= q [*q*uoq(ue), line a13]
ci	= ci [*ci*rca, line a3]	**s**	= s [*s*criptores, line a2]
cl	= cl [p(rae)*cl*aros, line a2]	**s**	= s [*s*ollicitudo, line a14]
co	= co [p(rae)*co*niis, line a7]	**t**	= t [relucet, line a10]
d	= d [insu*d*are, line a5]	**v**	= v [*v*iuendi, line a11]
do	= do [sollicitu*do*, line a14]	**x**	= x [conte*x*tu, line a9]
g	= g [*g*esta, line a8]	**z**	= z [Na*z*anzenus, line b13]
h	= h [*h*istorico, line a9]		

10–11 Newberry Library, MS 33.1, fol. 15r.
(*opposite*) Full page (380 × 260 mm).
(*above*) Detail of upper portion of page.

The coexistence in the Gothic period of formal hands employed for the copying of books and cursive scripts used for documentary purposes eventually resulted in cross-fertilization between these two fundamentally different writing styles. Notably, scribes began to upgrade some of the cursive scripts to make them suitable for use as bookhands. A cursive script that has been thus formalized is known as a *bastard* script (whereas a bookhand that has had cursive elements fused onto it is known as a *hybrid* script). The advantage of such a script was that it could be written more quickly than a pure bookhand; it thus recommended itself to scribes in a period when demand for books was increasing and authors were tending to write longer texts. In England during the fourteenth and fifteenth centuries, many books were written in the script known as Bastard Anglicana. The example shown here comes from a copy of Ranulph Higden's *Polychronicon* made in the first half of the fifteenth century.

The Anglicana roots of the hand are to be seen in such forms as the tall *s* and *f* extending below the baseline, with the descender bending to the left. The looped variety of round *s* so commonly found in Anglicana script at word endings is here occasionally used at word beginnings: see *sollicitudo* (line a14), *soleat* (line b3), and *sc(r)ibenciu(m)* (line b7). On the other hand, the elaborate loops characteristic of cursive Anglicana have been rejected or restrained: the ascender of *d* is here formed without a loop, while the ascenders of *b*, *h*, and *l* have a neatly hooked loop. Especially indicative of the extent to which the script has been formalized into a bookhand is the application of feet to the bottoms of minims; see, for example, the three minims of the *m* of *modestia(m)* in line a4. The bows of *d*, *g*, *o*, *p*, and *q*, rather than being rounded as in a rapidly written cursive, are carefully formed of a series of short strokes (called "broken strokes" by M. B. Parkes). Other characteristic forms of the hand include two-compartment *a* that rises above the headline; initial *v* with the left limb rising above the headline and curving to the left (as in *viuendi*, line a11); and an *x* in which both limbs descend below the baseline (see *contextu*, line a9). The 2-shaped form of *r* is used following *o*, as in *norma mor(um) forma* (line a11), and occasionally when *r* follows other letters: see *rer(um)*, line a3, and *q(u)adriuiu(m)*, line a12. There is occasional biting of the bows of letters, apparently to save space at line endings: see the *po* of *poste/ris* (lines a8–9), the *do* of *sollicitudo* (line a14), and the *be* of *labe(n)s* (line a17). Care must be taken to distinguish between the *c* and the *t*, for the left side of the *c* sometimes extends above the top of the headstroke, as in *dulce* (line a6); the shaft of the *t* is, however, somewhat taller (compare the *ts* of *velut vtile* in line a6). Notable features of the layout of the page include the use of alternating red and blue paraph marks to divide the text into sections; the application of a stroke of red pigment to the first letter of each new sentence; the underlining in red of the names of authors who are cited (see *g(re)g(orius)*, line b13); and the provision of a running title, *liber P(r)imus*, written in formal Gothic bookhand at the top of the page. All these features seek to ease the reader's path through the text.

Higden's *Polychronicon* was one of the most popular historical texts of the late Middle Ages; more than one hundred manuscripts survive. The work is a universal history extending from the creation of the world to Higden's own time. It would appear that the original version finished at the year 1327; Higden himself later extended it to 1352, and others supplied later continuations. The work was translated into English by John Trevisa in 1387, this version being updated and printed by William Caxton in 1482 and by Wynkyn de Worde in 1495. One major reason for the work's popularity is that Higden set out to entertain as well as to educate; the *Polychronicon* liberally mixes legend with fact. The first of the seven books into which the work is divided is concerned with the geography of the known world, and in some manuscripts—but not this one—the text is preceded by a world map. Little is known of the author except that he entered the Benedictine abbey of St. Werburgh in Chester in 1299 and eventually had charge of the abbey's library and scriptorium; he died in 1364. He identifies himself as the author of the work by an acrostic embedded in book I: the capital letters that begin the chapters of the book spell out the message "PRESENTEM CRONICAM CONPILAVIT FRATER RANULPHUS CESTRENSIS MONACHUS" (Brother Ranulph, monk of Chester, compiled this chronicle). In the Newberry copy, there are two errors in the acrostic, as a result of modifications to the text of book I made presumably after Higden's time by someone unaware of the acrostic: "FRATER" wrongly appears as "SRATER" because of the addition of material about Brabant to the beginning of chapter 28, on Flanders; and "MONACHUS" appears as "MONACHQS" as the result of the suppression of a clause at the beginning of the penultimate chapter of the book.

The page illustrated contains the beginning of Higden's preface to the work. The preface opens with a historiated initial *P* containing within its bow a depiction of St. Antony (d. 356), revered as the founder of monasticism. Antony is here shown carrying a bell and a candle with a tusked boar emerging from behind him, a widespread iconography that originated with the Order of Hospitallers of St. Antony founded around 1100 at La Motte in France. The relics of St. Antony at La Motte were reputed to cure the malady known as St. Antony's Fire, believed now to have been ergotism (a convulsive condition resulting from the consumption of toxic levels of the ergot fungus, usually found in grain). Possibly used by the Hospitallers to attract attention to themselves when begging, the bells associated with the order may also have functioned as a type of talisman, being given to pilgrims to the shrine to ward off St. Antony's Fire and being hung around the necks of livestock to protect them from disease. St. Antony is said to have tamed a wild boar, and the Hospitallers were allowed to let their pigs run free through the streets; hence the saint's frequent depiction with a pig or boar. The initial is here accompanied by a magnificent trellis-and-scrollwork frame that surrounds the page and divides the text into two columns. It is fortunate that this decoration has survived, for the large initial that begins book I of the *Polychronicon* has been cut out

of the manuscript (see chap. 7, fig. 7-33), as has a smaller initial on a later page. Centered in the lower border are the arms of the Bothe family, consisting of three boars' heads (see fig. 7-19). The manuscript was evidently made for a member of this prominent English family, which produced several leading churchmen in the fifteenth century, among them two archbishops of York; it is presumably because the Bothe crest included boars' heads that the artist chose the iconography of St. Antony with a boar for the opening initial. An inscription added to folio 14v, the originally blank page that faces the opening of Higden's preface, requests prayers for the soul of Robert Bothe, dean of York, and records Bothe's bequest of the manuscript in 1489 to King's Hall, Cambridge, where he had been a student in the early 1470s (see chap. 7, figs. 7-21 and 7-22).

10-12 Newberry Library, MS 33.3, fol. 177v.
(above) Full page (289 × 195 mm).
(opposite) Detail of lower right portion of page.

Fifteenth-Century English Secretary Hand

Affter the deþe of þis marcial man
I meen þis noble worthi Constantyn
Co(m)meþe the Apostata cursed Julian
Which bi descent to Constantyn was cosyn
His gynnyng cursed had a cursed fyne
Entred religion as bokes specifie
Vndre a colo(u)r of fals ypocrysi

Hit haþe be seyde of antiquite
Where at there is dissimuled holynes
Hit is called doble iniquite
ffy on al such feyned p(er)fitenes
ffor similacion cured w(i)t(h) doblenes
And fals semblant w(i)t(h) a sobre face
Of all fals sectes stonde forthest owte of g(r)ace

Beginning in the third quarter of the fourteenth century, the handwriting of English scribes was greatly influenced by a new cursive script that perhaps first emerged in Italy but that underwent significant transformation in France, from where it reached England. In its English form, this script is known as Secretary hand. In the course of time, scribes adopted it for every kind of documentary and more formal purpose, until by the sixteenth century it had become the dominant form of script practiced in England. In the second half of the fifteenth century, a well-formed version of Secretary was quite

DISTINCTIVE LETTER FORMS, LIGATURES, AND ABBREVIATIONS			
𝔞	= a [a, line b26]	ℓ	= l [marcial, line b22]
𝔟	= b [borne, line b8]	ɳ	= n [dongeon, line a24]
𝔡	= d [had, line b12]	oꝛ	= or [ordre, line b39]
f	= f [Of, line b35]	ꝛ	= s [As, line b13]
ff	= ff [ffor, line b33]	ſ	= s [souereyn, line b10]
𝔤	= g [glad, line a29]	ƥ	= þ [þat, line a31]
3	= 3 [3ere, line b15]	ʋ	= V [Vndre, line b28]
ß	= h [had, line b10]	w	= W [Which, line b25]
ɦ	= h [chese, line b13]	ʯ	= y [gynnyng, line b26]
ᵬ	= k [token, line a32]	⁊	= (and) [(and), line b42]

[167]

frequently used for copying the works of the major vernacular authors Chaucer, Gower, and Lydgate. Often scribes would incorporate elements of the older Anglicana script into their version of Secretary hand, as has happened here, in a copy of John Lydgate's *The Fall of Princes* made ca. 1470.

Characteristic of Secretary hand are the neat loops at the tops of the ascenders of *b, h, k,* and *l,* to be seen here, for example, in *Affryke* (line b18), *holynes* (line b30), and *doble* (line b31); note also the straight extension of the right limb of *h* below the baseline and the shortened form of the right limb of *k,* which must not be confused with capital *R* (in line b8, contrast the *R* of *Reioyse* with the *k* of *folkes*). Lowercase *r* occurs in both the regular and the 2-shaped form, with both forms displaying an angularity that is typical of Secretary. For regular *r,* the angularity results from the construction of the arm of the letter with a short hairline rising to the right followed by a thick stroke descending to the right; the 2-shaped form resembles a modern lowercase *z* (see *Fforsoke* and *ordre,* line b39). The letter *y* has an extremely fine hairline stroke as its descender (see *gynnyng* and *fyne* in line b26). The letters *n* and *u* are virtually indistinguishable from one another. The *v* that is used at word beginnings has a tall left limb (*victorye,* line a17; *vision,* line a22) and must not be misread as *b;* the tall limb curves to the left rather than to the right as in the loop of *b.* The influence of Anglicana on this scribe is to be seen in such features as the use of two-compartment *a* (pure Secretary hand favored single-compartment *a*) and the closed lower bow of *g.*

Certain features of the script of this page reflect the fact that the scribe is here copying a vernacular rather than a Latin text. The old Anglo-Saxon letter *thorn* is frequently, but not invariably, used to represent *th:* see, for example, *þis* in lines b22 and b23, but contrast *the* earlier in line b22. The Middle English character *yogh,* resembling an arabic numeral 3, is used to represent the sounds of consonantal *y* and voiced *gh* (see *ʒere,* line b15, and *Brouʒte,* line b11). Note, however, that the same form also represents the letter *z* (as in *Byzante,* line b2) and serves as an abbreviation symbol for suspended final *–us* (as in *Pheb(us),* line b16). Capital *F* is represented by a doubling of the letter (see the first letters in lines b32, b33, b39, and b42). Superscript 2-shaped *r* at the end of the word indicates that a preceding *u* has been omitted, as in *aucto(u)r* (line a4), *fayto(u)r* (line a9), and *colo(u)r* (line b28). Often the letters *d* and *h* at the end of a word have a horizontal or curved stroke crossing or extending to the right of their ascender; the stroke is redundant and does not signify an abbreviation (see, for example, *furth* and *fostred* in line b11, *Which* in line b25, and *Entred* in line b27). The relatively few abbreviations on the page include *þ* with superscript *t* for *þ(a)t* and *w* with superscript *t* for *w(i)t(h).* The Tironian symbol is used for *and;* it here has both a horizontal cross-stroke and an additional horizontal stroke above it (see lines b13, b17, b20, etc.).

John Lydgate (ca. 1370–1449), who throughout his life was a monk of the great Benedictine abbey of Bury St. Edmunds in Suffolk, wrote *The Fall of Princes* in response to a commission given him by Humfrey, Duke of Gloucester, the brother of King Henry V and an important literary patron who was responsible for bringing several Italian humanists to England. At 36,365 lines, *The Fall of Princes* is Lydgate's longest work, completed over a period of seven years (1431–38). It is a translation of Giovanni Boccaccio's *De casibus illustrium virorum* based not on the original Latin but on an intermediary French version made for the Duc de Berry by Laurent de Premierfait. Boccaccio's work, cast in the form of a vision experienced by the poet as he sits in his study, seeks to provide a "mirror for princes" by outlining the misfortunes that overcame prominent characters in history and mythology, both male and female, when they succumbed to pride or ambition. The page illustrated carries lines 1401–84 of book VIII of Lydgate's version. Much of the page is taken up by the conclusion of the account of the Emperor Constantine. Lydgate has here greatly expanded upon Boccaccio's original text to provide an extended eulogy of the first Christian emperor; he also incorporates an allusion to Constantine's supposed British origin (lines b8–14). The last three stanzas on the page begin Lydgate's highly unfavorable account of the career of Constantine's nephew, Emperor Julian the Apostate. Although the new section has no rubricated title here as it does in some manuscripts, it is clearly signaled by the two-line gold initial *A* on a paneled background, with a foliate spray extending in both directions in the intercolumn. The manuscript includes more elaborate decoration on pages that carry the openings of the individual books of Lydgate's work. The decoration of the manuscript has been attributed by Kathleen Scott to an illuminator known to have been active in London in the years 1455–75. Other notable features of the layout of this manuscript include the clear separation of the poetic stanzas, with alternating blue and red paraph marks at the beginning of each stanza; the stroke of red pigment that marks out the first letter of each line and that is also used to highlight capital letters occurring within lines; and the red underlining of capitalized words (most, but not all of which are personal or place names). The wavy and straight red lines at the right side of each stanza serve to indicate the rhyming scheme to the reader; such aids are quite common in manuscripts of later medieval rhymed verse. Lydgate's rhyming scheme for *The Fall of Princes* is ABABBCC. The red lines link those verses that rhyme with one another, the horizontal lines being extended to the left when the verse line is short. There are occasional errors, as in the second stanza on the page, where the rubricator has failed to link the two C verses that complete the stanza. This manuscript has suffered quite extensive water damage, evidenced on this page by the blurring of the book number entered in the upper margin and of the decoratively extended ascenders in the first line of text.

Lettre Bâtarde

Honnourable
et discret Ber-
tran aubert es-
cuier de terreston frere
 Jehan
ferron des freres prescheurs
de paris son petit et humble
chappellain salut Toute la
sainte escripture dist que
dieu nous a fait a ch(ac)un
commandement de pour-
(/column b) chassier a tous
 noz pro-
chains leur sauuement.

10–13 Newberry Library, MS 55.5, fol. 96r (340 × 238 mm).

DISTINCTIVE LETTER FORMS AND ABBREVIATIONS

𝒶 = *a* [*a*, line b1]	ḣ = *h* [presc*h*eurs, line a5]	𝖜 = *re* [aut*re*s, line b9]
𝔁 = *d* [*d*e, line b5]	𝖂 = *pp* [cha*pp*ellain, line a7]	ƒ = *s* [*s*ont, line b4]
ƒ = *f* [*f*rere, line a4]	ꝙ = *q* [*q*ue, line b3]	𝕾 = *s* [vng*s*, line b8]
𝖌 = *g* [vn*g*, line b4]	𝟤 = *r* [p*r*o-, line b1]	𝔥 = *v* [*v*ngs, line b8]

Lettre Bâtarde

The most highly developed and calligraphic of the "bastard" scripts of the late Middle Ages was *lettre bâtarde*, which emerged in Flanders in the fifteenth century. Used especially for the production of deluxe copies of vernacular texts for rich patrons, including two dukes of Burgundy, Philip the Good (1419–67) and Charles the Bold (1467–77), it is often known under the alternative name of *lettre bourguignonne*. The beautifully illuminated page here illustrated comes from a copy of Jean Ferron's French translation of the *Liber de moribus hominum et de officiis nobilium ac popularium sive super ludo scaccorum*, a work originally written ca. 1300 by the Dominican friar Jacobus de Cessolis. This copy of Ferron's version dates from the third quarter of the fifteenth century.

Features of the hand that point to the cursive origin of *lettre bâtarde* include the elongated tall *s* and *f* descending below the line, a characteristic that first developed in charter script. The rightward lean of these two letters gives the script some of its typical appearance, as does the thickening of the middle portion of their stems, an effect apparently resulting from the use of a very flexible nib: the scribe applied extra pressure to produce the thickening. At the end of line b3, where the last word is *prochains*, the scribe has had to give the final *s* an especially sinuous form to prevent its trespassing too far beyond the edge of the column, and the artist has had to interrupt the frame surrounding the text to prevent its covering the letter. Another indicator of the cursive origin of *lettre bâtarde* is the use of simplified forms for certain letters, notably single-compartment *a* and a *g* that in place of a fully formed lower bow has a simple stroke extending toward the left. The *q*, which must not be misread as *g*, resembles an arabic numeral 9 (see *que*, lines a8 and b3). As in other Gothic scripts, round *s* is used in preference to tall *s* at word endings (as in the three consecutive words *des freres prescheurs*, line a5); and the 2-shaped form is used for *r* when it follows a letter with a bow (see the first *r* of *prescheurs*, line a5, and *or*, line b2). The *d* derives from the uncial form so prevalent in the Gothic period but has here developed a loop to the ascender that gives the letter the appearance of a figure eight. At word beginnings, *v* is preferred to *u* and includes a taller left limb that ends with a curve toward the right (see *vng*, line b4, and *vngs*, line b8); the letter must not be mistaken for *b*, which has a completely straight ascender (see *humble*, line a6). In general, the loops that are so characteristic of cursive have been eliminated to give the script its formal appearance, and it is lent delicacy by the slanted, finely tapered strokes that form the ascender of *t* and the descenders of *p* and *q*.

The page carries the opening of Jean Ferron's preface to his translation of the *Liber . . . super ludo scaccorum*, which Ferron completed in 1347. The preface is addressed to Ferron's patron, Bertrand Aubert, whom Ferron—a Dominican friar like de Cessolis, the original author of the *Liber*—served as chaplain. De Cessolis's work enjoyed extraordinary popularity in the late Middle Ages and quickly spawned vernacular translations, including *The Game of Chess*, the English version that was the second book printed by William Caxton. The work, cast in the form of a set of sermons, is an allegorization of the game of chess in which the different pieces serve as a basis for comment upon the various estates of society. The major pieces represent royalty and nobility while the eight pawns respectively represent a peasant and members of various *métiers* or professions: carpenter, notary, banker, physician, innkeeper, watchman, and messenger. Much of the interest of the work lies in its opening section, which reveals how chess was played in the late Middle Ages. The miniature that dominates the present page shows Jean Ferron in the habit of a Dominican, offering his translation to his patron. This miniature, along with others in the manuscript, has been attributed to the Master of Anthony of Burgundy, who worked at Bruges in the 1460s and 1470s and is named for his work for Anthony, illegitimate son of Duke Philip the Good. Antoine de Schryver has suggested that the master should be identified as Philippe de Mazerolles (d. 1479), an artist who is known from court documents to have served the Burgundian ducal family, but the identification has been disputed. The decoration of the page includes the blue initial *H* that opens the preface and is set in a paneled gold background inhabited by foliate scrollwork and the multicolored floral spray that serves as the right-hand border of the left column of script and echoes the much larger border that fills the margins. The coat of arms that overlies the border in the lower margin is that of Wolfart VI van Borselen (d. 1487), for whom the manuscript was made. Because the coat of arms does not include the insignia of the Burgundian Order of the Golden Fleece, to which Wolfart was elected in 1478, the manuscript presumably predates his election. The shield is quartered with the arms of the duchy of Buchan (three golden wheatsheafs), which Wolfart acquired through his marriage to Mary, daughter of James I of Scotland. Mary died in 1467, and in 1469 James III restored the territory of Buchan to the Stuarts. The appearance here of the Buchan quartering in Wolfart's arms may imply that the manuscript was made before 1469.

Italian Semigothic Script

10-14 Newberry Library, MS 97.1, fol. 22v (203 × 144 mm).

TRANSCRIPTION OF LINES 8–17:

Io me alegro molto de la (con)u(er)satione (*recte* conserua-
tione) de la tua fama.

Lętor plurimu(m) te i(n)columem (con)s(er)uasse.

No(n) p(ar)ua afficior leticia tua(m) no(min)is
existimatio(n)em te i(n)tegra(m) deffendisse.

No(n) dici posset q(u)antum gaudeam honore(m) tuum
illesum retinuisse.

Io desidero molto da podere essere i(n)siema.

Qua(m) optare(m) ut m(u)ltis ex causis una esse possemus.

Desiderare(m) uehem(en)tissime ut cum plurib(us) de
reb(us) p(raese)nciam n(ost)ram

collere possemus.

Qua(m) uellem ut m(u)ltis ac magnis rer(um)
accessionib(us) ad ut(r)iusq(ue)

nostrum p(er)tine(n)tibus s(er)mone(m) coram
co(mmun)icare ualeremus.

Italian Semigothic Script

During the second half of the fourteenth century, prominent Italian scholars—notably Francesco Petrarca (Petrarch, 1304–74), Giovanni Boccaccio (1313–75), and the chancellor of Florence, Coluccio Salutati (1331–1406)—became dissatisfied with what they saw as the excesses of the Gothic scripts of their time, which they proclaimed to be difficult to read for a variety of reasons: the small size of the script, overelaboration of letter forms, excessive use of abbreviations, and so on. In their own handwriting, these scholars sought to develop a simplified type of script that eliminated several of the features they found objectionable. This simplified script is now known as Semigothic and was in some senses the precursor of humanistic bookhand, although the emergence of the latter was a much more important development and depended on conscious imitation of manuscripts from an earlier era written in Caroline minuscule (see the following section). Although the humanistic bookhand spread quite rapidly after its invention in the very first years of the fifteenth century, it was not universally adopted; many scribes continued to write the Semigothic well into the fifteenth and even the sixteenth century. The page illustrated here provides a late example of the script, coming from a manuscript that, according to its colophon, was the work of the otherwise unknown scribe Jacobus Mafeus and was completed in 1463.

The basic simplicity of the script is clear from this page. Nevertheless, there are several features worthy of mention. As

<table>
<tr><td colspan="2">DISTINCTIVE LETTER FORMS AND LIGATURES</td></tr>
<tr><td>℔</td><td>= be [benignitatem, line 1]</td></tr>
<tr><td>ꞅ</td><td>= ci [officiosos, line 4]</td></tr>
<tr><td>ꝺ</td><td>= d [iocu(n)ditate, line 24]</td></tr>
<tr><td>ẟ</td><td>= d [admirari, line 5]</td></tr>
<tr><td>ꝺℯ</td><td>= de [defuerit, line 2]</td></tr>
<tr><td>ꞓ</td><td>= g [negociis, line 1]</td></tr>
<tr><td>ꞕ</td><td>= h [honore(m), line 11]</td></tr>
<tr><td>ℏℯ</td><td>= he [uehem(en)tissime, line 14]</td></tr>
<tr><td>ꞁ̈ꞁ</td><td>= ii [negociis, line 1]</td></tr>
<tr><td>ꝫ</td><td>= m [benignitatem, line 1]</td></tr>
<tr><td>ꝛ</td><td>= r [retinuisse, line 11]</td></tr>
<tr><td>ꞅ</td><td>= s [benignitas, line 2]</td></tr>
<tr><td>ꝓ</td><td>= s [facultas, line 21]</td></tr>
<tr><td>ſꞇ</td><td>= st [est, line 4]</td></tr>
</table>

was common in the Gothic scripts, round *s* is preferred to Caroline *s* at word endings, but here the round *s* has a stylized, sweeping form, with the lower portion of the letter descending below the baseline (see, for example, *benignitas* and *mireris* in line 2). Mafeus uses both regular *m* and the alternative, 3-shaped form of the letter at word endings (contrast *i(n)columem* and *illesum* in lines 9 and 11 with *benignitatem tuam* in line 1). As in other Gothic scripts, the 3-shaped form also serves as an abbreviation symbol, replacing final –*us* in third-declension dative and ablative plural endings (as in *plurib(us) de reb(us)*, line 14) and the –*ue* of enclitic –*que* (see *ut(r)iusq(ue)*, line 16). When two *i*s follow one another, the second is written as *i*-longa, that is, it descends below the line and curves like a *j* (*negociis*, line 1; *(con)siliis*, line 19). The 2-shaped form of *r*, in addition to its use following *o*, may occur at word beginnings (*retinuisse*, line 11). Humanist influence will account for Mafeus's use of Caroline straight-backed *d* (as in *iocu(n)ditate*, line 24); but he also uses uncial *d*, the form favored in Gothic scripts (see, for example, *admirari*, line 5). He consistently favors the straight-backed form when *d* is followed by *e*, making the two letters bite together (see *defuerit*, line 2; *possiderem*, line 19; etc.). Biting of bows, such a typical feature of Gothic scripts, occurs frequently on this page. It is also notable that the spelling reforms of the humanists seem largely to have passed Mafeus by. Not only does he use *e*-caudata or simple *e* where correct orthography required *ae* (*Lętor*, line 9; *leticia*, line 10; *illesum*, line 11), but he is also quite uncertain when a consonant should be doubled and when it should be single (thus he writes *asistant* for *assistant*, line 3; *deffendisse* for *defendisse*, line 10; *collere* for *colere*, line 15). Although a reduced number of abbreviations was favored by those who first developed the Semigothic script, abbreviations are quite plentiful on this page. Among the noticeable features are Mafeus's frequent use of a curved rather than straight macron; the reduction of superscript *a* to little more than a wavy line in the abbreviation for *nu(n)q(u)a(m)* (line 19); and the use of the normal abbreviation for *per*—*p* with a horizontal bar crossing the descender—to replace *par* (as in *p(ar)ua*, lines 10 and 26).

The decoration of the first page of this manuscript includes a coat of arms and the initials *CA* within a laurel wreath, but as yet it has not been possible to identify the individual for whom Mafeus was working. The manuscript contains two works by the minor humanist Stefano Fieschi of Soncino (d. ca. 1462), who, after spending five years in Normandy (1424–29) as secretary to Zanone Castiglioni, bishop of Lisieux, returned to Italy to study under Gasparino Barzizza (ca. 1370–1431) and from 1444 to 1459 was *rector scholarum* in the Dalmatian city of Ragusa (modern Dubrovnik, Croatia). Fieschi was the author of several grammatical manuals that enjoyed extraordinary popularity throughout Europe (rather beyond their merit) in his own lifetime and for several decades thereafter. The page illustrated here comes from his *Synonyma sententiarum*, a work composed ca. 1437 and dedicated to Giovanni Meglioranza, chancellor of Padua. As Fieschi observes in the preface, the work was intended to assist rhetori-

cal and epistolary composition in Latin by providing sets of useful phrases, grouped according to the various parts of rhetorical discourse. His method was to set down a phrase in the vernacular and then offer several different ways of expressing the phrase in Latin. In this manuscript, the vernacular phrases are rubricated so that they can be picked out easily. The page illustrated offers alternative ways to say, "Since you are gracious toward all men, it is no surprise if all men seek you out in their time of need," "I rejoice greatly at the preservation of your reputation," "I greatly desire that we should be able to be together," "If I could have my wish, you would never be ab-

sent from my deliberations," and "I value our association very greatly." Such phrases all come within the category of *captatio benevolentiae*, the subdivision of rhetoric whereby one seeks to secure the goodwill of a listener or correspondent. One of the reasons for the international popularity of Fieschi's work was that in manuscripts and printed editions produced outside Italy, the key phrases were translated from Italian into the appropriate vernaculars, with the result that the treatise could serve large numbers of those who had to write official letters in Latin.

CLARISSIMI POETAE LAUREATI

FRANCISCI PETRARCAE DE VITA

SOLITARIA LIBER PRIMUS

PAVCOS HOMINES NO
VI QVIBVS OPVSCVLOR
MEORVM TANTA DIGNA
tio. tantusq; sit amor. quantus tibi
fidentissime non uidetur esse. sed
est. dixerim · Nam neque de since
ro & niueo candore tui pectoris fictum fu
catumq; aliquid suspicor · neque fictione
siqua ess& tam diu tegi potuisse arbitror:
ut xx est immortalis ueritas : sic fictio
et mendatium non durant. Simulata
illico patescunt · & magno studio compta
caesaries uento turbatur exiguo:& ope
rose lic& impressus fucus leui sudore
diluitur · & argutum quoque mendatium uero cedit.
coramq; pr[e]ssus intuent[e] diaphanum est · Operti
omne retegitur: Abeunt umbrae natiuusq; color ma
net · & Latere diutius magnus est labor · Nemo sub
aquis diu uiuit : erumpat oport&, et frontem quam ce
labat aperiat · His argumentis inducor ut credam
quod ualde cupio · sumus autem faciles ad credendum
qd delectat: posse tibi res meas pater optime placere.
quae ut paucis placeant · Laboro · Quoniam ut uides.
saepe res nouas tracto: durasque & rigidas peregrinasq;
sententias, & ab omnibus moderantis uulgi sensibus
atq; auribus abhorrentes · Si indoctis ergo non placeo.
nihil est quod querar: habeo quod optaui: bonam de

10–15 Newberry Library, MS 95, fol. 1r (278 × 196 mm).

Italian Humanistic Bookhand

CLARISSIMI POETAE LAVREATI
FRANCISCI PETRARCAE DE [OCIO/VITA]
[RELIGIOSO/SOLITARIA] LIBER PRIMVS.
PAVCOS HOMINES NO-
VI QVIBVS OPVSCVLOR(VM)
MEORVM TANTA DIGNA-
tio. tantusq(ue) sit amor. quantus tibi
fidentissime non uidetur esse. sed
est. dixerim. Nam neque de since-
ro (et) niueo candore tui pectoris fictum fu-
catumq(ue) aliquid suspicor: neque fictione(m).
si qua ess(et) tam diu tegi potuisse arbitror.
Ut (enim) est immortalis ueritas: sic fictio
et mendatium non durant.

Humanistic script originated in Italy in the early fifteenth century as a conscious reaction against the Gothic scripts. As pointed out in the preceding section, in the second half of the fourteenth century, significant literary figures and scholars such as Petrarch, Boccaccio, and Salutati were already complaining about the difficulty of reading Gothic scripts and had developed a simplified form of script now known as Semigothic. It was Salutati's protégé, the notary Poggio Bracciolini (1380–1459), who in the years 1400–1403 developed a new, fully reformed script—humanistic bookhand—modeled on Caroline minuscule (which the humanists called *littera antiqua*). Because the new script was associated with the classically oriented humanist literary movement, its practitioners devoted considerable attention to correct orthography, eliminating many of the nonclassical spelling practices that had arisen during the Middle Ages.

Newberry Library MS 95, written in Lombardy in the mid-fifteenth century (before 1464), is in a somewhat informal grade of humanistic bookhand that incorporates certain features of humanistic cursive, the other major script developed in the early fifteenth century (see the next section). These features include the rightward lean of the script and the form of the letter *a*: the scribe rejects the small uncial *a* of Caroline minuscule in favor of the half-uncial *a* adopted in humanistic cursive. Again, whereas pure humanistic bookhand insisted on the use of the tall Caroline *s*, this scribe consistently uses round *s* at word endings and sometimes within words. His abbreviations, as is characteristic of humanistic script, are few and simple. On this page, abbreviations are restricted to the ampersand, which replaces *et* both as a complete word (lines 10, 15, etc.) and as a letter sequence within longer words (lines 12, 17, 22); the genitive plural *-orum* ending (line 5); enclitic *-que* (lines 7, 11, 19, etc.); the relative pronoun *quod* (line 25); the macron for suspended final *m* (lines 11, 19); and the old abbreviation for *enim*, resembling a capital *H* (line 13). The only

a	= *a*	[ta*n*tusq(ue), line 7]
	= *ct*	[fi*ct*ione, line 11]
d	= *d*	[*d*e, line 9]
	= (*et*)	[(*et*), line 10]
	= *g*	[te*g*i, line 12]
m	= *m*	[Na*m*, line 9]
n	= *n*	[ca*n*dore, line 10]
q	= *q*	[ne*q*ue, line 11]
	= *s*	[*s*it, line 7]
S	= *s*	[es*s*e, line 8]
	= *st*	[e*st*, line 9]
	= *tr*	[arbi*tr*or, line 12]
u	= *u*	[*u*eritas, line 13]

ligatures used are for *ct* (lines 10, 11, 13, etc.) and *st* (lines 9, 13, 15, etc.); these, along with a ligature for *rt*, had been permissible in the best Caroline minuscule. Humanist concern for correct orthography can be seen in the scribe's preference for *æ* over *e*-caudata or simple *e* (for example, *umbræ* [line 20] and *quæ* [line 26]). As the humanists modeled their reformed script on that of an earlier age, so they also revived former codicological practices, including those for ruling: it is characteristic that this page is ruled in drypoint, not in plummet or ink.

The text on the page is the opening of the epistle dedicatory of Petrarch's *De vita solitaria*. Petrarch composed the first draft of this work, which extols the leisured life of the countryside, close to nature and to God, while he was staying at Vaucluse, the country retreat of his friend Philippe de Cabassoles, bishop of Cavaillon, in 1346. The epistle is addressed to Philippe and thanks him for his praise of Petrarch's writings, a praise that Petrarch is confident is unfeigned. It took Petrarch twenty years to complete *De vita solitaria*, for not until 1366 did Philippe receive the dedication copy. One reason for the delay was the difficulty Petrarch encountered in trying to find a suitable scribe to copy the work. However, in a letter to Philippe of 6 June 1366, Petrarch noted that he had assigned the work to a Paduan priest and praised the priest's script for its plain clarity, "suitable for our age and for every age." The letter includes one of Petrarch's most notable complaints against Gothic script, for he contrasts the priest's penmanship with that of younger scribes who favor "tiny, compressed little letters that frustrate the eye, heaping and cramming everything together. . . . These things the scribe himself can barely read

when returning after a brief interval, while the purchaser buys not so much a book, as blindness in the guise of a book."[2]

The scribe of the Newberry copy erroneously believed *De vita solitaria* to be a part of Petrarch's other work on the life of contemplative tranquility, *De otio religioso*, which the manuscript also contains: in their original form, his titles to the two books of *De vita solitaria* incorrectly identified them as the first two books of *De otio religioso*, while his titles for that work's two books numbered them as books 3 and 4. As can be seen in lines 2–3 of this page, the erroneous titles were erased and corrected, either by the original scribe himself or by a near contemporary. The magnificent decoration of the page both commemorates Petrarch and identifies the original owner of the book. Petrarch is depicted within the bow of the opening initial *P*, wearing the crown of laurel that he was awarded at

Rome in 1341, when the people and Senate proclaimed him *magnus poeta et historicus*. The scrolling white vine stems that wind around this initial and fill much of the border of the page were the most typical form of decoration in humanist manuscripts; here they are interspersed with laurel leaves in various formations, recalling Petrarch's crown. The laurel garland at the foot of the page contains the arms and initials of the patron for whom this copy of *De vita solitaria* was made: *Co(mes) Fi(lippus)*, that is, Count Filippo Borromeo (1419–64), head of the great Borromeo Bank and one of the principal figures in fifteenth-century Lombard politics. Married to Francesca Visconti, daughter of the last Visconti duke of Milan, Filippo was instrumental in enabling Franceso Sforza to assume the insignia of the Duchy of Milan in 1450.

2. Petrarch, *Senilium rerum libri*, VI, 5; cf. Petrarch, *Letters of Old Age*, trans. Aldo S. Bernardo et al., 2 vols. (Baltimore, 1992), 1:198.

10–16 Newberry Library, MS 91, fol. 212r
(132 × 100 mm).

TRANSCRIPTION OF LINES 1–10:

Incipit Libellus valde elegans/ Beati Joannis
Chrysostomi: de Laudibus diui Pauli Ap(osto)li :–
NIHIL P(–)
RORSVS
ERRAVIT
QVI PRATVM QVODdAM
insigne uirtutum/ ac paradisum spiritualem:
animam dixerit Pauli. Tam enim m(u)lta
gratia floruit: tamque huic gratię/ congru-
ente vitae perfectione resplenduit.

α = *a* [grati*a*, line 9]

🙰 = *ct* [perfe*ct*ione, line 10]

d = *d* [*d*ixerit, line 8]

& = (*et*) [(*et*), line 13]

f = *f* [*f*loruit, line 9]

g = *g* [*g*rati*ę*, line 9]

g = *g* [insi*g*ne, line 7]

h = *h* [C*h*rysostomi, line 2]

3 = *m* [paradisu*m*, line 7]

r = *r* [quatuo*r*, line 15]

st = *st* [e*st*, line 11]

υ = *v* [*v*alde, line 1]

Italian Humanistic Cursive

Humanistic cursive was first developed during the early 1420s by the Florentine Niccolò Niccoli (1364–1437), a great collector who encouraged his contemporaries, including Poggio Bracciolini, in their searches for manuscripts and in their copying, editing, and translating of classical texts. Having enthusiastically championed the cause of the formal bookhand originated by Poggio, helping to foster its adoption by other scribes, Niccoli himself developed a more informal, cursive script that he used for copying books and that was also admirably suited to letter writing. This humanistic cursive, which was a natural complement to the bookhand, was soon adopted

and perfected by other scribes. Following the invention of printing, humanistic cursive served as the model for the italic font, just as humanistic bookhand served as the model for the roman font.

When scribes used the cursive for copying books, they often gave it a more formalized and decorative appearance, as has happened on this page from a manuscript copied in central Italy in the mid-1480s. The basic cursive character of the script can be seen in the frequent occurrence of linking strokes that connect letters to one another—for example, in *animam* and *enim* (line 8)—as well as in individual letter forms such as the half-uncial *a* and the *h* with rounded arm. However, the scribe has given the page as a whole a highly formal character by the use of capitals for the opening words of the text (he has even placed small decorative separators between each of the capitalized words), by the use of yellow pigment to pick out these as well as other capitals on the page, and by the decorative lower bow, resembling a figure eight lying on its side, of the *g*s in lines 7 and 16. His abbreviations and special forms include the 3-shaped version of final *m* (lines 6 and 7), a form that was to be taken over into early printed books.

The page carries the opening of *De laudibus sancti Pauli apostoli* by St. John Chrysostom (ca. 349–407), a work originally written in Greek in which Chrysostom, who was the author of more than two hundred homilies on the Pauline Epistles, praises Paul for having spread the Christian faith so widely and compares him favorably with various Old Testament figures. The manuscript as a whole comprises a collection of edifying works, most of them by patristic authors; the presence of one or two more recent works by Franciscans, including St. Bonaventure (ca. 1217–74) and Jacopone da Todi (ca. 1230–1306), suggests that this small-format paper manuscript may have served as a handbook for a Franciscan. The scribe has entered a date, January 24, 1484/5, at the end of the *Laude* of Jacopone da Todi (immediately before the Chrysostom text); this provides an approximate date of production for the entire manuscript.

PART THREE

Some Manuscript
Genres

The Bible and Related Texts

s Beryl Smalley observes in the opening of her classic, *The Study of the Bible in the Middle Ages*, "The Bible was the most studied book of the middle ages."[1] The reading of the Bible, the *lectio divina*, was at the heart of medieval religious life. The most significant and voluminous intellectual products of medieval Bible study were commentaries, usually on a single book of scripture. It is important to note that later commentators were not commenting just on scripture itself but also on earlier and even contemporary commentators. Medieval commentators held the church fathers in highest esteem, but their interpretations were sometimes contested, both because the fathers disagreed with one another and because later commentators believed they had information unavailable to the fathers.

Medieval exegesis, the process of explicating the various meanings of scripture, acknowledged various levels of meaning: literal (historical), allegorical, tropological (moral), and anagogical (mystical or eschatological). These categories were divided broadly into the literal and spiritual meaning of the text—with the spiritual encompassing the allegorical, tropological, and anagogical. Medieval thinkers also made a distinction between intrinsic and extrinsic meaning; the extrinsic was the historical, the meaning the passage had for the Jews, and the intrinsic was the hidden meaning "revealed" by later Christian exegetes. For the most part, the fourfold explication of scripture was reserved for the books of the Hebrew Bible, and it was meant on some basic level to harmonize the Jewish scriptures with the Christian. An interesting graphic representation of the allegorical reading of the Hebrew Bible can be found in Pseudo-Ludolph of Saxony's *Speculum humanae salvationis* (The mirror of human salvation), which dates from the early fourteenth century. Here, depictions of events from the Hebrew Old Testament were placed beside events from the New Testament to illustrate how the Old Testament foreshadowed the New. In the two-page spread from the mid-fifteenth-century copy of the French

translation of the *Speculum* shown in chapter 7 (see figs. 7-25 and 7-26), the four panels depict one New Testament scene, Jesus being placed in the tomb, and three Old Testament scenes that prefigure it: David mourning over Abner, unjustly killed by Joab; Joseph being cast into the well by his brothers; and Jonah being thrown overboard and swallowed by the whale. Each picture has a rubricated identifying title (in Latin) above it and, below it, a reference to the biblical passage describing the incident depicted. The text occupying the rest of the page explains how the Old Testament episodes prefigure the New Testament one. The artist has provided his own nonverbal gloss by using full color for the figures occurring in the New Testament panel and grisaille (monochromatic gray) enhanced by mere touches of color for the Old Testament figures.

The importance of the literal meaning of scripture was the subject of intense debate. In the twelfth century, the canons of St. Victor in Paris were renowned for their biblical scholarship. Two in particular, Hugh of St. Victor (1096–1141) and Andrew of St. Victor (ca. 1110–75), stressed the need to understand the literal/historical meaning before one could properly interpret the spiritual meaning. To gain a literal understanding, Hugh and Andrew may have approached local rabbis for their interpretations and Andrew may even have learned some Hebrew. The emphasis that these two Victorines placed upon the primacy of the literal was, however, exceptional. Many other exegetes, by contrast, thought the literal could be ignored in favor of the spiritual; some even thought that the literal meaning should be interpreted spiritually, particularly in passages with puzzling or erotic content, such as those in the Song of Songs. Those who clung to the historical meaning of the scriptures were sometimes labeled "Judaizers." Andrew of St. Victor was accused by no less than Richard of St. Victor (d. 1173), a fellow student of Hugh's, prior of the house and noted exegete in his own right, for preferring a Jewish reading of the scriptures. In fact, biblical exegetes from the Victorines Hugh and Andrew to the Franciscan Nicholas of Lyra (1270–1340), probably a convert from Judaism, sought out Jews, both for their understanding of the Hebrew scriptures and to learn of rabbinic commentary on those passages. As Beryl Smalley pointed out, such interactions

1. Beryl Smalley, *The Study of the Bible in the Middle Ages*, 3rd ed. (Oxford, 1983), xxvii.

11-1 Fragment of a twelfth-century glossed Bible with text of Matthew 22:10–17.
Newberry Library, Medieval Manuscript Fragment 53, recto.

did not result in an uncritical acceptance of Jewish interpretation;[2] often the Jewish interpretation was provided only to be criticized, but in many areas there is no doubt that Christian exegesis was influenced by rabbinic sources.

The most important and common gloss on the Bible was the *glossa ordinaria* (often called simply the gloss); it was a compilation from earlier sources, including the work of the church fathers, and was largely a product of the twelfth-century cathedral schools. In all manuscripts in which it is found, the *glossa ordinaria* includes both a marginal gloss and an interlinear gloss. Formerly the marginal gloss was attributed to Walafrid Strabo (ca. 807–49) and the interlinear gloss (which explained word meanings and derivations) to Anselm of Laon (d. 1117).[3] More recently it has been shown that the compilation of the entire *glossa ordinaria* resulted from an enterprise begun in the cathedral school of Laon, with Anselm himself contributing the gloss on the Psalms, the Pauline Epistles, and the Gospel of St. John; his brother Ralph the gloss on the Gospel of St. Matthew; and various others, notably Gilbert the Universal (d. 1134)—who taught at the cathedral school of Auxerre before becoming bishop of London—contributing other portions. The whole Bible had been covered by about the middle of the twelfth century.[4] The layout of the *glossa ordinaria* was similar to that of other glosses, such as those on legal texts, with the commentary usually entered in a significantly smaller script than the biblical text itself (see also the discussion of glossing practices in chapter 3). Figure 11-1 shows a fragment of a glossed Bible with a traditional layout, the gloss being distributed between the margins and interlines. It was rare for a single codex to

11-2 Fragment of a fourteenth-century glossed Bible with text of II Timothy 3:2-8. Newberry Library, Medieval Manuscript Fragment 59, verso.

contain the entire glossed Bible. Rather, individual codices contained one or more biblical books with their gloss; an entire Bible might take twenty or more separate codices.[5] Although the *glossa ordinaria* provided a useful reference tool for biblical study, its layout became problematic, particularly when further material was added with the result that the amount of gloss increased in proportion to the text. Scribes and scholars experimented with several layouts, most varying the amount of biblical text in relationship to the gloss on each page until, on many pages, a tiny amount of text was dwarfed by a mass of commentary (see

2. Ibid., 157.

3. On the erroneous attribution of the *glossa ordinaria* to Strabo, which originated in the late fifteenth century and has long persisted, see Karlfried Froehlich, "Walafrid Strabo and the *Glossa Ordinaria*: The Making of a Myth," *Studia Patristica* 28 (1993): 192–96.

4. See Smalley, *The Study of the Bible*, 46–66, and Karlfried Froehlich and Margaret T. Gibson, eds., *Biblia Latina cum Glossa Ordinaria: Facsimile Reprint of the Editio Princeps, Adolph Rusch of Strassburg, 1480–81*, 4 vols. (Turnhout, Belg., 1992), 1:15.

5. Froehlich and Gibson, *Biblia Latina cum Glossa Ordinaria*, 1:16.

fig. 11-2); the commentary itself could be divided into two, three, or four columns.

In time the *glossa ordinaria* became dated; the thirteenth century saw the development of *postillae*, commentaries that encompassed the whole of a biblical book. Early *postillae*, such as those of the Dominican Hugh of St. Cher (ca. 1200–1263), were based on scholarship that had taken place since the completion of the *glossa*. Later *postillae*, which often incorporated or contested earlier commentaries, also provided their own, often unique, understanding of the text. The new work required a different format, as the ratio of commentary to text was so high. The commentary was now written out, not in the margins or interlines but as blocks of text that followed the scriptural verses being commented upon. The term *postilla* may itself derive from this layout, for the most plausible explanation offered for it is that it comes from Latin *post illa [verba textus]*, "after those [words of the text]." To make it easier for the reader to follow the postillator's commentary, the individual words or phrases of scripture that were commented on within the *postilla* were marked out, usually by being underlined in red (such words or phrases are known as *lemmata*). The most comprehensive and influential of all *postillae* was the massive *Postillae perpetuae in universam sanctam scripturam* of Nicholas of Lyra, completed in the years 1322–31, which survives in some seven hundred manuscripts (see fig. 11-3). Lyra's influence persisted to the end of the Middle Ages and into the sixteenth century; it has traditionally been held that his commentaries had a major impact upon Martin Luther. It is interesting that, following the advent of printing, several early printed Bibles took on the character of "study Bibles" by combining the biblical text with Lyra, adopting a layout in which the main text was printed in a larger font in the central area of the page and was surrounded by Lyra's commentary. The ratio of text to commentary varied from page to page, and where the commentary was especially dense, the text was reduced to little more than an island in the middle of the page. As Paul Saenger has argued, this layout represented a revival of twelfth-century style; the high Middle Ages most often had *postillae* as a separate book with *lemmata* (see Lyra's *Postilla*, fig. 11-3).

In addition to commentaries, medieval exegetes employed a variety of study aids to understand and explain scripture and to locate particular passages within the holy text. Newberry Library MS 22, a Bible most likely written in Spain around 1300, contains some common aids to the use and interpretation of the scriptures: an alphabetically arranged glossary of Hebrew names, a list of the incipits of the chapters of the general prologue to the Bible, a list of the incipits of the chapters of the Pentateuch, and a short list of the generations from Adam to Noah.[6] The *Interpretationes hebraicorum nominum* and *Liber de situ et nominibus lo-*

11-3 Page of a fifteenth-century German copy of Nicholas of Lyra's *Postilla* on the Epistle of St. Paul to the Romans. Underlining (here in black) indicates passages from the Epistle; the remaining text is commentary. Newberry Library, MS 154, fol. 1v.

6. Saenger, *Catalogue*, 38–39.

corum hebraicorum provided etymologies of Hebrew names and were mined for the insight they provided into the spiritual reading of the scriptures. For example, the *Interpretationes* in Newberry Library MS 22 explains the name Michal (Saul's daughter and David's wife) as meaning "aqua omnis uel aqua ex omnibus" (fol. 298v; all water or water from all); David's name is interpreted as meaning "fortis manu, uel uultu desiderabilis" (fol. 290r; strong of hand or desirable of countenance). Another popular aid to exposition was the *Historia scholastica* of Peter Comestor (d. ca. 1169), which provided a summary of biblical history from Genesis to the Gospels, completed by Peter of Poitiers (ca. 1130–1215), who added material from the Acts of the Apostles and who wrote a *Genealogia Christi* containing the names and dates of important biblical figures, often found together with the *Historia* (cf. chap. 16, figs. 16-6 and 16-7). The Dominicans also authored a list of *correctoria*, comprising variant readings and amendments to the biblical text that foreshadowed the work of sixteenth-century Christian humanists such as Desiderius Erasmus (1466–1536).[7]

Canon tables, first compiled in the fourth century by Eusebius (ca. 260–ca. 340), bishop of Caesarea, were an early study aid. The purpose of canon tables was to demonstrate the essential harmony among the different accounts of Christ's life in the four Gospels by listing those passages in each Gospel that were paralleled by passages in one or more of the other three. To achieve this, Eusebius compiled a set of ten tables. Of these, the first listed passages for which there were parallels in all four Gospels; the second listed parallel passages in Matthew, Mark, and Luke; the third covered Matthew, Luke, and John; the fourth covered Matthew, Mark, and John; the fifth covered Matthew and Luke; the sixth covered Matthew and Mark; the seventh covered Matthew and John; the eighth covered Luke and Mark; and the ninth covered Luke and John. The tenth table was divided into four parts and listed those passages of each Gospel that had no parallel in any of the others. Within the tables, the passages of the Gospels were referred to by section numbers. The division of the text of the Gospels into numbered sections is said to have been devised in

11-4 Canon table from the Harley Golden Gospels, produced at Charlemagne's court ca. 790–800. Atop the arches are the evangelists' symbols: an angel for Matthew, a lion for Mark, an ox for Luke, and an eagle for John. London, British Library, MS Harley 2788, fol. 7r.

the third century by Ammonius of Alexandria. Eusebius expanded the numbering to cover the full text of all four Gospels. The Eusebian sections, as they are called, do not correspond with the chapter and verse divisions used today, which originated much later (see below). Eusebius's system included no chapter divisions but divided Matthew's Gospel into 355 sections, Mark's into 233 sections, Luke's into 342 sections, and John's into 232 sections. The canon tables found in numerous late antique and medieval Gospel books—including such well-known manuscripts as the Lindisfarne Gospels (London, British Library, MS Cotton Nero D. iv) and the Book of Kells (Dublin, Trinity College, MS 58)—all use these section numbers. Canon tables lent themselves to artistic decoration, as can be seen from the example illustrated here (fig. 11-4), which comes from a Gospel book made in the 790s at the court of Charlemagne

7. Smalley, *The Study of the Bible*, 270. These *correctoria* could circulate as separate lists or be placed in the margin of the Bible itself.

(London, British Library, MS Harley 2788). The page reproduced has the last part of canon 1, listing passages with parallels in all four Gospels. It is therefore divided into four columns of numbers, with each column headed by the name of the appropriate evangelist and with the evangelist's symbol pictured above the arcade; the five pillars that divide the text into columns have decorative Corinthian capitals. To find the parallel passages, the user would read across the page. For example, the first line records that section 284 in Matthew's Gospel is paralleled by section 165 in Mark's Gospel, by section 266 in Luke's, and by section 63 in John's. Using present-day chapter and verse numbering, these passages are Matthew 26:26, Mark 14:22, Luke 22:19 (in all three of which Christ declares that the bread he breaks at the Last Supper is his body), and John 6:48 (where Christ proclaims himself to be the bread of life).

Canon tables are commonly found in manuscripts down to the thirteenth century. To assist the use of the tables, many Gospel manuscripts had the Eusebian section numbers (usually written in regular ink) entered in the left margin next to the beginning of each section of the Gospel text; below the section number was entered (usually in red) the number of the canon table in which the user would find the section listed (see chap. 10, fig. 10-4). St. Jerome described this practice of entering the section numbers in black and the canon table numbers in red in the letter that he sent to Pope Damasus upon completing his Latin translation of the Gospels in 384 AD.[8] Centuries later, Hugh of St. Victor explained the use of the section numbers and canon tables at greater length in his *Didascalicon*, in a passage taken almost verbatim from the *Etymologiae* of Isidore of Seville:[9]

> Ammonius of Alexandria was the first to set up the Gospel tables; afterwards, Eusebius of Caesarea following him, worked them out more fully. They were set up in order that by their means we might discover and know which of the Evangelists said things similar to those found in the others, and unique things as well. These tables are ten in number. . . . This is how these tables are used: throughout each Evangelist, a certain number is fixed in the margin beside small sections of text, and under such numbers is placed a certain space marked in red and indicating in which of the ten tables one will find the section number to which that space is subjoined. For example, if the space indicated is the

first, this number will be found in the first table; if the second, in the second; if the third, in the third, and so through the series till one comes to the tenth. If, therefore, with any one of the Gospels open before one, one should wish to know which of the other Evangelists has spoken similarly, one would take the number placed beside the section of text and look for that same number in the table indicated for it, and there one would find who has said what. Finally, looking up in the body of the text the places indicated by the numbers listed in the tables, one would find passages on the same subject in the individual Gospels.

Out of canon tables grew Gospel harmonies, attempts to harmonize the differences among the Gospels by laying out their texts in four parallel columns, with parallel passages alongside one another and with a gap left in a column when one of the Gospels did not have a corresponding passage. While this format worked quite well for the three synoptic Gospels (Matthew, Mark, and Luke), it was more problematic for John's Gospel, of which the content is significantly different: in many places the four-column format results in three short or even blank columns from the other Gospels alongside a long page of text from John alone. Figure 11-5 shows a page from Newberry Library MS 161, a Gospel harmony made in Flanders in the middle of the fifteenth century. By this time, the Eusebian section numbers had long fallen out of use; MS 161 uses instead the Parisian division of the Bible into chapters (on which see below). Each of the four Gospels is given its own column. A blank space is left when a Gospel has no relevant text, although the blank space may then be used for overspill from the adjacent column, as has happened in the middle of the page shown in fig. 11-5, where for six lines the text of Luke's Gospel spans the columns for both Mark and Luke. The formatting makes clear what material belongs to each Gospel. Another Gospel harmony of somewhat different format, the *Unum ex quattuor*, had been popularized in the twelfth century by Zacharias of Besançon (d. ca. 1155), also known as Zacharias Chrysopolitanus; in this, the arrangement was under titles rather than in parallel columns.

The rise of the mendicant orders in the thirteenth century produced a new emphasis upon preaching and a consequent need for additional tools, primarily concordances, that would facilitate the rapid location of specific passages of scripture. Scholars developed two types of concordances for such use: verbal concordances, in which words from the Bible were listed alphabetically and were accompanied by references to the biblical passages in which the particular word occurred; and topical or subject concordances, in which relevant passages were listed under subject headings. Topical concordances never attained the same popularity as verbal concordances, but one remarkable example was produced in the late 1230s or 1240s by Robert Grosseteste (ca. 1175–1253), who taught at Oxford before becoming bishop

8. See Robert Weber, ed., *Biblia sacra iuxta Vulgatam editionem*, 3rd ed. (Stuttgart, 1983), 1516.

9. Hugh of St. Victor, *Didascalicon: A Medieval Guide to the Arts*, trans. Jerome Taylor (New York, 1961), bk. IV, chap. 10, 112–13. See also W. M. Lindsay, ed., *Isidori Hispalensis episcopi etymologiarum sive originum libri XX* (Oxford, 1911), VI.xvi.1–4. The passage may also be found in Rabanus Maurus's *De universo*, V.vi.

of Lincoln in 1235 and who was a great admirer of the Franciscans.[10] Grosseteste's concordance, which was expanded by his close friend, the Franciscan Adam of Marsh (d. ca. 1258), includes over four hundred topical headings organized into nine sections; typical headings are *De unitate Dei* (On the oneness of God), *De trinitate Dei* (On the threeness of God), *De dignitate conditionis hominis* (On the dignity of the human condition), and *Unde malum* (On the source of evil). Under each heading, the concordance lists not only the biblical passages in which the particular topic is touched upon but also relevant passages from the church fathers and even from pagan classical authors such as Aristotle, Cicero, and Seneca. To aid quick referencing, Grosseteste devised an ingenious system of symbols, assigning each topic its own symbol (for example, a single dot for *De unitate Dei*, a triangle for *De trinitate Dei*). Then, in his own manuscripts of the Bible and of the patristic and other texts upon which his concordance draws, he entered in the margin the appropriate symbol next to those passages that touched upon the particular topic.

Grosseteste's concordance was very much a personal compilation, not intended for general circulation; only one surviving manuscript is known, now Lyons, Biblothèque municipale, MS 414. However, there survive other examples of topical concordances. Newberry Library MS 19.1 contains a topical concordance to the Bible made in southern France ca. 1400. As in Grosseteste's concordance, relevant passages are listed under subject headings. For example, on folio 34v (fig. 11-6), under the heading *Contra cantationes siue coniurationes demonum uel sortilegium* (Against incantations or conjurations of demons, or soothsaying) are listed passages from Leviticus and Deuteronomy that make reference to the condemnation of conjurors. The passages are identified by chapter number and by a letter of the alphabet that refers to the section within the chapter. The opening of this concordance details the manner in which it was organized (fol. 1r):

> Here begins the concordance of the Bible divided into five books. The first book deals with those matters pertaining to the corruption of the first man and their opposites, and includes four parts: the first is about sin and its effects; the second is about the principal vices, under their respective headings; the third is about vices

11-5 This Gospel harmony presents the four Gospels in parallel columns. On this page are passages recording Christ's Passion from Matthew 27, Mark 14, Luke 23, and John 19. Newberry Library, MS 161, fol. 142v.

of the mouth, under their headings and with their opposites, and about the five senses; the fourth is about the aforesaid vices in multiple combination, and their opposites. . . .

A concordance organized along these lines would clearly have been a valuable tool for preachers, who through it could find biblical texts to quote in their sermons.

Verbal concordances to the Bible seem to have enjoyed a much wider circulation than topical concordances. They were largely developed by members of the Dominican order during the thirteenth century, with three principal stages in their evolution.[11] The first verbal concordance

10. See S. Harrison Thomson, "Grosseteste's Topical Concordance of the Bible and the Fathers," *Speculum* 9 (1934): 139–44.

11. On the development of verbal concordances, see Richard H. Rouse and Mary A. Rouse, "The Verbal Concordance to the Scriptures," *Archivum Fratrum Praedicatorum* 44 (1974): 5–30.

11-6 Detail of a topical concordance made in southern France ca. 1400, including listings for the heading *Contra cantationes*. Newberry Library, MS 19.1, fol. 34v.

is known as the *Concordantiae sancti Jacobi* (Concordance of St. Jacques) after the Dominicans of St. Jacques in Paris. It is usually attributed to Hugh of St. Cher, active at St. Jacques 1230–35, although it may have been completed after his departure from the house (the earliest surviving datable copy was made sometime between 1239 and 1247);[12] Hugh is traditionally said to have been assisted in his task by five hundred fellow Dominicans. The Concordance of St. Jacques was skeletal, for it provided no actual quotations but merely cited the biblical passages where particular words could be found. Because it included no quotations, it gave no idea of the content of the passages listed and was therefore of limited use for preachers seeking relevant biblical material for their sermons (see fig. 11-7). In an attempt to make the concordance more serviceable, around the middle of the thirteenth century an English Dominican, Richard Stavensby, probably working at St. Jacques in collaboration with others, added complete quotations of the passages listed.[13] This version is known as the *Concordantiae Anglicanae* (English Concordance); no complete copy survives, and it never attained great popularity as the quotations were too long and sometimes irrelevant. The most successful concordance was the third, produced before 1286, probably at St. Jacques; in the past it has been attributed, almost certainly erroneously, to Conrad of Halberstadt (fl. 1321).[14] In this third version, the quotations were reduced to their essence, greatly condensing the size of the work (see fig. 11-8). This concordance was made available to *pe-*

cia stationers for the production of multiple copies for students and, as a result, it survives in many manuscripts (on the *pecia* system, see chapter 2); the Paris stationer's copy consisted of 108 six-leaf quires.[15] It was also the first concordance to be printed, at Strasbourg ca. 1470.

In order for concordances to be useful, there had to be a consistent manner of dividing up the text of the books of the Bible. Division of the Bible into the chapters and verses still used today first appears in printed Bibles.[16] Before that, there were several different methods used to navigate the Bible. Among them were the Eusebian section numbers mentioned above, but these covered only the four Gospels. Most other methods divided the biblical books into chapters (although where those chapters began and ended varied) and then further subdivided the chapters into sections (not verses). The various books of the Bible had been divided into chapters numerous times before the thirteenth century, but the most influential division is attributed to the Parisian teacher (and later archbishop of Canterbury) Stephen Langton (d. 1228), whose divisions were codified in the thirteenth-century Paris Bible, made canonical by the mendicants of the university.[17] Langton's chapter divisions were used in the Dominican concordances. To make the references in the concordances more precise, however, the Dominicans devised a system that subdivided each chapter into sections identified by letters of the alphabet. The Concordance of St. Jacques divided each chapter into seven sections, *a* through *g*. The third concordance refined this system somewhat by retaining the sevenfold division for longer chapters while using a fourfold division, *a* through *d*, for shorter chapters. The system is described in the prologue to the concordance:

> One point must be heeded at the outset by anyone wishing to search the concordance in this book: namely that whereas in the first concordance, called the Concordance of St. Jacques, each chapter is divided into seven sections by the seven first letters of the alphabet, namely *a*, *b*, *c*, *d*, *e*, *f*, *g*, in the present work, longer chapters are divided in the same way, into the same number of sections, but shorter chapters are divided into only four sections, that is, into *a*, *b*, *c*, and *d*: *a* contains the first part; *b* the second part that moves further away from the beginning and extends to the middle; *c* moves away from the middle and contains

12. Ibid., 8.
13. Ibid., 13–16.
14. Ibid., 18–20.

15. Ibid., 20.
16. Verse numbers were applied first to the Psalms, then extended to the entire Bible in the mid-sixteenth century. See Paul Saenger, "The Impact of the Early Printed Page on the History of Reading," *Bulletin du bibliophile* 11 (1996): 237–300, at 291–92. See also Paul Saenger, "The British Isles and the Origin of the Modern Mode of Biblical Citation," *Syntagma: Revista del Instituto de Historia del Libro y de la Lectura* 1 (2005): 77–123.
17. Smalley, *The Study of the Bible*, 222–24.

11-7 A fragment from the first verbal concordance to the Bible has here been reused as an endleaf. Each word is followed by a list of those places within the Bible where it may be found, without giving the word in context. The referencing system uses letters of the alphabet from *a* to *g* to refer to the different subdivisions of biblical chapters. Newberry Library, MS 185, front flyleaf, verso.

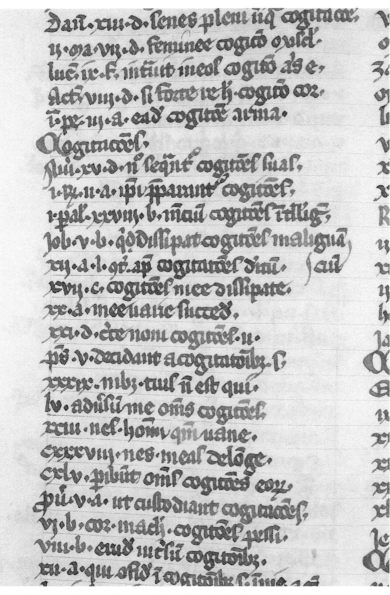

11-8 Third verbal concordance to the Bible, detail of entries for the heading *Cogitaciones*. France, ca. 1300. Newberry Library, MS 179, fol. 56v.

beginning with the Bible published by Bernhard Richel at Basel in 1477.[18]

The Dominican method of dividing chapters into sections was not the only one known and used in the late Middle Ages, as can be seen from the interesting example of Newberry Library MS 22, the Spanish Bible, ca. 1300, mentioned above. The text of this Bible is formatted in chapters, with rubricated chapter headings, chapter numbers entered in blue and red roman numerals, and pen-and-ink initials opening the chapters. Figure 11-9 shows folio 67r, which includes the pen-and-ink initial *P* of *Philistim*, beginning the last chapter of 1 Samuel, and the large red and blue initial *F* of *Factum* that opens 2 Samuel.[19] Two different systems of referencing, neither of them corresponding to the Dominican system, have been added in the margins of several chapters within the manuscript. One system divides the text up into eight roughly equal sections with letters running from *a* to *h*. The other system divides the text into blocks of three: *primus* (*p*), *secundus* (*s*), and *tertius* (*t*). *Primus* always aligns with *a*, but *secundus* and *tertius* often divide the text differently than the sequential lettering system. Both systems mark the text with a bracket sign (⌐) that indicates the beginning of the section whose letter is in the margin. What is most striking about both systems is that they conflict with the Bible's chapter divisions: as can be seen in the right-hand column of figure 11-9, the letter sequences run across chapter breaks. Both systems must have been intended to assist a reader to locate passages of text, and presumably they relate to a reference work that was known to users of this Bible and was based on a different chapter division of the biblical text. That reference work has not yet been identified.

Biblical study was central to the lives of medieval monks, priests, students, and teachers. It exercised the keenest minds and resulted in the production of some remarkable works whose scope attests to the dedication, ingenuity, and extraordinary learning of those who created them while also recording both the strengths and the weaknesses of their methods of study. Through the pages of the manuscripts containing those works, the rich and fascinating world of medieval Bible scholarship can come alive again today, revealing itself in all its variety and complexity.

the third part of the shorter chapter; and *d* extends from the third part to the end of the chapter.

This system of lettering was used in all the references within the concordance. It can be seen, for example, in Newberry Library MS 179, a copy of the concordance made in France ca. 1300 (fig. 11-8). Thus, under the heading *Cogitaciones* on folio 56v, the first entry is "Nu(mer)i .xv. d. No(n) seq(u)ant(ur) cogit(aci)o(n)es suas," meaning that the phrase quoted may be found in section *d* of chapter 15 of the book of Numbers. The letters used in the concordance references were not normally entered into manuscripts of the Bible itself, so the user of the concordance had to mentally subdivide into seven or four sections the chapter in which he was seeking a passage cited in the concordance. There are, however, some Bible manuscripts in which the letters from *a* to *g* or *a* to *d* have been entered in the margin, and several early printed Bibles took over the system,

18. See Saenger, "Impact of the Early Printed Page," 280. In Richel's Bible, the lettering system was used in the New Testament only. Later printers applied it to the Old Testament as well.

19. Note that in many medieval Bibles, as here, 1 and 2 Samuel are referred to as I and II Regum, with 1 and 2 Kings being designated III and IV Regum.

11-9 Bible with chapter divisions and two systems for dividing the chapters into smaller units.
Spain, ca. 1300. Newberry Library, MS 22, fol. 67r.

Liturgical Books and Their Calendars

arge numbers of manuscripts produced during the Middle Ages were intended for use in church. Because they served the rituals of divine worship, these books were often among the most finely written and richly decorated of all medieval manuscripts. With the passage of time, an increasing degree of specialization developed, with particular types of manuscripts being made to serve specific liturgical purposes. This chapter will provide a brief orientation to some of the principal types of liturgical books most commonly encountered and will offer an analysis of the calendars that are to be found at the front of many of these books.[1]

One basic and important distinction is between books that were intended for the celebration of Mass and books that served the requirements of the Divine Office. The Mass, the service that had at its heart the consecration and distribution of the eucharistic bread and wine in commemoration of Christ's Crucifixion and the redemption of mankind, was celebrated in all churches and monasteries on a daily basis; on the most important feast days there would be two or even three masses during the day. The Office, termed by St. Benedict the *opus Dei*, was the daily round of services offered up to God in all Benedictine monasteries and adopted as well in nonmonastic churches.[2] These services consisted of a combination of psalms, prayers, readings, antiphons, and versicles and responses. In monasteries, the Office included a total of eight services, punctuating the day from beginning to end: matins, lauds, prime, terce, sext, none, vespers, and compline (for a fuller description of these "hours," see the next chapter).

Although the Mass and the Office each spawned their own service books, several of these books had the common characteristic that they were divided into two main sec-

tions, termed the *temporale* and the *sanctorale*. The *temporale* section (also known as the Proper of Time) provided material for services celebrated during the basic church year, which was organized around the commemoration of the major events in Christ's life. The church year, and therefore the *temporale* section of these books, begins with Advent Sunday (some four weeks before Christmas Day), when the Church starts to prepare for the celebration of Christ's Incarnation. The major markers in the *temporale* are Christmas Day (25 December); the feast of the Circumcision (1 January), commemorating Christ's circumcision eight days after he was born; Epiphany (6 January), commemorating the manifestation of Christ to the Gentiles in the person of the Three Magi; the Presentation of Christ in the Temple (2 February), also known as the Purification of the Virgin Mary and Candlemas, commemorating Mary's offering Christ at the temple in Jerusalem forty days after he was born; Lent, the period of fasting that precedes Easter; Palm Sunday, commemorating Christ's entry into Jerusalem before the Crucifixion; Holy Week and Easter Sunday, the climax of the Christian year, commemorating Christ's Passion and Resurrection; the Ascension, commemorating Christ's withdrawal into heaven forty days after the Resurrection; and Pentecost, commemorating the descent of the Holy Spirit upon the apostles on the fiftieth day after Easter. The weeks between Pentecost and the following Advent were normally identified in liturgical books by reference back to Pentecost: thus the Sundays during this period were designated as the first Sunday after Pentecost, the second Sunday after Pentecost, and so on, up to the twenty-fifth Sunday after Pentecost. It will be seen that while the first-mentioned feasts, from Christmas to Candlemas, have fixed calendar dates (that is, they occur on the same date every year), the others do not. That is because these others all depend upon the date of Easter, which varies from year to year because it is calculated each year by reference to the lunar calendar. Christ was crucified at the time of the Jewish Passover, and the Jews used a lunar calendar. Passover was celebrated at the first full moon of spring (which commenced with the vernal equinox, 21 March); the Christian Easter was celebrated on the first Sunday after that full moon. Because the date of Easter was variable and

1. For a comprehensive survey and analysis of the books used in the liturgy, see especially Andrew Hughes, *Medieval Manuscripts for Mass and Office: A Guide to Their Organization and Terminology* (Toronto, 1982).

2. For a full, clear account of the monastic celebration of the Office, see the introduction to volume 6 of J. B. L. Tolhurst, ed., *The Monastic Breviary of Hyde Abbey, Winchester*, 6 vols. (London, 1932–42).

depended upon the lunar calendar, lunar calculations were of crucial importance for the medieval Church. It is for this reason that the calendars in medieval service books include important lunar information (see below).

While the *temporale* covered the basic church year, enabling Christians to commemorate annually the principal events in the life of the Savior, the *sanctorale* section of service books (known in English as the Proper of Saints) provided texts for the celebration of saints' days throughout the year. In many manuscripts, the *sanctorale* begins with texts for the feast of St. Andrew (30 November) and ends with the feast of St. Catherine of Alexandria (25 November). The *sanctorale* thus mirrors the *temporale* in that it runs roughly from Advent to Advent (the first Sunday in Advent, with which the *temporale* begins, is always the Sunday closest to St. Andrew's Day). Some manuscripts, however, begin their *sanctorale* at Christmastide, with the feast of St. Stephen on 26 December, and end with the feast of St. Thomas the Apostle on 21 December. While every *sanctorale* will include the feasts of major saints, the minor saints included will vary from one manuscript to another and can offer important evidence for establishing the origin and provenance of a manuscript (see the sections "Evidence within the Contents" and "Evidence of Added Texts, Glosses, and Notes" in chap. 8). The prayers and musical texts in the *sanctorale* name the saints in whose honor they were written and usually allude to some notable incidents in the saint's life. The *sanctorale* was normally supplemented by a shorter section known as the *commune sanctorum* (Common of Saints). This provided texts that a church could draw upon to celebrate the feast of a saint who had no liturgical texts specifically written in his or her honor. The *commune sanctorum* was arranged into subsections for the different ranks of saint (apostle, martyr, confessor, virgin); for each rank, it offered one set of texts for commemorating a single saint and another set for commemorating two or more saints (for example, a group of martyrs whose feast was celebrated on the same day).

The most important service book for the celebration of Mass throughout the year was the missal. This contained the full range of texts said and sung at Mass, including the prayers recited by the celebrant, the scriptural readings, and the chants sung by the choir (see fig. 10-7 for a page from a missal). Often, however, as in figure 10-7, just the opening words of the readings and chants would be given, the full text of these being found in other types of service books. A missal that includes not just the words of the chants but also the music to which they were sung is known as a noted missal.[3] A particular variety of Mass book intended for the use of the celebrant was the sacramentary. This included

just the prayers that were recited by the officiating priest. Its opening section presented those texts that were exactly the same at every Mass. The greater part of the book then provided the texts of the four "proper prayers," the prayers whose wording changed from one feast day to another. These four prayers were the *collecta* recited at the beginning of the Mass; the *secreta*, so called because the priest recited it to himself after offering the bread and wine; the *praefatio*, the first part of the eucharistic prayer; and the *post-communio*, recited at the end of the Mass, after the communion (see fig. 10-6, with accompanying description). While Newberry Library MS 7 is a missal, it exhibits the characteristics of a sacramentary on the page shown in figure 10-6. In addition to containing the prayers recited by the celebrant at Mass, sacramentaries often also included texts for the ceremonies of baptism and ordination, along with certain other materials for the use of a priest or bishop. A lectionary provided the passages of scripture (Epistles and Gospels) that were read out as lessons during Mass (see fig. 10-3 for a fragment of a lectionary). This type of book is sometimes called a *comes* (companion) or *liber comitis*; but the *comes* may provide just the opening words of each lesson rather than the full text. Alternatives to the lectionary were the epistolary and evangelistary, which, rather than combining Epistles and Gospels into a single comprehensive volume, separated them out into their own volumes. Variant names for the evangelistary, which contained the Gospel readings, were Gospel lectionary and pericope book (a pericope being a section or extract of text). The Gospel lectionary differed from a Gospel book in that, whereas the latter contained the full text of the four Gospels in sequential order, the Gospel lectionary provided just the passages that were read out at Mass, presenting those passages in the order in which they would be recited during the church year, beginning with the Gospel for Advent Sunday and continuing through all the Gospel readings for the *temporale* and *sanctorale* cycles.

Some manuscripts intended for use at Mass included just the musical portions of the Mass and were intended for the use of the choir. The most important of these books was the gradual, which contained a full set of the musical texts: the introit antiphon sung at the beginning of the Mass, the gradual antiphons sung after the first lesson, the alleluia sung after the second lesson, the offertory antiphon sung at the offering of the bread and wine, and the communion antiphon sung as the Eucharist was administered, as well as the tract that was sung on certain penitential days in place of the alleluia. This type of book was also sometimes called the antiphonal of the Mass. The troper, a type of manuscript found more commonly in the early than the late Middle Ages, contains the music and texts for tropes, which were special musical embellishments tagged onto sung portions of the Mass and Office on high feast days.

The principal manuscript for the performance of the Office throughout the year was the breviary. This contained

3. On the forms of musical notation used in manuscripts, see Nicolas Bell, *Music in Medieval Manuscripts* (Toronto, 2001), which covers both the use of staveless neumes in early manuscripts and the development of the four-line stave.

the full complement of texts, both said and sung, for all the hours; the texts included psalms, antiphons, lessons, prayers, and so on. Like the missal, the breviary was structured according to the liturgical year and had *temporale* and *sanctorale* sections. A breviary that includes the music for the sung sections is called a noted breviary. The collectar, or collect book, contained the prayers recited at the Office and often also contained the blessings for the Office and the short scriptural readings known as *capitula* (see fig. 10–8 for a page of a collectar that includes *capitula*); the Office lectionary contained scriptural readings alone. The manuscript that contained just the musical elements of the Office and was therefore intended for the use of the choir was the antiphonal (or antiphonary), sometimes called more specifically the antiphonal of the Office to distinguish it from the antiphonal of the Mass or gradual.

Other types of liturgical books supplemented those for the Mass and Office by providing for other occasions and by catering to the requirements of specific ranks of the clergy. The manual (also known as the ritual) was a handbook intended for parish priests that supplied the texts for the liturgical rites that a priest would conduct outside the Mass and Office. These included baptism, marriage, visiting the sick, extreme unction, and burial (the exact contents varied from one manuscript to another). The pontifical was intended specifically for the use of a bishop and therefore contained the orders of service for rites that a bishop could perform. These included confirmation, ordination of the clergy, consecration of bishops, consecration of churches and altars, consecration of oils, coronation of a king, and excommunication. Up until the thirteenth century, some pontificals furnished the texts for the rite of trial by ordeal, but ordeals were banned at the Fourth Lateran Council in 1215. Many pontificals also cover the rites of baptism, marriage, and extreme unction, which were not restricted to bishops but could also be performed by priests. The benedictional was another book for the use of a bishop. It contained the blessings that were pronounced by the bishop at masses throughout the church year; he would recite the blessing before the *Pax Domini*, the mutual greeting of the faithful that precedes the communion. Sometimes a pontifical and benedictional were combined within a single codex.

Two other types of manuscripts were not intended for liturgical use within the Church but were an important resource for monastic communities in particular and are found in many surviving examples. The passional or legendary contained a collection of saints' lives, usually arranged in calendar order. Strictly speaking, a passional should contain accounts of the lives of martyrs only, whereas a legendary could also include saints who were not martyrs, but the terms were often used loosely. The passional or legendary was often kept in the monastic refectory and used for reading aloud at meal times. The martyrology provided a listing of those saints who had died on each day of the year, and gave brief details of their lives and the manner of their death; it normally was not restricted to martyrs but included other saints as well. Several different martyrologies were produced during the Middle Ages. The most popular was that completed ca. 865 by Usuard, monk of Saint-Germain-des-Prés, which was the first to include an entry for every single day of the year (Usuard's was the basis of the official Roman martyrology printed in 1584). Many communities would supplement their copy of Usuard's martyrology by adding to its entries further information about saints whose relics they possessed or whom they otherwise held in particular reverence. It was standard practice in Benedictine monasteries that when the monks came together each day in the chapter house to hear a chapter read out from the *Rule of St. Benedict*, the lector would also read the martyrology entry for that day or the following day so that the community would know whose feasts they were celebrating.

Many liturgical books have a calendar at their front.[4] The calendar served a most important purpose by providing a swift and easy means of ascertaining which events in Christ's life and which saints were being commemorated on any given day of the year. Yet while these calendars served a highly practical purpose for their medieval readers, they require analysis and explanation if they are to be properly understood by modern readers.

Almost all medieval calendars give each day's date according to the Roman method of reckoning time (some calendars at the end of the Middle Ages, however, use the modern method, numbering the days from the first through the twenty-eighth, thirtieth, or thirty-first of the month). In the Roman system, each month had three fixed points, known as the kalends (from whence the word *calendar*), the nones, and the ides. The kalends was always the first of the month. The nones fell on the fifth of the month in January, February, April, June, August, September, November, and December, but on the seventh of the month in March, May, July, and October. The ides fell on the thirteenth in those months in which the nones fell on the fifth, and on

4. For a helpful account of medieval calendars, see Jacques Dubois and Jean-Loup Lemaitre, *Sources et méthodes de l'hagiographie médiévale* (Paris, 1993), 135–50. See also C. R. Cheney, ed., *A Handbook of Dates for Students of British History*, 2nd ed., rev. by Michael Jones (Cambridge, 2000), 1–20; Hermann Grotefend, *Taschenbuch der Zeitrechnung des deutschen Mittelalters und der Neuzeit*, 13th ed. (Hanover, 1991), 1–29; and F. P. Pickering, *The Calendar Pages of Medieval Service Books: An Introductory Note for Art Historians* (Reading, U.K., 1980). The liturgical books most likely to include calendars are missals, sacramentaries, and breviaries; calendars are not normally found in books intended specifically for the use of the choir. For the calendars in Books of Hours, see the next chapter.

the fifteenth in the other four months. All other days were dated by the number of days by which they preceded one of these fixed points (beginning the count from the fixed point itself). For example, 4 January (the day before the nones) was II Non. Jan., 3 January was III Non. Jan., and 2 January was IV Non. Jan. Days following the ides of each month were dated by reference to the Kalends of the next month. Thus 31 January was II Kal. Feb., 30 January was III Kal. Feb., and so on, all the way down to 14 January, which was XIX Kal. Feb. The full list of dates for all twelve months was thus as follows:

JANUARY, AUGUST, DECEMBER	MARCH, MAY, JULY, OCTOBER	APRIL, JUNE, SEPTEMBER, NOVEMBER	FEBRUARY
Kal. (1)	Kal. (1)	Kal. (1)	Kal. (1)
IV Non. (2)	VI Non. (2)	IV Non. (2)	IV Non. (2)
III Non. (3)	V Non. (3)	III Non. (3)	III Non. (3)
II Non. (4)	IV Non. (4)	II Non. (4)	II Non. (4)
Non. (5)	III Non. (5)	Non. (5)	Non. (5)
VIII Id. (6)	II Non. (6)	VIII Id. (6)	VIII Id. (6)
VII Id. (7)	Non. (7)	VII Id. (7)	VII Id. (7)
VI Id. (8)	VIII Id. (8)	VI Id. (8)	VI Id. (8)
V Id. (9)	VII Id. (9)	V Id. (9)	V Id. (9)
IV Id. (10)	VI Id. (10)	IV Id. (10)	IV Id. (10)
III Id. (11)	V Id. (11)	III Id. (11)	III Id. (11)
II Id. (12)	IV Id. (12)	II Id. (12)	II Id. (12)
Id. (13)	III Id. (13)	Id. (13)	Id. (13)
XIX Kal. (14)	II Id. (14)	XVIII Kal. (14)	XVI Kal. (14)
XVIII Kal. (15)	Id. (15)	XVII Kal. (15)	XV Kal. (15)
XVII Kal. (16)	XVII Kal. (16)	XVI Kal. (16)	XIV Kal. (16)
XVI Kal. (17)	XVI Kal. (17)	XV Kal. (17)	XIII Kal. (17)
XV Kal. (18)	XV Kal. (18)	XIV Kal. (18)	XII Kal. (18)
XIV Kal. (19)	XIV Kal. (19)	XIII Kal. (19)	XI Kal. (19)
XIII Kal. (20)	XIII Kal. (20)	XII Kal. (20)	X Kal. (20)
XII Kal. (21)	XII Kal. (21)	XI Kal. (21)	IX Kal. (21)
XI Kal. (22)	XI Kal. (22)	X Kal. (22)	VIII Kal. (22)
X Kal. (23)	X Kal. (23)	IX Kal. (23)	VII Kal. (23)
IX Kal. (24)	IX Kal. (24)	VIII Kal. (24)	(bis VI Kal.: the extra day in a leap year)
VIII Kal. (25)	VIII Kal. (25)	VII Kal. (25)	VI Kal. (24/25)
VII Kal. (26)	VII Kal. (26)	VI Kal. (26)	V Kal. (25/26)
VI Kal. (27)	VI Kal. (27)	V Kal. (27)	IV Kal. (26/27)
V Kal. (28)	V Kal. (28)	IV Kal. (28)	III Kal. (27/28)
IV Kal. (29)	IV Kal. (29)	III Kal. (29)	II Kal. (28/29)
III Kal. (30)	III Kal. (30)	II Kal. (30)	
II Kal. (31)	II Kal. (31)		

The Roman method of dealing with a leap year was to intercalate an extra day after 23 February. Because 24 February was the sixth (Latin *sextus*) day before the kalends of March, the intercalated day was known as *dies bissextus* and the leap year as *annus bissextilis*. In medieval Easter tables, which provide long lists of years followed by the date of Easter in each year, leap years are commonly identified by having a capital *B* (for *bissextilis*) placed next to them.

Medieval calendars do much more than just list the dates for each month in the year, as a glance at figures 12-1 and 12-2 will show. Often, the page for each month begins with a note providing certain basic information about the

umn carries the appropriate roman numeral while the second has an abbreviation for the kalends, nones, or ides; the normal abbreviations are *Kl*, *N* (or *Nos* with superscript *a*), and *Id*.[5] When there is just one column for the date, as in figures 12-1 and 12-2, the abbreviations for kalends, nones, and ides are omitted except on those three days themselves, leaving just the appropriate roman numeral for every other day (with the exception that the day following the ides may be identified fully as being so many days before the kalends of the following month: thus 14 January is listed as *xix kls febroarii* in figure 12-1). The pages of many calendars have a large, decorated *KL* in the upper left area for the first day of the month.

The text to the right of the date provides the information that is central to all medieval calendars by listing the saints and events in Christ's life that are celebrated on the different dates in the year. In any given month, some dates will have no text in this area, indicating that there was no feast to celebrate (early calendars tend to have many such blank dates; as the Middle Ages progressed, an effort was made to fill up the calendar by including more saints). When saints are listed, their names are given in the genitive case, normally followed by an indication of their status (apostle, martyr, confessor, virgin, pope, abbot, bishop, etc.). For example, in figure 12-1, the three entries for 16–18 January (XVII–XV Kal. Feb) are *Marcelli pape et martyris*, *Antonii abbatis confessoris*, and *Prisce uirginis et martyris*. In some calendars, the names of the saints or events being celebrated are all entered in regular ink (as in fig. 12-1). In others, the more important entries are written in red—whence the term "red letter day"—or in other colors such as blue and gold. Figure 12-2 shows the page for August from Newberry Library MS 59.1, a missal of ca. 1470 from Ghent. Here certain entries are written in red (such as the Assumption of the

month: how many days it has, how many days there are in the lunar month that falls within the calendar month (lunar months, also known as lunations, were alternately twenty-nine and thirty days long), how many hours of light and darkness the days have. For example, the page for January in Newberry Library MS 69, a fifteenth-century Carthusian missal from Spain, has this two-line note at its head (see fig. 12-1): *Ianuarius habet dies xxxi luna xxx. Nox habet horas xvi dies uero viii* (January has thirty-one days, the moon thirty days. The night has sixteen hours, the day eight hours). Below any headnote are listed the days of the month. The date is given in either one or two columns toward the left of the page, with other numerals and letters (discussed below) in additional columns to the left and with text to the right. When the date occupies two columns, the first col-

5. See, for example, Roger S. Wieck, *Painted Prayers: The Book of Hours in Medieval and Renaissance Art* (New York, 1997), 29, fig. 13.

Virgin Mary on 15 August/XVIII Kal. Sept. and the feast of the Apostle Bartholomew on 24 August/IX Kal. Sept.); others are underlined in red (for example, the feasts of St. Bernard on 27 August/ VI Kal. Sept. and St. Augustine on 28 August/V Kal. Sept.). The saints whose names were highlighted by the use of color included the major saints of the Church (the Virgin Mary, apostles, and others) but also saints held in special reverence in the region from which the calendar came or by the religious order to which the community owning the calendar belonged; saints singled out in this way might include the first bishop of the diocese, the founder of the order, or a saint whose relics the community possessed. It is therefore worth paying attention to these names, as they can help to establish the origin of the manuscript to which the calendar belongs (see the section "Evidence within the Contents" in chap. 8). In figure 12-2, the red underlining of the name of St. Eleutherius in the entries for 25 August (VIII Kal. Sept.) and 31 August (II Kal. Sept.) is an indication that this calendar is of the Tournai type, for St. Eleutherius was the first bishop of Tournai (in modern-day Belgium).

For the most important feast days in the year (those commemorating the major events in Christ's earthly life, the Assumption of the Virgin, the feasts of the apostles, St. John the Baptist, and All Saints), the preceding day was designated as the Vigil of the feast, and the liturgy for that day would include appropriate texts and chants that looked ahead to the event being commemorated on the following day. Thus, in figure 12-2, the

12-2 Calendar page for the month of August from a missal made ca. 1470 for the church of Saint Michael in Ghent. Newberry Library, MS 59.1, fol. 6v.

feast of the Assumption is entered under 15 August (XVIII Kal. Sept.), and 14 August (XIX Kal. Sept.) is designated as *Vigilia*. Again, the principal feasts were observed for a full week after the day on which they fell; the last day of the observation (which always fell on the same day of the week as the feast itself) was known as the octave and was recorded in calendars. In figure 12-1, 2 January (IV Non. Ian.) is designated as *Octaue sancti Stephani*, the Octave of St. Stephen, the first Christian martyr, whose feast fell on 26 December; 3 January (III Non. Ian.) is *Octaue sancti Iohannis*, the Octave of St. John the Apostle, whose feast fell on 27 December; 4 January (II Non. Ian.) is *Octaue innocentum*, the Octave of Holy Innocents' Day, which fell on 28 December; Epiphany

is recorded on 6 January (VIII Id. Ian.), and 13 January (Id. Ian.) is designated as *Octaue epiphanie*. The majority of saints were commemorated on just one day each year—the day on which they died, which in the Church's terms was their *dies natalis*, the day on which they were born into heavenly life. Some saints, however, had an additional feast in honor of their translation. This commemorated the occasion on which, at some point after their death, their bodily remains were translated—that is, either removed from one place to another (as in the case of St. Benedict, whose relics were said to have been taken from Monte Cassino to Fleury in the seventh century) or taken out of their original tomb to be reinterred in a more magnificent tomb in the same

church (as in the case of St. Swithun, who was translated at Winchester in 971, 109 years after his death). Figure 12-2 provides an example of the commemoration of a translation in its entry for 25 August (VIII Kal. Sept.): *Translatio sancti Eleutherii episcopi confessoris.*

Different feast days were marked by different levels of liturgical elaboration in honor of the saint or event being commemorated. The commemoration took place at the Mass, the Office, or both, by means of antiphons, chanted versicles and responses, and prayers referring to the saint or event. The manner in which the day would be celebrated is often indicated in the calendar by a short note following the entry recording who or what is being commemorated. In figure 12-1, these notes are all in red, whereas in figure 12-2, they are in the same color as the entry to which they relate. Feast days actually began at vespers of the preceding day (which was known as "first vespers" of the feast). For the most elaborate feasts, which in modern terminology are known as "double feasts," there would be antiphons, versicles and responses, and prayers in honor of the saint at both first vespers and second vespers (second vespers being vespers on the feast day itself). At matins, lauds, and vespers the antiphons would be "doubled," that is, they would be chanted both before and after the psalms; further, at matins there would be twelve lessons (in a monastic community) or nine lessons (in a secular church). There would also be antiphons in the saint's honor at Mass, and the proper prayers of the Mass (the *collecta, secreta, praefatio,* and *postcommunio*, described above) would invoke the saint. For a lesser feast, while first vespers would include material proper to the saint, second vespers would not; there would be no doubling of the antiphons, which would be sung in entirety only after the psalms, and there would be just three lessons at matins.

By the late Middle Ages there were several different levels at which feasts could be celebrated, and the picture is complicated by variations that existed from one region to another and between the different religious orders; the terminology used to designate the feasts also varied somewhat. In figure 12-2, the feasts of highest status are designated *Triplex* and *Duplex* (referring to two different levels of "double feast"); see, for example, the entries for 15 August (XVIII Kal. Sept.), 3 August (III Non. Aug.), and 6 August (VIII Id. Aug.). In the latter case, the abbreviation *du* with a superscript *x* is used, directly following the reference to Christ's Transfiguration (*Transfiguratio domini*). Several feasts on this page have the designations *ix lc* and *iii lc*: see, among others, the entries for 4 August (II Non. Aug.; Octave of St. Anne) and 2 August (IV Non. Aug.; feast of Pope Stephen the Martyr). The designations respectively abbreviate *ix lectiones* and *iii lectiones* and indicate that there would be either nine or three lessons at matins. These lessons would typically narrate episodes from the life of the saint being commemorated and were normally extracted from an existing *Vita* of the saint (sometimes, in manuscripts of saints'

lives, one sees numbers entered in the margins to signal where the different lessons would begin—an indication that these manuscripts were used for the liturgical readings). Other terms used in the calendar illustrated in figure 12-2 include *proprium* and *hore*, respectively indicating that the saint would be honored with proper forms at the Mass or with appropriate texts and chants in the hours of the Office; see, for example, the entries for 7 August (VII Id. Aug.), 8 August (VI Id. Aug.), and 12 August (II Id. Aug.). The simplest level of commemoration was designated *memoria* or *commemoratio* and was used for a minor saint or for a saint whose feast day coincided with a more important feast, which itself would be celebrated with greater elaboration; a *commemoratio* was restricted to an antiphon, versicle and response, and collect in the saint's honor at lauds and vespers. The *commemoratio* is abbreviated in figure 12-2 as *co* with a macron above the *o*. Several entries on this page demonstrate how the *commemoratio* took second place to a more important celebration. For example, the entry for 22 August (XI Kal. Sept.) shows that the major celebration on that day was for the Octave of the Assumption (a double feast) but that there was also a *commemoratio* of the martyrs Timothy and Symphorian.

The terminology for feast days adopted by the Carthusian order was somewhat different from that of other religious orders, as can be seen from figure 12-1. The Carthusians designated a feast of the most solemn kind as *Festum candelarum*. Two feasts in January were celebrated at this level: the Circumcision on 1 January (Kal. Ian.) and Epiphany on 6 January (VIII Id. Ian.). Each of these has the designation *candele* in figure 12-1. Below the *Festum candelarum* came the *Festum capituli*, signaled in the calendar by the letters *cp* with a superscript *m* (abbreviating *capitulum*; see the entries for 17 January/XVI Kal. Feb. and 22 January/XI Kal. Feb.). The other designations were, in descending order, *Festum XII lectionum, Missa,* and *Commemoratio*. The first of these is abbreviated in figure 12-1 as *XII lc* or simply *XII l* (see the entries for 13 January/Id. Ian., 21 January/XII Kal. Feb., 22 January/XI Kal. Feb., and 25 January/VIII Kal. Feb.); the second as a capital *M* with a superscript open-topped *a* (see the entries for 2–4 January/IV–II Non. Ian. and 20 January/XIII Kal. Feb.). The lesser status of a *commemoratio* is apparent in the entry for 13 January (Id. Ian.), where the commemoration of St. Hilary, bishop and confessor, takes second place to the more important Octave of Epiphany.

Some monastic calendars may also indicate the level of importance of the feast by noting how the community should be vested at Mass on the feast day. For major feast days the monks would typically wear the cope, the semicircular cloak that was open at the front, and the calendar entry would include the note *cappae* or *in cappis*. On lesser feast days they might wear the alb, the white garment reaching from neck to ankles; for such days the calendar would include the note *in albis*.

Many calendars—although not the ones illustrated here

—include other types of information in the right-hand area of the page, in addition to the names of the saints being commemorated and the level at which the feast was celebrated. This additional information is typically astronomical and/or prognostic. For example, many calendars include, on the appropriate day of each month, an entry noting the passage of the sun into the next sign of the zodiac.[6] Some calendars that lack such entries include instead an illustration of the appropriate sign of the zodiac somewhere on the page, usually in the lower half.[7] The prognostic element consisted in the designation of particular days as *dies mali* (evil/bad days; sometimes merely the letter *d* is entered next to the day). There were two of these days in each month, one in the first half and the other in the second half; their designation as *dies mali* gave rise to the English word "dismal." Because this system of prognostication was believed to have been invented by Egyptian astrologers, such days were also known as *dies aegyptiaci*; another appellation was *dies aegri* (sick days).[8] Important enterprises were not to be begun on these unlucky days, which were also held to be unfavorable for medical treatments such as bloodletting. In England, this system of prognostication can be found in the calendars of such high-status manuscripts as the Queen Mary Psalter (London, British Library, MS Royal 2 B. vii) and the Gorleston Psalter (London, British Library, MS Additional 49622), both made in the early fourteenth century. Certain manuscripts, rather than placing a note alongside the unlucky days themselves, incorporated the information in a verse written at the top of the page. This is the case in Newberry Library MS 59.1, where the first line on the page for August (fig. 12-2), *Augusti nepa prima fugat fine secunda*, designates the first and the second-to-last days of the month as unlucky.

The columns located on the left-hand side of calendar pages, to the left of the date, contain numbers and letters

6. See, for instance, the early-eleventh-century Winchester calendar in Cambridge, Trinity College, MS R. 15. 32. The page for July (p. 21) is reproduced in Simon Keynes, *Anglo-Saxon Manuscripts and Other Items of Related Interest in the Library of Trinity College, Cambridge*, Old English Newsletter Subsidia 18 (Binghamton, NY, 1992), pl. 19; the entry for 18 July (XV Kal. Aug.) includes the note *Sol intrat in leonem*, recording the sun's entry into Leo.

7. A good example of a calendar with such illustrations may be found in London, British Library, MS Cotton Tiberius B. v, made probably at Winchester in the second quarter of the eleventh century. The calendar is reproduced in the full facsimile of the manuscript: Patrick McGurk et al., eds., *An Eleventh-Century Anglo-Saxon Illustrated Miscellany: British Library Cotton Tiberius B. V, Part I, Together with Leaves from British Library Cotton Nero D. II* (Copenhagen, 1983).

8. See R. Steele, "Dies Aegyptiaci," *Proceedings of the Royal Society of Medicine* 12 (1919): 108–21. See also the calendar page in Keynes, *Anglo-Saxon Manuscripts*, pl. 19, where 13 July and 22 July are designated as *dies malae*.

that indicate when the new moon falls in each month and that make it possible to establish which day of the week any given date will fall on in any year. Most late medieval calendars have just two columns in this area; earlier calendars may have three or even more columns. The information provided in these columns was closely connected with the need to calculate accurately the day on which Easter, the high point in the Church's calendar, fell in each year.

The column immediately to the left of the date in figures 12-1 and 12-2 contains a continuously repeating sequence of letters running from *a* through *g*; thus, in fig. 12-1, *a* is entered next to 1 January, *b* next to 2 January, *c* next to 3 January, and so on; *g* stands next to 7 January, after which the sequence begins again with *a* next to 8 January, and so on. Every day of the year has one of these seven letters entered next to it. In many manuscripts, as in figure 12-1, the letter *a* is colored every time it occurs, to draw attention to the beginning of a new sequence; the letter may also be capitalized, as in figure 12-2. These letters entered next to the date are known as Dominical Letters. They enable the user of the calendar to establish the day of the week on which any date in the year will fall. The user must, however, first know the Dominical Letter assigned to the year in question. For example, for any year in which 1 January was a Sunday, the Dominical Letter for the year was *a*. This meant that all dates in the calendar that had an *a* entered next to them would in that year be Sundays, while all dates with a *b* next to them would be Mondays, all dates with a *c* next to them would be Tuesdays, and so on. For a year in which 2 January was a Sunday, the Dominical Letter was *b*; in such a year, all dates with a *b* next to them would be Sundays, all dates with a *c* would be Mondays, and so on. Leap years had to be assigned two Dominical Letters, one of which was valid up until VII Kal. Mart. (23 February), the day before the intercalated leap year day, while the second covered the rest of the year. In other words, if the two letters assigned to the leap year were *ba*, up until VII Kal. Mart. all dates with a *b* next to them were Sundays, whereas for the rest of the year, all dates with an *a* next to them were Sundays. The table appended to this chapter shows the Dominical Letters for all years between 600 and 1582, when the calendar was reformed.

The column at the far left in figures 12-1 and 12-2 contains roman numerals entered next to certain dates. These numerals are known as Golden Numbers and establish the day of the month on which the new moon will fall in each year. The numerals are based on a nineteen-year cycle that was the most accurate cycle for reconciling the courses of the sun and the moon known in the Middle Ages. The cycle is based on the fact that while a solar year consists of 365 days, there are only 354 days in twelve lunar months. Therefore, the age of the moon on a particular calendar date varies from one year to the next: if the moon is new on 1 January in a given year, the following year 1 January will be the twelfth day of the lunar month, and so on.

According to the nineteen-year cycle, it takes the moon and the sun nineteen years to reconcile their courses; that is, if the new moon fell on 1 January in the year 800 (as it did), it would not again fall on 1 January until 819. In figure 12-1, the Golden Number *III* has been entered next to 1 January. This means that the new moon fell on 1 January in every year 3 of the nineteen-year cycle. No number has been entered next to 2 January because according to the cycle the new moon never fell on that date. It fell on 3 January in every year 11 of the cycle, on 5 January in every year 19 of the cycle, and so on. In order to be able to draw practical benefit from these Golden Numbers, the user of the calendar had to know within which year of the nineteen-year cycle the current year fell. That information was often provided in a table of years that might supplement the calendar or that might be found in another manuscript. It could also be worked out mathematically by adding one to the number of the year itself and dividing by nineteen. The remainder was the Golden Number for the year; if there was no remainder, the Golden Number was XIX. For example, the Golden Number for 1066 was III ([1066 + 1] ÷ 19 = 56, remainder 3); the Golden Number for 1204 was VIII ([1204+1] ÷ 19 = 63, remainder 8); the Golden Number for 1500 was XIX ([1500 + 1] ÷ 19 = 79, remainder 0). The Golden Numbers for the years 600–1582 are included in the table appended to this chapter.

The Golden Numbers in calendars make it possible to establish the phase of the moon for every single date in the year. For example, if the current year was year 3 of the nineteen-year cycle, the new moon fell on all dates in the calendar next to which the numeral III was entered, and the age of the moon on all other dates of the year could be established by simply counting forward from the last occurrence of the numeral III. Some early calendars, however, made the task simpler by including a third column at the left side of the page and by entering in this column letters of the alphabet known as Lunar Letters.[9] The Lunar Letters ran from *a* to *u* (a total of twenty letters, since there was no *j* in the Roman alphabet), then began a second sequence of the same letters, with a dot after each letter (*a.* to *u.*, another twenty letters), then a third sequence in which the letters were each preceded by a dot and in which the last letter was *t* (*.a* to *.t*, nineteen letters). There

were thus fifty-nine different symbols available (20 + 20 + 19), a number matching the total number of days in two lunar months; the lunar month is approximately twenty-nine and a half days long, but in medieval reckoning, lunar months were alternately thirty and twenty-nine days long (and were known respectively as "full" and "hollow" lunations). The three sequences (*a* to *u*, *a.* to *u.*, and *.a* to *.t*) were repeated until every single date in the calendar had a Lunar Letter entered next to it. To find out how old the moon was on any given date of the year, the user looked for the Lunar Letter entered next to that date, then searched for that letter in a separate table that listed the Lunar Letters and the phase of the moon to which they corresponded for each year of the nineteen-year cycle. Bede provided such a table in his great computistical work *De temporum ratione*, which offered medieval readers a clear, comprehensive guide to the science of chronology; the table also occurs in other contexts.[10]

By referring to the Golden Numbers and the Dominical Letters in the calendar, a user could establish the date of Easter in any given year. As mentioned above, Easter always fell on the Sunday following the first full moon of spring. The earliest possible date for that full moon was 21 March, the vernal equinox, so the earliest possible date for Easter Sunday was 22 March (its latest possible date was 25 April). The user first searched the calendar pages for March and April, looking for the Golden Number for the current year. The Golden Number recorded the date of the new moon; the user therefore had to count forward fourteen days from the date next to which the Golden Number was entered in order to find the date of the full moon. Having established this, he then consulted the column of the calendar containing the Dominical Letters in order to establish which of the immediately following days was a Sunday; that day would be the day on which Easter would be celebrated. Provided that the Golden Numbers and Dominical Letters had been entered correctly in the calendar, this process would inevitably produce a correct result. However, it involved several different steps, and it is therefore not surprising that in many manuscripts, the task of establishing the date of Easter was simplified by the inclusion of an Easter table in addition to a calendar. Easter tables came in a variety of formats. One format provided a list of years, with the date of Easter entered alongside each year; tables adopting this format often spanned several hundred years (in his *De temporum ratione*, Bede presented a table spanning 532 years, from 532 AD to 1063 AD).[11] Another type of Easter

9. Lunar Letters can be seen in the calendar page reproduced in Keynes, *Anglo-Saxon Manuscripts*, pl. 19; the Lunar Letters occupy the second column from the left, between the Golden Numbers and the Dominical Letters. For a facsimile of a complete calendar that includes Lunar Letters, see H. A. Wilson, ed., *The Calendar of St. Willibrord from MS. Paris. Lat. 10837: A Facsimile with Transcription, Introduction, and Notes* (London, 1918; repr., Woodbridge, U.K., 1998); here the Lunar Letters occupy the leftmost column. Ironically, scribes often made errors when copying Lunar Letters into calendars; this rendered the letters effectively useless.

10. See Charles W. Jones, ed., *Bedae opera de temporibus* (Cambridge, MA, 1943), 225, and Faith T. Wallis, ed., *Bede: The Reckoning of Time* (Liverpool, 1999), 72.

11. See Wallis, *Bede: The Reckoning of Time*, 155–56, 352–53, and (for the table itself) 392–404. It was significant that the period covered by the table spanned 532 years, for as Bede realized, this period, produced by multiplying nineteen (the

table, popular in the late Middle Ages, adopted a grid format occupying just a single page; this table made it possible to calculate the date of Easter in any year. Such a table occurs in Newberry Library MS 82, an early-fifteenth-century Italian Book of Hours (fig. 12-3); it occupies the page immediately preceding the manuscript's calendar. Entered across the top of the page are the Dominical Letters, in the sequence F, E, D, C, B, A, G; they are identified as *Littere dominicales*. Running down the left side of the page are the Golden Numbers, entered as roman numerals in sequence from I to XIX and with the title *Aureus numerus* entered at the top of the column; down the right side of the page, the Golden Numbers are given as arabic numerals. The rest of the grid is filled up with numbers entered variously in black and in red. A note at the bottom of the page, labeled *Rubrica*, explains how to use the table, with the part of the note written in black referring to the black numbers in the grid and the part written in red referring to the red numbers: "Nota quod quotus numerus niger obuians littere dominicali et auro numero tot diebus erit pasca domini intrante aprili. Et similiter quotus fuerit numerus rubeus obuians littere dominicali et auro numero tot diebus exeunte martio erit pasca domini." The note explains that the user had to search the grid to find the square that related to the Golden Number and the Dominical Letter for the year for which the date of Easter was being sought. If the number within that square was entered in black, the user had to count forward that number of days from 1 April; if the number was entered in red, he had to count backward that number of days from 31 March. For example, for the year 931, the Dominical Letter was B and the Golden Number was I. A user of the table seeking to find out the date of Easter in 931 located square B I in the grid and found therein the number X written in black. This meant that he had to count forward ten days from 1 April (beginning the count on 1 April itself); the table thus established that Easter in 931 oc-

12-3 Easter table from a Book of Hours of the Use of Rome, produced in central Italy, first half of the fifteenth century. Newberry Library, MS 82, fol. 2r.

curred on 10 April. Again, for the year 1095, the Dominical Letter was G, and the Golden Number was XIII. Square G XIII of the grid contains the number VII in red. Counting back seven days from 31 March (beginning the count with 31 March itself), the user established that Easter in that year occurred on 25 March.

Of course, just like a written text of prose or poetry, calendars, Easter tables, and other computational aids were subject to scribal corruption as they were copied from one manuscript to another. While it is rare for saints' days to be entered under the wrong date, the columns of calendars and computational tables that contained just letters and numbers were more subject to miscopying. Lunar Letters in particular, with their combinations of letters and dots, seem to have invited scribal error (some scribes may not have fully understood the significance of the dots variously following and preceding the letters); it is perhaps for this reason that they are rarely to be found in late medieval

number of the years in the solar-lunar cycle) by twenty-eight (the number of years after which each date in each year occurs on exactly the same day of the week as in the previous cycle), was a Great Paschal Cycle; that is, at the end of this period, a new cycle of 532 years would begin, with Easter occurring on exactly the same dates as in the cycle just completed. On the basis of this cycle, the date of Easter could be calculated ad infinitum.

calendars. Dominical Letters and Golden Numbers might also be copied erroneously, and when this happened, the errors made it impossible for these letters and numbers to serve the purpose for which they had been designed.

By now it will be clear that a great deal of information was compacted into the pages of the calendars found in many of the liturgical manuscripts of the Middle Ages. While these pages challenge the interpretive skills of the novice paleographer, when rightly understood, they have much to reveal about medieval methods of reckoning, habits of thought, and the manner in which the medieval Church sought to mark the high days and holidays of the year. The calendars, like the liturgical books they preface, help to bring into focus for us the rhythm of celebration and commemoration that underlay the lives of many thousands of monks, nuns, and clergy throughout the medieval centuries. It was, indeed, a rhythm that molded the day-to-day existence of the entire Christian population of Western Europe.

Dominical Letters and Golden Numbers, 600–1582

The table lists the Dominical Letters and Golden Numbers for each year within the span 600–1582, the year in which Pope Gregory XIII authorized reform of the calendar. All leap years have two Dominical Letters. The first letter was valid for the period from 1 January up until the intercalation of the extra day on 24 February (*bis* VI Kal. Mart.); the second was valid for the rest of the year, following the intercalation.

600 CB XII	631 F V	662 B XVII	693 E X	724 BA III
601 A XIII	632 ED VI	663 A XVIII	694 D XI	725 G IV
602 G XIV	633 C VII	664 GF XIX	695 C XII	726 F V
603 F XV	634 B VIII	665 E I	696 BA XIII	727 E VI
604 ED XVI	635 A IX	666 D II	697 G XIV	728 DC VII
605 C XVII	636 GF X	667 C III	698 F XV	729 B VIII
606 B XVIII	637 E XI	668 BA IV	699 E XVI	730 A IX
607 A XIX	638 D XII	669 G V	700 DC XVII	731 G X
608 GF I	639 C XIII	670 F VI	701 B XVIII	732 FE XI
609 E II	640 BA XIV	671 E VII	702 A XIX	733 D XII
610 D III	641 G XV	672 DC VIII	703 G I	734 C XIII
611 C IV	642 F XVI	673 B IX	704 FE II	735 B XIV
612 BA V	643 E XVII	674 A X	705 D III	736 AG XV
613 G VI	644 DC XVIII	675 G XI	706 C IV	737 F XVI
614 F VII	645 B XIX	676 FE XII	707 B V	738 E XVII
615 E VIII	646 A I	677 D XIII	708 AG VI	739 D XVIII
616 DC IX	647 G II	678 C XIV	709 F VII	740 CB XIX
617 B X	648 FE III	679 B XV	710 E VIII	741 A I
618 A XI	649 D IV	680 AG XVI	711 D IX	742 G II
619 G XII	650 C V	681 F XVII	712 CB X	743 F III
620 FE XIII	651 B VI	682 E XVIII	713 A XI	744 ED IV
621 D XIV	652 AG VII	683 D XIX	714 G XII	745 C V
622 C XV	653 F VIII	684 CB I	715 F XIII	746 B VI
623 B XVI	654 E IX	685 A II	716 ED XIV	747 A VII
624 AG XVII	655 D X	686 G III	717 C XV	748 GF VIII
625 F XVIII	656 CB XI	687 F IV	718 B XVI	749 E IX
626 E XIX	657 A XII	688 ED V	719 A XVII	750 D X
627 D I	658 G XIII	689 C VI	720 GF XVIII	751 C XI
628 CB II	659 F XIV	690 B VII	721 E XIX	752 BA XII
629 A III	660 ED XV	691 A VIII	722 D I	753 G XIII
630 G IV	661 C XVI	692 GF IX	723 C II	754 F XIV

755 E XV	801 C IV	847 B XII	893 G I	939 F IX
756 DC XVI	802 B V	848 AG XIII	894 F II	940 ED X
757 B XVII	803 A VI	849 F XIV	895 E III	941 C XI
758 A XVIII	804 GF VII	850 E XV	896 DC IV	942 B XII
759 G XIX	805 E VIII	851 D XVI	897 B V	943 A XIII
760 FE I	806 D IX	852 CB XVII	898 A VI	944 GF XIV
761 D II	807 C X	853 A XVIII	899 G VII	945 E XV
762 C III	808 BA XI	854 G XIX	900 FE VIII	946 D XVI
763 B IV	809 G XII	855 F I	901 D IX	947 C XVII
764 AG V	810 F XIII	856 ED II	902 C X	948 BA XVIII
765 F VI	811 E XIV	857 C III	903 B XI	949 G XIX
766 E VII	812 DC XV	858 B IV	904 AG XII	950 F I
767 D VIII	813 B XVI	859 A V	905 F XIII	951 E II
768 CB IX	814 A XVII	860 GF VI	906 E XIV	952 DC III
769 A X	815 G XVIII	861 E VII	907 D XV	953 B IV
770 G XI	816 FE XIX	862 D VIII	908 CB XVI	954 A V
771 F XII	817 D I	863 C IX	909 A XVII	955 G VI
772 ED XIII	818 C II	864 BA X	910 G XVIII	956 FE VII
773 C XIV	819 B III	865 G XI	911 F XIX	957 D VIII
774 B XV	820 AG IV	866 F XII	912 ED I	958 C IX
775 A XVI	821 F V	867 E XIII	913 C II	959 B X
776 GF XVII	822 E VI	868 DC XIV	914 B III	960 AG XI
777 E XVIII	823 D VII	869 B XV	915 A IV	961 F XII
778 D XIX	824 CB VIII	870 A XVI	916 GF V	962 E XIII
779 C I	825 A IX	871 G XVII	917 E VI	963 D XIV
780 BA II	826 G X	872 FE XVIII	918 D VII	964 CB XV
781 G III	827 F XI	873 D XIX	919 C VIII	965 A XVI
782 F IV	828 ED XII	874 C I	920 BA IX	966 G XVII
783 E V	829 C XIII	875 B II	921 G X	967 F XVIII
784 DC VI	830 B XIV	876 AG III	922 F XI	968 ED XIX
785 B VII	831 A XV	877 F IV	923 E XII	969 C I
786 A VIII	832 GF XVI	878 E V	924 DC XIII	970 B II
787 G IX	833 E XVII	879 D VI	925 B XIV	971 A III
788 FE X	834 D XVIII	880 CB VII	926 A XV	972 GF IV
789 D XI	835 C XIX	881 A VIII	927 G XVI	973 E V
790 C XII	836 BA I	882 G IX	928 FE XVII	974 D VI
791 B XIII	837 G II	883 F X	929 D XVIII	975 C VII
792 AG XIV	838 F III	884 ED XI	930 C XIX	976 BA VIII
793 F XV	839 E IV	885 C XII	931 B I	977 G IX
794 E XVI	840 DC V	886 B XIII	932 AG II	978 F X
795 D XVII	841 B VI	887 A XIV	933 F III	979 E XI
796 CB XVIII	842 A VII	888 GF XV	934 E IV	980 DC XII
797 A XIX	843 G VIII	889 E XVI	935 D V	981 B XIII
798 G I	844 FE IX	890 D XVII	936 CB VI	982 A XIV
799 F II	845 D X	891 C XVIII	937 A VII	983 G XV
800 ED III	846 C XI	892 BA XIX	938 G VIII	984 FE XVI

985 D XVII	1031 C VI	1077 A XIV	1123 G III	1169 E XI
986 C XVIII	1032 BA VII	1078 G XV	1124 FE IV	1170 D XII
987 B XIX	1033 G VIII	1079 F XVI	1125 D V	1171 C XIII
988 AG I	1034 F IX	1080 ED XVII	1126 C VI	1172 BA XIV
989 F II	1035 E X	1081 C XVIII	1127 B VII	1173 G XV
990 E III	1036 DC XI	1082 B XIX	1128 AG VIII	1174 F XVI
991 D IV	1037 B XII	1083 A I	1129 F IX	1175 E XVII
992 CB V	1038 A XIII	1084 GF II	1130 E X	1176 DC XVIII
993 A VI	1039 G XIV	1085 E III	1131 D XI	1177 B XIX
994 G VII	1040 FE XV	1086 D IV	1132 CB XII	1178 A I
995 F VIII	1041 D XVI	1087 C V	1133 A XIII	1179 G II
996 ED IX	1042 C XVII	1088 BA VI	1134 G XIV	1180 FE III
997 C X	1043 B XVIII	1089 G VII	1135 F XV	1181 D IV
998 B XI	1044 AG XIX	1090 F VIII	1136 ED XVI	1182 C V
999 A XII	1045 F I	1091 E IX	1137 C XVII	1183 B VI
1000 GF XIII	1046 E II	1092 DC X	1138 B XVIII	1184 AG VII
1001 E XIV	1047 D III	1093 B XI	1139 A XIX	1185 F VIII
1002 D XV	1048 CB IV	1094 A XII	1140 GF I	1186 E IX
1003 C XVI	1049 A V	1095 G XIII	1141 E II	1187 D X
1004 BA XVII	1050 G VI	1096 FE XIV	1142 D III	1188 CB XI
1005 G XVIII	1051 F VII	1097 D XV	1143 C IV	1189 A XII
1006 F XIX	1052 ED VIII	1098 C XVI	1144 BA V	1190 G XIII
1007 E I	1053 C IX	1099 B XVII	1145 G VI	1191 F XIV
1008 DC II	1054 B X	1100 AG XVIII	1146 F VII	1192 ED XV
1009 B III	1055 A XI	1101 F XIX	1147 E VIII	1193 C XVI
1010 A IV	1056 GF XII	1102 E I	1148 DC IX	1194 B XVII
1011 G V	1057 E XIII	1103 D II	1149 B X	1195 A XVIII
1012 FE VI	1058 D XIV	1104 CB III	1150 A XI	1196 GF XIX
1013 D VII	1059 C XV	1105 A IV	1151 G XII	1197 E I
1014 C VIII	1060 BA XVI	1106 G V	1152 FE XIII	1198 D II
1015 B IX	1061 G XVII	1107 F VI	1153 D XIV	1199 C III
1016 AG X	1062 F XVIII	1108 ED VII	1154 C XV	1200 BA IV
1017 F XI	1063 E XIX	1109 C VIII	1155 B XVI	1201 G V
1018 E XII	1064 DC I	1110 B IX	1156 AG XVII	1202 F VI
1019 D XIII	1065 B II	1111 A X	1157 F XVIII	1203 E VII
1020 CB XIV	1066 A III	1112 GF XI	1158 E XIX	1204 DC VIII
1021 A XV	1067 G IV	1113 E XII	1159 D I	1205 B IX
1022 G XVI	1068 FE V	1114 D XIII	1160 CB II	1206 A X
1023 F XVII	1069 D VI	1115 C XIV	1161 A III	1207 G XI
1024 ED XVIII	1070 C VII	1116 BA XV	1162 G IV	1208 FE XII
1025 C XIX	1071 B VIII	1117 G XVI	1163 F V	1209 D XIII
1026 B I	1072 AG IX	1118 F XVII	1164 ED VI	1210 C XIV
1027 A II	1073 F X	1119 E XVIII	1165 C VII	1211 B XV
1028 GF III	1074 E XI	1120 DC XIX	1166 B VIII	1212 AG XVI
1029 E IV	1075 D XII	1121 B I	1167 A IX	1213 F XVII
1030 D V	1076 CB XIII	1122 A II	1168 GF X	1214 E XVIII

1215 D XIX	1261 B VIII	1307 A XVI	1353 F V	1399 E XIII
1216 CB I	1262 A IX	1308 GF XVII	1354 E VI	1400 DC XIV
1217 A II	1263 G X	1309 E XVIII	1355 D VII	1401 B XV
1218 G III	1264 FE XI	1310 D XIX	1356 CB VIII	1402 A XVI
1219 F IV	1265 D XII	1311 C I	1357 A IX	1403 G XVII
1220 ED V	1266 C XIII	1312 BA II	1358 G X	1404 FE XVIII
1221 C VI	1267 B XIV	1313 G III	1359 F XI	1405 D XIX
1222 B VII	1268 AG XV	1314 F IV	1360 ED XII	1406 C I
1223 A VIII	1269 F XVI	1315 E V	1361 C XIII	1407 B II
1224 GF IX	1270 E XVII	1316 DC VI	1362 B XIV	1408 AG III
1225 E X	1271 D XVIII	1317 B VII	1363 A XV	1409 F IV
1226 D XI	1272 CB XIX	1318 A VIII	1364 GF XVI	1410 E V
1227 C XII	1273 A I	1319 G IX	1365 E XVII	1411 D VI
1228 BA XIII	1274 G II	1320 FE X	1366 D XVIII	1412 CB VII
1229 G XIV	1275 F III	1321 D XI	1367 C XIX	1413 A VIII
1230 F XV	1276 ED IV	1322 C XII	1368 BA I	1414 G IX
1231 E XVI	1277 C V	1323 B XIII	1369 G II	1415 F X
1232 DC XVII	1278 B VI	1324 AG XIV	1370 F III	1416 ED XI
1233 B XVIII	1279 A VII	1325 F XV	1371 E IV	1417 C XII
1234 A XIX	1280 GF VIII	1326 E XVI	1372 DC V	1418 B XIII
1235 G I	1281 E IX	1327 D XVII	1373 B VI	1419 A XIV
1236 FE II	1282 D X	1328 CB XVIII	1374 A VII	1420 GF XV
1237 D III	1283 C XI	1329 A XIX	1375 G VIII	1421 E XVI
1238 C IV	1284 BA XII	1330 G I	1376 FE IX	1422 D XVII
1239 B V	1285 G XIII	1331 F II	1377 D X	1423 C XVIII
1240 AG VI	1286 F XIV	1332 ED III	1378 C XI	1424 BA XIX
1241 F VII	1287 E XV	1333 C IV	1379 B XII	1425 G I
1242 E VIII	1288 DC XVI	1334 B V	1380 AG XIII	1426 F II
1243 D IX	1289 B XVII	1335 A VI	1381 F XIV	1427 E III
1244 CB X	1290 A XVIII	1336 GF VII	1382 E XV	1428 DC IV
1245 A XI	1291 G XIX	1337 E VIII	1383 D XVI	1429 B V
1246 G XII	1292 FE I	1338 D IX	1384 CB XVII	1430 A VI
1247 F XIII	1293 D II	1339 C X	1385 A XVIII	1431 G VII
1248 ED XIV	1294 C III	1340 BA XI	1386 G XIX	1432 FE VIII
1249 C XV	1295 B IV	1341 G XII	1387 F I	1433 D IX
1250 B XVI	1296 AG V	1342 F XIII	1388 ED II	1434 C X
1251 A XVII	1297 F VI	1343 E XIV	1389 C III	1435 B XI
1252 GF XVIII	1298 E VII	1344 DC XV	1390 B IV	1436 AG XII
1253 E XIX	1299 D VIII	1345 B XVI	1391 A V	1437 F XIII
1254 D I	1300 CB IX	1346 A XVII	1392 GF VI	1438 E XIV
1255 C II	1301 A X	1347 G XVIII	1393 E VII	1439 D XV
1256 BA III	1302 G XI	1348 FE XIX	1394 D VIII	1440 CB XVI
1257 G IV	1303 F XII	1349 D I	1395 C IX	1441 A XVII
1258 F V	1304 ED XIII	1350 C II	1396 BA X	1442 G XVIII
1259 E VI	1305 C XIV	1351 B III	1397 G XI	1443 F XIX
1260 DC VII	1306 B XV	1352 AG IV	1398 F XII	1444 ED I

1445 C II	1473 C XI	1501 C I	1529 C X	1557 C XIX
1446 B III	1474 B XII	1502 B II	1530 B XI	1558 B I
1447 A IV	1475 A XIII	1503 A III	1531 A XII	1559 A II
1448 GF V	1476 GF XIV	1504 GF IV	1532 GF XIII	1560 GF III
1449 E VI	1477 E XV	1505 E V	1533 E XIV	1561 E IV
1450 D VII	1478 D XVI	1506 D VI	1534 D XV	1562 D V
1451 C VIII	1479 C XVII	1507 C VII	1535 C XVI	1563 C VI
1452 BA IX	1480 BA XVIII	1508 BA VIII	1536 BA XVII	1564 BA VII
1453 G X	1481 G XIX	1509 G IX	1537 G XVIII	1565 G VIII
1454 F XI	1482 F I	1510 F X	1538 F XIX	1566 F IX
1455 E XII	1483 E II	1511 E XI	1539 E I	1567 E X
1456 DC XIII	1484 DC III	1512 DC XII	1540 DC II	1568 DC XI
1457 B XIV	1485 B IV	1513 B XIII	1541 B III	1569 B XII
1458 A XV	1486 A V	1514 A XIV	1542 A IV	1570 A XIII
1459 G XVI	1487 G VI	1515 G XV	1543 G V	1571 G XIV
1460 FE XVII	1488 FE VII	1516 FE XVI	1544 FE VI	1572 FE XV
1461 D XVIII	1489 D VIII	1517 D XVII	1545 D VII	1573 D XVI
1462 C XIX	1490 C IX	1518 C XVIII	1546 C VIII	1574 C XVII
1463 B I	1491 B X	1519 B XIX	1547 B IX	1575 B XVIII
1464 AG II	1492 AG XI	1520 AG I	1548 AG X	1576 AG XIX
1465 F III	1493 F XII	1521 F II	1549 F XI	1577 F I
1466 E IV	1494 E XIII	1522 E III	1550 E XII	1578 E II
1467 D V	1495 D XIV	1523 D IV	1551 D XIII	1579 D III
1468 CB VI	1496 CB XV	1524 CB V	1552 CB XIV	1580 CB IV
1469 A VII	1497 A XVI	1525 A VI	1553 A XV	1581 A V
1470 G VIII	1498 G XVII	1526 G VII	1554 G XVI	1582 G VI
1471 F IX	1499 F XVIII	1527 F VIII	1555 F XVII	
1472 ED X	1500 ED XIX	1528 ED IX	1556 ED XVIII	

CHAPTER THIRTEEN

Books of Hours

OOKS OF HOURS were the most popular books of the late Middle Ages. They survive in significantly greater numbers than any other genre of manuscript. Originating around the middle of the thirteenth century and retaining their popularity well into the sixteenth, they were made in the thousands for royal, aristocratic, and middle-class owners. Frequently commissioned to mark a marriage, they were often treated as heirlooms and handed down from one generation of a family to the next; they could become so closely identified with a family that the names of children born to the family might be entered on the endleaves of the manuscript (see p. 111). Books of Hours offered the opportunity for lavish decoration, and it has been well observed that the whole history of late medieval manuscript illumination, at least in northern Europe, may be studied through them.[1]

Books of Hours were made for laypeople. Their purpose was to provide men and women with a means by which they could participate for themselves in the daily round of prayer and worship that typified the lives of monks and priests. The proliferation of Books of Hours is thus itself a testimony to the marked increase of lay literacy in the last centuries of the Middle Ages. It is also noteworthy that large numbers—indeed, the majority—of Books of Hours were made for female owners. The "hours" alluded to were of course the hours of the monastic Divine Office, the times of day at which monks gathered in church to pray. There were eight of these hours: matins, for which monks rose from their beds at about two a.m. and which was immediately followed by lauds; prime, marking the first hour of the day, around six a.m.; terce, sext, and none, respectively marking the third, sixth, and ninth hours (nine a.m., noon, and three p.m.); vespers, marking the onset of evening; and compline, which brought the day to a close. Although within the monastery these hours would be strictly observed at the appropriate time, when laypeople practiced their own private devotions by reading from their Books of Hours, their observance tended to be rather looser. For example, a sixteenth-century devotional book recommended saying matins and prime after rising at six o'clock in the morning, completing all the hours up to terce before the main meal of the day, and reciting the remainder by suppertime.[2]

The central text in every Book of Hours was the Hours of the Virgin, also known as the Little Office of the Blessed Virgin Mary. All Books of Hours, however, include several other texts, although the exact number of these texts and the order in which they appear vary from one manuscript to another. Almost all Books of Hours began with a calendar similar to those found in the liturgical books of monasteries and churches (see chap. 12). The other texts most commonly found in Books of Hours, all of which are described below, were a set of four Gospel lessons (also called Gospel sequences); the account of Christ's Passion from St. John's Gospel; two prayers in honor of the Virgin, the *Obsecro te* and the *O intemerata*; the Hours of the Cross and the Hours of the Holy Spirit; the Seven Penitential Psalms; a litany; the Office of the Dead; and Suffrages of the Saints. The saints listed in the calendar and the texts included in the Hours of the Virgin and the Office of the Dead varied somewhat from one Book of Hours to another, depending on the particular "use" followed in each individual book. There were a number of these different uses. The most important, found in many Books of Hours, were the uses of Rome and of Paris; other important ones included the uses of Sarum (found in England), Bruges, Reims, and Rouen. The use can be a helpful indicator of the region in which a Book of Hours was made or for which it was intended. (Books of Hours were sometimes made in one region with the intention that they would be used in another; for example, Newberry Library MS 35 [figs. 7-29 and 13-30] was written and decorated in Flanders but displays the use of Sarum because it was made for an English owner.) The evidence can, however, be complicated, for sometimes the

1. See Roger S. Wieck, *Painted Prayers: The Book of Hours in Medieval and Renaissance Art* (New York, 1997), 24, and Roger S. Wieck, *Time Sanctified: The Book of Hours in Medieval Art and Life* (New York, 1988), 28–31. Wieck's beautifully illustrated volumes offer an excellent introduction to the study of Books of Hours. Also valuable is John Harthan, *Books of Hours and Their Owners* (London, 1977).

2. Quoted in Wieck, *Painted Prayers*, 22.

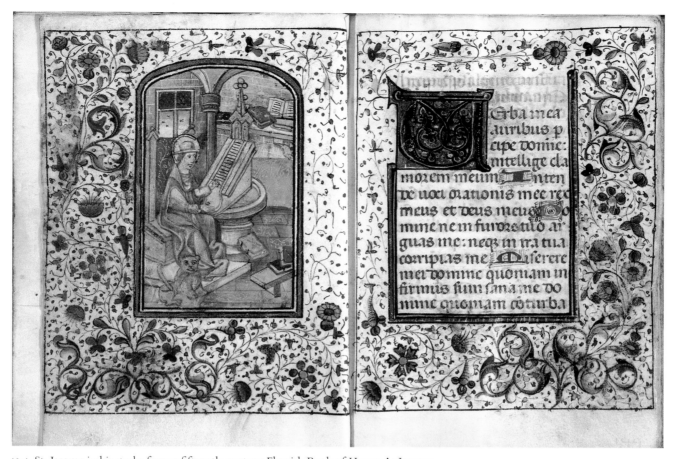

13-1 St. Jerome in his study, from a fifteenth-century Flemish Book of Hours. As Jerome
is shown writing with his left hand, the illumination was probably made from a reversed
tracing. Newberry Library, MS 53, fols. 148v–149r.

Hours of the Virgin in a given manuscript will follow one
use while the Office of the Dead follows another, and cal-
endars may be composite, combining elements from dif-
ferent uses.[3]

In addition to the essential texts listed above, most Books
of Hours include a selection of "accessory texts," of which
the most common are the Fifteen Gradual Psalms (Psalms
119–133, believed to have been recited by Jewish pilgrims
"going up" to Jerusalem); the Psalter of St. Jerome (a se-
lection of 183 verses from the Psalms, erroneously attrib-
uted to Jerome and intended to be used by the sick; see fig.
13-1); and the Joys of the Virgin (which varied in number
from five to fifteen and commemorated happy moments
in Mary's life, from the Annunciation to the Assumption).
The illumination shown in figure 13-2 illustrates a French
text of the Joys of the Virgin and depicts the book's owner
before the Virgin and Child with a book with a textile
cover (perhaps a girdle book) lying on the floor in front

of her. Various other ancillary prayers may be included,
the exact number and sequence thereof depending on the
wishes of the patron for whom the manuscript was being
made.

The calendar that began almost every Book of Hours
sometimes had just a single page for each month, but often,
given the small physical dimensions of many such books,
the first half of a month appeared on the recto of a leaf,
with the rest on the verso. The purpose of the calendar was
exactly the same as in liturgical books: to inform the user
which saint or saints were being commemorated on any
given day. As in the liturgical books, different colors might
be used to distinguish between major and minor feast days.
The calendars of some Books of Hours include illustrations.
The illustrations most commonly found are occupations
of the months, but signs of the zodiac also occur quite fre-
quently; both may appear on the same page, but some-
times, when each month spans two pages, the occupation
will be on the recto and the sign of the zodiac on the verso.
Figure 13-3 shows a detail of the first of two pages for Janu-
ary from the calendar in Newberry Library MS 82, a Book
of Hours made probably at Gubbio in central Italy during
the first half of the fifteenth century. This manuscript, like
most Books of Hours, uses the Roman calendar; and at the

3. For a discussion of some of the complexities involved in
the interpretation of the evidence of use in Books of Hours,
see the chapter by John Plummer, "'Use' and 'Beyond Use,'" in
Wieck, *Time Sanctified*, 149–56.

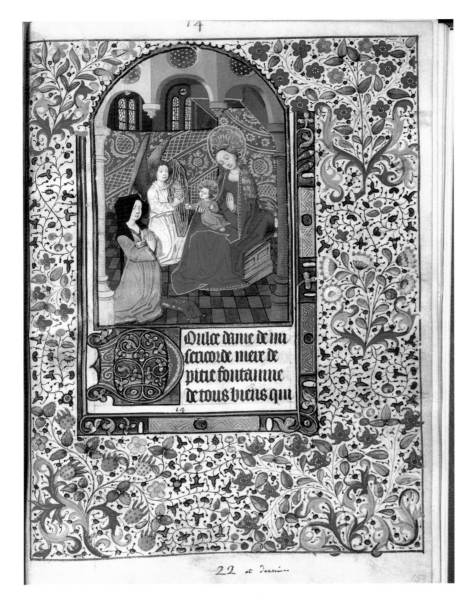

13-2 A vernacular Book of Hours with supplicant before the Virgin and Child. Note the book placed on the ground in front of the supplicant. Newberry Library, MS 42, fol. 153r.

Ascension, which brought to a close his sojourn on earth. These four readings were in fact the Gospel lessons used at Mass on four of the Church's principal feast days: Christmas (25 December), the Annunciation (25 March), Epiphany (6 January), and the Ascension. At a time when most laypeople did not possess their own Bibles, the inclusion of these readings in Books of Hours provided their owners with scriptural accounts of the major events in Christ's life, accounts that they could read and ruminate upon in their own time.

In most Books of Hours, each of the Gospel sequences is preceded by an illustration depicting the evangelist who wrote it. These illustrations are usually simple portraits that show the evangelist writing in a study, or, in John's case, on the island of Patmos, to which he had been exiled by the Emperor Domitian. John is often shown vexed by a devil, who may steal his pen case

13-3 A man eating at a table warms himself beside a fire in the illustration of this calendar page for the month of January. Newberry Library, MS 82, fol. 3r.

left of the page are the Golden Numbers and Dominical Letters (see chap. 12). The large initials *KL* in the top left area of the page enclose a scene of a man warming himself before a fire, a common choice for the occupation of the month for January.

The calendar is usually followed by the Gospel lessons or sequences, which comprise four readings, one from each Gospel. These readings tell of major events in Christ's life. First comes the opening passage of St. John's Gospel (John 1:1–14), describing the mystery of the Incarnation. This is followed by St. Luke's account of the Annunciation (Luke 1:26–38), telling of how the archangel Gabriel appeared to Mary to announce that the Savior would be born to her. The passage from St. Matthew's Gospel describes Christ's Nativity, his adoration by the Three Magi, and the angel's command to Joseph to take Mary and the Christ child to Egypt (Matthew 2:1–12). The fourth reading, from the end of St. Mark's Gospel (Mark 16:14–20), narrates Christ's final appearance to the disciples after the Resurrection and his

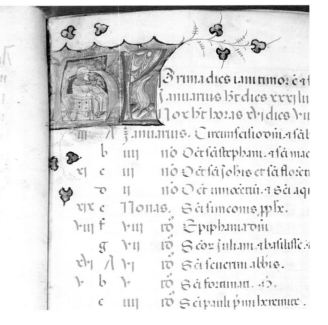

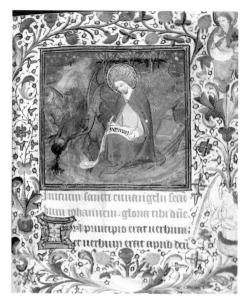

13-4

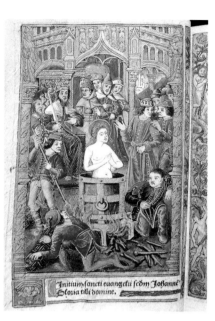

13-5

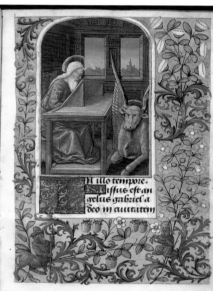

13-6

13-4 St. John on the island of Patmos. The devil empties John's ink pot into the water, but the completed book lies behind the saint. Newberry Library, MS 52, fol. 20r.

13-5 Hand-colored woodblock print depicting the boiling of St. John, from which he emerged unharmed. Newberry Library, Inc. 8178.3, fol. 8v.

13-6 St. Luke composes his Gospel on a slanted desk with his symbol, the ox, on the floor. Newberry Library, MS 47, fol. 15r.

13-7 St. Matthew composes his Gospel on a scroll with an angel holding his ink pot. Newberry Library, MS 52, fol. 23v.

13-8 St. Mark writes his Gospel with his symbol, the winged lion, at his feet. The first words on the scroll wrongly identify the evangelist as Luke. Newberry Library, MS 47, fol. 19r.

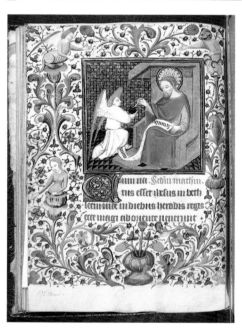

13-7

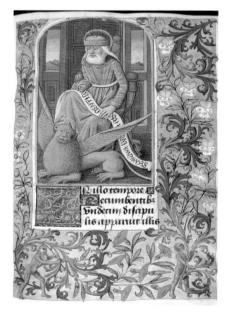

13-8

(see fig. 13-9 below) or empty his ink pot into the water (fig. 13-4). Sometimes, however, the illustrations of the Gospel sequences show notable events from the evangelist's life; St. John, for example, may be depicted being boiled in oil, an ordeal he is said to have undergone and miraculously survived at Ephesus (see fig. 13-5). For simple portraits, the evangelist is generally shown accompanied by his symbol. Figure 13-6 illustrates the portrait of St. Luke that precedes the reading from his Gospel in Newberry Library MS 47, a Book of Hours made in France ca. 1490 and illustrated by an artist influenced by the style of the great miniaturist Jean Bourdichon. The transparently nimbed St. Luke writes at a sloping lectern, in front of which is his symbol, the ox; the border decoration includes the figure of a centaur. The words *In illo tempore* that precede the opening words of Luke 1:26, *Missus est angelus Gabriel*, are a formula, meaning "At that time," which was commonly used to introduce Gospel readings (the phrase usually occurs at the beginning of all readings in a Gospel lectionary). In figure 13-7, St. Matthew is shown with his traditional angel, who supports his ink pot. Figure 13-8, drawn by the same artist who drew St. Luke in figure 13-6, includes a notable mistake. The artist has represented St. Mark accompanied by his symbol, the lion, and the evangelist's scroll correctly includes the opening word of Mark 16:14, *Recumbentibus*; but the inscription on the scroll begins with the identifier *Secundum Lucam* (partly covered by the lion's wing), in error for *Secundum Marcum*.

Some Books of Hours, instead of having a portrait of each evangelist preceding the passage from his Gospel, have a single illustration showing all four evangelists, which is placed at the beginning of the Gospel sequences (see fig. 13-9). Some Books of Hours include a fifth reading, St. John's account of Christ's Passion (John 18:1–19:42), from his arrest to his Crucifixion and entombment. This fifth reading, found occasionally in manuscripts, became a regular feature of printed Books of Hours in the sixteenth century; it is commonly illustrated with a miniature of the Crucifixion.

Two prayers addressed to the Virgin, known from their first words as *Obsecro te* (I beseech thee) and *O intemerata* (O spotless one), are found in numerous Books of Hours, commonly placed between the Gospel sequences and the Hours of the Virgin. Both are impassioned prayers that seek to secure the Virgin's intercession on behalf of the one praying. *Obsecro te* movingly commemorates the joys that Mary experienced in bringing Christ into the world and her sorrow at the Crucifixion; the prayer then petitions for her assistance in all that the devotee does and requests that she may reveal herself to the devotee at the moment of death. Because the early part of the prayer focuses on the Virgin's joys, it is normally illustrated with a picture of Mary holding the Christ child. However, in Newberry Library MS 50.5, a mid-fifteenth-century Book of Hours illuminated by the master of Sir John Fastolf, the focus is on the *Pietà*, with Mary holding the body of the dead Christ in her arms; in the background are scenes showing Christ proceeding to Golgotha and being nailed to the cross, while the rising sun symbolizes the Resurrection (fig. 13-10). The second prayer, *O intemerata*, invokes both the Virgin and St. John, the "disciple whom Jesus loved," who, with Mary, witnessed the Crucifixion. The prayer requests Mary and John to watch over the devotee throughout life and to intercede on his or her behalf before God, "because you can immediately obtain whatever you want from God." The prayer may be preceded by an illustration of the *Pietà*, as in the Prayerbook of Marguerite de Croy (see chap. 4, fig. 4-23).

The Hours of the Virgin, the heart of every Book of Hours, usually comes next. The purpose of the Hours of the Virgin was to provide a set of devotional texts that pious laypeople could recite to themselves in their homes. The name comes from the fact that prayers within the hours are addressed to Mary, the great mediator between man and God and intercessor on behalf of humanity; also, each hour began with the recitation of the Hail Mary (although the text of the Hail Mary was rarely written down in Books of Hours; users would know that they were expected to recite it). Each hour included a combination of versicles and responses, psalms, antiphons, hymns, canticles,

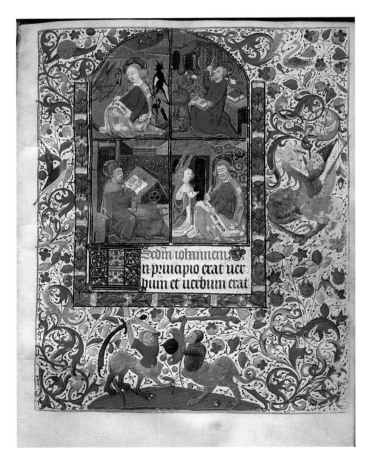

13-9 A single panel with all four evangelists and their symbols. Newberry Library, MS 43, fol. 13r.

Old Testament readings, and prayers. Many of these texts had originally been composed to be chanted by a choir; the user of the Book of Hours, however, would simply recite them. Each individual text would be preceded by its own brief rubric—*V* and *R* for a versicle and its response, *Ps* for a psalm, *Ant* for an antiphon, *Cap* (abbreviating *Capitulum*) for a reading, *Or* (*Oratio*) for a prayer, and so on. Matins, lauds, and vespers were the longest hours, while prime, terce, sext, and none, often called the "little hours," were the shortest and simplest, containing just a versicle and response, three psalms with antiphons, a reading followed by versicles and responses, and one or more prayers. Each hour was recited in exactly the same way on every day of the year, except that the choice of psalms for matins depended on the day of the week, with one set of three psalms being used on Sundays, Mondays, and Thursdays, another set of three on Tuesdays and Fridays, and a third set of three on Wednesdays and Saturdays. Also, some Books of Hours included slightly different texts for Advent (from the first Sunday in Advent until Christmas Eve) and for Christmastide (from Christmas Day until Candlemas, 2 February) than for the rest of the year (from 3 February until the day before Advent Sunday).

The section of a Book of Hours that contained the Hours of the Virgin was often embellished with a sequence of eight illustrations, one at the beginning of each hour. Most commonly, the illustrations depicted events in the Virgin's life surrounding the birth and childhood of Christ. A typical sequence would include the Annunciation, with the archangel Gabriel appearing before Mary to announce that the Savior would be born to her (matins; see fig. 13-11); the Visitation, Mary's visit to her cousin, St. Elizabeth, the mother-to-be of St. John the Baptist (lauds; see fig. 13-12); the Nativity of Christ (prime; see fig. 13-13); the Annunciation to the Shepherds, which offered the artist an opportunity to paint a rustic scene showing the angel appearing to the shepherds tending their flocks in a field (terce; see fig. 13-14); the Adoration of the Magi, with the Three Wise Men presenting their gifts to the newborn Christ (sext; see fig. 13-15); the Presentation in the Temple, with Simeon taking the Christ child into his arms (none; see fig. 13-16); the flight into Egypt, showing the Holy Family escaping from Herod's threats (vespers; see fig. 13-17); and the Coronation of the Virgin in heaven (compline; see fig. 13-18). While the Hours of the Virgin are very often illustrated with such a sequence focusing on Mary's life, some Books of Hours have a different sequence with illustrations of the events of Christ's Passion, from the agony in the Garden of Gethsemane to the entombment.

Many Books of Hours contain, in addition to the Hours of the Virgin, two shorter devotions known as the Hours of the Cross and the Hours of the Holy Spirit. These include no psalms and have no set of texts for lauds. For each of the other hours, there are two versicles and responses, a *Gloria*, an antiphon, a hymn followed by a versicle and response,

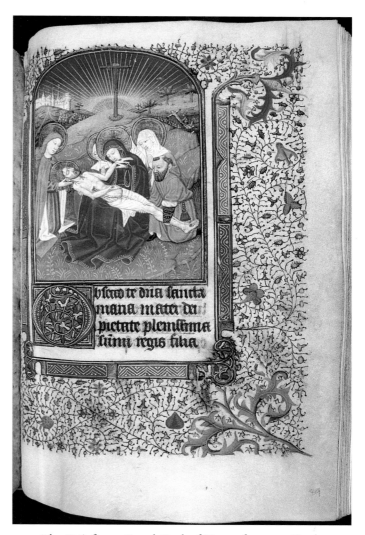

13-10 The *Pietà*, from a French Book of Hours of ca. 1450. Newberry Library, MS 50.5, fol. 89r.

and a prayer. The texts respectively focus on the Cross and the events of Christ's Passion and on the role of the Holy Spirit in the scheme of redemption. The Hours of the Cross typically begins with a depiction of the Crucifixion, while the Hours of the Holy Spirit is normally preceded by a Pentecost scene, showing the descent of the Holy Spirit in the form of a dove on the gathered apostles and Virgin (see figs. 13-19 and 13-20). When present, these two texts normally follow the Hours of the Virgin, but in some manuscripts they are integrated: matins and lauds of the Hours of the Virgin are followed by matins of the Cross and then by matins of the Holy Spirit, prime of the Hours of the Virgin by prime of the Cross and prime of the Holy Spirit, and so on. Time permitting, the owner of a Book of Hours containing these texts would include the Hours of the Cross and the Hours of the Holy Spirit along with the Hours of the Virgin in his or her daily devotion.

The hours are generally followed by two items found in nearly all Books of Hours: the Seven Penitential Psalms and the litany. The Penitential Psalms (nos. 6, 31, 37, 50, 101, 129,

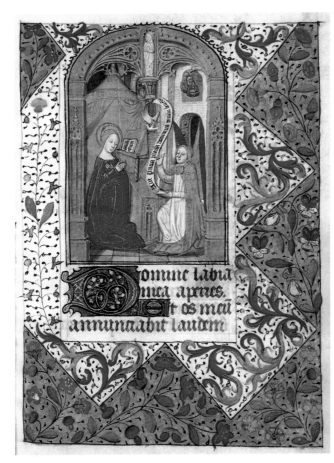

13–11

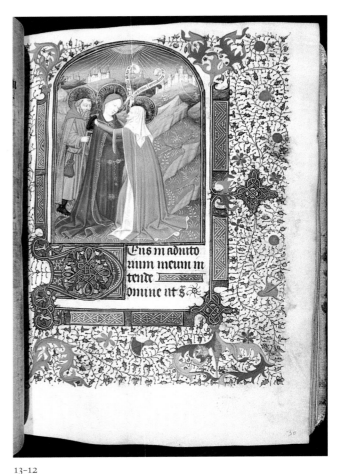

13–12

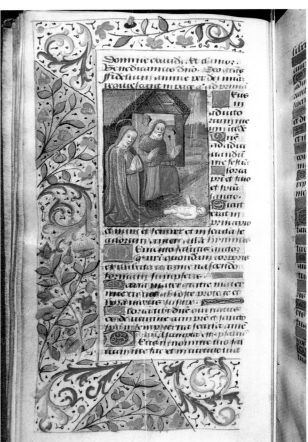

13–13

13–11 The Annunciation, illustrating matins of the Hours of the Virgin, from a French Book of Hours of ca. 1460. As in many Annunciation scenes, Mary is shown with a book before her, while the words that the archangel addresses to her are inscribed on a scroll. Newberry Library, MS 42, fol. 31r.

13–12 The Visitation, with Joseph standing behind Mary and Elizabeth, illustrating lauds. Newberry Library, MS 50.5, fol. 30r.

13–13 The Nativity, illustrating prime. Newberry Library, MS 50, fol. 22v.

13–14 The Annunciation to the Shepherds, illustrating terce. Note the elephant and the bird-man in the border. Newberry Library, MS 43, fol. 61r.

13–15 The Adoration of the Magi, illustrating sext. Newberry Library, MS 50.5, fol. 49r.

13–16 The Presentation in the Temple, illustrating none. Newberry Library, MS 50.5, fol. 52r.

13–17 The Flight into Egypt, illustrating vespers. Newberry Library, MS 50.5, fol. 55r.

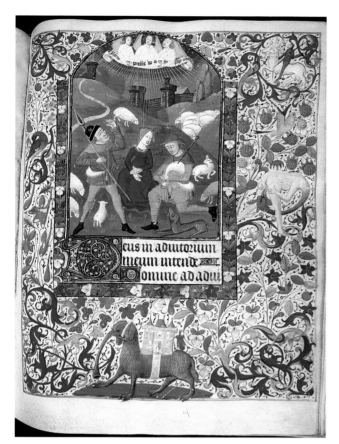

13–14

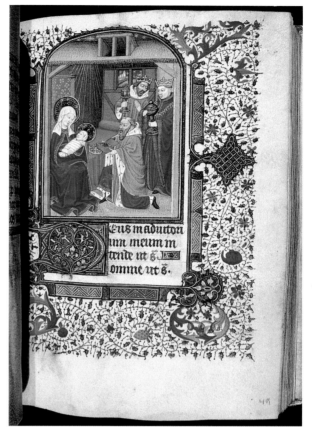

13–15

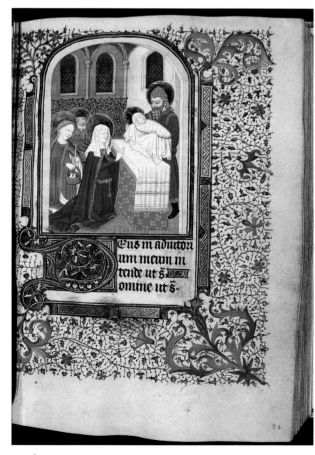

13–16

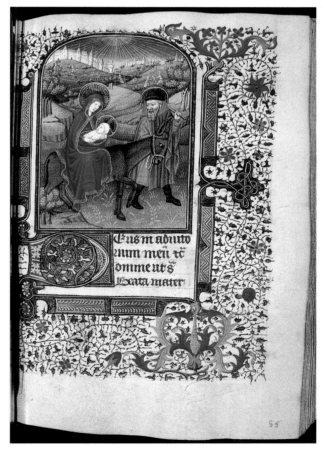

13–17

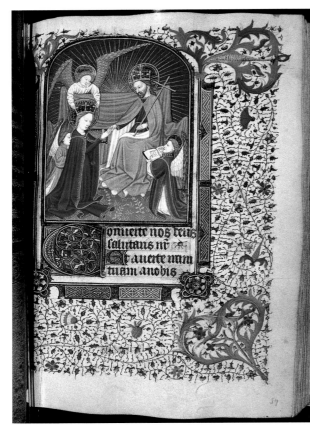

13-18

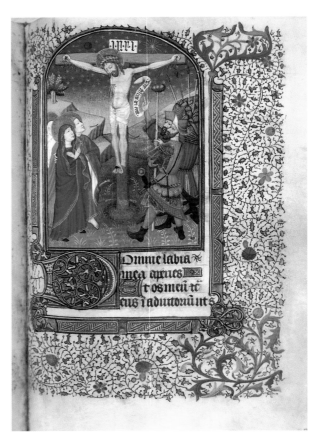

13-19

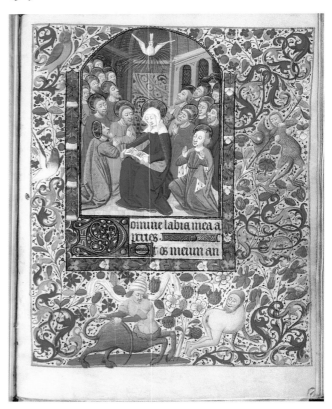

13-20

13-18 The Coronation of the Virgin, illustrating compline.
Newberry Library, MS 50.5, fol. 57r.

13-19 The Crucifixion, opening the Hours of the Cross.
On the scroll are the words of the centurion recorded in St.
Mark's Gospel, "Vere filius dei erat." Newberry Library, MS
50.5, fol. 83r.

13-20 Pentecost, illustrating the Hours of the Holy Spirit.
The dove of the Spirit descends on the Virgin and disciples,
with a ribald scene in the lower border. Newberry Library,
MS 43, fol. 108r.

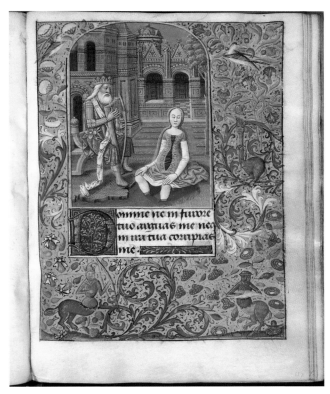

13-21 Bathsheba in her bath before King David, shown with his harp. Embroidered on Bathsheba's dress are words from the genealogy of Jesus in Matthew's Gospel: "David autem rex genuit Salomon." Newberry Library, MS 47, fol. 117r.

and 142 in the Vulgate numbering), which acknowledge guilt for sin and request God not to chastise but to have mercy, were held to be especially efficacious for obtaining forgiveness for sins. Because they were seven in number, they were often linked with the Seven Deadly Sins (pride, avarice, lust, envy, gluttony, anger, and sloth). During the Middle Ages, it was believed that King David was the author of all the Penitential Psalms and that he composed them as penance for his sins. These included his lust for Bathsheba when he spied her taking a bath, which led him to arrange the death of her husband, Uriah, by sending him into the front line of battle, where he was slain by the Ammonites (see 2 Samuel 11:2–12:14). In Books of Hours, the Penitential Psalms are therefore frequently illustrated with a scene showing David watching Bathsheba at her bath, as in Newberry Library MS 47, where David is given his traditional attributes, a crown and a harp (fig. 13-21). The litany that follows the Penitential Psalms is normally unillustrated. Beginning with a shortened form of the appeal for divine mercy that was recited at the opening of every mass — *Kyrie eleison, Christe eleison, Kyrie eleison* (Lord have mercy, Christ have mercy, Lord have mercy) — it then invoked Christ, God the Father, the Holy Spirit, and the Trinity before moving on to a long roll call of saints, with the petition *Ora pro nobis* or (when two or more saints were named together) *Orate pro nobis* following each invocation. The saints are listed in hierarchical order, beginning with

the Virgin Mary, continuing with the archangels, angels, and John the Baptist, before moving on to apostles, martyrs, confessors, and virgins. The list of saints is followed by a set of petitions requesting deliverance from a variety of earthly perils and praying for eternal life for the faithful departed. Figure 13-22, from Newberry Library MS 83, made for Anne of Brittany some time after her marriage in 1499 to King Louis XII of France, shows a typical double-page spread of a litany. The left page and the upper portion of the right page show the end of the list of saints, naming confessors and virgins; each saint's name is followed by the abbreviation *or* for *ora pro nobis* (in line 6 of the right-hand page, *ort* abbreviates the plural *orate*). Following two requests for the Lord's mercy — *Propitius esto. Parce nobis domine* (Be merciful: spare us, o Lord) and *Propitius esto. Exaudi nos domine* (Be merciful: hear us, o Lord) — the right page ends with entreaties for deliverance from all evils, from all sins, from the snares of the devil, and from eternal damnation. The abbreviation at the end of the last three lines stands for *libera nos domine* (deliver us, O Lord).

The Office of the Dead, one of the longest texts in Books of Hours, typically comes toward the end of the book and often follows the Penitential Psalms and litany. The Office includes texts for vespers, matins, and lauds. It has exactly the same form in Books of Hours as in breviaries, and it was prayed over a dead person's coffin, by monks hired specially for the purpose, on the evening before the funeral (vespers) and on the morning of the funeral (matins and lauds). It was believed that reciting the Office would help reduce the time that the soul of the departed would spend in Purgatory. Laypeople who had the text of the Office in their Books of Hours were encouraged to recite it on major feast

13-22 The litany, from Anne of Brittany's *Prayerbook*. Newberry Library, MS 83, fols. 15v–16r.

days and whenever else they could, to speed the entry of their dead family members into heaven. Vespers and lauds of the Office included psalms, antiphons, canticles, versicles and responses, and prayers; matins included psalms, antiphons, versicles and responses, and nine readings from the Book of Job. These readings speak of the righteous Job's desolation after he had been stripped of his prosperity and afflicted with illness; they express the powerlessness of the individual human before God while voicing the hope that the resurrected dead will behold the Lord. Matins began with the antiphon *Dirige domine deus meus in conspectu tua uiam meam* (O Lord my God, direct my steps in your sight); from the first word of this antiphon comes the term *dirge*, meaning a solemn song of mourning.

The Office of the Dead was normally prefaced with just one illustration, but the content of that illustration varied widely. Many Books of Hours focused on the events surrounding death and burial. Popular subjects for such illustrations included a depiction of the dying man or woman lying in bed and receiving the last rites from a priest, monks chanting over the dead person's coffin, the funeral Mass (see fig. 13-23), the struggle between the Archangel Michael and a demon for the soul of the departed (see fig. 13-24), and the interment of the corpse (see figs. 13-25 and

13-26). Other commonly occurring scenes are scriptural or allegorical and include the Last Judgment; the Parable of Dives and Lazarus, which related how the unjust rich man was condemned to hell while the righteous poor man entered heaven; the Raising of Lazarus by Jesus; and the Three Living and the Three Dead (see fig. 13-27), an allegorical scene in which three princes in the prime of life are reminded of their mortality when they come upon a graveyard and are confronted by three corpses rising from their tombs. In Newberry Library MS 50, made in France around the turn of the sixteenth century, the scene chosen to illustrate the Office of the Dead depicts the naked Job on his dung heap, addressed by his three comforters, Eliphaz the Temanite, Bildad the Shuhite, and Zophar the Naamathite (fig. 13-28).

The last section in a Book of Hours is often the set of texts known as the Suffrages of the Saints. These are short devotions that invoke individual saints and consist of an antiphon, a versicle and response, and a prayer that highlights one or more aspects of the saint's life and seeks the saint's intercession and help (*suffragium*) in obtaining some benefit from God. The number of suffrages included in a Book of Hours varies from six or seven to twenty or thirty, and in some outstanding cases rises to more than one hundred. The

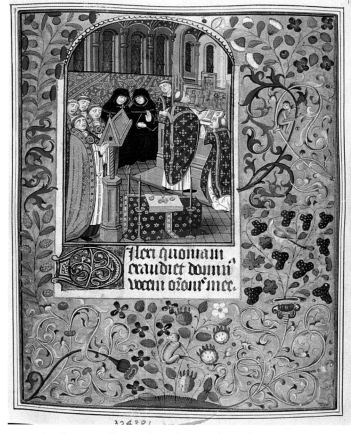

13-23 This fragment shows a funeral Mass taking place within a church, illustrating the Office of the Dead. The coffin is draped in fabric and surrounded by four candles. Newberry Library, MS 49, fol. 13r.

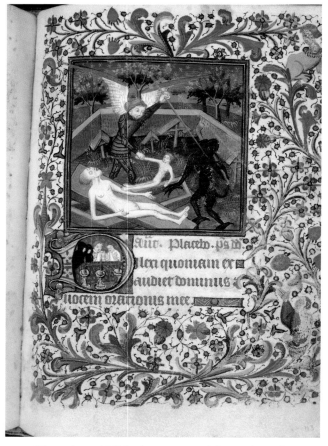

13-24 The archangel Michael rescues a soul from a demon's clutches. Wooden grave markers can be seen behind St. Michael. Newberry Library, MS 52, fol. 113r.

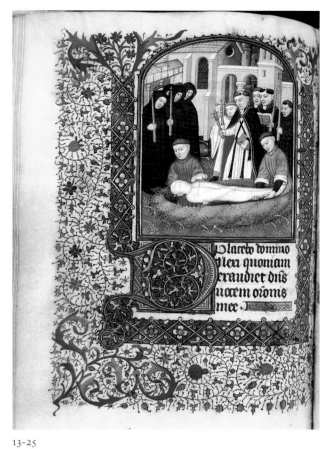

13-25

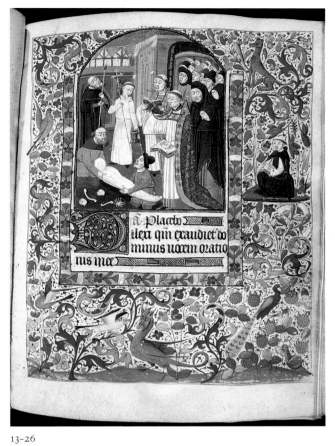

13-26

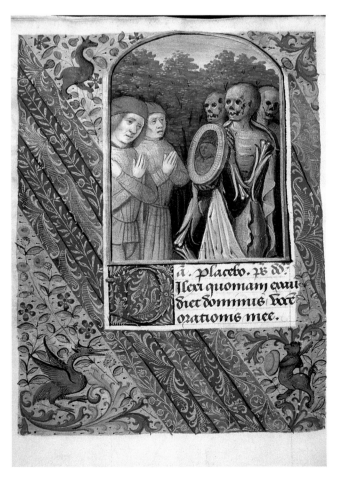

13-27

13-25 A body in a shroud, marked with a red Jerusalem cross, is placed in the earth. Monks carry tapers while the priest sprinkles the grave with holy water. Newberry Library, MS 50.5, fol. 96v.

13-26 A body in a shroud is laid in a previously used grave, as evidenced by the bones in the foreground. Newberry Library, MS 43, fol. 111r.

13-27 Two living men contemplate their reflections in a mirror held by three dead men in this illustration for the Office of the Dead. Newberry Library, MS 47, fol. 135v.

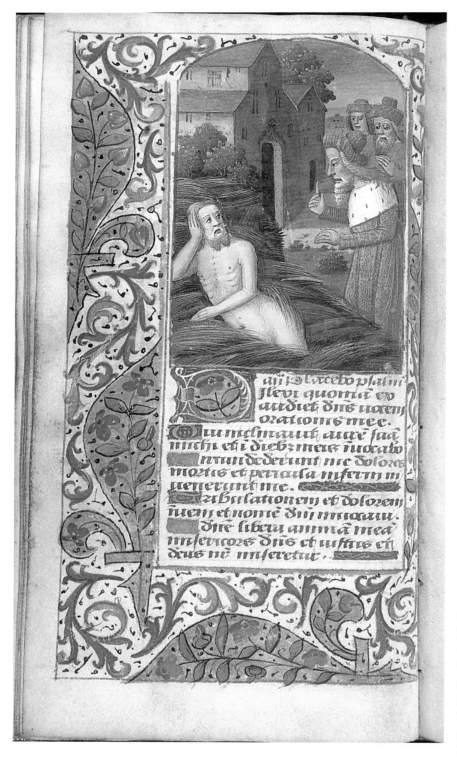

the stigmata, with Assisi in the background. Figure 13-30 shows the illustration preceding the suffrage for St. Margaret of Antioch in Newberry Library MS 35, made in Bruges ca. 1455 for English use (see p. 111 for the ownership of this manuscript). St. Margaret reportedly underwent the direst of tortures for refusing the amorous advances of Olybrius, governor of Antioch. She is said to have promised at the end of her life that those who read her story would receive an unfading crown in heaven, that those who invoked her on their deathbeds would be divinely protected from devils, and that pregnant women who prayed to her would escape the dangers of childbirth. With the power to bestow such benefits, she was an especially popular saint. The scene in the Newberry manuscript depicts one of the most notable episodes in her legend when, having been swallowed alive by a dragon, she miraculously burst forth again, alive and unharmed.

This chapter has described the essential texts that are to be found in all, or almost all, Books of Hours. But in a genre that proliferated so widely and that embodied the devotional aspirations of so many people across different ranks of society, it is not surprising that these core texts were often accompanied by a variety of accessory texts that could differ widely from one Book of Hours to another and that served to customize individual manuscripts to the wishes and tastes of their owners. The most common of these accessory texts (Gradual Psalms, Psalter of St. Jerome, Joys of the Virgin) have been mentioned above. Others included popular texts such as the Seven Requests to Our Lord, the Seven Prayers of Our Lord, and the *Stabat mater* (which me-

first suffrages were addressed to God or the three persons of the Trinity, the Virgin, the archangel Michael, and John the Baptist; the saints who followed were in hierarchical order, as in the litany. The Suffrages of the Saints are among the most richly decorated sections of Books of Hours, with each individual suffrage being preceded, in deluxe manuscripts, by an illustration depicting some episode from the particular saint's life. Figure 13-29, from a late-fifteenth-century French Book of Hours, shows St. Francis receiving

morializes the Virgin standing before the Cross in witness of the Crucifixion). Sometimes individual manuscripts included additional short hours such as the Hours of John the Baptist or the Hours of St. Catherine; sometimes there was a compendium of prayers that had special significance for particular owners. In their complexity and diversity, Books of Hours present a window onto the world of late medieval devotion, even as their illustrations afford a panoramic view of the richness of late medieval manuscript art.

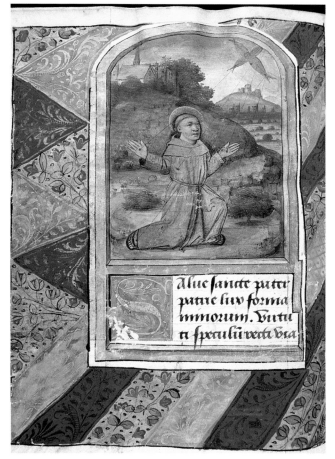

13-29 St. Francis receiving the stigmata, from a French Book of Hours most likely owned by a tertiary of the Franciscan order. Newberry Library, MS 47, fol. 192v.

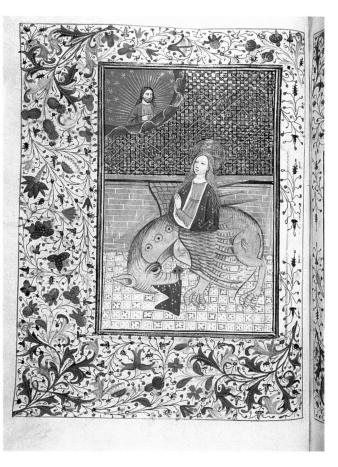

13-30 St. Margaret of Antioch, a popular saint for women in childbirth, emerging from the dragon's belly without injury. Newberry Library, MS 35, fol. 33v.

Charters and Cartularies

CHARTERS

The most voluminous records produced and preserved in the Middle Ages were charters. Although they had numerous functions, charters generally documented the transfer of property or rights from one individual or group to another. The transactions they recorded could be perpetual or limited in duration. Because of their importance, charters were also liable to be forged, and over time several methods were developed to protect these documents against forgery, although forgers were usually able to adapt to innovations designed to thwart them. The papal chancery, which may have been the earliest medieval institution to issue written documents, modeled itself on the Roman imperial chancery and was copied in turn by both episcopal and royal chanceries, although it always retained certain distinctive characteristics, which will be discussed below.

The study of charters is called diplomatics, from the word *diploma*, meaning literally a document "folded twice" that gave authority to the person who carried it. While most medieval diplomas were on parchment, ancient diplomas were made of almost any material, including papyrus, stone, and metal (see chap. 1, "Writing Supports"). Marc Bloch, in *The Historian's Craft*, calls diplomatics the cross-examination of documents to establish their authenticity and determine their meaning.[1] A useful survey and standardization of terms can be found in Leonard Boyle's chapter on "Diplomatics" in James Powell's *Medieval Studies: An Introduction.*[2] The science of diplomatics requires a great deal of advanced study, both archival and in secondary literature; what follows is a brief introduction to orient the reader and provide impetus for further work.

The modern study of diplomatics began with the French Benedictine Jean Mabillon (1632–1707), who, in his *De re diplomatica* (1681), sought to determine the authenticity of the Merovingian charters in the archive of the abbey of Saint-Denis in Paris. Mabillon found that many of these charters were fakes of one sort or another, and he substantiated his claims by providing a detailed analysis of the script, dating, standard forms of address, and other factors. These criteria have continued to be used by historians to validate or invalidate the charters under study up to the present. As the science of diplomatics has evolved, more has become known about various chancery practices and the task of authentication has become somewhat easier. Although charters vary according to region and period, there are certain basic characteristics that are present in most charters. It is imperative for the researcher to determine local practices at the time the charter was produced or copied in order to interpret properly the evidence at hand. The charter should be in the possession of the receiver; if it is in the hands of the sender, it may have been a draft or a canceled charter. The form of the charter is very simple. It is usually a single piece of parchment; charters that were to receive a seal usually have a fold at the bottom (called a *plica*) through which the cords or parchment tag were inserted to attach the seal (see figs. 10-10 and 14-2).

Scripts

Most scribes had a special script reserved for charters. While most chanceries modeled themselves on some other court, either papal or imperial, there were distinct variations in style depending on which court was being imitated and when. Because chancery scripts were stereotypical, it can be difficult to distinguish the work of individual scribes by examining the script. Luckily, the scribe is sometimes named in the documents, as will be discussed below.

Form

Most often in the form of a letter, addressed either to specific individuals or to posterity, the charter usually has three distinct sections: the protocol, in which the parties are named and greeted; the corpus or text, which conveys the purpose of the charter and includes prohibitions and punishments; and the eschatocol (sometimes called the final protocol), which includes the names of those present at the issuing of the grant, the date, and a formulaic ending. These three can be broken down into the following:

1. Marc Bloch, *The Historian's Craft* (New York, 1953), 64 and chap. 3.

2. Leonard E. Boyle, "Diplomatics," in *Medieval Studies: An Introduction*, ed. James M. Powell, 2nd ed. (Syracuse, 1992), 82–113.

INITIAL PROTOCOL

Invocatio: invocation of the Deity, either by a symbolic chrismon or cross, or in words

Intitulatio: name of individual issuing charter

Inscriptio: name of individual(s) to whom charter is addressed

Salutatio: greeting

TEXT

Narratio: background of the case

Dispositio: what is enacted by charter

Final clauses

FINAL PROTOCOL OR ESCHATOCOL

Subscriptio: names of principal(s), witnesses, and officials

Datum: date clause, stating when, where, and by whom charter was written

Finally, there would be marks of authentication, designed to convey the authority of the individual or institution that granted the charter and to guarantee its genuineness. These included subscriptions, signatures, and seals, which are discussed in more detail below.

Dates and Chronology

Because there were many different ways of dating charters, because there were various practices for determining when one year ended and the next began, and because some charters before the thirteenth century were undated, establishing an accurate date for a charter can be one of the more difficult tasks facing the medievalist. Above all, the researcher needs to determine what the practice was at the time and in the institution that produced the charter before making final judgments on the date as found. Many charters use multiple dating systems or no dating system at all (it was not the universal practice to date private charters in England until the late thirteenth century), so a familiarity with common practices is vital. In fact, one of the ways to detect fraud is to note the use of a dating system not practiced by the chancery that purportedly produced the charter. However, there are some authentic charters that exhibit two or more dating systems (such as the year of grace and the regnal year) that are inconsistent with one another, because sometimes individuals and institutions would make mistakes or not know the correct regnal year. Discrepancies between dating systems are not, in and of themselves, evidence of fraud. The following are some of the basic methods of dating found in charters; the bibliography at the end of this book lists further sources of information on this topic.

The Julian Calendar

The Julian calendar, named after its initiator, Julius Caesar, was used throughout the Middle Ages, from its introduction in 45 BC until its reform in 1582. Julius divided the year into 365 days based on the solar cycle, with every fourth year a leap year (called *annus bissextilis*) in which a day was added after February 23 (called the *dies bissextus*; see the discussion of the calendar in chapter 12). Unfortunately, the leap year was at first misunderstood and was celebrated every third year with the result that the calendar quickly became inaccurate. In 8 BC, the Emperor Augustus decreed a period of twelve successive years in which there would be no leap year in order to make up for the disparity; after that time, the leap year was regularly observed every fourth year.

The Julian calendar as revised by Augustus divided the year into twelve months and each of the twelve months into days based on a system of three reference points in each month known as the kalends, nones, and ides. The system is described in detail in chapter 12, with a table showing the modern equivalents for each day in the Julian calendar. The Church brought about widespread acceptance of the cycle of weeks of seven days, with primacy given to Sunday, to replace the pre-Christian days of the week named after gods and celestial phenomena. The Church also introduced numerous feast days into the calendar, some movable (including Easter and the feasts dependent on Easter such as Good Friday, Ascension Day, etc.) and some fixed to the Julian calendar (saints' days, Christmas, etc.). Tables to determine when Easter fell or will fall in a given year can be found in any chronology such as Cheney's *A Handbook of Dates*, Grotefend's *Taschenbuch der Zeitrechnung*, or Cappelli's *Cronologia e calendario perpetuo*; see also chapter 12 and figure 12-3.

The Julian calendar was not entirely accurate, and by the sixteenth century it had accumulated ten additional days (that is, the calendar year diverged from the true solar year by a total of ten days). Pope Gregory XIII issued a bull in 1582 eliminating those ten days and instituting new, more accurate leap years to avoid future accumulations. Because of the fragmented state of Europe after the Reformation, however, only Catholic countries switched to the Gregorian system in the sixteenth century. Most Protestant countries switched in the eighteenth century and eastern European states in the twentieth. In England, the change was made in 1751 as a result of legislation introduced by Lord Chesterfield. A historian working with a document dated after 1582 must determine whether the document was dated using the Gregorian or Julian calendar in order to make sense of it.

Regnal Years

The earliest dating system for our period was by the year of the ruler. It is therefore necessary to know precisely the regnal year of the different rulers and whether reckoning began from the day of the death of the predecessor or the coronation of the succeeding monarch—or, in the case of popes and prelates, their election or consecration. Another twist was that in England, the exchequer year began at Michaelmas (29 September). Thus if a king ascended the

throne before that date, the period until Michaelmas would be the first regnal year, regardless of its actual length, even though, after Edward I, the kings themselves usually began computation of their regnal years immediately on the death of their predecessors. Cappelli's *Cronologia* contains much of the basic regnal information for larger territories; John Baldwin's *The Government of Philip Augustus* deals with the *mos gallicanus* (see below).[3] For the early Middle Ages, the exact regnal years of some kings are speculative, based on fragmentary evidence and the chance survival of records. Similarly, abbots, bishops, and popes would often date according to their year in office.

The Indiction

The indiction is a number assigned to each year that repeats in a fifteen-year cycle. Originally a Roman civil reckoning used for tax purposes, the indiction cycle began in the year AD 312. There were, however, various methods of determining the start of the year. The Greek system (also called the Constantinopolitan system) began on 1 September. This system was used in the West by the papacy until 1087, after which it varied between 1 September and 25 December, the Roman or pontifical indiction. Some popes started the indiction on 1 January, so the practice of each pope should be studied before coming to a conclusion. A third system, called the Bedan, Caesarean, or imperial indiction started the year on 24 September. This was the system introduced by Bede, used regularly in England, and adopted by Pope Alexander III (1159–81). Chanceries used the indiction up until the thirteenth century, when it fell out of general use; the papal chancery, indeed, continued to use it into modern times. To determine the indiction, take the year AD, subtract 312, and divide by 15. The remainder is the indictional year (a number between 1 and 15). Care should be used to determine when the year starts and ends because this formula gives the indiction for the *greater* part of the year. The lesser part of the year is one year higher. Thus, for example, to determine the indiction for the year 1279 assuming the Roman or pontifical system (25 December as the first of the year), one subtracts 312 from 1279. Dividing the resulting sum 967 by 15 yields 64 with a remainder of 7, so for the *greater* part of the year the indiction is 7 (before 25 December), and for the *lesser* it is 8 (after 25 December).

The Christian Era

Dating by reference to the Christian era, often called the year of the lord (*annus domini*), the year of grace (*annus gratiae*), or the year from the incarnation (*annus ab incarnatione domini*), did not come into widespread use until relatively late. Begun by the monk Dionysius Exiguus in 525, the use of the year of grace came into acceptance first in England,

where Bede adopted it in the eighth century. From there, the practice spread to the Continent and was used in every Western European country with the exception of Spain and its satellite areas by the high Middle Ages. In Spain (apart from Catalonia) and areas under its influence (Portugal and southwestern France), the era began not in 1 AD but in 38 BC, a year they took from Roman Spanish Christians and that originated with an Easter table whose first cycle began in 38 BC. The Spanish era was used until 1180 in Catalonia, 1350 in Aragon, 1358 in Valencia, 1382 in Castile, and 1420 in Portugal, and the dating formulas began with the word *era* rather than with *anno* (for example, *era millesima secunda* rather than *anno millesimo secundo*). To convert from the Spanish era to the Christian, simply subtract 38 from the date. Because Christians begin with the year 1 (there is no 0), centuries begin not when the year reaches –00, but when it reaches –01, although this was a matter of confusion as much in the Middle Ages as it is in our own day. The greatest difficulty with determining dates in the Christian era results from the various possible start dates of the new year.

> 1 January: The modern system of starting the new year on 1 January was also the ancient Roman civil system and was widely in use in the early centuries after the fall of Rome. However, the Church wished to see its own festival marking the new year, so 1 January fell out of favor, although it continued to see sporadic use in the Middle Ages.
>
> 25 December: Starting the year with the feast of the birth of Jesus became the common usage in medieval Europe through the twelfth century. This was also the date preferred by most Benedictines, as can be seen in many of their chronicles.
>
> 25 March: The Annunciation—which marked the beginning of Christ's Incarnation—was another popular starting date, first used in the ninth century. There were, however, two variant systems of dating from the Annunciation. One system, adopted at Arles in the late ninth century and spreading from there to Burgundy and northern Italy, reckoned year 1 as beginning on 25 March *preceding* Christ's Nativity. This system was used by the papacy from 1088 to 1145; it survived at Pisa until 1750, which is why the system is sometimes called the *calculus Pisanus*.[4] The other system reckoned year 1 as beginning on 25 March *following* Christ's Nativity. This style was in use at Fleury by 1030 and spread under Fleury's influence. It was adopted by the Cistercians, was used by the papal chancery from 1098 in some types of documents, and was employed at Florence out of a sense of rivalry with

3. John Baldwin, *The Government of Philip Augustus: Foundations of French Royal Power in the Middle Ages* (Berkeley, 1986).

4. For the complexities of this system, see Charles Higounet, "Le style pisan: Son emploi, sa diffusion géographique," *Le Moyen Âge* 68 (1952): 31–42.

Pisa; it is often called the *calculus Florentinus*. Found in England as early as the middle of the eleventh century, it became common there in the late twelfth century and continued until 1752.

Easter Day: Starting the year at Easter (a movable feast whose date depends on the lunar rather than the solar calendar) was introduced by Philip Augustus, king of France (1180–1223) and is called the Gallican custom, or *mos gallicanus*. It was never widely accepted except in regions with ties to Philip. One needs to use an Easter table to determine the date for Easter in each year.

1 or 24 September: These dates were primarily used in early English dating, as noted above for the indictional year.

Papal year: It was customary to give the year of the pope's tenure in all documents issuing from the papal chancery. One must note whether the year was begun on the day of the pope's election or on that of his enthronement; the latter has been the practice from Innocent III (1198) to the present (see below for more information on the papal year). Bishops and abbots also tended to date their charters with their year of office. Researchers should consult one of the many ecclesiastical biographical dictionaries to determine the years of an abbot's or bishop's tenure. One should use great caution, however, in the case of figures about whom little is known or who had a short tenure, for such information is often open to question. Equally problematic is the fact that individuals who share a surname are rarely distinguished by sequential numbering or by family or place of origin.

Authentication

While the various dating systems can help historians verify charters, the issuers of the charters themselves often developed or adopted complex methods to ensure that only the documents they actually produced carried their name and authority. The most popular means of authentication were subscriptions, signatures, seals, and the chirograph format.

Subscriptions

These are not signatures in the modern sense but symbols and marks that represent the individual in whose name the charter was written or authenticated or the names of those who witnessed the writing of the charter. Jerusalem crosses, the letter *E* for *Ego*, and the letters *SS* (often with a line through them, standing for *subscripsi*) were common subscriptions. The signs or letters in a subscription may or may not have been made by the hand of the individual whose sign is on the document. Cardinals' subscriptions were autograph, but the pope usually only made the *E* for *Ego* and the small cross within the *rota* (see below).

Autograph Signatures

By the end of the fourteenth century in most European chanceries, the autograph signature of the monarch was in use. For certain documents, the grantor would sign his or her name, often in a unique style to avoid unauthorized use. There were obvious limitations to this system, however, because it required the issuer to be present at the granting of every charter, a practical impossibility in most royal courts when the king was away from the court for much of the time and when there were numerous charters that went out bearing his name. Seals enabled charters to be issued with the king's authority but without his physical presence.

Seals

Because they were less easily forged, seals gradually replaced subscriptions, although many documents contain both seals and subscriptions. A seal is an image made on wax or some other impressionable material affixed either directly to the document or to threads or tags attached to the document. (A document that could be read without breaking the seal was called *breve patens*, or open letter; a *breve clausum*, or closed letter, had a seal or string that had to be broken to examine the contents.) The die or matrix (the terms are interchangeable) used to make the impression was often made of silver, lead, copper alloy, or another precious metal; rarely, seals (particularly signets) were engraved in ivory, soapstone, or precious or semiprecious gems. There was a great variety of sizes and types of seals; some seals had removable centers so that the image without the legend could be used; others had multiple matrices, requiring successive stamping to build up a complex image on the wax. Single seals could be applied by hand, but double seals (those with two sides) required the use of a sealpress that aligned the two sides of the seal and provided enough pressure to create the designed relief. Seals were originally restricted to popes, emperors, and kings, but by the thirteenth century lesser knights had them, and by the fifteenth century even common people owned and used them. To economize on the wax for certain routine documents, the charter would be sealed with a *pes sigilli* (foot of the seal). The name is a slight misnomer because it was often the top of the seal that was used to make the impression.[5]

Images found on seals can be used to determine the class of the individual granting the charter. For royal seals, the ruler seated on the throne and holding the symbols of majesty was usually represented on the obverse (the front of a double-sided seal) while the reverse side often depicted an armorial device or the king mounted on his steed. Kings also had various seals for different transactions, from the

5. See P. D. A. Harvey and Andrew McGuinness, *A Guide to British Medieval Seals* (Toronto, 1996), 33.

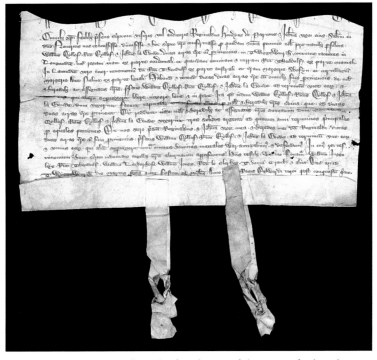

14-1 A chirograph dating from the fourth year of the reign of Edward III (1327–77). Collection of David and Sharon MacDonald, MS 1.

great seal for matters pertaining to the kingdom to signet rings for private affairs. The knightly class was often represented by a knight on horseback or the family coat of arms. Aristocratic women were often shown standing. Bishops' seals depict the bishop in full regalia, either standing with a crosier and making the sign of blessing or kneeling in supplication. Toward the end of the Middle Ages, bishops were also represented in their cathedrals, often with great architectural detail. Corporate bodies (such as universities, guilds, monasteries, towns, etc.) could also have seals. Double seals might indicate multiple titles (king on one side, duke on the other). Around the outside edge of the seal beginning at the top was the legend, which indicated whose seal it was. These seals became more detailed and larger in size as time went on.

The signet was a private seal used in personal or private communications. The images on these rings might be secular (fleur-de-lis, animals, initials, etc.) or religious (Virgin Mary, *Agnus Dei*, crosses, etc.) and tended to be very small compared with the larger seals used by the aristocracy and the Church. Despite or perhaps because of their large numbers, signet rings are difficult to study because they tend to lack unique information that would enable the historian to identify their users.

The color of the wax used for a seal was sometimes significant because it could indicate the nature of the document sealed. In English royal chanceries, green was used for perpetual grants, which were sealed on silk threads; white was used for temporary grants, which were sealed on parchment tags; and red was used with privy seals and with signets for private correspondence, although this was not a rigid practice, and numerous exceptions exist.[6] The wax itself was beeswax, sometimes mixed with hair or surrounded by straw to strengthen and protect it. Green wax appears to have been made by mixing beeswax with verdigris, red wax by mixing with vermilion. Different colors of wax could be mixed to give various effects. Medieval seals were often varnished to protect them. When the varnish breaks down, it may appear as dark reddish flakes on the seal; with the varnish intact, seals appear darker than the original color of the wax.

There were various methods of attaching the seal to the document. The seal could be applied directly to the document, or it could be appended by using parchment tags or cords. An early method was to cut a strip (called a tongue) from the charter, leaving it attached to the charter at one end, and attach the seal directly to that. Often a smaller strip called a tie was cut from the same parchment and was used to close the document. Another method of sealing was to attach to the document one or more separate strips of parchment called tags (see fig. 14-1). Each tag was threaded through a horizontal slit made in the *plica*. A vertical cut would be made in the tag and one end would be threaded through the cut. The wax seal would then be applied to the tag; the wax filled the knotted surface, making it impossible to remove the tag without cutting it or breaking the seal. Figure 14-1, a chirograph with two tags that is missing its seals, illustrates the way in which the tags were tied. Finally, seals could be attached by cords. Figure 14-2 shows a hemp thread with a seal intact. Paper might be used to ensure the seal did not stick to the matrix and served the added benefit of protecting the seal (see figs. 14-3 and 14-4). Newberry Library MS 145, no. 5 (fig. 14-4) is an unusual charter in that few charters were illuminated. In this case, the initial letter has been brilliantly executed with a crowned blue snake spewing forth a red infant.[7] This was the emblem of the Sforza (who inherited the device from the Visconti in 1447); this charter was issued by Francesco Sforza, Duke of Milan (1450–66). Although the charter is

6. These observations are made by Chaplais and repeated by Harvey in reference to the English practice. See Pierre Chaplais, *English Royal Documents: King John–Henry VI, 1199–1461* (Oxford, 1971), 15, and Harvey and McGuinness, *Guide to British Medieval Seals*, 17.

7. Alciati's *Emblematum Liber* of 1541 in its dedication to Maximiliano, duke of Milan, explicates the device: "Super insigni Ducatus Mediolanensis/Ad illustrissimum Maximilianum, Ducem Mediolanensem/Exiliens infans sinuosi e faucibus anguis/Est gentilitiis nobile stemma tuis. . . ."

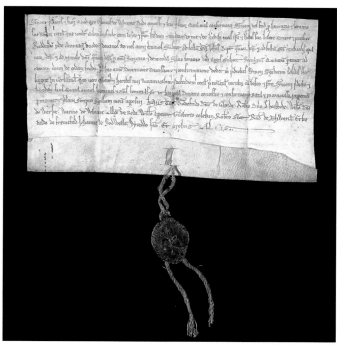

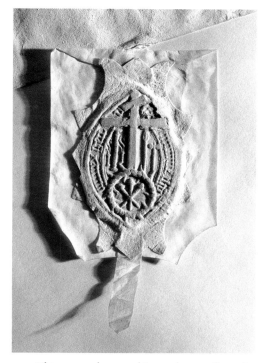

14-2 A charter of Osbert of Woburn granting Simon del Frid the land called Colemanesrede for sixteen shillings, in exchange for homage and service and an annual rent of twelve pence to be paid on three dates in the year. Ca. 1200. Collection of David and Sharon MacDonald, MS 2.

14-3 This wax seal covered in parchment, from the monastery of San Gerónimo de la Murta, shows the instruments of Christ's Passion. Barcelona, 1453. Newberry Library, MS 106, no. 2.

14-4 Charter granting privileges issued by Francesco Sforza, duke of Milan, 7 September 1452. The signature on the lower right belongs to Bartholomaeus Chalcus, senior grammarian of the duchy. Newberry Library, MS 145, no. 5.

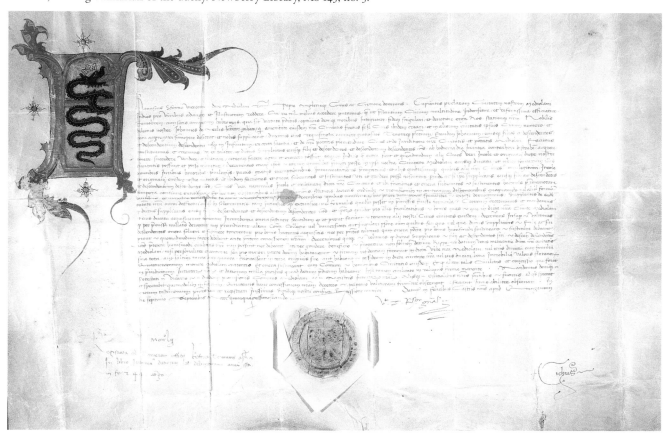

14-5 A fifteenth-century apostolic notarial signature with typical "keys" iconography. Newberry Library, MS 106, no. 5.

14-6 Notarial signatures on a privilege issued by Filippo Maria Visconti in Milan, 12 April 1432. Newberry Library, MS 145, no. 3.

14-7 A notarial copy made in 1404 of a bull issued in 1374 by Gregory XI. Note how both notaries have incorporated their marks into the word *signum*. Newberry Library, MS 106, no. 18.

on parchment, paper has been used to protect the wax at the time of sealing and remains affixed to it.

Registration

Before a document was issued to its recipient, it was commonly copied into a register so that a record could be kept by the issuing authority. For important acts of state, the royal or papal chancery would maintain its own register of its charters. For smaller matters, such as rentals or business or marriage contracts, the notary acting as the agent of an institution would preserve the agreements in notarial registers. There was a charge for registration, and in some cases the fact that it had been registered was noted on the document itself. Often the notation explicitly described the registration, but registration might also be represented by a simple notation of receipt (perhaps specifying just the amount paid to register the document) or a symbol of some sort. The notation on Newberry Library MS 145, no. 5 indicates where it was registered and identifies both the volume and the folio number within the volume in which it was registered (see fig. 14-4).

Notarial Signs

Notaries were a creation of the Roman world, and their employment in the Middle Ages was spread through contact with Italian or papal chancery practice. Pope Alexander III, in a letter of the late 1160s to Bishop Roger of Worcester, wrote: "Original documents, if the witnesses mentioned in them have died, do not seem to us to have any validity, unless perchance they were made by a public [i.e., a notary public's] hand, so that they may be seen to be public, or unless they have an authentic seal by means of which they can be proven."[8] Notarial signs incorporated elaborate designs, often based on a cross motif and incorporating the letters of the scribe's name. These marks always occur in the eschatocol. In some areas, particularly those most influenced by Roman practice through Justinian's *Code* and *Digest*, notaries public were required to authenticate public acts. In most of Europe, however, earlier customs prevailed, and while notaries could be used for such purposes, they were not required. In England, for example, the use of seals was relied upon more than the employment of notaries.

Notaries had their authority from a government or an institution. Most common were imperial, royal, and papal notaries. Within these parameters, notaries can be further defined as those permanently employed by a governing power and those who were merely authorized by the governing power. Notaries authorized by the papacy often incorporated the keys of St. Peter into their sign, as is the case in Newberry Library MS 106, no. 5 (see fig. 14-5). In

Newberry Library MS 145, no. 3 (see fig. 14-6), a privilege issued by Filippo Maria Visconti in 1432, we find the marks of two imperial notaries, Johannes Franciscus Galvia, who wrote the charter, and Petrus Aluisius of St. Peter, who corroborated it. Royal notaries played the same role as imperial notaries; in figure 14-7 we see two notaries with radically different scripts confirming that the charter is an authentic copy of the original. Notaries often transcribed all or part of the acts they notarized into registers that are an invaluable resource because in the case of most minor and temporary transactions, the charters themselves no longer exist.

Chirographs

From roughly the ninth century on, chirographs were used (principally in England) as a means of documenting an agreement between two—or occasionally more—parties, with each party retaining a copy of the agreement. The text would be written on a single membrane of parchment as many times as there were parties to the transaction. The recording scribe would then enter the word *chirographum* or *indentura*, or an appropriate phrase, or a decorative pattern, between each copy of the text. The membrane was cut so that each occurrence of the word, phrase, or pattern was dissected; documents with a straight cut were "polled," those with a jagged cut "indented" (the term derives from Latin *dens*, a tooth, because the jagged cut was toothlike in appearance). One copy would be given to each party and the document could be verified by bringing the copies together. A large number of chirographs survive, but in most cases no more than one of the original copies has come down to us (see fig. 14-1 for a fourteenth-century example).

Canceled Charters/Drafts/Notarial Copies

Occasionally, charters canceled because they were no longer in force, or because a mistake had been made in them, would be kept in an archive. Usually the seal has been removed, and sometimes slits were made in the parchment. These slits should not be confused with the slits made to affix the seals with parchment tags; the slits on canceled charters will appear on the face, often over the text, while slits for tags will normally occur in the *plica* and will not overlap text. Drafts of charters can normally be determined by the appearance of interlinear additions, erasures, and the lack of marks of authentication. If a charter has corrections, they will often be mentioned in the text and the marks of authentication will be present. Usually, however, if a charter contained mistakes, it would be destroyed at the time of production and an accurate version would be produced in its place. A notarial copy, on the other hand, might be produced because the original charter was deteriorating or if several parties needed a true copy of the charter in their possession. The notary indicated his role in the eschatocol, informing the reader both of his authority

8. Latin text quoted in C. R. Cheney, *Notaries Public in England in the Thirteenth and Fourteenth Centuries* (Oxford, 1972), 5–6. This passage was later incorporated into the *Decretals* of Pope Gregory IX (1227–41), also known as the *Liber extra*.

and that he had copied the charter from the original, which he had seen with his own eyes. Notarial copies usually describe the marks of authentication (subscription, seal, etc.), but practices varied widely.

PAPAL BULLS

The practices of the papal chancery must be discussed separately. The papal chancery was the longest continuing governmental organization in the Middle Ages, and both secular and ecclesiastical chanceries imitated some of its practices. Because papal charters were extremely valuable, often guaranteeing rights in perpetuity to ecclesiastical institutions and individuals, a large number survive to the present in their original form. Aside from a small fragment of a bull issued by Hadrian I in 781, the earliest surviving papal charter is a grant made to the church of Ravenna by Pope Paschal I on 11 July 819. Both of these documents were written on papyrus, which continued to be used by the papacy long after its disappearance from the rest of Europe: the latest surviving papyrus bull dates from 1057, during the pontificate of Victor II, after which the papacy switched to parchment.[9] Historians divide the history of the papal chancery into four periods. The first—now attested only by copies or abstracts of original documents—begins with the earliest popes and ends with Hadrian I. The second begins in 781, the tenth year of Hadrian's pontificate, from which time papal documents were no longer dated by the regnal year of the Eastern emperor. The third period begins with Leo IX in 1049 and is marked by distinct changes in the form of papal letters and specifically by the employment of unique signs of authentication to distinguish between great bulls (or privileges) and letters. The fourth period begins with Innocent III in 1198 and ends with the election of Martin V in 1417; this was a time of little change in the form of letters and a massive growth in letter production.

In addition to distinctive authenticating practices, papal letters had a unique Latin cadence that made them identifiable even if all that existed was a copy of the original letter in a cartulary. This sentence structure, called the *cursus curiae Romanae*, governed the rhythmic proportion and cadence of each sentence or period within a sentence. Like most medieval prosody, the rhythm was based on accent, not on quantity as in classical texts.[10] This practice was sometimes taken over by secular chanceries.

Papal letters are called bulls after the lead seals known as *bullae* that hung from silk threads or hemp strings attached to the letter. Because the opening lines of every bull are formulaic, bulls are distinguished in modern study by using the first two or three words of the first sentence following the address. For example, Boniface VIII's famous bull championing the rights of the Church over those of secular rulers (specifically, Philip the Fair of France) is called *Unam Sanctam* after the first words following the address. Philipp Jaffé and those who continued his work attempted to catalogue every bull written from the inception of the Roman Church to 1198 and assigned each bull a unique number.[11] These numbers are often used in citations. In such citations, the abbreviation JK (for Jaffé-Kaltenbrunner) accompanies the catalogue numbers covering the period up to 590, JE (for Jaffé-Ewald) is used for the years 590–882, and JL (for Jaffé-Loewenfeld) represents the years 883–1198. August Potthast composed a similar register for the period from 1198 to 1304, and those bulls are similarly identified with the name "Potthast" and then the number assigned to a given bull.[12] These catalogues contain a tremendous number of bulls but are by no means complete, so the researcher will almost certainly come upon authentic materials that have not been included. In 1896, Paul Fridolin Kehr proposed the publication of all papal documents in European archives. In 1931 a trust, the *Pius-Stiftung für Papsturkunden*, was established to support the project. The volumes are organized geographically, and at present there are several volumes for Western European areas. The project is ongoing, with editors currently working on areas of Europe and the world not already covered.[13]

The papal chancery reached its apogee in the thirteenth century under the administrator-pope Innocent III (1198–1216). According to Léopold Delisle, papal charters went through four stages of production under Innocent, each handled by a separate office in the papal chancery.[14] The

9. On the use of papyrus in the papal chancery and the transition to parchment, see Harry Bresslau, "Papyrus und Pergament in der päpstlichen Kanzlei bis zur Mitte des 11. Jahrhunderts: Ein Beitrag zur Lehre von den älteren Papsturkunden," *Mittheilungen des Instituts für Österreichische Geschichtsforschung* 9 (1888): 1–30.

10. See Noël Valois, "Étude sur le rythme des bulles pontificales," *Bibliothèque de l'École des Chartes* 42 (1881): 161–98, 257–72.

11. Philipp Jaffé, *Regesta pontificum romanorum ab condita ecclesia ad annum post Christum natum MCXCVIII*, 2nd ed., corrected and supplemented by Samuel Loewenfeld, Ferdinand Kaltenbrunner, and Paul Ewald, 2 vols. (Leipzig, 1885–88; repr., Graz, Aus., 1956).

12. August Potthast, *Regesta pontificum romanorum inde ab a. post Christum natum MCXCVIII ad a. MCCCIV*, 2 vols. (Berlin, 1874–75; repr., Graz, Aus., 1957).

13. For more information on the Papsturkunden project, see Paul Fridolin Kehr, "Über den Plan einer kritischen Ausgabe der Papsturkunden bis Innocenz III," *Mitteilungen der königlichen Gesellschaft der Wissenschaften zu Göttingen* (1896): 1–15, and Paul Fridolin Kehr, "Über die Sammlung und Herausgabe der älteren Papsturkunden bis Innocenz III," *Sonderausgabe aus den Sitzungsberichte der Prüssischen Akademie der Wissenschaften* (Berlin, 1934), 71–92. See also Thomas Frenz, *Papsturkunden des Mittelalters und der Neuzeit* (Stuttgart, 1986).

14. Léopold Delisle, *Mémoire sur les actes d'Innocent III, suivi de l'itinéraire de ce pontife* (Paris, 1857).

first stage was the initial redaction of the charter by the abbreviators who would carry out the drafting of the papal letter. These drafts, called *litterae notatae*, were routinely destroyed, although through chance occurrence some have been preserved. The draft was then approved by the pope, the vice-chancellor, or a notary, depending on its importance, and was sent to the *scriptores*, who produced the *grossa littera* (also known as the engrossed letter or engrossment, i.e., fair copy), the finished bull that would be sent from the chancery. From the *scriptores* it was sent to the *registratores,* who transcribed important acts in the papal register (see the section on registration below). Finally, the bull was sent to the *bullatores*, who would affix the lead seal with the pope's name on the obverse and the images of Peter and Paul on the reverse. It was extremely expensive to obtain a papal bull, especially if litigants/supplicants traveled to Rome, which they were advised to do by Innocent to further ensure a document's authenticity.

Great Bulls (Solemn Privileges)

The papacy issued several different types of letters. The most important was the solemn privilege, which was a very large document with many marks of authentication. R. L. Poole gives a schematic breakdown of the formal privilege.[15] Not every bull conforms in each aspect to his schema, but even the simplest letters often have at least some form of protocol, text, and eschatocol, although on less important papal letters these elements may be less elaborate or missing altogether. The structure is as follows:

INITIAL PROTOCOL
Intitulatio:

 pope's name (without number before fifteenth century)

 title (*episcopus, servus servorum Dei*)

Inscriptio: name of individual(s) to whom the letter is sent

Salutatio: greeting *Salutem et apostolicam benedictionem* for simple privilege and letter; solemn privileges have no greeting, their protocol ending with the words *In perpetuum*

TEXT
Arenga, proem or preamble: enunciation of the pope's duty or authority

Narratio: statement of case

Dispositio: enacting clause (confirmation of rights, grant of license, etc.)

Sanctio:

 prohibitive clause: *Nulli ergo . . .*

 penal clause or curse: *Si quis . . .*

Benedictio: blessing to those who carry out pope's instructions

Amen (often repeated)

FINAL PROTOCOL OR ESCHATOCOL
Subscriptio: pope's subscription

Scriptum: name of the notary who wrote the document, and the month (not the day or year)

Datum: day of the month in Roman style, regnal year of the emperor, pontifical year, and occasionally the year of grace

The form of address varied according to the recipient of the letter. Archbishops and bishops were addressed as *venerabili fratri*; other ecclesiastics were addressed as *dilecto filio*. Kings were addressed as *charissimo in Christo filio*; for nobility the address was *dilecto filio nobili viro*. Names in papal documents were latinized and were usually written with a large initial letter.

Like charters, bulls have various marks on the face and dorse that indicate facets of their production, transmission, reception, and storage. The scribe who wrote the letter sometimes wrote his name on the *plica*, usually on the right-hand side. From Alexander IV (1254–61) forward, marks for taxes assessed for the document are often found underneath the *plica*. If a letter needed to be corrected, the corrector might have marked the document with the abbreviation *cor.* in the center of the upper margin. If the letter had been checked and approved, it might bear the word *auscultetur*. On the dorse, the document may have an *R* or other symbol indicating it was registered in the pope's register (see below).

Authentication

Papal bulls had numerous means of authentication that varied according to period and the solemnity of the document. The most significant and numerous forms of authentication are found on solemn privileges. Many were instituted by Leo IX (1049–54) and continued in later pontificates—for example, the *rota*, a simple cross with the pope's name surrounded by concentric circles. Within the concentric circles was the device, usually a single quotation from the Bible, used to identify a particular pope and authenticate his writings. The *rota* remained unchanged throughout the pontificate of each pope. Figure 14-8 shows a famous, perhaps notorious, bull of Innocent III to King John, confirming the king's submission of England and Ireland to the pope, ending a seven-year dispute between the English crown and the papacy.[16] In 1207, when King John had refused to install the papal candidate, Stephen Langton,

15. Reginald Lane Poole, *Lectures on the History of the Papal Chancery down to the Time of Innocent III* (Cambridge, 1915), 42–50.

16. For a description, see Jane E. Sayers, *Original Papal Documents in England and Wales from the Accession of Pope Innocent III to the Death of Pope Benedict XI (1198–1304)* (Oxford, 1999), 27–28 (no. 5); for an edition and translation see C. R. Cheney and W. H. Semple, eds., *Selected Letters of Pope Innocent III concerning England (1198–1216)* (London, 1953), 177–83.

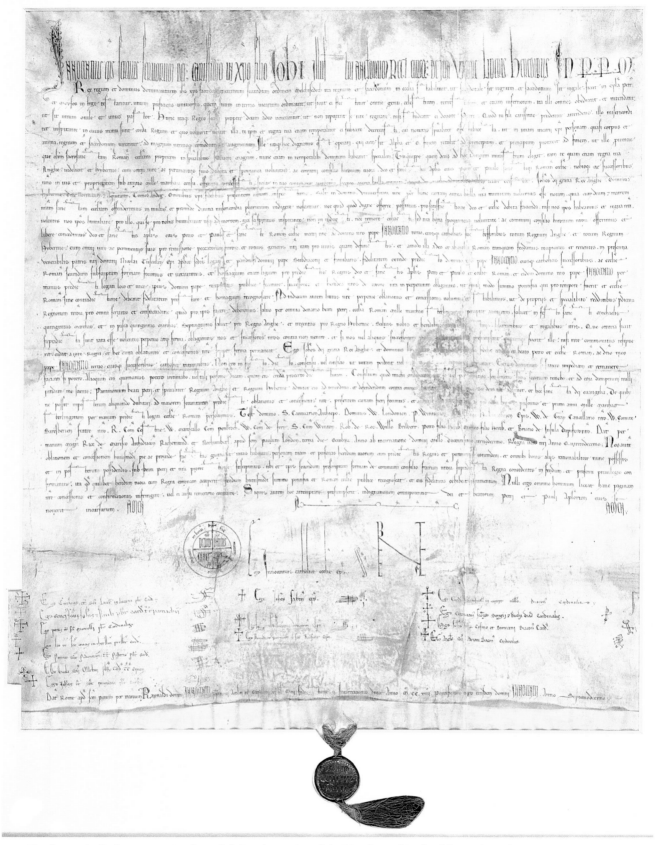

14-8 The famous bull of Innocent III acknowledging the receipt of the kingdom of England from King John and granting it back to him as a vassal. London, British Library, Cotton Charter viii. 24.

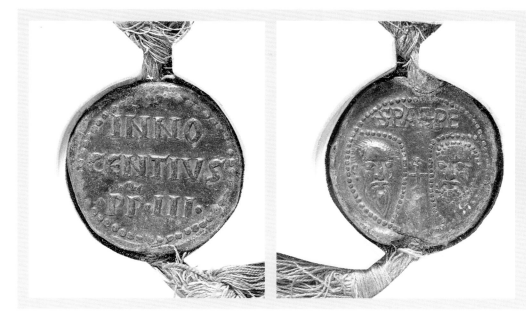

14-9 The obverse of the *bulla* of Innocent's charter, with the pope's name and number. London, British Library, Cotton Charter viii. 24.

14-10 The reverse of Innocent's *bulla*, with the heads of the apostles Peter and Paul. London, British Library, Cotton Charter viii. 24.

in the see of Canterbury, Innocent III put the entire country under interdict, and the king himself was eventually excommunicated. When, under pressure, King John finally acceded to the pope's demand, he sent the pope a charter sealed with a golden seal in which he pledged his kingdom to the Church and the pope, receiving it back as a vassal. The papal bull confirms the terms of the charter and includes the text of the king's pledge. Innocent's *rota* appears at the bottom, to the left of his subscription. A cross divides the *rota* into four quadrants. At the upper left and right are the names of Sts. Peter and Paul; at the lower left are the first four letters of Innocent's name, with the remainder of his name to the right. All three names are written in elongated letters, while below Innocent's, in smaller script, is the abbreviation for *papa* (left) and his number, *iii* (right):

sc̄s	sc̄s
PETRUS	PAULUS
INNO	CENTIUS
p̄p̄	iii

Around the rim of the *rota* is Innocent's device, *Fac mecum domine signum in bonum* (Make of me, Lord, a token for good; Psalm 85:17).

Cardinals also signed bulls with distinctive crosses that remained the same throughout their tenure. On this bull, the first three cardinals signed under Innocent are "Ego Johannes Sabinensis episcopus," "Ego Hugo Hostiensis et Velletrensis episcopus," and "Ego Benedictus Portuensis et sancte Rufine episcopus," each with a unique cross and subscription. The privilege was photographed in its frame (as can be seen by the notch in the matte cut out to display the cardinals' crosses on the far left), which makes it difficult to

determine if there are additional markings in the margins of the bull. On the last line of the privilege, one finds the name of the officer responsible for issuing the bull and the date. The bull is dated *per manum* by Raynald, acolyte and chaplain, and includes the place, calendrical date, indiction, year of incarnation, and pontifical year.[17]

Bullae

Each pope had a unique seal that he used throughout his pontificate. The *bulla* was always made of lead and was affixed at the final stage in the document's production. The obverse bore the pope's name, title, and number surrounded by a unique number of dots; the reverse depicted the heads of St. Peter and St. Paul also surrounded by a unique number of dots (see figs. 14-9 and 14-10). The Dominican Martinus Polonus (d. 1278), in his *Summa decreti et decretalium*, described how the unique number of dots could be used as a test for forged bulls:

> One is able to determine whether a [papal] letter is false by counting the points on the *bulla*, for a true bull has seventy-three points in the circle where the apostles are or where their heads are. On the other side, the circle has seventy-five [points]. Another circle above the head of St. Peter has twenty-five; these are around the forehead of St. Peter. But around the forehead of St. Paul there are only twenty-four, and in the beard of St. Peter, twenty-eight.[18]

17. "Datum Rome apud sanctum petrum per manum Raynaldi domni INNOCENTII papae tertii acoliti et capellani xi kal. Maii, Indictione ii, Incarnationis dominice anno m° cc xiiii° Pontificatus uero eiusdem domini INNOCENTII anno septimodecimo."

18. Latin text in Delisle, *Mémoire sur les actes d'Innocent III*, 48.

While Martinus's rule about using points to determine the authenticity of the bull is accurate, the number of dots changed for each pontificate or if the matrix for the *bulla* had to be replaced, as happened twice in the pontificate of Innocent IV (1243–54). Innocent III's *bulla*, shown here in worn condition, originally had seventy-three points around the perimeter of the reverse; twenty-six around the head of St. Peter and twenty-five around the head of St. Paul; twenty-five on St. Peter's forehead and twenty-eight in his beard. There were forty-eight dots around the circumference of the obverse.[19] In the time between the election of a pope and his coronation, seals called *dimidiae bullae*, or demi-bulls, were issued, which had the heads of Peter and Paul but not the name of the pope on the obverse.

Bullae were attached to the parchment by threads with special significance. Hemp string was used for mandates, while silk threads were used for privileges and letters of grace, according to the specification outlined above. It should be noted, however, that these criteria, established in the twelfth century, were not always strictly followed.

Registration

Registers were copies of letters sent by the papacy that were kept in the papal archives. There is some evidence that papal registers, taken from Roman imperial practice, may have been kept from the third or fourth century. Although the originals no longer exist, Gregory the Great's registers were contained in fourteen papyrus rolls, one for each year of his pontificate. The earliest surviving contemporary papal register, now fragmentary, is that of Gregory VII (1073–85), in which he seems to have catalogued mostly letters rather than privileges (a second register of privileges was probably maintained). Innocent III is the first pope whose register survives virtually complete (although some of its volumes are later copies and those made during Innocent's pontificate were probably fair copies of the original registers); it was during his tenure that the documents produced by the papal chancery became increasingly uniform in production and authentication. Besides the annual register of his correspondence, Innocent kept a special register for correspondence dealing with the emperor, the *Registrum super negotio imperii*. Innocent's registers were composed from the completed documents, usually not from drafts, although this practice was not uniformly adhered to by later popes. The registration mark, usually a large *R*, can often be found on the dorse of a papal privilege. Sometimes the bow of the *R* contained further information about the volume in which the registration was recorded.

Letters: Simple Privileges, Letters of Grace, Mandates

The vast majority of the documents issued by the papacy were somewhat less formal than the solemn privilege. The simple privilege was a smaller document that contained the words *Salutem et apostolicam benedictionem* in the greeting and included the full dating clause (*Datum per manum . . .*) but had fewer marks of authentication (for example, it usually lacked the *rota* and monogram). Innocent III began to substitute letters for simple privileges during his pontificate. Plainer documents than privileges with still fewer forms of authentication than the simple privilege, letters contained *Salutem et apostolicam benedictionem* in the greeting but lacked the full chancery date clause, giving instead just the date and place of issue (in Florence, at the Lateran, etc.); from 1188, the pontifical year was included as well. From the twelfth century, letters can be classified into three categories: *litterae solemnes* (solemn letters or simple privileges), *tituli* (also called *litterae de gratia* or letters of grace), and *mandamenta* (also called *litterae de iustitia*). The *litterae solemnes* functioned much as the solemn privilege had but with less grandiosity in layout. Letters of grace granted or confirmed rights or privileges. They had silk threads, little abbreviation, and calligraphic elements—the pope's name written in elongated letters with a large capital first letter, dramatic ascenders in the first line, little abbreviation, decorative ligatures, letters, and abbreviation marks when used—taken over from privileges (see fig. 14-11). Mandates were orders that required the recipient to do something; they had hemp threads, more abbreviation, and fewer calligraphic elements. They survive in small numbers because they were often discarded after their purpose was fulfilled. Often when a mandate was given, the name of the addressee was omitted and two points (often called the *gemmipunctus*) were put in its place; this was to ensure that even if the office changed hands, the mandate would still be obeyed.

The various practices observed in letters of grace and mandates were described in a papal formulary that outlined the rules that chancery scribes must observe. Although the earliest surviving manuscript of this formulary dates from the pontificate of Boniface VIII (1294–1303), many of the practices it lays down are to be found in papal documents dating from the late twelfth century onward.[20] The formulary provided illustrative examples to demonstrate its rules. The translation below substitutes for the examples in the earliest manuscript forms taken from the letter of Gregory IX shown in figure 14-11. Although this letter predates the manuscript by some seventy years, it exemplifies well the practices described in the formulary.

It should be noted that some papal letters have the *bulla* attached with silk threads [letters of grace], others with hemp string [mandates]. When the *bullae* are attached with silk, all the letters in the name of the pope should

19. See ibid. for information on Innocent's *bulla*.

20. For the Latin text of the formulary, see Poole, *Lectures on the History of the Papal Chancery*, 188–93. The earliest manuscript containing the formulary is Paris, Bibliothèque nationale de France, MS lat. 4163.

be written tall, with the first letter always be-
ing the tallest and having some open space
within it, and with the remaining letters of
his name reaching from line to line, either
with or without flourishes, in this manner:

O̶, etc. And where it says *Dilecto filio*, the
letter *D* ought to be made taller, in this manner:

D̶, etc. *Salutem et apostolicam benedictio-
nem* is written thus in all [apostolic] letters:
S̶. The initial of the first word
that immediately follows *apostolicam benedic-
tionem* ought always to be large . . . , like this:
I̶, except in simple letters where it
ought to be medium-sized. . . . It should
also be noted that in those letters with silk
threads, there should be an abbreviation sign
above nouns . . . like this: e̶p̶s̶, or otherwise, as
will please the scribe, but not in all places. In
those letters with hemp string, [the abbrevia-
tion sign is] always flat, like this: ⁻. It should
also be noted that in letters with silk threads,
when *s* touches *t*, occupying the place before
it in the same word, the *t* should be distanced
somewhat from the *s*, in this way: s̶t̶, etc.
The same is done with the letter *t* when it is
joined to *c* in the same word, in this way:

D̶i̶l̶e̶c̶t̶e̶, etc. It should also be noted
that the *N* in N̶u̶l̶l̶i̶ e̶r̶g̶o̶, etc., and the *S* in
Siquis autem, etc., in all letters in which [these
phrases] are written, should be big and tall, as
here, and larger, as will suit the form. Note also that
in all papal letters, not all abbreviations are accepted,
such as p̶, q̶, p̶ [i.e., the abbreviations for *per*, *-que*, and
pro], and others similar to these, nor this one: ᵒ [i.e.,
the abbreviation for *-ur*]. Note also that letters of the
pope ought not to be ruled with plummet or with ink:
if this should happen, [the letters] should be suspect.
Note also that in no part [of a letter] should there be a
hole or obvious mend. Note also that in letters of in-
dulgence [the phrase] *Nulli ergo*, etc., should not occur,
and if it is included, the letters ought to be rewritten;
nevertheless, [these letters] have silk threads. It should
be noted that the word that comes before the dating
clause of the letter ought not to be divided—for ex-
ample, *per* on one line and *hibere* on another—but it
should be placed entirely on one line. It should also
be known that, when within a letter [the phrase] *ad
instar* is used, the letters in the pope's name ought to
be tall and compressed. . . . In simple letters it is to be
observed that if [the end of the text] occupies only
two parts of the last line, the entire date must be on
that line; if it occupies three parts, then the year of

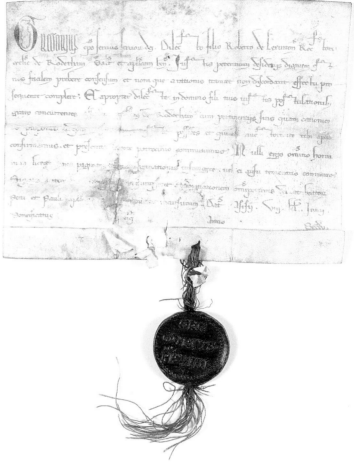

14-11 A bull of Gregory IX from 1228, granting the church of Rotherham to its
rector, Robert of Lexington. London, British Library, Harley Charter 111 A. 8.

the pontificate can go on a second line. Note also that
when the renewal of any privilege is sought because
of age (the original privilege having decayed through
old age), so that the terms of this privilege are to be
inserted into the letter of another pontiff, the letters
in the name of the pontiff ought to be small. . . . Note
also that those letters sealed with hemp thread ought
to have the first letter of the name of the pope tall and
the rest of normal size. . . . Note also that in all apos-
tolic letters the entire dating clause ought to be on the
same line, or on two lines, so that *Datum Laterani* is al-
ways on one line, or *Datum Laterani Kal. Ianuarii* is on
one line and *Pontificatus nostri anno septimo* on another.
But if it should happen otherwise, the letters should
be corrected—that is, if *Dat. Laterani kalendis* were to
be on one line and that which follows on another; or
else they might perchance be suspect. Note also that in
apostolic letters all proper names of people, places, and
the names of offices and ranks ought to have the first

letter tall, thus: R̶o̶b̶e̶r̶t̶o̶ d̶e̶ L̶e̶x̶i̶n̶t̶o̶n̶, and the like.

Figure 14-11 shows a letter of grace from Gregory IX (1227–41) to Robert of Lexington written in the second year of Gregory's pontificate (1228). The letter confirms Rotherham Church and its appurtenances to Robert, its rector.[21] It shows many of the distinctions mentioned above. The *bulla* is on silk, not hemp. All the letters in Gregory's name are written tall, with the initial letter larger and more ornate and with the rest of the letters of his name touching or nearly touching one another, for a compressed effect. The *D* in *Dilecto filio* is capitalized, and the greeting, *Salutem et apostolicam benedictionem*, is written in the abbreviated style required. The two *R*s beginning *Roberto* and *Rectori* are both capitalized. The initial of the first word following the greeting, *Iustis*, is written large. The abbreviations are consistently made in the 8 form (sometimes called the papal knot) rather than with a straight line. The ligatures are distinctive and exaggerated—the *ct* (*Dilecto* and *Rectori* in line 1) and *st* (*Iustis* and *est* in line 2) have the letters separated and are joined with a unique symbol, which looks something like an *f* joined to an elongated omega (*fΩ*). The *N* in *Nulli ergo* (line 7) is written large, and there are no abbreviations deemed unacceptable in the formulary quoted above. Finally, the date clause (25 May, at Assisi) is on two lines, with the pontificate on the second line: *Dat. Asisii. viii kl. Iunii./Pontificatus n(ost)ri anno Sec(un)do.*

The majority of letters sent by the papacy were sent open, although there survive some letters sent closed. The latter were sent to individuals, not to corporations, and were always sealed with a hemp thread. They deal mainly in matters that were controversial and often required some action on the part of the individual addressed, although some seem to have been for personal rather than official correspondence. Closed letters were also sent with envoys dispatched by the papacy to carry out its wishes, either to inquire into a matter, to negotiate on behalf of the pope, or to convey information verbally from the pope. Closed letters were folded several times and then pierced in two places where the hemp thread would be passed through and then sealed, requiring the parchment to be torn open. In the fifteenth century, secret letters were replaced by *brevia*. Instead of the traditional leaden *bullae*, these *brevia* were sealed with red wax.

MEDIEVAL FORGERY

Forgery covers a wide range of practices in the Middle Ages and modern period. Researchers who are familiar with methods of forgery will be better equipped to detect forgeries in the archive. Forging was widespread in the Middle Ages, and several theories have been put forward as to the motivations of the forgers; the practice of forging medieval documents continues today. The most developed literature on forgery concerns diplomatics because the first

documents investigated for forgery were diplomas, but a great variety of documents, from inquisition records to maps, have been forged.[22] At the same time that Mabillon was investigating Merovingian charters, Daniel van Papenbroeck (1628–1714) was making similar investigations of hagiographical material to determine what material should be published in the *Acta sanctorum*, the first critical history of saints and their cults.[23] Some forgers simply created documents for their own profit or to defraud others. This may have been the case with the "Spanish Forger," an individual living in the late nineteenth and early twentieth centuries who illuminated on parchment cut from genuine medieval books.[24] Some forgeries, called "pious forgeries," were undertaken to replace charters that had been lost or to codify practices long transmitted orally at a time when written charters were the only ones deemed binding on both parties. Others were forged to win rights or gain privileges not previously held.

Pope Innocent III, who was particularly concerned about the authenticity of papal bulls, warned prospective readers of the various ways in which papal letters might be forged. His enumeration of five different methods of forgery was prompted by a case at Milan in which a genuine *bulla* had been detached from the original document with the bottom threads intact, then attached to a false document by heating the lead and inserting new threads into the top:

> So that you will be able to discover in the future the varieties of forgery that we have discovered up to now, we have thought it good to describe them to you in the present letter. The first type of forgery is when a fake bull is put on a letter. The second type is when the thread is removed in its entirety from an authentic bull and the bull is attached to a false letter by having

21. For a description of this letter see Sayers, *Original Papal Documents in England and Wales*, 70 (no. 145).

22. Independently, Richard Kieckhefer and Norman Cohn discovered that Étienne Léon de Lamothe-Langon's *Histoire de l'Inquisition en France*, published in 1829, was a fabrication based entirely on nonexistent sources: see Richard Kieckhefer, *European Witch Trials: Their Foundations in Popular and Learned Culture, 1300–1500* (London, 1976), ix and 17–18, and Norman Cohn, *Europe's Inner Demons: An Enquiry Inspired by the Great Witch-Hunt* (London, 1975), 132–38. The most famous map that many reckon to be a forgery is the Vinland map in the collections of the Beinecke Library, Yale University; see the discussion in chap. 8, p. 124. There are three world maps in the Newberry's collections that may be fakes. See David Woodward, "Could These Italian Manuscript Maps Be Fakes?" *The Map Collector* 67 (1994): 2–10.

23. Daniel van Papenbroeck, "Propylaeum antiquarium circa veri et falsi discrimen in vetustis membranis," in *Acta sanctorum*, April 2 (Antwerp, 1675).

24. The "Spanish Forger," who may have been French, is so called because his paintings were falsely attributed to a Spanish artist working in the late Middle Ages. The Spanish Forger's work became famous after an exhibition and catalogue at the Pierpont Morgan Library in 1978 gathered together over 150

another thread inserted. The third is when the thread is cut from the part where the document is folded and is attached with the authentic bull to a forged charter, while under the same *plica* similar thread is added to make up what has been removed. The fourth is when another part of the thread is cut away from under the lead at the top of the bull, and the bull is attached to a false letter by the same thread, which is reinserted under the lead. The fifth is when in an authentic letter something is changed by light erasure.[25]

Two additional methods of forgery were described when Innocent's letter was incorporated into the *Decretals* of Gregory IX:

The sixth is when the text of the letter to which an authentic bull had been attached is entirely effaced or erased with water or wine, and the same charter is then whitened with chalk and other agents used by artificers and written anew. The seventh is when a charter to which an authentic bull had been attached is entirely effaced or erased and another very thin charter of the same size is joined to it with very strong glue.[26]

Although forgery was common in some areas—particularly before the late twelfth century, when individuals sought to consolidate their holdings previously granted by oral tradition or by charters destroyed by age or violence—the practice clearly troubled contemporaries. The ramifications of forging a papal bull, for example, were commented on by John of Salisbury: "we do not doubt that the Roman pontiff is the vicar of the chief among the Apostles: as the helmsman with his tiller guides the ship, so he by his seal's control guides the whole Church, corrects it and directs it. Thus the falsification of that seal is a peril to the universal Church, since by the marks of a single impress the mouths of all the pontiffs may be opened or closed, and all forms of guilt may pass unpunished, and innocence be condemned."[27] Lay individuals caught forging would be mutilated, clerics were to be defrocked and exiled. Despite the threat of such harsh punishments, one method for reproducing seals from original impressions, perhaps to catalogue or collect them, appeared in Jean le Bègue's *Experimenta de coloribus* (1431):

To take the impression of seals and other things with engraved or raised surfaces: Take two parts of gypsum and one of flour, mix them together and make them into a paste with glue made of hartshorn and reduce them until they become of the consistence [*sic*] of soft wax. Then make two small tablets of this paste and before they dry press between them the seal or image or other form which must be wrapped in onion skins. Then take out the seal or image, let the tablets dry, then melt lead or wax and pour it into the mould. When cool remove it from the mould or tablets, and you will have what you desire.[28]

Whatever the forger's methods, there are several strategies for determining forgery, some of which are discussed here. Diplomatic historians make a distinction between *ficta* (often copies of originals intended to pass for originals that have perished) and *falsa* (forged charters that describe a transaction that never took place). *Ficta* may have the text copied from a cartulary or draft of the original charter, so the body of the text may be correct, but the authentications such as dating, address, and sealing may be missing or suspect. In a false charter (*falsa*) the elements of authentication are often copied or taken from an original, but the body of the charter is suspect, granting unusual or unlikely privileges or containing historical inaccuracies. These inaccuracies can include such features as the naming of individuals who could not have been living when the charter purports to have been drawn up or the use of anachronistic words or forms. Some basic methods of determining forgery include checking dates, scripts, seals, signs, vocabulary, and style. For dates, one can use modern biographical dictionaries and lists of office holders to determine the years of service of the official in whose name a document was issued and thereby to ascertain whether the date given in the document is in fact a year within the individual's known period of tenure. One can also check the method of dating (by regnal year, by indiction, etc.) to ensure that the style used in the charter was indeed that adopted by the individual or institution in whose name the charter was issued. A charter purportedly from the Merovingian King Dagobert (ca. 612–ca. 639) that uses the year of incarnation is probably a forgery because that style of dating did not come into common use until much later. The script should be one known to have been commonly in use at the institution during the period in question. If a charter is written in a hand characteristic of a later period, this may mean that it is a later copy or it may indicate forgery. Seals and signs can be compared with those used on documents that have been verified as genuine. Seals should be checked to see that their attachment is original. Finally, one should consider the style of composition and the vo-

illuminations attributed to this artist. See William Voelkle assisted by Roger S. Wieck, *The Spanish Forger* (New York, 1978), and Curtis Carter and William Voelkle, *The Spanish Forger: Master of Deception* (Milwaukee, 1987).

25. See Poole, *Lectures on the History of the Papal Chancery*, 154–56; the Latin text of Innocent's letter is quoted at 156n1.

26. See ibid. for the Latin text.

27. *The Letters of John of Salisbury*, I: *The Early Letters (1153–1161)*, ed. W. J. Millor, H. E. Butler, and C. N. L. Brooke (London, 1955; repr., Oxford, 1986), 109.

28. Mary P. Merrifield, ed., *Original Treatises on the Arts of Painting*, 2 vols. (London, 1849; repr., New York, 1967), 1:74.

14-12 A Provençal roll cartulary containing transcripts of five charters, dated 1283–84, written by a notary from Asprières, France. Newberry Library, Greenlee MS 39.

cabulary employed, using a dictionary that notes the dates at which words first occur with particular meanings; the charter should not employ terms that were not in use during the period when it purports to have been granted, nor should it use words in senses they had not yet acquired. Lorenzo Valla (1405–57) was able to prove that a document commonly called the Donation of Constantine, which the papacy used to justify the preeminence of the sacred over the secular power, was a forgery by demonstrating that it used words that were not in existence during Constantine's reign or that did not have the meanings the forger had ascribed to them.

CARTULARIES

Cartularies are, as the word suggests, collections of charters, often in codex form, but the term is flexible and can refer to letter collections and other materials, such as wills and bequests, that document the history of an institution. A cartulary was a means of collecting and often organizing the most important documents an institution or individual owned. The originals could be deposited in an armoire for consultation if there was some controversy over the copy. Often, cartularies can reveal more about the institution than the original documents: because cartularies are usually (although not always) selective, an analysis of what the scribe chose to include and exclude may provide insight into what the individual or institution valued most at the time the collection was made. The organizing principle used to arrange the cartulary (chronology, hierarchy, topography) also reveals something about the institution or individual that produced it. In cartularies belonging to religious institutions, for example, papal bulls usually come first, followed by secular privileges. There are some cartularies, particularly in the early modern period, that are archival in function and attempted to copy every charter in the institution's collections. Cartularies can be useful especially if some of the original charters represented in them are missing, which is often the case for a variety of historical reasons.

One must be careful when using editions of cartularies because some early modern and even modern editors rearrange the materials in the cartulary, often to make them chronological or to conform to some other ordering principle. In general editors will disclose such reorganization in their preface, but one should check to see whether or not the folio numbers of the cartulary referred to in the edition are consecutive. Some editors have also "made up" missing information by taking it from the original charter if it was available. Often the editor indicates what text was taken from the original charter and what was in the cartulary, but sometimes such material is added silently.

Although most cartularies were in codex form, this was not exclusively so. A roll cartulary from southern France now in the Newberry (Greenlee MS 39) records the transfer of properties and was probably composed for a single individual rather than an institution (see fig. 14-12). Newberry Library MS 20.1, on the other hand, was composed by a community (in this case the Abbaye-aux-Bois) to document its foundation, privileges, and the rents due from properties it owned (see chap. 3, figs. 3-3, 3-8, 3-9). As is typical, the charters it contains have not always been copied verbatim (witnesses and notaries are often omitted, and often the preamble is suppressed). No effort has been made to describe the seals and other marks of identification that are on the original charters. In the case of MS 20.1, we are in the fortunate position of having both the cartulary and many of the original documents represented in it.[29] The

29. See Brigitte Pipon, *Le Chartrier de l'Abbaye-aux-Bois (1202–1341): Étude et édition*, Mémoires et documents de l'École des Chartes 46 (Paris, 1996).

cartulary documents the revenue of the abbey from various sources as well as some of its expenditures and includes a table of contents that describes the organization of the charters within the cartulary and within the abbey's archive. Each document described in the cartulary is followed by a number, which matches a number written on the dorse of the original document; thus the cartulary functioned not only to preserve and organize the documents but also as a finding aid for locating and storing the charters.[30] A more formal cartulary, Newberry Library MS 189, has taken great care to record the notary's authentication, going so far as to copy the notarial signature (see fig. 14-13). This cartulary gathered together the privileges of patronage granted to the de Portis family in Venice by the Franciscan chapter of Vicenza and confirmed by the papacy between 1442 and 1614. Such a document was designed to codify rights and privileges of an individual family and probably did not serve an administrative or organizational function.

Cartularies were not only created for local purposes. Newberry Library MS 80, composed between 1464 and 1471, is a cartulary of papal bulls (called a *bullarium*) relating to the entire Franciscan order. It may have been used by an individual house within the order to safeguard the rights granted both to itself and to the order as a whole. The bulls are taken from originals and also from the *Corpus iuris canonici*. The *bullarium* includes a topical table of contents with references to folios for easy consultation. In addition to providing excerpts from the text of the bulls, some entries include information about the date and place at which the bull was promulgated, where the original or copy that was used for the cartulary was found (usually in a Franciscan house), and whether the copy consulted still had the *bulla* attached.

Cartularies commissioned by secular lords were not merely a convenient collection of records but served to express the power of the individual compiling the collection. Some cartularies are illustrated or decorated, providing additional insight into the individual or group that composed them. Other cartularies convey authority by imitating the layout and/or the script of the charters themselves, making these cartularies almost a facsimile of the originals on which they are based.

The study of diplomatics is a lifelong endeavor. This chapter has sought to convey some of the richness of the mate-

14-13 Page of an illuminated cartulary recording privileges granted to the de Portis family of Venice. Newberry Library, MS 189, fol. 17r.

rials researchers may encounter when they begin study, but it has not attempted to give the information necessary to draw historical conclusions from charters and cartularies. To properly interpret diplomatic sources requires a great deal of study and, in many cases, years of experience working in archives. Despite the work, however, the rewards for such study are tremendous; many archives contain charters that have never been studied and await discovery and interpretation. Researchers who are less interested in charters as their main focus will also benefit from understanding how most rights and privileges were communicated from one person or institution to another and from one age to another.

30. Ibid., 23.

Maps

MEDIEVAL manuscripts contain a variety of illustrations that served as maps, including marginal diagrams representing the world or the cosmos in schematic fashion, world maps that combined historical and mythical information, itineraries for pilgrims, and charts for sailing across the Mediterranean. But as Evelyn Edson and P. D. A. Harvey have noted, until the fifteenth century, medieval people seem not to have relied on maps for many purposes for which we use them today; in fact they seem in many cases to have preferred a detailed written account to a graphic representation.[1] Modern historians have attempted to categorize medieval maps into representative types, such as mappaemundi, regional maps, cadastral maps, and portolan charts—each with numerous subdivisions. Such attempts at taxonomy often fail or at the very least cause confusion because most medieval maps have characteristics from several categories. With a presentation of some examples of the types of maps frequently encountered in manuscript study, these few pages will provide a rough outline of the history of cartography in manuscripts and present the basic terms used by cartographers.

ITINERARIES

Usually simple lists of towns and the distances between them written to instruct various travelers, such as soldiers, pilgrims, or merchants, itineraries were occasionally constructed in graphic format to provide greater information about routes and their topographic features, both manmade and natural. Even in the most graphic itineraries, however, such features were most often represented symbolically rather than realistically. Towns, for example, were usually depicted as walled cities; the larger or more important the city, the larger the representation. Very few itineraries survive from the Middle Ages. Those that exist from the early and high Middle Ages were mostly verbal, and by the time pilgrimage maps began to be produced in the fourteenth century and following, they tended to be more complex and less linear than itineraries. The earliest surviving manuscript copy of an itinerary from the Roman Empire is the Peutinger map (Vienna, Österreichische Nationalbibliothek, Codex Vindobonensis 324), a twelfth- or thirteenth-century copy of what is believed to have been a fourth-century original.[2] A rare survivor not only because of its age but also for its graphic complexity, the Peutinger map is a roll, roughly 34 cm wide by 6.75 m long, that displays the roads between the major cities from southern Britain to India and Egypt.

Another notable exception to the medieval trend of creating itineraries that were predominantly verbal is presented by Matthew Paris (d. 1259), a monk in the monastery of St. Albans in England, who, among numerous writings, composed a number of maps and several itineraries. It is not known on what models, if any, Paris based his itineraries. The itinerary in his *Historia Anglorum* represents several routes from England to Jerusalem with symbols representing towns and natural features (see fig. 15-1). While the document is certainly unique for its type and time, certain design features may provide clues about the influences in Paris's work. The itinerary was intended to be read from bottom to top in each column; while this might seem like a strange arrangement, it is likely that before it was transcribed into the present codex, Paris's itinerary was originally in roll format or at least composed in the fashion of a roll; the long narrow columns suggest a layout such as the English Stations of the Cross roll (see fig. 16-4) examined in chapter 16. The lines that represent the day's journey and the cities and churches that represent the stopping points are strikingly similar to the roll genealogies that represent the kings of France by their religious foundations, such as Newberry Library MS 132 (see chap. 16, fig. 16-2).

Matthew Paris made no effort to achieve scale in his drawings; his intention was simply to communicate the order in which the traveler would encounter these places. Each city is a day's journey from the next city on Paris's itinerary, indicated by the red roads labeled *jurnee* connect-

1. Evelyn Edson, *Mapping Time and Space: How Medieval Mapmakers Viewed Their World* (London, 1997), esp. 101, and P. D. A. Harvey, *Medieval Maps* (London, 1991), 7–9.

2. For a facsimile, see Ekkehard Weber, ed., *Tabula Peutingeriana: Codex Vindobonensis 324* (Graz, Aus., 1976).

ing them. This map begins in the lower left corner with the city of London, for which Paris provides recognizable landmarks—from left to right, the Tower of London on the far side of the Thames, London bridge (labeled *punt*) crossing the Thames, the Church of St. Paul in the center of the city with its tall spire, Southwark Cathedral, Lambeth Palace, and finally the Abbey Church of Westminster on the far right. Above the city he explains London's mythic origins: "La cite de Lundres ki est chef dengleterre. Brutus ki primes enhabita engleterre la funda e lapela troie la nuuele" (The city of London which is the capital of England. Brutus, who was the first inhabitant of England, founded it and called it New Troy). Traveling out of London one first reaches Rochester, then Canterbury, and finally Dover, from where one would travel by boat to Wissant. Here Matthew's itinerary gives a choice of two routes: one can stay on the middle path from Wissant, to Boulogne, to Montreuil, to Saint-Riquier, to Poix, and ultimately to Beauvais, or one can travel from Calais, to Arras, Saint-Quentin, and finally to Reims. Continuing on the verso and breaking into three paths at one point, the itinerary guides the reader through France to the Apulia region of Italy, from where the traveler could take a boat to the Holy Land. The cities of Acre and Jerusalem are illustrated in detail in separate maps appended to the itin-

15-1 Page of Matthew Paris's *Itinerary* from England to Jerusalem, showing the route between London and Beauvais. London, British Library, MS Royal 14 C. vii, fol. 2r.

erary. Matthew's graphic itinerary provides quite a different type of information from that available from text-only itineraries because it represents the relative size of cities, the natural features along the way, and various alternate routes one might take to arrive at one's destination.

MAPPAEMUNDI

The types of map most people are familiar with from history textbooks covering the Middle Ages are mappaemundi, or maps of the world. Mappaemundi are essentially representations of the earth as it was known from the ancient world, including Asia, Africa, and Europe as seen from a celestial perspective. The maps are usually centered on the Mediterranean or Jerusalem, the first possibly a relic

of the Roman concept of the world as an *orbis terrarum* that surrounded the Mediterranean, the latter reflecting a religious belief in the importance of Jerusalem in the origin of Christianity.[3] *Mappa* means "cloth"; these maps were often written and displayed as large wall hangings. Two of the most famous are the large Hereford (ca. 1290) and Ebstorf (ca. 1235, destroyed 1943) maps, both composed in the

3. An excellent, concise introduction to world maps along with a convincing schema of types is Peter Barber, *Medieval World Maps: An Exhibition at Hereford Cathedral* (Hereford, U.K., 1999). Edson, *Mapping Time and Space*, provides insight into the mapmaker's mentality, while Harvey, *Medieval Maps*, gives a basic history illustrated with many color reproductions.

tween them. Several rivers flow out of Eden. (Mappaemundi usually represent three to five rivers. The Psalter map has five: from left to right the Ganges, the Euphrates, the Tigris, the Gihon, and the Phison.) To the right is the Red Sea, easily recognizable as the only body of water colored red. At the upper left is a wall, semicircular in form with a gate. In some mappaemundi these walls hold back the forces of Gog and Magog, which will be let loose at the Apocalypse (Revelation 20:7). Just outside the wall, beyond the gate, one finds Noah's Ark nestled in the Armenian mountains, a detail probably taken from St. Jerome's *Liber de situ et nominibus locorum hebraicorum*.[4] On the lower right the map depicts the monstrous races, such as the *cynocephali*, who had the heads of dogs, or *sciopodes*, who had one large foot, which they used to shade themselves from the sun.[5] In many maps, these races were relegated to the unknown section of the world, usually in remote Africa but sometimes also in the fourth continent theorized by Macrobius. In the Psalter map, the monstrous races are separated from the rest of Africa by the Nile River, whose oversized delta flows into the Mediterranean. Europe forms the bottom left portion of the map with the Alps and Pyrenees located accurately. Italy, however, has a round rather than boot-shaped appearance, with the city of Rome represented by the icon for a walled town. Britain is shown within the continent of Europe, sepa-

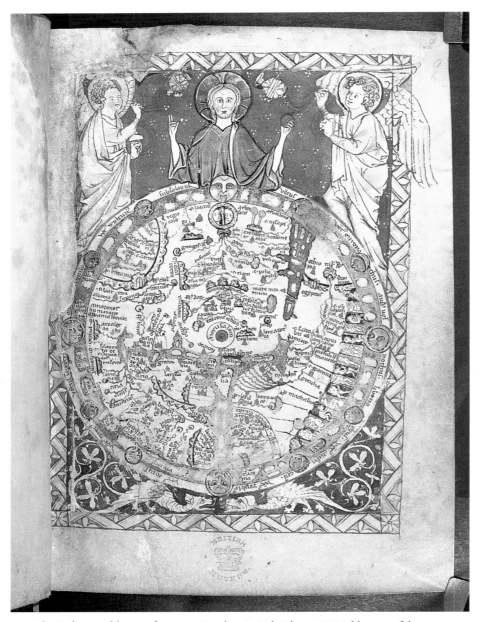

15-2 The Psalter world map of ca. 1265. London, British Library, MS Add. 28681, fol. 9r.

thirteenth century and designed for public display. Smaller maps, such as the Psalter map, so called because of its inclusion in a thirteenth-century psalter (ca. 1265), incorporate the basic shapes and communicate the same worldview as the larger maps, and all attempt to survey the entire inhabited surface of the earth by representing historical as well as topographical features (see fig. 15-2).

The Psalter map measures only 14.3 × 9.5 cm. The world is depicted as a part of Christ's body. Christ is shown holding a T-O representation of the world in his left hand (see below for an explanation of the T-O map). Two angels flanking Christ swing thuribles (containers used for burning incense) that represent the sun and moon. The faces of Adam and Eve appear at the top of the map itself, with the tree of the knowledge of good and evil growing be-

rated by the English Channel. Ireland, on the other hand, is depicted as an island in the waters that surround the three continents. The faces around the circle represent the winds. Shown at the exact center of the map, Jerusalem appears larger than any other place, except Eden, directly above. The medieval understanding of the world, as evident in its graphic representation in the Psalter map, was largely theological; the map is as much a statement about the nature of

4. *S. Eusebii Hieronymi liber de situ et nominibus locorum hebraicorum*, s.v. *Ararat, Armenia*; see Migne, *Patrologia latina*, vol. 23, col. 905.

5. See John Friedman, *The Monstrous Races in Medieval Thought and Art* (Syracuse, 2000), and Claude Lecouteux, *Les monstres dans la pensée médiévale européenne* (Paris, 1993).

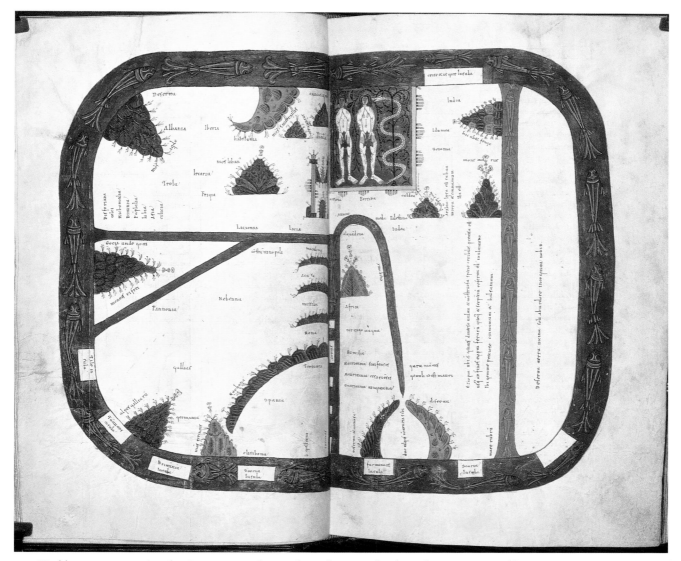

15-3 World map accompanying the *Commentary on the Apocalypse* of Beatus of Liébana, from a copy made at Santo Domingo de Silos in the early twelfth century. London, British Library, MS Add. 11695, fols. 39v–40r.

the world and its relationship to its creator as it is a representation of landmasses and bodies of water.

Mappaemundi can be very complex, encompassing not only the known and unknown world but also all of time, from the Garden of Eden to the Last Judgment. The world map that accompanies illustrated copies of the commentary on the Apocalypse by Beatus of Liébana, written in eighth-century Spain, illustrates well the mappamundi's interaction between space and time and between the known and unknown (see fig. 15-3). The landmass is surrounded by water populated by fish; several islands are represented schematically as rectangles along the base of the image. The Red Sea is a vertical red band to the right, and the Mediterranean is a vertical band drawn halfway down the gutter of the opening. The Nile is represented by an inverted *J* that originates at the top of the Mediterranean and ends at the juncture of two mountain ranges. Rocks with plants superimposed on them represent mountains. Adam and

Eve, with the serpent whispering into Eve's ear, appear at the top of the map as the codex is read. In fact, the map has no top or bottom; the illustrator has drawn the map with features labeled along two orientations (it can be read with the book opened to the bottom or right margin), requiring that the reader rotate the manuscript ninety degrees in order to read some of the inscriptions. The map includes a fourth, unknown continent, labeled "Deserta terra uicina soli ab ardore incognita nobis" (Desert land close to the sun, unknown to us because of its heat). Possibly the home of the monstrous races from classical antiquity, this continent may have represented the final nation of people to be converted before the Apocalypse would occur.

While maps are, by nature, representational, there were distinct categories of medieval maps that sought to portray landforms with geographical accuracy while emphasizing less the historical or symbolic elements of most mappaemundi. One of the oldest surviving geographically accurate

15-4 The Cotton world map, mid-eleventh century.
London, British Library, MS Cotton Tiberius B. v, fol. 56v.

15-5 Matthew Paris's schematic world map. Cambridge,
Corpus Christi College, MS 26, p. 284.

maps, usually dated to the mid-eleventh century, is the Cotton world map (named after its seventeenth-century owner, Sir Robert Cotton), also called the Anglo-Saxon world map and the Tiberius map. The Cotton world map (see fig. 15-4) is rectangular in shape, and it presents the cities and areas of biblical importance, but unlike the Beatus map, it provides a geographically detailed representation of the land-masses in each of the three continents. Although the Cotton map is found in an Anglo-Saxon miscellany that also contains a description of the monstrous races with large, colorful illuminations of the strange ani-mals and people that inhabit the world's unexplored lands, such mythic creatures are not represented on the Cotton map except in textual labels in their tra-ditional location in the far southern lands. The Cot-ton map may have been included to complement the information in the rest of the codex. Unlike most medieval mappaemundi, which label regions without providing boundaries, the author of the Cotton map has imposed a schematic gridlike structure over the map so that each region can be named and separated from its neighbors. These boundaries are not based on any recognized boundaries but may have helped the viewer to distinguish the various cultural entities, particularly in Asia. Despite its rectangular format and its relative lack of attention to historical and religious events, the Cotton world map shows striking similari-ties in layout with later mappaemundi such as the Psal-ter map produced some two hundred years later. Both have the same eastern orientation (i.e., east is at the top of the map); depict three major landmasses in sim-ilar ways; locate mountains, oceans, and rivers in the same places; and share a common iconography used to represent land, mountains, rivers, and cities. The Cotton world map, like a projection map, features the Mediterranean in its center; as a result, the Greek is-lands appear larger and more detailed than landmasses in the map's periphery. While the Cotton map's de-piction of Britain and Ireland is uncannily accurate, the map places Britain and Spain in close proximity, which may reflect an early medieval belief about their respective locations.[6]

Matthew Paris, the thirteenth-century historian ex-amined above for his itineraries, also created a unique

6. Harvey, *Medieval Maps*, 24.

world map (see fig. 15-5). Like the Cotton map and many others at the time, Paris oriented his map with east at the top, but he rearranged the continents so that Greece appears to the north of Italy. His schematic map does not represent the British Isles at all, which seems somewhat odd given the assumption that the book was written, like his others, at St. Albans. He also neglected the coastline of Western Europe, seemingly constrained by the end of the page. We know from Paris's other maps, however, that he knew the coast of Western Europe and the British Isles in great detail, so his decision to truncate it here may be ascribed to a desire to present a schematic rather than realistic view of the world. Many rivers have been included in France, Germany, and Spain, but only one past his westernmost mountain range and none in Italy south of the Alps. Africa is to the south (the right margin of the page); Asia to the east has a straight coastline. Jerusalem is the only city marked in Palestine. As interesting as the map itself is the inscription (in red), which mentions three large wall maps in London, none extant: one composed by Robert of Melkeley, a second from Waltham in Essex, and a third owned by the king at Westminster. This indicates that large world maps were displayed and suggests that Paris's map may be descended from one or a combination of these lost exemplars.

Unlike Matthew's world map, the extensively detailed world map commonly but mistakenly attributed to Henry of Mainz is a clear attempt to represent the earth's surface in a realistic manner (see fig. 15-6). At the top (east), Paradise is represented as an island with four unlabeled rivers flowing from it. The large tower just below paradise is the Tower of Babel. The Mediterranean is shaped like the arabic numeral 7, distorting the shapes of Italy, Greece, and Asia Minor. Palestine has been divided into tribes. The angel in the upper left points to the walled city that holds Gog and Magog. Color is used sparingly but conventionally—the seas are blue-green with only the shoreline shaded in the Mediterranean; land features such as mountains are reddish brown. At the center of the map is not Jerusalem but the Cyclades, a circular arrangement of islands surrounding Delos, indicating the author's reliance on a classical model.

THE T-O MAP AND ZONAL MAPS

Most of the maps found in medieval codices are marginal diagrams rather than full-page illuminations. The T-O and zonal maps are most often found as marginal diagrams in astrological or encyclopedic works. The T-O map is the most common representation of the earth's surface and appears in a variety of contexts. Found in the earliest manuscripts of the *De natura rerum* of Isidore of Seville (ca. 560–

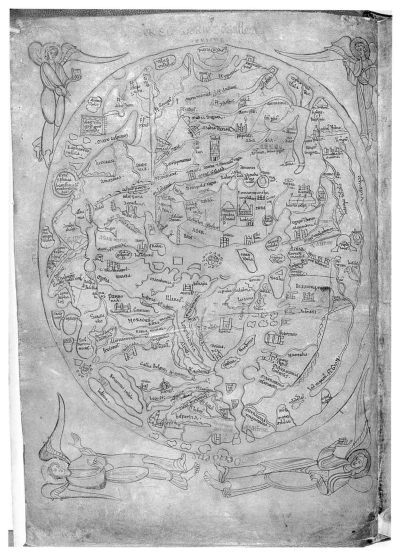

15-6 World map attributed to Henry of Mainz, late twelfth century. Cambridge, Corpus Christi College, MS 66, p. 2.

636) and in later manuscripts of his *Origines vel Etymologiae*, T-O maps represent the earth as a circle, bifurcated by a horizontal line across its circumference.[7] The lower half is divided in half again, creating a rough *T* in the circle. The vertical line of the *T* represents the Mediterranean, the right leg the Red Sea or Nile River, and the left leg the Black Sea or the Don River. The two smaller landmasses are Europe and Africa; the larger is Asia. The first printed edition of Isidore's *Etymologiae* includes the classic T-O map (see fig. 15-7). In some manuscripts the three regions are assigned to the descendants of Noah's sons, Ham, Shem, and Japheth. Some others list the various countries within each continent. T-O maps are often framed as an orb in the hand of God or the emperor (see above, fig. 15-2). Gregorio Dati (1362–1435) was the first to give the distinctive

7. Wesley M. Stevens, "The Figure of the Earth in Isidore's 'De natura rerum,'" *Isis* 71 (1980): 268–77.

15-7 T-O map from a copy of Isidore of Seville's *Etymologiae* printed at Augsburg in 1472. Newberry Library, oversize Inc. 227, fol. 117v.

15-8 A T-O map and a realistic world map in the margins of Gregorio Dati's *La sfera*. Newberry Library, Ayer MS Map 1, fol. 14v.

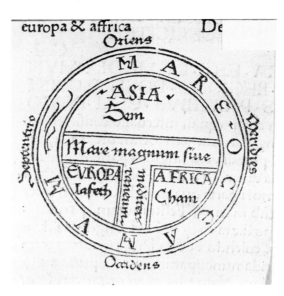

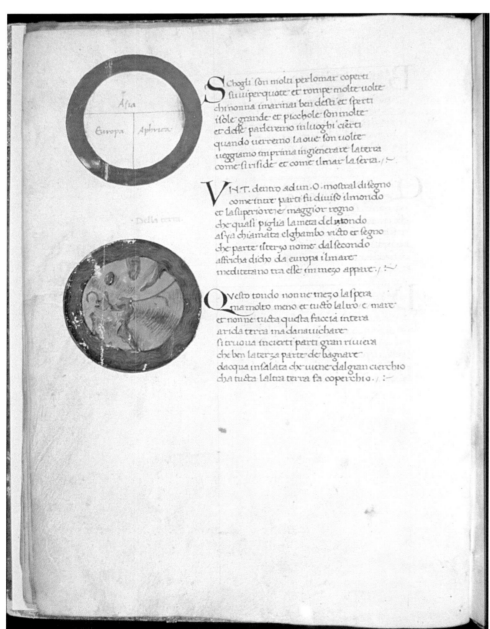

map its name; in *La sfera*, a cosmographical treatise written in rhyming verse, he included such a map with a realistic picture of the earth below it to indicate that the Isidorian diagram is a useful mnemonic but not a realistic depiction of the earth's surface (see fig. 15-8).

The zonal map, the other significant model from the early Middle Ages, is based on the *Commentary* on Cicero's *Dream of Scipio* by Macrobius (ca. 395–423). It is most distinctive for its concepts of geographical zones or climates: the two polar zones were frigid, the zone at the equator was hot, and on either side of the equator and between the poles were two habitable zones—the northern zone contained Europe, Asia, and Africa, and the southern zone contained the fictional Antipodeans (see fig. 15-9). In the early printed Macrobius map shown here (the second printed edition to include the map), much of Britain and Scandinavia are in the northern frigid zone; the region surrounding the Mediterranean is in the temperate zone. The regions of Hispania, Gallia, and Italia are labeled, as are the islands of Sardinia and Sicily and the towns of Carthage, Alexandria, Jerusalem, and Babel. Southern Africa and the ocean are in the equatorial zone, and beneath them is the temperate land of the Antipodeans (with the comment "unknown to us" helpfully added). Macrobius believed that the equatorial zone was too hot to be habitable or even traversable by human beings, a view that was discovered to be false as the Portuguese began exploring the western coast of Africa in the fifteenth century.

PORTOLAN CHARTS

Portolan charts are entirely different from the maps discussed above. In their earliest form they were created to help sailors navi-

gate the Mediterranean, Black Sea, and English Channel. They represented the coastlines of Asia, Europe, and Africa with surprising accuracy; for the most part they included few inland features because such information would not have been useful to sailors. Their name derives from Italian *portolano*, signifying a written set of sailing directions. The first reference to a portolan chart is in Guillaume de Nangis's *Deeds of St. Louis*, which describes how during a storm at sea when Louis IX was on his way to crusade in 1270, the sailors unrolled a chart to determine their course.[8] Portolans could be made from a single sheet of parchment or several sheets glued to wooden boards, forming a rough early atlas. In codex form, until the age of exploration, the charts usually proceeded from west to east.

The earliest surviving portolan chart is the *Carte Pisane* (Paris, Bibliothèque nationale de France, Cartes et Plans, Rés. Ge B 1118), dating from the late thirteenth century. The development from written to graphic charts must have predated the *Carte Pisane*, but that history is as yet largely unknown. Other than the likelihood that it was produced in Genoa, we know little about the *Carte Pisane*. The earliest charts were produced by Catalans and Italians, and Catalan charts can be distinguished from Italian mainly by their iconographic representations; by the fourteenth century there developed a standard iconography, listing of cities, and ordering of maps (if bound in a collection).

Petrus Roselli of Majorca was a famous mapmaker whose portolan chart, shown here, is dated 1461 (see fig. 15-10). Made from a single sheet of parchment, the chart was designed to be rolled, perhaps for better storage. The holes in the western edge of the chart indicate where the roll was attached to its wooden roller. Roselli followed convention in marking the larger cities and ports in red lettering and the smaller ones in black. Crosses or a series of black dots indicate rocks, while red dots indicate shallow water. Flags indicate territories, and the islands are also colored to indicate to whom they belonged. The map has no single orientation for its inscriptions. Rather, the reader must rotate

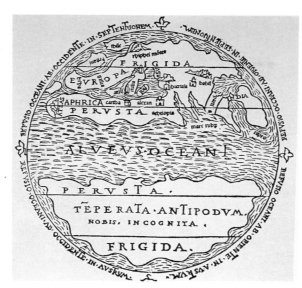

15-9 Zonal map with outline of the known world in the northern temperate zone, from Macrobius, *Somnium Scipionis ex Ciceronis libro de republica excerptum* (Brescia, 1485). Newberry Library, Inc. f6962, fol. 45r.

the map following the coastline to read port names. Notably, on the opposing coasts of England and France, port names are oriented so that the reader of the English names will see the names of French port cities upside down. In a decorative border on the north and south edges are mile scales. At the far east end—where the unevenness of the parchment preserves the neckline of the animal from which it was prepared—is Roselli's colophon: "Petrus Roselli compossuit hanc cartam in civitate Maioricarum anno domini m.cccc.lxi." Although the map was produced in Majorca, Venice is the largest city on it. Ironically, to accommodate its size, Petrus had to move the island city-state to the interior of the map. Jerusalem is the only walled city represented on the map without a flag. Many islands in the eastern Atlantic, including the Canary Islands, Madeira, and the Azores, are clearly represented. The inland topography, however, is markedly less precise. There is a large, unidentified mountain range in southern Spain; inland rivers are represented only as wavy blue lines, and inland cities are located at best in approximate rather than accurate location. The Red Sea is missing, and the Arabian Peninsula, Africa, and the Middle East are merged into a single landform. Such distortions would not have affected those sailing in the Mediterranean, but they would have affected those consulting such maps to determine how goods from the East might be imported to the West. While originally drawn with a specific purpose, the features of portolan charts were incorporated into other maps because of their high degree of accuracy. Atlases, which began to be produced from portolan charts in the fourteenth century, often contained deluxe copies of portolan maps and world maps with more detailed and accurate coastlines.

PTOLEMAIC MAPS

The second major influence on map production in the fifteenth century was the reintroduction of Ptolemy's *Geography* and the maps that accompanied it. This work was translated into Latin from the Greek by Jacobus Angelus in 1406–7, after which it became immensely influential. It is unclear whether the maps that accompany Ptolemy's *Geography* were copied from Byzantine exemplars (most likely) or re-created from the text itself, which gave detailed coordinates for each city listed. The manuscript Ptolemaic map of Africa shown here was bound in an edition of Pomponius Mela's *Cosmographia* printed in 1518 (see fig. 15-11).

8. Guillaume de Nangis, "Gesta sanctae memoriae Ludovici," in *Recueil des historiens des Gaules et de la France*, ed. J. Naudet and P. Daunou, vol. 20 (Paris, 1840), 444. Cited in J. B. Harley and David Woodward, eds., *The History of Cartography*, vol. 1 (Chicago, 1987), 439n484.

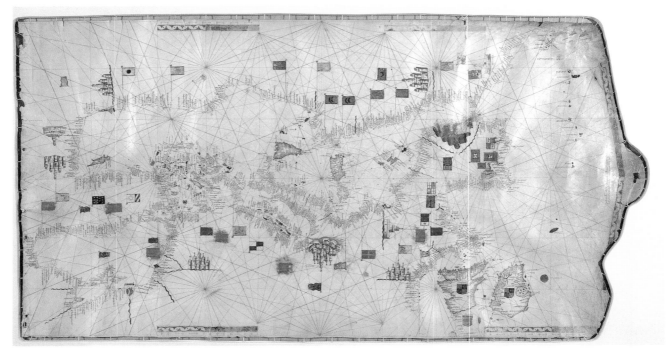

15-10 A portolan chart made by Petrus Roselli in Majorca, 1461.
Newberry Library, Ayer MS Map 3.

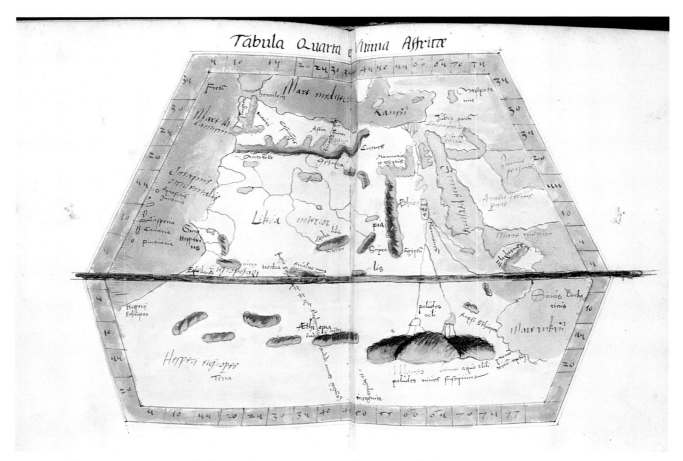

15-11 A Ptolemaic manuscript map of Africa with a Donis projection, from a printed edition
of Pomponius Mela's *Cosmographia* (1518). Newberry Library, *6 P9 MS 1518, fols. 27v–28r.

It is based on the trapezoidal Donis projection, originated by Nicholaus Germanus in his 1466 edition of Ptolemy's *Geography*. In this projection, the lines of latitude are equidistant, but the meridians converge at the poles and reach maximum separation at the equator (represented here by a gold band), thereby giving a clear sense of the earth's curvature.

Despite its late date, the manuscript maps in the Newberry edition of Pomponius Mela's *Cosmographia* do not include new information about Africa known through Portuguese exploration. In sharp contrast, the world map of Henricus Martellus, made before 1488 by a German cartographer who worked in Florence, contains a detailed account of the progress of the Portuguese around the western and southern coasts of Africa (see fig. 15-12). Martellus inscribed on the map itself that he had received his information on Africa from Portuguese sailors. This world map occurs in an *Isolario*, or book of islands. The first part of Martellus's *Isolario* was taken almost entirely from Cristoforo Buondelmonti's *Liber insularum archipelagi* written in 1420, a popular work with numerous deluxe editions surviving. In addition to the islands, Martellus also included a map of the Holy Land and several regional maps of Europe that appear to be based on Ptolemaic maps. In many ways the most interesting map in the collection is the world map, shown here. Although based on the Ptolemaic world map, this map has been updated to include the discoveries made since Ptolemy's maps were reintroduced in the early fifteenth century. The basic outline of Western Europe is accurate, as are the coast of the Mediterranean and the western coast of Africa, details probably provided by portolan charts. Africa dominates the map as it did the fifteenth-century imagination, even overstepping the painted border to include its southernmost point. The continent has become elongated in part to display the detailed coasts that, according to Martellus, constituted the "true form" of Africa, which he had received from the Portuguese who had explored Africa from the Mediterranean to the Indian Ocean. The interior of Africa, as yet unexplored, was taken wholly from Ptolemy (see fig. 15-11,

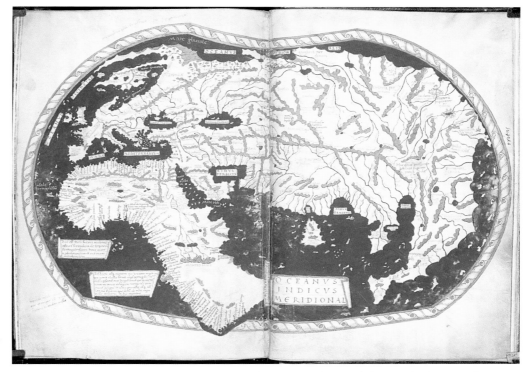

15-12 A world map made by Henricus Martellus before 1488, with extended coast of Africa. London, British Library, MS Add. 15760, fols. 68v–69r.

above), but Martellus extended the Nile well below the equator and depicted it flowing from the Montes Lunae, a prominent feature on early maps of Africa that gradually disappeared as the interior was explored. The map retains some mythical elements; in the mountains above India, Martellus noted: "Here lives Prester John, Emperor of all India." Prester John was a fictitious Christian king, usually located in central Asia although sometimes placed in Africa, who reportedly fought the Arabs controlling the Holy Land.

Although manuscript maps (such as the Ptolemaic map in the Pomponius volume discussed above) continued to be produced after the introduction of printing, the age of exploration and the need for new and updated maps for various purposes demanded printed maps that could be quickly produced and rapidly disseminated. Medieval mappaemundi continued to be consulted (Henry VIII had a mappamundi in addition to portolan charts, as may have Christopher Columbus) but gradually came to be only of antiquarian interest. The effects of the portolan maps and the reintroduction of Ptolemaic maps led to more accurate depiction of landforms, topographic features, and bodies of water, but well into the modern era maps continued to contain information about the peoples who inhabited the lands both inside and outside Europe.

Rolls and Scrolls

HISTORIANS often assume that the roll was entirely replaced by the codex with the rise of Christianity in the first centuries of the first millennium. While the codex certainly supplanted the roll for most purposes, it did not entirely replace it, for several reasons. Rolls carried with them a symbolic cultural significance, particularly in regard to royal proclamations and certain religious texts. In many situations rolls were seen as more practical than codices. They were less expensive to produce than books because they did not need to be bound but were more substantial than single sheets, which might get lost or damaged. The form of the roll, although simple, is very effective in protecting its contents when it is rolled up, usually with the hair-side outward. For records that would be expanded on a regular basis, such as court records or collections of monastic prayers for the dead, the roll allowed for economical accumulation of material over time with additional membrane added only as needed. In addition, rolls lent themselves to continuous reading and oral recitation.

Although the terms *roll* and *scroll* are often used interchangeably, some scholars reserve the first for documents that are read from top to bottom and have a vertical orientation, keeping the second for documents that are read from left to right and have a horizontal orientation. Papyrus was the original medium employed for making rolls or scrolls (see the description in chap. 1); later, parchment was used. The method was simple, and the form allowed for a continuous narrative. There has been much debate about why the roll was replaced by the codex after the dawn of the Christian era, but no one reason seems to account for the change. Users familiar with codices may have found rolls difficult to handle: they had to be held open with both hands (making them difficult to annotate or correct); finding specific references required unrolling and rerolling; only one side was usable for a continuous text; and the roll itself could be difficult to hold and read at the same time. If the roll was not stored or carried in a case, its outer leaf was exposed to the elements. There is also the issue of size: a single codex could hold the material of three or four rolls, allowing the reader to consult many places in a longer text without needing additional volumes. Additionally,

the rectilinear shape of codices allowed for ease of storage on shelves. The problem with roll storage is seen today in modern archives: no satisfactory method has been found to store rolls of various sizes; instead, they are often placed in boxes that can be labeled and serve to protect the roll.

Despite the shift from roll to codex, the codex never completely supplanted the roll because there were practical and symbolic reasons to continue to write on rolls. The continuous narrative on a roll could be read uninterrupted, which was useful for public reading, proclamations, or in the theater. As Mary and Richard Rouse have convincingly argued, many compositions by poets and songwriters were first committed to and performed from rolls before being copied into codices for transmission to posterity.[1] In the ninth century, the monk Notker the Stammerer of St. Gallen described how, at his teacher's order, his hymns were first copied onto rolls for public singing and only later written into a book for presentation to a bishop. Rolls consisting of just enough sheets of parchment to contain a fresh set of compositions were less costly to produce than a bound book. The portability of the roll made it eminently suitable for carrying from court to court. Because such rolls were more ephemeral than codices, very few of them have survived. From the thirteenth century, there survive two fragments of a roll of songs by the Middle High German poet Reinmar von Zweter; the roll predates the earliest codices of Reinmar's works, and the fragments are known today only because the roll was cut up and these two pieces reused as endleaves in an early printed book.[2] The record of a thirteenth-century English lawsuit implies that song rolls could be purchased and demonstrates that they were considered worth stealing but that they commanded a much lower price than codices: "A lady claims a missal worth twenty shillings, a manual worth 6s. 8d., and two rolls of songs worth sixpence and twopence respectively, which

1. See Mary A. Rouse and Richard H. Rouse, "Roll and Codex: The Transmission of the Works of Reinmar von Zweter," in *Authentic Witnesses: Approaches to Medieval Texts and Manuscripts* (Notre Dame, IN, 1991), 13–29.

2. Ibid., 13–16.

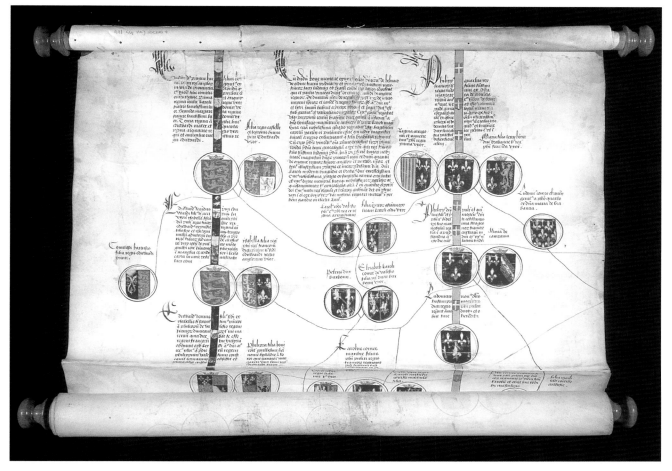

16-1 Roll of ca. 1465, tracing the genealogies of the kings of England and France.
Individuals are represented by their coats of arms. Newberry Library, MS 166.

were snatched from her on the king's highway between Boughton and her home at Wereham on Easter day 1282."[3]

Under some circumstances, rolls were more portable than codices; they could be stuffed in a bag to be carried on foot or on horseback. They could also be expanded easily, a characteristic that helps to account for the genre of the mortuary roll. Mortuary rolls were used by monasteries to announce the death of a significant member of their community and to request prayers on behalf of the soul of the deceased. The roll would be taken from one monastic house to another. Each house would add its promise to pray for the soul of the deceased and might also add the names of its own dead; additional sheets of parchment would be sewn to the end of the roll as required. A famous early example is the mortuary roll of Abbot Vitalis of Savigny (d. 1122), which within two years accumulated inscriptions from more than two hundred ecclesiastical institutions in France and England.[4] These rolls could be as much

as twenty meters long by the time they were complete. Early booklists from libraries such as Durham Cathedral in England were first written on rolls, of which only fragments survive today.[5] Important families and institutions (particularly abbeys) would often record their history on long, impressive rolls. While these were a deluxe production and the form as symbolic as it was practical, the roll format recommended itself for this purpose because of the ease with which the roll could be extended when new text was to be added.

In addition, rolls were superior to codices for depicting large, graphically complex images, such as genealogies. The roll format allowed the lines of descent to be depicted without break and could represent complex interrelationships better than the codex format would allow. Newberry Library MSS 166 and 132 are both roll genealogies, but they

3. Quoted ibid., 27.

4. See Léopold V. Delisle, *Rouleau mortuaire du b. Vital, abbé de Savigni, contenant 207 titres écrits en 1122–1123 dans différentes églises de France et d'Angleterre* (Paris, 1909), and N. R. Ker, *English*

Manuscripts in the Century after the Norman Conquest (Oxford, 1960), 16 and pls. 14–15.

5. See A. J. Piper, "The Libraries of the Monks of Durham," in *Medieval Scribes, Manuscripts and Libraries: Essays Presented to N. R. Ker*, ed. M. B. Parkes and Andrew G. Watson (London, 1978), 213–49, at 213–14 and pl. 58.

16-2 Roll genealogy of the kings of France from their mythical origins in the fifth century down to Louis XI (1461–83). Roundels contain images of churches and abbeys founded by the royal family. Newberry Library, MS 132.

of Burgundy (1467–77), who traced his lineage to Charlemagne's father, Pepin the Short. Unlike roll chronicles, MS 166 conveys its message more through images than text: the roundels with heraldic coats of arms, the royal lines of descent—blue on the left for England, yellow on the right for France—and thinner lines linking the roundels through blood or marriage. The text that accompanies each image is, in the majority of cases, genealogical; little history is given besides parentage and marriage.

Like MS 166, MS 132 is a genealogy roll, but it also incorporates a reign-by-reign chronicle into its format. Written in French, it depicts a single line of descent of the French kings from the mythical Pharamond in the fifth century to the fifteenth-century present; rather than using heraldic devices, the roll depicts churches and abbeys founded by French kings as symbols of devotion and power. In the portion of the roll covering pre-Christian history (seen in fig. 16-2), cities are represented as castles. This roll is made up of nine narrower sheets that have been pasted together with a strip of parchment providing support; the parchment itself is rougher and darker than that of MS 166. The illumination of MS 132 is muted—mostly tans, greens, and grays—although some of the initial letters are in dark blue and gold, the French royal colors. The original roll extended to Louis XI (1461–83) and so must be dated during his reign. It was then continued by another scribe, who included Charles VIII (1483–98) and Louis XII (1498–1515). Although the text is the predominant feature of the roll, the graphic layout is obviously important to convey the meaning of the text. The vertical bands suggest a single lineage and a divine order in the history of the royal house. The religious foundations that represent the kings and queens—in preference to other common forms of representation such as coats of arms or human figures—are iconic rather than realistic. As the scroll progresses, the churches and abbeys become more detailed and colorful, but although more colors are employed, the hue of the palette remains muted. The simple linear structure gives way to more complex trees and branches as there arises the need to represent more figures and more foundations. Stressing the buildings rather than heraldic emblems, the designer of this roll was concerned more with the relationship between royal and ecclesiastical power and perhaps less with the bloodlines that are such a prominent feature of MS 166. The rougher appearance, the length, and the language of MS 132 suggest it was a volume to be read. MS 166, by contrast, may have been hung to be viewed rather than read.

are markedly different, both in production and in purpose (see figs. 16-1 and 16-2). MS 166 is a fifteenth-century genealogical roll depicting the royal houses of France and England. The roll consists of two large pieces of parchment that have been pasted together by a third thin parchment strip. Although the roll is complete from top to bottom, there are lines of descent to expand the genealogy to collateral members of the house; these indicate that the scribe evidently planned additional panels at the sides, but it is not known whether these were ever written or, if they were, whether they survive. The prologue at the head of the roll praises Vincent of Beauvais (ca. 1190–1264), author of the well-known *Speculum historiale*; the compiler of the roll was perhaps seeking to claim the mantle of historical legitimacy as the literary successor of Vincent, for the genealogy on the roll begins at the point where Vincent's account of the French royal house leaves off, that is, in the late thirteenth century. The text itself is in Latin, written in the script known as *lettre bâtarde* (for which see chap. 10, fig. 10-13); a major purpose of the roll, as the preface makes clear, is to demonstrate the royal descent of Duke Charles the Bold

Evangelists, prophets, angels, and others are often depicted

uese beacæ nox quæ sepolecuu tzypseos. diæænuc

hébteos. nox Inquæ atsteris cælestï æ Iunguncuus ...

fæmus æt dominæ uct cstæus iste In honoæm nominisæu

consecæceuus. æd noecris hulus cælzginæm destfuæidæm

Indesicrus persicuefæt. & In odoæm suicruæteæss æcceptæus.

supætnus luminæcbbus miscæcuus

læmmæs sus lucisæt maccuccnus Inuæniæc. ille Inquæm

16-3 Exultet roll written in Beneventan script at the abbey of Montecassino, ca. 1072. Note that the image is upside down in relation to the text. London, British Library, MS Add. 30337.

16-4 English devotional roll of ca. 1400, containing the Middle English *Stations of Rome*. Newberry Library, MS 32.

holding rolls or streamers, called *banderoles*, inscribed with the individual's name or a message. In depictions of the Annunciation, the archangel Gabriel typically holds an unfurled roll, which often contains the opening words of his speech to the Virgin. Mary, on the other hand, is often depicted reading a book; the iconographic shift from roll to codex thus symbolizes the transition from old to new brought about by Christ's incarnation. The roll played an important part in other religious contexts. The Torah, for example, continues to be written in scroll form to the present day, as do individual books such as Esther, which were sometimes written on leather or parchment scrolls. In the Christian context, an important genre that emerged in southern Italy in the tenth and eleventh centuries was the Exultet roll, used for the rite of blessing the Paschal candle on Easter Saturday; the name comes from the opening words of the service, "Exultet iam angelica turba" (Let the angelic throng now rejoice). What is especially distinctive about these Exultet rolls is that they include illustrations that are upside down in relation to the text (see fig. 16-3). As the deacon recited the text, he would unfurl the roll over the edge of the lectern, so that the illustrations would then become visible, right way up, to the congregation.

A most interesting genre of devotional text popular in the late Middle Ages was the indulgence roll, inscribed with prayers whose recitation was said to confer remission of sins. These rolls were apparently hung in churches, where they would be visible to parishioners and visitors. One special form of indulgence roll, of which several examples survive, was the *Arma Christi* roll, which contained illustrations of the instruments of Christ's Passion (the crown of thorns, the lance, the sponge, and so on), with accompanying prayers focusing on each instrument. In this case, indulgence was conferred by merely contemplating the images. The *Arma Christi* rolls were evidently aimed at those who could not read; Rossell Hope Robbins has suggested that a priest or friar would display the roll by holding it up or by suspending it from a niche in the church wall or from the pulpit, the congregation gaining their indulgence by gazing at the roll while the priest described the instruments.[6] Newberry Library MS 32, a roll dating from about the year 1400, may have been used in a similar way (see fig. 16-4). It is related to the *Arma Christi* rolls in that it begins with a depiction of Christ on the Cross accompanied by the instruments of the Passion. Its text, however, is the Middle English *Stations of Rome*, which relates the churches and shrines in Rome, the relics to be found there, and the

6. See Rossell Hope Robbins, "The 'Arma Christi' Rolls," *Modern Language Review* 34 (1939): 415–21, at 419–20. For a Latin and Middle English prayer roll in the Pierpont Morgan Library (MS 486), ending with a sixteen-stanza vernacular poem on Christ's Passion, see Curt F. Bühler, "A Middle English Prayer Roll," *Modern Language Notes* 52 (1937): 555–62.

indulgences available for those traveling to the shrines, especially during the Lenten period. It reads very much like an itinerary, giving the distances between shrines in miles but never providing a map that would make deviation from the itinerary possible. It is composed of five membranes sewn together for a total length of 461 cm. The roll is rather narrow, only 10 cm wide, and as is usual for rolls, it is written on the flesh-side. Some care was evidently taken over the layout; each membrane contains exactly 167 lines of text.

Another devotional roll, Newberry Library MS 122, is about 4 cm wider than MS 32 but is only about 106 cm long (see fig. 16-5). Originally made in the mid- to late fifteenth century, it is now attached to two carved ivory spindles (probably added in the nineteenth century) to facilitate unrolling and rerolling as the reader progressed through the text. The roll contains a collection of Italian verse prayers praising St. Jerome (a seminal figure in late medieval Italian devotion); the text was written around 1447 by the Clarissan nun Battista da Montefeltro (1384–1448), who entered the order following the death of her husband after forty years of marriage. The feminine forms of the adjectives within the text indicate that MS 122 was used by a woman or group of women. This is the only surviving copy of Battista da Montefeltro's compositions in roll format; all other examples are in codices. It is also the only copy to include an illumination. This shows St. Jerome holding a stone against his chest in a gesture of penance, an iconography that contrasts with depictions of the saint that emphasize his scholarship and his activities as a translator (see figs. 4-24 and 13-1). The brown marks of wear around the illumination do not continue further down the roll, suggesting that the picture of Jerome may have been exposed to view while the rest of the document remained rolled up.

A *Genealogy of Christ* attributed to Peter of Poitiers (d. 1215) affords us the opportunity to see the same work as presented in both codex and roll formats. The codex (see fig. 16-6), from the second half of the fourteenth century, contains the vital information allowing a reader to follow the bloodline from Adam to Jesus and includes devices that help to link one page to the next. At the top of the illustrated page (fig. 16-6), the letters *a*, *g*, and *c* above the three leftmost lines of descent serve to tie these lines to their equivalents on the preceding page; however, the fourth line—the one leading to Esrom and his descendants—has been left unlabeled. Within the body of this page, there is no line linking the set of medallions extending from Moses down to Abimelech because the individuals named here (Joshua, Othniel, Ehud, Shamgar, Deborah, Gideon) did not represent a bloodline but rather were successively appointed to lead Israel. In the right-hand area of the page is a diagram of the forty-two houses of Israel, founded during the first, second, and third year in the desert, and below it a schematic representation of the tribes of Israel grouped

16-5 Italian roll containing prayers to St. Jerome, ca. 1350–1400. Newberry Library, MS 122.

around the tabernacle; this is oriented with south (*Meridies*) at the top. The symbols at the foot of the two left-hand text blocks direct the reader to the continuation of each column on the following page. The roll version of the text (fig. 16-7) avoids the multiple breaks of the codex, giving the reader a clearer sense of the descendants' lines, and the text is continuous. Both formats clearly served their purpose; each has elements that recommend it and certain inherent limitations.

One especially important and frequent use of the roll format was for administrative functions, particularly for judicial and accounting purposes. In England, many manor accounts were kept on continuous rolls, and there survives a thirteenth-century Florentine transcription of an account book in roll format.[7] The Newberry has in its collections a private Provençal cartulary roll made in the thirteenth century (see chap. 14, fig. 14-12) that was most likely written

7. For the Florentine example, see Arrigo Castellani, ed., *Nuovi testi fiorentini del Dugento con introduzione, trattazione linguistica e glossario*, 2 vols. (Florence, 1952), 2:207.

16-6 *Genealogy of Christ* attributed to Peter of Poitiers, in codex format. Italy, second
half of the fourteenth century. Newberry Library, MS 29, fol. 3r.

16-7 *Genealogy of Christ* attributed to Peter of Poitiers, in roll format. Southern
France, early thirteenth century. Newberry Library, MS 22.1.

for an individual.[8] The best-known and most thoroughly studied administrative rolls are the "great pipe rolls" of the English exchequer, the largest series of English public records in existence, covering a span of nearly seven hundred years from the middle of the twelfth century up until 1832. The practices of the exchequer are described in minute detail in the thirteenth-century treatise known as the *Dialogus scaccarii*, and the exchequer rolls have long been the subject of scholarly attention through their publication by the Pipe Roll Society, founded in 1883. The rolls are the written record of the annual audit of the royal accounts. The financial year ran from one Michaelmas (29 September) to the next; the audit would begin as soon as the financial year was over and could take up to ten months to complete. Pipe rolls have a particular format unlike that of other rolls (see fig. 16-8). The accounts were recorded on both sides of a number of *rotuli*, each of which consisted of two parchment membranes stitched together in the middle. All the *rotuli* for the year were then sewn together at the head and rolled up so that they resembled a length of pipe—thus the name. At the foot of the reverse side of each *rotulus* was entered a brief note or docket recording its content; these dockets are particularly useful because they can be read without much unrolling. The exchequer pipe rolls measure between about a meter and a meter and a half in length, and are about 35 cm wide. They bear the regnal year of the monarch who was in power at Michaelmas, regardless of whether he had only recently come to the throne; the roll for the first year of a new king therefore often contains much material from the last year of the preceding king. When stored, the rolls were normally covered with waxed parchment for protection.

Less often studied are local pipe rolls that recorded everything from the revenues and decisions of a county court to manorial accounts (called *compotus*). Figure 16-8 illustrates a local pipe roll now among the Bacon manuscripts in the Department of Special Collections of the University of Chicago Library (MS Bacon 24). The roll carries the record of court cases heard at the manor of Redgrave, Suffolk, between the years 1369 and 1377. The manor belonged to the abbey of Bury St. Edmunds, and dating is by reference to the year of the ruling abbot, in this case the ninth to sixteenth years of John Brinkley; some rolls in the series also include the regnal year, here the forty-third through fifty-first years of Edward III. The roll includes a brief sentence summarizing each case heard and a note of the fine to be collected by the court. There was wide variation in the size of the sheets used from year to year. The roll includes a total of twenty-nine sheets ruled in hardpoint down both right and left margins; the ruling on the right margin was used only if the reverse side of the sheet was written on.

The layout is simple: two columns, one for the summary of the case, the other for the fine assessed. Although there is no evidence of horizontal ruling, the lines of script are remarkably straight. The head of the roll contains the particulars about the date and place of the roll's composition, and that information is repeated in abbreviated form upside down on the back so that it could be read without opening the entire roll. The sheets for individual years are sewn together at their head with hemp thread; the pipe roll joins these sheets together with a parchment tag inserted through two large holes at the head of each sheet.

The survival of numerous rolls of varying formats and purposes, combined with evidence pointing to the loss or destruction of many rolls of a more ephemeral nature, offers convincing proof that, far from being eclipsed by the codex, the roll continued to perform a most important function in a variety of literary, devotional, genealogical, symbolic, and administrative contexts throughout the entire medieval period.

16-8 Pipe roll containing the record of county court cases heard at the manor of Redgrave, Suffolk, 1369–77. University of Chicago, Bacon MS 24.

8. William Paden, "A Notarial Roll in Latin and Occitan from Asprières (Aveyron), 1284, in the Newberry Library, Chicago," *Cultura Neolatina* 63 (2003): 7–55.

Tools for the Study of Medieval Latin
by Anders Winroth

INTRODUCTION

The minutiae of classical Latin have been studied at least since the Renaissance and are easily accessible in lexicographical, grammatical, and metrical handbooks. Medieval Latin, on the other hand, is less well researched, and complete, definitive handbooks do not exist. There are, however, preliminary surveys and several major projects in progress (although in some cases the progress is painfully slow). The present overview aims at surveying the most important handbooks that are available, with an eye toward giving practical advice.

As medieval Latin developed out of the Latin of antiquity, it is natural that scholars will primarily use dictionaries of classical Latin. The best and most comprehensive one-volume dictionary is the *Oxford Latin Dictionary* (*OLD*). This excellent reference tool has one significant drawback for the medievalist: it registers only words used before 200 AD and it excludes those Christian authors who lived before that date. *OLD* is, however, really useful for the classical words that survived into the Middle Ages—and they are many. The other large English-language dictionary of classical Latin, "Lewis and Short" (i.e., Charlton T. Lewis and Charles Short, *A New Latin Dictionary*), includes also later words but is now somewhat outdated and is sometimes imprecise. The medievalist must be very careful when using any of the smaller dictionaries, which often lead astray.

The first stop after the classical dictionaries is usually one of the four smaller dictionaries of postclassical Latin that cover the entire alphabet: Souter (*A Glossary of Later Latin to 600 A.D.*), Niermeyer (*Mediae latinitatis lexicon minus*), Blaise (*Lexicon latinitatis medii aevi praesertim ad res ecclesiasticas investigandas pertinens*), or Latham (*Revised Medieval Latin Word-List from British and Irish Sources*). One should note that each one of them has strengths and weaknesses in different subject areas. Souter is a dictionary of the Latinity of late antiquity but is very useful, since it explains many Christian words. Niermeyer and Blaise cover only the vocabulary of the early Middle Ages, while Latham includes also sixteenth-century words but not so many words used only during the early Middle Ages. Of course, most words used by, say, a fourteenth-century author would have been used also five hundred or one thousand years earlier, but some words will not be found in either Souter, Niermeyer, or Blaise. Even within the respective chronological limits, none of these dictionaries claims to contain the entire vocabulary. Niermeyer is oriented toward secular, political, legal, and administrative terms, while Blaise is more concerned with ecclesiastical and religious vocabulary. A reader of, e.g., Peter Abelard might thus prefer Blaise, while anyone studying a medieval cartulary would probably be more helped by Niermeyer. Latham covers all genres but is restricted to British and Irish sources. This does not mean that the dictionary is useless for understanding texts written elsewhere. Latin was an international language, and most of the vocabulary used

by a theologian writing in Britain, such as Anselm of Canterbury, would also have been used by a contemporary continental theologian, such as Anselm of Laon. Latham is, however, a "word list," which means that not all words are translated (if their meaning can be derived from a related word that has been translated) and that the translations given are sketchy.

It is important to note that these dictionaries give translations of words but do not indicate how they are construed (that is, they do not discuss the syntactical use of a word), which in an analytical language such as Latin is an issue of great importance. The word *astruo*, for example, is translated in Niermeyer as "argue," which in English can be used either transitively or intransitively. However, even in medieval Latin *astruo* is used only transitively (like "assert," which is a better English translation).

To get information about constructions and a more nuanced and detailed account of the meanings of words, the student should use one of the major dictionaries. Foremost among these is the *Thesaurus linguae latinae*, which aims at a very comprehensive survey of the Latin vocabulary up to 600 AD. It thus includes the vocabulary of most patristic texts, which heavily influenced medieval Latin. Syntactical and morphological developments during the Middle Ages are often foreshadowed here. The verb *immineo*, for example, lacks a perfect stem in classical Latin. The *Thesaurus*, however, registers two examples from late antiquity, which indicates that the form *imminerit* (appearing in two manuscript copies of a papal letter from the 1060s) really is a possible form. It does not have to be corrected to *immineat,* as has been done in the standard edition of this letter.[1] Unfortunately, the *Thesaurus* does not yet cover the end of the alphabet (after P), for which the only alternative, Forcellini's eighteenth-century dictionary, is much outdated and is not as good as the *Thesaurus* in covering late antique Latin.

Because of its obvious chronological limitations, the *Thesaurus* often cannot help the medievalist, who then must consult one of several dictionaries, depending on where in the alphabet the problematic word appears. The only modern pan-European dictionary of medieval Latin is the *Novum glossarium mediae latinitatis*, which covers the period 800–1200 for the letters L, M, N, O, and part of P. If the problematic word appears earlier in the alphabet, one should use either the *Mittellateinisches Wörterbuch* (only A, B, and part of C have hitherto been published) or the *Dictionary of Medieval Latin from British Sources* (the fascicles so far published cover the letters A–O and part of P). The former is in general more thorough and better for constructions, while the latter is rich in examples and good

1. The letter is no. 4470 in Philipp Jaffé, *Regesta pontificum Romanorum*, 2nd ed., 2 vols. (Leipzig, 1885–88), and is incorporated into Ivo of Chartres, *Decretum*, X.177, which is printed by J.-P. Migne in *Patrologia latina*, vol. 161, cols. 742–43.

on nuances of meaning. The *Dictionary of Medieval Latin* has the same chronological limits as Latham's *Word-List* and is thus especially useful for late medieval vocabulary; it is significantly stronger than the *Word-List* for the early medieval period. Of course these two dictionaries, the *Mittellateinisches Wörterbuch* and the *Dictionary of Medieval Latin*, cover the Latin vocabulary in Germany and Great Britain, respectively, but this by no means restricts their usefulness to texts from these countries. The *Wörterbuch* contains the entire philosophical vocabulary of Albertus Magnus and can thus be immensely useful also for the Latin of his student Thomas Aquinas, although Aquinas was Italian. The same reasoning can be applied also to dictionaries for even more peripheral countries. In fact, one should not give up the hope of being able to explain a problematic word before one has examined *all* national dictionaries that include the word in question. It is only a small class of Latin words that were not spread over all of Europe in the Middle Ages: Latinized versions of vernacular words, such as *schopa, -ae* (English "shop"), *bondo, -onis* (Swedish *bonde*, "farmer"), and *cosakus, -i* (Polish for "bandit").

Finally, there is Du Cange, *Glossarium ad scriptores mediae et infimae latinitatis*, which many scholars avoid as long as possible. This still unsurpassed dictionary can be frustrating to use but is a veritable gold mine of information. It explains words by giving definitions in "humanistic" Latin, which can sometimes be at least as hard to understand as the word for which one is seeking a translation. There are occasionally translations into French, either medieval French or seventeenth-century French. The dictionary was first published in 1678 but was reedited numerous times. In most cases the different editors added material, which was always placed at the end of the article, usually with some kind of typographical indication. Each article thus consists of different layers, each one of which has a logical structure, while the article as a whole lacks such structure. However, Du Cange also has real advantages compared with more modern compilations. First, it covers the entire alphabet and does not have any chronological restrictions. (As the title indicates, it also covers postmedieval Latin.) Second, it provides a very full treatment of every word, providing not only linguistic but also encyclopedic information. The article on *treuga*, for instance, goes on for several columns and contains a survey, although outdated, of the history of the *treuga Dei* (truce of God). Similarly, Du Cange can be very useful for expressions consisting of two or more words. One may compare the quite short article on *lex* in the *Novum glossarium* with that in Du Cange. The former explains only a handful of the many compounds that the latter furnishes. *Lex paribilis* ("ordeal") is, for example, explained only in Du Cange.[2]

If one is looking for a very unusual word and no dictionary comes to help (which is especially common for the last part of the alphabet, Q–Z, which is not treated in any full-sized modern dictionary of medieval Latin), the last resort is to be one's own lexicographer. The many available databases of medieval Latin texts (such as *CETEDOC, Index Thomisticus,* and the electronic *Patrologia Latina*) can be searched for the word in

2. The adjective *paribilis* is overlooked in the *Novum glossarium*, although it is found in texts from the period between 800 and 1200.

question and the resulting set of examples may provide otherwise unobtainable information about meaning and syntactical usage.

THE LEXICOGRAPHICAL MAINSTAYS

For most translation of medieval Latin, the following dictionaries should be sufficient. Use them when whatever dictionary you might own yourself does not help.

Glare, P. G. W., ed. *Oxford Latin Dictionary*. Oxford, 1968–82. Covers A–Z. Contains the entire Latin vocabulary to 200 AD, except for specifically Christian terminology. Includes a selection of proper names. This dictionary should be the first port of call when looking up a problematic word.

Souter, A. *A Glossary of Later Latin to 600 A.D.* Oxford, 1949. Covers A–Z. This dictionary covers new Latin vocabulary from 200 to 600. It is especially useful for looking up most basic ecclesiastical words. Most "nonstrange" words in medieval Latin may be found here.

Niermeyer, J. F., and C. van de Kieft. *Mediae latinitatis lexicon minus.* 2nd ed. Revised by J. W. J. Burgers. Leiden, Neth., 2002. Covers A–Z. Definitions of words are in English, French, and German. The dictionary is strong on juridical and institutional vocabulary, less comprehensive on philosophic, scientific, and literary vocabulary. (Most words encountered in the volumes of *Monumenta Germaniae Historica* and similar works may be found here.) Covers the period 500–1150. Contains only nonclassical words and meanings. Note that verbs appear under their infinitive forms. Niermeyer was a great institutional and social historian, so this dictionary is especially helpful for words in those fields.

Blaise, Albert. *Lexicon latinitatis medii aevi praesertim ad res ecclesiasticas investigandas pertinens.* Turnhout, Belg., 1975. Covers A–Z. Definitions are in French. Contains only nonclassical words and senses, especially Christian vocabulary. Nicely complements Niermeyer.

Latham, R. E. *Revised Medieval Latin Word-List from British and Irish Sources.* London, 1965. Covers A–Z. Covers texts written up until the second half of the sixteenth century. This dictionary is a good place to start for the more unusual words found in medieval Latin. Definitions are in English. The usefulness of the dictionary is certainly not restricted to British and Irish sources.

Latham, R. E., and David R. Howlett, eds. *Dictionary of Medieval Latin from British Sources.* London, 1975–. Currently covers A–Pel. This dictionary is very comprehensive and good on the meanings of words. In structure and layout it resembles the *Oxford Latin Dictionary*. It is still in progress.

Lewis, Charlton T., and Charles Short. *A New Latin Dictionary*. New York, 1879, with many subsequent editions. Not as good as it is often made out to be, but it is very widely diffused and is better than the *Oxford Latin Dictionary* on Christian terms.

THE PROBLEM SOLVERS

Sometimes the mainstays do not help, and one must have recourse to the great multivolume works of Latin lexicography.

Thesaurus linguae latinae. Leipzig, 1900–. Currently covers A–Pius, Porta–Protego. This great work, which is still in progress, is a general inventory of the Latin vocabulary before 600. Explanations are in Latin. *TLL* offers a strict linguistic perspective and is extremely good at explicating nuances of meaning (and their development) and syntactical constructions. It often provides the final answer to the really difficult questions, but it can also be rather daunting to use (starting with the sheer weight of the volumes). Do not overlook the *Index librorum scriptorum inscriptionum ex quibus exempla afferuntur* (2nd ed., Leipzig, 1990), which lists all the works forming the basis for *TLL*. The *Index* is in itself an invaluable work, since it gives bibliographical details for editions of Latin writers before 600 and is a great resource for finding editions of unusual works.

Forcellini, Egidio. *Totius latinitatis lexicon*. 1771. New ed., 1864–87. Reprint, Padua, 1940. Covers A–Z. Useful especially for the last letters of the alphabet, to which the *Thesaurus linguae latinae* does not yet extend.

Du Cange, Charles du Fresne. *Glossarium ad scriptores mediae et infimae latinitatis*. Paris, 1678. New ed. Niort, 1883–87. Reprint, Paris, 1937–38, and Graz, Aus., 1954. Covers A–Z. A classic, still very useful. Explanations are in (humanistic) Latin. Contains only nonclassical words and senses. Verbs are entered under their infinitive forms. Later editions contain supplementary material that was added by other scholars at the end of the articles. The structure of specific articles is therefore often illogical. The work also contains much factual information about the things signified by the word. The *Glossarium* can sometimes be a good starting point for research on obscure institutional and other points.

Arnaldi, Francesco, and Franz Blatt, eds. *Novum glossarium mediae latinitatis ab anno DCCC usque ad annum MCC*. Copenhagen, 1900–. Currently covers L-Pezzola. Known as "New Du Cange." Contains the entire Latin vocabulary found in every type of text from the period 800–1200, including words already used in classical Latin. Definitions and explanations are in French. Unusually, the work does not start with A but in the middle of the alphabet. Do not overlook the *Index scriptorum novus mediae latinitatis ab anno DCCC usque ad annum MCC qui afferuntur in novo glossario* (Copenhagen, 1973), and *Supplementum* (Copenhagen, 1989). These books list the texts that form the basis of the *Novum glossarium*, with references to editions.

HELP WITH THORNY PROBLEMS

There are a number of specialized dictionaries, encompassing either a particular genre (legal texts, philosophical texts, etc.) or a particular geographical area. Many of them are being compiled as collections of materials for the "New Du Cange." Note that all these specialized dictionaries can be useful also for texts not falling within their particular area of focus. Useful examples include the following:

Balon, Joseph. *Grand dictionnaire de droit du Moyen Âge*. Namur, Belg., 1972–74. Covers A–Charon. Legal terms defined in French, with ample examples.

Mittellateinisches Wörterbuch bis zum ausgehenden 13. Jahrhundert. Munich, 1959–. Currently covers A–Coniugium. Covers the entire vocabulary in texts written in central Europe (not only today's Germany) from the fifth century to 1280 (the date of the death of Albertus Magnus). Definitions are in Latin and German. Very comprehensive and exact; very good on constructions.

For further national dictionaries, see the list posted on the website of the Académie des Inscriptions et Belles-Lettres at http://www.aibl.fr/fr/travaux/medieval/ducange.html.

THE GRAMMAR OF MEDIEVAL LATIN

Elliot, Alison Goddard. "A Brief Introduction to Medieval Latin Grammar." In *Medieval Latin*, edited by K. P. Harrington, revised by Joseph Pucci, 1–51. Chicago, 1997. A good, brief introduction.

Stotz, Peter. *Handbuch zur lateinischen Sprache des Mittelalters*. Munich, 1996–2004. The only really thorough treatment of the grammar of late Latin and medieval Latin. Written in German and published in five volumes covering vocabulary, semantics, phonology, and syntax (the fifth volume comprising a bibliography, list of sources, and index). The wealth of information is so great that this is not a good place to go for a quick answer. It is easier to use if one has a Latin school grammar to hand, since it presupposes good knowledge of the grammar of classical Latin.

Hofmann, J. B., and Anton Szantyr. *Lateinische Syntax und Stilistik*. Munich, 1965. Serves as a supplement to Stotz on syntax. Is the most detailed grammatical handbook available for Latin in general, with decent coverage of medieval features, but is no easier to use than Stotz.

GENERAL INTRODUCTIONS TO THE LANGUAGE

McGuire, Martin R. P. *Introduction to Mediaeval Latin Studies*. Washington, DC, 1964. A detailed and very useful bibliography rather than an introduction.

Norberg, Dag. *Manuel pratique de latin médiéval*. Paris, 1968. Perhaps the best modern introduction to the medieval Latin language, providing the fullest treatment. The emphasis is on the early medieval period; the book is particularly strong on meter and prose rhythm. The commentaries on the examples contain much value and should not be overlooked.

Rigg, A. G., and F. A. C. Mantello, eds. *Medieval Latin: An Introduction and Bibliographical Guide*. Washington, DC, 1996. Includes essays by experts on many different genres of medieval Latin texts, with extensive bibliography on each subject area.

Strecker, Karl, and R. B. Palmer. *Introduction to Medieval Latin*. Berlin, 1957. Brief but useful.

Traube, Ludwig. *Einleitung in die lateinische Philologie des Mittelalters*. Edited by Paul Lehmann. Munich, 1911. Reprint, 1965. A classic, still very useful.

Glossary

This glossary provides brief definitions of technical terms used in this book as well as of some terms that do not occur here but that the reader may encounter in other books on manuscript studies. Any words within the definitions that appear in SMALL CAPITALS have their own entries in the glossary. More extensive glossaries may be found in Michelle P. Brown, *Understanding Illuminated Manuscripts: A Guide to Technical Terms* (London, 1994); Olga Weijers, ed., *Vocabulaire du livre et de l'écriture au moyen âge* (Turnhout, Belgium, 1989); and Bernhard Bischoff, G. I. Lieftinck, and Giulio Battelli, *Nomenclature des écritures livresques du IXe au XVIe siècle* (Paris, 1954).

ACANTHUS In the context of manuscript decoration, a conventionalized representation of the fleshy leaf of the acanthus plant.

ALUM-TAWED SKINS Skins soaked in an alum potash solution (often with the addition of salt, egg yolks, and—if color was desired—dye). The alum preserved the skin and allowed it to be flexible. Alum-tawed skins were often used for the covers of medieval bookbindings.

ASCENDER The part of the vertical stroke of a letter that rises above the HEADLINE. In MINUSCULE script, the letters *b*, *d*, *f*, *h*, *k*, *l*, and tall *s* all have ascenders. See also DESCENDER.

ASPECT The general appearance of a SCRIPT.

ATELIER The workshop or studio of an artist. The term applies both to the physical location and to the personnel working under the artist's direction and in his style.

AUTOGRAPH A manuscript written in the author's own HAND.

AZURITE A blue PIGMENT made from copper carbonate. Also known as copper blue.

BANDS See CORDS.

BAR The horizontal stroke between the OBLIQUES of *A* and the UPRIGHTS of *H*. Also called crossbar.

BASELINE The writing line, the ruled line on which the scribe enters text and below which the DESCENDER of a letter extends. See also HEADLINE.

BASTARD A CURSIVE script to which formal elements have been added to make it suitable for use as a BOOKHAND. See also HYBRID.

BEVELED BOARDS See CHAMFERED BOARDS.

BIANCHI GIRARI See WHITE VINE-STEM DECORATION.

BIFOLIUM A single sheet of PARCHMENT folded in half to yield two LEAVES.

BINDING MEDIUM An ingredient that binds the constituents of a PIGMENT together and makes it adhere to the surface to be decorated. In the Middle Ages, gum arabic and egg white (GLAIR) were the usual binding media.

BITING LETTERS Consecutive letters whose BOWS overlap with a shared stroke, such as *æ*. Biting letters are frequent in Gothic scripts.

BLIND TOOLING A technique for decorating the binding of a manuscript in which a design is made on the surface of the cover with a heated metal tool and is left uncolored.

BOARDS The rectangular cuts of wood used to make the front and back covers of a CODEX. The type of wood used varied by region, but boards were often made of oak in the north and beech in the south. The boards were normally covered by prepared animal skins (see ALUM-TAWED SKINS).

BOLE A clay, reddish or brownish in color, used as a colorant in GESSO to impart undertones to GOLD LEAF laid on top of it.

BOOKHAND A formal SCRIPT in which the pen was lifted from the page between the individual strokes of each letter. Bookhands were meant to be aesthetically appealing and are usually easier to read than CURSIVE scripts.

BOSS A raised, round metal fitting applied to a book cover to protect the book when it was laid flat. Typically, bosses were applied to the four corners and the center of both the front and back cover.

BOUNDING LINES The ruled vertical lines that set the boundaries of a column of SCRIPT.

BOW The closed curve of the letters *b*, *d*, *g*, *p*, and *q*. Also called lobe.

BROKEN STROKE The stroke of a letter that is made when the scribe changes the direction of the pen without lifting it from the writing surface.

BUILT-UP INITIAL An INITIAL executed in INK, with its individual parts thickened by the use of several pen strokes. Built-up initials were often used at sentence beginnings in manuscripts of the twelfth century.

BURNISHING The process of enhancing the smoothness and brightness of a metal surface such as GOLD LEAF by rubbing it with a burnishing tool such as a dog's tooth mounted in a handle.

CANON TABLE A chart that allowed quick comparison of common and unique elements of the four Gospels.

CAPITALS Large letters, usually of different formation than the smaller letters of a SCRIPT.

CAROLINE A The form of the letter *a* found in CAROLINE MINUSCULE and based on the UNCIAL version of the letter; the same form is used today in Times New Roman font.

The letter consists of a STEM at the right with a closed LOBE attached to its lower left side; the top of the stem turns to the left.

CAROLINE MINUSCULE A SCRIPT developed in the late eighth century, during the reign of Charlemagne, king of the Franks (768–814). It is noted for its clarity, especially when compared with pre-Caroline scripts. Also known as Carolingian minuscule.

CARTOUCHE An ornamental figure that serves as the frame for either an inscription or a coat of arms. The cartouche is usually in the form of an oval, a shield, or a scroll and may be surrounded by ornamentation.

CATCHWORD A word written at the bottom of the last page of a QUIRE that matches the first word of the next quire. Catchwords were used to facilitate the binding of quires in their proper order. Also called stitchword, *Stichwort*, guide-word, or direction word.

CAUTIO A pledge note entered in a manuscript when it was pawned for money.

CHAINED BOOK A book attached to a lectern, desk, or book-case with a chain long enough to permit reading of the book while preventing theft.

CHAIN-LINES The vertical lines visible in paper, made by the vertical wires of the papermaker's mold. Chain-lines are more widely spaced than the horizontal LAID-LINES.

CHAMFERED BOARDS BOARDS of a bookbinding on which the edges have been cut at an angle to give them a slope. Also called beveled boards.

CHANCERY The department in a governing organization (papacy, royal court, etc.) in which documents, especially charters, were made.

CHARTERHAND A SCRIPT used specifically to produce char-ters. In the case of the papal chancery, this is a unique hand found only in papal documents. Outside the papal chancery, there was greater variation in the composition of the script.

CHEMISE A slip-on cover placed over or attached to the bind-ing of a book. Chemises were made variously of leather or of a textile such as linen or velvet; the edges of the che-mise often extended far beyond the edge of the book so that they could be wrapped around it to offer additional protection.

CHIROGRAPH A document consisting of two (or more) iden-tical copies written on a single sheet of parchment. The document was divided with either a straight or a jagged cut through the word *chirographum*, which was written across the sheet, between the copies. One copy would be given to each of the parties involved in the agreement attested by the document, and the document could subsequently be verified by bringing the copies together again.

CHRYSOGRAPHY Writing in gold letters, either by using gold ink, produced by mixing powdered gold with a BINDING MEDIUM, or by mordant gilding, a technique that involved first writing the letters in gum or GLAIR, then applying GOLD LEAF.

CLASP A mechanism for holding a book shut, popular from the fourteenth century. The clasp consisted of fittings that were mounted at the FORE-EDGE of the front and back covers and that could be fastened together. See also STRAP AND PIN.

CLOTHLET A piece of cloth that has been saturated with an organic PIGMENT, both to preserve the pigment and in some cases to intensify its color.

CLUBBED ASCENDER An ASCENDER that is thickened at the top, giving it a blunt or "clubbed" appearance.

CODEX Originally meaning a tree trunk, a word later used to designate a set of wooden writing boards linked together. It then became the common term for any materials bound together in book form.

CODICOLOGY The study of the physical aspects and structure of a book, including the material on which it is written, its COLLATION, its PRICKING and RULING, and the manner in which the book was bound.

COLLATION The description (diagrammatic or written) of the physical structure of a book: the number of its QUIRES and the arrangement of the leaves within the quires.

COLOPHON An inscription, entered usually at the end of a book, providing such information about its production as the name of the scribe, the place where the book was made, and the date of its completion.

CONCLUDING TITLE The title or statement that comes at the end of a text. Usually rubricated and typically beginning with the word *Explicit*, the concluding title was often fol-lowed immediately by the OPENING TITLE of the next text in the book.

CONJOINT LEAVES Two leaves that are attached to one an-other, i.e., the two leaves of a BIFOLIUM. Also called con-jugate leaves.

CONJUGATE LEAVES See CONJOINT LEAVES.

CONSTRUE MARKS Marks placed above or below the words of a passage of text (usually a Latin text) to make it easier for the reader to construe the passage. One system involved placing letters of the alphabet above the words of a Latin text to help the reader reconfigure the words in a more eas-ily understood order.

CONTRACTION An abbreviation that includes the first and last letters of a word, and perhaps some letters in between, with the other letters omitted. Contractions were used es-pecially for the NOMINA SACRA. See also SUSPENSION.

COPPER BLUE See AZURITE.

CORDS The supports onto which the QUIRES of a manu-script are sewn at the time of binding. Cords were typically made of HEMP or of ALUM-TAWED SKIN; often they were split along most of their length so that the needle could be passed through them, not just around them. When all the quires had been sewn to the cords, the loose ends were at-tached to the BOARDS of the binding by passing them through channels cut in the wood and pegging them in place. In a bound book, the cords are visible as raised bands beneath the covered spine of the book. Also referred to as bands or thongs.

CORNERPIECE A metal plaque attached to the outside corners of both back and front covers of a book to protect it from damage. Found on many late medieval bindings.

CROSSBAR See BAR.

CROSS-STROKE The center stroke of the letters *E* and *F*. Also called hasta.

CUE INITIAL A letter that a scribe entered discreetly on a page to signal to a rubricator or artist the INITIAL that

should be entered in the area left blank for the purpose. The cue initial was normally entered either in the margin or in the blank area; in the latter case it would be covered by the colored initial entered by the artist. Also called guide letter or *lettre d'attente*.

CURSIVE A SCRIPT in which letters are formed without lifting the pen between strokes. A cursive script can therefore be written more rapidly, and is more informal, than a BOOKHAND.

CUTTING Material cut from a manuscript, often MINIATURES or HISTORIATED INITIALS, sometimes glued into scrapbooks or otherwise reconfigured.

DECKLE The removable wooden frame of a papermaker's mold.

DECKLE-EDGE The edge of the paper that has not been cut and so retains a fine, feathery edge.

DENTELLE A decorative pattern tooled (usually in gold) onto the leather cover of a binding. Also used to describe the patterning of the decorative borders of some late medieval manuscripts.

DESCENDER The part of the vertical stroke of a letter that extends below the BASELINE, as in the letters *p* and *q*. See also ASCENDER.

DEVICE A figure or design, often accompanied by a motto, used by individuals or groups as a mark of either ownership or production.

DIGRAPH Two letters written as one. A common digraph is *æ*.

DIMINUENDO A gradual decrease in the size and level of embellishment of letters, often used at the beginning of INSULAR manuscripts to make the transition from a large opening INITIAL to the standard text SCRIPT.

DIPHTHONG Two vowels that are voiced as one sound.

DIPLE A mark placed in the margin of a manuscript to draw attention to a noteworthy passage of text or to identify a quotation, usually a quotation from scripture. The diple normally took the form of a sideways V (>) or a comma-shaped mark.

DIRECTION WORD See CATCHWORD.

DISPLAY SCRIPT A decorative SCRIPT often used in early medieval manuscripts, along with a decorated INITIAL, to emphasize and embellish the opening of a text. The display script may use letter forms of a higher grade than the regular text script.

DISTINCTIO In the DISTINCTIONES system, a mark consisting of a single point placed at the height of the top of the preceding letter, used to indicate the end of a sentence.

DISTINCTIONES A system of punctuation that originally used a single point placed at different heights to indicate the value of the mark. In a later adaptation, the value was indicated by the number of marks used. See also DISTINCTIO, MEDIA DISTINCTIO, and SUBDISTINCTIO.

DITTOGRAPHY A common type of scribal error in which a scribe copied a passage of text twice as a result of the same word's occurring twice: having reached the second occurrence of the word, the scribe looked back to the first occurrence in the EXEMPLAR and erroneously recopied the passage. The opposite error is EYESKIP.

DOWNSTROKE A downward stroke of the pen.

DRYPOINT A technique involving the use of a metal or bone stylus to make marks on the page. Manuscripts were ruled in drypoint in the early Middle Ages, and the technique was also used for glossing (see GLOSS) and for making preliminary sketches of decorative elements (INITIALS and MINIATURES). Also known as hardpoint.

DUCTUS The way in which a SCRIPT is written; its speed and care of execution.

DUODECIMO See FOLIO.

E-CAUDATA An *e* written with a hook below it, where classical Latin would use *ae*.

ENDLEAF A leaf at the front or back of a book, between the binding and the manuscript proper. Endleaves served to protect the text; usually blank when they were placed in the book, they often acquired miscellaneous notes, PEN TRIALS, and marks of PROVENANCE. Also called flyleaf.

EXEMPLAR A book from which a copy is made.

EX LIBRIS INSCRIPTION See OWNERSHIP INSCRIPTION.

EXPLICIT The closing words of a text.

EXPUNCTION See SUBPUNCTION.

EYESKIP A common type of scribal error in which the scribe omitted to copy a passage as a result of his eye's skipping from one occurrence of a word or phrase in the EXEMPLAR to a subsequent occurrence of the same word or phrase. Also called *saut du même au même*. See also HAPLOGRAPHY, HOMOEOARCTON, and HOMOEOTELEUTON. The opposite error is DITTOGRAPHY.

FINIAL See SERIF. The decorative terminal of an INITIAL may also be called a finial.

FLAKE-WHITE See LEAD WHITE.

FLAT-TOPPED G A form of the letter *g* found in HALF-UNCIAL script and adopted in INSULAR scripts. The upper portion of the letter, instead of having a closed BOW, ends at the top with a horizontal HEADSTROKE.

FLESH-SIDE The side of a sheet of PARCHMENT that originally faced inward on the animal. It is usually lighter in color than the HAIR-SIDE.

FLYLEAF See ENDLEAF.

FOLIO A leaf of PARCHMENT or PAPER, of which the two sides are respectively the RECTO and the VERSO. Manuscript pages are normally (but not always) referred to by folio numbers rather than page numbers. Thus folio 1r refers to the recto side of the first leaf, folio 1v to its verso side. In catalogue descriptions, the term *folio* may describe the size of a book, indicating that the leaves have the dimensions of a single sheet of parchment folded in two; additional folds yield sizes known as quarto, octavo, and duodecimo.

FOLIUM A purple PIGMENT produced from the seeds of the herb turnsole.

FORE-EDGE The outer edge of a book, opposite the spine.

FOXING The spotted brownish discoloration sometimes found on the pages of PAPER books.

FRONTISPIECE An image at the front of a book, before the opening of the text.

FULL BINDING A binding in which the entire outer surface of the BOARDS is covered with a single material, usually leather. See also HALF BINDING, QUARTER BINDING.

GALLNUT A rounded excrescence that is produced on the bark of an oak tree when a gall wasp lays its eggs in the

tree. The resulting growth is high in tannic acid and is used in the preparation of iron-gall INK. Also called oak gall.

GATHERING See QUIRE.

GESSO A thick, water-based preparation made from plaster of Paris or gypsum, commonly used as an underlay in GILDING. Imparts depth to gilded images and helps to make gilded surfaces suitable for BURNISHING.

GILDING The process of applying thin metal (usually GOLD LEAF or SILVER LEAF) to a surface.

GIRDLE BOOK A book that could be carried by suspending it from a belt or girdle worn around the body. The binding of a girdle book usually had extra material extending beyond the bottom of the BOARDS; the end of the material was gathered in a Turk's head knot that could be slipped under the girdle.

GLAIR Clarified egg white, frequently used in the Middle Ages as a BINDING MEDIUM.

GLOSS A comment on the text, typically entered either in the interline above the word or phrase to which it refers or in the margin.

GOLD LEAF Gold that has been beaten very thin for use in decoration. In manuscript ILLUMINATION, gold leaf was normally laid on a base of GLAIR or GESSO and then burnished (see BURNISHING).

GRISAILLE Monochrome painting in shades of gray. The technique was popular in manuscript art of the fourteenth century, having been used, for example, by Jean Pucelle.

GUIDE LETTER See CUE INITIAL.

GUIDEWORD See CATCHWORD.

GUTTER The fold area of a BIFOLIUM, where it meets the spine in a bound book.

HAIRLINE STROKE The narrowest stroke of the pen, produced by drawing the nib sideways across the page.

HAIR-SIDE The side of a sheet of PARCHMENT that originally faced outward on the animal. It is usually darker than the FLESH-SIDE, often bearing visible hair follicles.

HALF BINDING A style of binding in which just the spine, the inner area, and the four corners of the BOARDS are covered with a material (usually leather). The rest of the boards may be either covered with another material or left bare. See also FULL BINDING, QUARTER BINDING.

HALF-SHEET See SINGLETON.

HALF-UNCIAL A MINUSCULE script popular from the fifth to the eighth century. In its INSULAR form it was used for copying the text of such manuscripts as the Lindisfarne Gospels and the Book of Kells.

HAND The SCRIPT or style of writing of an individual scribe.

HAPLOGRAPHY A common scribal error in which the scribe copied a sequence of letters once when they should have been copied twice: for example, *tinnabulum* instead of *tintinnabulum*. See also EYESKIP, HOMOEOARCTON, and HOMOEOTELEUTON.

HARDPOINT See DRYPOINT.

HASTA See CROSS-STROKE.

HEADLINE The line that serves as the upper boundary for letters of MINIM height, and above which ASCENDERS extend. In most manuscripts there is no actual ruling for the headline, but in some early deluxe manuscripts both the headline and the BASELINE were ruled.

HEADSTROKE The top horizontal stroke of letters such as *f* and *t*.

HEMP A plant whose fibers are used to make string or rope. Hemp was often the material used for the CORDS onto which the QUIRES of a manuscript were sewn and for attaching seals to charters.

HERSE The frame on which a parchment maker hangs a skin to dry under tension.

HISTORIATED INITIAL An INITIAL containing a scene including human or other figures.

HOMOEOARCTON An error of scribal omission caused when two words in close proximity in the exemplar have the same letters at the beginning.

HOMOEOTELEUTON An error of scribal omission caused when two words in close proximity in the exemplar have the same letters at the end.

HYBRID A type of SCRIPT that results when a BOOKHAND has acquired CURSIVE elements. See also BASTARD.

ILLUMINATION The process of decorating a manuscript with bright colors, in particular with gold and silver, which reflect the light. A MINIATURE may also be called an illumination.

INCIPIT The opening words of a text.

INCUNABLE A book printed before 1500. The term derives from the Latin *in cunabula* (in the cradle), referring to the infancy of the art of printing.

INITIAL An enlarged letter, often decorated, that marks the beginning of a new section within a text. See also BUILT-UP INITIAL, HISTORIATED INITIAL, LITTERA NOTABILIOR, PEN-FLOURISHED INITIAL.

INK The term derives from the Latin *encaustum* or *incaustum*, meaning "burned in." Ink is made from acidic ingredients that eat their way into the surface of the page. See also GALLNUT and LAMPBLACK.

INK LAKE A stained area of a page where the INK has become wet and has run.

INSULAR A term referring to the cultural nexus of the British Isles (Ireland, England, Wales, and Scotland) in the early medieval period, from ca. 550 to ca. 900.

KERMES A red PIGMENT made from the larvae of insects of the *Kermes* genus.

LAID-LINES The horizontal lines visible in PAPER, made by the horizontal wires of the papermaker's mold. Laid-lines are more numerous and are set closer together than the vertical CHAIN-LINES.

LAMPBLACK A type of INK made from a mixture of dense carbon (usually obtained by scraping the carbon off a metal object placed in the flame of a candle), gum, and water.

LAPBOARD A flat board that a scribe could lay on his or her knees and use as a substitute for a writing desk.

LEAD POINT See PLUMMET.

LEAD WHITE A white PIGMENT produced from the crust formed on strips of lead when suspended above acidic vapor in the presence of carbon dioxide. Also known as flake-white.

LEAF/LEAVES Single sheets of PARCHMENT or PAPER.

LECTIO DIFFICILIOR Literally, the "more difficult reading." Used as a principle in textual criticism to decide between variant readings; based on the idea that the less common

word is more likely to be correct, as scribes copying a text would be more prone to change a less common word to a more common one than vice versa.

LETTRE D'ATTENTE See CUE INITIAL.

LIGATURE Strictly, the connective line joining one letter to another, but the term is frequently used to mean a combination of two or more letters joined to one another in a way that modifies the form of one or more of them. Ligatures are very frequent in pre-Caroline scripts, but in CAROLINE MINUSCULE are normally restricted to the combinations *ct*, *et*, *rt*, and *st*.

LIMB The curved stroke attached to the upright of the letter *h*.

LIMP VELLUM BINDING A style of binding without wooden BOARDS. Instead, the body of the book was attached to a cover of VELLUM by lacing the SEWING SUPPORTS through the cover. Limp vellum bindings were often used as covers for less expensive books in the late Middle Ages.

LINE FILLER A device used by scribes and artists to fill up blank space at the end of a line to preserve the justified right margin. Line fillers may be entered in regular INK or colored PIGMENT and may consist of simple forms, such as MINIMS, or more decorative forms; they are common in high-status Gothic manuscripts but are also found earlier.

LITTERA NOTABILIOR A "more noticeable" letter, a letter that is larger or more decorative than the standard text letters. Used at text openings and to mark the beginnings of sections and subsections within a text.

LOBE See BOW.

LOW-SET F A form of the letter *f* in which the CROSS-STROKE rests on the BASELINE and the STEM descends below the baseline. The form occurs in UNCIAL script and was taken over into INSULAR scripts.

LOW-SET S A form of *s* of which the basic shape is that of a TALL S but which descends below the BASELINE.

LUNELLUM The blade used by a parchment maker to scrape any remaining hair, fat, and flesh off a skin while it is suspended on a HERSE. The name derives from the crescent shape of the blade.

MACRON A horizontal line placed above a letter or group of letters to indicate an abbreviation.

MAJUSCULE A SCRIPT in which all the letters are the same height. Also called a bilinear script because all the letters fit between the HEADLINE and the BASELINE.

MALACHITE A green PIGMENT made from copper carbonate.

MANICULA A small sketch of a hand with the index finger extended, entered in the margin of a book by a reader to draw attention to a significant passage of text.

MEDIA DISTINCTIO In the DISTINCTIONES system, a mark consisting of a single point placed at the height of the middle of the preceding letter, used to indicate a pause of medium value.

MEMBRANE A generic term used to refer to all forms of animal skin that have been prepared to receive writing.

MINIATURE An illustration within a manuscript. The term derives from *minium*, the Latin word for the RED LEAD pigment in which manuscript decoration was once executed.

MINIM The short vertical stroke used to make the letters *i*, *n*, *u*, and *m* in MINUSCULE scripts. The letter *i* has a single minim (and had no dot above it in medieval scripts; originally consisting of a minim alone, the letter was topped with a diagonal slash from the thirteenth century); the letters *n* and *u* are each made up of two minims, linked respectively at the top and the bottom; and the letter *m* is made up of three minims. The word *minim* itself consists of ten minims.

MINIUM See RED LEAD.

MINUSCULE A SCRIPT in which some of the letters have ASCENDERS and DESCENDERS, so that not all letters are of the same height.

MISE-EN-PAGE The layout of a page; the manner in which text and decoration are entered on the page.

MODEL BOOK A book containing designs and patterns that could serve as models for artists.

MONUMENTAL CAPITALS See SQUARE CAPITALS.

MORDANT GILDING. See CHRYSOGRAPHY.

MOSAIC GOLD A gold-colored PIGMENT made from tin disulfide, often used in the late Middle Ages as a substitute for gold. Also called musive gold.

MUREX PURPLE See TYRIAN PURPLE.

NOMINA SACRA Literally "holy names," the names of the Deity, which in manuscripts were regularly abbreviated by CONTRACTION. The singular is *nomen sacrum*.

NOTARIAL SCRIPT A rapid, CURSIVE script used by notaries for transcribing documents, especially charters.

OAK GALL See GALLNUT.

OBLIQUES Letter strokes made at an angle, such as those in *A*, *V*, and *W*.

OCTAVO See FOLIO.

OFFSET The term used to refer to text or decoration entered on one page that has transferred to the facing page, producing a mirror image. Offset can result either from the simple pressure of one page upon the other while the book is shut or from the pages having once been pasted together.

OPENING The two pages of a book that are visible when the book is opened at any point.

OPENING TITLE The title at the head of a text within a manuscript. The title was normally rubricated (see RUBRICATION) and often began with the word *Incipit*. See also CONCLUDING TITLE.

OPTIMIST METHOD A method of textual editing in which the editor selects one manuscript as the best and bases the edited text on that manuscript. Sometimes called the Bédier method because of its association with French textual scholar Joseph Bédier (1864–1938). See also RECENSIONIST METHOD.

ORPIMENT A yellow PIGMENT made of arsenic trisulfide.

OTIOSE STROKE An unnecessary stroke, usually decorative, that is not part of the structure of the letter.

OWNERSHIP INSCRIPTION An inscription, entered usually at the front of a book, that records the institution to which or individual to whom the book belonged. Also called an *ex libris* inscription.

PALEOGRAPHY The science of the study of handwriting. The aims of paleography are to read scripts accurately and to date and localize them.

PALIMPSEST A reused writing support from which the original text has been removed by scraping and a new text

entered in its place. Derived from a Greek term meaning "scraped again."

PAPER A writing support made from macerated fibrous material. Paper produced in Europe in the late Middle Ages was made from macerated rags.

PAPYRUS An ancient writing support made from the papyrus plant, native to Egypt.

PARAPH A symbol (such as ¶) used by scribes to indicate the beginning of a new paragraph or section of a prose text or a new stanza of a poem.

PARCHMENT A generic term referring to an animal skin that has been prepared to receive writing.

PASTEDOWN A leaf that is pasted to the inner surface of the BOARD of a binding to hide the channeling of the CORDS into the board. Sometimes the pastedown was one leaf of a BIFOLIUM, with the other leaf serving as a protective ENDLEAF.

PECIA SYSTEM A method of book production used in some universities to facilitate the copying of books required in the curriculum. The separate QUIRES, or *peciae*, of an unbound EXEMPLAR were hired out to scribes for copying piecemeal.

PEN-FLOURISHED INITIAL An INITIAL embellished with decorative pen strokes that extend down the margin of the page. Pen-flourished initials were especially popular in manuscripts of the Gothic period; often, a red initial would be decorated with blue flourishes and vice versa.

PEN TRIAL A scribe's test of a newly trimmed pen. The pen trial often consisted of letters of the alphabet, a name, or a brief quotation from a text such as the Psalms. Scribes often entered pen trials in the margins or other blank areas of a manuscript, including the ENDLEAVES. Also called *probatio pennae*.

PER COLA ET COMMATA A type of layout used in some early manuscripts of the Vulgate. Including no marks of punctuation, the text was laid out with each sense unit beginning on a new line.

PIGMENT A coloring agent produced by the combination of organic or inorganic materials with a BINDING MEDIUM.

PIPPIN A small, round pebble around which a parchment maker wraps the edge of an animal skin in order to protect the skin from tearing when it is attached to the HERSE with cord.

PLUMMET A lead point regularly used for RULING manuscripts and for UNDERDRAWINGS from the later eleventh century onward. Leaves a faint, grainy, grayish or reddish line on the page.

POSITURAE A system of punctuation employing the PUNCTUS, PUNCTUS ELEVATUS, PUNCTUS FLEXUS, PUNCTUS INTERROGATIVUS, and PUNCTUS VERSUS.

POUNCING The word has two quite different meanings in relation to manuscript studies. (1) It may refer to the process of smoothing a sheet of PARCHMENT by rubbing it with pumice. (2) Pouncing was also a method for duplicating an illustration. The artist would place a sheet of PARCHMENT or PAPER under the illustration to be copied, pricking around the contour of the illustration so that the pricks pierced the lower sheet. The sheet was then removed and laid on top of another page; powder rubbed over it passed

through the prickings onto the page below. To produce the new illustration, the artist connected the dots left by the powder on the lower page.

PRESSMARK See SHELFMARK.

PRICKING The process of making holes in a sheet of PARCHMENT in preparation for its RULING. The lines were then made by ruling between the prick marks.

PROBATIO PENNAE See PEN TRIAL.

PROVENANCE The history of ownership of a book. Types of evidence that can attest to provenance include OWNERSHIP INSCRIPTIONS and SHELFMARKS.

PULP The slurry of water and macerated rags used to make PAPER.

PUNCH A metal die used to impart a decorative element, usually to the leather covers of bindings.

PUNCTUS A punctuation mark consisting of a single point, like a modern period. In the POSITURAE system, the *punctus* was first used to indicate a minor pause but later was also used to mark sentence endings.

PUNCTUS ELEVATUS In the POSITURAE system, a punctuation mark used to indicate a pause of medium value. The mark consisted of a single point with a checklike mark above it.

PUNCTUS FLEXUS In the POSITURAE system, a mark whose value fell between the PUNCTUS used to indicate a minor pause and the PUNCTUS ELEVATUS. It consisted of a single point with a circumflex-like mark above it.

PUNCTUS INTERROGATIVUS In the POSITURAE system, a mark used to indicate a question. It consisted of a single point with a mark resembling an inverted sideways *S* above it.

PUNCTUS VERSUS In the POSITURAE system, a mark used at sentence endings until it was replaced for this purpose by the simple PUNCTUS. Its form resembled that of a modern semicolon.

PURPLE See FOLIUM, TYRIAN PURPLE.

QUARTER BINDING A style of binding in which just the spine and the inner area of the BOARDS are covered with a material (usually leather). The rest of the boards may be covered with another material or may be left bare. See also FULL BINDING, HALF BINDING.

QUARTER-SAWN Describes wood that has been cut in a certain way to produce the BOARDS of a binding. A pie-shaped section is first cut from the wood; the boards are then cut from this section. This technique reduces the tendency of the boards to warp.

QUARTO See FOLIO.

QUATERNION A QUIRE of four sheets folded to form eight LEAVES.

QUINION A QUIRE of five sheets folded to form ten LEAVES.

QUIRE A group of LEAVES gathered together as a unit. Most quires consist of several (usually four or five) BIFOLIA folded one inside the other, but many quires also include one or two SINGLETONS. Also called a gathering.

REAGENT A chemical (such as hydrophosphate of ammonia) applied to a page of SCRIPT to make faded or damaged text more legible.

RECENSIONIST METHOD A method of textual editing in which the editor seeks to establish the earliest recoverable

form of a text through painstaking examination of all the surviving manuscripts. Sometimes called the Lachmann method because of its association with German philologist and textual critic Karl Lachmann (1793–1851). See also OPTIMIST METHOD.

RECTO The front side of a leaf of PARCHMENT or PAPER. See also VERSO.

RED LEAD A red PIGMENT produced by firing LEAD WHITE. Red lead was commonly used in manuscripts for RUBRICATION as well as for coloring decorated INITIALS and MINIATURES. Also called minium.

RETTING The process of fermenting PULP to make PAPER.

RINCEAUX A form of decoration commonly used in the borders of late medieval manuscripts and consisting of scrolling stems with leaves and flowers.

ROLL A manuscript that is made by pasting or sewing together sheets of PAPYRUS or PARCHMENT joined in a vertical orientation; the manuscript is rolled up for storage and unrolled as it is read. In the Middle Ages, rolls were usually sewn together with HEMP thread or parchment. See also SCROLL.

ROUNDED D See UNCIAL D.

ROUNDEL A round panel that contains decoration or an image.

ROUND R A form of the letter r resembling an arabic numeral 2, originally used only when r followed o, but in Gothic scripts frequently used whenever r followed a letter with a BOW. Also called 2-shaped r.

ROUND S The form of the letter s that resembles the modern letter. See also LOW-SET S, TALL S.

RUBRICATION The process of providing a manuscript with titles written in red. The medium normally used for rubrication was RED LEAD.

RULING The process of entering ruled lines on the page to serve as a guide for entering the text. Most manuscripts were ruled with horizontal lines that served as the BASELINES on which the text was entered and with vertical BOUNDING LINES that marked the boundaries of the columns; a few manuscripts were also ruled with HEADLINES. Until the thirteenth century, scribes entered the first line of text above the top ruled line; thereafter they entered it below the top line, that is, on the second ruled line. Until the late eleventh century, ruling was in DRYPOINT; thereafter it was in PLUMMET, although INK (including colored ink) was used in some manuscripts of the thirteenth century and later. Drypoint ruling was revived by the humanists of the fifteenth century.

RUSTIC CAPITALS A MAJUSCULE script that was the principal BOOKHAND used for copying literary texts in antiquity. Regularly used from the first to the sixth century and revived for certain Anglo-Saxon and Carolingian manuscripts in the eighth and ninth centuries, thereafter it was quite commonly used for the rubricated titles and the opening words of texts up until the twelfth century.

SAP GREEN A green PIGMENT produced from ripe buckthorn berries.

SAUT DU MÊME AU MÊME See EYESKIP.

SCRIPT A particular form or style of handwriting. Scripts may be categorized broadly as MAJUSCULE and MINUSCULE, BOOKHAND and CURSIVE, or more narrowly as particular styles such as RUSTIC CAPITALS, UNCIAL, HALF-UNCIAL, CAROLINE MINUSCULE, Protogothic, and Gothic.

SCRIPTIO CONTINUA See SCRIPTURA CONTINUA.

SCRIPTORIUM The room in a monastery or church set aside for the copying of manuscripts.

SCRIPTURA CONTINUA A method of copying a text used in late antiquity in which the scribe left no spaces between words. Also called scriptio continua.

SCROLL A manuscript that is made of sheets of PARCHMENT joined together in a horizontal orientation, unlike a ROLL, which is rolled and unrolled vertically.

SCUDDING The process of removing hair from an animal skin with a long, curved, two-handled blade.

SERIF The finishing stroke at the beginning or end of a letter. Also called a finial.

SEWING STATIONS The points in the GUTTER of the leaves through which the needle is passed to sew the QUIRES of a manuscript to the CORDS.

SEWING SUPPORTS See CORDS.

SHELFMARK An inscription entered in a book to show where it was shelved. The shelfmark normally consists of a combination of letters and numbers identifying both the bookcase and the shelf on which the book was stored; some also identify the position on the shelf that the book occupied. Also called a pressmark.

SHELL GOLD A gold PIGMENT produced by mixing powdered gold with gum. The pigment was often mixed in a shell—hence its name. It was applied with a brush or pen.

SHOWTHROUGH The term used when text or decoration entered on one side of a leaf can be seen from the other side.

SIGLUM The designator (often a single letter of the alphabet) that an editor assigns to a manuscript to aid quick referencing. Plural sigla.

SIGNE-DE-RENVOI A symbol that, when paired with a matching symbol, serves to direct a reader's attention from one part of a page to another. Signes-de-renvoi were typically used to link a correction or GLOSS entered in the margin with the point in the text to which it related: one mark would be entered at the beginning of the correction or gloss, the other over the appropriate point in the text. Also called a tie-mark.

SILVER LEAF Silver that has been beaten very thin, for use in decoration.

SINGLE-COMPARTMENT A A form of a in which the letter consists of just one closed compartment. See also TWO-COMPARTMENT A.

SINGLETON A single leaf within a QUIRE. Many quires include one or two singletons in addition to BIFOLIA. Also called a half-sheet.

SIZING The process whereby PAPER was dipped in size, usually made of gelatin produced by boiling PARCHMENT or leather, rendering the paper more stiff and less absorbent in preparation for writing.

SQUARE CAPITALS The formal MAJUSCULE script used for inscriptions on stone in antiquity, when it was also occasionally employed for copying literary texts. In medieval manuscripts square capitals were sometimes used for titles. Also called monumental capitals.

STAMPED BINDING A binding decorated with a pattern embossed on the cover by means of an engraved stamp or panel.

STAMPER A wooden pestle or hammer, often tipped with iron or bronze, used to macerate rags in the preparation of PULP to make PAPER.

STATIONER The official in a university who had oversight over the production of textbooks.

STEM The upright portion of a letter that supports another part—for example, the left stroke of *h*.

STEMMA CODICUM The "family tree" that an editor draws up to express in tabular form the postulated interrelationships between the different manuscripts (both surviving and lost) of a particular text.

STICHWORT See CATCHWORD.

STITCHWORD See CATCHWORD.

STRAIGHT-BACKED D The form of the letter *d* found in CAROLINE MINUSCULE and still used today, the STEM of the letter being straight and vertical. See also UNCIAL D.

STRAP AND PIN A mechanism for keeping a book shut, first found in the twelfth century. A small metal plate with a raised pin was placed in the center of one BOARD while a long leather strap was attached to the other board. The strap ended in a metal fixture pierced with a hole that could fit over the pin. In England and parts of France the strap was attached to the front board with the pin on the back board; elsewhere the arrangement was reversed. See also CLASP.

STYLUS A pointed implement, usually made of metal or bone, used for writing on WAX TABLETS and for entering DRY-POINT RULING, GLOSSES, and UNDERDRAWINGS in manuscripts. The stylus often had a flat head that could serve for smoothing the wax in preparation for reuse.

SUBDISTINCTIO In the DISTINCTIONES system, a mark consisting of a single point placed on the BASELINE, used to indicate a minor pause.

SUBPUNCTION A method of correction that involved placing dots under letters that the reader should ignore. Also called expunction.

SUSPENSION An abbreviation in which one or more letters are omitted at the end of a word. Some suspensions are syllabic; that is, letters are omitted at the end of the individual syllables of a word. See also CONTRACTION.

TACKETING A method used by some scribes to keep the leaves of a QUIRE together during the process of writing: thread or a thin strip of PARCHMENT was passed through the gathered leaves, usually in the upper inner corner. The term also refers to the method used to secure a LIMP VELLUM BINDING to a book.

TALL S The form of *s* used in CAROLINE MINUSCULE and other SCRIPTS. The letter resembles an *f* without the CROSS-STROKE.

TANNING A method used to turn animal skins into leather. The method involved soaking the skins in a solution containing tannin (usually from organic sources such as oak trees) for between three months and a year. An alternative method was tawing (see ALUM-TAWED SKINS).

TERMINUS AD QUEM In dating, indicates the date that is the latest possible at which an event could have occurred.

TERMINUS ANTE QUEM Indicates the date before which an event must have occurred.

TERMINUS ANTE QUEM NON Indicates the date before which an event cannot have occurred.

TERMINUS A QUO Indicates the date that is the earliest possible at which an event can have occurred.

TERMINUS POST QUEM Indicates the date after which an event must have occurred.

TERMINUS POST QUEM NON Indicates the date after which an event cannot have occurred.

THONGS See CORDS.

THUMB-SCORING A method of marking one's place in a book by using the thumbnail to score the page.

TIE-MARK See SIGNE-DE-RENVOI.

TIPPED IN The term used to describe a leaf that has been inserted into a book after the book was bound; usually such a leaf was held in place by pasting its inner edge to the adjacent leaf.

TIRONIAN NOTES A system of shorthand said to have been invented by Cicero's secretary M. Tullius Tiro. Some Tironian symbols were used in medieval abbreviations; the most common of these was the symbol resembling the arabic numeral 7 used to represent the word *et*.

TOOLING See BLIND TOOLING.

TRAILING-HEADED A A form of the CAROLINE A in which the upper stroke of the letter extends farther to the left than the closed lower portion. The form is found in English manuscripts of the twelfth century, when *a* falls in the word-initial position.

TURN-INS The edges of the leather cover of a book that are turned over the edges of the BOARDS and secured (usually by pasting) to the inner surface of the boards.

TWO-COMPARTMENT A A form of CAROLINE A in which the upper portion is not open but makes a closed compartment, like the lower portion. Found in the late medieval English SCRIPT known as Anglicana.

TYRIAN PURPLE Purple dye or PIGMENT produced from a gland found in certain types of mollusk. Also known as *murex* purple.

ULTRAMARINE A highly prized blue PIGMENT made from lapis lazuli.

UNCIAL The most popular BOOKHAND in use from the fifth century to the eighth. The SCRIPT is basically MAJUSCULE in character, although certain of its letters rise above the HEADLINE or descend below the BASELINE.

UNCIAL D A form of the letter *d* in which the ASCENDER is not straight and vertical but curves back toward the left. Also called rounded *d*.

UNDERDRAWING A preliminary sketch that served as a guide for the final image drawn or painted by an artist. In early manuscripts, up until the eleventh century, the underdrawing was usually in DRYPOINT; thereafter, PLUMMET and diluted INK were commonly used.

UPRIGHTS Vertical letter strokes, such as the left and right STEMS of *H*.

UPSTROKE An upward stroke of the pen.

UTERINE VELLUM A soft, very thin vellum prepared from the skin of unborn or stillborn calves. Some manuscripts

formerly believed to have been made of uterine vellum are now thought to consist of regular vellum that was split to produce two sheets from a single thickness.

VELLUM A writing material prepared from calfskin. Sometimes, however, the term is used generically to refer to writing material prepared from any animal skin. See also LIMP VELLUM BINDING.

VERDIGRIS A green PIGMENT produced by mixing copper filings with vinegar and other ingredients, or by hanging strips of copper above hot vinegar and scraping off the green crust that forms on the copper.

VERMILION A red PIGMENT produced from mercuric sulfide.

VERSO The reverse or back side of a LEAF of PARCHMENT or PAPER. See also RECTO.

VIRGULA SUSPENSIVA A punctuation mark consisting of a forward slash (/), used in the fourteenth, fifteenth, and sixteenth centuries to mark a minor pause.

VOLVELLE A revolving wheel made of PARCHMENT or PAPER secured to the page by a thread or string. The volvelle was usually attached to a page that carried a scientific table in circular format (for example, a table about the movement of the planets). By revolving the wheel, the user could obtain information from the table.

WATERMARK An identifying image in a sheet of PAPER. The watermark was produced by attaching a DEVICE to the screen of a papermold.

WAX TABLETS Tablets frequently used in antiquity and the Middle Ages for taking notes and drafting texts. Made variously of wood, bone, or ivory that was partly hollowed out, the tablet was filled with wax and written on with a STYLUS. When the text on the tablet was no longer required, the wax could be smoothed over and written on again.

WHITE VINE-STEM DECORATION A style of decoration popular in fifteenth-century manuscripts written in humanistic SCRIPT, used for both INITIALS and borders. Also called *bianchi girari* when describing borders.

YAPP EDGE A term used to describe a binding in which the VELLUM cover extended somewhat beyond the edge of the BOARDS. The FORE-EDGES of the cover could then be turned in toward one another and might be tied together with strings attached to them, thus protecting the leaves when the book was not in use.

Bibliography

PART 1: MAKING THE MEDIEVAL MANUSCRIPT

GENERAL

Bennett, H. S. "The Production and Dissemination of Vernacular Manuscripts in the Fifteenth Century." *The Library*, 5th ser., 1 (1947): 167–78.

Bischoff, Bernhard. *Latin Palaeography: Antiquity and the Middle Ages*. Translated by Dáibhí Ó Cróinín and David Ganz. Cambridge, 1990.

Boyle, Leonard E. *Medieval Latin Palaeography: A Bibliographical Introduction*. Toronto, 1984.

Brownrigg, Linda L., ed. *Making the Medieval Book: Techniques of Production*. Los Altos Hills, CA, 1995.

———. *Medieval Book Production: Assessing the Evidence*. Los Altos Hills, CA, 1990.

Clanchy, Michael. *From Memory to Written Record: England 1066–1307*. 2nd ed. Oxford, 1993.

Clement, Richard W. "A Survey of Antique, Medieval, and Renaissance Book Production." In *Art Into Life: Collected Papers from the Kresge Art Museum Medieval Symposia*, edited by Carol Garrett Fisher and Kathleen L. Scott, 9–28. East Lansing, MI, 1995.

De Hamel, Christopher. *A History of Illuminated Manuscripts*. Oxford, 1986.

———. *Scribes and Illuminators*. Medieval Craftsmen Series. Toronto, 1992.

Doyle, A. I., and M. B. Parkes. "The Production of Copies of the *Canterbury Tales* and the *Confessio Amantis* in the Early Fifteenth Century." In *Medieval Scribes, Manuscripts and Libraries: Essays Presented to N. R. Ker*, edited by M. B. Parkes and A. G. Watson, 168–210. London, 1978.

Friedman, John B. *Northern English Books, Owners and Makers in the Late Middle Ages*. Syracuse, 1995.

Griffiths, Jeremy, and Derek Pearsall, eds. *Book Production and Publishing in Britain 1375–1475*. Cambridge, 1989.

Hindman, Sandra, and James Douglas Farquhar. *Pen to Press: Illustrated Manuscripts and Printed Books in the First Century of Printing*. College Park, MD, 1977.

Putnam, George Haven. *Books and Their Makers during the Middle Ages: A Study of the Conditions of the Production and Distribution of Literature from the Fall of the Roman Empire to the Close of the Seventeenth Century*. 2 vols. 1896–97. Reprint, New York, 1962.

Roberts, C. H., and Skeat, T. C. *The Birth of the Codex*. London, 1983.

Robinson, Pamela R., and Rivkah Zim, eds. *Of the Making of Books: Medieval Manuscripts, Their Scribes and Readers. Essays Presented to M. B. Parkes*. Brookfield, VT, 1997.

Rouse, Richard H., and Mary A. Rouse. "The Commercial Production of Books in Late-Thirteenth-Century and Early-Fourteenth-Century Paris." In *Medieval Book Production: Assessing the Evidence*, edited by Linda L. Brownrigg, 103–15. Los Altos Hills, CA, 1990.

Shailor, Barbara A. *The Medieval Book Illustrated from the Beinecke Rare Book and Manuscript Library*. Medieval Academy Reprints for Teaching 28. Toronto, 1991.

Vezin, Jean. "La réalisation matérielle des manuscrits latins pendant le haut Moyen Âge." *Codicologica* 2 (1978): 15–51.

Wattenbach, Wilhelm. *Das Schriftwesen im Mittelalter*. 3rd ed. 1896. Reprint, Graz, Aus., 1958.

CHAPTER 1: WRITING SUPPORTS

Papyrus

Turner, E. G. *Greek Papyri: An Introduction*. 1968. Reprint, Oxford, 1980.

Metal

Brashear, William. "À propos des tablettes magiques." In *Les tablettes à écrire de l'Antiquité à l'Époque Moderne*, edited by Élisabeth Lalou, 149–58. Bibliologia 12. Turnhout, Belg., 1992.

Wax

Büll, Reinhard. *Das grosse Buch vom Wachs: Geschichte, Kultur, Technik*. 2 vols. Munich, 1977.

———. *Literarische und experimentelle technologische Studien über Wachsbeschreibstoffe unter besonderer Berücksichtigung der Giessener Wachsschreibtafeln*. Giessen, Ger., 1969.

Büll, Reinhard, Ernst Moser, and Hermann Kuhn. "Wachs als Beschreib- und Siegelstoff, Wachsschreibtafeln und ihre Verwendung." In *Vom Wachs-Hoechster: Beiträge zur Kenntnis der Wachse*. Vol. 1, pt. 9, 785–894. Frankfurt, 1968.

du Méril, Edelstand. "De l'usage non interrompu jusqu'à nos jours des tablettes de cire." *Revue archéologique*, new ser., 2 (1860): 1–16, 91–100.

Grassmann, Antjekathrin. "Das Wachstafel-Notizbuch des mittelalterlichen Menschen." In *Zur Lebensweise in der Stadt um 1200: Ergebnisse der Mittelalter-Archäologie. Bericht über ein Kolloquium in Köln, 1984*, edited by Heiko Steuer, 223–35. *Zeitschrift für Archäologie des Mittelalters*, Beiheft 4. Cologne, 1986.

Hughes, T. McKenny. "On Some Waxed Tablets Said to Have Been Found at Cambridge." *Archaeologia* 55 (1897): 257–82.

Lalou, Élisabeth. "Inventaire des tablettes médiévales et présentation générale." In *Les tablettes à écrire de l'Antiquité à*

l'Époque Moderne, edited by Élisabeth Lalou, 233–88. Bibliologia 12. Turnhout, Belg., 1992.

———. "Les tablettes de cire médiévales." *Bibliothèque de l'École des Chartes* 147 (1989): 123–44.

Lalou, Élisabeth, and Robert Henri Bautier. *Les comptes sur tablettes de cire de la Chambre aux Deniers de Philippe III le Hardi et de Philippe IV le Bel: 1282–1309*. Paris, 1994.

Marichal, Robert. "Les tablettes à écrire dans le monde romain." In *Les tablettes à écrire de l'Antiquité à l'Époque Moderne*, edited by Élisabeth Lalou, 166–85. Bibliologia 12. Turnhout, Belg., 1992.

O'Connor, Sonia, and Dominic Tweddle. "A Set of Waxed Tablets from Swinegate, York." In *Les tablettes à écrire de l'Antiquité à l'Époque Moderne*, edited by Élisabeth Lalou, 307–22. Bibliologia 12. Turnhout, Belg., 1992.

Slate

Bliss, A. J. "The Inscribed Slates at Smarmore." *Proceedings of the Royal Irish Academy* 64 (1965): 33–60.

Díaz y Díaz, Manuel C. "Un document privé de l'Espagne wisigothique sur ardoise." *Studi medievali* 1 (1960): 52–71.

Mundó, A. M. "Pizarra visigoda de la época de Khindasvinto 642–649." In *Festschrift Bernhard Bischoff zu seinem 65. Geburtstag*, edited by Johanne Autenrieth and Franz Brunhölzl, 81–89. Stuttgart, 1971.

Wood

Bowman, A. K., and J. D. Thomas. *Vindolanda: The Latin Writing Tablets*. Britannia Monograph 4. London, 1983.

Courtois, C., L. Leschi, C. Perrat, and C. Saumagne. *Tablettes Albertini*. Arts et Métiers Graphiques. Paris, 1952.

Hope, Colin A. "Three Seasons of Excavation at Ismant el-Gharab in Dakhleh Oasis, Egypt." *Mediterranean Archaeology* 1 (1988): 160–78.

Jenkinson, Hilary. "Exchequer Tallies." *Archaeologia* 62 (1911): 367–80.

———. "Medieval Tallies, Public and Private." *Archaeologia* 74 (1925): 289–353.

Painter, Kenneth. "A Roman Writing Tablet from London." *British Museum Quarterly* 31 (1966): 101–10.

Sharpe, John Lawrence III. "The Dakhleh Tablets and Some Codicological Considerations." In *Les tablettes à écrire de l'Antiquité à l'Époque Moderne*, edited by Élisabeth Lalou, 127–48. Bibliologia 12. Turnhout, Belg., 1992.

Thomas, J. David. "The Latin Writing-Tablets from Vindolanda in North Britain." In *Les tablettes à écrire de l'Antiquité à l'Époque Moderne*, edited by Élisabeth Lalou, 203–9. Bibliologia 12. Turnhout, Belg., 1992.

Paper

Basanoff, Anne. "L'emploi du papier à l'Université de Paris 1430–1473." *Bibliothèque de l'humanisme et Renaissance* 26 (1964): 305–25.

———. *Itinerario della carta dall'oriente all'occidente e sua diffusione in Europa*. Milan, 1965.

Blum, André. *On the Origin of Paper*. Translated by Harry Miller Lydenberg. New York, 1934.

Hills, Richard. "Early Italian Papermaking: A Crucial Technical Revolution." *IPH Congressbook* 9 (1992): 37–47.

Hunter, Dard. *Papermaking: The History and Techniques of an Ancient Craft*. 2nd ed. New York, 1947.

Le Clert, Louis. *Le papier: Recherches et notes pour servir à l'histoire du papier, principalement à Troyes et aux environs depuis le quatorzième siècle*. Paris, 1926.

Lopez, Robert. "The English and the Manufacture of Writing Materials in Genoa." *The Economic History Review* 10/2 (1940): 132–37.

Watermarks

Bayley, Harold. *A New Light on the Renaissance Displayed in Contemporary Emblems*. 1909. Reprint, New York, 1967.

Briquet, C.-M. *Les filigranes: Dictionnaire historique des marques du papier dès leur apparition jusqu'en 1600*. 2nd ed. 4 vols. Leipzig, 1923. Reprinted with supplementary material in C.-M. Briquet. *Les filigranes*. Edited by Allan Stevenson. 4 vols. Amsterdam, 1968.

Krisch, William. "The *raison d'être* of Mediaeval Papermarks." *Baconiana* 1/3 (1903): 225–35.

Mošin, V. A., and S. M. Traljič. *Filigranes des XIIIe et XIVe siècles*. 2 vols. Zagreb, 1957.

Piccard, Gerhard. *Wasserzeichen*. Veröffentlichungen der Staatlichen Archivverwaltung Baden-Württemberg, Sonderreihe: Die Wasserzeichen Piccard im Hauptstaatsarchiv Stuttgart. 17 vols. in 25 parts. Stuttgart, 1961–97.

Parchment and Its Preparation

Brown, T. J. "The Distribution and Significance of Membrane Prepared in the Insular Manner." In *La paléographie hébraïque médiévale*, 127–35. Paris, 1974. Reprinted in *A Palaeographer's View: The Selected Writings of Julian Brown*, edited by Janet Bately, Michelle P. Brown, and Jane Roberts, 125–39. London, 1993.

Clarkson, Christopher. "Rediscovering Parchment: The Nature of the Beast." In *Conservation and Preservation in Small Libraries*, edited by Nicholas Hadgraft and Katherine Swift, 75–96. Cambridge, 1994.

Johnson, Richard R. "Ancient and Medieval Accounts of the 'Invention' of Parchment." *California Studies in Classical Antiquity* 3 (1970): 115–22.

Reed, R. *Ancient Skins, Parchments and Leathers*. London, 1972.

Rück, Peter, ed. *Pergament: Geschichte, Struktur, Restaurierung, Herstellung*. Sigmaringen, Ger., 1991.

Ryder, Michael L. "Parchment: Its History, Manufacture and Composition." *Journal of the Society of Archivists* 2 (1964): 391–99.

Säxl, Hedwig. "Histology of Parchment." In *Technical Studies in the Field of the Fine Arts*, 3–9. Boston, 1939.

Thompson, Daniel V. "Medieval Parchment Making." *The Library*, 4th ser., 16 (1935): 113–17.

Vorst, Benjamin. "Parchment Making: Ancient and Modern." *Fine Print* 12 (1986): 209–11, 220–21.

Quire Formation

Bozzacchi, Giampero, and Marco Palma. "La formazione del fascicolo nel codice altomedievale latino: Ipotesi e verifiche sperimentali." *Scrittura e civiltà* 9 (1985): 325–36.

Gilissen, Léon. "La composition des cahiers: Le pliage du parchemin et l'imposition." *Scriptorium* 26 (1972): 3–33.

Gregory, C. R. "Les cahiers des manuscrits grecs." *Comptes rendus de l'Académie des Inscriptions et Belles-Lettres*, 4th ser., 13 (1885): 261–68.

Irigoin, Jean. "Les cahiers des manuscrits grecs." In *Recherches de codicologie comparée: La composition du codex au Moyen Âge en Orient et en Occident*, edited by Philippe Hoffmann, 1–20. Paris, 1998.

Lieftinck, G. I. "Mediaeval Manuscripts with 'Imposed' Sheets." *Het Boek*, 3rd ser., 34 (1960–61): 210–20.

Pollard, Graham. "Notes on the Size of the Sheet." *The Library*, 4th ser., 22 (1941–42): 105–37.

Sirat, Colette. "Pour quelle raison trouve-t-on au Moyen Âge des quinions et des quaternions? Une tentative d'explication." In *Recherches de codicologie comparée: La composition du codex au Moyen Âge en Orient et en Occident*, edited by Philippe Hoffmann, 137–52. Paris, 1998.

Pricking

Jones, L. W. "Ancient Prickings in Eighth-Century Manuscripts." *Scriptorium* 15 (1961): 14–22.

——. "Pricking Manuscripts: The Instruments and Their Significance." *Speculum* 21 (1946): 389–403.

——. "Prickings as Clues to Date and Origin: The Eighth Century." *Medievalia et Humanistica* 14 (1962): 15–22.

——. "Pricking Systems in New York Manuscripts." In *Miscellanea Giovanni Mercati*. Vol. 6, 80–92. Studi e testi 126. Vatican City, 1946.

——. "Where Are the Prickings?" *Transactions and Proceedings of the American Philological Association* 75 (1944): 71–86.

Ruling

Coveney, Dorothy K. "The Ruling of the Exeter Book." *Scriptorium* 12 (1958): 51–55.

Gilissen, Léon. "Un élément codicologique trop peu exploité: La réglure." *Scriptorium* 23 (1969): 150–62.

——. *Prolégomènes à la codicologie*. Ghent, Belg., 1977.

——. "Les réglures des manuscrits: Réflexions sur quelques études récentes." *Scrittura e civiltà* 5 (1981): 231–52.

Pattie, T. S. "The Ruling as a Clue to the Make-up of a Medieval Manuscript." *British Library Journal* 1 (1975): 15–21.

Tschichold, Jan. "Non-Arbitrary Proportions of Page and Type Area." In *Calligraphy and Palaeography: Essays Presented to Alfred Fairbank on His 70th Birthday*, edited by A. S. Osley, 179–91. New York, 1966.

CHAPTER 2: TEXT AND DECORATION

Writing and Rubrication

Avrin, Leila. *Scribes, Script, and Books: The Book Arts from Antiquity to the Renaissance*. Chicago, 1991.

Boyle, Leonard E. "The Nowell Codex and the Poem of *Beowulf*." In *The Dating of Beowulf*, edited by Colin Chase, 23–32. Toronto Old English Series 6. Toronto, 1981.

De Hamel, Christopher. *Scribes and Illuminators*. Medieval Craftsmen Series. Toronto, 1992.

Destrez, Jean. "L'outillage des copistes du XIIIe et du XIVe siècles." In *Aus der Geisteswelt des Mittelalters: Studien und Texte Martin Grabmann zur Vollendung des 60. Lebensjahres von Freun-

den und Schülern gewidmet*, edited by Albert Lang et al. Vol. 1, 19–34. Münster, Ger., 1935.

Gilissen, Léon. "Un élément codicologique méconnu: L'indication des couleurs des lettrines jointe aux 'lettres d'attente.'" In *Paläographie 1981: Colloquium du Comité International de Paléographie, München, 15.–18. September 1981*, edited by Gabriel Silagi, 186–91. Munich, 1982.

Gullick, Michael. "How Fast Did Scribes Write? Evidence from Romanesque Manuscripts." In *Making the Medieval Book: Techniques of Production*, edited by Linda L. Brownrigg, 39–58. Los Altos Hills, CA, 1995.

Hurm, Otto. *Schriftform und Schreibwerkzeug: Die Handhabung der Schreibwerkzeuge und ihr formbildender Einfluss auf die Antiqua bis zum Einsetzen der Gotik*. Vienna, 1928.

Ker, N. R. "Copying an Exemplar: Two Manuscripts of Jerome on Habakkuk." In *Miscellanea codicologica F. Masai dicata MCMLXXIX*, edited by Pierre Cockshaw, Monique-Cécile Garand, and Pierre Jodogne. Vol. 1, 203–10. Les Publications de Scriptorium 8. Ghent, Belg., 1979. Reprinted in N. R. Ker, *Books, Collectors and Libraries: Studies in the Medieval Heritage*, edited by Andrew G. Watson, 75–86. London, 1985.

——. "From 'Above Top Line' to 'Below Top Line': A Change in Scribal Practice." *Celtica* 5 (1960): 13–16. Reprinted in N. R. Ker, *Books, Collectors and Libraries: Studies in the Medieval Heritage*, edited by Andrew G. Watson, 71–74. London, 1985.

Lehmann, Paul. "Blätter, Seiten, Spalten, Zeilen." *Zentralblatt für Bibliothekswesen* 53 (1936): 333–61, 411–42.

Martin, Henri-Jean, and Jean Vezin, eds. *Mise en page et mise en texte du livre manuscrit*. Paris, 1990.

Metzger, Bruce M. "When Did Scribes Begin to Use Writing Desks?" In *Historical and Literary Studies, Pagan, Jewish, and Christian*, 123–37. Grand Rapids, MI, 1968.

Obbema, Pieter F. J. "Writing on Uncut Sheets." *Quærendo* 8 (1978): 337–54.

Parkes, M. B. "Tachygraphy in the Middle Ages: Writing Techniques Employed for *Reportationes* of Lectures and Sermons." *Medioevo e rinascimento* 3 (1989): 159–69. Reprinted in M. B. Parkes, *Scribes, Scripts and Readers: Studies in the Communication, Presentation and Dissemination of Medieval Texts*, 19–33. London, 1991.

Samaran, Charles. "Contribution à l'histoire du livre manuscrit au Moyen Âge: Manuscrits 'imposés' et manuscrits non 'coupés.'" In *Atti del X Congresso internazionale di studi storici*, 151–55. Florence, 1957.

——. "Manuscrits 'imposés' à la manière typographique." In *Mélanges en hommage à la mémoire de Fr. Martroye*, 325–36. Paris, 1940.

——. "Manuscrits 'imposés' et manuscrits non coupés: Un nouvel exemple." *Codices manuscripti* 2 (1976): 38–42.

The Pecia *System*

Bataillon, Louis, Bertrand Guyot, and Richard Rouse, eds. *La production du livre universitaire au Moyen Âge: Exemplar et pecia. Actes du symposium tenu au Collegio San Bonaventura de Grottaferrata en mai 1983*. Paris, 1988.

Destrez, Jean. *La pecia dans les manuscrits universitaires du XIIIe et du XIVe siècle*. Paris, 1935.

Destrez, Jean, and Marie-Dominique Chenu. "*Exemplaria* uni-

versitaires des XIIIe et XIVe siècles." *Scriptorium* 7 (1953): 68–80.

Fink-Errera, Guy. "Une institution du monde médiéval: La 'pecia.'" *Revue philosophique de Louvain* 60 (1962): 184–243.

Pollard, Graham. "The *Pecia* System in the Medieval Universities." In *Medieval Scribes, Manuscripts and Libraries: Essays Presented to N. R. Ker*, edited by M. B. Parkes and Andrew G. Watson, 145–61. London, 1978.

Inks and Pigments Manufacture

Bommarito, Domenico. "Il ms. 25 della Newberry Library." *La Bibliofilia* 87 (1985): 1–38.

Carvalho, David N. *Forty Centuries of Ink*. 1904. Reprint, New York, 1971.

Cennini, Cennino d'Andrea. *Il libro dell'arte (The Craftsman's Handbook)*. Translated by Daniel V. Thompson. 1933. Reprint, New York, 1960.

Clarke, Mark. *The Art of All Colours: Mediaeval Recipe Books for Painters and Illuminators*. London, 2001.

de Pas, Monique. "La composition des encres noires." In *Les techniques de laboratoire dans l'étude des manuscrits*. Colloques internationaux du Centre National de la Recherche Scientifique 548, 121–32. Paris, 1974.

———. "Les encres médiévaux." In *La paléographie grecque et byzantine*. Colloques internationaux du Centre National de la Recherche Scientifique 559, 55–60. Paris, 1977.

Feller, Robert L., ed. *Artists' Pigments: A Handbook of Their History and Characteristics*. 2 vols. Washington, DC, 1986–93.

Gullick, Michael. "A Bibliography of Medieval Painting Treatises." In *Making the Medieval Book: Techniques of Production*, edited by Linda L. Brownrigg, 241–44. Los Altos Hills, CA, 1995.

Merrifield, Mary P., trans., ed. *Original Treatises Dating from the XIIth to the XVIIIth Centuries on the Arts of Painting*. 2 vols. 1849. Reprint, Mineola, NY, 1999.

Mitchell, C. A., and T. C. Hepworth. *Inks: Their Composition and Manufacture*. London, 1904.

Petzold, Andreas. "*De coloribus et mixtionibus*: The Earliest Manuscripts of a Romanesque Illuminator's Handbook." In *Making the Medieval Book: Techniques of Production*, edited by Linda L. Brownrigg, 59–65. Los Altos Hills, CA, 1995.

Pigments et colorants de l'Antiquité et du Moyen Âge: Teinture, peinture, enluminure. Études historiques et physico-chimiques. Colloque international du CNRS, Département des sciences de l'homme et de la société, Département de la chimie. Paris, 1990.

Porter, Cheryl. "Laser Raman Spectroscopy: A Tool for Non-Destructive Pigment Analysis of Manuscripts." *The Paper Conservator* 16 (1992): 93–97.

———. "You Can't Tell a Pigment by Its Color." In *Making the Medieval Book: Techniques of Production*, edited by Linda L. Brownrigg, 111–16. Los Altos Hills, CA, 1995.

Roosen-Runge, Hans, and A. E. A. Werner. "The Pictorial Technique in the Lindisfarne Gospels." In *Codex Lindisfarnensis*, edited by T. D. Kendrick et al. Vol. 2, 261–77. Olten, Switz., 1960.

Smith, C. S., and J. G. Hawthorne. "*Mappae Clavicula*: A Little Key to the World of Medieval Techniques." *Transactions of the American Philosophical Society* 64/4 (1974): 1–128.

Theophilus. *On Divers Arts*. Translated by J. G. Hawthorne and C. S. Smith. 2nd ed. New York, 1979.

Thompson, Daniel V. *The Materials of Medieval Painting*. New Haven, 1936.

———. "Trial Index to Some Unpublished Sources for the History of Medieval Craftsmanship." *Speculum* 10/4 (1935): 410–31.

Decorated Initials

Alexander, Jonathan J. G. *The Decorated Letter*. London, 1978.

———. "Scribes as Artists." In *Medieval Scribes, Manuscripts and Libraries: Essays Presented to N. R. Ker*, edited by M. B. Parkes and Andrew G. Watson, 87–116. London, 1978.

Nordenfalk, Carl. *Die spätantiken Zierbuchstaben*. Stockholm, 1970.

Schardt, Alois. *Das Initial: Phantasie und Buchstabenmalerei des frühen Mittelalters*. Berlin, 1938.

Scott-Fleming, Sonia. *The Analysis of Pen Flourishing in Thirteenth-Century Manuscripts*. Leiden, Neth., 1989.

van Moé, Émile. *La lettre ornée*. Paris, 1949.

Illumination

Alexander, Jonathan J. G. *Italian Renaissance Illuminations*. New York, 1977.

———. *Medieval Illuminators and Their Methods of Work*. New Haven, 1992.

Backhouse, Janet. *The Illuminated Manuscript*. Oxford, 1979.

———. *The Illuminated Page: Ten Centuries of Manuscript Painting in the British Library*. London, 1997.

———. "An Illuminator's Sketch-Book." *British Library Journal* 1 (1975): 3–14.

Bland, David. *A History of Book Illustration: The Illuminated Manuscript and the Printed Book*. Berkeley, 1969.

Bologna, Giulia. *Illuminated Manuscripts: The Book before Gutenberg*. New York, 1988.

Branner, Robert. *Manuscript Painting in Paris during the Reign of Saint Louis*. Berkeley, 1977.

Brenni, Vito Joseph. *Book Illustration and Decoration: A Guide to Research*. Westport, CT, 1980.

Brown, Michelle P. *Understanding Illuminated Manuscripts: A Guide to Technical Terms*. Malibu, CA, 1994.

Calkins, Robert G. *Illuminated Books of the Middle Ages*. Ithaca, 1983.

Camille, Michael. *Image on the Edge: The Margins of Medieval Art*. Cambridge, MA, 1992.

De Hamel, Christopher. *The British Library Guide to Manuscript Illumination: History and Techniques*. Toronto, 2001.

———. *A History of Illuminated Manuscripts*. Oxford, 1986.

———. *Scribes and Illuminators*. Medieval Craftsmen Series. Toronto, 1992.

Diringer, David. *The Illuminated Book: Its History and Production*. Rev. ed. New York, 1967.

Harthan, John P. *The History of the Illustrated Book: The Western Tradition*. London, 1981.

———. *An Introduction to Illuminated Manuscripts*. London, 1983.

Hindman, Sandra. *Text and Image in Fifteenth-Century Illustrated Dutch Bibles*. Leiden, Neth., 1977.

Ives, Samuel A., and Hellmut Lehmann-Haupt. *An English 13th Century Bestiary: A New Discovery in the Technique of Medieval Illumination*. New York, 1942.

Lehmann-Haupt, Hellmut. *The Göttingen Model Book*. Columbia, MO, 1972.

Miner, Dorothy. "More about Medieval Pouncing." In *Homage to a Bookman: Essays on Manuscripts, Books and Printing Written for Hans P. Kraus on his 60th Birthday*, edited by Hellmut Lehmann-Haupt, 87–107. Berlin, 1967.

Nordenfalk, Carl. *Celtic and Anglo-Saxon Painting: Book Illumination in the British Isles, 600–800*. New York, 1977.

Pächt, Otto. *Book Illumination of the Middle Ages: An Introduction*. London, 1986.

Randall, Lillian M. C. *Images in the Margins of Gothic Manuscripts*. Berkeley, 1966.

Robb, David M. *The Art of the Illuminated Manuscript*. Cranbury, NJ, 1973.

Ross, D. J. A. "A Late Twelfth-Century Artist's Pattern Sheet." *Journal of the Warburg and Courtauld Institutes* 25 (1962): 119–28.

Scheller, R. W. *A Survey of Medieval Model Books*. Haarlem, 1963.

Scott, Kathleen L. "A Fifteenth-Century English Illuminating Shop and Its Customers." *Journal of the Warburg and Courtauld Institutes* 31 (1986): 170–96.

Thompson, Daniel V. *The Materials and Techniques of Medieval Painting*. New York, 1956.

Williams, John. *Early Spanish Manuscript Illumination*. New York, 1977.

Chapter 3: Correction, Glossing, and Annotation

De Hamel, C. F. R. *Glossed Books of the Bible and the Origins of the Paris Book Trade*. Woodbridge, U.K., 1984.

Draak, Martje. "Construe Marks in Hiberno-Latin Manuscripts." *Mededelingen der Koninklijke Nederlandse Akademie van Wetenschappen, Afdeling Letterkunde*, new ser., 20 (1957): 261–82.

———. "The Higher Teaching of Latin Grammar in Ireland during the Ninth Century." *Mededelingen der Koninklijke Nederlandse Akademie van Wetenschappen, Afdeling Letterkunde*, new ser., 30 (1967): 109–44.

Korhammer, Michael. "Mittelalterliche Konstruktionshilfen und altenglische Wortstellung." *Scriptorium* 34 (1980): 18–58.

Lowe, E. A. "The Oldest Omission Signs in Latin Manuscripts." In *Miscellanea Giovanni Mercati*. Vol. 6, 36–79. Studi e testi 126. Vatican City, 1946. Reprinted in E. A. Lowe, *Palaeographical Papers, 1907–1965*, edited by Ludwig Bieler. Vol. 2, 349–80, and pls. 61–70. Oxford, 1972.

Natale, Alfredo R. "Marginalia: La scrittura della glossa dal V al IX secolo (nota paleografica)." In *Studi in onore di Carlo Castiglioni, prefetto dell'Ambrosiana*, 613–30. Milan, 1957.

Robinson, Fred C. "Syntactical Glosses in Latin Manuscripts of Anglo-Saxon Provenance." *Speculum* 48 (1973): 443–75.

Stoddard, Roger. *Marks in Books Illustrated and Explained: An Album of Facsimiles*. Cambridge, MA, 1985.

Chapter 4: Assembling, Binding, and Storing the Completed Manuscript

Assembling

Budny, Mildred. "Assembly Marks in the Vivian Bible and Scribal, Editorial, and Organizational Marks in Medieval Books." In *Making the Medieval Book: Techniques of Production*, edited by Linda L. Brownrigg, 199–239. Los Altos Hills, CA, 1995.

Courtenay, William J. "Nicholas of Assisi and Vat. Chigi B V 66." *Scriptorium* 36 (1982): 260–63.

———. *Parisian Scholars in the Early Fourteenth Century*, chap. 1. Cambridge, 1999.

Robinson, Pamela R. "The 'Booklet': A Self-Contained Unit in Composite Manuscripts." *Codicologica* 3 (1980): 46–69.

Rodríguez Díaz, Elena E. "El uso del reclamo en España: Reinos occidentales." *Scriptorium* 53/1 (1999): 3–30.

Vezin, Jean. "Observations sur l'emploi des réclames dans les manuscrits latins." *Bibliothèque de l'École des Chartes* 125 (1967): 5–33.

Binding

Brassington, W. Salt. *A History of the Art of Bookbinding*. New York, 1894.

Clarkson, Christopher. "English Monastic Bookbinding in the Twelfth Century." In *Ancient and Medieval Book Materials and Techniques*, edited by Marilena Maniaci and Paola F. Munafó. Vol. 2, 181–200. Studi e testi 358. Vatican City, 1993.

Diehl, Edith. *Bookbinding: Its Background and Technique*. 2 vols. New York, 1946.

Gilissen, Léon. *La reliure occidentale antérieure à 1400*. Bibliologia 1. Turnhout, Belg., 1983.

Goldschmidt, E. P. *Gothic and Renaissance Bookbindings*. London, 1928.

Ker, N. R. *Pastedowns in Oxford Bindings*. Oxford Bibliographical Society Publications. Oxford, 1954.

Loubier, Hans. *Der Bucheinband in alter und neuer Zeit*. Leipzig, 1904.

Needham, Paul. *Twelve Centuries of Bookbindings, 400–1600*. New York, 1979.

Nixon, Howard M. *The History of Decorated Bookbinding in England*. Oxford, 1992.

Pollard, Graham. "Changes in the Style of Bookbinding, 1550–1830." *The Library*, 5th ser., 11 (1956): 71–94.

———. "The Construction of English Twelfth-Century Bindings." *The Library*, 5th ser., 17 (1962): 1–22.

———. "Describing Medieval Bookbindings." In *Medieval Learning and Literature: Essays Presented to Richard William Hunt*, edited by J. J. G. Alexander and M. T. Gibson, 50–65. Oxford, 1976.

———. "Some Anglo-Saxon Bookbindings." *The Book Collector* 24 (1975): 130–59.

Pollard, Graham, and Esther Potter. *Early Bookbinding Manuals: An Annotated List of Technical Accounts of Bookbinding to 1840*. Oxford Bibliographical Society Occasional Publications 18. Oxford, 1984.

Sanders, Henry A. "The Beginnings of the Modern Book: The Codex of the Classical Era." *University of Michigan Quarterly Review* 44/15 (1938): 95–111.

Sheppard, Jennifer M. "Some Twelfth-Century Monastic Bindings and the Question of Localization." In *Making the Medieval Book: Techniques of Production*, edited by Linda L. Brownrigg, 181–98. Los Altos Hills, CA, 1995.

Szirmai, J. A. *The Archaeology of Medieval Bookbinding*. Aldershot, U.K., 1999.

———. "Carolingian Bindings in the Abbey Library of St Gall." In *Making the Medieval Book: Techniques of Production*,

edited by Linda L. Brownrigg, 157–79. Los Altos Hills, CA, 1995.

Van Regemorter, Berthe. *Binding Structures in the Middle Ages: A Selection of Studies.* Translated and annotated by Jane Greenfield. Brussels, 1992.

⁓ *Girdle Books*

Alker, Lisl, and Hugo Alker. *Das Beutelbuch in der bildenden Kunst.* Mainz, 1966.

Blumenthal, Walter Hart. "Girdle Books for Waist Wear." *The American Book Collector* 13 (1963): 17–23.

Bruckner, Ursula. "Beutelbuch-Originale." *Studien zum Buch- und Bibliothekswesen* 9 (1995): 5–23.

———. "Das Beutelbuch und seine Verwandten—der Hülleneinband, das Faltbuch und der Buchbeutel." *Gutenberg-Jahrbuch* 72 (1997): 307–24.

Glauning, Otto. "Der Buchbeutel in der bildenden Kunst." *Archiv für Buchgewerbe und Gebrauchsgraphik* 63 (1926): 124–52.

Juntke, F. "Ein altes Nürnberger Beutelbuch." *Marginalien* 26 (1982): 47–50.

Küp, Karl. "A Fifteenth-Century Girdle Book." *Bulletin of the New York Public Library* 43 (1939): 471–84.

Neumüllers-Klauser, Renate. "Auf den Spuren der Beutelbücher." *Gutenberg-Jahrbuch* 55 (1980): 291–301.

Petersen, Heinz, and Dag-Ernst Petersen. "Unbekannte Beutelbuchdarstellungen." *Philobiblon* 11 (1967): 279–82.

Schreiber, Heinrich. "Buchbeutel und Hülleneinband." *Archiv für Buchgewerbe und Gebrauchsgraphik* 76 (1939): 492–96.

———. "Neues von alten Bucheinbandformen." *Archiv für Buchbinderei* 39 (1939): 71–73.

Szirmai, J. A. "The Girdle Book of the Museum Meermanno-Westreenianum." *Quaerendo* 18 (1988): 17–34.

⁓ *Collecting, Organizing, and Storing Books*

Balsamo, Luigi. "Information about Books and Book Distribution in the Middle Ages." In *Bibliography: History of a Tradition.* Translated by William A. Pettas, 7–15. Berkeley, 1990. Originally published as *La bibliografia: storia di una tradizione.* Florence, 1984.

Beddie, James Stuart. "The Ancient Classics in the Mediaeval Libraries." *Speculum* 5 (1930): 3–20.

———. "Libraries in the Twelfth Century: Their Catalogues and Contents." In *Haskins Anniversary Essays in Mediaeval History,* edited by Charles Taylor and John La Monte, 1–23. Boston, 1929.

Cavanaugh, Susan H. *Books Privately Owned in England, 1300–1450.* Manuscript Studies 4. Cambridge, 1988.

Courtenay, William J. "Book Production and Libraries in Fourteenth-Century Paris." In *Filosofia e teologia nel Trecento: Studi in ricordo di Eugenio Randi,* edited by Luca Bianchi, 367–80. Louvain-la-Neuve, 1994.

———. "The Registers of the University of Paris and the Statutes against the *Scientia Occamica.*" *Vivarium* 29 (1991): 13–49.

———. *Schools and Scholars in Fourteenth-Century England.* Princeton, 1987.

de Ghellinck, Joseph. "Les bibliothèques médiévales." *Nouvelle revue théologique* 65 (1939): 36–55.

Delisle, Léopold. *Recherches sur la librairie de Charles V, Roi de France, 1337–1380.* 1907. Reprint, Amsterdam, 1967.

de Vleeschauwer, H. J. *Libraria magna et libraria parva dans la bibliothèque universitaire du XIIIe siècle.* Mousaion 7. Pretoria, 1956.

Franklin, Alfred. *Les anciennes bibliothèques de Paris.* 3 vols. Paris, 1867.

———. *La Sorbonne: Ses origines, sa bibliothèque, les débuts de l'imprimerie à Paris et la succession de Richelieu d'après des documents inédits.* Paris, 1875.

Glorieux, Palémon. *Aux origines de la Sorbonne.* 2 vols. Études de Philosophie Médiévale 53–54. Paris, 1965–66.

Gottlieb, Theodor. *Ueber mittelalterliche Bibliotheken.* 1890. Reprint, Graz, Aus., 1955.

Humphreys, K. W. "The Early Medieval Library." In *Paläographie 1981: Colloquium des Comité International de Paléographie, München, 15.–18. September 1981,* edited by Gabriel Silagi, 59–70. Munich, 1982.

Kibre, Pearl. "Intellectual Interests Reflected in Libraries of the Fourteenth and Fifteenth Centuries." *Journal of the History of Ideas* 7 (1946): 257–97.

Krochalis, Jeanne E. "The Books and Reading of Henry V and His Circle." *Chaucer Review* 23 (1988–89): 50–77.

Laistner, M. L. W. "The Library of the Venerable Bede." In *Bede: His Life, Times, and Writings,* edited by A. Hamilton Thompson, 237–66. Oxford, 1935.

Lesne, Émile. *Les livres, "scriptoria" et bibliothèques du commencement du VIIIe à la fin du XIe siècle.* Histoire de la propriété ecclésiastique en France 4. Lille, 1938.

Merryweather, F. S. *Bibliomania in the Middle Ages; Being Sketches of Bookworms, Collectors, Bible Students, Scribes and Illuminators, from the Anglo-Saxon and Norman Periods to the Introduction of Printing into England, with Anecdotes Illustrating the History of the Monastic Libraries of Great Britain in the Olden Time.* Rev. ed., prepared by H. B. Copinger and Walter A. Copinger. London, 1933.

Molencki, Rafal. "Early Medieval Manuscripts in the Durham Cathedral Library." *Kwartalnik Neofilologiczny* 35 (1988): 85–89.

Parkes, M. B. "Book Provision and Libraries at the Medieval University of Oxford: The Robert F. Metzdorf Memorial Lecture, 1987." *University of Rochester Library Bulletin* 40 (1987–88): 28–43. Reprinted with revisions in M. B. Parkes. *Scribes, Scripts and Readers: Studies in the Communication, Presentation and Dissemination of Medieval Texts,* 299–310. London, 1991.

———. "The Provision of Books." In *The History of the University of Oxford.* Vol. 2, *Late Medieval Oxford,* edited by J. I. Catto and Ralph Evans, 407–83. Oxford, 1992.

Piper, A. J. "The Libraries of the Monks of Durham." In *Medieval Scribes, Manuscripts and Libraries: Essays Presented to N. R. Ker,* edited by M. B. Parkes and Andrew G. Watson, 213–49. London, 1978.

Pollard, Graham. "Mediaeval Loan Chests at Cambridge." *Bulletin of the Institute of Historical Research* 17 (1939–40): 113–29.

Rickert, Edith. "King Richard II's Books." *The Library,* 4th ser., 13 (1933): 144–47.

Rouse, Richard H. "The Early Library of the Sorbonne." *Scriptorium* 21 (1967): 42–71, 227–51. Reprinted in Richard H. Rouse and Mary A. Rouse, *Authentic Witnesses: Approaches to Medieval Texts and Manuscripts,* 341–408. Notre Dame, IN, 1991.

Rouse, Richard H., and Mary A. Rouse. "La bibliothèque du collège de Sorbonne." In *Histoire des bibliothèques françaises*. Vol. 1, *Les bibliothèques médiévales du VIe siècle à 1530*, edited by André Vernet, 112–23. Paris, 1989.

——. "The Franciscans and Books: Lollard Accusations and the Franciscan Response." In *From Ockham to Wyclif*, edited by Anne Hudson and Michael Wilks, 369–84. Studies in Church History, Subsidia 5. Oxford, 1987. Reprinted in Richard H. Rouse and Mary A. Rouse, *Authentic Witnesses: Approaches to Medieval Texts and Manuscripts*, 409–24. Notre Dame, IN, 1991.

——. "'Potens in Opere et Sermone': Philip, Bishop of Bayeux, and His Books." In *Authentic Witnesses: Approaches to Medieval Texts and Manuscripts*, 33–59. Notre Dame, IN, 1991.

Savage, E. A. *Old English Libraries: The Making, Collection and Use of Books during the Middle Ages*. London, 1912.

Shinners, John. "Parish Libraries in Medieval England." In *A Distinct Voice: Medieval Studies in Honor of Leonard E. Boyle, O.P.*, edited by Jacqueline Brown and William P. Stoneman, 207–30. Notre Dame, IN, 1997.

Stratford, Jenny. "The Royal Library in England before the Reign of Edward IV." In *England in the Fifteenth Century: Proceedings of the 1992 Harlaxton Symposium*, edited by Nicholas Rogers, 187–97. Harlaxton Medieval Studies 4. Stamford, U.K., 1994.

Streeter, B. H. *The Chained Library: A Survey of Four Centuries in the Evolution of the English Library*. London, 1931.

Sutton, Anne F., and Livia Visser-Fuchs. *Richard III's Books: Ideals and Reality in the Life and Library of a Medieval Prince*. Stroud, U.K., 1997.

Talbot, C. H. "The Universities and the Medieval Library." In *The English Library before 1700: Studies in Its History*, edited by Francis Wormald and C. E. Wright, 66–84. London, 1958.

Thompson, James Westfall. *The Medieval Library*. 1939. Reprint, New York, 1957.

Thornton, Dora. *The Scholar in His Study: Ownership and Experience in Renaissance Italy*. New Haven, 1998.

Ullman, B. L. "The Library of the Sorbonne in the Fourteenth Century." In *The Septicentennial Celebration of the Founding of the Sorbonne College in the University of Paris*, 33–47. Chapel Hill, NC, 1953. Reprinted as "The Sorbonne Library and the Italian Renaissance" in B. L. Ullman. *Studies in the Italian Renaissance*, 41–53. Rome, 1955.

Vernet, André, ed. *Histoires des bibliothèques françaises*. Vol. 1, *Les bibliothèques médiévales du VIe siècle à 1530*. Paris, 1989.

Webber, Teresa, and Elisabeth Leedham-Green, eds. *The Cambridge History of Libraries in Britain and Ireland*. Vol. 1, *From the Early Middle Ages to the Civil War*. Cambridge, 2006.

Wilson, R. M. "The Contents of the Mediaeval Library." In *The English Library before 1700: Studies in Its History*, edited by Francis Wormald and C. E. Wright, 85–111. London, 1958.

Wormald, Francis, and C. E. Wright, eds. *The English Library before 1700: Studies in Its History*. London, 1958.

Medieval Library Catalogues

Bayerische Akademie der Wissenschaften. *Mittelalterliche Bibliothekskataloge Deutschlands und der Schweiz*. 4 vols. in 8 pts. Munich, 1918–79. Vol. 1, *Die Bistümer Konstanz und Chur*, edited by Paul Lehmann. 1918. Reprint, 1969. Vol. 2, *Bistum Mainz, Erfurt*, edited by Paul Lehmann. 1928. Reprint, 1969. Vol 3.1, *Bistum Augsburg*, edited by Paul Ruf. 1932. Reprint, 1969. Vol. 3.2, *Bistum Eichstätt*, edited by Paul Ruf. 1933. Reprint, 1969. Vol. 3.3, *Bistum Bamberg*, edited by Paul Ruf. 1939. Reprint, 1969. Vol. 3.4, *Register*. 1962. Vol. 4.1, *Bistümer Passau und Regensburg*, edited by Christine E. Ineichen-Eder. 1977. Vol. 4.2, *Bistum Freising*, edited by Günther Glauche; *Bistum Würzburg*, edited by Hermann Knaus. 1979.

Becker, Gustav Heinrich. *Catalogi bibliothecarum antiqui*. Bonn, 1885.

British Medieval Library Catalogues Committee. *Corpus of British Medieval Library Catalogues*. In progress. London, 1990–. Vol. 1, *The Friars' Libraries*, edited by K. W. Humphreys. 1990. Vol. 2, *Registrum Anglie de Libris Doctorum et Auctorum Veterum*, edited by Richard H. Rouse and Mary A. Rouse. 1991. Vol. 3, *The Libraries of the Cistercians, Gilbertines and Premonstratensians*, edited by David N. Bell. 1992. Vol. 4, *English Benedictine Libraries: The Shorter Catalogues*, edited by Richard Sharpe, James P. Carley, Rodney M. Thomson, and Andrew G. Watson. 1996. Vol. 5, *Dover Priory*, edited by William P. Stoneman. 1999. Vol. 6, *The Libraries of the Augustinian Canons*, edited by Teresa Webber and Andrew G. Watson. 1998. Vol. 7, *The Libraries of King Henry VIII*, edited by James P. Carley. 2000. Vol. 8, *Peterborough Abbey*, edited by Karsten Friis-Jensen and James M. W. Willoughby. 2001. Vol. 9, *Syon Abbey*, edited by Vincent Gillespie and A. I. Doyle. 2001. Vol. 10, *The University and College Libraries of Cambridge*, edited by Peter D. Clarke and Roger Lovatt. 2002. Vol. 11, *Henry of Kirkestede, Catalogus de libris autenticis et apocrifis*, edited by Richard H. Rouse and Mary A. Rouse. 2004. Supplement: *List of Identifications*, edited by Richard Sharpe, L. O. Ayres, and David N. Bell. 1993. 2nd ed., 1995.

Courtenay, William J. "The Fourteenth-Century Booklist of the Oriel College Library." *Viator* 19 (1988): 283–90.

De Hamel, Christopher. "Medieval Library Catalogues." In *Pioneers in Bibliography*, edited by Robin Myers and Michael Harris, 11–23. Winchester, U.K., 1988.

Derolez, Albert. *Les catalogues des bibliothèques*. Typologie des sources du Moyen Âge occidental 31. Turnhout, Belg., 1979.

Humphreys, K. W. *The Library of the Franciscans of Siena in the Late Fifteenth Century*. Studies in the History of Libraries and Librarianship 4. Amsterdam, 1978.

James, M. R. *The Ancient Libraries of Canterbury and Dover: The Catalogues of the Libraries of Christ Church Priory and St. Augustine's Abbey at Canterbury and of St. Martin's Priory at Dover*. Cambridge, 1903.

Nortier, Geneviève. *Les bibliothèques médiévales des abbayes bénédictines de Normandie*. Caen, 1966.

Österreichische Akademie der Wissenschaften. *Mittelalterliche Bibliothekskataloge Österreichs*. 5 vols. in 6 pts. Vienna, 1915–71. Vol. 1, *Niederösterreich*, edited by Theodor Gottlieb. 1915. Vol. 2, *Niederösterreich. Register zum I. Band*, edited by Artur Goldmann. 1929. Vol. 3, *Steiermark*, edited by Gerlinde Möser-Mersky. 1961. Vol. 4, *Salzburg*, edited by Gerlinde Möser-Mersky and Melanie Mihaliuk. 1966. Vol. 4a, *Nachtrag zu Band I: Niederösterreich. Bücherverzeichnisse in Korneburger, Tullner, und Wiener Neustädter Testamenten*, edited by Paul Uiblein. 1969. Vol. 5, *Oberösterreich*, edited by Herbert Paulhart. 1971.

PART 2: READING THE MEDIEVAL MANUSCRIPT

INTRODUCTION TO PART 2

Manuscript Survival

Babcock, Robert G. *Reconstructing a Medieval Library: Fragments from Lambach*. New Haven, 1993.

Backhouse, Janet. "Founders of the Royal Library: Edward IV and Henry VII as Collectors of Illuminated Manuscripts." In *England in the Fifteenth Century: Proceedings of the 1986 Harlaxton Symposium*, edited by Daniel Williams, 23–41. Woodbridge, U.K., 1987.

Barker, Nicolas, ed. *Treasures of the British Library*. London, 1988.

Birrell, T. A. *English Monarchs and Their Books: From Henry VII to Charles II*. Panizzi Lectures 1986. London, 1987.

Carley, James P., and Colin G. C. Tite, eds. *Books and Collectors, 1200–1700: Essays Presented to Andrew Watson*. British Library Studies in the History of the Book. London, 1997.

Chartier, Roger. *The Order of Books: Readers, Authors, and Libraries in Europe between the Fourteenth and Eighteenth Centuries*. Stanford, 1994.

Christ, Karl. *The Handbook of Medieval Library History*. Revised by Anton Kern. Translated and edited by Theophil M. Otto. Metuchen, NJ, 1984.

Clark, John Willis. *Libraries in the Medieval and Renaissance Periods*. 1894. Reprint, Chicago, 1968.

De Hamel, Christopher. *The Rothschilds and Their Collections of Illuminated Manuscripts*. London, 2005.

De la Mare, A. C. "Manuscripts Given to the University of Oxford by Humfrey, Duke of Gloucester." *Bodleian Library Record* 13 (1989): 112–21.

Delisle, Léopold. *Le cabinet des manuscrits de la bibliothèque impériale*. 3 vols. Paris, 1868–81.

De Ricci, Seymour. *English Collectors of Books and Manuscripts (1530–1930) and Their Marks of Ownership*. 1930. Reprint, Bloomington, IN, 1960.

Hall, F. W. "The Nomenclature of Greek and Latin MSS. with the Names of Former Possessors." Chap. 9 in *A Companion to Classical Texts*, 286–357. Oxford, 1913.

Hindman, Sandra, Michael Camille, Nina Rowe, and Rowan Watson. *Manuscript Illumination in the Modern Age: Recovery and Reconstruction*. Evanston, IL, 2001.

Irwin, Raymond. *The English Library: Sources and History*. London, 1966.

——. *The Heritage of the English Library*. London, 1964.

James, M. R. *The Wanderings and Homes of Manuscripts*. Helps for Students of History 17. London, 1919.

Ker, N. R. *Books, Collectors and Libraries: Studies in the Medieval Heritage*. Edited by Andrew G. Watson. London, 1985.

——, ed. *Medieval Libraries of Great Britain: A List of Surviving Books*. 2nd ed. Royal Historical Society Guides and Handbooks 3. London, 1964.

——. "The Migration of Manuscripts from the English Medieval Libraries." *The Library*, 4th ser., 23 (1942–43): 1–11.

Ker, N. R., with A. J. Piper, Ian Cunningham, and A. G. Watson. *Medieval Manuscripts in British Libraries*. 5 vols. Oxford, 1969–2002.

Page, R. I. *Matthew Parker and His Books*. Sandars Lectures in Bibliography 1990. Kalamazoo, MI, 1993.

Pellegrin, Élisabeth. *Bibliothèques retrouvées: Manuscrits, bibliothèques et bibliophiles du Moyen Âge et de la Renaissance. Recueil d'études publiées de 1938 à 1985*. Paris, 1988.

Posner, Ernst. "Public Records under Military Occupation." *American Historical Review* 49 (1943–44): 213–27.

Quynn, Dorothy Mackay. "The Art Confiscations of the Napoleonic Wars." *American Historical Review* 50 (1944–45): 437–60.

Rogers, David. *The Bodleian Library and Its Treasures, 1320–1700*. Henley-on-Thames, 1991.

Strong, Roy. *Lost Treasures of Britain: Five Centuries of Creation and Destruction*. London, 1990.

Taylor, Francis Henry. "The Rape of Europa." *Atlantic Monthly*. January 1945, 52–58.

Thomas, Alan G. *Great Books and Book Collectors*. London, 1975.

Tite, Colin G. C. *The Manuscript Library of Sir Robert Cotton*. Panizzi Lectures 1993. London, 1994.

Watson, Andrew G., ed. *Medieval Libraries of Great Britain: A List of Surviving Books. Supplement to the Second Edition*. Royal Historical Society Guides and Handbooks 15. London, 1987.

Webber, Teresa, and Elisabeth Leedham-Green, eds. *The Cambridge History of Libraries in Britain and Ireland*. Vol. 1, *From the Early Middle Ages to the Civil War*. Cambridge, 2005.

Wilson, Robert A. *Modern Book Collecting*. New York, 1992.

Wright, C. E. *Fontes Harleiani: A Study of the Sources of the Harleian Collection of Manuscripts Preserved in the Department of Manuscripts in the British Museum*. London, 1972.

Important Libraries and Modern Catalogues

Centre National de la Recherche Scientifique. *Bibliothèques de manuscrits médiévaux en France: Relevé des inventaires du VIIIe au XVIIIe siècle*. Paris, 1987.

De Ricci, Seymour, with the assistance of William J. Wilson. *Census of Medieval and Renaissance Manuscripts in the United States and Canada*. 3 vols. New York, 1935–40.

Faye, C. U., and W. H. Bond. *Supplement to the Census of Medieval and Renaissance Manuscripts in the United States and Canada*. New York, 1962.

Gottlieb, Theodor. *Ueber mittelalterliche Bibliotheken*. 1890. Reprint, Graz, Aus., 1955.

Kristeller, Paul Oskar. *Latin Manuscript Books before 1600: A List of the Printed Catalogues and Unpublished Inventories of Extant Collections*. 3rd ed. New York, 1965.

Nickson, M. A. E. *The British Library Guide to the Catalogues and Indexes of the Department of Manuscripts*. London, 1982.

Directories of Archives and Research Libraries

The Europa World of Learning. 57th ed. 2 vols. London, 2007. Companion: *The Directory of University Libraries in Europe*. 3rd ed. London, 2006.

CHAPTER 5: WORKING WITH MEDIEVAL MANUSCRIPTS

Textual Editing

Barbiche, Bernard, and Monique Chatenet, eds. *L'édition des textes anciens, XVIe–XVIIIe siècle*. Paris, 1990.

Bédier, Joseph. "La tradition manuscrite du *Lai de l'Ombre*: Réflexions sur l'art d'éditer les anciens textes." *Romania* 54 (1928): 162–86, 321–56.

Boyle, Leonard E. "Optimist and Recensionist." In *Latin Script and Letters A.D. 400–900. Festschrift Presented to Ludwig Bieler on the Occasion of His 70th Birthday*, edited by John J. O'Meara and Bernd Naumann, 264–74. Leiden, Neth., 1976.

Goldschmidt, E. P. *Medieval Texts and Their First Appearance in Print*. London, 1943.

Greetham, D. C. *Textual Scholarship: An Introduction*. London, 1992.

Hellinga, Lotte. "Editing Texts in the Fifteenth Century." In *New Directions in Textual Studies*, edited by D. Oliphant and R. Bradford, 126–49. Austin, 1990.

Housman, A. E. "The Application of Thought to Textual Criticism." *Proceedings of the Classical Association* 18 (1921): 67–84. Reprinted in the following: *Selected Prose*, edited by J. Carter, 131–50. Cambridge, 1961; *Art and Error: Modern Textual Editing*, edited by Ronald Gottesman and Scott Bennett, 1–16. Bloomington, IN, 1970; *The Classical Papers of A. E. Housman*, edited by James Diggle and F. R. D. Goodyear. Vol. 3, 1058–69. Cambridge, 1972.

Huygens, R. B. C. *Ars Edendi: A Practical Introduction to Editing Medieval Latin Texts*. Turnhout, Belg., 2000.

Maas, Paul. *Textual Criticism*. Translated by Barbara Flower. Oxford, 1958.

McGann, J. J. *A Critique of Modern Textual Criticism*. Chicago, 1983.

Reynolds, L. D., and N. G. Wilson. "Textual Criticism." In *Scribes and Scholars: A Guide to the Transmission of Greek and Latin Literature*. 3rd ed., 207–41. Oxford, 1991.

Tanselle, G. Thomas. *A Rationale of Textual Criticism*. Philadelphia, 1989.

West, M. L. *Textual Criticism and Editorial Technique*. Stuttgart, 1973.

Chapter 6: Punctuation and Abbreviation

Punctuation

Clemoes, Peter. *Liturgical Influence on Punctuation in Late Old English and Early Middle English Manuscripts*. Occasional Papers of the Department of Anglo-Saxon, Norse and Celtic 1. Cambridge, 1952. Reprinted as *Old English Newsletter*. Subsidia 4. Binghamton, NY, 1980.

Greidanus, Johanna. *Beginselen en ontwikkeling van de interpunctie, in 't bijzonder in de Nederlanden*. Utrecht, Neth., 1926.

Hubert, Martin. "Corpus stigmatologicum minus." *Archivum latinitatis medii aevi* 37 (1969–70): 5–171.

———. "Le vocabulaire de la 'ponctuation' aux temps médiévaux: Un cas d'incertitude lexicale." *Archivum latinitatis medii aevi* 38 (1971–72): 57–168.

Jenkinson, Hilary. "Notes on the Study of English Punctuation of the Sixteenth Century." *Review of English Studies* 2 (1926): 152–58.

Jeudy, Colette. "Signes de fin de ligne et tradition manuscrite." *Scriptorium* 27 (1973): 252–62.

Laistner, M. L. W. "Source-Marks in Bede Manuscripts." *Journal of Theological Studies* 34 (1933): 350–54.

McGurk, Patrick. "Citation Marks in Early Latin Manuscripts." *Scriptorium* 15 (1961): 3–13.

Moreau-Maréchal, Jeannette. "Recherches sur la ponctuation." *Scriptorium* 22 (1968): 56–66.

Parkes, M. B. "The Contribution of Insular Scribes of the Seventh and Eighth Centuries to the 'Grammar of Legibility.'" In *Grafia e interpunzione del latino nel medioevo*, edited by A. Maierù, 15–29. Rome, 1987. Reprinted in M. B. Parkes, *Scribes, Scripts and Readers: Studies in the Communication, Presentation and Dissemination of Medieval Texts*, 1–18. London, 1991.

———. *Pause and Effect: An Introduction to the History of Punctuation in the West*. Berkeley, 1993.

Saenger, Paul H. *Space between Words: The Origins of Silent Reading*. Stanford, 1997.

Sorbelli, Albano. "Dalla scrittura alla stampa: Il segno di paragrafo." In *Scritti di paleografia e diplomatica in onore di Vincenzo Federici*, 335–47. Florence, 1944.

Vezin, Jean. "Le point d'interrogation, un élément de datation et de localisation des manuscrits: L'exemple de Saint-Denis au IXe siècle." *Scriptorium* 34 (1980): 181–96.

Abbreviation

Cappelli, Adriano. *Lexicon abbreviaturarum: Dizionario di abbreviature latine ed italiane usate nelle carte e codici specialmente del Medio-Evo*. 6th ed. Milan, 1990.

Châtelain, Émile. *Introduction à la lecture des notes tironiennes*. Paris, 1900.

Hellmann, Martin. *Tironische Noten in der Karolingerzeit am Beispiel eines Persius-Kommentars aus der Schule von Tours*. Monumenta Germaniae Historica, Studien und Texte 27. Hannover, 2000.

Lindsay, W. M. *Notae Latinae: An Account of Abbreviation in Latin MSS. of the Early Minuscule Period (c. 700–850)*. Cambridge, 1915. See also Doris Bains. *A Supplement to Notae Latinae*. Cambridge, 1936.

Menz, Artur. *Die tironischen Noten: Eine Geschichte der römischen Kurzschrift*. Berlin, 1944.

Parkes, M. B. "Tachygraphy in the Middle Ages: Writing Techniques Employed for *Reportationes* of Lectures and Sermons." *Medioevo e rinascimento* 3 (1989): 159–69. Reprinted in M. B. Parkes, *Scribes, Scripts and Readers: Studies in the Communication, Presentation and Dissemination of Medieval Texts*, 19–33. London, 1991.

Pelzer, Auguste. *Abbréviations latines médiévales*. Louvain, Belg., 1964.

Traube, Ludwig. *Nomina sacra: Versuch einer Geschichte der christlichen Kürzung*. Munich, 1907.

Numbers

Hill, G. F. *The Development of Arabic Numerals in Europe Exhibited in Sixty-Four Tables*. Oxford, 1915.

Lemay, R. "The Hispanic Origin of Our Present Numeral Forms." *Viator* 8 (1977): 435–62.

Chapter 7: Encounters with Damaged Manuscripts

Reading Damaged Manuscripts

Barrow, William J. *Manuscripts and Documents: Their Deterioration and Restoration*. 2nd ed. Charlottesville, VA, 1972.

Benton, John F., Alan R. Gillespie, and James M. Soha. "Digital Image-Processing Applied to the Photography of Manuscripts." *Scriptorium* 33 (1979): 40–55.

Boutaine, J. L., J. Irigoin, and A. Lemonnier. "La radiophotographie dans l'étude des manuscrits." In *Les techniques de laboratoire dans l'étude des manuscrits*, 159–76. Colloques internationaux du Centre National de la Recherche Scientifique 548. Paris, 1974.

Clarkson, Christopher. "Preservation and Display of Single Parchment Leaves and Fragments." In *Conservation of Library and Archive Materials and the Graphic Arts*, edited by Guy Petherbridge, 201–9. London, 1987.

Fink-Errera, Guy. "Contribution de la macrophotographie à la conception d'une paléographie générale." *Bulletin de philosophie médiévale* 4 (1962): 100–18.

Haselden, R. B. *Scientific Aids for the Study of Manuscripts*. Oxford, 1935.

Kiernan, Kevin S. "Digital Image-Processing and the *Beowulf* Manuscript." *Literary and Linguistic Computing* 6 (1991): 20–27.

———. "Digital Preservation, Restoration, and Dissemination of Medieval Manuscripts." In *Scholarly Publishing on the Electronic Networks: Gateways, Gatekeepers, and Roles in the Information Omniverse*, edited by Ann Okerson and Dru Mogge, 37–43. Washington, DC, 1994.

Pratesi, Alessandro. "A proposito di tecniche di laboratorio e storia della scrittura." *Scrittura e civiltà* 1 (1977): 199–209.

Prescott, Andrew. "The Electronic Beowulf and Digital Restoration." *Literary and Linguistic Computing* 12 (1997): 185–95.

Samaran, Charles. "Nouvelles perspectives sur la lecture des textes détériorés par grattage, lavage, ou simple usure." In *Miscellanea codicologica F. Masai dicata MCMLXXIX*, edited by Pierre Cockshaw, Monique-Cécile Garand, and Pierre Jodogne. Vol. 2, 597–99. Les Publications de Scriptorium 8. Ghent, Belg., 1979.

⌐Conservation

Adam, Claude. *Restauration des manuscrits et des livres anciens*. Puteaux, Fr., 1984.

"Conservation at the Newberry Library: A Case History. The Newberry Library's MS 40: The Mirror of Human Salvation." Report housed in the Department of Special Collections, The Newberry Library, Chicago.

Conservation et reproduction des manuscrits et imprimés anciens. Colloque international organisé par la Bibliothèque vaticane, 21–24 octobre 1974. Studi e testi 276. Vatican City, 1976.

Greenfield, Jane. *The Care of Fine Books*. New York, 1988.

Hadgraft, Nicholas, and Katherine Swift, eds. *Conservation and Preservation in Small Libraries*. Cambridge, 1994.

Hickin, Norman. *Bookworms: The Insect Pests of Books*. London, 1985.

Nesheim, Kenneth. "The Yale Non-Toxic Method of Eradicating Book-Eating Insects by Deep-Freezing." *Restaurator* 6 (1984): 147–64.

Pickwoad, Nicholas. "Determining How Best to Conserve Books in Special Collections." *The Book and Paper Group Annual* 13 (1994): 35–41.

Pollard, Graham. "On the Repair of Medieval Bindings." *The Paper Conservator* 1 (1976): 35–36.

Prescott, Andrew. "'Their Present Miserable State of Cremation': The Restoration of the Cotton Library." In *Sir Robert Cotton as Collector: Essays on an Early Stuart Courtier and His Legacy*, edited by C. J. Wright, 391–454. London, 1997.

CHAPTER 8: ASSESSING MANUSCRIPT ORIGIN AND PROVENANCE

⌐Mutilation of manuscripts

Backhouse, Janet, and Christopher de Hamel. *The Becket Leaves*. London, 1998.

De Hamel, Christopher. *Cutting Up Manuscripts for Profit and Pleasure: The 1995 Sol M. Malkin Lecture on Bibliography*. Charlottesville, VA, 1996.

De Hamel, Christopher, Joel Silver, John P. Chalmers, Daniel Wayne Mosser, and Michael Thompson. *Disbound and Dispersed: The Leaf Book Considered*. Chicago, 2005.

Graham, Timothy. "Changing the Context of Medieval Manuscript Art: The Case of Matthew Parker." In *Medieval Art: Recent Perspectives. A Memorial Tribute to C. R. Dodwell*, edited by Gale R. Owen-Crocker and Timothy Graham, 183–205. Manchester, U.K., 1998.

⌐Strategies for Dating and Localization of Manuscripts

Boyle, Leonard E. "The Date of the San Sisto Lectionary." *Archivum fratrum praedicatorum* 28 (1958): 381–89.

Destrez, Jean, and Guy Fink-Errera. "Des manuscrits apparemment datés." *Scriptorium* 12 (1958): 56–93.

Gibson, Strickland. "The Localization of Books by Their Bindings." *Transactions of the Bibliographical Society*, 1st ser., 8 (1904–06): 25–38.

Gruys, Albert. "L'expertise du papier: Possibilités et limites de son application en codicologie. Un exemple: La Chronique de Doesburg." In *Miscellanea codicologica F. Masai dicata MCMLXXIX*, edited by Pierre Cockshaw, Monique-Cécile Garand, and Pierre Jodogne. Vol. 2, 501–10. Les Publications de Scriptorium 8. Ghent, Belg., 1979.

Irigoin, Jean. "La datation des papiers italiens des XIIIe et XIVe siècles." *Papiergeschichte* 18 (1968): 49–52.

Ker, N. R. "From 'Above Top Line' to 'Below Top Line': A Change in Scribal Practice." *Celtica* 5 (1960): 13–16. Reprinted in N. R. Ker, *Books, Collectors and Libraries: Studies in the Medieval Heritage*, edited by Andrew G. Watson, 71–74. London, 1985.

Madan, Falconer. "The Localization of Manuscripts." In *Essays in History Presented to Reginald Lane Poole*, edited by H. W. C. Davis, 5–29. Oxford, 1927.

Patterson, Sonia. "Comparison of Minor Initial Decoration: A Possible Method of Showing the Place of Origin of Thirteenth-Century Manuscripts." *The Library*, 5th ser., 27 (1972): 23–30.

———. "Minor Initial Decoration Used to Date the Propertius Fragment (MS. Leiden Voss. lat. O. 38)." *Scriptorium* 28 (1974): 235–47.

Petrucci, Armando. "Istruzione per la datazione." *Studi medievali*, 3rd ser., 9/2 (1968): 1115–26.

Powitz, Gerhardt. "Datieren und Lokalisieren nach der Schrift." *Bibliothek und Wissenschaft* 10 (1976): 124–37.

Trombelli, Giovanni Crisostomo. *Arte di conoscere l'età de' codici latini, e italiani*. 1756. Reprint, Milan, 1971.

Van Dijk, S. J. P. "The Lateran Missal." *Sacris eruditi* 6 (1954): 125–79.

Vezin, Jean. "Le point d'interrogation, un élément de datation et de localisation des manuscrits: L'exemple de Saint-Denis au IXe siècle." *Scriptorium* 34 (1980): 181–96.

⁓ Colophons

Colophons de manuscrits occidentaux des origines au XVIe siècle. 6 vols. Fribourg, 1965–82.

Gougaud, Louis. "Les scribes monastiques d'Irlande au travail." *Revue d'histoire ecclésiastique* 27 (1931): 293–306.

Plummer, Charles. "On the Colophons and Marginalia of Irish Scribes." *Proceedings of the British Academy* 12 (1926): 11–44.

Reynhout, Lucien. *Formules latines de colophons.* 2 vols. Turnhout, Belg., 2006.

⁓ Watermarks

Briquet, C.-M. "De la valeur des filigranes de papier comme moyen de déterminer l'âge et la provenance des documents non datés." *Bulletin de la société d'histoire et d'archéologie de Genève* 1 (1892): 192–202.

———. *Les filigranes: Dictionnaire historique des marques du papier dès leur apparition jusqu'en 1600.* 2nd ed. 4 vols. Leipzig, 1923. Reprinted with supplementary material in C.-M. Briquet. *Les filigranes.* Edited by Allan Stevenson. 4 vols. Amsterdam, 1968.

Mošin, V. A., and S. M. Traljič. *Filigranes des XIIIe et XIVe siècles.* 2 vols. Zagreb, 1957.

Piccard, Gerhard. *Wasserzeichen.* Veröffentlichungen der Staatlichen Archivverwaltung Baden-Württemberg, Sonderreihe: Die Wasserzeichen Piccard im Hauptstaatsarchiv Stuttgart. 17 vols. in 25 parts. Stuttgart, 1961–97.

Stevenson, Allan. "Watermarks Are Twins." *Studies in Bibliography* 4 (1951–52): 57–91.

⁓ Coats of Arms

Aubert de la Chesnaye-Desbois, François-Alexandre, *Dictionnaire généalogique, héraldique, chronologique et historique.* 3 vols. Paris, 1942.

Franklyn, Julian, and John Tanner. *An Encyclopaedic Dictionary of Heraldry.* Oxford, 1970.

Friar, Stephen, ed. *New Dictionary of Heraldry.* London, 1987.

Marks, Richard, and Ann Payne, eds. *British Heraldry from Its Origins to c. 1800.* London, 1978.

Neubecker, Ottfried, and Wilhelm Rentzmann. *Wappenbilderlexikon.* Munich, 1974.

Pastoureau, Michel. *Les armoiries.* Typologie des sources du Moyen Âge occidental 20. Turnhout, Belg., 1976.

———. *Heraldry: An Introduction to a Noble Tradition.* Translated by Francisca Garvie. London, 1997.

Rietstrap, J. B. *Armorial général précédé d'un dictionnaire des termes du blason.* 2 vols. 1884. Reprint, Baltimore, 2003.

Rolland, V., and H. V. Rolland. *Illustrations to the "Armorial Général."* 3 vols. London, 1967.

⁓ Fakes and Forgeries

Carter, Curtis, and Wilhelm Voelkle. *The Spanish Forger: Master of Deception.* Milwaukee, 1987.

Fälschungen im Mittelalter: Internationaler Kongress der Monumenta Germaniae Historica, München, 16.–19. September 1986. Schriften der Monumenta Germaniae Historica 33. 6 vols. Hannover, 1988.

Myers, Robin, and Michael Harris, eds. *Fakes and Frauds: Varieties of Deception in Print and Manuscript.* Winchester, U.K., 1996.

Parkes, M. B. "Archaizing Hands in English Manuscripts." In *Books and Collectors, 1200–1700: Essays Presented to Andrew G. Watson,* edited by James P. Carley and Colin G. C. Tite, 101–41. London, 1997.

Saenger, Paul. "Vinland Re-Read." *Imago Mundi* 50 (1998): 199–202.

Skelton, R. A., et al. *The Vinland Map and the Tartar Relation.* 2nd ed. New Haven, 1995.

Voelkle, William, assisted by Roger S. Wieck. *The Spanish Forger.* New York, 1978.

CHAPTER 9: MANUSCRIPT DESCRIPTION

Beaud-Gambier, Marie-Josèphe, and Lucie Fossier. *Guide pour l'élaboration d'une notice de manuscrit.* Paris, 1977.

Casamassima, Emmanuelle. "Note sul metodo della descrizione dei codici." *Rassegna degli archivi di stato* 23 (1963): 181–205.

Colker, Marvin L. "The Cataloguing of Mediaeval Manuscripts: A Review Article." *Mediaevalia et humanistica,* new ser., 2 (1971): 165–73.

Coveney, Dorothy K. "The Cataloguing of Literary Manuscripts." *Journal of Documentation* 6 (1950): 125–39.

Köttelwesch, Clemens, ed. *Zur Katalogisierung mittelalterlicher und neuerer Handschriften.* Frankfurt, 1963.

Macken, Raymond. "Bref vade-mecum pour la description sur place d'un manuscrit médiéval." *Bulletin de philosophie médiévale* 21 (1979): 86–97.

Ouy, Gilbert. "Projet d'un catalogue de manuscrits médiévaux adapté aux exigences de la recherche moderne." *Bulletin des bibliothèques de France* 6 (1961): 319–35.

Pfaff, Richard W. "M. R. James on the Cataloguing of Manuscripts: A Draft Essay of 1906." *Scriptorium* 31 (1977): 103–18.

Reingold, N. "Subject Analysis and Description of Manuscript Collections." *Isis* 53 (1962): 106–12.

Richtlinien Handschriftenkatalogisierung. 5th ed. Bonn, 1992.

Thiel, E. J. "Die liturgischen Bücher des Mittelalters: Ein kleines Lexikon zur Handschriftenkunde." *Börsenblatt für den deutschen Buchhandel, Frankfurter Ausgabe* 23 (1967): 2379–95.

Wilson, William J. "Manuscript Cataloging." *Traditio* 12 (1956): 457–555.

CHAPTER 10: SELECTED SCRIPTS

⁓ General

Bischoff, Bernhard. *Latin Palaeography: Antiquity and the Middle Ages.* Translated by Dáibhí Ó Cróinín and David Ganz. Cambridge, 1990.

———. *Manuscripts and Libraries in the Age of Charlemagne.* Translated by Michael M. Gorman. Cambridge Studies in Palaeography and Codicology 1. Cambridge, 1994.

———. *Mittelalterliche Studien: Ausgewählte Aufsätze zur Schriftkunde und Literaturgeschichte.* 3 vols. Stuttgart, 1966–81.

Bischoff, Bernhard, G. I. Lieftinck, and Giulio Battelli. *Nomenclature des écritures livresques du IXe au XVIe siècle: Premier colloque international de paléographie latine, Paris, 28–30 avril 1953.* Paris, 1954.

Boyle, Leonard E. *Medieval Latin Palaeography: A Bibliographical Introduction.* Toronto, 1984.

Brown, Michelle P. *Anglo-Saxon Manuscripts*. Toronto, 1991.

———. *A Guide to Western Historical Scripts from Antiquity to 1600*. Toronto, 1990.

Brown, Michelle P., and Patricia Lovett. *The Historical Source Book for Scribes*. Toronto, 1999.

Brown, T. J. "Aspects of Palaeography." In *A Palaeographer's View: The Selected Writings of Julian Brown*, edited by Janet Bately, Michelle P. Brown, and Jane Roberts, 47–91. London, 1993.

———. "Latin Palaeography since Traube." In *A Palaeographer's View: The Selected Writings of Julian Brown*, edited by Janet Bately, Michelle P. Brown, and Jane Roberts, 17–37. London, 1993.

Hector, L. C. *The Handwriting of English Documents*. 2nd ed. London, 1966.

John, James J. "Latin Paleography." In *Medieval Studies: An Introduction*, 2nd ed., edited by James M. Powell, 1–68. Syracuse, 1992.

Ker, N. R. *English Manuscripts in the Century after the Norman Conquest*. Lyell Lectures 1952–53. Oxford, 1960.

Kirchner, Joachim. *Scriptura latina libraria a saeculo primo usque ad finem medii aevi*. 2nd ed. Munich, 1970.

Knight, Stan. *Historical Scripts: A Handbook for Calligraphers*. New York, 1984.

Lowe, E. A. *Codices Latini Antiquiores: A Palaeographical Guide to Latin Manuscripts Prior to the Ninth Century*. 12 vols. Oxford, 1934–72.

———. *English Uncial*. Oxford, 1960.

———. *Handwriting: Our Medieval Legacy*. Rome, 1969.

———. *Palaeographical Papers, 1907–1965*. Edited by Ludwig Bieler. 2 vols. Oxford, 1972.

Parkes, M. B. *English Cursive Bookhands 1250–1500*. 1969. Reprint, Berkeley, 1980.

Petrucci, Armando. "L'onciale romana: Origini, sviluppo e diffusione di una stilizzazione grafica altomedievale (sec. VI–IX)." *Studi medievali*, 3rd ser., 12 (1971): 75–134.

Preston, Jean F., and Laetitia Yeandle. *English Handwriting 1400–1650: An Introductory Manual*. Binghamton, NY, 1992.

Prou, Maurice. *Manuel de paléographie latine et française du VIe au XVIIe siècle*. 4th ed. Paris, 1924.

Roberts, Jane. *Guide to Scripts Used in English Writings up to 1500*. London, 2005.

Steffens, Franz. *Lateinische Paläographie*. 2nd ed. 1909. Reprint, Berlin, 1964.

———. *Lateinische Paläographie: Hundert Tafeln in Lichtdruck, mit gegenüberstehender Transscription nebst Erläuterungen und einer systematischen Darstellung der Entwicklung der lateinischen Schrift*. Freiburg, Ger., 1903.

Ullman, B. L. *The Origin and Development of Humanistic Script*. Rome, 1960.

Luxeuil Minuscule

Ganz, David. "The Luxeuil Prophets and Merovingian Missionary Strategies." In *Beinecke Studies in Early Manuscripts*, edited by Robert G. Babcock, 105–17. *Yale University Library Gazette*, supplement to vol. 66. New Haven, 1991.

Lowe, E. A. *Codices latini antiquiores: A Palaeographical Guide to Latin Manuscripts Prior to the Ninth Century*, vol. 6, xv–xvii. Oxford, 1953.

———. *Codices latini antiquiores: A Palaeographical Guide to Latin Manuscripts Prior to the Ninth Century*, vol. 11, 20. Oxford, 1966.

———. "The 'Script of Luxeuil': A Title Vindicated." *Revue Bénédictine* 63 (1953): 132–46. Reprinted in *Palaeographical Papers*, edited by Ludwig Bieler, 2:389–98. 2 vols. Oxford, 1972.

Masi, Michael. "Newberry MSS Fragments, s. VII–s. XV." *Mediaeval Studies* 34 (1972): 99–112, at 100.

Putnam, M. C. J. "Evidence for the Origin of the 'Script of Luxeuil.'" *Speculum* 38 (1963): 256–66.

Tribout de Morembert, Henri. "Le plus ancien manuscrit de Luxeuil (VIIème s.): Les fragments de Metz et de Yale." *Mémoires de l'Académie nationale de Metz* 14 (1972): 87–98.

Insular Minuscule

Amos, Thomas L. "The Origin and Nature of the Carolingian Sermon," 207–8. PhD diss., Michigan State University, 1983. (On the sermons of Pseudo-Boniface.)

———. "Preaching and the Sermon in the Carolingian World." In *De Ore Domini: Preacher and Word in the Middle Ages*, edited by Thomas L. Amos, Eugene A. Green, and Beverly Mayne Kienzle, 41–60. Kalamazoo, MI, 1989.

Baesecke, Georg. "*De gradibus Romanorum*." In *Kritische Beiträge zur Geschichte des Mittelalters: Festschrift für Robert Holtzmann zum sechzigsten Geburtstag*, edited by Walter Möllenberg and Martin Lintzel, 1–8. 1933. Reprint, Vaduz, Liechtenstein, 1965.

Barnwell, P. S. "*Epistula Hieronimi de gradus Romanorum*: An English School Book." *Historical Research* 64 (1991): 77–86.

Brown, Michelle P. *Anglo-Saxon Manuscripts*. London, 1991.

Brown, T. J. "Tradition, Imitation and Invention in Insular Handwriting of the Seventh and Eighth Centuries." In *A Palaeographer's View: Selected Writings of Julian Brown*, edited by Janet Bately, Michelle P. Brown, and Jane Roberts (London, 1993), 179–200. London, 1993.

Keller, Wolfgang. *Angelsächsische Palaeographie: Die Schrift der Angelsachsen mit besonderer Rücksicht auf die Denkmäler in der Volkssprach*. 2 vols. 1906. Reprint, New York, 1970–71.

Levison, Wilhelm. *England and the Continent in the Eighth Century*. Oxford, 1946. (On the Anglo-Saxon missionaries to the Continent.)

German Minuscule

Bischoff, Bernhard. "Die karolingische Minuskel." In *Karl der Grosse: Werk und Wirkung*, edited by Wolfgang Braunfels, 201–10. Aachen, Ger., 1966. Reprinted in Bernhard Bischoff. *Mittelalterliche Studien: Ausgewählte Aufsätze zur Schriftenkunde und Literaturgeschichte*, vol. 3, 1–5. Stuttgart, 1981.

———. *Die südostdeutschen Schreibschulen und Bibliotheken in der Karolingerzeit*, vol. 2, 256. Wiesbaden, 1980. (On Newberry Medieval Manuscript Fragment 4 and its sister fragments.)

———. *Katalog der festländischen Handschriften des neunten Jahrhunderts (mit Ausnahme der wisigotischen)*, vol. 1, 149 and 196. Wiesbaden, 1998.

Ganz, David. "The Preconditions for Caroline Minuscule." *Viator* 18 (1987): 23–44.

Masi, Michael. "Newberry MSS Fragments, s. VII–s. XV." *Mediaeval Studies* 34 (1972): 99–112, at 100.

Hughes, Andrew. *Medieval Manuscripts for Mass and Office: A*

Guide to Their Organization and Terminology, 246–47 and 257. Toronto, 1982. (On the chanting of the Passion readings in Holy Week.)

Weinberger, Wilhelm. "Bruchstücke von Handschriften und Wiegendrucken in der Boczek-Sammlung des Mährischen Landesarchivs." *Zeitschrift des deutschen Vereins für die Geschichte Mährens und Schlesiens* (1928): 69–70. (On the sister fragments of Newberry Medieval Manuscript Fragment 4.)

Young, Karl. "Observations on the Origin of the Mediaeval Passion-Play." *PMLA* 25 (1910): 309–54, at 311–33. (On the chanting of the Passion readings in Holy Week.)

Caroline Minuscule

Bischoff, Bernhard. *Katalog der festländischen Handschriften des neunten Jahrhunderts (mit Ausnahme der wisigotischen)*, vol. 1, 196. Wiesbaden, 1998.

———. *Latin Palaeography: Antiquity and the Middle Ages*, 112–27. Translated by Dáibhí Ó Cróinín and David Ganz. Cambridge, 1990.

Boeckler, Albert. "Die Evangelistenbilder der Adagruppe." *Münchener Jahrbuch der bildenden Kunst*, 3rd ser., 3–4 (1952–53): 121–44. (On canon tables.)

Brown, Michelle P., and Patricia Lovett. *The Historical Source Book for Scribes*, 67–74. London, 1999.

John, James J. "Latin Paleography." In *Medieval Studies: An Introduction*, 2nd ed., edited by James M. Powell, 3–81, at 25–28. Syracuse, 1992.

Masi, Michael. "Newberry MSS Fragments, s. VII–s. XV." *Mediaeval Studies* 34 (1972): 99–112, at 100.

Nordenfalk, Carl. *Die spätantiken Kanontafeln: Kunstgeschichtliche Studien über die eusebianische Evangelien-Konkordanz in den vier ersten Jahrhunderten ihrer Geschichte*. Göteborg, Swed., 1938.

Rand, E. K. *A Survey of the Manuscripts of Tours*. Cambridge, MA, 1929. (On manuscript production at Tours.)

Shailor, Barbara A. *The Medieval Book*, 57–59. Toronto, 1991. (On limp vellum bindings.)

English Protogothic Bookhand

Alexander, J. J. G. "Scribes as Artists: The Arabesque Initial in Twelfth-Century English Manuscripts." In *Medieval Scribes, Manuscripts and Libraries: Essays Presented to N. R. Ker*, edited by M. B. Parkes and Andrew G. Watson, 87–116, at 103–4. London, 1978.

Bishop, T. A. M. *English Caroline Minuscule*. Oxford, 1971.

Brown, Michelle P., and Patricia Lovett. *The Historical Source Book for Scribes*, 75–86. London, 1999.

Brown, Peter. *Augustine of Hippo: A Biography*, 158–81. London, 1967. (On Augustine's *Confessions*.)

Coates, Alan. *English Medieval Books: The Reading Abbey Collections from Foundation to Dispersal*, esp. 27, 52–54, 59, 106, 137, and 145–46. Oxford, 1999.

Courcelle, Pierre. *Recherches sur les Confessions de saint Augustin*. 2nd ed. Paris, 1968.

Gorman, Michael M. "The Early Manuscript Tradition of St. Augustine's *Confessions*." *Journal of Theological Studies*, new ser., 34 (1983): 114–45.

Ker, N. R. *English Manuscripts in the Century after the Norman Conquest*. Oxford, 1960.

Knight, Stan. *Historical Scripts from Classical Times to the Renaissance*, 52–57, 60–61. Rev. ed. New Castle, DE, 1998.

Liddell, J. R. "Some Notes on the Library of Reading Abbey." *Bodleian Quarterly Record* 8 (1935): 47–54, at 53–54.

Saenger, Paul. *A Catalogue of the Pre-1500 Western Manuscript Books at the Newberry Library*, 22–28.

Verheijen, Luc, ed. *Sancti Augustini Confessionum libri XIII*. Corpus Christianorum Series Latina 27. Turnhout, Belg., 1981.

Webber, Teresa. "The Diffusion of Augustine's *Confessions* in England during the Eleventh and Twelfth Centuries." In *The Cloister and the World: Essays in Medieval History in Honour of Barbara Harvey*, edited by John Blair and Brian Golding, 29–45. Oxford, 1996.

German Protogothic Bookhand

Bischoff, Bernhard. *Latin Palaeography: Antiquity and the Middle Ages*, 120–23. Translated by Dáibhí Ó Cróinín and David Ganz. Cambridge, 1990.

Die Handscriften-Verzeichnisse der Cistercienser-Stifte, 192–93. Vienna, 1891. (On Newberry Library MS 7.)

Jungmann, J. A. *The Mass of the Roman Rite: Its Origins and Development*, vol. 1, 60–63, 104–7. Trans. Francis A. Brunner. New York, 1951. (On missals, sacramentaries, and their structure.)

Plummer, John. *Liturgical Manuscripts for the Mass and the Divine Office*, 9–14 and 23–27. New York, 1964.

Smith, C. "Christmas and Its Cycle." In *New Catholic Encyclopedia*, vol. 3, 655–60, esp. 656–57. New York, 1967. (On the liturgical celebration of Christmas.)

Valuable Manuscripts of the Middle Ages, Mostly Illuminated, with XVI Plates, 25–27 and pl. 14. Emil Hirsch Sales Catalogue. Munich, n.d. (On Newberry Library MS 7.)

van Dijk, S. J. P. *Sources of the Modern Roman Liturgy*, esp. 2:167, 301, 374. 2 vols. Leiden, Neth., 1963. (On missals and sacramentaries.)

Waddell, Chrysogonus. "Memorandum on the Date and Provenance of Chicago, Newberry Library, MS 7." Unpublished assessment kept in the information file on MS 7 at the Newberry Library.

Beneventan Minuscule

Avery, Myrtilla. *The Exultet Rolls of South Italy*. Princeton, 1936.

Bischoff, Bernhard. *Latin Palaeography: Antiquity and the Middle Ages*, 109–11. Translated by Dáibhí Ó Cróinín and David Ganz. Cambridge, 1990.

Brown, Virginia. "A Second New List of Beneventan Manuscripts (III)." *Mediaeval Studies* 56 (1994): 299–350, at 342.

Cappelli, Adriano. *Cronologia, cronografia e calendario perpetuo*, 125–53. 7th ed. Milan, 1998. (On saints and saints' days.)

Cavallo, Guglielmo. "La genesi dei rotoli liturgici beneventani alla luce del fenomeno storico-librario in Occidente ed Oriente." In *Miscellanea in memoria di Giorgio Cencetti*, edited by Alessandro Pratesi, 213–29. Turin, 1973.

———. *I Rotoli di Exultet dell'Italia meridionale*. Bari, 1973.

Cheney, C. R., ed. *A Handbook of Dates for Students of British History*, 59–93. Royal Historical Society Guides and Handbooks 4. 2nd ed., revised by Michael Jones. Cambridge, 2000. (Provides a listing of saints' days.)

Lowe, E. A. *The Beneventan Script: A History of the South Italian Minuscule*. 2nd ed., prepared and enlarged by Virginia Brown. 2 vols. Rome, 1980.

———. "A New List of Beneventan Manuscripts." In *Collecta-*

nea Vaticana in honorem Anselmi M. Card. Albareda a Bibliotheca Apostolica edita, 2:211–44, at 219. 2 vols. Vatican City, 1962.

———. Scriptura Beneventana: Facsimiles of South Italian and Dalmatian Manuscripts from the Sixth to the Fourteenth Century. 2 vols. Oxford, 1929.

Newton, Francis. "Beneventan Scribes and Subscriptions, with a List of Those Known at the Present Time." The Bookmark 43 (1973): 1–35.

Wurfbain, M. L. "The Liturgical Rolls of South Italy and Their Possible Origin." In Miniatures, Scripts, Collections: Essays Presented to G. I. Lieftinck, 9–15. Leiden, Neth., 1976.

Gothic Quadrata Bookhand

Bischoff, Berhnard. Latin Palaeography: Antiquity and the Middle Ages, 127–36. Translated by Dáibhí Ó Cróinín and David Ganz. Cambridge, 1990.

Brown, Michelle P. A Guide to Western Historical Scripts from Antiquity to 1600, 80–89. London, 1990.

Colophons de manuscrits occidentaux des origines au XVIe siècle, vol. 5, no. 15003. Fribourg, Switz., 1979.

Crous, Ernst, and Joachim Kirchner. Die gotischen Schriftarten. Leipzig, 1928.

Derolez, Albert. The Palaeography of Gothic Manuscript Books: From the Twelfth to the Early Sixteenth Century. Cambridge, 2003.

John, James J. "Latin Paleography." In Medieval Studies: An Introduction, 2nd ed., edited by James M. Powell, 3–81, at 28–33. Syracuse, 1992.

Kautsch, Rudolf. Die Entstehung der Frakturschrift. Mainz, 1922.

Kirchner, Joachim. Scriptura gothica libraria a saeculo XII usque ad finem medii aevi. Munich, 1966.

Plummer, John. Liturgical Manuscripts for the Mass and the Divine Office, 40–41. New York, 1964. (On collect books and their structure.)

Saenger, Paul. A Catalogue of the Pre-1500 Western Manuscript Books at the Newberry Library, 118–19. Chicago, 1989.

Thomson, S. Harrison. Latin Bookhands of the Later Middle Ages, 1100–1500. Cambridge, 1969.

Wordsworth, Christopher, and Henry Littlehales, The Old Service-Books of the English Church, 123–29. London, 1904. (On collect books and their structure.)

Italian Gothic Rotunda

Bischoff, Bernhard. Latin Palaeography: Antiquity and the Middle Ages, 129–30. Translated by Dáibhí Ó Cróinín and David Ganz. Cambridge, 1990.

Cabrol, Fernand. "Breviary." In The Catholic Encyclopedia, vol. 2, 768–77, at 770–71. New York, 1913. (On the sanctorale and the Common of Saints.)

Hughes, Andrew. Medieval Manuscripts for Mass and Office: A Guide to Their Organization and Terminology, 75–80, 237–38. Toronto, 1982. (On the structure of the "little hours," the sanctorale, and the Common of Saints.)

John, James J. "Latin Paleography." In Medieval Studies: An Introduction, 2nd ed., edited by James M. Powell, 3–81, at 34. Syracuse, 1992.

Pagnin, Beniamino. Le origini della scrittura gotica padovana. Padua, 1933. (On the origins of Italian rotunda script.)

Saenger, Paul. A Catalogue of the Pre-1500 Western Manuscript Books at the Newberry Library, 136–38. Chicago, 1989.

Scrivener, F. H. "Lectionary." In Dictionary of Christian Antiquities, edited by William Smith and Samuel Cheetham, 2:953–67. 2 vols. London, 1893.

van Doren, R. "Liturgical Year in Roman Rite." In New Catholic Encyclopedia, vol. 8, 915–19. New York, 1967. (On the structure of the liturgical year.)

English Cursive Documentary Script (ca. 1300)

Bischoff, Bernhard. "Zur Frühgeschichte des mittelalterlichen Chirographum." In Mittelalterliche Studien: Ausgewählte Aufsätze zur Schriftenkunde und Literaturgeschichte, vol. 1, 118–22. Stuttgart, 1966.

Boyle, Leonard E. "Diplomatics." In Medieval Studies: An Introduction, 2nd ed., edited by James M. Powell, 82–113. Syracuse, 1992.

Chaplais, Pierre. English Medieval Diplomatic Practice. 2 vols. in 3. London, 1975–82.

———. English Royal Documents, King John–Henry VI, 1199–1461. Oxford, 1971.

Hall, Hubert. A Formula Book of English Official Historical Documents. 2 vols. 1908–9. Reprint, New York, 1969.

Jenkinson, Hilary. Palaeography and the Practical Study of Court Hand. Cambridge, 1915.

[Jenkinson, Hilary.] Guide to Seals in the Public Record Office. London, 1954.

Johnson, Charles, and Hilary Jenkinson. English Court Hand A.D. 1066 to 1500, Illustrated Chiefly from the Public Records. 2 vols. 1915. Reprint, New York, 1967.

Lowe, Kathryn A. "Lay Literacy in Anglo-Saxon England and the Development of the Chirograph." In Anglo-Saxon Manuscripts and Their Heritage, edited by Phillip Pulsiano and Elaine M. Treharne, 161–204. Aldershot, U.K., 1998.

Newton, Kenneth C. Medieval Local Records: A Reading Aid. London, 1971.

Owen, Dorothy. The Library and Muniments of Ely Cathedral. Ely, 1973.

Parkes, M. B. English Cursive Book Hands 1250–1500. 1969. Reprint, Berkeley, 1979.

Tessier, Georges. La diplomatique. Paris, 1952. (On the study of charters.)

Bastard Anglicana Script

Babington, Churchill, and J. R. Lumby, eds. Polychronicon Ranulphi Higden monachi Cestrensis. 9 vols. 1865–86. Reprint, Nendeln, Liechtenstein, 1964.

Emden, A. B. A Biographical Register of the University of Cambridge to 1500, 79–80. Cambridge, 1963. (On Robert Bothe.)

Gransden, Antonia. Historical Writing in England, vol. 2, 43–57. Ithaca, 1982. (On Ranulph Higden.)

Matheson, Lister M. "Printer and Scribe: Caxton, the Polychronicon, and the Brut." Speculum 60 (1985): 593–614.

Parkes, M. B. English Cursive Book Hands 1250–1500. 1969. Reprint, Berkeley, 1979.

Raine, James, et al., eds. Testamenta Eboracensia, 3:248 and 4:30. 6 vols. Durham, 1836–1902. (On Robert Bothe and his family.)

Saenger, Paul. A Catalogue of the Pre-1500 Manuscript Books at the Newberry Library, 59–60. Chicago, 1989.

Taylor, John. "The Development of the *Polychronicon* Continuation." *English Historical Review* 76 (1961): 20–36.

———. *The "Universal Chronicle" of Ranulph Higden.* Oxford, 1966.

Fifteenth-Century English Secretary Hand

Dawson, Giles E., and Laetitia Kennedy-Skipton. *Elizabethan Handwriting 1500–1650: A Manual.* New York, 1966.

Parkes, M. B. *English Cursive Book Hands 1250–1500.* 1969. Reprint, Berkeley, 1979.

Pearsall, Derek. *John Lydgate,* esp. 223–54. Charlottesville, VA, 1970. (On Lydgate's *The Fall of Princes.*)

Preston, Jean F., and Laetitia Yeandle. *English Handwriting 1400–1650.* Binghamton, NY, 1992.

Saenger, Paul. *A Catalogue of the Pre-1500 Manuscript Books at the Newberry Library,* 60–61. Chicago, 1989.

Scott, Kathleen L. *Later Gothic Manuscripts 1390–1490,* 2:319. A Survey of Manuscripts Illuminated in the British Isles 6. London, 1996.

Lettre Bâtarde

Bischoff, Bernhard. *Latin Palaeography: Antiquity and the Middle Ages,* 143. Translated by Dáibhí Ó Cróinín and David Ganz. Cambridge, 1990.

Brown, Michelle P. *A Guide to Western Historical Scripts from Antiquity to 1600,* 110–11. London, 1990.

de Schryver, Antoine. "L'œuvre authentique de Philippe de Mazerolles, enlumineur de Charles le Téméraire." In *Cinqcentième anniversaire de la bataille de Nancy, 1477,* 135–44. Nancy, Fr., 1979.

Kaeppeli, Thomas. "Pour la biographie de Jacques de Cessole." *Archivum Fratrum Praedicatorum* 30 (1960): 149–62.

———. *Scriptores ordinis praedicatorum medii aevi,* vol. 2, 311–18. Rome, 1975. (On Jacobus de Cessolis.)

Kessler, Herbert. *French and Flemish Illuminated Manuscripts from Chicago Collections,* no. 10. Chicago, 1969.

Kliewer, Heinz-Jürgen. *Die mittelalterliche Schachallegorie und die deutschen Schachzabelbücher in der Nachfolge des Jacobus de Cessolis.* Giessen, 1966.

Knight, Stan. *Historical Scripts from Classical Times to the Renaissance,* 70–71. Rev. ed. New Castle, DE, 1998.

Lieftinck, G. I. "Pour une nomenclature de l'écriture livresque de la période dite gothique." In *Nomenclature des écritures livresques du IXe au XVIe siècle: Premier colloque international de paléographie latine, Paris, 28–30 avril 1953,* 15–34, at 23 and 28–29. Paris, 1954.

Rychner, Jean. "Les traductions françaises de la *Moralisatio super ludum scaccorum* de Jacques de Cessoles." In *Recueil de travaux offert à M. Clovis Brunel,* 2:480–93. 2 vols. Paris, 1955.

Saenger, Paul. *A Catalogue of the Pre-1500 Western Manuscript Books at the Newberry Library,* 97–98. Chicago, 1989.

Winkler, Friedrich. *Die flämische Buchmalerei des XV. und XVI. Jahrhunderts: Künstler und Werke von den Brüdern van Eyck bis zu Simon Bening,* 261. Leipzig, 1925.

Italian Semigothic Script

de la Mare, A. C. *The Handwriting of Italian Humanists,* vol. 1. Oxford, 1973. (Includes discussion of the hands of Petrarch, Boccaccio, and Salutati.)

Derolez, Albert. "The Script Reform of Petrarch: An Illusion?" In *Music and Medieval Manuscripts: Paleography and Performance. Essays Dedicated to Andrew Hughes,* edited by John Haines and Randall Rosenfeld, 3–19. Aldershot, U.K., 2004.

Dizionario biografico degli italiani, vol. 47, 525–26. Rome, 1997. (On Stefano Fieschi.)

Mazzuconi, Daniela. "Stefano Fieschi da Soncino: un allievo di Gasparino Barzizza." *Italia medioevale e umanistica* 24 (1981): 257–85.

Petrucci, Armando. *Il protocollo notarile di Coluccio Salutati (1371–1373).* Milan, 1963. (On Salutati's script.)

———. *La scrittura di Francesco Petrarca.* Vatican City, 1967.

Ross, Braxton. "Salutati's Defeated Candidate for Humanistic Script." *Scrittura e civiltà* 5 (1981): 187–98.

Saenger, Paul. *A Catalogue of the Pre-1500 Western Manuscript Books at the Newberry Library,* 186–87. Chicago, 1989.

Italian Humanistic Bookhand

de la Mare, A. C. *The Handwriting of Italian Humanists,* vol. 1. Oxford, 1973.

———. "Humanistic Script: The First Ten Years." In *Das Verhältnis der Humanisten zum Buch,* edited by Fritz Krafft and Dieter Wuttke, 89–110. Boppard, Ger., 1977.

Fairbank, A. J., and R. W. Hunt. *Humanistic Script of the Fifteenth and Sixteenth Centuries.* 2nd ed. Oxford, 1993.

Jasenas, Michael. *Petrarch in America: A Survey of Petrarchan Manuscripts,* 14, 35, and pl. 18. Washington, DC, 1974.

Morison, Stanley. "Early Humanistic Script and the First Roman Type." In *Selected Essays on the History of Letter-Forms in Manuscript and Print,* edited by David McKitterick, 1:206–21. 2 vols. Cambridge, 1981.

Saenger, Paul. *A Catalogue of the Pre-1500 Western Manuscript Books at the Newberry Library,* 182–83. Chicago, 1989.

Ullman, B. L. "The Composition of Petrarch's *De vita solitaria* and the History of the Vatican Manuscript." In *Studies in the Italian Renaissance,* 2nd ed., 135–75. Rome, 1973.

———. *The Origin and Development of Humanistic Script.* Rome, 1960.

———. "Petrarch Manuscripts in the United States." *Italia medioevale e umanistica* 5 (1962): 443–75, at 450n21.

Wardrop, James. *The Script of Humanism: Some Aspects of Humanistic Script 1460–1560,* 1–10. Oxford, 1963.

Italian Humanistic Cursive

Fairbank, Alfred J., and Bruce Dickins. *The Italic Hand in Tudor Cambridge.* London, 1962.

Fairbank, Alfred J., and R. W. Hunt. *Humanistic Script of the Fifteenth and Sixteenth Centuries.* 2nd ed. Oxford, 1993.

Fairbank, Alfred J., and Berthold Wolpe. *Renaissance Handwriting: An Anthology of Italic Scripts.* London, 1960.

Kelly, J. N. D. *Golden Mouth: The Story of John Chrysostom—Ascetic, Preacher, Bishop.* London, 1995.

Piédagnel, Auguste, ed. *Panégyriques de S. Paul.* Paris, 1982. (Critical edition of Chrysostom's *De laudibus sancti Pauli apostoli,* with French translation.)

Saenger, Paul. *A Catalogue of the Pre-1500 Western Manuscript Books at the Newberry Library,* 169–72. Chicago, 1989.

Ullman, B. L. *The Origin and Development of Humanistic Script,* 59–77. Rome, 1960.

Wardrop, James. *The Script of Humanism: Some Aspects of Humanistic Script 1460–1560*. Oxford, 1963.

PART 3: SOME MANUSCRIPT GENRES

CHAPTER 11: THE BIBLE AND RELATED TEXTS

Cahn, Walter. *Romanesque Bible Illumination*. Ithaca, 1982.

De Hamel, Christopher. *The Book: A History of the Bible*. New York, 2001.

Fischer, Bonifatius. *Lateinische Bibelhandschriften im frühen Mittelalter*. Freiburg, Ger., 1985.

Froehlich, Karlfried. "Walafrid Strabo and the *Glossa Ordinaria*: The Making of a Myth." *Studia Patristica* 28 (1993): 192–96.

Froehlich, Karlfried, and Margaret T. Gibson, eds. *Biblia Latina cum Glossa Ordinaria: Facsimile Reprint of the Editio Princeps, Adolph Rusch of Strassburg, 1480–81*. 4 vols. Turnhout, Belg., 1992.

Gameson, Richard, ed. *The Early Medieval Bible: Its Production, Decoration and Use*. Cambridge, 1994.

Gibson, Margaret T. *The Bible in the Latin West*. Notre Dame, IN, 1993.

Gross-Diaz, Theresa. *The Psalms Commentary of Gilbert of Poitiers: From "Lectio Divina" to the Lecture Room*. Leiden, Neth., 1996.

Light, Laura. "Versions et révisions du texte biblique." In *Le Moyen Âge et la Bible*, edited by Pierre Riché and Guy Lobrichon, 55–93. Paris, 1984.

Mangenot, Eugène. "Concordances de la Bible." *Dictionnaire de la Bible*. Vol. 2, 901–2. Paris, 1926.

Rouse, Richard H., and Mary A. Rouse. *Preachers, Florilegia and Sermons: Studies on the "Manipulus Florum" of Thomas of Ireland*. Toronto, 1979.

——. "The Verbal Concordance to the Scriptures." *Archivum fratrum praedicatorum* 44 (1974): 5–30.

Saenger, Paul, and Kimberly Van Kampen, eds. *The Bible as Book: The First Printed Editions*. London, 1999.

Sharpe, John L., III, and Kimberly Van Kampen, eds. *The Bible as Book: The Manuscript Tradition*. London, 1998.

Smalley, Beryl. *The Study of the Bible in the Middle Ages*. 3rd ed. Oxford, 1983.

Stegmüller, Friedrich. *Repertorium biblicum medii aevi*. 9 vols. Madrid, 1950–80.

Thomson, S. Harrison. "Grosseteste's Topical Concordance of the Bible and the Fathers." *Speculum* 9 (1934): 139–44.

Zier, Mark A. "Peter Lombard and the *Glossa ordinaria* on the Bible." In *A Distinct Voice: Medieval Studies in Honor of Leonard E. Boyle, O.P.*, edited by Jacqueline Brown and William P. Stoneman, 629–41. Notre Dame, IN, 1997.

Canon Tables

Klemm, Elisabeth. "Die Kanontafeln der armenischen Handschrift Cod. 697 im Wiener Mechitaristenkloster." *Zeitschrift für Kunstgeschichte* 35 (1972): 69–99.

Leroy, J. "Recherches sur la tradition iconographique des canons d'Eusèbe en Éthiopie." *Cahiers archéologiques* 12 (1962): 173–204.

Nordenfalk, Carl. "The Apostolic Canon Tables." *Gazette des Beaux-Arts*, 6th ser., 62 (1963): 17–34.

——. *Die spätantiken Kanontafeln*. 2 vols. Göteborg, Swed., 1938.

CHAPTER 12: LITURGICAL BOOKS AND THEIR CALENDARS

Burn, A. E. *An Introduction to the Creeds and to the "Te Deum."* London, 1899.

Hughes, Andrew. *Medieval Manuscripts for Mass and Office: A Guide to Their Organization and Terminology*. Toronto, 1982.

Leroquais, Victor. *Les bréviaires manuscrits des bibliothèques publiques de France*. Paris, 1934.

——. *Les manuscrits liturgiques latins du haut Moyen Âge à la Renaissance*. Paris, 1931.

——. *Les psautiers manuscrits latins des bibliothèques publiques de France*. Paris, 1940–41.

——. *Les sacramentaires et les missels manuscrits des bibliothèques publiques de France*. Paris, 1924.

Ottosen, Knud. *Responsories and Versicles of the Latin Office of the Dead*. Aarhus, Den., 1993.

Palazzo, E. *A History of Liturgical Books: From the Beginning to the Thirteenth Century*. Collegeville, MN, 1993.

Pfaff, Richard W. *Medieval Latin Liturgy: A Select Bibliography*. Toronto, 1992.

Pickering, F. P. *The Calendar Pages of Medieval Service Books: An Introductory Note for Art Historians*. Reading Medieval Studies Monographs 1. Reading, U.K., 1980.

Vogel, Cyrille. *Medieval Liturgy: An Introduction to the Sources*. Translated and revised by William G. Storey and Niels K. Rasmussen. Washington, DC, 1986.

Handbooks of Dates

Cheney, C. R., ed. *A Handbook of Dates for Students of British History*. Royal Historical Society Guides and Handbooks 4. 2nd ed., revised by Michael Jones. Cambridge, 2000.

Grotefend, Hermann. *Taschenbuch der Zeitrechnung des deutschen Mittelalters und der Neuzeit*. 13th ed. Hannover, 1991.

CHAPTER 13: BOOKS OF HOURS

Avril, François, and Nicole Renaud. *Les manuscrits à peintures en France, 1440–1520*. Paris, 1993.

Clancy, Stephen C. "The Illusion of a 'Fouquet Workshop': The Hours of Charles de France, the Hours of Diane de Croy, and the Hours of Adelaïde de Savoie." *Zeitschrift für Kunstgeschichte* 56 (1993): 207–33.

Defoer, Henri L. M., et al. *The Golden Age of Dutch Manuscript Painting*. New York, 1990.

Donovan, Claire. *The de Brailes Hours: Shaping the Book of Hours in Thirteenth-Century Oxford*. London, 1991.

Duffy, Eamonn. *Marking the Hours: English People and Their Prayers, 1240–1570*. New Haven, 2006.

Harthan, John P. *The Book of Hours*. New York, 1977.

Henisch, Bridget Ann. "In Due Season: Farm Work in the Medieval Calendar Tradition." In *Agriculture in the Middle Ages: Technology, Practice, and Representation*, edited by Del Sweeney, 309–36. Philadelphia, 1995.

Leroquais, Victor. *Les livres d'heures manuscrits de la Bibliothèque nationale*. 2 vols. Paris, 1927.

Marrow, James H. *The Hours of Margaret of Cleves*. Lisbon, 1995.

Naughton, Joan. "A Minimally-Intrusive Presence: Portraits in Illustrations for Prayers to the Virgin." In *Medieval Texts and Images: Studies of Manuscripts from the Middle Ages*, edited

by Margaret M. Manion and Bernard J. Muir, 111–26. Chur, Switz., 1991.

Orth, Myra Dickman, and Thierry Crépin-Leblond. *Livres d'heures royaux: La peinture de manuscrits à la cour de France au temps de Henri II*. Paris, 1993.

Owens, Margareth Boyer. "The Image of King David in Prayer in Fifteenth-Century Books of Hours." *Imago Musicae* 6 (1989): 23–38.

Saenger, Paul. "Books of Hours and Reading Habits of the Later Middle Ages." In *The Culture of Print: Power and the Uses of Print in Early Modern Europe*, edited by Roger Chartier, 239–69. Princeton, 1989.

Schaefer, Claude. *Jean Fouquet: An der Schwelle zur Renaissance*. Dresden, 1994.

Smeyers, Maurits. "An Eyckian Vera Icon in a Bruges Book of Hours, ca. 1450 (New York, Pierpont Morgan Library, Ms. 421)." In *Serta Devota in Memoriam Guillelmi Lourdaux. Pars Posterior: Cultura Mediaevalis*, edited by Werner Verbeke, Marcel Haverals, Rafaël de Keyser, and Jean Goossens, 195–224. Louvain, Belg., 1995.

Sterling, Charles. *La peinture médiévale à Paris, 1300–1500*. 2 vols. Paris, 1987–90.

Sutton, Anne F., and Livia Visser-Fuchs. *The Hours of Richard III*. Wolfeboro Falls, NH, 1990.

Wieck, Roger S. *Painted Prayers: The Book of Hours in Medieval and Renaissance Art*. New York, 1997.

——. "The Savoy Hours and Its Impact on Jean, Duc de Berry." *Yale University Gazette* 66 (1991): 159–80.

——. *Time Sanctified: The Book of Hours in Medieval Art and Life*. New York, 1988.

Wordsworth, Christopher, ed. *Horae Eboracenses: The Prymer or Hours of the Blessed Virgin Mary according to the Use of the Illustrious Church of York*. London, 1920.

CHAPTER 14: CHARTERS AND CARTULARIES

General

Bedos-Rezak, Brigitte. "Towards an Archaeology of the Medieval Charter: Textual Production and Reproduction in Northern French *Chartriers*." In *Charters, Cartularies, and Archives: The Preservation and Transmission of Documents in the Medieval West*, edited by Adam J. Kosto and Anders Winroth, 8–21. Papers in Medieval Studies 17. Toronto, 2002.

Bishop, T. A. M., and Pierre Chaplais. *Facsimiles of English Royal Writs to A.D. 1000 Presented to V. H. Galbraith*. Oxford, 1957.

Boyle, Leonard E. "Diplomatics." In *Medieval Studies: An Introduction*, 2nd ed., edited by James M. Powell, 82–113. Syracuse, 1992.

Bresslau, Harry. *Handbuch der Urkundenlehre für Deutschland und Italien*. 2nd ed. 2 vols. Leipzig, 1912–31.

Cárcel Ortí, María Milagros. *Vocabulaire international de la diplomatique*. 2nd ed. Valencia, 1997.

Chaplais, Pierre. "The Anglo-Saxon Chancery: From the Diploma to the Writ." *Journal of the Society of Archivists* 4 (1966): 160–76.

——, ed. *Diplomatic Documents Preserved in the Public Record Office, 1101–1272*. London, 1964.

——. *English Royal Documents: King John–Henry VI, 1199–1461*. Oxford, 1971.

——. "The Origin and Authenticity of the Royal Anglo-Saxon Diploma." *Journal of the Society of Archivists* 3 (1965): 48–60.

Chartae Latinae Antiquiores: Facsimile Edition of the Latin Charters Prior to the Ninth Century. Edited by Albert Bruckner, Robert Marichal, Guglielmo Cavallo, and Giovanna Nicolaj. Lausanne, Switz., 1954–.

Cheney, C. R. *English Bishops' Chanceries, 1100–1250*. Manchester, U.K., 1950.

——. *Notaries Public in England in the Thirteenth and Fourteenth Centuries*. Oxford, 1972.

de Boüard, Alain. *Manuel de diplomatique française et pontificale*. 2 vols. Paris, 1929–52.

Fichtenau, Heinrich. *Arenga. Spätantike und Mittelalter im Spiegel von Urkundenformeln*. Graz, Aus., 1957.

Galbraith, V. H. *Introduction to the Use of the Public Records*. 2nd ed. Oxford, 1954.

——. *Studies in the Public Records*. London, 1948.

Genicot, Léopold. *Les actes publics*. Typologie des sources du Moyen Âge occidental 3. Turnhout, Belg., 1972.

Giry, Arthur. *Manuel de diplomatique*. 1894. Reprint, Hildesheim, Ger., 1972.

Guyotjeannin, Olivier, Jacques Pycke, and Benoît-Michel Tock. *Diplomatique médiévale*. L'atelier du médiéviste 2. Turnhout, Belg., 1993.

Hill, Rosalind. "Bishop Sutton and His Archives: A Study in the Keeping of Records in the Thirteenth Century." *Journal of Ecclesiastical History* 2 (1951): 43–80.

Kosto, Adam J., and Anders Winroth, eds. *Charters, Cartularies, and Archives: The Preservation and Transmission of Documents in the Medieval West*. Papers in Medieval Studies 17. Toronto, 2002.

Mabillon, Jean. *De re diplomatica libri VI. in quibus quidquid ad veterum instrumentorum antiquitatem, materiam, scripturam & stilum, quidquid ad sigilla, monogrammata, subscriptiones ac notas chronologicas, quidquid inde ad antiquariam, historicam forensemque disciplinam pertinet, explicatur & illustratur*. 2nd ed. Paris, 1709.

Maffei, Scipione. *Istoria diplomatica che serve d'introduzione all'arte critica in tal materia*. Mantua, It., 1727.

Major, Kathleen. "The Teaching and Study of Diplomatic in England." *Archives* 8, no. 39 (1968): 114–18.

Nicolaj, Giovanna. "*Originale, authenticum, publicum*: Una sciarada per il documento diplomatico." In *Charters, Cartularies, and Archives: The Preservation and Transmission of Documents in the Medieval West*, edited by Adam J. Kosto and Anders Winroth, 8–21. Papers in Medieval Studies 17. Toronto, 2002.

Petrucci, Armando. *Notarii. Documenti per la storia del notariato italiano*. Milan, 1958.

Prou, Maurice. *Manuel de paléographie latine et française*. 4th ed. Paris, 1924.

——. *Recueil de fac-similés d'écritures du Ve au XVIIe siècle (manuscrits latins, français et provençaux). Accompagnés de transcriptions*. 2 vols. Paris, 1904.

Public Record Office, Great Britain. *A Guide to the Contents of the Public Record Office*. 3 vols. London, 1963.

Santifaller, Leo. *Neuere Editionen mittelalterlicher Königs- und Papsturkunden*. Vienna, 1958.

——. *Urkundenforschung: Methoden, Ziele, Ergebnisse.* 2nd ed. Cologne, 1967.

Stenton, F. M. *Latin Charters of the Anglo-Saxon Period.* Oxford, 1955.

Van Caenegem, R. C. *Royal Writs in England from the Conquest to Glanvill.* London, 1959.

Dating

Cheney, C. R., ed. *A Handbook of Dates for Students of British History.* Royal Historical Society Guides and Handbooks 4. 2nd ed., revised by Michael Jones. Cambridge, 2000.

Declercq, Georges. *Anno Domini: The Origins of the Christian Era.* Turnhout, Belg., 2000.

de Mas-Latrie, L. M. J. L. *Trésor de chronologie, d'histoire et de géographie pour l'étude et l'emploi des documents du Moyen Âge.* Paris, 1889.

Fry, Edward Alexander. *Almanacks for Students of English History.* London, 1915.

Ginzel, F. K. *Handbuch der mathematischen und technischen Chronologie. Das Zeitrechnungswesen der Völker.* 3 vols. Leipzig, 1906–14.

Poole, Reginald Lane. *Medieval Reckonings of Time.* Helps for Students of History 3. London, 1921.

——. *Studies in Chronology and History.* 1934. Reprint, Oxford, 1969.

Seals

Bedos-Rezak, Brigitte. *Form and Order: Essays in Social and Quantitative Sigillography.* London, 1993.

——. "Seals and Sigillography, Western European." In *Dictionary of the Middle Ages,* edited by J. R. Strayer. Vol. 11, 123–31. New York, 1982–89.

Friedenberg, D. M. *Medieval Jewish Seals from Europe.* Detroit, 1987.

Harvey, P. D. A. "Personal Seals in Thirteenth-Century England." In *Church and Chronicle in the Middle Ages: Essays Presented to John Taylor,* edited by Ian Wood and G. A. Loud, 117–27. London, 1991.

Harvey, P. D. A., and Andrew McGuinness. *A Guide to British Medieval Seals.* London, 2001.

Heslop, T. A. "English Seals from the Mid-Ninth Century to *c.*1100." *Journal of the British Archaeological Association* 133 (1980): 1–16.

Jenkinson, Hilary. *A Guide to the Seals in the Public Record Office.* 2nd ed. London, 1968.

——. "The Study of English Seals: Illustrated Chiefly from Examples in the Public Record Office." *Journal of the British Archaeological Association,* 3rd ser., 1 (1937): 93–127.

Kingsford, H. S. *Seals.* Helps for Students of History 30. London, 1920.

Maxwell, Robert A. "Sealing Signs and the Art of Transcribing in the Vierzon Cartulary." *Art Bulletin* 81 (1999): 576–97.

McGuinness, Andrew F. "Non-Armigerous Seals and Seal-Usage in Thirteenth-Century England." *Thirteenth Century England* 5 (1995): 165–77. Woodbridge, U.K., 1995.

Pastoureau, Michel. *Les sceaux.* Typologie des sources du Moyen Âge occidental 36. Turnhout, Belg., 1981.

Rigold, S. E. "Two Common Species of Medieval Seal-Matrix." *Antiquaries Journal* 57 (1977): 324–29.

Robinson, Gertrude, H. Urquhart, and Alice Hindson. "Seal Bags in the Treasury of the Cathedral Church of Canterbury." *Archaeologia* 84 (1935): 163–211.

Woods, C. "The Nature and Treatment of Wax and Shellac Seals." *Journal of the Society of Archivists* 15 (1994): 203–14.

History of the Papal Chancery

Barraclough, Geoffrey. *Public Notaries and the Papal Curia.* London, 1934.

Cheney, C. R. *The Study of the Medieval Papal Chancery.* Glasgow, 1966.

Poole, Reginald Lane. *Lectures on the History of the Papal Chancery down to the Time of Innocent III.* Cambridge, 1915.

Ullmann, Walter. *The Growth of Papal Government in the Middle Ages: A Study in the Ideological Relation of Clerical to Lay Power.* 3rd ed. London, 1970.

Papal Documents and the Vatican Archive

Bartoloni, Franco. "Suppliche pontificie dei secoli xiii e xiv." *Bulletino dell'Istituto Storico Italiano per il Medio Evo e Archivio Muratoriano* 47 (1955): 1–188.

Battelli, Giulio, ed. *Bibliografia dell'Archivio Vaticano.* 4 vols. Vatican City, 1962–66.

——. "Le ricerche storiche nell'Archivio Vaticano." *Relazioni del X Congresso internazionale di scienze storiche,* 451–77. Rome, 1955.

Boyle, Leonard E. *A Survey of the Vatican Archives and of Its Medieval Holdings.* Toronto, 1972.

Brackmann, Albert, Hermann Jacobs, Wolfgang Seegrun, Theodor Schieffer, Heinrich Buttner, and Egon Boschof, eds. *Germania pontificia; sive, Repertorium privilegiorum et litterarum a romanis pontificibus ante annum MCLXXXXVIII Germaniae ecclesiis monasteriis civitatibus singulisque personis concessorum.* In progress. Berlin, 1911–.

de Mas-Latrie, Comte L. "Éléments de la diplomatique pontificale." *Revue des questions historiques* 39 (1886): 415–51.

Erdmann, Carl. *Papsturkunden in Portugal.* Abhandlungen der Gesellschaft der Wissenschaften zu Göttingen, Philologisch-historische Klasse, 20/3. 1927. Reprint, Nendeln, Liechtenstein, 1970.

Fink, Karl August. "Die ältesten Breven und Breven-register." *Quellen und Forschungen aus italienischen Archiven und Bibliotheken* 25 (1933–34): 292–307.

——. *Das Vatikanische Archiv.* Rome, 1951.

Frenz, Thomas. *Papsturkunden des Mittelalters und der Neuzeit.* Stuttgart, 1986.

Gasnault, Pierre. "Suppliques en matière de justice au XIVe siècle." *Bibliothèque de l'École des Chartes* 115 (1957): 42–57.

Herde, Peter. *Beiträge zum päpstlichen Kanzlei- und Urkundenwesen im 13. Jahrhundert.* Münchener historische Studien. Abteilung Geschichtl. Hilfswissenschaft 1. Kallmünz, Ger., 1961.

Holtzmann, Walther. *Papsturkunden in England.* 3 vols. Abhandlungen der Akademie der Wissenschaften in Göttingen, Philologisch-historische Klasse 3/14–15 and 3/33. 1930–52. Reprint, Berlin, 1970.

Initienverzeichnis zu August Potthast, Regesta pontificum Romanorum (1198–1304). Monumenta Germaniae Historica, Hilfsmittel 2. Munich, 1978.

Jaffé, Philipp. *Regesta pontificum romanorum ab condita ecclesia ad annum post Christum natum MCXCVIII.* 2nd ed. Corrected and supplemented by Samuel Loewenfeld, Ferdinand Kaltenbrunner, and Paul Ewald. 2 vols. 1885–88. Reprint, Graz, Aus., 1956.

Kehr, Paul Fridolin. *Papsturkunden in Italien: Reiseberichte zur Italia Pontificia.* 6 vols. Vatican City, 1977.

———. *Papsturkunden in Spanien: Vorarbeiten zur Hispania Pontificia.* 2 vols. Abhandlungen der Gesellschaft der Wissenschaften zu Göttingen, Philologisch-historische Klasse 18/2 and 22/1. 1926–28. Reprint, Nendeln, Liechtenstein, 1970.

Kehr, Paul, Walter Holtzmann, and Dieter Girgensohn, eds. *Italia pontificia; sive, Repertorium privilegiorum et litterarum a romanis pontificibus ante annum MCLXXXXVIII Italiae ecclesiis, monasteriis, civitatibus singulisqve personis concessorum.* 10 vols. Berlin, 1906–86.

Meinert, Hermann, Johannes Ramackers and Dietrich Lohrmann. *Papsturkunden in Frankreich.* New ser. 8 vols. Abhandlungen der Gesellschaft der Wissenschaften zu Göttingen, Philologisch-historische Klasse 3/3–4, 21, 23, 27, 35, 41, and 95. Berlin, 1932–76.

Potthast, August. *Regesta pontificum romanorum inde ab a. post Christum natum MCXCVIII ad a. MCCCIV.* 2 vols. 1874–75. Reprint, Graz, Aus., 1957.

Ramackers, Johannes. *Papsturkunden in den Niederlanden (Belgien, Luxemburg, Holland und Französisch-Flandern).* 2 vols. Abhandlungen der Gesellschaft der Wissenschaften zu Göttingen, Philologisch-historische Klasse 3/8 and 3/9. Berlin, 1933–34.

Sayers, Jane E. *Original Papal Documents in England and Wales from the Accession of Pope Innocent III to the Death of Pope Benedict XI (1198–1304).* Oxford, 1999.

Somerville, Robert. *Scotia Pontificia: Papal Letters to Scotland before the Pontificate of Innocent III.* Oxford, 1982.

Tessier, Georges. "Du nouveau sur les suppliques." *Bibliothèque de l'École des Chartes* 114 (1956): 186–92.

Wiederhold, Wilhelm. *Papsturkunden in Frankreich. Reiseberichte zur Gallia pontificia.* With an index by Louis Duval-Arnould. 2 vols. Acta Romanorum Pontificum 7–8. Vatican City, 1985.

Forgery

Brooke, C. N. L. "Approaches to Medieval Forgery." *Journal of the Society of Archivists* 3 (1965–69): 377–86. Reprinted in C. N. L. Brooke, *Medieval Church and Society: Collected Essays,* 100–120. London, 1971.

Brown, Elizabeth A. R. "*Falsitas pia sive reprehensibilis*: Medieval Forgers and Their Intentions." In *Fälschungen im Mittelalter: Internationaler Kongress der Monumenta Germaniae Historica, München, 16.–19. September 1986,* 1:101–19. Schriften der Monumenta Germaniae Historica 33. 6 vols. Hannover, 1988.

Carlone, Carmine. *Falsificazioni e falsari cavensi e verginiani del secolo XIII.* Altavilla, It., 1984.

Constable, Giles. "Forgery and Plagiarism in the Middle Ages." *Archiv für Diplomatik* 29 (1983): 1–41.

Fälschungen im Mittelalter: Internationaler Kongress der Monumenta Germaniae Historica, München, 16.–19. September 1986. Schriften der Monumenta Germaniae Historica 33. 6 vols. Hannover, 1988.

Fuhrmann, Horst. *Einfluss und Verbreitung der pseudoisidorischen Fälschungen: Von ihrem Auftauchen bis in die neuere Zeit.* Schriften der Monumenta Germaniae Historica/Deutsches Institut für Erforschung des Mittelalters 24. 3 vols. Stuttgart, 1972–73.

———. "Die Fälschungen im Mittelalter. Überlegungen zum mittelalterlichen Wahrheitsbegriff." *Historische Zeitschrift* 197 (1963): 529–54, 555–79.

Hector, L. C. *Palaeography and Forgery.* London, 1959.

Myers, Robin, and Michael Harris, eds. *Fakes and Frauds: Varieties of Deception in Print and Manuscript.* Winchester, U.K., 1996.

Cartularies

Baldwin, John W. "Étienne de Gallardon and the Making of the Cartulary of Bourges." *Viator* 31 (2000): 121–46.

Bisson, Thomas, ed. *Fiscal Accounts of Catalonia under the Early Count-Kings (1151–1213).* 2 vols. Berkeley, 1984.

———. *Medieval France and Her Pyrenean Neighbours: Studies in Early Institutional History.* Studies presented to the International Commission for the History of Representative and Parliamentary Institutions 70. London, 1989.

Bouchard, Constance B. "Monastic Cartularies: Organizing Eternity." In *Charters, Cartularies, and Archives: The Preservation and Transmission of Documents in the Medieval West,* edited by Adam J. Kosto and Anders Winroth, 22–32. Papers in Medieval Studies 17. Toronto, 2002.

Davis, G. R. C. *Medieval Cartularies of Great Britain.* London, 1958.

Foulds, Trevor. "Medieval Cartularies." *Archives* 18 (1987): 3–35.

Freed, John B. "The Creation of the Codex Falkensteinensis (1166): Self-Representation and Reality." In *Representations of Power in Medieval Germany 800–1500,* edited by Björn Weiler and Simon MacLean, 189–210. International Medieval Research 16. Turnhout, Belg., 2006.

Geary, Patrick. *Phantoms of Remembrance: Memory and Oblivion at the End of the First Millennium.* Princeton, 1994.

Guyotjeannin, Olivier, Laurent Morelle, and Michel Parisse, eds. *Les Cartulaires. Actes de la table ronde organisée par l'École nationale des chartes et le G.D.R. 121 du C.N.R.S. (Paris, 5–7 décembre 1991).* Mémoires et documents de l'École des chartes 39. Paris, 1993.

Kosto, Adam J. "The *Liber Feudorum Maior* of the Counts of Barcelona: The Cartulary as an Expression of Power." *Journal of Medieval History* 27 (2001): 1–22.

———. *Making Agreements in Medieval Catalonia: Power, Order, and the Written Word, 1000–1200.* Cambridge, 2001.

McCrank, Lawrence. "Documenting Reconquest and Reform: The Growth of Archives in the Medieval Crown of Aragon." *American Archivist* 56 (1993): 256–318.

Rosenwein, Barbara H. *To Be the Neighbor of Saint Peter: The Social Meaning of Cluny's Property, 909–1049.* Ithaca, 1989.

Stein, Henri. *Bibliographie générale des cartulaires français ou relatifs à l'histoire de Paris.* Paris, 1907.

Walker, David. "The Organization of Material in Medieval Cartularies." In The *Study of Medieval Records: Essays in Honour of Kathleen Major,* edited by D. A. Bullough and R. L. Storey, 132–50. Oxford, 1971.

Chapter 15: Maps

⌐General

Andrews, Michael. "The Study and Classification of Medieval Mappaemundi." *Archaeologia* 75 (1925–26): 61–76.

Arentzen, Jörg-Geerd. *Imago Mundi Cartographica: Studien zur Bildlichkeit mittelalterlicher Welt- und Ökumenenkarten unter Berücksichtigung des Zusammenwirkens von Text und Bild.* Munich, 1984.

Barber, Peter. "The Evesham World Map: A Late Medieval View of God and the World." *Imago Mundi* 47 (1995): 13–33.

Barber, Peter, and Michelle Brown. "The Aslake World Map." *Imago Mundi* 44 (1992): 24–44.

Brincken, Anna-Dorothee von den. *Fines Terrae: Die Enden der Erde und der vierte Kontinent auf mittelalterlichen Weltkarten.* Hannover, 1992.

Brodersen, Kai. *Terra Cognita: Studien zur römischen Raumerfassung.* Hildesheim, Ger., 1995.

Destombes, Marcel, ed. *Mappemondes, AD 1200–1500: Catalogue préparé par la Commission des Cartes Anciennes de l'Union Géographique Internationale.* Amsterdam, 1964.

Duchet-Suchaux, Gaston, ed. *Iconographie médiévale: Image, texte, contexte.* Paris, 1990.

Harley, J. B., and David Woodward, eds. *The History of Cartography.* Vol. 1, *Cartography in Prehistoric, Ancient, and Medieval Europe and the Mediterranean.* Chicago, 1987.

Harvey, P. D. A. *Medieval Maps.* Toronto, 1991.

———. "The Sawley Map and Other World Maps in Twelfth-Century England." *Imago Mundi* 49 (1997): 3–42.

Williams, John. "Isidore, Orosius and the Beatus Map." *Imago Mundi* 49 (1997): 7–32.

⌐Surveys

Beazley, C. Raymond. *The Dawn of Modern Geography.* 3 vols. London, 1897–1906.

Crone, G. R. *Early Maps of the British Isles A.D. 1000–A.D. 1579 with Introduction and Notes by G. R. Crone, M.A.* London, 1961.

Dilke, O. A. *Greek and Roman Maps.* London, 1985.

Kimble, George H. T. *Geography in the Middle Ages.* London, 1938.

⌐Reproductions

Harvey, P. D. A. *Mappa Mundi: The Hereford World Map.* London, 1996.

Kamal, Prince Youssuf. *Monumenta Cartographica Africae et Aegypti.* 5 vols. Cairo, 1921–51.

Miller, Konrad. *Mappaemundi: Die ältesten Weltkarten.* 6 vols. Stuttgart, 1895–98.

Nordenskiöld, A. E. *Facsimile-Atlas to the Early History of Cartography with Reproductions of the Most Important Maps Printed in the XV and XVI Centuries.* Translated from the Swedish original by Johan Adolf Ekef and Clements R. Markham. 1889. Reprinted with a new introduction by J. B. Post. New York, 1973.

———. *Periplus: An Essay on the Early History of Charts and Sailing-Directions, translated from the Swedish original by Francis A. Bather, with numerous reproductions of old charts and maps.* Stockholm, 1897.

Chapter 16: Rolls and Scrolls

Avery, Myrtilla. *The Exultet Rolls of South Italy.* Princeton, 1936.

Bauer-Smith, Charlotte. "Lineage, Language and Legitimacy: Visual and Textual Modes of Genealogical Display." Master's thesis, University of Illinois, 1999.

Bäuml, Franz, and Richard Rouse, "Roll and Codex: A New Manuscript Fragment of Reinmar von Zweter." *Beiträge zur Geschichte der deutschen Sprache und Literatur* 105 (1983): 192–231, 317–330.

Bühler, Curt. "A Middle English Prayer Roll." *Modern Language Notes* 52 (1937): 555–62.

Cavallo, Guglielmo, ed. *Exultet: Rotoli liturgici del medioevo meridionale.* Rome, 1994.

Delisle, Léopold V. *Rouleau mortuaire du b. Vital, abbé de Savigni, contenant 207 titres écrits en 1122–1123 dans différentes églises de France et d'Angleterre.* Paris, 1907.

De necessariis observantiis scaccarii dialogus, commonly called Dialogus de scaccario, by Richard, son of Nigel, Treasurer of England and Bishop of London. Edited by A. Hughes, C. G. Crump, and C. Johnson. Oxford, 1902.

Fossier, François. "Chroniques universelles en forme de rouleau à la fin du moyen âge." *Bulletin de la Société nationale des Antiquaires de France* (1980–81): 163–83.

Gilson, J. P. *An Exultet Roll Illuminated in the XIth Century at the Abbey of Monte Cassino Reproduced from Add. MS. 30337.* London, 1929.

Poole, Reginald Lane. *The Exchequer in the Twelfth Century: The Ford Lectures Delivered in the University of Oxford in Michaelmas Term, 1911.* 1912. Reprint, London, 1973.

Rice, Eugene F. *Saint Jerome in the Renaissance.* Baltimore, 1985.

Robbins, Rossell Hope. "The 'Arma Christi' Rolls." *Modern Language Review* 34 (1939): 415–21.

Rouse, Richard H. "Roll and Codex: The Transmission of the Works of Reinmar von Zweter." *Münchener Beiträge zur Mediävistik und Renaissance-Forschung* 32 (1982): 107–23. Reprinted in Richard H. Rouse and Mary A. Rouse, *Authentic Witnesses: Approaches to Medieval Texts and Manuscripts,* 13–29. Notre Dame, IN, 1991.

Triggiano, Tonia. "Piety among Women of Central Italy (1300–1600): A Critical Edition and Study of Battista da Montefeltro-Malatesta's Poem in Praise of Saint Jerome." PhD diss., University of Wisconsin, 1999.

Wettstein, Janine. "Un rouleau campanien du XIe siècle conservé au Musée San Matteo à Pise." *Scriptorium* 15 (1961): 234–39.

Index